THE TRADITIONAL ARTIST IN AFRICAN SOCIETIES

Warren L. d'Azevedo, Editor

THE TRADITIONAL ARTIST IN AFRICAN SOCIETIES

Indiana University Press | *Bloomington & London*
for International Affairs Center

TO MELVILLE J. HERSKOVITS

for whom individual creativity was the essence of humanity, and who persistently urged his students and colleagues to discover the art in culture.

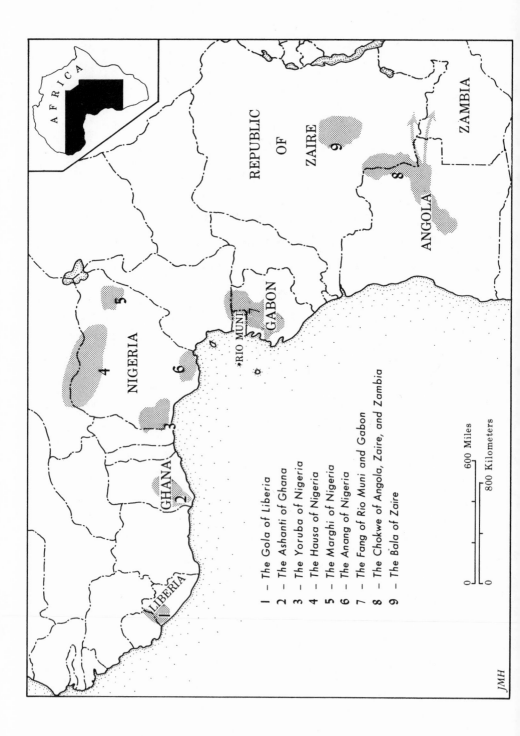

AFRICA

REPUBLIC
OF
ZAIRE

ZAMBIA

ANGOLA

GABON

RIO MUNI

•RIO MUNI

NIGERIA

GHANA

LIBERIA

1 – The Gola of Liberia
2 – The Ashanti of Ghana
3 – The Yoruba of Nigeria
4 – The Hausa of Nigeria
5 – The Marghi of Nigeria
6 – The Anang of Nigeria
7 – The Fang of Rio Muni and Gabon
8 – The Chokwe of Angola, Zaire, and Zambia
9 – The Bala of Zaire

0 600 Miles
0 800 Kilometers

JMH

CONTENTS

II: COMMENTARIES

ILLUSTRATIONS

xi

NOTES ON CONTRIBUTORS

Relevant publications of each of the authors appear in the Bibliography of this volume.

David W. Ames

Professor of Anthropology at California State University, San Francisco. Research interests: Afro-American and African ethnology, economic anthropology, ethnomusicology and folklore. Field investigation: Havana tenement residents, Cuba, 1948; rural Wolof of the Gambia, 1950 and 1951; Menominee Indian Reservation from 1955 to 1957; at Oaxaca, Mexico, 1960 and 1962; the Hausa and Igbo of Nigeria, 1963 and 1964.

William Bascom

Professor of Anthropology and Director of the Robert H. Lowie Museum of Anthropology at the University of California, Berkeley. Research interests: West African ethnology, religion, art and folklore. Field investigation: the Kiowa Indians of Oklahoma, 1935; the Yoruba of Nigeria, 1937 and 1938; the Gullah of Georgia and South Carolina, 1939; at Accra, Ghana, from 1942 to 1945; Ponape in the Caroline Islands, 1946; Cuba in 1948; the Yoruba of Nigeria from 1950 to 1951, 1960 and 1965.

Daniel J. Crowley

Professor of Anthropology and Art at the University of California, Davis. Research interests: Afro-American and African ethnology, ethnoaesthetics and folklore. Field investigation: West Indies, from 1952 to 1958; collections of European ethnographic museums in 1959; the Chokwe and Luena of Zaire, 1960; at Michoacan in Mexico, 1962; Trinidad, 1966; Ghana, 1969 and 1970.

Warren L. d'Azevedo

Professor of Anthropology at the University of Nevada. Research interests: African and North American ethnology, ethnohistory, social organization, religion and ethnoaesthetics. Field investigation: the Washo Indians of California and Nevada, intermittently between 1952 and 1955, 1963 to the present; the Gola of Liberia, 1956 and 1957; the western province of Liberia, 1966 and 1967.

K. Peter Etzkorn

Professor and Chairman of the Department of Sociology and Anthropology at the University of Missouri. Research interests: ethnomusicology, the sociology of music and leisure.

James Fernandez

Professor of Anthropology at Dartmouth College. Research interests: cultural change, religion and cognitive behavior. Field investigation: Gabon, Cameroon, and Rio Muni from 1958 to 1960; Natal, 1965; Togo, Dahomey and Ghana, 1966; Northern Spain, 1971 and 1972.

John Ladd

Professor of Philosophy at Brown University. Research interests: ethics, legal and political philosophy. Field investigation: the Navaho Indians of the American Southwest, 1951 and 1952.

Alan P. Merriam

Professor of Anthropology at Indiana University. Research interests: ethnomusicology of North American Indians and of Africa south of the Sahara, the arts in culture. Field investigation: the Flathead Indians of western Montana, 1950 and 1958; Zaire, Ruanda and Burundi, 1951 and 1952; the Basongye of Kasai Province, 1959 and 1960.

John C. Messenger

Professor of Anthropology at Ohio State University. Research interests: African and European ethnology, religion, folklore, acculturation, sexual behavior, personality and culture. Field investigation: the Anang Ibibio of Nigeria, 1951 and 1952; the Aran Islanders of Ireland, 1958 to 1968; the Montserrat Islanders of the West Indies from 1965 to 1972; Northern Ireland, 1968 to 1971.

George Mills

Professor of Anthropology at Lake Forest College, Illinois. Research interests: ethnology of the American Southwest, art and culture, the individual in society. Field investigation: the Navaho and other peoples of New Mexico and Arizona from 1946 to 1952.

J. W. Kwabena Nketia

Professor and Director of the Institute of African Studies at the University of Ghana, and Professor of the Department of Music at the University of California, Los Angeles. Research interests: African music, literature and arts.

Roy Sieber

Professor of Art History at Indiana University. Research interests: comparative art, the arts of Africa. Field investigation: Nigeria, 1957 and 1958; Ghana, 1964, 1966 and 1967; Nigeria, 1971. Museum of Modern

Art exhibition *African Textiles and Decorative Arts* (New York, Los Angeles, San Francisco, Cleveland), 1972–1973.

Robert Farris Thompson
 Associate Professor of the History of Art at Yale University. Research interests: African and Afro-American art history. Field investigation: the Yoruba of Nigeria from 1962 to 1965; western Cameroon, 1969.

James H. Vaughan, Jr.
 Professor and Chairman of the Department of Anthropology at Indiana University. Research interests: African ethnology, social change and political anthropology. Field investigation: the Marghi of Cameroon and Nigeria, 1959 to 1960 and 1971.

ACKNOWLEDGMENTS

THE AUTHORS whose work is presented in this volume are indebted to a number of individuals and agencies for their aid toward this collective endeavor. In particular, we wish to note the support of the Joint Committee on African Studies of the American Council of Learned Societies and the Social Science Research Council which utilized a grant from the Ford Foundation to sponsor a Conference on the Traditional Artist in African Society at Lake Tahoe Alumni Center of the University of California on May 28–30, 1965. Indiana University and the Desert Research Institute of the University of Nevada co-sponsored the event. Those participating in the Conference included the ten writers of ethnological papers and the four discussants whose contributions appear in this volume. Also participating were the members of the Joint Committee on African Studies who—in addition to Alan P. Merriam, its chairman and Roy Sieber—were L. Gray Cowan, Phillip D. Curtin, William O. Jones, Horace M. Miner, and Benjamin E. Thomas. Rowland L. Mitchell, Jr., Staff Associate of the Social Science Research Council, provided continuous guidance and encouragement in the planning of the Conference as well as toward the eventual publication of the papers.

The publication of this volume was finally made possible by a subsidy from the International Affairs Center and the sponsorship of the African Studies Program at Indiana University. We wish also to express appreciation to Mrs. Edith Greenburg Albee, Editor, International Affairs Center Publications, Indiana University Press, and to Mrs. Lou Ann Brower, the manuscript editor, for their expert advice in the preparation of these materials for publication. Mrs. Alma Smith is to be thanked for her valuable services as secretary to the Conference and her patient reading and typing of the many revisions of the manuscript.

PREFACE

In RECENT years social scientists—perhaps especially anthropologists—
have become increasingly interested in the study of artistic aspects of
culture. In part, at least, this interest is a response to a certain im-
balance in available publications, which tend to concentrate largely
upon the technical aspects of art in human society. Also, the artistic
aspects of culture are a legitimate concern of the social scientist in his
search for an understanding of all facets of human behavior.

A number of possible approaches present themselves to the student
of the arts; any one of these approaches may constitute a specialty, but
all are closely interrelated. One of them involves the technical struc-
tural aspects of art products; that is, the student must know and
understand form, styles, tools, techniques, media, and other factors in
the analysis of, let us say, the visual arts. In music he must be able to
discern elements of melody, rhythm, form, harmony, counterpoint,
and the relationships among them; dance requires knowledge of hu-
man motor behavior, the spatial context, and the use of rhythm
patterns; and similar kinds of problems are present in the study of
other arts.

A particular art may also be studied in terms of its organization as
human behavior. Of importance here are the physical behavior which
goes into producing the art product, the verbal behavior which sur-
rounds its production as well as the contemplation of it, the cognitive
behavior which underlies its production, and the social behavior of
those who produce it and those who respond to it.

A related approach involves the context of human societies. Art
commands the interest of social scientists, whose basic assumption is
that societies and cultures are not composed of unrelated bits and
pieces of behavior, but rather are integrated entities. Thus art func-
tions in meaningful ways in relation to political and social structure,

to religion, education, economics; indeed, to all facets of human experience.

The historical approach potentially includes any or all of the above factors in the study of persistence and change. Form, style, modes of production and functions of products, and the interrelationships of arts and culture are studied not only independently but as aspects of the larger study of cultural dynamics.

These various approaches have seldom been successfully interrelated in studies of the arts, and yet their fusion is sought by those who endeavor to understand the arts to the fullest possible extent. The failure to do so results primarily from a lack of information concerning art as human behavior and the relationship of that behavior to other behaviors in a given society. While the literature abounds with technical as well as historical descriptions of aspects of music, art, oral literature, and even to some extent dance and drama, we know virtually nothing of the artist as a creative member of his society, of the ethnoscientific views of the arts shared by members of cultures, of the cognitive processes involved, or even of the descriptive terminology employed in societies other than our own.

It was with this challenge in mind that the present writers first suggested the possibility of a "Conference on the Traditional Artist in African Society" to the Joint Committee on African Studies of the American Council of Learned Societies and the Social Science Research Council at its meeting of April 27–28, 1963, in Palo Alto, California. By June, 1963, a formal proposal prepared by Warren d'Azevedo had been approved by the Committee and he consented to serve as chairman of the proposed conference. In May, 1964, a letter of invitation was sent to potential participants which read, in part, as follows:

The Conference will deal with three fundamental issues. The first concerns the role, status and social function of those Africans who produce objects considered artistic by Western observers. The second involves the definition of art, and whether Western concepts and theories about art and esthetics are sufficient for cross-cultural identification of art—either through "works of art" or through observation of modes of social behavior which produce these objects. The third issue is that of the universality of art, its expression in different kinds of societies, its degree of institutionalization, and the possiblity that a formal definition of art may lead to the conclusion that in some societies artistic activity is minimal or even lacking, or that we are dealing with a social phenomenon which is manifested in vastly divergent and multiple ways among human societies. These prob-

lems, it must be emphasized, will be approached through the accumulation of basic data on the artist himself, as presented in the Conference papers.

In response to the invitation, ten Africanists agreed to write papers which would provide the basic data around which the conference was to be structured. In addition, four discussants were invited from the fields of fine arts, philosophy, sociology, and anthropology to prepare initial comments on the papers, and all of these materials were distributed among the participants well in advance of the conference itself.

The ten basic papers were presented by their authors at the sessions of a graduate seminar on "The Humanities in Sub-Saharan Africa" conducted by the present writers at Indiana University during the spring semester of the 1964 academic year. Thus all participants had the opportunity to present their papers to a critical audience and to revise them before the conference.

Following the conference, the authors were asked to prepare final versions of their papers for publication, and the discussants were invited to contribute written commentaries. Much careful and time-consuming work has gone into revisions and the editing of the papers for the present volume. Neither the conference nor this volume could possibly address all of the problems in the study of the arts which were raised initially by the planners, and certainly none of the participants would suggest that any final resolution was achieved. But in our view the achievement remains one of considerable importance in bringing forward new data and fresh insights concerning the artist in society and culture, and in providing the participants an opportunity to examine collectively the intriguing and long-neglected question of the social functions of the arts in different societies. Warren d'Azevedo's introduction to this volume and the papers of the discussants in Part II raise some of the broader questions dealt with at the conference, but it has been our mutual discovery that the field is too new and vast to allow any encompassing summary of the results. It is hoped, however, that the way has been opened for new lines of investigation by social scientists of arts and the artist in society and culture.

Alan P. Merriam
Roy Sieber

THE TRADITIONAL ARTIST IN AFRICAN SOCIETIES

In one way or another esthetic pleasure is felt by all members of mankind. No matter how diverse the ideals of beauty may be, the general character of the enjoyment of beauty is of the same order everywhere. . . . The very existence of song, dance, painting and sculpture among all the tribes known to us is proof of the craving to produce things that are felt as satisfying through their form, and of the capability of man to enjoy them.

<div align="right">

FRANZ BOAS (1927:9)

</div>

. . . I will postulate the esthetic impulse as one of the irreducible components of the human mind, as a potent agency from the very beginnings of human existence. In other words, I hold with Jochelson that 'the esthetic taste is as strong and spontaneous a longing of primitive man as are beliefs.' Accordingly, its interaction with other such elements rather than its derivation from qualitatively distinct phenomena will form the subject of this chapter; nay, I shall not be afraid to suggest that sometimes the ostensibly religious is rather to be traced to an esthetic source than vice versa.

<div align="right">

ROBERT H. LOWIE (1924:260)

</div>

Philosophy, from its earliest recorded days, has struggled with the problem of whether the impulse to create and appreciate beauty is inherent in man's nature; whether beauty, in itself, arises out of a conception of what is held to be beautiful or transcends the ways in which beauty is manifested. The universality of the drive to embellish useful objects, often so elaborately that the utility of an implement is lessened in the process, has posed questions that seriously embarrass those who have interpreted human experience in strict rationalistic terms.

<div align="right">

MELVILLE J. HERSKOVITS (1948:378)

</div>

INTRODUCTION

AFRICAN art has fascinated the Western world for more than a century and this fascination has given rise to a vast literature of description and criticism by scholars unfamiliar with the way of life of African peoples and without first-hand knowledge of the conditions or processes by which their art was produced. Museums, galleries, libraries and private collections have housed a plethora of alien things divested of their real humanity, their culture. The creators of these things have been largely anonymous, and the social functions of their activities as well as their creations have been the subject of boundless speculation. Until quite recently this general approach to non-Western art had accustomed us to a peculiar appreciation of songs without singers, tales without tellers and sculpture without sculptors wrenched from an exotic and unreal nether world—the realm of "primitive peoples."

As Gerbrands (1957:62–66) has pointed out, it was not until well after the turn of the twentieth century, and mainly under the influence of Boas, that art began to be a subject of field research in its own right. Many of the earliest efforts of this kind were carried out in areas of west and central Africa long recognized for the prolific and highly specialized productivity in certain forms and media of artistry which had attracted the admiration of European artists and critics. And it was in Africa that, with few exceptions, investigators at last turned their attention to the study of artists themselves. Olbrechts, Himmelheber, Herskovits, Cordwell and Vandenhoute were among the few who attempted to identify the artist as an individual and as an active participant in the cultures of non-Western peoples. Yet it is a matter of some significance that the promise of such pioneering work has not given rise to any appreciable growth of interest in the study of comparative art and aesthetics on the part of modern social scientists. This general neglect of the subject is all the more remarkable in view of the important place that it has had as a major concern of Western thought.

1

In the late nineteenth century artistry as a prime manifestation of the creative processes of technology was one of the central concerns of the study of man. The apparent freedom of art, its power to express ultimate human values, and its access to the wellsprings of sentiment gave promise of discoveries about human need and motive beyond the provinces defined by rationalistic models of social behavior. What, for example, are the sources and effects of individual human inventiveness in social systems: to what extent, and by what means, does any society achieve integration; how do societies change; what is the relation of the pliable and ambiguously bounded entity of culture to ostensibly basic institutions? And, consequently, what are the bounds of humanity and of the self-consciously probing human mind?

These and many other questions—some of them, if rephrased, as ancient as recorded thought—strained the limits of social inquiry, and for this reason art and aesthetics were seldom felt to be outside the scientist's concern and were appealed to as potential sources of new insight. Weber, Durkheim, Freud, Sorokin, and Boas, working in the vigorous intellectual climate of the turn of the century, were among many who attempted a theoretical placement of artistry in social analysis. However, at the same time that a theory of art clearly delineated from religious, recreative, and other expressive behaviors was in the making, social science recoiled from the evolutionary concepts and grand designs of the past century. The study of art and other aspects of culture that did not readily fit into the rigors of scientific method were swept out of favor along with Social Darwinism.

The reaction against the excesses of nineteenth-century social evolutionism, along with the rapid accumulation of new data from comparative ethnology, engendered a legitimate distrust of generalizations derived from anticipations of our own culture. The notion that European institutions represented a pinnacle in a unilinear scale of progressive development collapsed as knowledge of the enormous variety of human cultural and social forms increased and as a skeptical relativism replaced earlier assurances. Emphasis was placed upon empirical research and the obligation to study each society in its own terms. The test of cross-cultural validity was applied to any statement that purported either to illuminate a common human condition or, conversely, to delimit the range of any cultural expression as the property of particular societies. Interest was focused on the nature of society itself and the discovery of those fundamental structures and other conditions that might be considered a requirement of any viable social system. Scientific investigation of political and economic relations, of

kinship and law, of religion and communication have advanced to the point where they can be empirically and analytically differentiated as interrelated systems of society. They constitute, it seems, the stuff of crucial institutions and suggest to us certain universal categories of human social organization.

Art and aesthetics, having been linked to the most speculative and inconclusive flights of earlier theory, seemed so interwoven with European romantic humanism that they were quickly relegated to low priority in research. They came to represent a congeries of disparate approaches and insular objectives—the special preserve of philosophers, art historians, and critics into which the social scientist might intrude only occasionally on an expedition of peripheral interest.

It was the anthropologists whose pioneering studies brought into bold relief the creative vigor of non-European peoples living under a great variety of social and environmental conditions, undermining the myopic view that European society and arts represented an exemplary and culminative tradition for mankind. And yet anthropology too has assigned low priority to the study of art and aesthetics. The ethnological study of art has scarcely advanced beyond the formal analysis of design, distribution of styles, or the function of products presumed to be art within a social context. A recent and unprecedented effort to evaluate the status of scholarship in comparative art reveals that despite the steady accumulation of empirical studies there are large areas of the world for which systematically collected data are lacking. The range of materials discussed as art is limited to forms either arbitrarily or conventionally designated as such by investigators, and there is little development in theory and method. Anthropologists and other students differ widely among themselves over such issues as the scope of the field, the problems of first importance, and the relevance of art for their disciplines or individual research orientations (Haselberger 1961).

It is particularly noteworthy that the art historian has emerged as the major arbiter of ethnological materials concerning art and is producing significant writings to which social scientists must eventually turn when the inevitable revival of interest in art and aesthetics occurs. The increasing participation of art historians in the symposia of anthropological meetings and their close working association with those anthropologists who maintain an interest in the subject is a significant though quite recent development. It has provided considerable stimulus to new research and the reassessment of concepts. However, the emphasis continues to be placed on a narrow range of artistic products

such as sculpture in wood, stone, or metals, while the relationship of many other expressions of artistry to a more encompassing field of study remains undefined. Dance, music, oral literature, drama, architecture, painting, and a vast variety of other possible media for artistic activity have attracted the interest of very few modern anthropologists or other social scientists. No organized body of concepts about art obtains within the disciplines and there is but minimal agreement on the boundaries of the field.

This general avoidance of aesthetic and artistic phenomena by students of human behavior in the mid-twentieth century has been noted occasionally by members of the various disciplines (e.g. Langfeld 1936; Munro 1948, 1963; Morgan 1950; d'Azevedo 1958; Barnett 1959; and Devereux 1961). A few have attempted an explanation of the trend. Harry Lee (1947), for example, refers to it as "the cultural lag in aesthetics." He suggests that social scientists have come to look upon art as the last bastion of mystification after the conquest of religion, as an aspect of human experience incompatible with the hard facts of social structure and process. In his view, the avoidance of art is a result of "the scientist's misconception of his problem," and "our lifelong indoctrination by culture with the idea that art is an echo of divinity."

Writing a decade earlier, and in a similar vein, John Mueller (1938) suggests that the growing isolation of the arts from social analysis could be attributed to the tenacity of a number of folkways about art and aesthetics, most particularly the view of art as a luxury, an escape, or an autonomous experience. In essence, social science has abdicated its responsibilities to a field opened by earlier students of human society, and succumbed to ethnocentrism in accepting the romantic conception of artistic activity maintained in Western culture.

As Peter Etzkorn points out in this volume, there is a peculiar incongruity between the apparent general acceptance by social scientists of the universality of art and their lack of a systematic search for some explanation of that assumption. Despite the great number of specific studies that deal with particular aspects of aesthetic or artistic behavior, or with products of this behavior, few contemporary sociologists have attempted any comprehensive coverage of the field or dealt with art as a major institution of society. Consequently, in sociology as well as the other social sciences there is little common ground concerning either the nature of art or its place among relevant subjects of inquiry.

The dilemma seems identical to that described by Spiro (1968) in his discussion of definitional controversies about the nature of religion.

He points out that most studies of religion in social science are not concerned with the explanation of religion, but with the explanation of society. Definitions emerge out of essentially jurisdictional disputes over the range of phenomena that should be considered as empirical referents of the term, while the question "What is religion?" is relegated to a realm of impounded queries awaiting future development of relevant psychological or motivational research. Yet assumptions about the universality of religion, its function as a prime factor in social solidarity or as the fulfillment of some basic human "need," continue to appear in generalizations, perhaps as a convention that was inherited from earlier theory or in anticipation of validations promised by research in progress. A special source of confusion is what Spiro (1968:86–87) calls the "obsession with universality" that permeates our thinking about ostensibly requisite sociocultural phenomena. He writes:

This insistence on universality in the interests of a comparative social science is, in my opinion, an obstacle to the comparative method for it leads to continuous changes in definition and, ultimately, to definitions which, because of their vagueness or abstractness, are all but useless. (And of course they commit the fallacy of assuming that certain institutions must, in fact, be universal, rather than recognizing that universality is a creation of definition.)

But this does not mean that the making of definitions is a worthless task. To the contrary, it calls for the construction of workable definitions, the value of which is not made contingent upon universal application—"an ostensive or substantive definition that stipulates unambiguously those phenomenal variables which are designated by the term." While this approach does not remove religion from the arena of definitional controversy, "it does remove it from the context of fruitless controversy over what religion 'really is' to the context of formulation of empirically testable hypotheses which, in anthropology, means hypotheses susceptible to cross-cultural testing." Spiro argues that merely because a term has cross-cultural application does not imply universality. Moreover, a term such as "religion" has "historically rooted meanings" that must satisfy "the criterion of intra-cultural intuitivity" as well as the criterion of comparative application (Spiro 1968:91).

"Art," too, is a term with historically rooted meanings and has been the subject of definitional controversies in Western thought for at least as long as—and often in close association with—religion. However,

unlike the case for religion, remarkably little of the search for explanation of art has taken place within social science. The relevant empirical referents of art are taken for granted, and these have been narrowed almost exclusively to the description and analysis of its formal products in our own and other societies. Implications of universality underlie textbook discussions of art as well as specialized studies, and we are frequently assuming the universality of something for which our definitions are both inadequate and inappropriate, and to which our empirical referents are not clearly related. This, together with the fact that social scientists borrow their language for discussion of aesthetics and art largely from other disciplines such as philosophy, psychoanalysis or psychology, makes difficult the communication of results for comparative purposes.

It is clear that a new approach is needed in the study of the arts of our own society as well as in comparative studies—one that would concentrate on artists and their public. This is the most neglected of the four primary tasks for the comparative study of art that have been singled out by Haselberger (1961:343): the detailed systematic study of individual art objects; biographical data on the artist; the study of art in the whole structure of the culture; and the history of art in particular societies. These tasks are mutually dependent but have been carried out very unevenly. Efforts to understand the artist as producer and as a member of society have been given the least attention. The problem, rather than one of "biography," however, is essentially one of identifying a type of individual behavior and a type of social action that can be designated as the loci of artistry.

This is the crux of the matter, at least for the social scientist. As long as art is conceived only in terms of its results, no social theory of artistry is possible. Artistry is no more the exclusive property of "art objects" than religiosity is of ritual or of sacred emblems. If a phenomenon such as "art" exists at all, it comprises a sector of sociocultural behavior in which observable acts, ideas, and products cluster in such a way as to be distinguishable from other behaviors. In this sense social science has not used the same approach to art as it has for other aspects of society and culture. Art remains an enigma, not because its secret is locked in unexplored recesses of the human mind among the mysteries of the creative process, but because we are almost entirely intent upon studying its manifestation in arrested forms rather than the more inclusive and dynamic arena of its social expressions.

The authors of the ethnological papers in this volume were confronted directly with these issues when they undertook to deal with

artistry in a number of African societies in terms of the artist's role rather than in terms of the form and functions of the products alone. They proposed to view art as a way of doing, a way of behaving as a member of society, having as its primary goal the creation of a product or effect of a particular kind. This means giving emphasis to persons and social events rather than to artifactual objects abstracted from either the processes of production or consumption. The term art is immediately broadened in scope, for its referents must include the values, motives, and acts of individuals as part of interacting groups—that is, its reference is to an aspect of social organization.

However, the task is easier stated than done. Our problem is complicated by the fact that we share the normative predilection in Euro-American culture for thinking of art as *things*—especially that unique category of aesthetic things denoted as the fine arts. At the same time, the word carries with it some of its earlier connotation of a special skill or technique. But it is the former meaning of the word that usually directs our determination of certain materials in non-Western cultures as art. These designations are made by analogy. The formal elements of an alien product strike us as remotely familiar and as serving a purpose similar to something in our own culture. The actual conditions of their creation, the motivations of those who produce them or of those who respond to them, are largely assumed. Much of the attribution of universality to art and aesthetic evaluation has been based upon conjecture of this kind.

The problem for social scientists studying art is made even more difficult because of the high degree of specialization and professionalism of certain artistic activities in our society and the existence of formal aesthetic standards and traditions of criticism with regard to them. The apparent absence of these factors, as well as the lack of clearly explicated concepts equivalent to *art* or *aesthetics* in most non-Western cultures, has caused us to suspect that the expression of artistry may be somehow fundamentally different from our own. It seems less divorced from the ordinary activities of life, more accessible to all, and more practical. We frequently distinguish these creative expressions as "utilitarian," "applied," or "folk" in the same sense that creative phenomena other than the "fine arts" in our society are distinguished. Terms like "craftsman" or "artisan" serve much the same function, distinguishing a person with marginal orientation to art from the supposedly more creative and independent "artist."

The epitome of art has come to be that which is not profaned by popular interpretation or susceptible to mundane uses. As one writer

has said, art in our society stands by itself, and for itself, to be appreciated by those "who command the leisure to pursue their avocation." Moreover, "considerations of utility, or associations with everyday living render the object, the melody, the poem, something less than a work of art." In contrast, "it can safely be said that there are no non-literate societies where distinctions of this order prevail. Art is a part of life, not separated from it" (Herskovits 1951:378-379).

In a similar vein, Firth writes:

Primitive art is highly socialized . . . in many respects it is the handmaid of technology. One of its great applications is for the adornment of objects of everyday use—spears, pots, adze handles, fish-hooks, boats. In Western culture most people seem to think of art as something that no ordinary citizen has in his home. . . . In a primitive community, art is used by the ordinary people, in embellishment of their domestic implements, and in their ordinary social gatherings. . . . All this means that the primitive artist and his public share essentially the same set of values. It means that, in contrast to what is generally the case in Western societies, the artist is not divorced from his public. (Firth 1951: 171-173)

Herskovits and Firth have been foremost among those few modern anthropologists devoting serious attention to the study of art in non-Western societies, and reveal the core of the difficulty in our approach to the comparative study of art. Without an adequate social theory of art, the social scientist tends to rely upon the normative attitudes of his own society—the stereotype of the alienated art and artist derived from the conflicting ideologies and class interests of industrialized capitalist societies—and to contrast this social role with that of the non-Western artist who is depicted in a state of harmonious connectedness with the world around him.

The type of Western art referred to constitutes, in fact, a very small fraction of the activities and products of art in our society. For every artist who works in a sphere of exalted or reviled independence, whose products are displayed only in museums, theaters, or concert halls, who is available to but a select audience of knowledgeable or affluent appreciators, there are thousands applying their special talents to the adornment of objects of everyday use, and in ordinary social gatherings. The enormous fecundity of artistic production in our society extends into every industry, every medium of communication, every market place, and exerts a decisive influence on the selection of every kind of consumer good as well as on the standardization of taste. It cannot be

said that the average citizen of our society is any less inclined to enhance his domestic life with embellishments than the citizen of simpler and more homogeneous societies. A case might even be made for the more varied and intensive use of art throughout Euro-American culture than obtains among our so-called primitive contemporaries. Moreover, it might be argued that art in general is no more separated from life nor is the artist any more divorced from his public in our society than in any other.

It may be misleading to presume that the prolific role-differentiation and institutionalization of art in our society necessarily means that the basic functions of art are fundamentally different in those societies where this complexity does not prevail. A normative, nonanalytic concept of art or the artist, derived from a particular tradition of our own culture, cannot be expected to comprehend either the manifold expressions of artistry in our society or in others any more than the formal tenets and social structure of Protestantism would comprehend the varieties of religious expressions among human groups. If the assumption of universality is to be tested, our concept of art must cut through our constricted and often arbitrary designations of only certain of its manifestations and must identify its distinctive character in diverse kinds of human behavior. Social science has progressed little in this direction, and Sorokin's (1937:198) challenging statement to students of art history some thirty or more years ago is still pertinent to the task before us:

It goes without saying that many art phenomena, and especially the constituent or generic elements of art phenomena, recur in space as well as in time. Otherwise we should not be talking of *art* of primitive and "civilized" peoples; of Greece, Babylon, Egypt, Russia, or France; of the Ancient period, the Middle Ages, or modern times. Since it is *art* and not something else (say law or science) that is thought of as appearing in all these societies, the constituent elements of this class of social phenomena must be the same everywhere and at any time that its phenomena are found and designated by the single term *art*. In spite of everchanging concrete forms in this mutable Becoming, there remains an unchangeable kernel of Being which generically, whether as a reality or a concept, always and everywhere remains the same.

The core problem of the ethnologist studying art in another culture becomes the identification of *the artist*, the person who performs the acts of artistry. Here we are faced with difficulties much like those of identifying the products of art, but with fewer comforting precedents

that tend to shield us from recognizing our avoidance of central issues. In the absence of a general theory of art there are a number of alternative approaches possible. One is to designate the artist as anyone who has produced the things which conventionally have been taken to be art by other investigators from our society and thus to avoid altogether the problem of definition. Another approach is to employ a convenient normative concept of artistry from our own culture to make distinctions between persons who seem more creative in ways familiar to us—"artists"—and persons whose activities and products seem more routinized by the prescriptions of tradition or utility—"craftsmen." Or, one may attempt to set aside preconceptions altogether, as well as the Western words which embody them, hoping that native concepts and patterns will emerge from investigation uncontaminated by anticipation. Though this has the aura of ideal scientific objectivity in cross-cultural research, its actual implementation often proves to be illusory and its results tacitly antitheoretical. Still another approach attempts to construct preliminary hypotheses about the nature of artistry in any society which provide a statement of the variables one expects or does not expect to be denoted by the term. This approach makes its premises explicit, and the inevitable element of arbitrariness in definitions becomes more susceptible to comparative testing and is a stimulus for the building of theory.

All of these approaches are represented in varying degrees among the papers presented here. The study of art is in a sense at the mercy of the subjective and diverse orientations of independent investigators each with what George Mills, in this volume, calls his own "anthropological lens" tempered by his personality, his culture, and the predilections accumulated in his special training and research. Consequently, attempts to define art are likely to be conceptually ambiguous and eclectic in terminology. John Ladd and Roy Sieber, in somewhat different terms, express the same concern: that most of the authors of these papers are, to some extent, guilty of ethnocentrism by the tacit application of Western concepts of art, artist, and aesthetics to non-Western cultures. Ladd, for example, sees a tendency among the authors to rely on ad hoc definitions rather than to *discover* actual relationships and relevant meanings within the cultures themselves. He believes that such concepts as "art" and "aesthetics" are not definable in the same sense as the technical constructs of science, and that to attempt to submit them to technical definition destroys their open-textured quality and distorts our perception of the reality. Sieber goes on to state that culture-bound definitions have characterized most

Western comment on the arts of other peoples and have been applied to Subsaharan Africa "with the inevitable result that our understanding of those arts has been warped." Peter Etzkorn, on the other hand, finds that "the ideological overtones characteristically found in descriptions of art activities in the West are notably absent in these papers. This may be attributed primarily to the successful effort of these anthropologists to avoid imposing their own."

These differing assessments of one aspect of the approaches taken by the contributors to this volume underscore the initial difficulty which faces contemporary students of aesthetics and art as social phenomena. All of the contributors, whether their views were expressed in conference discussion, in their papers, or both, were faced with the problem of reappraising—and, in some instances, discovering—the functions of artistry in the societies which they had studied and of dealing with it in a framework amenable to cross-cultural comparison. In most of the ethnological papers the problem is made explicit by the writers who felt compelled to re-examine the premises which had guided their selection of certain artists or art products for analysis. A few hint at impatience with what might be construed as a premature requirement to define art universally or even with reference to a particular society. Still others have let the materials speak for themselves and do not attempt a justification of their use of the terms.

While there was preliminary agreement among all the contributors to focus attention upon the artist rather than on products of art, it was neither intended nor expected that the participants would adhere closely to any suggestion of common format or statement of general concerns as contained in the initial conference call (see Preface). It was understood that each was to approach the task of preparing a paper in terms prescribed by his own orientation and available data. The papers, as well as the conference discussion, were to be conceived as explorations into a potential field of study long neglected by social science, and where previous empirical research as well as theoretical and methodological guidelines were at a minimum.

It was further understood that the papers were to devote particular attention to the "traditional artist" rather than to those who represent new roles and productive processes which have emerged under conditions of European cultural domination and rapid social change in Africa during the twentieth century. This does not mean that the "traditional" artist is not continually responsive to changes and new ideas affecting his socio-cultural environment, but only that his activities are oriented primarily to institutions which derive from the

ancient and relatively conservative local heritage of the indigenous so-
ciety of which he is a part. The role and work of such an artist are in
themselves traditions rather than responses to opportunities or al-
ternatives presented by the more recent urban, national, or interna-
tional spheres of relations. Though this formulation cannot be applied
to make rigid distinctions in the dynamic and flexible societies dealt
with in this collection, it did provide a useful guide to the selection of
comparable subject matter.

Artistic activities are described for nine widely separated societies of
west and equatorial Africa. The Ashanti of Ghana and the Yoruba
and Hausa of Nigeria are peoples who developed large centralized
states. Other peoples such as the Marghi of eastern Nigeria and the
Bala and Chokwe of the Congo, though exhibiting well-defined class
stratification and a history of periodic involvement in extensive con-
federacies, are today members of relatively small and less centralized
societies. The Anang of southeastern Nigeria, the Fang of Gabon,
and the Gola of Liberia represent kin-based societies of even smaller
scale where the largest organizational unit was the politically
autonomous village or chiefdom with minimal class structure and a
considerable degree of cultural homogeneity. All of the societies dealt
with are predominantly agricultural and, with the exception of the
Chokwe and the Ashanti, have kinship systems based upon prin-
ciples of patrilineal descent. Thus, the distribution is scarcely repre-
sentative of the wide range of types of societies in western and
equatorial Africa, while eastern and southern Africa are not repre-
sented at all. We look forward to further studies that will focus on
artists employing the same media in different cultures or on a compari-
son of the dominant expressions of artistry in a number of societies of
different types. The utility of materials for comparative purposes might
be further enhanced by concentrating on a cluster of closely connected
cultures in one region or even by the careful selection of representative
cultures from the major areas of Africa. Certainly the question of the
historical development and changing external relations of societies in
which artistry is observed is due for intensive examination in future
studies.

These critical observations were made by the authors themselves
during conference discussion following the presentation of the papers.
The exchange of views among participants and the assessment of their
collective effort raised a number of questions which may not have been
otherwise noted. In addition to the general comments indicated above,
it was pointed out that most of the papers deal with sculptors and

musicians while four are concerned with singers, orators, smiths and critics. Some brief attention is given to weavers, dancers, storytellers and acrobats. This slim roster of media does not go much beyond the range of types of artistic expression usually identified by Euro-American observers and it underscores the necessity for more exploratory work aimed at the discovery of artistic and aesthetic activities in their varied and less obvious manifestations.

Do woodcarving and musicianship, for example, constitute focal expressions of artistry and aesthetic values in these societies of west and central Africa or have they been given an arbitrary emphasis by observers for whom they represent familiar and particularly attractive creative forms? Do artistic activities and roles actually tend to cluster in the few vocational specializations implied by the writers' selection of materials for discussion, or would further ethnographic investigation and finer analytic distinctions disclose important aspects of artistic behavior in other activities and situations? A related question is posed by the apparent predominance of males as artistic producers. Are women actually less involved in artistic activities and, if so, how is this to be explained with regard to societies such as these in which women frequently perform leading roles in the political, economic and ritual spheres of action?

One of the more intriguing matters raised by the papers is the ambivalent social status which is shown to adhere to most of those performing artistic roles. The activities as well as the products of artistry appear to function as references for remarkably similar role stereotypes among societies of differing historical development, scale and degree of complexity. In a number of instances this phenomenon seems to obtain almost independently of professionalization, of class stratification, or of the existence of vocational castes, associations or guilds. Moreover, producers of artistic effects are frequently shown to have a self-identity and an estimate of their contribution quite distinct from that conferred by their public whether their work is central or peripheral to crucial communal interests. The artist emerges as a mediator—explicit or tacit—between collective and individual striving for expression, a phenomenon reminiscent of the tension in our own society between the alternative roles available to its creative members suggested by Weber's work on religion and Rank's on the artist. This mediation is enacted not only in the context of the relation of artistry to expressive values and myth, but also in social relations involving the exercise of unique creative abilities and the acting out of specific culturally defined roles whose performance and products seem on the one hand to be taken as

essentials and on the other hand as expendable if not disturbing elaborations of the normal conditions of society.

But along with the indication of similarities of this kind there are also some significant divergences. For example, how can we account for the great differences in the degree of expliciteness of aesthetic evaluation between the Yoruba and the Bala? Yoruba criticism of sculpture seems tantamount to an ideology of moral order and elegance. Among the Bala, on the other hand, articulation of evaluative criteria for musicianship appears to be so minimal and so undifferentiated from other cultural processes that the observer is led to conclude that neither art nor a corresponding aesthetic system, as we understand it, can be identified empirically or analytically. It is certainly possible that what is involved here are differences in interpretation affected by selection of particular materials for study, or by the special theoretical orientation and methodology which every observer carries with him into the field. But it is just as likely that the existence of artistry as a separable system does vary greatly from society to society in accordance with the extent and type of institutional complexity and the numerous other historical and structural factors that also concern us in the search for comparative models in the cross-cultural study of religious, political and economic behavior. Neither the assumption of universality—which has been so compelling a notion in our approach to certain social phenomena—nor the assumption that these phenomena are uniquely characteristic of specific types and levels of social development has yet brought us closer to consensus in explanations of art. Our understanding of artistry in society has suffered not so much from the lack of vigorous speculation and generalization as from the dearth of adequate comparative data by which to test our embedded assumptions and to construct eventually the kind of hypotheses and theories that will motivate and guide relevant research in the field.

The authors of this collection of papers are fully aware that they have penetrated only the outer boundaries of a relatively unexplored area of research and that many of the basic problems raised in discussion are far from being resolved. However, the materials brought together here make a most valuable contribution to the current need. The diversity of approaches and points of view raises to high relief many of the fundamental questions which confront social science in the long-neglected study of the artist in society. But also—and of more immediate concern—these papers serve to amplify our meagre store of information about a little known facet of African social relations and culture—the role of producers of artistic effects and the func-

tions of the aesthetic values which they manipulate and share with their fellows. The mutual intent of the authors has been clearly expressed by Boas' dictum concerning the study of the origin of styles and the phenomenon of creative genius: "We have to turn our attention first of all to the artist himself."

Warren L. d' Azevedo

NOTE Five of the authors of papers in this volume used the variant "esthetic" in their original manuscripts (d'Azevedo, Messenger, Etzkorn, Mills, Sieber). For editorial convenience, the usage "aesthetic" has been standardized throughout except, of course, for quotations.

As there have been extensive changes in names of political entities and places since some of these papers were written, the editor has not attempted to bring all such terms up to date except where this was essential for clarity.

I

On African Artists

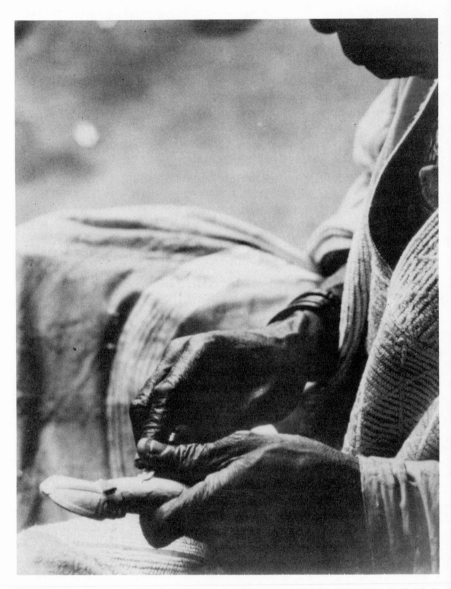

Plate I The Alaga of Odo-Owa polishing a woodcarving with the side of his knife blade.

Robert Farris Thompson

YORUBA ARTISTIC CRITICISM

THERE exists in Subsaharan Africa, locked in the minds of kings, priests, and commoners, a reservoir of artistic criticism. Wherever tapped, this source lends clarity to our understanding of the arts of tropical Africa. The Western scholar may assign value to a work which would elicit equal praise in the compound of a traditional king, assuming the work and critics were from the same African society, but he cannot assume that the reasons for his choice are present in the mind of the native critic.[1]

Africans may admire works of art, or categories of artistic expression, which a Westerner, in the ethnocentric conviction that he had mastered all the relevant issues, might pass over in ignorance. African criticism enriches, in these cases, our sense of definition. By definition I mean the identification and characterization of expressive media which, like African dancing, might pass largely unanalyzed through the filter of Western scholarship. Conversely, consideration of African judgment of African art protects the student from the dangers of reading into a work of art aesthetic principles which might not be present in the native imagination.

More important is the fact that African aesthetics opens onto African sensibility. Aesthetic criticism suggests the relation of art to emotional ideals. These ideals, in turn, reveal the hidden unities which impose meaningful design upon the face of a culture. The mosaic may, of course, be apprehended only in fragments by members of the society.

CONTEXTS OF YORUBA ARTISTIC CRITICISM

Yoruba art critics are experts of strong mind and articulate voice who measure in words the quality of works of art.

Yoruba artistic criticism may occur at a dance feast where the excellence of sculpture and motion becomes a matter of intense concern.

19

In Iperu-Rẹmọn, Nigeria, "loads" (headdresses) for the Orò cult are judged competitively on the basis of sculptural and choreographic appeal. Similarly, in Ajilete, Nigeria, "battles of dance" decide which quarter at a given festival has triumphed and brought glory to the town. The elders of Igogo-Ekiti critically observe the dance movement of young men who aspire to the honor of carrying the senior headdresses of the local Ẹpa cult. Young men of legitimate birth, physical, moral, and artistic powers are chosen. In this way festivals provide a setting of criticism.

In addition to the cult context, where critical acuity seems to increase under the stimulus of expressive sounds and sights, artistic criticism seems to flourish among the Yoruba in those situations where money provides auxiliary excitement or agitation. In the market, workshop, and other places, the quality of a work of art can become the essence of commercial transaction. Here aesthetic products again meet articulated conventional tests of quality. An apprentice, for example, who has attempted to sell an indifferent example of his work to a bona fide patron may find himself called into the workshop of the village master where the master criticizes him (Cordwell 1952:292). The master indicates, either by carving a new piece or by improving the finish of the unsatisfactory work, proper control and care. He tells the carver what went wrong with the work and warns him to do better. The criteria of the master are frequently regarded as trade secrets, which explains why so few have been shared in the past with Westerners.[2]

Mutual criticisms among sculptors are an especially sensitive source of information about Yoruba aesthetics. When a master carver impugns the abilities of a lesser carver, his gestures and facial expression can be as eloquently derisive as his words. Alaga of Odo-Owa, for example, dilated his nostrils with disgust when he met a carelessly rendered Ẹpa headdress at Egbe: "Á! À! the juju gourds are unpleasingly lumpy. The face of the man is crooked. Ó burú tó bẹ̀ẹ̀ gẹ́—it's as bad as bad can be."

Apart from important chiefs and mutual friends, Yoruba critics will not criticize with style and precision unless it is made financially worth their while. This does not mean that they are professional. It simply means that Yoruba live traditionally in a world of money, personal honor, and entourage. By acts of generosity a Yoruba leader proves to his entourage that he is worthy of their acclaim. By the same token, the Western student proves by remuneration that he merits the honor of shared qualitative data. The size of a Yoruba ruler's entourage is a

mark of his generosity and importance (Bascom 1951:496); the quality of the data of the field worker may reflect the amount of money allocated to aesthetic research. This is in character with the importance that Yoruba give to spending money on oral skills. Drummers, for example, find livelihood in the praise of rich men, and one woman of Ikare has earned 75 pounds a year in recompense for prayer of surpassing beauty and force.[3]

The oral art of criticism also moves within the sphere of money. It is certain, moreover, that few traditional Yoruba make gratuitous statements of opinion on any subject in the presence of foreigners. No informant ever discussed with me the notion of multiple souls, but this did not mean that such a belief was not indigenous, as the researches of P. Amaury Talbot (1926:261–2) and William Bascom (1960) attest. We must therefore weigh the following report with special care:

I have never heard a spontaneous discussion on the form, proportion or expression of a piece of sculpture—although I have lived twelve years in Yoruba country and have moved a great deal among priests and worshippers in shrines full of religious carvings. (Beier 1963:6)

This does not imply an absolute lack of spontaneous discussion in aesthetic merits in Yorubaland. It may mean that outside the festival, the commercial transaction involving sculpture, the admonitions of master to apprentice, the mutual criticisms among sculptors, and so forth, it is rare. Entrance into a shrine full of carving clearly does not guarantee an audience with a traditional critic. After all, do Roman Catholics analyze the aesthetic merits of cathedral images when at worship?

A Westerner may be lucky enough to overhear some fragment of spontaneous criticism. By chance I observed a mother of twins abuse an apprentice because he had brought her an image which she said did not resemble a human being. Again by chance I observed the head of the Mẹkọ Gẹlẹdẹ cult motivate his hired carver, by worriedly knitting his brows, to rectify certain proportional improprieties.

Is it possible to distinguish criticism to paying outsiders from ingroup criticism? In both instances critics name abstractions and cite common terminology in order to define the qualities which distinguish aliveness from, say, woodenness. However, it seems likely that critics who are also master carvers may rise to a higher level of nuance and precision in their conversations about quality. In point of fact, some sculptor-critics use a set of analytical verbs which are as sure in effect as the defining strokes of their adzes. These verbs grant them the

power to measure the relative weight and shading of linear properties with an accuracy which might well provoke astonishment in the West.

As in the professional jargon of the social scientist, the proliferation of conceptual vocabulary among the better Yoruba critics "corresponds to an intensely sustained attention toward the properties of reality." This is an instance of Lévi-Strauss' important observation that in their appetite for objective knowledge we have one of the most neglected aspects of the thinking of those whom some still dare to call primitive (Lévi-Strauss 1962:5).[4]

CROSS-CULTURAL IDENTIFICATION OF THE CRITIC

Yoruba qualitative criteria are consensual. This means they are matters of opinion, widely shared, but perhaps only fully comprehended by the guardians of philosophic thought. The best example of the latter are the priests of the divination cult. Yoruba aesthetic criteria are perhaps best nuanced by sculptor-critics who lend to their words their special insights of process and form. But the roots of the criteria lie with the common people without whose supporting testimony the fabric of aesthetic thought loses conviction and certainty.

Aesthetics among the populous Yoruba people is thus the sum of simple statements about artistic quality and the sum of the verbal characterizations which qualify these statements. When the qualifications are weighed it is found that the simplicity of the vocabulary is only apparent. On the other hand, a Westerner might validly draw from random audiences the following conclusion:

I have seen people dancing and singing for a new work of art—but its merits as *art* are not normally discussed. It is possible to hear comments on the craftsmanship. Slovenly surface treatment in a piece of sculpture, and any kind of quick careless work will be condemned. (Beier 1963:6)

What looks like art criticism is here interpreted as conversation on craftsmanship. Nevertheless, *collective* rationalizations reveal true consciousness of aesthetic bearing. Yoruba, for example, consider haste indelicate. Delicacy is almost universally recognized as an important quality in the aesthetic systems of the world.

IDENTIFICATION OF THE AFRICAN CRITIC: The art critic in a traditional African society may be identified first on the basis of whether he has voiced elements which imply a theory of elegance or excellence in art. Secondly, one notes whether the critic successfully applies this theory

to particular cases. In the process, it is possible to distinguish the critic from the appreciator (Ballard 1957:194).

Appreciators identify with a work of art; in their vision the physical facts are in sharp focus, while aesthetic facets are blurred. An example: one evening while the harmattan blew chill into the air, a young man attempted to evaluate a twin statuette by the light of a native lamp. He dealt with the practical virtues of the cap depicted on the image's head; its flaps, he said, protect one from the cold. He had identified with the subject matter. A critic emerged from the shadows around the lamp and criticized the appreciator's lack of insight. He made comments about posture and vigor and qualified one of his standards. Appreciators only identify. Critics both identify (richly reflecting cultural preoccupations) and criticize (on the basis of relative formal elegance).

The most important criterion of identification of African critics is that their standards of judgment be qualified. Estimation of quality on grounds of coiffure may, if no further reasons are given, reflect associative values. Coiffure characterized in terms of delicacy of line and spacing does indeed constitute aesthetic criticism.

Judgments of better or worse imply an aesthetic when they are qualified and if the qualifications prove to be fairly systematic. Whatever else true criticism is, it is an applied aesthetic. Traditional African critics may qualify their remarks with subordinate clauses, as it were, in which the reasons behind each choice are spelled out and where, ideally, the reasons for the reasons are also given. At one end of the continuum of judgments one monitors the simple statement that such-and-such a work is "good"; in the middle one finds characterizations of aesthetic flavor, for example, "the features are handsome"; at the opposite end of the continuum one encounters aesthetic substance, as when a critic remarks on the delicacy of the modeling of lips.

One meets surprises. One may discover a rationale which is wholly "cultural" in flavor. Thus an Oke-Iho critic found fault with the carved image of a devotee in a shrine because the face was not beautiful. Why? Because the mouth was carved open. Why this objection? Because a fly (one of the traditional messengers of evil) might enter the mouth or dirt collect within the oral cavity (Yoruba fear imprecations uttered when the mouth is dirty, especially early in the morning).

Associative values, even of the most magico-religious nature, and true aesthetic sensibilities are not mutually exclusive any more than possession of the skill of reading and writing prevents one from worshiping the traditional Yoruba gods.

Yoruba Art Critics: Their Character and Contribution

The presence of sculpture in Yoruba country, together with a tradition of artistic criticism, provides a basis for the understanding of the relation of African sculptors to art itself.

As Bohannan has commented, definition of artistic criticism depends upon study of critics, not artists (see Smith 1961:94):

I was wrong in my field work because, Western fashion, I paid too much attention to artists, and when artists disappointed me I came away with nothing. When I return I shall search out the critics. There are as many reasoned art critics in Tiv society as there are reasoned theologians or political theorists, from whom we study Tiv ideas about their religion and politics.

Bohannan's conclusions gave direction to my program of study. He taught me to expect little from artists as informants on quality. Early in my field work I asked a Yoruba sculptor which were his finest works and was not surprised to hear that all of his works were fine. At the end of my field work I returned to his compound. This time he spoke of form and quality in sculpture although he still evaded analysis of his own works. What had opened his lips about quality? Rapport, *per se*, had little to do with it. What had happened was this: thanks to conversations with critics I now possessed some of the vocabulary of the Yoruba aesthetic. The sculptor confronted with the critical language of his peers is the sculptor partially disarmed.

THE COLLAPSE OF ''PRIMITIVE ART''

Criteria of primitivism in the main do not apply to the traditional Yoruba, which means that one must rethink the status of the arts and criticism of this important African people. For example, here are some of the characteristics of "primitive culture" (Hsu 1964): 1) non-literacy, 2) small-scale settlements, 3) isolation, 4) lack of historical records, 5) low level of technical achievement, 6) social relations based primarily on kinship, 7) nonindustrialization, 8) lack of literature, 9) relative homogeneity, 10) nonurban setting, 11) general lack of time reckoning, 12) moneyless economy, 13) lack of economic specialization, and 14) endowment with an overpowering sense of reality where everyday facts have religious and ritual meaning.

Only four of these criteria really apply to the Yoruba. It is true that Yoruba were nonliterate before the coming of the Europeans to their shores. They based their social relations primarily on kinship (and

they still do). They were not industrialized; they were endowed with an overpowering sense of reality (many still are). But their cities were not small in scale, nor were they isolated. Yoruba urbanism, Bascom (1959:29–44) indicates, predates the European penetration and probably was ancient. Court singing kept historical records alive (Biobaku 1955). The technical achievement of the Yoruba craftsmen is an historic fact.[5] Equally complex were and are the many genres of the rich oral resources of traditional Yoruba literature—hunters' ballads, ancestral songs, praise poems, divination verses, proverbs, and so forth.[6] Yoruba traditionally had a sense of time reckoning and a cowrie-shell currency.[7] Economic specialization, both in degree and incidence, was striking. If some traditional Yoruba are endowed with an overpowering sense of reality, it is difficult to see where their attitude differs from that of clergymen or philosophers in the West.

The issue of nonliteracy and industrialization seems important only to those for whom it is important to preserve the concept of "primitive art." Lack of factories and a high incidence of illiteracy have never prevented scholars from classifying the world of Gothic France as a civilization.

It is possible to stress, as definitively "primitive," the "absence of any concept of political organization, which is necessary before man-power can be trained and utilized for the construction of roads, aqueducts, or monumental architecture" (Wingert 1962:6). However, we know from the history of Yoruba architecture that a mighty rampart, the *eredo*, surrounded the inner kingdom of the Ijebu (Lloyd 1962:15–22). The ancient holy city of Ilé-Ifẹ̀ was superbly walled. Monumental royal architecture, necessitating politically organized units of communal labor, adorned the ancient cities of the Ekiti.[8]

It is interesting that a recent artistic geography of "primitive art" excludes the arts of the Andes. Is Great Benin or Ancient Ifẹ̀ more primitive than Chan-Chan? The separation of the civilizations of the world into great, in contrast to primitive, categories of culture appears meaningless when applied to the complex Guinea Coast cultures, but also when applied to simpler societies. The collapse of "primitive art" as a workable concept is nigh.

Once the mask of primitivism falls, what will we see? We may discover that the vision of African aesthetics as rudimentary or functional only projected our own weakly developed means of verbalizing the visual constituents of fine African sculpture. It is just possible, for example, that Yoruba critics surpass all but the most professional of Western students of Yoruba art in fluency of verbalization. To match

the level of competence with which a Yoruba cultivator estimates
artistic quality, one would have to deal with a specialist of Western art.
Wherever and whenever Yoruba critics of Yoruba sculpture analyze
sculpture, they do so with conviction and swiftness of verbalization.

YORUBA CRITICS: SELECTION AND PROFESSION

Artistic criticism was not requested in any village or town until data
about carvers, dating of works, names of woods, and so forth had been
collected. This art historical research served as a kind of lure. Potential
critics moved in the curious crowds of bystanders which always formed
around the writer, his wife, and assistant. The crowd was then asked,
while pieces of sculpture brought out for study were still in the sun-
light, was someone willing to rank the carvings for a nominal fee and
explain why he liked one piece over another? Owners sometimes im-
mediately made clear that they did not want to participate—"put it to
another person," a twin image owner protested once. Almost without
fail someone would step forward and immediately begin to criticize
the sculpture. The rare delays did not stem from lack of verbal skill.
Rather some informants were simply afraid that their efforts would
not really be compensated. Others wished to study the works with
care in the light, turning them around and testing their profile and
mass. The volunteer-critics were, with two exceptions, male.

Eighty-eight critics offered their services.[9] None was a full-time pro-
fessional, as far as could be determined, but as two entries in Bowen's
Grammar and Dictionary of the Yoruba Language of 1858—*amẹwa*
"to be a judge of beauty" and *mẹwa* "to be a judge of beauty"—broadly
suggest traditional Yoruba have long had a concept which substantially
overlaps our own notion of the connoisseur.[10]

But if Yoruba critics are not professionals, many of them prove to
be leaders of opinion in other areas. Sixteen informants were village
chiefs, nine were heads of traditional cults, four presided over quarters
of towns, fifteen were artists, eleven were in trade, and seven were in
the employ of the Nigerian government. All drew upon their im-
portance or self-esteem as the basis for their authority. In the male-
oriented Yoruba world it was not surprising that only two women
appeared as critics. But also many of the images under discussion were
twin images, and women are the owners of these images. As such, they
were understandably reluctant to rank their own possessions.

Yoruba criticism is not the prerogative of kings or of politically
important persons. Almost anyone is free to criticize art if he (or she)

so desires. Thus 20 cultivators, some of them of very humble economic means, balanced the simplicity of their material possessions against the riches of their mind. Their powers of qualitative characterization compared favorably with the commentaries of kings. Neither king nor commoner, however, could improve upon the insights of the sculptor-critics of Northern Ekiti. If the excellence of criticism is intellectually ranked among the Yoruba, the ranking depends upon the critic's individual talent and degree of familiarity with the forms of art.

Name, approximate age, village, profession, and religion were tabulated insofar as possible. In this way it was discovered, for example, that practicing Christians and Muslims used the same criteria by which worshipers of traditional Yoruba gods judged art. But only 19 exclusively Christian and five exclusively Muslim responded. The remainder (64 critics) were practicing devotees of one or more of the traditional Yoruba gods.

The variable of ownership seems pertinent. Of a total of 88 informants, only 32 actually owned the pieces of sculpture under discussion. They may have possessed sculpture in their own compounds but none of them offered to fetch and analyze their own possessions. This suggests that Yoruba more readily evaluate sculpture when it belongs to somebody else.

Nevertheless, 32 critics saw no harm in ranking their own possessions provided they were paid for doing so. But no mother of twins was ever persuaded to judge her own twin statuettes. Years of ritual had made these images seem alive. In point of fact, twin mothers handle their statuettes lovingly. Some explain that they are alive. One cannot expect a mother in such circumstances to play favorites. To do so is positively dangerous: the spirit of a slighted twin may strike the mother with sterility or cause her to "swell up" and die. In the Aworri bush village of Ayobo, a middle-aged critic had begun an interesting recital of the "proper" physiognomy of the *ibéjì* face when suddenly he cut himself short and became silent. When asked to resume the thread of his argument, he refused and stated firmly: "We cannot so abuse these *ibéjì*. We are afraid of what they might do to us."

THE ARTIST AS SELF-CRITIC

An American photographer was once asked to rank and edit his works for an exhibition catalogue. He replied bitterly that he would rather edit his own children. There is little reason to believe that less emotion attaches to the works which Yoruba sculptors create or that

they might rank in public their own works with pleasure. Compare Bohannan's experience among the Tiv: he asked a calabash carver which was his favorite design, and the artist reasonably replied that he normally liked the one he was working on, so he liked them all.

Yoruba carvers had a stock reply for Justine Mayer Cordwell when she asked them to evaluate their preference of one form over another: "I do whatever the customer orders." In the light of this and similar admissions heard in Yoruba country from carvers, it seems likely that when sculptors rank their works equally, they do so with an eye to commercial advantage and that, in any event, inability to criticize their own works is shammed. I did not embarrass the Alaga of Odo-Owa (formerly known as Bamgboye) with direct questions about the qualities of his recent work, but I could not fail to note the enthusiasm with which he led me around the Ẹpa headdresses which he carved before 1955 and which were of good quality and the sadness which came into his face when he stood before his last Ẹpa headdress, at Obo Ayegunle, carved in 1959 when his physical strength had declined.

It is significant that the carvers and blacksmiths who served as critics judged the work of rivals and not their own handiwork. Their gusto and precision might well have evaporated had they been asked to analyze their own creations. Nevertheless, one Yoruba sculptor, Bandele Areogun, has proved willing to criticize (at least retrospectively) his own works.[11]

IDENTIFICATION OF BASIC CRITERIA: Conversation with the critics was straightforward. When an Egbado critic observed that the lineage marks on the face of an image pleased him, a simple pointing question, nítorí kíni (Why?), sufficed to elicit an aesthetic response.

All responses were translated into English in the following manner: 1) the field interpreter wrote out a verbatim text of the critic's comments on the spot and checked it with him, 2) the field interpreter and the author wrote out together a rough translation of the comments on the spot and checked it with the critic, 3) the translations were evened out and polished at the author's base at Lagos or Ilé-Ifẹ̀, 4) finished typescripts of vernacular text and English translation were rechecked for accuracy and searched for nuances of idiom and vocabulary by Mr. Samuel Adetunji of Ilesha in New Haven, Connecticut.

When I analyzed the comments of the 88 critics, common denominators of taste emerged, representing the rationale behind the individual choices. This rationale is the "Yoruba aesthetic."

Yoruba Aesthetic Criteria

Eighteen indigenous criteria of sculptural excellence are presented in this section. Each criterion, a named abstraction, defines the categories of elegance by which Yoruba recognize the presence of art. No single Yoruba provided all these ideas. Canonical notions developed by the investigator were discussed with individual Yoruba sculptors who sometimes added important insights or refinements of their own.

Before examining the criteria in detail the general Yoruba notion of the aesthetic will be discussed.

THE YORUBA NOTION OF THE AESTHETIC

To speak of a native aesthetic presupposes basic questions. First, have the Yoruba a notion of the aesthetic? The answer, as might be plain by now, is "yes." Artistic sensibility, mixed with a hint of the hierarchy of the beautiful, is a clear power of the following verse from the oral literature of divination:

Anybody who meets beauty and does not look at it will soon be poor.
The red feathers are the pride of the parrot.
The young leaves are the pride of the palm tree.
The white flowers are the pride of the leaves.
The well-swept verandah is the pride of the landlord.
The straight tree is the pride of the forest.
The fast deer is the pride of the bush.
The rainbow is the pride of heaven.
The beautiful woman is the pride of her husband.
The children are the pride of the mother.
The moon and the stars are the pride of the sun.
Ifa says: beauty and all sorts of good fortune arrive.
(Beier and Gbadamosi 1959:30)

Discrete visual phenomena intersect: beautiful possessions (verandah, wife, children) whose quality the owner maintains or protects; ephemeral beauty (leaves, flowers, rainbows) at its prime; the beauty of more permanent things, earthly and celestial, which a sensitive man does not take for granted. Prize these things, the god of divination warns, for mental richness creates material wealth.

Aesthetic impulse alone brought together these felicities; their unifying aspect was beauty. The poem has the effect of an *aide-mémoire:* it safeguards, as it were, the natural resources of Yoruba aesthetic experience.

It is clear that a classification of visual powers, systematically developed, does not constitute mere function or utility. On the contrary, the moral is clear: aesthetic sensibility brilliantly embarks a man upon his career.

This poem, as well as other passages which might be cited from the oral literature of the Yoruba, refutes the old assumption that Africans lack experienced appreciation of natural beauty for its own sake. Yoruba, for instance, greatly admire the quality of verdancy which is implicit in one line of the poem and explicit in the common phrase, *ilè yìí tútù yòyò*, "this land is verdant" (Abraham 1958:658).[12]

If it is accepted that Yoruba truly appreciate physical beauty, the next question is: have the Yoruba a notion of aesthetic quality in sculpture; have they precise criteria by which to analyze the constituents of the beautiful in plastic expression? The answer again is yes. The plastic order of Yoruba sculpture is so striking as to stimulate an immediate awareness of its concrete manifestations in the minds of native critics. They speak fluently of the delicacy of a line, of the roundness of a mass. This eliminates the general question of whether or not Yoruba identify the aesthetic components of form.

ART AS USE—THE PIDGIN ENGLISH OF AFRICAN AESTHETICS: Few old-fashioned ethnologists dreamed that the peoples they investigated experienced aesthetic responses. And they never dreamed that "primitive man," himself conversant with art and noting few men of like experience among the emissaries from Europe he met in the nineteenth century, might be addressing to Westerners the same reproach.

Some traditional Yoruba seem to assume a white man's ability to perceive aesthetic import in art is weak or underdeveloped. One illustration must suffice: asked why he was most proud of a certain carved divination dish, a diviner at Ilobi replied: "It is a container of good divination things." Outwardly, he was "incapable of aesthetic analysis." But inwardly, he had assumed that utility was the only trait a foreigner might comprehend. When assured of the true direction of the inquiry, he spoke at once of quality.

The alleged lack of aesthetics among ethnographic peoples may well have derived from a kind of conceptual pidgin which arose when "civilized" and "primitive" man met and spoke of art, neither believing the other capable of aesthetic analysis. Thus, as Bohannan observed, the Tiv weaver keeps his best piece for his mother-in-law and sells his worst piece to foreigners who, presumably, would not know the difference (See Smith 1961:92). The Fon brass caster sells the coarsest of

his creations to foreigners and excellent pieces in traditional styles to indigenous patrons (Herskovits 1938:358).[13] An Anago Yoruba wood sculptor, although locally noted for an especially sensitive handling of earth colors, permits enamel paint to be splashed in garish patterns over commissions for Westerners, obliterating the fine cuts of his knife, because "that is what those Europeans like." In the process, Western and African prejudices are mutually reinforced.

YORUBA QUALITATIVE CRITERIA

MIDPOINT MIMESIS: A value of Eastern art is exemplified by the story of the dragon which was painted with such aliveness that the creature flew out of the ink and into the air. The Western parallel tells of the birds who pecked at painted fruit. "What is the similar African story?" Mr. Kenneth Murray (1961:100) has asked.

The following African version, a precious fragment of the oral literature of the Yoruba, documents equal attention to shape, detail, and vitality, but these Western-sounding preoccupations dissolve in a solvent of native irony.

Motinu and the Monkeys is a fable about a beautiful girl, Motinu, who meets a magnificently handsome man near the Yoruba city of Owo. The man is actually a monkey in disguise who tricks Motinu into marrying him and moving to his forest eyrie where he transforms himself back into his true state and the hapless girl is forced to drum dance music and fetch wild corn for her captor and his chattering friends. By chance Motinu meets a hunter, when alone in the woods one day, and he promises to rescue her. The hunter's stratagem is a capsule rendering of the traditional Yoruba notion of mimesis:

On his return to Owo, the hunter called on a woodcarver in the town. He described to the carver Motinu's hairstyle, and tribal markings and asked him to make eight little images of her. When these had been carved and painted, the hunter carried them to the bush when he knew he would find Motinu alone, and then together, they set out quickly for Owo. Every few miles, the hunter dropped one of the carvings in a conspicuous place along the track. (The hunter) knew that these images would delay the monkeys when they tried to follow them. . . .

When the monkeys reached the first image they were very curious indeed and sat down to chatter and argue.

"What is this," they said, "that bears such a strong resemblance to Motinu?" . . . growing tired of it, they threw it away into the bush and went on in pursuit of their lost Motinu . . . Each image they came to ex-

asperated the monkeys more and more, and when they came upon one they would pounce on the image in anger and smash it up, chewing the pieces afterwards till nothing remained. By this means Motinu and (the hunter) were able to escape. (Fuja 1962:47–49)

This fable, to begin with, qualifies the degree of realism Yoruba critics desire: the village connoisseurs are pleased by conventionalized human faces sharpened with touches of individuality (lineage marks and coiffure). The monkeys, unlike the birds of the West, were not deceived. There was no reason that they would be, for one of the aims of the Yoruba sculptor is to strike through the individual personality of men and women to arrive at general principles of humanity.[14]

The monkeys puzzled over the images and, in a sense, appreciated their mimetic qualities—"What is this, that bears such a strong resemblance to Motinu"—but never did they confuse art with reality. Thus the fable summarizes Yoruba mimesis: the formulation of general principles of humanity, not exact likeness. Light touches of portraiture (hair, scars, dress) redress the balance in favor of individuality, yet not to the degree where even the vilest monkey cannot distinguish likeness from equivalence. Mimesis to modern traditional Yoruba means the cultivated expression of resemblances (*jíjọra*), not likenesses. It is "midpoint mimesis" between absolute abstraction and absolute likeness.

This is brought out by the vocabulary of the 20 critics who applied this criterion to their arguments. A single sentence, Ó jọ ènìọ̀n (It resembles a person), was the modal expression although an alternate phrasing, Ó dàbí ènìọ̀n (It looks like a person), was also heard. A healthy recognition of the limitations of illusion is implied in the verb jọ. Witness the common phrase, ó jọ bẹ́ẹ̀ (It *seems* to be the case). It is therefore significant that Yoruba critics qualify mimesis with a phrase which makes clear a desire for generalization. They did not say that carvings resembled specific personalities.

HYPERMIMESIS: Some of the reasons why Yoruba art comprehends mimesis as a process sited somewhere between abstraction and exact likeness can be found in the critic's rationale for disapproving of a work. Amos Tutuola plants one clue in his Yoruba folk novel, the *Palm-Wine Drinkard*, which is based upon traditional mythic themes. At one point the hero of the novel encounters his own portrait in wood and is frankly terrified (Tutuola 1952:68):[15] "Our own images that we saw there resembled us too much." There can be something sinister

about absolute mimesis. Why? One reason seems magical. A master carver of Ẹfọn-Alaiye, Owoeye Oluwuro, told me that a traditional *Ẹfọn* sculptor, before he initiated any important commission involving the carving of human eyes, mouth, and nose, had to make a sacrifice of sugarcane, dried maize with red palm oil, and pigeon to prevent the entrance of ugliness into his carving. What kinds of ugliness? A wrinkled man's wrinkles, a warty man's warts. If his adze slipped, as it were, and he began to carve the unpalatable truth in some of the faces which he saw around him, the danger existed that these very features might be transmitted to the face of his next-born child.

To one Yoruba critic a slight hint of individual expression sufficed to incur censure: "[One carving's mouth] comes out to form a laugh. That is bad." The lips of an ideal statue ought to be pursed. Such lips reflect impersonal calm.

Perhaps the most decisive factors behind the limitations placed upon mimesis in Yoruba art are aesthetic ones: the assumptions of the native critic (that sculpture be smooth, youthful, erect, and so forth) would be violated by direct rendering of the rough skin, gaunt appearance, and ruined posture of an elderly man.

EXCESSIVE ABSTRACTION: Related to the notion of mimesis, on a negative grid of disapproval, is the notion of excessive abstraction. Fine sculpture, to the Yoruba, is not too real, but neither does it absolutely depart from natural form. For example, a North Oyo critic stated that "if a person's ears were all round like that they would talk about him" and condemned a work of art while he went on to laud another piece with relatively realistic ears.

Carvers are amused by apprentices who fail to imprint human quality upon the principal masses of their work. Bandele Areogun once studied a carved house column by Ayantola of Odo-Ehin and commented derisively:[16] "It looks like an *àpótí*," and then laughed. In making this comparison with *àpótí*, a common Yoruba term for box, Bandele had impugned the ability of his rival to enliven brute timber with human presence.

VISIBILITY: Twenty-nine critics stressed this quality. A master sculptor, the Alaga of Odo-Owa, heartily concurred with their emphasis: "One knows from the visibility of the face and other parts of the image whether the work is beautiful." The artist used, as did some of the critics, the precise Yoruba word for visibility, *ìfarahòn*.

Some critics phrase the idea without refinement and simply assign

importance to sculpture of full, well-finished, organic details. Thus a critic of Tede: "the tribal marks are well cut . . . I like the eyelashes, they help make the face attractive . . . the hairdress is exact . . . all five fingers are complete . . . all five toes are complete. The other carvers did not show the toes so visibly."

But sculptors lend to their criticism a vocabulary of astonishing accuracy and range. Their works describe, to begin with, the stages of the process of carving. Bandele Areogun of Osi-Ilorin distinguishes four divisions in the making of sculpture:[17] 1) the first blocking out, 2) the breaking of the initial masses into smaller forms and masses, 3) the smoothing and shining of the forms, 4) the cutting of details and fine points of embellishment into the polished surfaces of the prepared masses.

Alaga of Odo-Owa views the process slightly differently: 1) the measuring of the wood, 2) the blocking out of the head, occiput, chest, torso, buttocks, thighs, legs, and feet in that order, 3) the smoothing and polishing of all masses, 4) the incising of details into the polished masses. Alaga insists that "above the shoulders the head must be readily visible." Visibility as criterion therefore is an assignment of the initial stages of adzework (are the major masses visible?) and the terminal stages of knifework (are the smaller embellishments and linear designs visible?).

The privilege of visibility must not be abused; as the Alaga told me, a sculptor must not only block out a schematic eye (*yọ ojú*) which provides a gross visibility and relief, he must also "open" the eye (*là ojú*) with sensitive lining. Visibility refers, therefore, to clarity of form and to clarity of line.

Let us consider the last quality first. Linear precision is largely a matter of knifework, whereas plastic clarity is summoned from the brute mass of the chunk of the log by means of adzework. Although knifework falls under Bandele's fourth category of *fífín* in Osi-Ilorin, this final stage cannot be described solely by means of the root verb *fín*, which means to carve or incise. Bandele uses an extended set of special verbs, each with its own nuance:[18] 1) *là*, which refers to the "lining" of eyes, mouth, fingers, ears, and toes, 2) *lọ*, which refers to the "grooving" of brass bracelets, 3) *gé*, which refers to the cutting of waistbeads and other forms of beads, 4) *fín*, which refers to the "incising" of coiffure, sash fringes, and special patterns and designs.

Bandele criticizes, for example, the lack of visibility of a certain cult container by means of these special verbs: "The mouth remains; they have not lined it. They have not incised the sash. They have grooved the sash."

The fact that a lexicon of linear qualities exists suggests the depth of the Yoruba aesthetic. Bandele uses verbs of line to estimate swiftly those carvers who have (or have not) liberated fine points of human appearance from the larger masses of the wood.

Alaga of Odo-Owa and Mashudi Latunji, who works in the faraway town of Mẹkọ in the province of the Ketu, use much the same sort of verbs Bandele employs in their criticisms. Like their colleague, the latter artists criticize the finishing of small detail, the rendering of its visibility, in terms of lining and incising and grooving but they criticize the cutting of coiffure and interlace patterns with the verb *dì*, which means, literally, to tie. Alaga insists one may judge the excellence of the rendering of cloth in sculpture by means of the verb *sán*. Thus: *Ó sán bàntẹ̀ dádá*—"He rendered the loincloth well." This refers, literally, to the tying on of the garment.

The apparent lack of specialized vocabulary in the criticisms by non-carvers might suggest that Yoruba criticism is intellectually stratified. Bandele, the sculptor, said: "They have not lined the eyes." But a carpenter (with no artistic pretentions) said: "The beautiful face has eyes which have lids and the ugly faces have lidless eyes." Yet all critics of Yorubaland hold the artist responsible for as complete a grid as possible of human anatomic coordinates. Carvers seek to express generalized principles of humanity. They must carve them, nonetheless, with ultimate sharpness of clarity and focus.

Thus the notion of linear connoisseurship is highly developed among traditional Yoruba. Symptomatically, the art of cicatrization in traditional times was of paramount importance, both as mark of lineage membership and aesthetic concern. Verbs of linear analysis in sculpture find a parallel in the language of the cicatrix specialist. This professional, like sculptors, has a verb for different visual effects. He cuts (*bu*) *àbàjà* marks, slashes (*ṣá*) *kéké* marks, digs or claws (*wa*) *gòmbọ́* marks, and splits open (*là*) *Ẹ̀fọ̀n* marks (Abraham 1958:301).

Relation of verb to sculptural effect seems meaningful. *Kéké* marks are bold; when they are faint, they are allegedly called *gòmbọ́*, a fact which might be conveyed by the concept of slashing the former and clawing the latter. *Ẹ̀fọ̀n* marks indeed seem to split open the flesh of the cheek.

Since antiquity, Yoruba have adorned their cheeks with lines. They associate line with civilization. "This country has become civilized" literally means in Yoruba "This earth has lines upon its face" (Abraham 1958:399). "Civilization" in Yoruba is *ìlàjú*—face with lined marks. The same verb which civilizes the face with the marks of membership in urban and town lineages civilizes the earth: *Ó ṣá kéké;*

Ó sáko (He slashes the *ḳẹ́ḳẹ́* marks; he clears the bush). The same verb which opens Yoruba marks upon a face, opens roads and boundaries in the forest: *Ó lànọ̀n; Ó là ààlà; ó lapa* (he cut a new road; he marked out a new boundary; he cut a new path). In fact, the basic verb to cicatrize (*là*) has multiple associations of the imposing of human pattern upon the disorder of nature: chunks of wood, the human face, and the forest are all "opened," like the human eye, allowing the inner quality of the substance to shine forth (Abraham 1958:399, 400, see also 602 as to *ṣá*).

This history of associations with the tradition of cicatrization sharpens the eye of the Yoruba critic and gives the sensitive noncarver the knack of talking about clarity of line with conviction. For example, an Aworri critic insisted that the coiffure on what he considered inferior sculpture was "too faint" and that the lines of good sculptural versions of hair must be seen. An Ijesha critic with a single comment—"the eyes really show on *Ẹ̀fọ̀n* pieces"—went to the heart of his taste for linear visibility.

Another sample criticism: Ojelabi of Oluponon admired an image because the face was "visible" and there was "a boundary line for the hair." These comments and many others which could be cited prove that noncarvers, with the simple verb *họ̀n* (becomes visible), are able to defend their tastes when judging sculpture which does or does not satisfy local feelings about linear visibility.

Visibility, as has already been pointed out, also refers to clarity of form. An Ijebu cultivator judged one twin image excellent on the ground that its forehead was "more visible than the other [piece]" —(*Otowá ó họ̀n jù eléyi lọ*). At Ṣepeteri a critic admired the nose on an image because it was readily visible. The taste for crispness of form affects the criticism of abstract shapes and ornament as well: a young citizen of Ajasse-Ipo viewed four carved door panels in the palace of the local chief and found the criterion of visibility the decisive means of distinguishing the best patterns. As in the discussion of line, plastic clarity is expressed by the verb *họ̀n* or grammatical units constructed from this verb.

Artistic integrity is also a factor which must be taken into account. This point might not have been documented but for the comment of a critic from the west of Igbomina country who singled out the sharp visibility of an image and added that "If you want to marry a person you have to see the body completely." Plastic and linear clarity become a matter of candor: all parts of the body are presented to the court of the eye. Visibility in this sense means that the honest carver has

nothing to hide; he nakedly exposes his imagination. He does not conceal an inability to portray a complicated hairdress under a cap or headtie.

To Bandele of Osi-Ilorin the head and the hands of images are the essential aspects of plastic clarity. "Don't we," he asked Kevin Carroll didactically, "look at the face at the top of the *Epa* headdress first and then we look at the hand? Those two places we first take notice of. The body is not so difficult." If the face and the hand of the *igi* (super-structure) are carved with proper conscientiousness the carving will become readily visible and therefore good and therefore beautiful.

SHINING SMOOTHNESS: Yoruba who invoke the quality of visibility simultaneously invoke the quality of luminosity. Alaga of Odo-Owa told me that when he finishes a work of art he stands back to examine the "shine" of the work, the polished surfaces and the shadows in between the lines of incisions.

This taste for luminosity appears to have considerable historical depth. We may infer that the Yoruba-influenced city of Great Benin reflected, as early as 1668, the Yoruba quest for luminosity in art (in this case architecture) as visual stimulus, for early explorers duly documented the extraordinary polish of the earthen red walls of Benin (Roth 1903:160–1).

Eleven modern Yoruba critics shed light on the nature of this canon. Onamosun of Iperu recalled: "When my father (Taiwo Olejiyagbe) objected to low quality in my early work he sometimes lashed me with a flywhisk. I did not make any serious slips of quality after I got the hang of carving from observing my father's work day after day. But if he told me to carve an image very smoothly and I failed to comply, I would be punished. The smoothing (*iṣé dídọ́n*) was done with a knife, with the side of the knife." (Plate I, p. 18.) An Aworri lineage head asserted that smoothness was a matter of skill: he praised the straightness of the hand of a sculptor and then commented upon his luminous touches of polish.

Headmen at Ilogbo-Aworri and Ipole-Ijesha made clear that they demanded smoothness and shining qualities in sculpture. Speaking of cheeks, a priest of Erinle at Oke-Iho said: "The cheek (of this image) is beautiful; it is not swollen but rather shining" (*Eèkée ó dára, kò wú, ṣùgbọ́n ó dọ́n*).

Creative enjoyment of art by Yoruba critics relates to the notion of luminosity in remarkable ways. Thus a cultivator at Odo-Nọpa in the kingdom of the Ijebu:

One image is ugly and can quickly spoil. Its maker did not smooth the wood. Another image was carved so smoothly that one hundred years from now it will still be shining, if they take proper care of it, while the ugly image will rot regardless.

One might compare this fragment of criticism (which seems to raise luminosity to talismanic powers of preservation) with a more idealized Yoruba notion of beauty as "guard" or "amulet," which is present in the pages of the novels of Amos Tutuola. Here is a passage from his *Palm-Wine Drinkard:*

If bombers saw him in a town which was to be bombed, they would not throw bombs on his presence, and if they did throw it it would not explode until this gentleman would leave that town, because of his beauty. (Tutuola 1952:25)

When Yoruba critics discuss luminosity, they almost unfailingly use the verb *dón.* The qualities conjured by the verb intermesh with aesthetic implications associated with the initial stages of carving. Thus Bandele:[19] "We know a carver's work is good if he has blocked it out well and by the shining smoothness of the wood" (*t'o ba ti bu ona, ti o ba ti lena ona lile da . . nipa igi didon*). Onamosun of Iperu and Bandele explain that *iṣé dídón* technically mean the smoothing of the forms of sculpture, respectively with a knife of Ręmon and with a knife and chisel in Northern Ekiti. Kevin Carroll has informed me that the old smoothing-tool in Ekiti dialect was called *unkan* and consisted of a handle and cutting edge formed from one iron bar. Bandele's phrasing refers to the Yoruba sculptor's intent to smooth down the surface of his wood so that it reflects light and seems to shine, as if from an inner source. The smoothness-shining duality emerges as both cause and effect. Surfaces are so smoothed that they give back the lights of intelligence which went into their making.

We are now prepared to suggest the background of one of the most striking of the habits of the Yoruba artist—his penchant for carving facial traits in (to academic Western tastes) excessive relief. The issue cannot be treated, of course, apart from other notions of quality. Linear and plastic clarity combine with shining smoothness to illumine the artistic intent behind this habit of carving.

The rounded shapes of the face of a Yoruba image have been smoothed so as to reflect light whether in sunlight or in shade. Eyes in protrusion cast meaningful shadows against the glowing surfaces of the face. The ink of shadow is calculatingly spilt below or above the eyes (according to the source of light), the better to mark off their

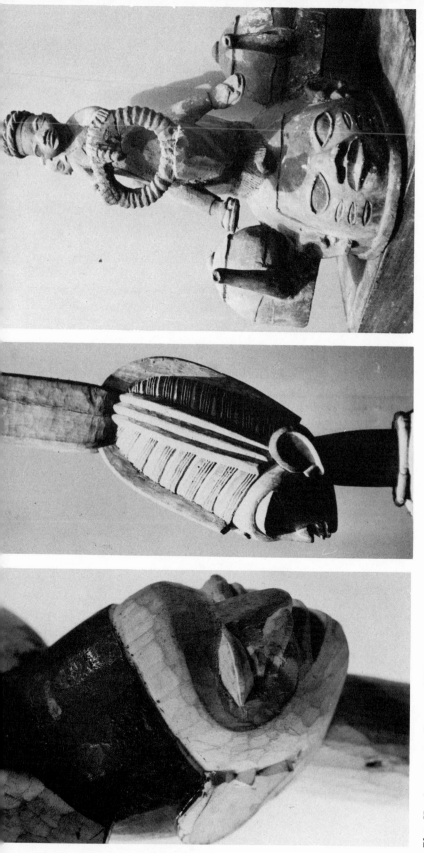

Plate II A carving by Owoeye of Efon-Alaiye, 1960.

Plate III Verandah post carved by the Alaga of Odo-Owa, 1931.

Plate IV Wooden headdress of the *Gelede* cult, representing the Muslim cleric. Carved by Duga prior to 1955.

form against the shine of the face, the better to make them "readily visible" (Plate II). The short durational values of Yoruba music propel sculpture in the dance with staccato movements that blur the vision. Shadow against shining surfaces acts as a countereffect to this blurring.

Moreover, Yoruba appreciate distinct intensities of shadow. I have observed Alaga turning a carved comb around in sunlight, testing the beat, as it were, of its rhythmic shadowed incisions. I have also observed a critic at Tede turning a twin statuette around in the sunlight, turning the image around several times, observing the flow of shadows.

Yoruba recognize that deliberate excresences and edges in sculpture cast darkened silhouettes which may be "read," as an abstract image, at considerable distance by an observer. Moreover, in the blur of the dance or under the shadows of a verandah, refinements of form must be made readily visible. Alaga tells us that the shadows between or within incisions and the shadows beneath or above relief are beautiful against the polished surfaces of the whole of a sculpture.

The eye primed to appreciate the canon of shining smoothness, as the foil of shadow, distinguishes master from apprentice in works of art. The adzemarks of the master, where the edges show, shine, while the adzemarks of the apprentice lack formal separation and do not shine.

We must be careful to point out that Yoruba seem to prefer the relative or moderate enunciation of any given criterion. An absolute polish, mirror-like and glittering, is as foreign to their art as is sculpture in which no attempt whatsoever has been made to polish surfaces. Moreover, as Kevin Carroll has usefully reminded me, the woods which Yoruba sculptors use are generally smooth in texture. And even the moderate or generalized shining of Yoruba sculpture is broken in some areas with crosshatching, and other designs, sometimes extensively.

One of the most interesting extensions of the Yoruba taste for luminosity is the depiction of clothing. Because Yoruba artists devoutly desire to create well polished surfaces that reflect large amounts of light, they do not treat substances, which in reality are soft, with realistically softened textures. When a Yoruba carves a headtie, turban, cap, or gown, he exaggerates its bulk and polishes it to a high sheen. Drapery conventionally has a consistency which resembles sheet-metal far more than it does cloth. The soft twists of the turban of the Muslim cleric—a favored theme in recent *Gẹlẹdẹ* carving of the Yoruba south-west—harden in the hands of a sculptor. Loose, or folded twists of female headties (*gèlè*) stiffen into architectonic forms. Èṣù, the

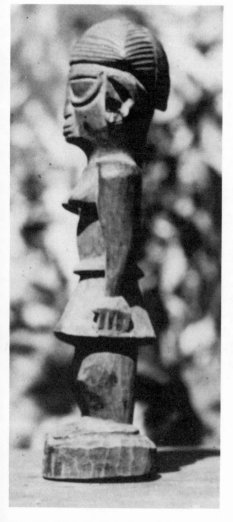

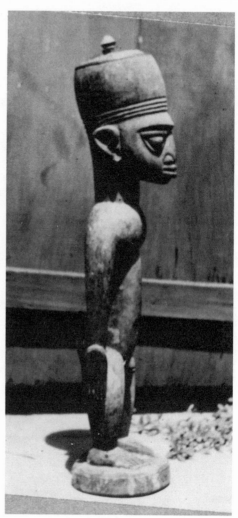

Plate V Twin by Bako from Iperu, 1940. Plate VI Image by Onamosun of Iperu, 1940.

trickster, in one instance wears a cloth cap which in sculpture becomes as unyielding as an iron helmet.

Thus the Yoruba aesthetic hardens and polishes the representation of the soft substances of life so that they will shine in harmony with the luminous whole of the image, so that the edges of a turban or a gown will cast the same strong shadows cast by eyes in expressive relief or by multifaceted foreheads and torso areas. Just as the sound of hard, metallic percussion dominates much Yoruba music—Yoruba iron bells and gongs are distinctive because of their high pitch (King 1961:11)[20] —so the creation of hard, almost metallic polished surfaces dominates Yoruba sculpture. With respect to representations of clothing, and even hair, Yoruba sculptors discover luminosity by thickening widths and polishing surfaces and sides.

A verandah post by Alaga which he carved for the house of a chief at Ekan-Meje *ca.* 1931 demonstrates most tangibly to what extent he successfully acquired the aesthetic of luminosity.[21] The distinction between the smooth radiance of the head and coiffure of the central figure and the duller lustre of the unfinished structural support above the head of the figure is decisive (Plate III): Hair, cloth, and flesh glow with equal intensity.

The Yoruba sense of luminosity is especially refined. Hunters in Yorubaland are sensitive to this quality and have, for example, a word (*rekina-rekina*) to describe the glittering effect of sunlight shining on wind-ruffled water.[22] And in their ballads and salutes hunters generally admire the gleaming surfaces of the pelt of a wild beast as they might have admired, when in town, the luminous refinements of a carved image.

EMOTIONAL PROPORTION: Yoruba notions of proportion form a dialogue between the permissive and the prescribed. Critics countenance certain dimensional liberties when they are charged with traditional sanction of aesthetic expression. Critics approve sculptural compositions set in "social perspective" where the sculptor indicates seniority by gradations of scale. At all times, however, critics rank sculpture upon a theory of relative proportion. The members of a king's entourage must be carved in proportion to one another, regardless of their scale in relation to the monarch.

A Ketu paradigm: the late Duga of Mẹkọ finished, probably before 1955, a striking headdress for the local cult of Gẹlẹdẹ. The headdress is surmounted by an Àlùfáà (the Muslim cleric), carved standing in a canoe with a helper (Plate IV). Two teakettles flank the canoe. The

cleric counts his beads. The size of his rosary is overpowering; the beads fill his hands as a chunky width of Manila hemp rope might fill them. This is a splendid example of fusion of proportion and empathy. The usage of "emotional proportion" contrives to communicate the psychological importance of a thing, as opposed to strict measurement. Duga enlarged the beads of the cleric for at least two purposes: 1) so that they would "read" easily in the motion of the dance, 2) in conformance with their role in the important Islamic ritual of *dhikr*—"telling beads"—in solitary communion with Allah and the Prophet (Trimingham 1961:93). The size of the rosary translates its fascination in the eyes of non-Muslim Yoruba who recognize the power *dhikr* acquires from use in initiation and cult practice.

Duga framed the canoe bearing the cleric and helper between two teakettles. These are strikingly out of proportion to the cleric and the canoe, but they are convincingly related to the dimensions of the head of the mask which serves as infrastructure. All Yorubaland has observed Muslim cattle-drivers from the north of Nigeria halt by the sides of roads and streets to pour ablutions from teapots. Recognition of the teakettle as a mark of modern Islam in West Africa would be immediate. Their symbolic dimensions are no more startling than the diminutive or heightened renderings of the Christian cross which are not taken as literal measurements of the True Cross but are tokens of faith.

Yoruba share a notion with Heraklitus: a man's character is his fate. Yoruba sculptors enlarge the human head to mark its importance as the seat of character, the part conversant with destiny. Heads, as wisdom symbols, mark the visual climax. But exaggeration of the head must not be ludicrous.

In the clear-cut instances of standing figures, the components of judicious proportion are swiftly identified by critics. Alaperu of Iperu minced no words: "The thighs are too thick for the body." Of a certain carver's work he said: "Bako carves figures with eyes too open. The lower part of the lid is too stretched out" (Plate V). A minor lapse of conception by the land of the local master, Onamosun, did not pass unremarked: "Actually the height of the figure shows some grace. So far as I look at the cheeks and the nose I like what I see. Only the eye is a bit out of proportion" (Plate VI). Significantly, the proportion of the head (which was slightly exaggerated) was not mentioned.

The criticism of Abinileko of Otta provided another source of Yoruba thinking about proportion in carving. Abinileko, who in 1964 presided over the Oruba quarter of the capital of the Aworri subtribe,

had been a tailor in his youth and kept a cloth measuring tape in a wooden chest as a memento. He applied this measuring instrument to a judgment of the relative merits of the works of Labintan and Salawu, two sculptors of Otta. The basis of his judgment were two Gẹlẹdẹ headdresses which he took down from nails on the walls of his parlor. "Labintan is the better carver," Abinileko began, tapping the best headdress with a stick. Breadth (ìbú) was to his mind an important variable. Labintan had conceived a human nose, for example, with pleasingly moderate measurements while Salawu had not. The critic reached for his measuring tape and marked off two and a half inches for the breadth of the ugly nose, one and a half for the finer nose.

He then compared mouths. Labintan's was two inches long, Salawu's three. He commented: "Labintan's mouth looks like the mouth of a person but Salawu's does not" (Ẹnun tí Lábíntán rí bi tí ẹnu ènìọn, sùgbón tí Salawu kò jọ ènìọn).

He dissected further deficiencies: "Salawu's forehead is too close to the edge of the headgear. The distance from cap to the top of the nose is too short." He buttressed this point with a measurement: two and a half inches described the distance between nose and hat in the image by Labintan, one and a half for Salawu.

Precise measurements are by themselves merely descriptive. But the critic analytically used measurement as a means of arriving at a concrete notion of proportion.

Moderation in small things, not too broad the lips, not too short the forehead, might be suggested as the sum of these notions. The use of a Western instrument here does not vitiate the traditional grounding of this exercise, for the measuring tape was simply a replacement of African prototypes. Thus Ketu sculptors use the length of the blade of their knives as a rough module to secure the proportion and symmetry. Finally, Kevin Carroll has observed Bandele of Osi-Ilorin "often use a measure of hand length, finger length, and knuckle length."

As he wove his way through a complex argument about the aesthetic merits of Eyinlẹ cult figures, an Oke-Iho critic made several observations which help us to understand how Yoruba view the proportion of facial traits. The critic liked one chin because it was not short (kò kúrú). He condemned the dimensions of another sculptor's version of the human chin with metaphor: "It is not beautiful. The chin rushes into its house" (Kò dá; àgbọn kó sílé). The lower lip of the mouth on this piece was neglected; the lower margin of facial outline and the lower lip had been made to coincide, as in a mode prevalent among the Western Ijọ. The fine piece, on the other hand, displayed a suitably

fleshy chin. The metaphor was apt: the chin of the inferior face did indeed seem to rush into the mouth and disappear.

The same critic found the lips of one figure "decently proportioned" (*Ó wa mogi-mogi*) and "terrible" on another figure. The "terrible" mouth was too big.

In conclusion, man is the module. As Alaga told me: "if the image represents a big man, the eyes must be big, if the image is small the eyes must be small." But inspiration and imagination are part of the process: "These measurements we use," Mashudi told me, "God gives them to us. No one is using the white man's instruments when they carve at Mękǫ. We take our measurements from our heart."

POSITIONING: This concept overlaps the notion of proportion. Alaperu, for instance, analyzed the proper placement of parts of the body: "The ears are good, well-fixed, not too far down, not too far up." Eleven critics made similar commentaries. Jogomi of Ajilete laid equal stress upon the correct placing of the navel. Otuşoga of Odo-Nopa was disgruntled by a nose which he felt had been placed too high upon a face.

Yoruba hunters attach importance to elision in recitals of their traditional ballads. Thus a Yoruba was once documenting the ballad of the monkey when another Yoruba interrupted: "No. Do not write it so, it does not sound sweet like that" (Collier 1953). The latter informant then proceeded to elide eight words to satisfy his tastes. On the other hand, there were many words which he did not run together, for as the distinguished late authority on Yoruba linguistics, Professor R. C. Abraham, was forced to admit, there is no underlying principle about elisions (Abraham 1958:xxxi).

By the same token, Ogidi of Igogo-Ekiti imitates the natural position of the shoulders and navel in his sculpture, but he connects the upper lip to the edge of the nose. One elides things for the sake of visual concord but there does not seem to be a fixed principle. Other North Ekiti carvers take pains to separate the nose from the lips.

COMPOSITION: The aesthetic spacing of things in relation to one another is a complication of the art of siting. Positioning of traits by means both mimetic and emotional becomes a more elaborate task of relating individuals (sometimes individuals, things, and animals) within a single composition.

On a minor level Yoruba composition means the pleasing articulation of limbs in spatial terms. Alado of Ado-Awaiye characterized his pleasure in the graceful placement of the hands of a figure which

embellished his own divination container. The curve of the wrist and the arm, the naturalness of the gesture, were stated as pleasing qualities.

Onamosun of Iperu reported that "one of the things that people are talking about when they see my work is my carving of the hands without detaching them from the body, with the outer side of the hand flat." The design element to which the carver refers is one of the striking qualities of his mode of figural composition (Plate VI).

Olodoye of Ijero-Ekiti briefly adumbrated a few compositional qualities. He liked the suppleness of the placement of a child within a mother's hand and he also expressed pleasure in the placement of a twin on the mother's back. Unfortunately, he did not qualify these remarks. It is possible that a cultural factor, namely the Yoruba intense appreciation of motherhood and children, guided his remarks more than aesthetic discernments.

As to free siting, critics did not discuss the matter but it seems probable that blendings of permissive and prescribed actions again apply. For instance, the members of a senior person's entourage are carefully positioned, normally, so that when seen full-front they do not obscure the view of their master.

DELICACY: Sixteen critics spoke of this quality, one of the few aesthetic notions for which we have scraps of nineteenth-century literary evidence. Thus the explorer Richard Lander in 1830: "The natives of that part of Africa appear to have a genius for the art of sculpture. Some of their productions rival in point of delicacy any of a similar kind I have seen in Europe" (Quoted in Allison 1956:18). Lander was an ethnocentric outsider but his disadvantages did not preclude a striking observation at an early date of one of the informing qualities of Yoruba sculpture.

Samuel Johnson, himself a Yoruba, understood the relevance of delicacy to the appreciation of other Yoruba arts. Here is a comment on coiffure written in the 1890's:

Hair is the glory of the woman. Unmarried ones are distinguished by their hair being plaited into smaller strips, the smaller and more numerous the plaited strips the more admired. (Johnson 1921:101)

Traditional connoisseurs of the arts of hairdressing today still nod in agreement with the notion of delicacy and closeness of spacing. The more closely spaced the braids, the more braids can be made to embellish the head. This taste informs the commentaries of modern tradi-

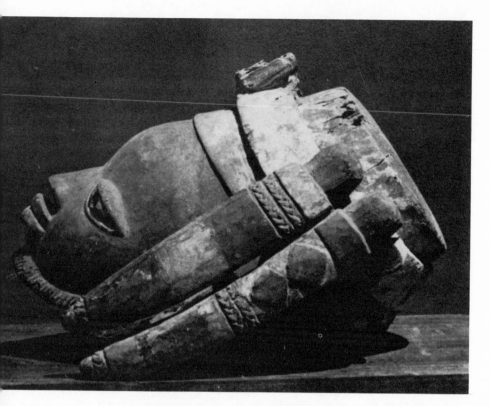

Plate VII Yoruba *Gẹlẹdẹ* headdress.

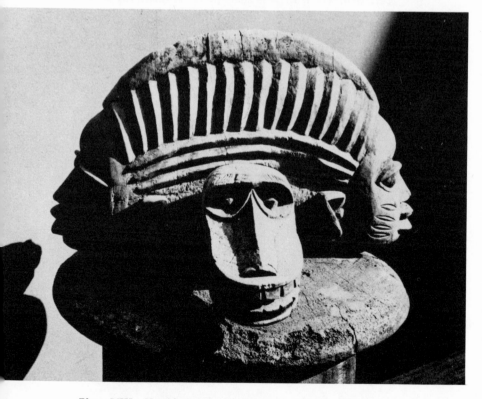

Plate VIII Headdress of the *Egungun* cult, from Anko.

tional critics of Yoruba sculpture. Thus an Egbado diviner at Ilobi
characterized the aesthetic appeal of a certain divination dish in terms
of its numerous faces and their diminutive eyes. "Small eyes" (*ojú
kékeré*), he added, make an image resemble a person.

Delicacy of eye cut and lining was a concern of an Egbado and an
Ijesha critic. The former liked the eyes of a twin image at Ajilete be-
cause the lids were thin (*ipénpéjú tínrín*); the latter remarked the
pleasing smallness of eyes and used the identical phrase employed by
the Ilobi diviner, *ojú kékeré*. An Ijebu critic isolated the element of
delicacy in the aesthetic character of a carved version of hairstyle. He
stressed the sensitive rendering of the plaits, saying literally that the
"cuts" or "lines" were thin.

Smallness suited the tastes of the Ijebu critic when applied to the
field of linear ornament. Smallness of anatomic mass provoked a dif-
ferent reaction. The critic denounced the slimness of an *ibéjì*'s arm
with the same adjective with which he had praised fineness of line:
Èyìí tínrín jù lọ (This one is thinner than the other). A thin line is
beautiful, a very thin mass is not. Thus one must take pains to plot
the usage of verbs which predict quality in Yoruba criticism according
to context and subject matter. Linear delicacy is a matter of admira-
tion. But excessive delicacy or thinness in the prortrayal of human
mass is condemned. It may be that the latter quality is associated with
the sinister, as suggested by a phrase in the pages of the Yoruba novel
Simbi and the Satyr of the Dark Jungle (Tutuola 1955:73): "Their
bodies were withered for fear." Ideally, the human frame in Yoruba
sculpture is carved with attributes full, vigorous, and fleshy. It is the
shape of confidence.

To return to linear finesse: a carpenter of Ṣepeteri used an interest-
ing verb in relation to this quality when he admired an especially
sensitively carved *ibéjì* and remarked that the coiffure was "just like a
crown," an appropriate simile for its well-finished elegance of form. He
refined his remark with a verb which seems to conjoin the notions of
delicacy in coiffure which Samuel Johnson had documented some 74
years before. "I like the lines of the hairstyle," he said, "[Each] is small
and tightly spaced" (*Ó wẹ́ dáda*). The verb *wẹ́*, according to Mr.
Samuel Adetunji, describes both delicacy of line and spacing.

Yoruba critics require delicacy in portrayals of human morphology.
An Ajilete critic liked the ears on an image because they were small;
an Oke-Iho critic voiced the same thought with the same phrase (*Ó
kéré*). This speaker condemned versions of ears which were "con-

spicuously" (*Ó hòn gbagadagbagada*) visible. This is interesting be-
cause it not only qualifies the notion of grossness as the opposite of
delicacy, but it also refines the notion of visibility. Elements which are
conspicuous—too visible—are indecorous. The aesthetic import of *kéré*,
like *tíńrín*, depends upon context. There is a difference between a
delicate nose and a nose which is simply too small. The vanishing nose
is censured with the phrase *Ó kéré*.

Thus four words, at least, form the Yoruba vocabulary of delicacy:
1) *kékeré*, "small," referring to delicacy of mass; 2) *kéré*, "is small,"
referring to delicacy of mass in the context of approval; excessive
diminution of proportion in the context of disapproval; 3) *tíńrín*,
"narrow," referring to delicacy of line, both as to fineness of outline
and as to sensitivity of grooving or incision patterns (*Tíńrín* when
applied to mass may acquire a negative denotation); and 4) *wé*,
literally "is slender," referring to linear delicacy in a special sense—tiny
lines spaced closely together in neat parallel incisions.

Clear-cut definitions of the verbs' meanings emerge in contexts in
which subtle sculpture stands beside brutal works. Taiwo of Ajilete
said of sensitively incised lineage marks: "That cicatrization pattern
pleases me. It is tiny and spaced tightly together and not conspicuously
big" (*Ilà nā wùn mi. Ó wé dáda. Kò tóbi gbagadagbagada*).

Yoruba oppose in their diction the synonyms and antonyms of the
delicate as skillfully as, in their traditional songs, the manifestations of
romantic and practical love are opposed, as in the stanza "love is of
many kinds, one love says 'if you die let me die with you,' another love
says 'if you buy the soup I will buy the yam!'" The antonyms of the
delicate in the parlance of Yoruba critics are "big" and "blunt," as
illustrated by the peculiarly expressive phrase *tóbi gbagadagbagada*
(conspicuously big). The dull or blunted edge is not aesthetic. The
fine edge *is* aesthetic. This notion overlaps to a great extent Western
notions. Thus a common dictionary definition:

> *Fine.* 1. Exquisitely fashioned; delicate ME.
> 2. Not coarse; delicate in structure, a texture . . .
> very thin or slender.

ROUNDNESS: Fourteen critics defined roundness as an aesthetic han-
dling of carved outlines and full spherical mass. As regards curved out-
lines the comment of an Igbomina critic is a useful introduction: "I
prefer the chin of one image—the other is flat and sharp—for the best

chin is moderate." Examination of the images he held in his hands as he judged them revealed that what he meant by "moderate" was pleasingly rounded, not angular.

The idea of full spherical mass was explored by Alaga of Odo-Owa. Alaga explains that the ideal form of the "pot mask," which serves as the helmet of the Ẹpa feast dancer, is rounded. He made signs of disgust when he stood before an Ẹpa headdress in Yagba territory which he felt failed to measure up to this standard. Alaga elaborated: "The pot-mask is not beautiful; it is not finished, it is not rounded" (Kòkò kò dá; Kò ṣe pé; kò ṣe róbótó). He referred to his own work as model. Failure to round major and minor masses not only destroys art, in Alaga's opinion, it can impair the prime mimetic function of art. Thus he found that small calabashes on the same headdress were lumpily rendered and therefore not realistic and not beautiful. Calabashes must be specially rounded.

Mashudi Latunji spoke of the rounding of the forms of good Gẹlẹdẹ masks. He alleged that carvers "invent" roundness after close observation of reality: "We use our eyes to observe how things are round." There is art historical truth to what he says. The basic roundness of Yoruba art is especially evident in the art of Ketu, the ancient Yoruba town under whose cultural influence Mashudi's own town of Mẹkọ lies. Mashudi has indeed used his eyes to absorb the penchant for rounded mass which characterizes the style range of Ketu.

The unified rounding of small masses in relation to larger masses is a hallmark of fine style. In Egba sculpture the eye often flattens to follow the curve of the temple. Ogundeji of Iseyin, in contrast to the Egba solution, rounds the sphere of the exaggerated eyes he carves so that when viewed in profile they are congruent with the rounded mass of the forehead. Ogidi of Igogo-Ekiti vividly rounds off all elements of his images; his works stand on rounded limbs; concave lines articulate arms from rounded torso; convex lines articulate fusions of loin and legs. Each marked division of mass is achieved with fluent curvilinearity.

Criticisms of human buttocks where represented in sculpture brings the Yoruba love of rounded shapes into focus. Jogomi of Ajilete likes his buttocks rounded and "human." By inhuman he means sharp protrusion. The head of the Shango cult in Ila-Orangun made the same distinctions. Departure from the idea of the rounded rump met with amusing ribaldry in an Ijebu village: "If a man wants to copulate, or if a man wants to have an affair, he would quickly and easily be able

to do what he wants to do [with this image] as its buttocks resemble those of a real person. But the second [image], its rump is raised up, its rump [stands up] high at the back" (*Ó se dó fún ọkùnrin, ti ó bá jẹ́ wípé ọkùnrin ba fẹ́ bá lò pọ̀, ó lè tètè rí ṣe ng kan ti ó fẹ nítoríwípé ìdí rẹ̀ dàbí ti ènìòn. Ṣùgbọ́n èkejì ìdí rẹ̀ wà lókè, kole rete di gíga ẹ̀yìn ni ìdí rẹ̀ wà.*)

PROTRUSIONS: A pleasing bulge, as opposed to displeasing or incompetent bulges, may be denoted by the verb of action, *yọ,* "sprouted," qualified by an appropriate adverb. Thus a critic of Ṣepeteri extoled the tactile structure of a nose quite simply: "It bulges" (*Ó yọ gbuñgbu*). "You can hold the beautiful nose with your fingers," he added, "you cannot do this with the unattractive nose." This criterion seems to distinguish the sculptural from the schematic. Moderate bulges are thus an accepted part of roundness.

NONPLEASING PROTRUSIONS: A definite vocabulary defines this negative taste. The modal response of the critics was *ó yọ sùta,* "it protrudes," and it was used, for example, by critics at Oke-Iho and Ilobi to portray, respectively, a jutting forehead and a jutting chin. The verb is rooted in the currency of abuse, as in the Yoruba phrase "he is troublesome" (*Ó yọnun*), meaning literally, "he is mouth-protruding."

The verb *yọ* by itself, of course, is neutral; adverbs shade the quality of the protrusion. Thus *ètèērẹ̀ẹ́ yọ dòdò* describes a pendulous lip, *ó lẹ́nun dòdò* a drooping mouth (Abraham 1958:141).[23] Here the adverb *dòdò* denotes a sagging curve of flesh. An Aworri critic used this word to characterize what he felt was wrong with the pectorals of a male *ibéjì* image. A deliberate usage of this effect in Yoruba art occurs in satiric sculpture for the *Egungun* cult. One mask, now in the collection of the Nigerian Museum, lampoons a nineteenth-century enemy of the Yoruba, the Dahomean, with a striking depiction of sagging jowls.

SINISTER BULGES: In general, rounded masses define Yoruba sculpture. Excessively curved swellings are not, however, looked upon with favor. One critic declared that swollen cheeks were bad art and puffed out his own cheeks in demonstration.

The verb this critic employed to denote swelling (*wú*) has sinister connotations. *Oríìmí wú,* literally "my head is swollen," means "I remember something which makes me apprehensive" (Abraham 1958:

673).[24] *Orí wíwú,* "the remembrance of a terrifying event," is another example.[25] Then there is the singularly cheerless phrase, *Á wú kó tó bé,* "Things will be worse before they are better."[26]

Amos Tutuola draws upon this folk fear of unusual swelling in his *Palm Wine Drinkard:*

> I noticed that the left hand thumb of my wife was swelling out as if it was a buoy, but it did not pain her. [A] child came out from the thumb. He began to talk to us as if he was ten years of age. I was greatly terrified. I was thinking in my mind how we could leave the child in the farm and run to the town, because everybody had seen that the left hand of my wife had only swelled out, but she did not conceive in the right part of her body as other women do. (Tutuola 1952:31; see also p. 32)

An excrescence which is sited "in the right part of the body," forming the "obstetric line" which defines the belly of a pregnant woman, does not of course generate fear, although it is infrequently seen in Yoruba sculpture. At least one obviously pregnant woman appears as a theme, carved, with humorous intent, for the *Epa* feasts of the town of Ipoti-Ekiti. Outside of the context of rational expectation a swelling shape recalls pathology and is to be feared. An Egbado mother warned Kenneth Murray once that if he kicked an *ibéjì* image about, as he was kicking about an abandoned celluloid European doll, he would swell up and die. A strange bulge of earth in the court of the priest of Orò at Iseyin is held dangerous: "if someone steps on Ota Orò they will swell up and die immediately." Fear of swelling, in fact, may well be diffused throughout West Africa.

Under the pressure of similar beliefs, an Ijebu cultivator immediately related the swollen upper arms of an *ibéjì* figure to pathology: *Ó tún wú bí ení pé ó dùn* "It is swollen doubly like a person in pain." An oral literary reflection of this visual prejudice is the ballad of the Scarlet River Hog or *Túùkú:* "River-Hog, a swelling has ruined your beauty" (*Túùkú, kókó ba ojú jé,* literally, "river-hog protuberance spoils face") (Abraham 1958:656).[27]

PLEASING ANGULARITY: Roundness is not an immutable law. One of the strengths of the Yoruba aesthetic is its flexibility. Yoruba critics may waive their tastes provided that novel departures are phrased with richness of human expression. Mr. William Fagg (1962) of the British Museum once told me: "The Yoruba roundness is not to be found in the works of Agunna of Oke Igbira. Agunna is more ascetic, concentrating the chin and the mouth into one point."

Within the style range of Ẹfọn-Alaiye, for example, there is a mode (much favored by chiefly patrons in Ilesha) whereby the chin is crisply pointed. Samuel Adetunji, a native of Ilesha, has described the effect: "You really notice the chin on *Èfòn* carvings. They carve chins which look like a blade." To Ẹṣo of Ipole-Ijesha *Èfòn* chins were "pointed" (*ṣóńṣó*).

Ṣóńṣó thus describes the sculptural concentration of human attributes into points. It is a usage slightly elevated from common speech where the verb acquires an occasionally whimsical tinge, as in the phrase "he has a pointed nose." But *ṣóńṣó* implies something more than a physical state, according to Samuel Adetunji. In its most refined nuance, the verb connotes boldness; it reflects character. Ẹṣo of Ipole invoked this special power of the word. This was entirely in keeping with the heroic stance and pose of fine Ẹfọn-Alaiye sculpture. The bold sharpness of the *Èfòn* chin seems to be a prerogative, interestingly enough, of the generalized representations of mounted warchiefs and kings in the Ilesha area.

The elements and counter elements of the Yoruba notion of roundness briefly reviewed include canonic roundness described as *róbótó*; pleasing bulges are greeted with the phrase *ó yọ gbuñgbu*; negative bulges described by a language apparently borrowed from abuse; sinister bulges fall under the verb *wú*; and, finally, one aspect of a pleasing angularity, at least, is characterized by the word *ṣóńṣó*. Yoruba in general admire roundness but will accept sharp, angular, or bulbous shapes if these present aesthetic credentials which are clearly legible. Ẹṣo of Ipole, for example, not only detected the expression which went into the making of an abstract mode of *Èfòn* chin, but he measured its visual impact with a verb nuanced with boldness.

STRAIGHTNESS: This quality ranks with roundness as a geometric trait of essential character in fine sculpture. Yoruba define straightness as upright posture and, by extension, balanced alignments and symmetry. When Bandele of Osi-Ilorin was asked by Kevin Carroll why he used to stand back from his work at Oye-Ekiti and look at it from a distance the sculptor replied: "We were looking at the straightness of the work" (*Gígún iṣé l'a nwò*), "So that it would not be crooked" (*Kí ò máà wọ́*) (Father Kevin Carroll, personal communication).

Sculpture must stand erect. This is one of the first demands made upon an apprentice striving to master the art of sculpture. At a later point in his career he can assume that the problem of straightness has been mastered, and he can concentrate his energies upon more chal-

lenging aspects of form. But in the beginning (and perhaps forever for third-rate carvers) the matter of alignment is a matter of paramount concern. Bandele confessed his own fledgling uncertainties: "I did not look to the quality of shining smoothness but to the straightness. If you will remember I wasn't as good then as I am now. At that time I did not know the art of blocking the main shapes out of the wood as I do now" (Father Kevin Carroll, personal communication).

If Bandele's enunciation of the problem is enlivened with memories of the mastery of process and form, the noncarving critics' detections of this quality are equally to the point. The head man of Ilogbo told me that he found the stooped posture of an *ibéjì* not beautiful (*kò dá*). In Central Ekiti a critic liked the back of an *ibéjì* because it was straight, while the back of a rival piece was not straight (*ò gún*) and, therefore, inappropriate.

I observed Ajanaku, a fine blacksmith of Ẹfọn-Alaiye, at work in his workshop on an iron staff. The staff was surmounted by an iron bird with an iron plume sprouting from the back of its head. The blacksmith in the last stages of the work attended to the straightening of the neck of the bird and to the straightening of the staff supporting the bird. He took the staff in his tongs and placed it in the sand upright and studied it critically before he was satisfied with the *gígún* (straightness) of the total effect.

That the testing of the staff for straightness was a mental process which did not operate at a subconscious or subliminal level, in a manner suggested by Ralph Linton (1958:11–12), was clearly demonstrated the next time Ajanaku was visited. On this occasion one of the sons of the blacksmith took over the anvil.

The straightening of the bird's neck was not to the taste of the father. Ajanaku softly told his son to reheat the neck of the bird in the furnace and to straighten it out, so that it would not be crooked (*Kí ò mà wọ́*). The son complied. In the glowing "charcoal" of palm kernels he turned the neck of the bird around several times, holding the object with his tongs. With pincers freshly moistened in water he bent the neck of the bird, now cherry-red, just behind the crest behind the bird's neck. At last the neck was suitably erect. Ajanaku smiled. He then told his son to bend the wings of the bird slightly down; this formed a pleasing visual contrast to the rigid axis of the neck and spike.

Here a blacksmith is communicating with verbal commands a canon of straightness tempered with contrast. Pointing commands are the means of the qualification of canons. Mere physical example does not

suffice. At some point the master must put into words what has gone wrong.

SYMMETRY: The calming virtues of symmetry are a constant in Yoruba art. The serene lips of a twin image find reflection in the balanced disposition of the image's hands. When a women kneels and presents her offering in a container, her hands fold symmetrically around the bottom of the object; when a warrior sallies forth on his mount his hands, if free, touch the reins at precisely mirrored points. Even the theme of a bird pecking a snake, potentially a scene of random coils and agitated posture, becomes, in the hands of Duga of Mẹ̀kọ, a concrete manifestation of pure form in even-sided resolution.

Alaga spoke of the nature of symmetry from a sculptor's point of view. Quite characteristically, he inextricably merged the concept with notions of straightness and siting. "One always positions the ears equal to each other," he asserted, "and one always keeps the ears and the eyes on the same line." He continued: "But there are some carvers [laughter] who are like small children and these put the ear on the jaw and do not think of the place of the eyes at the time they block out the ears and the mouth."

A sculptor in Ketu declared that a good carver never works without careful measurements either by adze-nicks or knifed incisions on the log, so that he can balance one effect against another as forms emerge from the raw chunk of the wood. One works quickly, he explained, but one does not work so hastily that one blocks out shapes which are not "straight." As a model of his ideal, he pointed to his own work, a headdress representing a market woman with wares on a tray atop her head. The wares were symmetrically disposed in a criss-cross of minor and major masses.

The critics made comments about straightness in the sense of symmetry, though not with the sophistication of carvers' commentaries. They spoke, for example, of the symmetry of lips, and one critic traced with his finger imaginary lines as he discussed the symmetrical disposition of facial traits and headtie on a Thundergod dance wand.

Straightness is extremely important in what might be phrased the *Ẹpa* cult aesthetic. Here it is canonic among the dancers who carry headdresses during feasts. The canon not only reflects the practical necessity of avoiding the dangerous tilting of the heavy superstructures during the ceremony but also links the pronounced straightness of the architectonic forms of the sculpture to the postures of the dance.

Allusions to the importance of straightness may be found in classical Yoruba poetry. One example is the sixth line of the divination verse quoted near the beginning of this paper. Another exists in the class of Yoruba poems known as àròfò (literally jokes, as in the term aláàròfò, witty person) which are verses aimed at abstract subjects. As their title implies, they probe the assumptions of daily life with irreverence:

> Why do we grumble because a tree is bent
> When, in our streets, there are even men who are bent?
> Why must we complain that the new moon is slanting
> Can any one reach the skies to straighten it?
> (Hodgkin 1960:326)[28]

Sculptors, however, are more committed than the makers of the oral arts. But they may approach the canonical with equal levity in the prescribed areas of moral inquisition, satire, and psychological warfare.

SKILL: Yoruba esteem skill. There are suitable means of phrasing the rare knowledgeability of the artist. A frequent source is the oríkì, or praise name. Oríkì are attributive names. They express a man's most noble qualities, real or imagined. For males they often bear heroic connotations. Thus the oríkì of a sculptor may allude not only to his skill but magnify the quality on an heroic scale.

Consider the oríkì of Taiwo of Ilaro, an excellent sculptor who died around 1920 and whose early twentieth century work is found in the study collections of the Royal Ontario Museum at Toronto. In the province of the Egbado, Taiwo was widely known under his attributive name of Onípàsónòbe which means possessed of a knife like a whip.[29] It is a miniature poem in praise of artistic cunning. Such was the skill of the late Taiwo that he summoned shapes, as with a whip, out of brute wood with his knife and made the shapes do as he bid them.

EPHEBISM: This is perhaps the most important criterion. It is, in a sense, the resolution of all the canons in combination. Ephebism means, broadly, the depiction of people in their prime. In accordance with this canon, critics pose this question: Does the image make its subject look young?

Yoruba sculpture is a mirror in which human appearances never age. In Ipokia, for example, an old priest pointed to a robust image and said with pride: "That stands for me." Yoruba art idealizes seniority. Divination poetry tells us wisdom is the finest beauty of a person.[30] Ergo, what could be more appropriate than to flatter the moral beauty of the elders with the physical beauty of the young?

Moreover, the actual physiognomy of the senior devotee often resists the flawless seal of Yoruba sculptural form. To imitate the masters of Yoruba life and religion as they really are would deny the Yoruba idea of sculpture from self-realization.

Critics led me to these conclusions. Thus the wife of the village blacksmith at Ilishan: "I like that carving—it makes the Ọba look so young." Study of the carving she criticized validates her judgment. Cheeks are firm, stance is sure, chinline is strong. The waist is slim and youthful, and the chest is muscular, if slightly androgynous.

At Shaki an Egungun worshipper pursed his lips and parried a request for artistic criticism of twin images with a question: "Between a beautiful young woman and an old woman which would you prefer for a wife?" The expected reply was given. The informant was amused for he had led his interrogator into corroborating his argument. "I like one image best," he then stated, "because it is carved as a young girl while the other three are like old women."

This ranking was one of the very few which did not coincide with the opinion of the present writer. Three twins which seemed slender and youthful to the writer and his wife were the very pieces which seemed old to the informant. What caused the divergence of views? The informant pointed to the breasts. The breasts of the "old" women were high, as if shrunken and withered, while the breasts of the "young" girl hung down and gave the impression of fullness.

A more important reason, however, was probably the erosion of features through ritual washing. The facial traits of the "old" pieces had been somewhat worn away by time and use. It is of interest that the informant was not swayed by the sumptuous money garments, made of cowries, which adorned two of the nonfavored *ibéjì*.

A critic of Ilogbo-Aworri immediately censured the hunched shoulders and fleshy pectorals of an *ibéjì* image. Good images, he said, were carved as youths, not old men. A critic at Ifaki-Ekiti made substantially the same point and added "The chest of a young man should look like this," pointing to a hard, polished surface. "It is beautiful because it makes the image look young."

Critics characterized the alleged age of an *ibéjì* (female) at Ṣepeteri on the basis of breasts. A favored image had breasts of equal length. "It resembles a young girl" (*Ó dàbí ọmọnge*). A rejected image had breasts which sagged, with the right breast longer than the left, a not infrequent phenomenon among Yoruba mothers whose children have favored one nipple over the other while nursing. Asiru of Ṣepeteri made this point concrete: the most elegant *ibéjì* possessed breasts of the same length and consequently resembled a young woman.

Abinileko of Otta established that ephebism can control the judgment of Gẹlẹdẹ masks: "Labintan's chin looks like the chin of a young man, but that of Salawu resembles someone who is middle-aged" (Àgbọ̀n ti Lábíntán dàbí ti ọ̀dọ́mokùnrin, ṣùgbọ́n ti Salawu dàbí ti àgbàlágbà). The main source of satisfaction with Labintan's image was that it had the look of a young boy.

The vocabulary of ephebism is simplified. It consists essentially of the key verb jọ (resembles) in combination with substantives denoting the quality of being young. Ephebism, as criterion, is a logical interpretation of certain of the visual constituents of Yoruba sculpture. For example, roundness connotes the vigorous period of existence, for human faces tend to become angular in old age.

Coiffure also points in the direction of youth. Irun àgògo, a bridal mode of the nineteenth-century Oyo, is frequently used in sculpture.[31] The high-keeled structure of the hair to a Yoruba immediately recalls the fresh beauty of the bride.

Mashudi of Mẹko reveals that one motive for the use of ephebism is commercial advantage:

If I am carving the face of a senior devotee I must carve him at the time he was in his prime. Why? If I make the image resemble an old man the people will not like it. I will not be able to sell the image. One carves images as if they were young men or women to attract people.

The Yoruba aesthetic qualifies the notion that Africans never seem to carve their subjects as of any particular age. The intent of the Yoruba sculptor is to carve a man at the optimum of his physical beauty between the extremes of infancy and old age. Even where a beard indicates maturity the brow of a Yoruba sculpture may glow with the freshness of early manhood (Plate VII).

Seen as a whole, the Yoruba aesthetic is not only a constellation of refinements. It is also an exciting mean, vividness cast into equilibrium. "The parts of this image are beautiful," an Oyo elder once said, "because they are equal to one another." Each indigenous criterion is a paradigm of this fundamental predilection. Thus mimesis, as traditional Yoruba understand it, is a mean between absolute abstraction and absolute likeness; the ideal representational age is the strong middle point between infancy and old age; the notion of visibility is a mean between faint and conspicuous sculpture; light is balanced by shade. That beauty is a kind of mean is explicitly stated by Tutuola in Feather Woman of the Jungle: "She was indeed a beautiful woman.

She was not too tall and not too short; she was not too black and not yellow."

Yoruba color preferences extend these beliefs. One schoolboy once stated on a questionnaire given by Justine Cordwell that his favorite color was blue because "it usually gives some attraction to the eyes. It is midway between red and black. It is not too conspicuous as red and it is not so dark as black. It is cool and bright to see." He spoke with the full authority of his ancestors. Most significant was the notion of blue, a highly favored traditional Yoruba color, as a mean between red and black.

Yoruba sculptors impose a truce upon the elements of their works, the elements themselves expressed in moderation. Even in the field of Egungun sculpture, where in order to suggest visitations from the world of the dead much license is allowed, one finds bestial and human attributes coexisting in a dignified manner because they have been balanced. Then, in turn, the sculpture will be balanced on the top of a dancer's head, and he himself will probably make symmetrical gestures with a pair of flywhisks as a countereffect to his occasional impassioned twirlings.

Increase and fertility are important preoccupations. But of themselves they constitute no more than the instincts of a beast. Yoruba artistic criticism seems to be saying that force or animal vitality must be balanced by ethics, the moral wisdom of the elders. Ethics in this special sense would be the peculiarly human gift of finding the tolerable mean between the good and the bad, the hot and the cold, the living and the dead, to safeguard man's existence.

NOTES

1. My intellectual debts incurred in the making of this paper are legion. First of all, I should like to thank the generosity of the Ford Foundation and The Concilium for International Studies at Yale for two generous grants which allowed me to study Yoruba responses to artistic quality during three field trips over the period 1962–1965. Secondly, I should like to thank Kenneth Murray and Father Kevin Carroll for a thoughtful criticism of the text and William Fagg, Leonard Doob, George Kubler, and Vincent Scully for many insights. Finally, I am grateful to Alan Merriam, Roy Sieber, and Warren d'Azevedo for many courtesies and for the example of their works. I also warmly thank Lila Hopkins Calhoun for clerical assistance and my wife, Nancy, for excellent criticism and sustained enthusiasm.

2. Thus Cordwell (1952:292): "none of the master carver informants would become more explicit about what it was that they would say to another carver in pointing out why and how the carving was not good."

3. Ikare informants told me very simply that beauty of voice is also considered by those who judge the quality of oral skills.

4. Thus: "Comme dans les langues de métier, la prolifération conceptuelle correspond à une attention plus soutenue envers les propriétés du réel."

5. See Murray (1938?). As to one of the monuments of Yoruba metallurgy see Williams (1964:152). "[The 'anvil' of Ladin], a drop-shaped block of iron 30 inches high with a girth of 41½ inches, still stands in the compound of the Oni of Ife. It was believed by Frobenius to be of cast iron, a claim which would suggest furnaces capable of generating temperatures in the region of 1,550°C. The block on close inspection, however, appears to have been built up from lumps of wrought iron which in any case represents a high degree of metallurgical skill."

6. An excellent survey of Yoruba literary types is Yoruba Poetry by Beier and Gbadamosi (1959).

7. As documented by D'Avezac (1845:78): ". . . markets . . . operate on a money basis—based on the cowrie shell, called owwo." On pp. 81–83 D'Avezac discusses the Ijebu Yoruba concept of the week, month, and year.

8. See, for example, Roth (1903:157–191). See also Weir (1933: par. 101). "The official residence of the Ologotun is maintained by the townsfolk and the share of the work is allocated as follows: (1) By all the town (a) the entrance gate to the forecourt known as enu geru (b) the forecourt known as ode gbaragada (c) the second court known as ode useroye (2) By the Uba quarter (a) the court for council meeting known as ode ayigi." Weir documents similar information in his Intelligence Report on the Ikerre District of the Ekiti Division of the Ondo Province (Lagos: 31 December 1933).

9. I have since this time interviewed many more critics. Eventually I hope to plot differences of taste by ethnic sub-group, though the task may prove difficult.

10. Bowen (1858). Amèwà seems formed of a mòn ẹwà "Knower (of) beauty," just as "lawyer" (amòfin) is literally a "knower (of the) law" (A mòn òfin).

11. Quoted in a personal communication to the author from Father Kevin Carroll of the Roman Catholic Mission, Ijebu-Igbo.

12. The details of spelling are taken from Abraham (1958). Thus, for example, I spell "enia" as he does, phonetically enion. Abraham's Dictionary is likely to stand for years as a standard reference and to facilitate thus the easy use of his intricately organized materials, I have used frequently his own system of orthography.

13. Thus: "Most of these commercial pieces exhibit a lack of feeling so marked that they can easily be distinguished from the figures made for Dahomeans, on which time and effort are lavished in the best traditional manner." Compare Kenneth Murray's experience with Suli Onigelede, a woodcarver of Lagos, circa 1946: "Suli . . . had some ibeji (twin statuettes) . . . unfortunately he smothered them in bright green enamel as he thought that Europeans would like them so, in spite of my instructions to use native colours" (Murray, unpublished manuscript).

14. Cf. a brief summary of the problem of portraiture in African sculpture may be found in Bohannan (1964:152–3).

15. These are described as real portraits "for remembrance."

16. For these and other remarks by Bandele I am indebted to the kindness of Father Kevin Carroll who shared the insights of this famous son of Areogun of Osi-Ilorin in a letter dated February 29, 1964.

17. Father Carroll has published the Ekiti Yoruba terms for these stages in his "Three Generations of Yoruba Carvers," *Ibadan* No. 12 (June 1961), p. 23.

18. These are points from tape-recorded conversations with Bandele which Father Carroll has shared with me.

19. Quoted in a personal communication from Father Kevin Carroll.

20. King (1961:11). Bells and gongs are made "visible" to the ear, as it were, because of their high pitch.

21. Nigerian Museum, Lagos (KCM 381). The housepost once stood in a courtyard in the house of the Elegbe.

22. Collier ("Yoruba Hunter's Salutes," p. 54): "Some hunters say *rekina-rekina* which I understand to mean "glistening" or "glittering"—like the sun shining on wind-ruffled water, I was told . . ."

23. See *dòdò* (Abraham p. 141).

24. *Wú* (Abraham p. 673).

25. *Ibid.*

26. *Ibid.*, p. 672.

27. Abraham's translation has greater focus than an earlier version of the ijala of the Red River Hog by F. S. Collier, who rendered the Yoruba "animal . . . with swelling on his face."

28. From E. L. Lasebikan, "The Tonal Structure of Yoruba Poetry," *Présence Africaine* No. 8–10 (1956), p. 49.

29. Mr. Kenneth Murray collected this information at or near Ilaro.

30. Cf. Beier and Gbadamosi (1959:30): "Wisdom is the finest beauty of a person. /Money does not prevent you from becoming blind/ Money does not prevent you from becoming mad.

31. *Agogo* coiffure also, of course, denotes subservience to a deity.

William Bascom

A YORUBA MASTER CARVER:
DUGA OF MĘKỌ

IT seems to me that there are several fruitful ways of approaching the study of the traditional artist in African societies. One is the analysis of the role, status, and social function of wood carvers, musicians, and other artists in various African societies. This approach has been badly neglected in the study of African art.

Another approach is the analysis of the works of individual artists. Maria Martinez and Nampeyo as potters, Tom Burnside as a silversmith, Dot-so-la-lee as a basketmaker, and other distinguished American Indian artists had received attention as individuals before there was any study of individual African artists. Few African museum pieces are identified by the name of the carver,[1] but in recent years William Fagg has been identifying and comparing the works of Yoruba carvers such as Agbonbiofe and Ologunde of Ęfọn-Alaiye, Olowe of Ise, Bamgboye and Arowogun from near Osi, Kobadoku of Igbesa, and Adugbologe and Ayo of Abeokuta. Father Kevin Carroll has added his study of the works of other Yoruba carvers: Areogun and Bandele of Osi, Lamidi of Ila, and Otoro of Ketu. This approach can tell us much about African artists and about African art itself.

In this paper I shall discuss the work of a master Yoruba carver who ranks with these others, Duga of Mękọ.[2] He was still alive in 1950 so that I could talk to him, talk to others about him, and observe him at his work. This approach provides an ideal situation for combining the study of an individual artist as a person with the analysis of his role and social function, and his style. I only regret not having probed more deeply into all these topics while I had this unexpected opportunity, but my research at the time committed me to the study of other problems. As a result this paper is based on data gathered incidentally and is not as complete as I would have wished. Unfortunately, the chances

Plate I A shrine for Shango, God of Thunder, at Mẹko, 1950. The largest of the three Shango dance wands (oṣe Ṣango) leaning against the wall was carved by Duga; it is the one of which he made a replica when its owner decided not to sell the original. An inverted mortar, decorated with a human face and a ram's head, is in the center; it serves as a stool when initiates to the cult of Shango are shaved. On the mortar sits a plate with "thunderstones" (prehistoric celts, sacred to Shango) and horns inside, and leaning against it is a gourd rattle behind two horns. A second inverted mortar is at the far left, and four appliquéd leather shoulder bags are hung on the wall. (From *The Yoruba of Southwestern Nigeria* by William Bascom. Copyright © 1969 by Holt, Rinehart, and Winston, Inc. Reproduced by permission of Holt, Rinehart, and Winston, Inc.)

for employing this approach are rapidly disappearing in Africa as the masters of traditional art styles die off.

This paper demonstrates that art as art exists among the Yoruba and that it is recognized by them as such. The final statement of this paper, in particular, should help to dispel the notion that the works of African carvers, which we find so aesthetically satisfying, have no aesthetic appeal to the Africans themselves, who regard them simply as sacred religious objects. Robert Farris Thompson's paper in this volume corroborates this point.

By way of introduction, let me give a little background on the Yoruba and on their wood carving and other arts. The Yoruba today may number 11,000,000, if we can put any faith in recent population statistics (Bascom 1969a:ix). No details were released for the controversial census of 1962; according to the previous census of 1952 there were 5,046,799 Yoruba in Nigeria, with an additional 168,594 in Dahomey and Togo according to still earlier reports. If the 1962 figures are exaggerated, as may be the case, those of the 1952 census were undoubtedly underestimated and no not allow for growth in the interim.

The Diversity of Yoruba Arts

The Yoruba are not only one of the largest ethnic groups in Africa; they are also one of those most productive of art. William Fagg of the British Museum has called them "the largest and most prolific of the art-producing tribes of Africa" (Fagg 1963:9). Despite my acknowledged personal pro-Yoruba bias, based on my long association with them, I suspect that this may be an overstatement after having seen something of Baule art in the field; but clearly the Yoruba rank with the most prolific art-producing peoples of Africa.

The Yoruba distinguish the word carvers, gbẹgigbẹgi (gbẹ-igi-gbẹ-igi: carve-wood-carve-wood) who produce mortars and other utilitarian objects from carvers, gbẹnagbẹna (gbẹ-ọna-gbẹ-ọna: carve-art-carve-art) who make masks, figures, and other sculpture. The sculptors are known as artists or "those who make art" (oniṣọna, oni-ṣe-ọna), along with those who do embroidery and other forms of decorative art. Sculpture and geometrical designs are both classed as art (ọna), but masks, figurines, and other sculptural forms are distinguished as ere, usually translated as images or idols. As in English, there is a separate term for beauty (ewa).

Aside from the archaelogical terracotta and bronze heads and figures

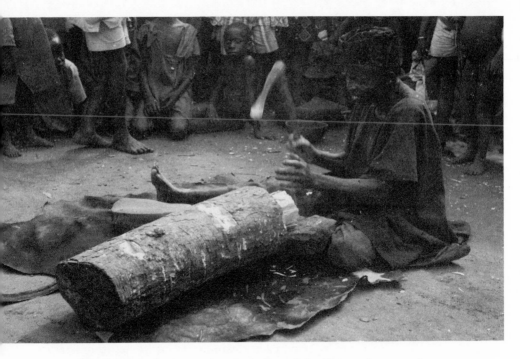

Plate II Duga begins carving the replica of the Shango dance wand, using a fresh log at least twice the length of the finished piece.

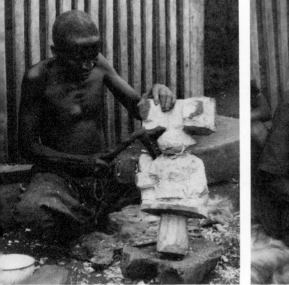

Plate III Duga continues the adzing, roughing out the form of the Shango dance wand.

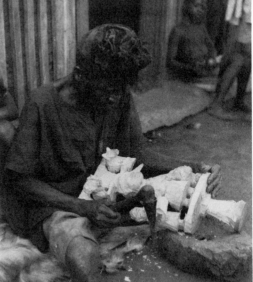

Plate IV Duga engaged in the second step of carving: fine work with the adze. (Photo courtesy of Milwaukee Public Museum, Milwaukee, Wis.)

from the city of Ifẹ, the Yoruba are most famous for their wood carvings. These include *Egungun, Gẹlẹdẹ, Ẹpa, Ẹlẹfọn,* and other classes of masks; trays, bells, cups, and bowls for *Ifa* divination; twin figures (*ibeji*); figurines for the shrines to the deities; dance wands, staffs, spears, and shields for Shango, Yewa, Eshu, Ẹrinlẹ, and other gods; drums, stools, doors, and house posts; kola bowls, spoons, dolls, loom pulleys, game boards, combs, and mirror cases.

The Yoruba also carve in ivory and bone and were still carving in stone in Ifẹ when I first visited Nigeria in 1937–1938. They decorate calabashes with low relief carving, house walls with paintings of animals and geometric designs, and metal with punch work designs. They cast metal using the lost wax process and forge metal into sculptural forms as well as utilitarian objects. They produce pottery, matting, basketry, weaving, dyeing, embroidery, leatherworking, appliquéing, and beadworking. Yoruba arts are as diverse as they are profuse; and many of them are stylistically distinct (Bascom 1969b).

Both men and women weave, the former using the horizontal narrow band loom and the latter the vertical cotton loom. Women do the spinning, dyeing, matting, and potting; and the remainder of the crafts are practiced by men. Few Yoruba artists can support themselves solely by their craft, and the amount of time that a man devotes to farming usually depends upon the volume of his trade. In Isẹyin, however, weavers are prohibited from farming and 90 per cent of the 2,500 men engaged in the craft in 1952–1953 were full-time weavers; the remaining 10 per cent did some Koranic teaching or sold cloth or thread on the side (Dodwell 1955:142). Spinning, dyeing, weaving, and blacksmithing are still flourishing industries despite the competition of the factories of Europe, India, and Japan. Matting and basketry, pottery, leather working, and calabash carving still hold their own, but wood carving, ivory carving, and brass casting are declining.

This decline is in large part due to the spread of Christianity and Islam, both of which have made considerable inroads among the Yoruba during the last 100 years. From the 1952 census one can estimate roughly that more than 40 per cent of the Yoruba professed Islam, less than 40 per cent professed Christianity, and less than 20 per cent acknowledged allegiance to the traditional Yoruba religion. Not all of the converts to Christianity and Islam have abandoned the traditional rituals, and by no means was all Yoruba art religious; but the wood carvers and the brass casters have lost a considerable proportion of their former customers and have suffered economically as a result. More money can be earned as clerks and in other white collar

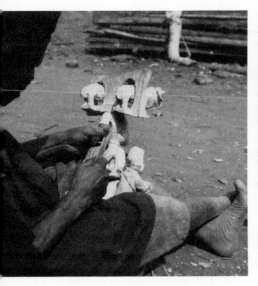

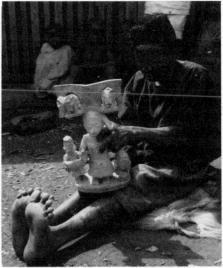

Plate V Smoothing the carving with a knife. Note the use of the left thumb. (Photo courtesy of Milwaukee Public Museum, Milwaukee, Wis.)

Plate VI Further work with the knife. Note Duga's toes.

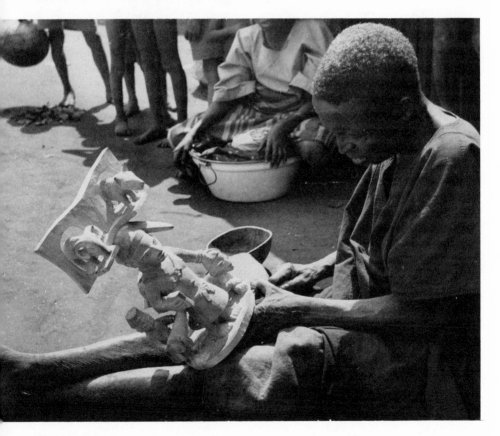

Plate VII Further work with the knife. Note the use of the legs as a vise, as in Plates V and VI.

positions in government and business, with the result that fewer young men find carving or casting attractive as careers. Most converts to the new outside religions have been taught to look down on religious sculpture as relics of the superstitions of the past, and thousands of carvings have been lost to the termites either through neglect or as the result of having been deliberately discarded or destroyed. Only a handful of educated Yoruba have begun to collect these sculptures as works of art, and only because of having seen how highly prized they are, as art, in Europe and America.

Selection and Training of Carvers

Schooling, which leads to white collar careers and which parents are anxious for their children to have, interferes directly with these crafts, either because of outside assignments or because children are sent away to boarding schools. In 1960, one of the leading carvers in the city of Ọyọ complained to me that his son, who was training under him, could hardly be expected to become a good carver because he was at home only a few months during the summer.

Yoruba children are taught their craft by their parents, or they learn through a system of apprenticeship. A boy may be apprenticed to a master craftsman, usually for a specified period and sometimes for a fixed fee. Some apprentices live with, and are fed by, their masters; others return home for their evening meals and lodging. The apprentice serves as his master's assistant, running errands and performing other odd tasks for him; and beginning with simple techniques and simple objects, he carves or weaves under the direction of his teacher until he has mastered his craft or completed his period of training. The master provides the necessary materials and owns whatever the apprentice produces. In some cases the apprentice must give his master part of his earnings from his craft after the period of apprenticeship has ended.

Whether a boy learns quickly or slowly and whether or not he becomes a successful carver or a poor one is explained by the Yoruba in terms of the personal destiny (iwa) assigned to him at birth by the Sky God (Ọlọrun). If an apprentice can do better work than his teacher, people know that his skill was given to him by the Sky God as part of his destiny, which also includes the occupation that he is to follow. Soon after a child is born, the parents consult a diviner (babalawo) to learn about its destiny, and in order to achieve it, an individual may have to sacrifice to the Sky God at various times during his lifetime when instructed by a diviner to do so. He may also have

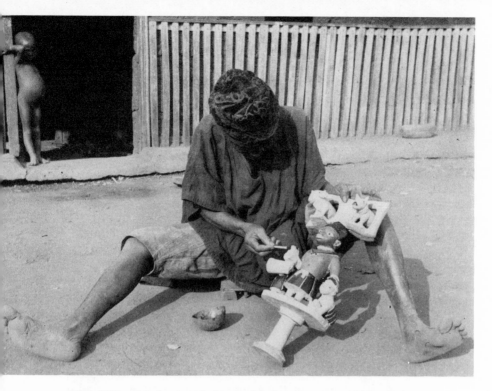

Plate VIII Painting in polychrome: black, red, tan, pastel blue, and natural wood. The verandah of Duga's house is in the background.

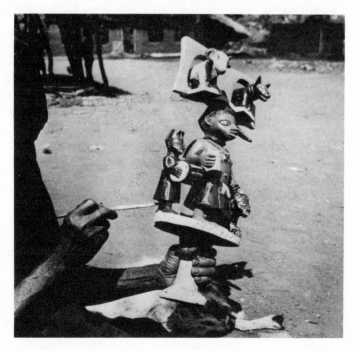

Plate IX Further painting, a chewed piece of wood serving as a brush. (Photo courtesy of Milwaukee Public Museum, Milwaukee, Wisconsin.)

to offer sacrifices to his head and his ancestral guardian soul, which are associated with his luck and destiny (Bascom 1960).

The Master Carver Duga

With this background, let us turn to Mẹkọ, a small Yoruba town in Nigeria which had a population of 5,047 in 1952. Mẹkọ is situated west of Abẹokuta, less than five miles from the boundary which divides Nigeria from Dahomey. Before this boundary was drawn, Mẹkọ belonged to the kingdom of Ketu, whose capital is now in Dahomey. Subsequently, Onimẹkọ, the town chief of Mẹkọ, was granted the right to wear a beaded crown and to assume the status of king (Ọba).

Duga was Mẹkọ's most skilled wood carver, and he was one of the master carvers of recent Yoruba history. When Mrs. Bascom and I knew him, in the fall of 1950, he must have been 70 years old. He was married and had several grown sons and, as far as I can recall, three wives at that time. Normally he did some farming on the side, but while we were in Mẹkọ his children were sick with smallpox (one of them died); it was not the season of heavy farm work; and we kept him busy carving for us. He was a quiet, friendly, modest man, but, although he did not express it openly, he obviously took both pride and pleasure in his work. He spoke no English. He lived modestly in a rather humble home, but he was respected by the people of Mẹkọ for his skill and his creative imagination. Robert Farris Thompson informs me that Duga died in 1960 but that, fortunately, a dozen carvers and apprentices were still active in Mẹkọ in 1964, including Duga's great rival, Mashudi Latunji, from whom I was carefully isolated because of my friendship with Duga. I only regret that it was not possible to revisit Mẹkọ and complete Duga's story at first hand when I was again in Nigeria in 1960, but it is gratifying to learn that Thompson has further details on his career.

Materials and Tools

Duga carved in the traditional Yoruba substyle of the Ketu kingdom. He sometimes used imported oil paints, as many Yoruba carvers have done for some time, but he had not forgotten the old ones made of local materials. At my request he used only the traditional paints on things he made for me. The chewed end of a splinter of wood served as his brush (Plates VIII, IX, XIII). Yoruba carvings are often polychrome, and Duga's work was no exception. He worked with a palette

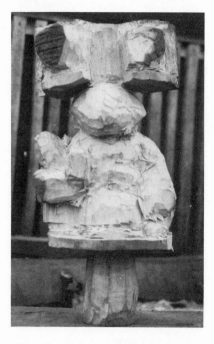

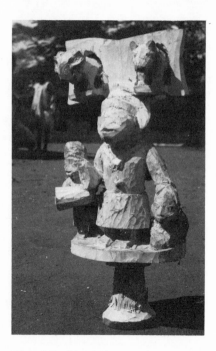

Plate X Step one: the roughed-out figure.

Plate XI Beginning of step two: fine work with the adze.

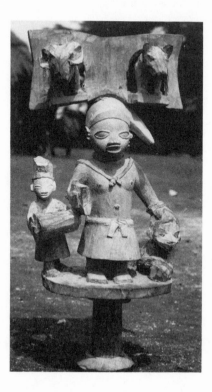

Plate XII End of step three: smoothing with the broad-bladed knife; the final step in carving will be the incised knife-work on the hair and on the edge of the base. The central figure represents a priest of Shango carrying a Shango dance wand in his right hand. His left hand rests on a female worshiper of Oya, Goddess of the River Niger and Shango's most loyal wife; she is giving the traditional greeting of Oya's worshippers to priests of Shango. The man at the other side is beating Shango's drums *(bata)*. The top, which usually represents two thunderstones, has been elaborated into a frame for a ram at the left and a dog at the right. There is a dog which is sacred to Shango, and the ram is his favorite sacrificial animal. Note that the subsidiary figures are carved to a markedly reduced scale in order to subordinate them to the main, center figure.

of nine colors which could be made either matte or glossy; this gave a total of 18 different effects whose shades could also be varied by adding more or less of the ingredients. The paints were normally matte but could be made glossy by the addition of a gum resembling gum arabic, but which Duga called *omi sogidoka* and which probably comes from *Lannea acida*.[3] Unfortunately, many of the other ingredients have not been identified.

White was made with chalk (*efun ile*) which is found in the ground when digging wells. Black was made from the wood, not the bark or roots, of an unidentified tree (*igi aisin*). Dark blue was made from the leaves of indigo or of the indigo vine (*ewe elu*), *Indigofera spp.* and *Lonchocarpus cyanescens*. A pastel blue was made from the same leaves, mixed with chalk. A pastel pink was made from the leaves of an unidentified plant (*ewe saparu*), apparently also mixed with chalk. A bright red was made with an unidentified stone (*aje*), and another shade of red was made with seeds which grow inside the prickly pod of an unidentified plant (*ebo*). A light green was made from the leaves of a bean (*apaku*), probably the lima bean or *Phaseolus lunatus* which is known in Dahomey as *akpaku* (the Yoruba p is pronounced kp). A light tan was made with another unidentified stone (*opun*).

One does not usually associate pastel colors with African carvings, but Duga's pink, light blue, and green were definitely of this category. Duga explained that he could not tell what colors would be good for a carving until he started to paint; in his own words, the wood "chooses its own color."

Like other carvers, Duga selected and collected his own materials for his paints and his own wood. For most sculpture the favorite woods are from the False Rubber Tree (*irena, ireno*), *Holarrhena Wulfsbergii*, or from the West African Rubber Tree (*ire*), *Funtumia elastica*; but the African Oak (*iroko*), *Chlorophora excelsa*, is used for some *Ifa* trays and some utilitarian bowls, tubs, and mortars. Several other woods are used for mortars, including *Afzelia africana* (*apa*) and two unidentified trees (*ole* and *asin*).[4] In most Yoruba towns carvers must pay for a license before they can fell certain trees for carving. Duga also carved in bone and ivory.

Duga used the traditional tools of the Yoruba carver. A small adze (*awon kekere, ahon kekere*) is used to block out the rough form of the object, and a narrow adze (*iso*) to carve it almost to the finished state. He worked with both adzes with great precision, sure of his strokes and certain of the image which he had only in his mind. The blades of both adzes could be removed from their forked handles and

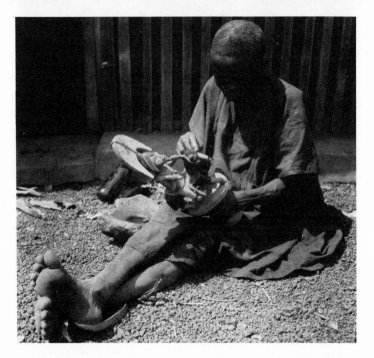

Plate XIII Duga repainting a second Shango dance wand, which had been previously carved by him: black, white, red, two shades of tan, and pastel pink.

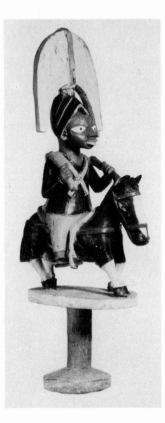

Plate XIV The second Shango dance wand, representing a Shango priest on horseback. Again note the subordination of the horse to its rider. (Photo courtesy of Milwaukee Public Museum, Milwaukee, Wisconsin.)

used as chisels to remove the wood between the legs of figures and in
other places difficult to reach with the adze; the adze handles then
served as hammers. Some carvers use a special chisel (*opipa, ǫpipa*).
To remove the adze marks a broad bladed knife (*ǫbẹ nla*) is used with
a shaving motion, held in the right hand and with pressure applied by
the left thumb (Plate V). This use of the knife is also found among
the Fǫn of Dahomey, and may be a widespread technique. A narrower
knife (*ǫbe kekere*) is used to make the ridges of hairdresses and other
incised designs. In working with a knife Duga often used his legs as a
vise (Plates V-VII), and in using an adze he turned the figure round
and round, right side up and upside down, viewing it from many angles,
and literally in its three dimensions. A larger adze (*awon nla, ahǫn nla*)
is used to fell the trees to get wood for carving, and an axe (*ake*) is used
to split it; but the two smaller adzes and the two knives are the main
tools for sculpture (Plate XV).[5]

Apprenticeship

Duga had served his apprenticeship as a boy under a master carver at
Ketu, an important art center and the capital of the kingdom to which
Mẹkǫ formerly belonged. To my knowledge, he is the only traditional
artist in a nonliterate society who is known to have received a scholar-
ship for his art training. His father and his grandfather had been wood
carvers before him, and his father had been an important member of
the Gẹlẹdẹ cult, which uses large numbers of masks in its ceremonies.
This cult paid the expenses of Duga's apprenticeship with the under-
standing that in return he would carve masks for the cult without
charge. It was also understood that when he carved for worshippers of
Shango or the other deities, and when he worked for other customers,
he could keep whatever fees he wished to charge for himself. However,
he checked with the cult officials before undertaking such assignments.

The Making of a Shango Staff

I met Duga when the owner of an excellent Shango staff (*oṣe Ṣango*,
Plate I) was unwilling to sell it to me. He told me that it had been
made by a carver who was still alive, and directed me to Duga. I com-
missioned him to copy it for me (Plates II-XII) and arranged to make
a color movie of the process, from the initial roughing out of the log
to the final painting in polychrome. As I had him stop at critical

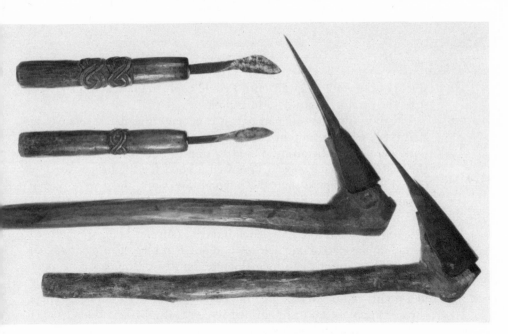

Plate XV A set of carver's tools from Oyo, Nigeria. See note 5.

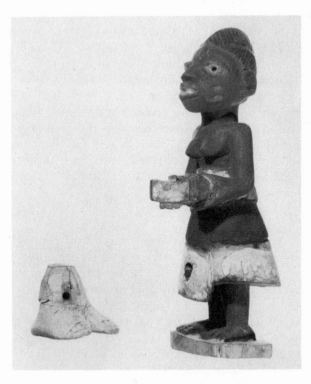

Plate XVI A figure from a termite-eaten stool carved by
Duga, with a new pair of legs also carved by him. On the
left are the legs carved by his apprentice.

stages of the work and wait until I could come to photograph the next step, the carving took weeks to complete.

The most illuminating part of this experience was that it made clear that Duga was not content with simply making a copy of what he had done before; he obviously wanted to improve on his earlier work. In the first place, having been promised a good fee for his services, he carved a larger figure than the original. Secondly, there were several minor variations in the carving, though these were largely matters of detail. Thirdly, there were deliberate variations in the painted colors. The top portion of the staff which frames a ram and a dog, was painted a solid tan instead of one half red and one half blue. Tan was retained as the skin color of the principal figure, but the drummer on his right was given black skin instead of red, while that of the woman reclining in a traditional posture of greeting became red instead of black. These three skin colors are distinguished linguistically (*awęja, dudu, pupa*) and are represented in several of Duga's carvings, but in the new carving those of the two subsidiary figures were reversed.

On several different occasions during the carving, starting when the form of the figures first began to emerge (Plate III), Duga asked me what color the ram should be painted. As I wished to leave the decision up to him, I gave evasive replies such as "As it would have been painted in the old days" or "As you think it should be painted." For several weeks this question bothered him, and he wrestled with it as an artist trying to choose between alternatives on purely aesthetic or ritual grounds. Finally he reached his decision and stopped asking his questions. He painted the ram's horns black, as they had originally been; but instead of painting its body white, he left it in the natural color of the unpainted wood. He was obviously satisfied with his choice, because he repeated this treatment on a ram's head in another carving he made for me several months later.

Duga's dedication to his work was that of a true artist. So that I could photograph him at his work, he moved out into the direct sunlight from the shaded verandah where he normally carved, but he was oblivious to the noonday West African sun. He sometimes became so absorbed in what he was doing that he remained there, intent on his carving, after we had said goodbye and driven away.

One could tell when he was concentrating on his work by watching his feet, which became tense with his toes spread tautly apart, when he was especially intent upon it (Plate VI). When engrossed in his art Duga neglected everything else, but he was neither an irresponsible person nor a rebel against society.

In addition to the carvings which he made for us, I was able to collect others for our personal collection and for the American Museum of Natural History, which asked me to make a Yoruba collection just before we left Mẹkọ. In both of these collections there are now some excellent *Gẹlẹdẹ* masks, *Shango* staffs, and stools for initiation into religious cults made by Duga.[6] While in Mẹkọ we kept these carvings in the rest house where we lived and sometimes worked. Informants who came to the house recognized his carvings and exclaimed with admiration at his work, or said simply in a tone of deep respect "Duga!"

I do not know how many apprentices Duga had during his lifetime: I met only one in 1950, a man about 40 years old who carved *Gẹlẹdẹ* masks and utilitarian objects. He was recommended by Duga, but his ineptitude only served to dramatize Duga's great skill. On one occasion, we purchased a small wooden figure from a termite-eaten stool which Duga said that he had carved. He was then too busy to carve new legs to replace those which had been destroyed, and he asked his former apprentice to make them for us; but the apprentice produced as crudely carved a set of legs as can be imagined. When I showed the results to Duga, he was so ashamed that he took us to his apprentice, berated him in front of us, and then carved another set of legs himself, without charge (Plate XVI). This incident shows not only that all Africans are not good carvers, but also what is happening to African wood carving.

Homage to Duga

The respect of the people of Mẹkọ for Duga's imagination and skill, and one of his creative achievements are recorded in a letter we received after having left Nigeria on that trip. The letter came from Tijani Isiaka, my Mẹkọ interpreter, informing us of the death of his father, Chief Isiaka, on March 2, 1953: (Incidentally, both Tijani and his father were Muslims.)

Duga and the other wood-carvers at Mẹkọ carved many kinds of *Gẹlẹdẹ* masks when we made the ceremony of *Gẹlẹdẹ* for my late father. The *Gẹlẹdẹ* and other dances for the sake of my late father were too [very] great and interesting. People came from many towns to see the display and witness the big occasion, especially *Gẹlẹdẹ*, and others came in interest of the Onimẹkọ [King of Mẹkọ]. The Ọba [King] of Aiyetoro came, Alaketu [King of Ketu] sent his followers, and all the rest of the Ọbas [Kings] around Mẹkọ came here and witnessed the ceremony.

Duga for the ceremony carved a horse of wood and gave it four wheels to walk on, and he made it so that four people could be hid in the mat with which he covered round the horse. Two people pushed it forward and two people pushed it backward. He trained the people to push it as if it were alive, and he trained the rider to dance with it as if he were riding a live horse. It was very wonderful and interesting indeed.

He carved the horse for about forty days with the other woodcarvers. Duga was given much money both by the natives of Mẹkọ and the strangers [from other towns] on the day of the ceremony. Dear Master, the people of Mẹkọ cannot forget Duga for his sense and for his many kinds of carvings.

NOTES

1. However, a Yoruba mask in the Berlin Museum für Völkerkunde (III C2332) is identified as "made by Angbologe, an Egbodo" in Frobenius (1899:24, figure 87, Plate IX). Egbodo probably means Ẹgbado, a Yoruba subgroup west of Abẹokuta; and Angbologe suggests Adugbologe of Abẹokuta.

2. Some of what I have to say about Duga, as well as remarks on several other individual carvers, appears in Bascom (1969b). For my own definition of art as the concern with "form for its own sake," see Bascom (1955:247).

3. Dalziel does not list the Yoruba name for this tree under Nigeria, but under Togo he gives asogedaka as the Atakpame name (Dalziel 1937:338). The Ana of Atakpame are a Yoruba offshoot in the Republic of Togo.

4. This information comes from Ifẹ, Nigeria, where licenses to fell a tree in 1937 cost 60 s. for an iroko, 40 s. for an apa, 16 shillings for an ọlẹ, and 12 s. 6 d. for an asin tree; no license was required for an irẹna, the most popular wood for sculpture. Carroll (1967:85) also notes the use of iroko, irẹ, and apa (or ayan). He adds abẹrinbẹrin (or ẹrinmado, ogbugbun, ọgbọ); Ricinodendron africanum (also known as erimado, erimodan, ọrọmọdọn, ọmọdọn, potopoto, putuputu, putuputu funfun, olobo-igbo); ahun, Alstonia congensis (also known as awun, ọwun); ọmọ, Cordia Millenii; and ọgọnọ, Khaya spp. (also known as ọganwo). He comments that the last named, mahogany, is not very popular, and I believe that its use by Yoruba wood carvers is recent.

5. A set of carvers tools (Plate XV) collected in Oyo, Nigeria, in 1951 consists of these two adzes and two knives. The distinctive interwoven designs carved in relief on the wooden handles enable the carver to tell by the feel, without taking his eyes from his carving, which tool he is picking up. Blades made from locally smelted iron were preferred and some were still in use; as this is no longer available, carvers now have blacksmiths fashion their tools from imported file blades.

6. Duga is shown carving a ceremonial staff or spear for Yewa, a river goddess, in one of the illustrations between pages 182 and 183 in Simon and Phoebe Ottenberg (1960). A Gẹlẹdẹ mask and a stool for the Iroko cult carved by Duga are illustrated in Bascom (1967:Nos. 91, 96); and an Ifa tray by him is illustrated in Bascom (1969a: Plate XII).

Plates I-XIII are by William and Berta Bascom, Plates XIV-XVI by Eugene R. Prince.

J. H. Kwabena Nketia

THE MUSICIAN IN AKAN SOCIETY

It has been said that "music, wherever found, is a product of social circumstances and is consequently to be evaluated in terms of these very circumstances" (Etzkorn 1964a:279). The need for recognizing the plurality of these factors that shape artistic forms and expressions has long been recognized, and this paper relates a number of these factors to the music of one African culture—the Akan.

A framework of observation and study based on this view may emphasize different facets of the problems involved. One line of approach is concerned principally with social actions that surround art, an approach which appears to suggest that the behavior which gives rise to art or in terms of which art is practiced is much more worthy of study and attention than the art itself and that consideration of the latter should be marginal rather than central in the scheme of things. While such an approach may contribute to our understanding and appreciation of art as a distinctive form of cultural expression, a more fruitful line of approach for those interested in art makes art forms central in any framework of observation, study, and analysis, while taking due notice of the implications of social and behavioral factors or the cultural context for the understanding and appreciation of the totality of different forms of artistic expression. As I have emphasized elsewhere (Nketia 1962a), this approach is not only theoretically desirable, but also a matter of practical necessity when dealing with African material, since some African societies attach associative meanings to art forms.

In this paper, which emphasizes the latter approach, our aim is to demonstrate how an understanding of the roles, functions, and personal life of the musician may contribute to our understanding of his music with respect to what it means both to him and to those who enjoy it with him. To this end, we shall take into account the structural relations in which he is involved by virtue of his art and which may

influence his music, the forms of behavior by means of which he main-
tains or creates these relations, the sources of his artistic experience,
and the modes of expression through which he conveys this experience.

Our observations will be based on field studies of individual and
group musical situations in Akan social life, personal histories of indi-
vidual musicians as well as examples of the actual music associated
with individual musicians and groups of musicians.

Akan is the largest linguistic group in Ghana, with Ashanti, Akyem,
Kwahu, Akwapim, Akwamu, Agona, and Fante as subgroups. Musi-
cally they form a homogeneous group and share many musical forms,
instruments, and modes of expression. The musical culture of the Akan
is historically very important in Ghana, for the Akan were in active
contact with neighboring African peoples. Ashanti, the last of the
successive Akan kingdoms which emerged as powerful political states
in Ghana in the precolonial era, had a large sphere of influence which
extended into northern and southern Ghana to the borders of the
Ivory Coast and Dahomey. Ashanti *atumpan* talking drums, which are
still played in Ashanti style with Ashanti texts as the basis, can be
found in Dagomba, Mamprusi, Gonja, and Wala areas of Northern
Ghana. Songs in Akan are performed in non-Akan areas—in the Ga
area of Southern Ghana and the Ewe area in the Volta region of
Ghana.

Music as a Part of Society

In this society, as indeed in the areas within its historical sphere of
influence, particular stress is laid on the creation and use of a variety
of expressions that could be described as artistic. A variety of formal
and informal occasions—on joyful as well as sad occasions, at festivals
and occasions of public worship as well as the celebration of events of
the life cycle—provide a setting for presenting, sharing, and the mutual
appreciation of artistic experience.

At the durbar, which marks the climax of an annual festival or the
40-day ritual cycle observed in honor of ancestor kings, there is usually
a traditional art exhibition. The paramount chief displays all the im-
portant regalia of his court in a procession in which he takes part—in
particular, artifacts in gold made by his predecessors, as well as those
that he has been able to make himself, for he is expected by custom
to make new additions to the treasure of art objects.

The inhabitants line up along the prescribed route of the procession
to enjoy the spectacle. This very long procession includes all the

principal servants of the court (each of whom would have something
to show) as well as the officials, the heads of the various groups of
servants, sandal bearers, stool carriers, sword bearers, shield bearers,
officials of the treasury, cooks, executioners, court criers, drummers,
horn blowers, minstrels, and so on. Each of these would dress as befits
his status or office, and the paramount chief himself would be richly
adorned (see Kyerematin 1964). A very vivid description of the kind
of costume worn on such occasions was given by Bowdich in 1819.
Describing the King of Ashanti, he wrote;

A delay of some minutes while we severally approached to receive the
king's hand afforded us a thorough view of him. . . . He wore a fillet of
aggry beads round his temples, a necklace of gold cockspur shells strung by
their largest ends, and over his right shoulder a red silk cord, suspending
three saphies cased in gold, his bracelets were the richest mixtures of beads
and gold, and his fingers covered with rings; his cloth was of a dark green
silk; a pointed diadem was elegantly painted in white on his forehead; also
a pattern resembling an epaulette on each shoulder, and an ornament like
a full blown rose, one leaf rising above another until it covered his whole
breast; his knee bands were of aggry beads, and his ankle strings of gold
ornaments of the most delicate workmanship, small drums, sankos, stools,
swords, guns, and birds, clustered together; his sandals, of a soft white
leather, were embossed across the instep band with small gold and silver
cases of saphies; he was seated in a low chair, richly ornamented with gold;
he wore a pair of gold castanets on his finger and thumb, which he clapped
to enforce silence. The belts of the guards behind his chair, were cased in
gold, and covered with small jaw bones of the same metal; the elephant
tails, waving like a small cloud before him, were spangled with gold, and
large plumes of feathers were flourished amid them. His eunuch presided
over these attendants, wearing only one massy piece of gold about his
neck; the royal stool entirely cased in gold, was displayed under a splendid
umbrella, with drums, sankos, horns, and various musical instruments,
cased in gold, about the thickness of cartridge paper: large circles of gold
hung by scarlet cloth from the swords of state, the sheaths as well as the
handles of which were also cased; hatchets of the same were intermixed
with them: the breasts of the Ocrahs, and various attendants, were adorned
with large stars, stools, crescents, and gossamer wings of solid gold. (Bow-
dich 1819:38–39)

These ornaments have elaborate designs, some of which are mean-
ingful, as students of Ashanti art have shown (see Antubam 1963:
127–186). To the Ashanti they are not just objects but artistic expres-
sions. They have a prestige value, but they are not displayed only
because they give indication of the measure of the wealth and power

of a chief; they also contribute to the spectacle admired by onlookers. From the crowd of female spectators who move round the procession would be heard appreciative comments: "What a beautiful spectacle [*ade a εyε fε ni*]." "Here is a chief worth looking at: there goes a chief [*ɔhene bi nam*]."

The drumming, singing, and dancing during the procession keep the procession alive. Different drum ensembles may be played simultaneously at various points within the procession.

At the end of the procession the chief and his retinue sit in state for the formal exchange of greetings, the renewal of bonds of loyalty, and formal enactment of tradition. The court minstrels recite the traditional praise poems while the drummer of the talking drums similarly drums appropriate eulogies or messages of the occasion. "Horn" blowers, players of signal drums, drummers of the royal dance drum ensembles also contribute to the activities of the occasion. As the music goes on, individuals may take turns at dancing in the open ring and the chief himself may grace the occasion by dancing to the music of the royal *fɔntɔmfrɔm drums*.

From a sociological point of view, one may see in all these phenomena nothing but modes of behavior which contribute to the solidarity of the group, just as one may see in the wealth that is displayed status symbols or a means of consolidating prestige and power. There is always a social or religious purpose which provides the basic motivation for a ceremonial occasion, but the framework of action by means of which this purpose is translated into concrete expression is that of the pageant or drama in which traditional art, music, dance, and other forms of bodily movement are integrated. That is to say, an Akan ceremonial may incorporate a range of expressions which could be interpreted at once in terms of both social and artistic values.

The enjoyment or satisfaction which a social occasion gives to the participants is directly related to its artistic content—to the scope it gives for the sharing of artistic experience through the display of art objects, the performance of music, dancing, or the recital of poetry. This is true even of the funeral—an important social occasion on which those who enjoyed particular music with the deceased or the bereaved may renew this experience, the occasion on which feelings of sorrow may be expressed in dirges. It is because of the stress laid on artistic expression that ceremonies and rites which could be completed in a few minutes are spread over hours or days. Invariably there is a gradual build-up, ending in a climactic durbar or a dance performance.

The musician in Akan society functions in this kind of social con-

text. He has the choice of attending social events as an artist—someone with a particular contribution to make to the artistic content of a ceremonial or a rite, as someone who has something to share with other members of his society. He cannot, of course, always exercise this right of choice. Performance may be a social duty, or a condition imposed on him by his membership in a kinship group or his relations with others.

It is important to emphasize here that while the musician is recognized in Akan society as a person whose gifts and services are needed by the community, he is not treated or regarded in a class apart from the rest of the members of his society. Nor can he himself find means of expressing his musicianship by working in isolation from everybody else. On the contrary, it is as a member of a group that it is believed he can make his distinctive contribution. He must function as an integral part of musical and nonmusical associations—with dancers, ritual experts, and others involved in the social events—for his role is to provide opportunities in social life for the sharing of his musical experience. His art is closely integrated with dance and drama and recitals of oral literature, while the setting for his performance may incorporate the works of traditional craftsmen and artists who may use musical instruments as their subjects for creative expression or for the artistic symbolization of proverbs, beliefs, and familiar concepts. He does not belong to a special caste, as appears to be the case with the *gewεl* of Senegambia (Gamble 1957:44). Nor is he conspicuous in ordinary life by his mode of dress, as we find in Melagassy (McLeod 1964). Neither will he be seen as a wandering musician carrying an instrument or performing primarily for money, as one finds in Dagomba, Yoruba, and Hausa societies.

In the past he could live on the bounty of the chief if it was his duty to perform on state occasions, but this was a privilege enjoyed by all servants of the state. In ordinary life he is like everybody else—a farmer, trader, carver, or fisherman who depends more on these for his living than on his music.

Evaluation of Musicians

Although there is considerable emphasis in Akan society on group participation in musical performances, distinctions are made between different grades of performers, on the basis of levels of performance skill coupled with knowledge and ability or skill, in apportioning musical roles. In general, those who play leading roles are those ac-

claimed as musicians (*gofoɔ*) in various performance categories—as singers (*dwontofoɔ*), as drummers (*akyerɛma*), or other instrumental-ists—while those who give them support as members of choruses are referred to as *gofomma*—children or followers of the musician (*gofoɔ*).

To be called a singer (*dwontofoɔ*), or to be recognized as such, one should have a good voice, that is, a quality of voice recognized in Akan society as pleasant (*nne a ɛyɛ dɛ*). Secondly, the voice must be strong or heavy (*nne a emu yɛ duru*), not thin or small (*nne a ɛsua*). A person whose voice is small cannot lead a chorus at a public performance, even though he may be quite pleasant to listen to at close quarters.

Various artists pointed out these two criteria to me. They mentioned people who had good voices but could not perform leading roles or who could at best take up only limited roles. Recordings showed that these distinctions had objective validity.

Another criterion seems to be a good ear and some amount of discipline. A singer must not be afflicted by what is described in the language as a disease called *nsoɔdɛ* (literally sweet ears), which refers to the lack of musical concentration which might prevent a performer from keeping time or making the right entry or keeping to the tune. A performer is said to be out of step (*w'afiri akyire*) when he makes this kind of mistake in rhythmic phrasing, but he is said to "spoil the song" (*ɔsɛe dwom*) when he does not use the right intonation, sings wrong notes, or sings out of tune.

Another qualification for the singer is the ability to create words, to set tunes to words extemporaneously, and the ability to remember the verses of songs or the leading lines. This may be linked with ideals of voice quality. The best singers are those who have the right kind of voice and the ability to handle texts. However, it is conceded that a person who has a somewhat small voice but can create words or make verbal contribution to a performance may also be recognized as a singer. Such a singer may start a song and then leave it to other cantors to go on when the chorus comes in.

To be able to make verbal references in songs, one must—in the words of one informant—have "clarity of mind" (*adwene-mu-da-hɔ*) so that one does not confuse the subject or mix up words. One must be sensitive to, or show a general awareness of situations.

Since the singer has to perform in public, a certain amount of his-trionic temperament is said to be desirable. Thus one singer called Akwasi Adɛɛ, who is famous in the Sekyere District of Ashanti and who claims to have performed successfully as a solo artist for over 40 years, told me that he had 37 children, most of whom knew his songs and

sang them for their own enjoyment. But he was of the opinion that none of them would develop as a public singer of note because they had neither his quality of voice nor his temperament. He was never shy in public when he performed, and when he drew crowds at his performances he was able to involve them in the performance by showing them the responses they could make when they joined in. On one occasion at Dunkwa, he had over a hundred people walking behind him singing as he strolled along the streets with his music.

A singer is thus recognized in Akan society by his natural gifts of voice and his musicianship—his performance skills and knowledge which give him his district leadership. His status is an achieved status and not an ascribed one. He achieves prestige and recognition through his natural gifts, his own effort, and the general acclamation of the public.

We can now distinguish between different types of singers of repute. There are those who perform as soloists and who may be accompanied either by an instrument which they play themselves—such as a bell or a chordophone—or by an ensemble. The player of the harp lute (*seperewa*) or the musical bow (*bɛnta*) belongs to this category of solo artists. Some soloists are supported by two or three people who chime in here and there with supporting notes or chords as we find in Ashanti *kurunku*.

Secondly there are those who perform as *cantors*—those who lead choruses by singing introductory phrases which are followed by chorus response. Every type of musical organization has its own set of cantors. Different musical bands like *adowa, sanga, asaadua, sawere, asiko, pongo, kɔnkɔmma*, etc., each has a singer who is familiar with the repertoire of the band he leads so that he can introduce as many of these as possible at a performance. There are some singers who are very versatile and who may be able to act as cantors for a number of musical types. In general the organization of musical bands tends to prevent the individual from the membership of many bands at the same time, owning to the problem of conflicting loyalties.

When we turn to instrumentalists, the picture is very much the same except that fewer performers achieve distinction. There are also restrictions as to who can play particular instruments. Women, as a rule, do not drum in Akan society. When they do, they may only play hourglass drums, as in puberty rite music—rather like the practice in some African societies in Tanzania, for example, where women are active as drummers in a number of restricted ritual contexts such as healing and circumcision ceremonies and initiation rites. Formerly

Akan women were not even allowed to touch the other drums for fear that they might defile them.

A number of instruments such as trumpets, certain drum ensembles, and long cane flutes (*odurugya*) are restricted to the court, and those who play them are recruited from households among whom the particular performance skills required are maintained. That is to say, individuals within households to which the role of playing these particular instruments is traditionally ascribed achieve the status of musicians before they are recruited by an association.

Two instrumental types can be generally distinguished on the basis of the amount of manual skill needed. Instruments such as bells, stick clappers, rattles, castanets, and other idiophones used principally as rhythm instruments do not require much dexterity, although maintaining the form of the rhythm assigned to them while keeping steady metronomic beats can be difficult. In my experience, not everybody can do this when the rhythm is complex and has to be repeated over and over again in that form throughout a performance. Those who cannot maintain this pattern may either lack the discipline or suffer from the defect of *nsoɔdɛ*, lack of musical concentration.

The other groups of instruments include those which demand manual dexterity or control of breath force: simple hand pianos, hand drums and drums of the pitch varying type, master drums, *atɛntɛbɛn* and *odurugya* flutes, and the two chordophones *seperewa* (harp lute) and *bɛnta* (musical bow) which are rapidly being replaced by the guitar tuned and played in the traditional Akan style. Here there is a tendency to specialize both in particular instrumental techniques as well as in the repertoire of the musical types in which the instruments are used. A master drummer of *kete* may not necessarily be able to play the master drum of *apirede*, *sanga*, *ntan* or *fɔntɔmfrɔm*.

Field investigation shows that the Akan recognize distinctions in levels of attainment of executant ability and resourcefulness with regard to particular types of instruments. The performance of one master drummer may be preferred to that of another. One drummer may be described as a better *atumpan* player than another. On one of my recording trips, a chief insisted on sending to a nearby village to fetch one particular drummer because, as he put it, he was the one whom he could "hear distinctly" whenever that drummer "called him on the drum."

The qualifications for the status of a musician—in general a prestige status—are natural gifts of voice, creative ability, performance skill, and knowledge of repertoire. Knowledge of oral literature—in particu-

lar its themes, techniques, and stock expressions—seems to be required of singers, since a good singer must, in a large measure, also be a creative musician. In the case of some court musicians, knowledge of history and tradition is an additional qualification. In general, however, executant ability is by far the most important and the most obvious indication of musicianship.

Musical Training

How does the musician acquire his technical training? What are the sources of his artistic experience?

Not so long ago a woman in Atwea, a coastal village about 65 miles west of Accra, called her daughter to her bed just as she was about to die so that she might pass on her quality of voice and her gift as a singer to her in her spittle. It was her last act, and of course, it created such a sensation in the village that people talked about it. When a colleague of mine in the field of drama visited the place a few days after this incident had occurred the daughter of the gifted singer was brought to her and the story was re-enacted.

While the first prerequisite for becoming a musician seems to be natural endowment and the ability and interest to develop on one's own, there is an Akan proverb which states, "One does not teach the blacksmith's son his father's trade; if he knows it, then it is God who taught him."

It is no wonder, therefore, that traditional instruction is not organized on an institutional basis. As far as it is known, the principle of musical education has always been that of *slow absorption* through exposure to musical situations and active participation, rather than formal teaching. The very organization of traditional music in social life enables the individual to acquire his musical knowledge in slow stages, to widen his experience of the music of his culture through the social groups into which he is progressively incorporated and the activities in which he takes part. For there is music for recreation, ceremonies, festivals, and worship. There is music for children as well as music for adults, music for men, music for women or mixed groups, music for various associations.

Right from the cradle, the mother sings to her child and introduces him to many aspects of the music of her culture. She instills in the child consciousness of rhythm and movement by rocking him to music. There are cradle songs especially suited for this. She sings to him in nonsense syllables imitative of drum rhythms. When he is old enough

to sing, he sings with the mother and learns to imitate drum rhythms vocally. As soon as he can control his arm, he is allowed to tap rhythms. A toy drum may be given to him.

There are many children's games incorporating songs in which he takes part as soon as he can. The stories that are told to him from this stage onward similarly contain many song interludes and drum rhythms. Through all these, he learns to sing in the style of his culture just as he learns to speak its language. His experience, even at this early age, is not confined to children's songs. Like other African peoples, Akan mothers often carry their children on their backs to public ceremonies, rites, and traditional dance arenas. Sometimes they even enter the dancing ring with their children on their backs. Later when the children are old enough, they are even encouraged to take part in the dancing.

By the time a child reaches adolescence, his musical experience has widened considerably. He may have learned to play on toy instruments by imitation. He may even have had the chance of playing minor instruments in adult ensembles, singing in a chorus, or taking quite a prominent part in a public dance.

Individual instruction at this stage is unsystematic and largely un-organized. The young have to rely largely on their imitative ability, and on correction by others when this is volunteered. They must rely on their own eyes, ears, and memory. They must acquire their own technique of learning. Those who attain distinction as *musicians* have gone through the same process of slow absorption without formal systematic instruction, except in very restricted cases demanding skills or knowledge which cannot be acquired by this method, or in cases in which the specific roles played later by the particular individuals make it imperative that they acquire the necessary technique and knowledge. For example, as it is the social duty of women to mourn their kinsmen with special dirges, many mothers in the past regarded it their duty to insure that their daughters knew these dirges, particularly those appropriate for mourning their parents. Accordingly, they would always find opportunity to teach some of them to their children so that they could fulfill their social role (Nketia 1955:117).

Specialization in playing particular musical instruments is associated with certain families or households. Children learn—through slow absorption—to play the instruments played by their fathers, brothers, or near relations. Where the instrument played by the father is in ful-fillment of a social role or obligation which may have to be fulfilled

by someone in the family or household, then the child is encouraged to start learning early—by slow absorption. Similarly young children in families that traditionally play an instrument difficult to master are nurtured by this process as well. In such instances, definite attempts at giving instruction may be made. The child who will grow up to become a player of the talking drum is helped by the master drummer who taps the rhythms on his shoulder blade for him to get the sensation of the motor-feeling involved (Nketia 1963:156). When he has to learn musical rhythms, he is taught appropriate sentences or nonsense syllables which convey the same sort of rhythm.

Training by temporary attachment is resorted to now and again. A drummer may be sent to another drummer in order to enlarge his repertoire or acquire technique. I have interviewed a number of drummers who have learned their art in this manner.

It seems safe to conclude, then, that the perpetuation of tradition has depended very largely on the opportunities created in a community for learning through participation, through imitation and slow absorption, rather than on institutional methods. Musical instruction is part of what students of culture have come to describe as the enculturative process. Traditional instruction thus includes all the means by which an individual, during his entire lifetime, assimilates the musical traditions of his culture to the extent that he is able to express himself in creative efforts and in performance in terms of that tradition.

In actual performance the different roles of the musicians are recognized as levels of attainment as mentioned above, but this is not usually a basis for competitive economic struggle among musicians. Musical instruction, where given, tends to strengthen such roles—in the main, prestige roles—rather than to bestow economic advantages.

The weakness in the traditional system will be obvious to anyone familiar with the contemporary scene. The lack of systematic formal instruction protracts the learning process, which depends too heavily on favorable social conditions. A change in social organization such as we find now minimizes the chances of learning by participation. In the past, the influence of the home was very important for the child who might grow up to be a musician. I have interviewed several instrumentalists who do not appear to have received any formal instruction but whose interests seem to have been kindled in the home by someone who played the particular instrument. This condition is changing. The cumulative effect of over a hundred years of Western education, which takes the child away from the traditional enculturative process, is great.

At the end of one's formal school education, one may become a mere spectator, having missed the opportunity of learning through participation.

Musical Associations

After considering the opportunities that there are for acquiring musicianship, we should now inquire into how the musician uses his art in social life and how such relations may influence his art.

In general, Akan musical traditions give more emphasis to group performances than individual performances. It is true, of course, that a woman singing a funeral dirge or a cradle song may sing alone. It is true, also, that any individual is free to sing or play for his own enjoyment, but this is by no means the pattern that is encouraged at public performances. Solo performances take place with the support of other artists. Someone may be needed to play a bell or a drum or to sing answering phrases or responses at appropriate points. If he plays the harp lute (*seperewa*), for example, he would sing as he plays but would—in a full performance—require one or two other people to sing the refrains of his songs and play an accompanying rhythm on a bell or a bottle. Solo singers rarely accompany themselves on drums. One would not find in this society the equivalent of the Dagomba praise singer who drums to accompany himself.

An Ashanti *kurunku* singer is primarily a soloist who is accompanied by a small chorus that hums response notes at appropriate points in the music. One such singer whom I interviewed had three other supporters. Neither of them lived in Hwedeɛmu, the village of the soloist. One lived in Gyamase six miles away, and the other two were at Appah and Kyekyewerɛ further on. They were the people who could sing the responses in the way he wanted and could learn new songs quickly. Together with these he performed wherever he was invited, particularly at funerals.

This dependence of the musician on the support of others is formalized in the social organization that forms the basis of Akan musical practice. A musician must invariably be in some sort of associative relationship with other musicians and sometimes with other supporters for the purpose of making music. Hence we find a large number of musical associations, each of which specializes in one particular musical type (see Nketia 1962b:15–21). Some of these associations are predominantly male or female, while others are mixed. There are associations of young people as well as associations of older people.

All the members of an association may not necessarily be competent musicians, either as singers or instrumentalists. In fact, quite often many of them are not; but they provide the necessary choral support and may contribute to the social life of the association.

There is usually a distribution of roles and responsibilities within these associations. In addition to cantors and instrumentalists, large associations generally have a head who may not necessarily be a competent musician but who may hold his position because of his ability to keep the association together. Some of these associations have two heads: one male and the other female. One or two other members of the association take it upon themselves to regulate the behavior of the members during performances and see to it that they all sing.

Whatever the organization, the leading musicians are always the most important members. Without them no public performance worth attending would take place. Indeed I have had the experience of not being able to record a particular musical type owing to the absence of the leading cantor or the master drummer. On some occasions I had to wait for hours while messengers went in search of the master drummer or the cantor in a nearby village. I know of instances in which musical associations have been rendered inactive simply by the absence of a competent master drummer.

In addition to musical associations, there are also nonmusical associations like hunters' associations, warrior associations, and cult groups which also have their distinctive forms of music and require the voluntary service of musicians (see Nketia 1963). Quite often these musicians are found within their membership. I have, however, come across instances in which musicians who are not regular members of cult groups or hunters' associations have had to be called upon to take part in a performance.

At the courts of Akan chiefs the problem of finding musicians and of forming ensembles is approached differently. Here the musician forms part of a centralized political organization in which specific duties are apportioned to households. It is the duty of particular households to maintain particular musical traditions at the court. Hence there is a household responsible for horn blowers, a household for minstrels, another for *fɔntɔmfrɔm, kete* or *apirede*. Individuals are appointed from these households as heads for the different instrumental ensembles or groups of players. They form the link between the performers and the traditional head of the chief's household or sometimes the chief himself. The heads of these groups of musicians may

not necessarily be competent or active performers themselves, but they are supposed to know the history and the traditions associated with their particular musical types—at any rate as they relate to their own state. Most of them can list those who acted as heads before them, the chiefs that they served or any particular innovations initiated by the chief or by their own predecessors. In addition, they are responsible for keeping and maintaining the particular set of instruments for use at court.

Sometimes the head of a group of musicians and the members of the group may come from one household. This is particularly true of single song types or single instruments played on state occasions. In some cases the membership of an ensemble may be drawn from different households in a single village.

Musicians of associations like the solo singers mentioned below can make limited use of music for personal communication during performances. They can make appropriate verbal references to their own plight, and comment on events. They can compose their own songs, but when they do, they must find opportunity to teach them to the rest of the association. But their primary task is to serve the collective interest of the association, to comment on events of significance to the group and its members.

Like solo musicians, musicians of associations may be invited or hired to perform at social functions. The procedure is pretty much the same except that the invitation may not come directly to the musicians, but to the heads of the associations. Drinks are customarily offered as this extract from the words spoken as a prelude to the performance of a Fante *kurunku* band relates. After the band has taken its place, the person who invited them goes to welcome them. Libation is poured by the leader as he says the following prayer:

> Departed Spirits of Kurunku Players,
> Come and receive this drink
> And help us
> So that this "play" may go down well.
> Father Kwabena Adu,
> Kurunku Players are here.
> This is the drink from the bereaved family.
> We the Kurunku Players are offering you this drink
> So that our "play" may go down well.

After the libation, drinks are served and the performance then begins. Naturally, it includes references to the host and to any important people who may be present.

Court musicians perform as a matter of duty, but they nevertheless expect to be given refreshments while they perform. If refreshments are not forthcoming, the master drummer may say in the appropriate drum language:

> You are not playing the game.
> The drummer is treated gently.
> A person becomes a drummer
> That he might get something to eat.
> A man fights, a man runs away.
> If you want to catch the monkey,
> Give it ripe plantain.

This would be addressed to a dancer in the ring who failed to show his appreciation to the drummers by giving them some money. Akan society gives drummers the privilege of making such remarks and of saying similar things to a chief if his presents of drinks are not forthcoming.

All dancers are expected to behave in a kind and courteous manner to drummers, always deferring to them and showing them abundant consideration so as not to overtax the drummers' patience and endurance. If the dancers were not considerate, the drummers could be rude to them.

Important court musicians, such as drummers of the *atumpan* drum, may also have certain privileges.

A drummer is protected from interferences whilst engaged in his drumming. A drummer in the act of drumming is considered a sacred person and is immune from assaults and annoyances—nor must he be interrupted: they are not as a rule regarded as sacred persons, but while engaged in the actual act of drumming, they are protected by the privileges of sacred persons. (Danquah 1928:51)

Another privilege of drummers is that they may not carry their own drums on the head. This privilege is enforced by the sanction of the belief that a drummer would go mad if he carried his own drums. In processions, therefore, all drums that have to be carried on the head are carried by non-drummers. (Nketia 1963:158)

Court musicians are expected to know the routine of ceremonies and the appropriate pieces to play for each, as well as for other situations that arise. The drummer of the talking drum is always the busiest person, for he must herald the movements of the chief. He must play a suitable piece when he is walking, another piece when he is about to sit down, a piece when he is seated, and another piece when he is about to rise and leave the place of assembly. As I have illustrated elsewhere,

there are also pieces for drum ensembles which are suitable for per-
formance for changing situations or changing participants (Nketia
1963:122–146).

Solo Musicians

Soloists as well as musicians and their supporters expect certain formal
courtesies for the privilege of enjoying their art. If a solo artist is in-
vited to perform on some social occasion or at a funeral, the invitation
must normally be accompanied by money and drinks—something to
show that the person is really in earnest and that he appreciates the
artist he is inviting. If the artist is to travel, he would expect to be
given money for his fare. He will also expect to be properly looked
after when he arrives, particularly with regard to refreshments, and
probably rewarded before he leaves.

On arrival it would be a matter of etiquette for him to mention his
host in his songs, and if the occasion is a funeral, to include suitable
references to the deceased and the bereaved. But, of course, there is
nothing to prevent him from singing his own favorite songs or what-
ever he considers appropriate.

A solo singer may also take the initiative to perform at a funeral
uninvited, either for prestige reasons or out of a genuine feeling of
sympathy. Under such circumstances he would not normally expect
any reward, though he knows that he might win admirers who might
show their appreciation by giving him gifts of money or drinks.

A solo singer may use his music in a very personal way as an avenue
for the release of emotion. One such musician whom I interviewed in
Ashanti, who is over 65 but still active, stated that sometimes he was
prompted to perform when he recalled sad events in his life or when-
ever he remembered his fellow musicians who had died. These sad
thoughts often came to him in the small hours of the morning, so he
would drink and perform for the best part of the day with the support
of his friends. For him the outlet for any form of deep emotional upset
seemed to be music.

This tendency to get violently emotional is common among solo
musicians. Hence solo instruments like the *seperewa* harp lute, and
now the guitar, are associated in popular mind with excesses, particu-
larly with regard to the taking of alcohol, so there has always been a
tendency for parents to discourage their sons from learning to play
them.

There is evidence that the solo artist may use his music as a means

of social action, as an avenue for comment, criticism, retort and insult. Kwame Tua, a famous solo musician who died some two decades ago, had the reputation throughout Ashanti for using the song as a weapon. If someone offended him, he was sure to pay him back in a song and make him the object of public ridicule. If he felt strongly about anything, he would sing about it. He would sing about himself and the opinion held about him. He would bemoan his fate, sing his own praises, or comment on what he had done.

Some of the songs composed and sung by Kwame Tua are still sung by other artists. Now and again one hears quotations of words from his songs. He lived a very adventurous life. In his youth he lived down the coast where he learned to be a carpenter and traded in rum which he bought and resold in Ashanti. At the outbreak of the Yaa Asantewa war in 1900—the last British-Ashanti war—he decided to fight on the side of the British against his own people, the Ashanti, and this brought him into conflict with his compatriots. During the 1914–1918 Great War he again joined the army and served as a soldier in East Africa. Some of his songs refer to his East African experience and to his life as a soldier. He has songs about the sergeant major of his unit and army rations which he did not very much fancy.

In his later life he managed to be installed as chief but soon got into trouble with his elders and had to be deposed. While the case was being considered, he used his music to sing against anyone who dared to give evidence against him and to praise anyone who put in a good word for him. This was a deterrent, but it did not prevent him from being deposed.

Kwame Tua married about 30 wives, most of them daughters and grandchildren of chiefs, and had about 50 children. As a solo musician he always needed the support of a fellow artist. Two people collaborated with him: Amankwaa who played the bell, and Dwenti who played the second bell and sang the responses for him. He had six brothers and two sisters and was the second child in the family.

Kwasi Adɛɛ, a contemporary of Kwame Tua who is still active as a solo musician, refers to him as a leading musician in his time. He still sings one or two of the songs of this famous musician, but like Kwame Tua, he also has a large number of songs of his own, some of which are well known in his district. His life is much less adventurous, but he shows the same sort of sensitivity to people and events in his songs. In ordinary life he is a farmer and owns plantations of cocoa and coffee. He has several wives and his children number 37.

There are stories behind many of Kwasi Adɛɛ's songs, though many

people are not aware of this, for his poetry is reflective and allusive but gives very little indication of the actual incidents which inspire him. He told me a very long story about the murder of his nephew and how he got to know who was responsible for it and tried to get court action but failed to get the murderer convicted. The song which refers to this is based on the imagery of *kwakuo*, a species of monkey caught unawares by a hunter in the forest and who turns to the hunter and exclaims: Kill me and let me go. But there is nothing about the trial.

Similarly one of his most popular songs in his district is about his wife Afua Kɔmfoɔ whose brother took her away from his house because he wanted 22 pounds from the musician at a time when he could not afford it.

During my interviews with this musician he always emphasized that the basis of his songs was often some painful experience or something he felt strongly about. From the recordings I made of his music it was clear that the basis of the appeal of his music was not only his poetry, which reflected his emotions, but also his musical style which was interesting in many ways.

Musical Resources and Style

As in many African societies, sounds of both definite and indefinite pitches fit into the Akan concept of music. There are idiophones like bells, double bells, castanets, rattles, stick clappers, stamped idiophones, and large hand pianos which are used throughout the Akan area. Of these, bells and castanets are those most widely used by solo performers as well as by associations. I have not come across any solo singer who accompanies himself with a rattle or the large hand piano. The Akan hand piano is melodically not as developed as those of East and Central Africa.

However, Akan society is rich in membranophones (see Nketia 1963). There are drums of various sizes and shapes which may be played by hand, by sticks, or stick and hand. Drums belong principally to associations and are played for accompanying music with strong implications of movement which may be articulated in the dance or in the movements of the procession. Drums are also used for conveying signals or for reproducing verbal texts.

A few aerophones are also found in the Akan area. There are trumpets played singly or in sets at the courts of chiefs, cane flutes (*odurugya*) played only to paramount chiefs, and the bamboo flute (*atɛntɛbɛn*) usually played in duos or in larger ensembles.

Only two chordophones have survived: the harp lute (*seperewa*) and the musical bow (*bɛnta*) already referred to. Both of these are essentially instruments for the solo singer and not for large bands or associations.

Musicians exercise discrimination in the selection of specific instruments. A particular bell or drum would be preferred to another because of its pitch or tone quality.

The problems involved in using these instrumental resources or the human voice are resolved by musicians in relation to their varied musical experience, knowledge of repertoire, and creative abilities. Basically, the creative performer has a body of usages to guide him.

In vocal music he would be aware of the methods of "converting" texts or verse into music, the method of singing a verbal phrase instead of speaking it. That is to say, he would establish, quite unconsciously, a relationship between the rhythm and intonation of the words that he wants to sing and the rhythm and melodic contour of the tune to be set to the words.

Secondly, his musical phrases and sentences would be guided—quite unconsciously—by usages of pauses in speech which define breath groups, and word-groups within the phrase or the sentence.

His musical art would then consist of how he treats the verbal groups in relation to one another in terms of levels of pitch. It is here that the musical processes of melody construction are sharply differentiated ship of words in groups may be reproduced in the melody, but the from the intonation processes of speech. The internal tonal relation-junctural relationships between the groups may be varied. There are various ways of modifying these internal relations, but the use of these will differentiate the artist from the ordinary performer. I have come across instances of people who compose their own verse and teach it to a singer, who then gives it a musical shape and performs it to the general public, and so makes it known.

Anyone who has learned to sing traditional Akan songs would similarly become accustomed to their melodic patterns and interval usages. The Akan use a heptatonic scale in several modal forms. The characteristic forms of melodic movement are stepwise movement in seconds, conjunct, interlocking and pendular movement in thirds and descending fourths. Rising fourths are rare.

In addition to interval usages, the creative singer would, of course, be aware of starting points, phrase endings and their relationship to phrase initials. He would be aware of the various ways in which songs end and how to arrive there.

All these details of form are not objectified in the language of Akan musicians, even though they seem to observe them in practice. The comments of Akan musicians that I have heard which refer to form deal mainly with pitch levels and types of endings. Some songs are said to "drop the voice" when they end, while others are said to "raise" it.

The next set of considerations concern the flow or lilt of the song or the instrumental piece. This is imparted to it through the choice of tempo, through the absence or presence of a regulative pulse which the creative performer carries in his head and in terms of which he organizes the constituents of his phrases, through the choice of points at which to begin phrases, where to pause, what orders of durational values to use, or what phrase lengths to employ.

The regulative pulse is sometimes externalized through movements of the body or some part of the limb, or sometimes through extra-musical noises which the performer makes quietly with his vocal apparatus at points in the music where the phrases start "off the beat." It may also be externalized by implication in the musical sounds which may accompany the song, such as handclapping, beats of sticks or an iron bell. The individual performer who sings and claps or accompanies himself on some instrument follows a single regulative pulse. It is also a common point of reference for the musician and the dancer.

What has been said of the construction of songs can be repeated for other types of melodies, except that considerations of text may not be relevant. But this is not always so. The Akan flute solo often has a verbal basis, and there are even drum pieces which are similarly oriented (see Nketia 1963).

Where an instrument such as the flute is capable of a fairly wide melodic compass, the creative performer will naturally produce phrases which are akin in shape to those of songs. In instruments of narrow compass of two or three tones such as trumpets and large hand pianos, the emphasis is invariably on using the tones as a framework for the formation of rhythm patterns or for reproducing speech texts.

In general, the character of music performed by instrumental means tends to reflect very closely the capabilities and limitations of the instruments used. Obviously instruments without sustaining power cannot be assigned notes of long duration. The music that is suitable for them is one which minimizes their natural limitations by providing notes that can be played in fairly rapid succession. The emphasis on percussion results in music that is racy in character, and generally precludes long drawn-out notes except as marginal units.

The relative importance of tone and rhythm in Akan music is obvious. Music proceeds by the introduction of new elements—a new tone, a fresh impulse, a new durational unit, or combinations of these. The rate at which changes take place, the extent and direction of such changes determine the character of a piece, a musical type, or even of a style.

Akan music emphasizes fairly rapid succession of durational values or changes in impulses and shows preference for this to rapid changes of tone. A piece of music with a narrow melodic range is felt to be dynamic and satisfying if it has a rhythmic drive. That is why, in instruments of short compass, tone mainly functions as a framework for organizing and modifying rhythm patterns, for heightening contrasts. In general, a tone repeated rhythmically would be of greater interest than one held for the same amount of time.

Because of the emphasis on dynamic rhythm, the organization of rhythm is more complex than the organization of melody. Indeed, often rhythm provides the dynamic framework in which melody is organized. Various artistic considerations will be found operative. For example, where two or more lines of music are going on simultaneously, all the parts need not show the same degree of complexity. Indeed, they could be graded in complexity, and the rate at which each part introduces new patterns may be controlled. Some parts may be assigned invariable rhythm patterns while others change at varying rates from one pattern to another. Where complex parts are assigned to more than one part, generally they contrast and are made to move independently so as to bring out this contrast.

In singing, voices may be combined simultaneously or in alternate sections. But when other sounds are added, the solo-chorus form of organization is very characteristic of Akan usage. One would meet it not only in singing but also in instrumental music.

Singing in parallel thirds is another very important feature of Akan music. This is one reason why the solo performer often feels the need for supporters.

From the point of view of the creative performer, musical structure must be seen in terms of procedures and usages and not just in terms of static elements, for music is primarily an event: it happens as the result of the activities of the creative performer and those with whom he collaborates. Such a performer must be guided by a knowledge of tradition, a knowledge of how to construct a phrase, how and where to add a second part, how to build up new material and place it against something that is already going on, how to increase the animation of the piece. He can always reproduce what he has learned, but always

the best performers—the top artists in Akan society—are those who can bring their own individual artistic contribution into what they are doing. Ability in handling these uncodified structural procedures enables the creative performer to create and recreate pieces in appropriate contexts.

Summary and Conclusions

In this paper, we have examined the role and functions of the musician in Akan society, the structural relations in which he is involved, the sources of his artistic experience and modes of expression. We have looked briefly at the musical usages which guide his creative performances and have suggested that since music occurs as an *event*, its study must also be considered from the point of view of the musician and that it should include the structural *procedures* which provide the basis for creative-performances, and which form part of the "dynamics" of a musical situation.

As an artist his function is not only to reproduce the traditional pieces that he knows. It is part of his role to recreate them or to make creative additions to them. It is his privilege to express himself in song, to sing about his own life or about the lives of those with whom he is in active contact by virtue of his art. It is his privilege to use music as a means of social action as well as an avenue for expressing his own emotions.

The society in which the musician lives makes the arts an important focus of social life. Together with dancers and other artists, therefore, he is able to make a contribution to the artistic content of ceremonies and rites and so enhance the meaning of such occasions for those who participate in the activities. Hence he will always find an appreciative audience who would identify themselves with his sentiments or comment even on the quality of his performance. If he is able to satisfy them, they will say to him: *w'agorɔ yi yɛ dɛ*, literally, your play is sweet, or *w'agorɔ yi yɛ fɛ*, literally, your play is beautiful, depending on whether the source of appeal is largely auditory or visual (taking into account the total spectacle including movement). But above all, the audience will endeavor to understand the meaning or message of his art, for artistic statements are, in Akan society, manifestations of the impulse to express, represent, or symbolize thoughts, beliefs, and feelings in culturally defined forms through a plastic medium, musical sounds, bodily movement, or by verbal means.

John C. Messenger

THE CARVER IN ANANG SOCIETY

In 1951 and 1952, my wife and I spent over a year in southeastern Nigeria studying Anang religious acculturation. The data reported in this paper were collected in the course of ascertaining the religious implications of wood carving.[1] Our personal interests and curiosity led us to record as much about the traditional craft as time permitted, to visit a "carving village" of past fame, to observe the mass production techniques of a modern urban guild, to photograph the several stages of manufacture of a human figurine and a mask, and to collect numerous carved pieces from artisans of exceptional talent.

The Anang are located mostly in Ikot Ekpene and Abak Counties of Calabar Province and make up the second largest of the six Ibibio-speaking groups, with a population of 375,000. They occupy an 850-square-mile territory, bounded on the east and south by the Eastern Ibibio, on the north by the Isuorgu Ibo, and on the west by the Ngwa and Ndokki Ibo. A "middle range society," the Anang lack centralized government but are formed into 28 village clusters (*iman*), each of which is delineated by a food taboo and other distinct cultural traits, as well as a consciousness of unity shared by its members and the territory its contiguous communities occupy. Ikot Ekpene County subsumes 16 such groups, among which eight are Anang, five Eastern Ibibio, two Enyong Ibibio, and one of Aro Ibo derivation; the Anang *iman* are the Abiakpo, Adiasim, Afaha, Ebom, Ekpu, Nyama, Ukana, and Utu. Although my wife and I worked in over 50 communities among eight of the northern and central Anang village groups, all of our wood carving information was procured from six craftsmen living in four Afaha settlements. The Afaha group of 30 villages is situated in the southwestern portion of Ikot Ekpene County, bordering the Ngwa Ibo, and its inhabitants are known as "the people who live between the Acaca and Kwa Ibo Rivers who do not eat squirrel."

Each Anang *iman* is ruled to a limited degree by a hereditary chief (*okuku*) who resides in its paramount village. While the village group

101

is the broadest political unit, the individual community (*obio*) is the most important one, and a hereditary leader (*ɔbɔŋ isɔŋ*) and council of elders direct its political as well as many of its religious and social affairs. We lived for nine months in the Afaha paramount settlement, Ikot Ebak, and two carvers from neighboring Ikot Ese—the village head, also a famous oath giver, and one of his sons—were our principal informants. The patrilineage (*ɛkpuk*), four to 19 generations in depth, is the largest kinship unit. It is composed of both nuclear and extended families whose members reside in compounds surrounded by forest, bush, palm tree groves, and farm land. Every patrilineage commands a segment of land within the community, and each family a tract within this segment. Central to the village is a clearing, or square, containing the court building, shrines, funeral monuments, and an area set aside for local marketing and performances of drama associations during the dry season. The *ɛkpuk* also possess squares on a smaller scale, while the paramount settlement has a subsidiary one in which once a year *imɑn* marriage ceremonies are conducted.[2]

Carving and raffia weaving are the major Anang crafts, and the objects produced by local artisans are widely renowned in West Africa and have found their way into museum and private collections the world over. Among other indigenous crafts (*usɔ*) practiced by the Anang are drum making, carpentry, pottery making, iron working, rope making, and the appliquéing of funeral cloths. The last mentioned skill is almost lost, and the painting of funeral murals to serve the same purpose (which preceded, and for a time was practiced concurrently with, appliquéing) has disappeared altogether. Iron working is also very nearly a lost art, but at one time craftsmen, working with scrap obtained from Aro Ibo traders, manufactured carving tools, machetes, knives, nails, "cap guns," and agricultural implements. Most of the carving and weaving prior to the age of the tourist and the export market was done for members of the 19 Anang voluntary associations. Four of the groups utilize wooden masks, four, raffia masks and costumes, and two, wooden puppets; all employ an assortment of minor carved and woven articles produced by professional artisans. One of the main reasons why the individual carver no longer thrives as he once did is that associations which required his services are dying out for lack of recruits.

Carving as an Occupation

Until the establishment of carving guilds in Anang towns during recent years, carvers (*ɔkwɔi nkwɔi*) plied their craft independently and

did not form associations as do workers of magic, diviners, actors, and musicians. Nor do raffia weavers, iron workers, or other artisans join together as is common in many West African societies. Among Anang craftsmen, the highest prestige ranking is ascribed to the carver. One of the major prestige symbols is the possession of wealth, measured in terms of property, money, and other attributes, and the skilled carver earns far more than his nearest competitor, the accomplished weaver. Moreover, the carver who excels is thought to do so, in part, because he is imbued with supernatural power, the possession of which also brings him prestige. (Elders, by virtue of having achieved old-age status, are held in esteem because their longevity proclaims spiritual approval.) The carver obtains additional prestige for being able to create objects which are aesthetically pleasing to his customers, a reflection of the high value the Anang place on artistic talent wherever it may be expressed: in singing, dancing, acting, or narrating folklore.

One measure of the prestige afforded the carver is the extent to which he must protect himself from poisoning, witchcraft, and evil magic perpetrated by jealous neighbors. All persons of exalted position in Anang society take magical precautions to guard against the malevolent actions of witches, sorcerers, and ghosts, especially those who are not religious practitioners and thus are not protected by powerful guardian spirits. The carver, more than any other craftsman, must seek out the worker of magic and bear the expense of his prescriptions. Our informant, who is also an oath giver (even though one of the most famous of Anang carvers), was little concerned with these malignant forces, as he believed that the oath spirit provided him with sufficient protection. But another informant was compelled to discontinue carving for us as the result of almost nightly attacks by female witches, who forced him to copulate continuously and scratched his body during orgasm. We often dressed wounds inflicted on him by these beings, and he and others suffering from their assaults came to us for medicines to alleviate the various illnesses visited on them.

Although ranked highest among Anang craftsmen, the carver does not necessarily rank high in the community at large by virtue of his profession alone. Other occupations, such as divining and practicing magic, are more prestigeful than carving; prestige is also conferred by political office, kinship position, titles, association membership, skill in warfare, as well as by possession of wealth and supernatural power and the ability to create beauty. The Anang carver does not occupy the unique status position his Western counterpart ordinarily does; his occupation is regarded as an ordinary one, and his personality traits do not deviate from the range found in his community.

Training

The art of carving usually is passed on from father to son or sons in a family, but it is possible for a youth who is not the son of a carver to attach himself as an apprentice to an artisan and learn the craft. A father chooses one or more of his offspring to perpetuate the family tradition on the basis of personal affection, a predilection or marked talent for carving displayed by the youth, or supernatural designation. It is customary for diviners, workers of magic, and members of the women's fattening association to be called to membership in their groups through violent headaches instigated by the deity (abassi) to make his wishes known. A diviner is able to determine whether the chronic headaches suffered by a client is a call to join a particular association. Sometimes the deity wills that a man become a carver in much the same manner. He designates his choice by instilling a dream in the person or subjecting him to an unusual experience—such as having millipeds seek him out—which can be interpreted by a diviner. A youth who is not a member of a family with carvers may also be called by the deity, but more often than not he comes to pursue the craft out of a quest for prestige and for monetary considerations, or because he has artistic inclinations by nature.

Not all carvers will accept outside apprentices, but some will instruct as many as a half dozen sons and outsiders. Most youths who learn the craft do so between the time of puberty and age 18, and they must serve as apprentices for at least a year. The young man who has selected a carver as his tutor must present him with a goat and a large calabash filled with palm wine, and then answer questions put to him concerning why he chose this profession, what talent he possesses, and related matters. If the carver decides to accept the youth, a stipend for teaching services to be rendered and the terms of payment are agreed on. The amount paid for a year's apprenticeship varies according to the reputation of the craftsman, but in 1952 the average was 6 pounds and 5 shillings. It may be paid before instruction commences, or in several installments over the course of the year; but the obligation must be met by the end of the period. If payments are halted at any time, the trainee is dismissed, and should he withdraw after the stipend is paid, he forfeits the entire amount.

Each day the carver-to-be visits the house in which his tutor works. He provides for his own meals. During the first week of the new regime, he merely observes the actions of the craftsman and asks questions; then he purchases all of the tools that he will need in the future. He is

now ready to undergo formal instruction. The teaching process involves constant interplay between carver and apprentice, the former giving verbal and manipulative directions and making criticisms, and the latter imitating and posing queries. If the artisan leaves his compound to carve at his customer's place of residence for weeks or even months, he is accompanied by his apprentice, who may have to arrange his own room and board while there. Once the pupil develops sufficient skill, he is allowed to carve simple parts of a larger piece or the initial stages of a more complex object, which will be worked further by his tutor. He is not paid for this contribution, nor for other pieces he may carve in their entirety later on, which may be sold by the carver with little or no retouching.

Rare indeed is the apprentice who does not develop the requisite abilities to become a professional carver, although another or even a third year of training may be deemed necessary. But one who fails to master the craft is not advised to abandon his training; rather, he is driven away by the ridicule directed against his efforts by the audience which invariably assembles to observe the artisan. In addition to verbal responses which either praise or damn the finished product of a carver, gestural responses are employed to express admiration, such as snapping the fingers in front of the chest, crying "yes" repeatedly in a shrill voice while lifting the head, and manipulating lightly a piece being examined. The first two responses are also used when reacting to aesthetically pleasing raffia objects, songs, dances, plays, and the like.

Religious Aspects of Carving

Only the carver among Anang craftsmen is guided and protected by a guardian spirit, and this entity is one of but seven assigned to occupational groups.[3] The Anang are monotheistic and worship a sky deity, who is assisted in his task of governing the universe and mankind by spirits (*nnɛm*) residing on earth in shrines (*idɛm*) and by souls of the dead (*ɛkpo*) awaiting reincarnation in the underworld. Of the 26 *nnɛm* recognized by the Anang, eight perform functions which are primarily economic in nature, seven religious functions, six social, and five political; in addition to these, every *iman* has a protective spirit living in a shrine served by the *okuku* in the square of the paramount village. Only three of the *nnɛm* are female, and all possess normal human figures (which they can alter in size instantaneously), visible only to religious specialists in a state of possession. Most shrines are diminutive replicas of the Anang house, constructed of woven palm

mats supported by boughs; but particular trees, groves, pools, rocks, and ant hills, as well as carved stakes and figurines, may serve to house spirits. Praise utterances, prayers, and sacrifices are offered at the *idɛm* and are carried by the *nnɛm* to the deity, who sends power (*odudu*) to aid the suppliant if his past behavior warrants it. Although *abassi* is considered both omniscient and omnipresent, he lacks ultimate omnipotence, for witches (*ifɔt*), ghosts (*ɛkpo ɔnyɔŋ*), and the spirit of evil magic (*idiok ibɔk*) manipulate power over which he sometimes exerts no control. It is not known where these malevolent forces originate, and they must be combated with good magic (*ibɔk*) and appeals for protection to *abassi* and the ancestors.

The guardian spirit of carvers (*obot usɔ*) is a male who inhabits a shrine (*iso usɔ*)[4] placed in the corner of the house in which the craftsman works. It is composed of a tortoise impaled on the end of a foot-long stake (*akwa*) at the base of which stands a small clay pot (*mkpakpa*) to receive sacrifices. Shielding the *idɛm* is a woven palm mat (*ɔdɔŋ*), two feet in height, attached to the walls on either side of the corner. The *iso usɔ* is constructed when the apprentice completes his training, and the young man cannot embark on his professional career until the shrine has been built and a ceremony performed which calls the spirit into residence.

My wife and I discovered only one Anang myth, and the only legends that we recorded deal with the migrations of various village groups into the regions that they presently inhabit, and the origins of some *iman* food taboos. The myth describes the formation of the universe by *abassi:* first the sun, moon, and stars; next the land, forests, rivers, sea, wind, rain, night, thunder, and lightning; and, finally, humanity and the spirits. All of mankind was created in the image of the deity at a single stroke, and half the human population was consigned to the surface of the earth and half to the village of souls (*obio ɛkpo*) beneath the earth. The order of creation of *nnɛm* is not known beyond the fact that the female fertility (*eka nnɛm*) and earth (*ikpa isɔŋ*) spirits, both female, were first formed, followed by the soul (*nsukhɔ ntiɛ*) and fate (*emana*) *nnɛm*. Corporeal and "bush" souls (*ɛkpo* and *ɛkpo ikɔt*) for every human being were installed by *nsukhɔ ntiɛ* and a fate assigned to each by *emana*, after which *ikpa isɔŋ* taught mankind to fashion shrines and worship the deity in appropriate ways. The explanation given for why women do not carve is that *abassi* wills it and has instructed the fate spirit not to assign the craft to a female.

Anang *nnɛm* are ranked according to the amount of power that they are given by the deity, and persons who have guardian spirits also differ in the amount of *odudu* that they can handle. The capacity of a person

to manipulate power depends on many factors over and above the *odudu* inherent in his *nnɛm*, such as his fate, his moral behavior within the narrow sphere free will is operative, his mastery of religious rituals, and the intervention of malignant forces operating independently of *abassi*. Our informant, who is an oath giver as well as a carver, does not fear witches because the oath spirit (*mbiam*) is far more powerful than the carving *nnɛm*, so powerful, in fact, that slight ritual imperfections can cause the death of an oath giver. Better protection can also be obtained from the magic spirit than from *obot usɔ*. Success at carving is measured, for the most part, by the amount of *odudu* that the artisan is able to command. His *nnɛm* guides his hands and tools, protects him, and affords him other benefits.

The carver calls on additional spirits and his ancestors from the underworld to aid him at shrines that he has erected in his compound and house. These *idɛm* are in the public domain and may be built by any man of prominence, given certain conditions. Below are listed the spirits, their respective shrines, and the functions that they perform for the craftsman:

SPIRITS	SHRINES	FUNCTIONS
emana	*iso ɛssiɛn emana*	provides a good fate
nsukhɔ ntiɛ	*iso ukpɔŋ*	assures longevity
ikpa isɔŋ	*iso ikpa isɔŋ*	affords protection, prosperity, success and longevity (built only if carver is patrilineage head)
idaha nda	*iso idaha nda*	guards compound against ghosts, witches, and sorcerers
isɔŋ uyo	*iso isɔŋ uyo*	helps carver speak the truth
iwok	*iso iwok*	prevents false rumors about carver from spreading

Before one shrine, *iso abassi*, the artisan can appeal directly to the deity for protection, prosperity, success, and longevity for himself and members of his family; he can pray for the same benefits from the ancestors at his *iso ɛkpo* house *idɛm* and *iso nkuku ɛkpo* at the entrance to his compound.

Each day before setting to work, the craftsman worships before the *iso usɔ*, as he also does after receiving an important order; and when he visits another compound to carve, he carries the shrine in a special bag to be implanted in the house placed at his disposal. Worship involves first praising *abassi*, and then *obot usɔ*, with common phrases employed by any suppliant before any shrine, after which a prayer is uttered naming both deity and spirit. A typical prayer is, "*abassi, obot*

uso, let whatever I touch prosper. Let me have many wives and chil-
dren. Let my life be long. Let people come to me often for carvings."
This is followed by a sacrifice of one or more objects, including yams,
palm wine, dried fish, fowl, and a substance known as *nsei*. The yam
(*iboro*) has been cooked in water with dried peppers, oil, and salt, and
afterwards pounded in a mortar; it is broken into small pieces and
sprinkled on the ground and in the clay pot near the stake, after which
palm wine may be poured on it. Dried fish are placed in the *mkpakpa*
or leaned against the *akwa*, and the throat of the fowl is cut and blood
allowed to drip on the shrine and floor around it. Made from a root
beaten to a pulp in water and then formed into small sticks, *nsei* is
pulverized in the hand and the powder sprinkled over the *iboro*.

On special occasions, a goat or other livestock may be sacrificed, but
animals are always butchered, cooked, and eaten following the ritual.
Sacrifices at *idɛm* are made with the right hand, and the throat of an
animal is cut with the machete held in this hand. In fact, all manual
acts, including carving, which can be accomplished with a single arm,
are done with the right one in order to honor the deity. When sacrifices
to ghosts and witches are performed, they are proffered with the left
hand to outwit them. To give a guest food or drink with this hand is
a gross insult.

An elaborate ritual marks the end of a youth's apprenticeship after
his carving shrine has been constructed. He gives to his tutor a goat, a
hen, a cock, a quart of "illicit gin" (distilled from palm wine), a
calabash of palm wine, several dried fish, two yards of cloth, and a
machete. After a long prayer offered by the artisan, the young man
holds first the goat and then the two fowl while their throats are cut
by the tutor with his gift machete. Gin and palm wine are poured be-
fore the *idɛm* and one dried fish placed in the clay pot. The left foreleg
of the goat is removed and given to the apprentice. A final prayer calls
the *nnɛm* into the shrine, and the youth then receives lengthy instruc-
tions on how the deity is to be worshiped. It is obvious from the
stipend paid by the trainee and the objects he must offer his instructor
as gifts and for sacrifice that becoming a carver is an expensive
endeavor.

Process of Carving

In general, successful carvers devote most of their time to carving,
while those of little reputation may spend more time at other activities
than in practicing their craft. An artisan of eminence will carve as
many as six hours a day for five or six days of the Anang eight-day week

and will refrain from farming and trading. His only respite from carving will be time spent in court or performing religious or association duties. On the other hand, a young craftsman just commencing his career may spend days or even weeks away from his carving, engaged in farming, trading, or some other economic pursuit. An artisan commences work after his morning meal served at dawn and labors until noon or early afternoon, when the heat of the day becomes enervating. No Anang person works on the day of the week that he was born, out of respect for *abassi*. The carver rests on this day, and he may be interrupted another day or two during the week by commitments that he cannot avoid. Sometimes his work will be further impeded by excess of sexual activity, as too many acts of intercourse is thought to weaken him for a day or two, inhibit his desire to carve and his creative impulse, cause him to shape his pieces poorly, and lead him to cut himself. He never engages in sexual intercourse on the night before he starts carving a major order. The craftsman greatly fears wounding himself, and should he carve on the day of the week that he was born, or neglect to perform religious rituals or do them imperfectly, *obot usɔ* will drive a knife or chisel into his body or cause a slight cut to become seriously infected.

Some artisans are so versatile that they can carve any piece requested of them, and often they prefer to shift from making one type of object to another regularly in order to alleviate boredom. But most limit themselves to carving related kinds of pieces such as figurines, masks, or puppets. Those craftsmen without apprentices work alone, and those with trainees utilize them according to their abilities. A carver may discover that his student does especially well with a certain type of piece or can paint or fashion hair better than he can manage other assignments, in which case he will take advantage of these special talents by having the youth devote more time to such skills than to others. Most carving is done on order, with clients visiting the artisan to place their requests; however, a few carvers, particularly those of lesser reputation, sell their wares in the markets or display them for sale before their compounds. Anang markets have special areas set aside for the sale of palm wine, livestock, butchered meat, and each craft commodity. In the carving villages all of the craftsmen exhibit what they have produced at their compound entrances.

Types of Carvings

The objects most often carved by Anang artisans are masks for the adult ancestor association (*ɛkpo*), its counterpart among children

(εkpo ntok eyεn), and the two drama associations (εkɔŋ and ɔffiɔŋ); puppets for the drama groups; and small human figurines for the shrines of diviners, workers of magic, oath givers, and members of several other associations. Human figurines also are sold for house decorations and toys, as are figures of small animals—leopards, dogs, cats, cocks, and camels.

At one time, carvers also produced dugout canoes and huge drums of the slit gong genre, but we were unable to examine a canoe and saw only one of the drums, which was in a ruinous condition with its relief carving almost completely destroyed by termites. We were told that once every village owned a drum (iso ikorok), located in the square and protected by a roof of woven palm mats supported by four posts. It was sounded only on nkai festival day and the night that an important man in the community died. It housed a spirit (ikorok) who served the villagers, and a person escaping persecution (witchcraft, debt, or a feud) in another settlement could, by reaching it, claim adoption in a village εkpuk. The drum we examined in Idung Esimuk was six feet in diameter and twelve feet long, and was carved from the trunk of an anyan tree. Such a drum took the craftsman a year to manufacture and was considered as consequential a project as carving the puppets and masks of a drama group, or the masks for an ancestor association. When the iso ikorok was completed, it was customary for the carver to play it and run away quickly, for if he was captured while escaping, he was adopted into the kin group of the ɔbɔŋ isɔŋ.

Materials and Tools

The favorite wood of the Anang craftsman is ukot, which is heavy with sap when first cut but dries to a remarkable lightness, and thus is ideal for the construction of pieces which must be worn or carried for long periods without rest. When a carver needs wood, he seeks a man owning an ukot tree and purchases it from him for between ten shillings and a pound, as well as the gift of a cock. The tree must be more than five years old to be suitable, and a large one will last the most prolific artisan for six months, after which it is useless for carving. It is the responsibility of the craftsman to cut down the tree and transport it or its parts to his compound, but if he is to work on a major order at the home of his client, the latter may be called on to furnish the needed amount of ukot.

Today, most carvers buy imported tools as iron workers no longer produce them, and modern tools have a larger variety of shapes and capacities, last longer, and can be brought to a sharper edge than the

indigenous ones. The basic implements are the knife (*onuk usɔ*) with four inch blade, and the machete (*eka ikwa usɔ*) that has been shortened, made more narrow, and given a razor sharpness near its tip. Three chisels are employed, one of which (*ɔkɔrɔ*) has a wide head and is used as a plane (called a "scraper" in English); the other two have narrow heads and differ only in length—one of six inches (*ɛkikarak*) and the other a foot long (*nduoho*). A hand axe (*ɛkut*) completes the array of cutting tools, and all are sharpened by the imported file (*aban idaŋ*). Before the file was introduced, stone age celts (*itiat ɛdim*), called "thunder stones" because they are thought to have been cast down by *abassi* from the sky during storms, were employed for sharpening. To burn holes for the attachment of raffia to carvings, a pointed metal bore (*ɛtip*) a foot in length and a quarter-inch in diameter is used, and completed pieces are "sandpapered" with the rough underside of the *ukuok* leaf. The only other tool among the traditional assortment is the wooden mallet (*ama*) for striking chisels, but some carvers prefer a heavy stick of wood for this task.

Just as carvers are coming to employ imported rather than indigenous tools, they also are abandoning paints manufactured from local ingredients and instead are purchasing those sold in the shops. Modern paints are preferred because they are brighter, last longer, can be applied more evenly, offer better protection against termites, and come in a greater variety of colors than traditional ones. Only five paint colors were known in the past: black, white, red, yellow, and brown. The technique of making these was widely known, and individual artisans did not try to develop new colors or experiment with shades which could be produced by mixing the basic five. Paints are manufactured in coconut shells and applied with brushes, one for each color, formed by chewing the end of a stick to spread its fibers. Two coats of paint are applied, following which palm oil is rubbed into the *ukot* to make it less susceptible to termite attacks. The ingredients which make up each color are: black—charcoal mixed with the sap of the *ukpa* tree; white—the ground up and burned periwinkle shell mixed with water; red—the sap of the *uyɛ* tree; yellow—water mixed with ground up *nsaŋ itiat* stone; and brown—the sap of the *ukpa* tree. We did not wish to pay the sum requested of us for further knowledge of the mixing of indigenous paints.

The Making of a Mask

Space does not permit me to describe the carving of more than one piece, so I have chosen to discuss the stages in the production of an

ɛkpo mask. The ancestor association is organized on the patrilineage level and includes most of the adult men of the ɛkpuk. A carver may on occasion be hired to live in the compound of the kin group head for several weeks and produce masks (mbɔp) for the entire membership, but more often individual customers visit the artisan and place their orders. Masks come in four sizes, two of which are large, one medium, and the other small; the medium-sized one is worn by ordinary ɛkpo members, the small mbɔp by children in ɛkpo ntok eyɛn, and the two large ones (including four varieties) by senior men who appear masked only on special occasions. The large mbɔp are two to three feet high and a foot to one-and-a-half feet wide, and it is the fashioning of one of these, called akpan ɛkpo, that I will describe presently.

A mask, if cared for properly, will last 20 years, but it must be re-painted and spread with oil every year and kept suspended where termites cannot reach it. Young men hang their mbɔp, when they are not in use, in the meeting house of the association, while elders place them on their iso ɛkpo with faces hidden. Although most men own their masks, some rent or borrow them for the "ɛkpo season," and it is unheard of for a person to buy a second-hand mbɔp. Many youth prefer to have a new mask made each year with different features, and one who has suffered bad luck during one season, such as falling or losing his mbɔp while dancing, invariably will substitute masks the next and probably seek out another carver. However, if a man con-tinues to have good fortune year after year and admires the design of a particular mbɔp, he will have replacements constructed with the same features.

The price of a mask depends on its size and shape, the reputation of the carver, and the excellence of its manufacture as to technique and design. In 1952, traditional carvers charged between 14 and 30 shillings for the large varieties of ɛkpo masks, 6 to 12 shillings for the ordinary mbɔp, and between 2 and 6 shillings for the one worn by children. Added to these costs were 7 shillings for the processing of the raffia to be used (including dyeing), 4 shillings for its attachment to the mask, and possibly 3 shillings for having the features painted; thus, an mbɔp could cost its purchaser as much as 2 pounds and 4 shillings. The buyer places his order with the craftsman and returns when instructed to, at which time a price is agreed on, usually after heated bargaining, and paid by the customer. If the mask is a large type, the buyer must present the artisan with a fowl when the order is placed. The animal is sacrificed at the iso usɔ after being rubbed across the face of the com-pleted mbɔp when its owner has paid for it, and the carver, as he

spills blood on the shrine, prays that the wearer will have good luck and return to him for another mask, and that his own future offspring will not have the ugly features that he has given the *mbɔp*.

In the past, carvers were able to process and attach raffia to the masks that they produced and paint them as well, but now four specialists may be called on at the main stages of construction, and often the customer must himself carry the piece from one artisan to the next. The carvers whom my wife and I employed all were able to carve and paint, but each of them was visited by a man skilled in attaching raffia, who in turn had purchased from a processor raffia that he carried with him to the house of the carver. On completion of the *mbɔp*, we paid the carver for his combined services and the other man for his services and costs. We were told that long ago some carvers excelled at painting, and sometimes customers would come to them with completed but unpainted masks to have the painting done by the experts.

Once the *ukot* tree is carried to the compound of the craftsman, it is allowed to dry for a week before being used. The size of the *mbɔp* to be carved determines which portion of the trunk or large branches will be selected, since the mask is shaped from a segment of the tree which has been split in half to furnish wood for two such pieces. Thus, the height of the *mbɔp* is the length of the segment, and its width the diameter of the trunk or branch; the face is carved from the rounded portion of the block after the bark has been removed, and the back of the block is hollowed out to accommodate the face of the wearer. Before commencing to carve, the artisan pictures in his mind the precise form that the mask is to have, guided in some cases by an old *mbɔp* whose owner wishes it duplicated or a verbal description by the customer of what features he wants the piece to have (or a photograph, in our case). Outstanding carvers are able to complete a mask without drawing guide lines, which ability seems extraordinary to the outsider in light of the fact that carving is done with great rapidity, although the artisan halts occasionally to appraise what he has thus far formed and to plan his future moves.

An *mbɔp* is carved in two stages, separated by a two day drying period when the piece is hung over a low fire. During the three hours of the first stage, the craftsman, using only machete and chisels, roughs out the features of the mask and completes its back. He crouches on his heels most of the time while working, and rests the block against a flat segment of a tree trunk placed on the ground to serve as a worktable of sorts. Using the end of the machete within two inches of its tip, he first rounds the top of the block to form the forehead of the

face, then with mallet and chisels he outlines the forehead design, if any, and shapes the eyes and nose. The chin is fashioned next with rapid strokes of the machete, and the mouth and cheeks are formed with a chisel. Finally, the sides of the mask are shaped with the machete and scraper, and the carver is ready to turn his attention to the back of the piece.

A brace two inches in width is allowed to stand across the back, above and below which the *mbɔp* is hollowed out. The brace is used to attach the headgear, made of woven plantain stalks, and gives structural strength to the carving; the hollowed out portion below the brace, with the headgear, encases the face of the wearer, who steadies the mask when it is worn by gripping between his teeth a *piassava* rope stretched taut across the inside. Most of the wood is removed with the machete, but for this task a portion of the blade four to six inches from its tip is used, and harder blows struck. The carver constantly checks with his fingers the thickness of the piece, not allowing it to get under an inch, and he once again employs mallet and chisels to put on the finishing touches. His final job is to turn over the *mbɔp* and rough out teeth and tongue, which might have broken off when the piece was turned face down had he fashioned them earlier.

The mask is dried slowly to prevent it from cracking later on and to make its surface more receptive to smoothing with the *ukuok* leaf. When the process is completed, the second stage of carving is undertaken with the knife and hand-pushed scraper. This takes two hours longer than the initial stage. The carver sits on the ground and holds the *mbɔp* between his legs, and he works more slowly and takes more time to appraise his progress than he did before. Now he carves the face, feature by feature, from top to bottom, seldom retouching a feature once it has been formed and another one undertaken. After the carving is completed to his satisfaction, triangular-shaped eye holes are driven through the *mbɔp* on either side of the nose with a chisel, and the piece sanded. It is now ready for a headgear and raffia to be attached, and for painting.

Use of Carved Objects

I have already mentioned that human figurines are carved for shrines and for use by members of several associations, as well as for house decorations and toys. They vary in height from six inches to three feet, as do animal figurines which also serve as ornaments and toys, and they are painted and may be composed of joined parts. Before turning

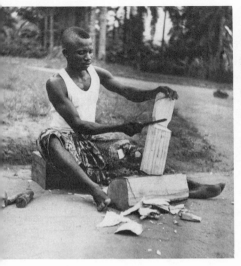

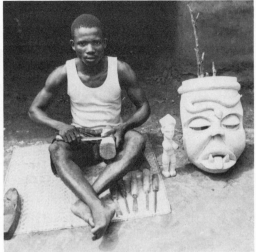

Preparation of the block for carving a figurine.

Finishing the figurine. Also a *nyama* figurine (center), to be carried by fattening girls, and an ɛ*kpo*, ancestral cult mask (right).

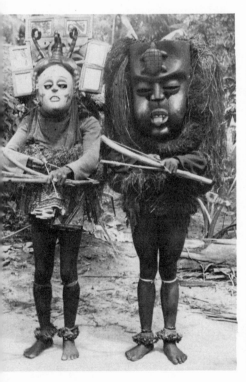

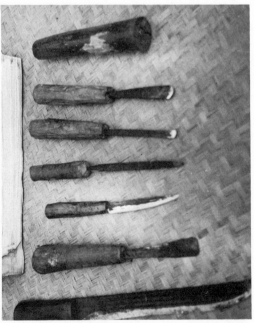

A "beautiful" and an "ugly" ɛ*kpo*.

An Anang carver's tools, inherited from his father.

to the more important subject of the use of puppets and masks by the εkɔŋ drama and ancestor associations, I will present two examples of the use of figurines, although many more might be given.

One form of shrine popular among workers of magic, diviners, and oath givers is the human figurine placed within the larger *idɛm* which houses the guardian spirit of the practitioner. For example, a worker of magic (*abia ibɔk*) who served as one of our major informants possesses an *iso ibɔk* along one whole wall which comprises numerous objects, including five identical figurines (*igwe ibɔk*, the first word, an Ibo one, meaning beauty); the magic spirit lives in the *iso ibɔk* where he inspires the prescription of charms, medicines, and incantations by the specialist, but he also resides in the figurines and performs a different function in each: in the "entrance" *igwe ibɔk* he helps the worker of magic come and go freely through the doorway; in the "praise" one he brings adulation from past customers for the excellence of his pieces; in the "permanence" one he gives him a long life; in the "roaming" one he seeks out new customers for him; and, in the "unity" one he urges *abassi*, all the *nnɛm*, and the ancestors from the underworld to unite in his aid. This worker of magic also has seven (the Anang sacred number) small wooden canoes fashioned by a carver, placed in various positions along the wall, which pitch and roll as in a rough sea when a client enters who is a witch or threatens sorcery.

Members of the almost extinct women's association, *nyama*, supervise the fattening of prospective wives, impart to them sexual knowledge, and perform clitoridectomy to enhance their child bearing propensities. During May, *iman* girls who are to be married that year in a mass ceremony in the paramount village square fatten themselves for a three month period (once a three year period). The bride-to-be lives in a special house in her compound and remains in bed most of the time while fed rich foods provided by her future spouse. Obesity in a woman is admired not only for aesthetic reasons, but because it is believed to ensure health, longevity, and the bearing of many offspring. A figurine (*udɛŋ nyama*), given to her by an *nyama* sponsor and which symbolizes the child it is hoped that she will bear within a year, is carried by the girl during her internment. In a foot square cradle constructed of bamboo sticks, placed at the entrance of the compound, lies another figurine, smaller and usually cruder in construction, which represents the fattening girl within. Ghosts are urged verbally and through sacrifice to attack the statue rather than the girl herself, a subterfuge which is considered as effective a protector as preventive magic.

A carver must work from four to eight weeks to manufacture the puppets, masks, and other pieces used by an ɛkɔŋ association, and usually he goes to live in the compound of the group leader where he labors daily. Before he departs from his own residence, he is presented with the same items given to him by an apprentice at the time the *iso usɔ* is built. He will wear the cloth and machete during the weeks that he is away carving, and before he sacrifices the objects proffered by the ɛkɔŋ head he prays, "*abassi, obot usɔ*, let me go to carve for these people freely and without trouble. Let me return in good health. Let no one poison me while I am away." While he resides in the alien village, no quarreling may be done by its inhabitants, for if they do, the actors will not perform successfully later on. Should a quarrel break out, the guilty party, as determined by the village court, must present the craftsman with a cock for sacrifice. A circle is drawn on the ground and a figurine placed in its center, over which the fowl's throat is cut by the carver; the guardian spirit of the association (ɛkɔŋ) enters the statue, and the artisan prays to him to prevent the actors from forgetting their lines and their masks from cracking and to protect them from harm. Payment is made to the craftsman after he has completed the order, and until the group performs publicly, he is called on yearly to inspect and repair the pieces.

Few ɛkɔŋ associations exist today among the Anang, but at one time almost every village had a troupe, sponsored by one or more patrilineages within the community, headed by the ɔbɔŋ isɔŋ, with a membership of over a hundred males between ages 12 and 30.[5] The purpose of the group is to amuse audiences with songs, dances, and plays which mostly ridicule the motives and behavior of well known persons and organizations in the *iman*. The members practice one day a week for six years, and then during the dry season of the seventh year perform publicly in communities of the *iman* and in bordering settlements of other village groups. A complicated seven hour routine is originated and mastered to perfection by the troupe, which includes music played by a percussion orchestra, dancing by a costumed chorus, songs of ridicule sung by the orchestra and dance chorus and masked soloists, plays enacted by puppets and an entourage of actors (some playing female parts) dancing on stilts, and the mystifying movement of a life-sized wooden figurine. When presented, the routine focuses on the plays, first those of the actors and then those of the puppets, and each skit is separated from the next by a dance, a song, or the antics of a mummer. The performance usually ends when the figurine is carried to the center of the square, where, over a period of 15 minutes, it turns slowly at the waist from side to side. Although the services of the

troupe are paid for by the village in which it performs, the audience
comes from miles around and may number several thousand.

To be called a mask, an object must be worn on the head and hide
the face. I have already described the construction of one kind of
mbɔp, but there are two others: the raffia headgear woven to resemble
a wasp, which covers the face of a member of the children's atat associ-
ation, and the figurine that the ɛkɔŋ dancer wears atop his head, which
is mounted on a platform with cloths hung from it to disguise his face.
A mask resembling the akpan ɛkpo, but painted differently, is worn by
soloists who entertain between ɛkɔŋ skits. The masked entertainer
impersonates a local person whose motor habits he mimics and whose
past actions he mocks in songs and in conversations with an accom-
panying "straight man." Between plays, other soloists appear with
figurine masks, some of which have platforms three feet square sup-
porting objects in addition to the statues, with cloths hanging to the
hips of the wearers. The player with such a mask alternately runs and
dances about the square performing feats of strength, agility, and en-
durance while singing humorous songs concerning the individual the
figurine represents. An mbɔp that my wife and I observed had a re-
splendent King of England sitting on his throne surrounded by symbols
of office; the enshrouded entertainer spoke for the monarch who
warned men in the audience to be wary of sexually promiscuous women
and asked everyone to take advantage of local government, which
had just been introduced.

Many wooden pieces are used in the various plays, all of them carved
by the artisan serving the association. One of the most amusing skits
we viewed, which satirized a nativist denomination—the Christ Army
Church—active in Ikot Ekpene County, depended on several carved
objects for much of its humor. Actors, dressed to resemble church
dignitaries, met in the square to cure the ills of their communicants
through soul possession by the "Holy Spirit." The teacher wore a pair
of large wooden spectacles with dark lenses; an evangelist wore wooden
earrings which dangled to her shoulders with matching necklace of
wooden beads four inches in diameter; and the minister carried on his
head an immense open wooden Bible, with carved inscriptions on the
revealed pages, and wore on his chest a foot long wooden crucifix. One
of the several members of the congregation who came to be helped
was a poor hunter who held under his arm a life-sized wooden dog.
Possession was induced in the animal and the promise made that it
would now become a skilled seeker of game and make its master
prosperous. The last person to be healed was a humpback, who, while

possessed, was surrounded by the church officials; his cure was almost immediate, and he sprang from the group wearing a long, red, wooden penis in place of the deformity and ran through the hysterical audience thrusting it at retreating women. He was followed by the hunter who caused his dog to bite men in the crowd with its hinged jaw.

During the last phase of the ɛkɔŋ performance, several puppet plays are presented by specially trained artists. The stage, backed against the bush at the edge of the square, is a roofless enclosure formed by bamboo poles driven into the earth and lashed together to support blankets and palm tree branches. The height of the gaily colored structure is seven feet, and thus allows the performers to stand erect and extend the figures above the stage level. Puppets are carved to represent males and females, children and adults, and range in size from one to three feet. Their arms are moveable and their hands shaped to clasp objects, such as umbrellas, machetes, and fans. A puppet is carved so that a handle projects a foot or two below the feet of the figure, and this handle is grasped by the man who manipulates the piece. Speech for the wooden actors is provided by artists who talk through reeds to disguise their voices, for the identity of mask wearers and puppeteers, those whose satire is most bitter and personal, is carefully guarded.

The figurine whose bewildering movement climaxes the ɛkɔŋ performance represents the female fertility spirit who resides in a number of abodes including shrines, ant hills, and streams. In this context, she is portrayed as river *nnɛm* with a python wrapped around her arms, waist, and neck, and she is known as "Marmee Water" (mother—*eka*— in the water). She also wears a Western dress and shoes, and her face is carved in the manner of the *mfɔn ɛkpo* mask that I will describe shortly. We were unable to learn how the movement of the figurine is achieved, but we suspect that a child is lodged within; a joint at the waist of the statue allows the upper part to pivot from side to side, and may also permit the piece to be lifted apart to reveal a hollowed out interior. Sometimes the display of Marmee Water does not end the ɛkɔŋ routine, but is followed by acrobats and tumblers, tightrope walkers, and sleight-of-hand magicians.

The Anang believe that at death a person's corporeal soul (*ɛkpo*), which is immortal (the bush soul [*ɛkpo ikot*] perishes at death), either transmigrates to the land beneath the earth to await reincarnation or is transformed into an evil ghost. Fate as ordained by *abassi*, and the consequences of immoral behavior within the realm of free will, condemn one to ghosthood, and an *ɛkpo ɔnyɔŋ* is unable to regain human

status but must wander the world homeless throughout eternity. In his frustration, he continually attempts to wreak vengeance on more fortunate human beings, even on relatives, and his attacks are countered with magic; sometimes, however, the deity will order a ghost to punish a person who has transgressed against his moral strictures. The εkpo in the underworld can return to patrilineage and family idεm to aid their kin when appealed to, but they remain in the village of souls most of the time.

Once each year for a two to three week period in October, both εkpo and εkpo ɔnyɔŋ visit their εkpuk and are impersonated with masks worn by members of the ancestor association. A special drum (obodum ɔnyɔŋ) is mounted on a platform high in a sacred tree near the square of the paramount village, and beaten without pause to allow souls of iman members passing by to dance on their way to their rendezvous. The members of εkpo convene every other day in a meeting house near the patrilineage square to sing and dance special association songs and dances, to initiate new members, and to venture out while masked to beg food and drink at compounds in the village. On the first and last day of the εkpo season, marked by the festivals nkai and ndɔk, the several associations of the community meet together to visit a nearby market and participate in a ceremony featuring the only appearance of special large masks: etε εkpo worn by the ɔbɔŋ isɔŋ, eka εkpo worn by the next most senior man in the village, akpan εkpo by each of the patrilineage leaders, and several mfɔn εkpo whose masks represent souls from the underworld. The other men wear ordinary masks which represent evil ghosts (idiok εkpo), and it is these which are worn at other times.

In the past it was thought that when an mbɔp was donned, the soul of the ancestor possessed the soul of the wearer, and the latter was not responsible for his own actions, even if they resulted in the destruction of valuable property or the death of others. The mfɔn εkpo moves slowly and gracefully and carries brightly colored cloths in his hands while possessed by an εkpo, but the idiok εkpo, whose soul is controlled by an εkpo ɔnyɔŋ, shakes his shoulders and arms, speaks in an unintelligible jargon, runs through the settlement climbing houses and palm trees, and shoots arrows at women and nonmembers. The reason why the association does not meet daily is to give women a chance to come out of hiding and farm and trade as usual; several times we dressed arrow wounds of unfortunate women who had ventured out on the days εkpo were abroad.

The mfɔn ɛkpo and idiok ɛkpo Masks

I will discuss only the *mfɔn ɛkpo* and *idiok ɛkpo* in some detail, for once again the matter of limited space intrudes, and it is these forms about which my wife and I collected the most extensive data, especially concerning styles, symbolic and decorative elements, and aesthetic evaluation. The word *mfɔn* means both "beautiful" and "good" and the term *idiok* "ugly" as well as "evil"; thus, a deceased person who had led a "good" moral life will be represented by a "beautiful mask" when he visits his *ɛkpuk*, and one whose "evil" deeds have caused him to become a ghost will be impersonated by an "ugly mask." Costumes and *mbɔp* worn by *mfɔn ɛkpo* are fashioned to embody elements of beauty, and the behavior of the wearers, as I have indicated, reflects the good character of the departed ancestors. The opposite is true of the costumes, masks, and actions of *idiok ɛkpo*, where ugliness and violence predominate.

The costume of an *mfɔn ɛkpo* features a raffia belt of short bristles from which hang foot-long, vividly colored cloths, knee bands of raffia, and rattles attached to the ankles. Sometimes an undershirt is worn to prevent the mask and its accouterments from chafing the wearer, but the sleeves and material below the chest may be cut off to make the outfit cooler. The *mbɔp* is backed with cloth or undyed raffia which covers the shoulders and upper back and chest. Instead of cloths, the masked man may carry in his hands a flashlight, fan, umbrella, or bell, among other objects of a pacific nature. The *idiok ɛkpo*, on the other hand, rubs his body with yam charcoal to blacken it and wears a vest of raffia with long bristles, in addition to knee bands, ankle rattles, and a raffia belt larger than that of the *mfɔn ɛkpo*. Dark cloths may be hung from the belt, but more often only a loin cloth is worn under it, and a machete in its scabbard is thrust through the belt on the left side of the wearer. The black dyed raffia which is attached to the *mbɔp* and covers its back merges with the vest, so that only the darkened arms and legs are bared.

The Anang evaluate colors as *mfɔn* and *idiok*; red, green (imported), yellow, and white are good colors, while black, brown, and blue (also imported) are evil ones. The face of a beautiful mask is painted either white or yellow to signify the good deeds of the *ɛkpo* and also the fact that he is abroad only during the daytime. Ordinarily, a ghost travels at night, but during the two weeks that he is visiting his kin group he will enter the body of a mask wearer day or night. The *mbɔp* repre-

senting him is painted black to symbolize both the darkness which
surrounds him and his evil ways. Good and evil masks never inter-
mingle, because souls from *obio ɛkpo* and ghosts roam the earth at
different times and do not encounter one another. At the time the
village ancestor associations visit the market together, the men who
wear *mfɔn ɛkpo* dance first and then retire before the ugly *mbɔp*
appear, and going to and from the market the two groups of mask
wearers are kept separated so as not to affront the ancestors.

The face of an *mfɔn ɛkpo* is oval-shaped and a foot in diameter. Its
features are Caucasoid with a narrow high-bridged nose, thin lips,
pointed chin, and high forehead. The wearer peers through the eyes of
the *mbɔp* rather than through openings beside the nose as in the case
of most ghost masks, and thin black eyebrows are traced above the
eyes. Carved open as if smiling, the mouth is colored red and reveals
white evenly-spaced teeth pressed together. Sometimes vertical black
lines are drawn on the chin and other small decorative designs on
cheeks and forehead. The *mbɔp* is given a woman's black hair, parted
in the middle, with six-inch braids on either side, and often two or
more additional braids stand vertically from the top of the head and
curl forward. What makes this mask compare in size to an *akpan
ɛkpo* are six or eight six-inch, square framed mirrors which ring the
face, attached to wooden projections from the sides of the *mbɔp*,
which may be elaborately carved. In style, the face resembles that of
puppets and human figurines, and its Caucasoid elements may well
reflect acculturative influences. Elders claim that the style has re-
mained virtually unchanged for at least a century, and that the features
embody an ancient ideal of human beauty. Light colored skin is an
Anang status symbol, and on several occasions I was asked by men to
have sexual relations with their wives so that their offspring might have
Caucasoid physical characteristics. The masks of *ɛkpo ntok eyɛn* re-
semble those of *mfɔn ɛkpo*, without mirrors, and the bodies of the
children are painted white because of the belief that the souls they
impersonate did not live long enough to commit grievous sins.

In portraying the features of a ghost mask, a carver is permitted more
freedom of expression than he is in fashioning any other piece. Over
two dozen symbols of ugliness are recognized by the Anang, and a
craftsman may combine as many as eight from among them, and
also include one or two decorative elements. Below are listed the
features of the face and the ways that each can be distorted to depict
ugliness:

FEATURES DEFORMITIES

forehead	wrinkled, bulbous, or pointed in the middle
eyes	bulging, small and depressed, or with flaps to signify blindness
ears	long or pointed at the top
nose	long, flat with wide nostrils, or curved to right or left
cheeks	puffed or hollowed
mouth	thick lips, turned down mouth, protruding tongue, long canines, large incisors with gaps between them, or mouth out of line to right or left
chin	cleft

Leprosy and yaws sores often are carved on the forehead, or the tongue is made to protrude through the upper lip which has been eaten away by leprosy. A snake, lizard, or spider (common witch familiars) also may be shaped on the forehead, although some men favor the revered tortoise, which is a decorative device rather than a symbol of evil in this case.

Colors other than black seldom are employed, but the teeth and eyes may be painted white, the inside of the mouth and tongue and leprosy sores red, the cheeks dark blue, and decorative elements several colors. The most often used decorative designs are raised ridges—rounded or squared and with or without relief carving—along the top of the *mbɔp*, down the center of its forehead, or from side to side above its eyes. Young men are prone to challenge tradition, and their masks sometimes deviate from the pattern that I have described; for example, their *idiok ɛkpo* may display regular features, utilize many colors and even emphasize good colors, and have natural rather than black dyed raffia attached to them. It should be mentioned that both *mfɔn ɛkpo* and *idiok ɛkpo* occasionally have animal instead of human faces—of cows, goats, and antelopes—but some carvers insist that these are creatures of beauty and ought not to portray evil ghosts.

Aesthetic Evaluation

The Anang conception of art has four dimensions: art embraces both artifacts and behavior, tangible carvings as well as intangible melodies; it is produced by both craftsmen and laymen, but primarily carvers, weavers, appliqué cloth makers, singers, dancers, musicians, actors, and narrators; it is mostly nonutilitarian—the creation of form for its own sake—and thus is not produced by iron workers, carpenters, rope

makers, drum fashioners, and pottery shapers; and, most importantly, it arouses both in its creators and in audiences what might be called a pleasurable "aesthetic feeling tone." This psychological state is termed *mfɔn*, which we have noted also signifies beauty and moral goodness. Of course, additional dimensions of art can be imputed, but the above are the components manifest to the Anang and do not include those latent to Western aestheticians.

Although the Anang admit that most carvings serve utilitarian ends, they nevertheless recognize that human and animal figurines, when used as house decorations, are nonutilitarian and that other pieces have, in addition to utilitarian elements, symbolic and decorative ones which serve aesthetic ends. An informant, in discussing this matter with my wife and me, after turning over a newly carved ghost mask to us, pointed to the eye holes as utilitarian, the spider that he had formed in the middle of the forehead as symbolic of evil, and the two rounded ridges at the top of the mask as decorative. Carvers hold iron workers and carpenters in low esteem because the products of the latter are strictly utilitarian; they lack *mfɔn* which the carver, by various devices, imparts to his pieces.

As an experiment, we exhibited an *idiok ɛkpo* and a human figurine (*udɛŋ nyama*), created by the same artisan, to three carvers and eight male laymen and asked them for their evaluations. All eleven pronounced the mask and statue excellently constructed and of great beauty, but they differed substantially in the criteria that they employed to form their judgments. The craftsmen stressed the smoothness of the pieces, the brightness of the paint and the evenness of its application, the combinations of colors chosen, the balance of features and impact of ugliness of the *mbɔp*, and the fact that the wood was not cracked. However, unanimity of opinion was lacking, for one criticized the artisan for using imported rather than indigenous paint; another thought that smoothness did not add to the beauty of the objects; and the third complained that the mask did not display enough originality.

The same criteria were mentioned by the laymen, but among them opinion was more varied and contradictory, and other standards of judgment were stressed. They were most concerned with the devices used to symbolize ugliness on the ghost mask, but were almost equally concerned with the high reputation of the carver (they invariably inquired about the identity of the carver, which the specialists did not), the amount of supernatural power that he controls, the good fortune that the *mbɔp* might bring its owner, and the cost of the pieces. It

appears that beauty as conceived by the Anang is an amalgam of aesthetic, economic, and religious factors. To illustrate that this conception is also shared among artists, I am reminded of a famous carver who stood at the edge of the hill on which our Ikot Ebak rest house was located and extolled the beauty of the valley; on questioning him, I learned that his evaluation was based on the abundance of oil palm trees below and the amount of wealth that they represented. Another artist, in this case a raffia weaver whose talents were widely lauded, declared a woman beautiful mainly because her breasts were long, signifying that she had suckled many offspring. (The primary status symbol among women is the number of children that they have borne.)

Our informants agreed with us that most Anang carving is rigidly circumscribed as to form by tradition, and that experimentation and innovation are most easily exercised in the making of *idiok ɛkpo*. However, we differed in our estimations as to the amount of freedom of expression allowed in the carving of even this object. After traveling throughout Ikot Ekpene County during the ɛkpo season of 1951 and photographing dozens of masks for analysis, we concluded that the variation of form is not nearly so great as imagined by our informants. Most carvers believe that they are innovators as well as reproducers, and many customers, especially young men who want to commission ghost *mbɔp*, will seek out an artisan who is known to stress originality. The ability to create original forms is believed to depend on both free will and the beneficence of the carving spirit. The craftsman who is fashioning a piece may be guided by a model, by a verbal description, by a desire to reduplicate nature (as in human and animal figurines and puppets), and in a few cases by a divinely inspired dream or the directions of a diviner (as in shrine figurines), but the mental image of the object to be formed may arise out of the psyche of the artisan and embody nontraditional elements. Generally speaking, innovation is less highly valued, if at all, by laymen than by carvers.

I called attention earlier to the fact that rarely does an apprentice fail to develop the requisite skills to pursue a professional career. This is so because the Anang entertain a different view of aesthetic talent than is common in the Western world. They assume that under ordinary circumstances any person can learn to sing, dance, act, weave, carve, play musical instruments, and recite folklore in a manner considered exceptional by unbiased Western aestheticians, and Anang culture rewards in numerous ways the acquisition of these abilities. In the Western world, artistic talent is believed to be relatively rare, the product of genetic forces or the possession of some mysterious spirit

or soul; but among the Anang it is thought to be a normal human capacity which is nurtured by cultural experiences. A wealth of evidence might be brought to bear to support a speculation that the Anang view of talent produces a greater amount of creativity and larger numbers of creative individuals than does the Western conception.

Several local communities once were known as carving villages in which most of the adult males practiced the profession. Anang, Eastern Ibibio, and even Ibo used to travel long distances to buy the pieces exhibited in the streets before almost every compound. My wife and I visited such a village of former renown—Ikot Abia—and talked about its past with a group of elders. They asserted that carving was so vital a concern to the inhabitants that there was no record of failure among apprentices for as long as they could remember. In fact, my question concerning the ratio of learners to nonlearners aroused bewilderment; they assumed that we held their view of aesthetic talent and that no alternative conceptions exist. They did reveal, however, the occasional appearance of one who might be considered a genius, but such a person, they explained, was fated by *abassi* to excel.

Modern Guilds

In 1940, a group of young men from Ikot Abia established the first carving guild in Ikot Ekpene town. Each carver of the organization specializes in fashioning a particular part of a particular piece or is skilled in painting or assembling a composite object, or in some other process associated with production. Customers visit the guild to purchase carvings, but most of the pieces turned out are sold to middlemen, who resell them in markets as far away as Calabar. The money earned is shared among the members of the group according to seniority, output, and the difficulty of the assembly line job performed. From time to time apprentices, who must pay a fee and spend at least three months learning the trade, are accepted. The carvings are poorly done—from the point of view of independent carvers, "sophisticated" buyers, as well as guild members themselves—but they sell for prices far below those charged by traditional craftsmen, and allow many Anang, who in the past could not afford them, to own pieces. We discovered that no matter how much money the guild is offered for a commissioned carving, the quality of the finished object remains the same.

Independent artisans bemoan the dissolution of indigenous associa-

tions which once supplied them with most of their work, and the growth of urban guilds whose mass production techniques are flooding the market with cheap, inferior carvings. They predict that their own days are numbered, and more of them are abandoning the craft and turning to other income pursuits. Not only are they bitter about economic competition from the guilds, but about the poorness of quality of Anang carvings today and the lack of taste of the ordinary African customer (not to mention the tourist here and the buyer abroad). My wife and I talked with old carvers who expressed ethnic pride in Anang carving, and criticized its debasement as they criticized the breakdown of Anang institutions and morality—all victims of an alien system of values.

NOTES

Linguistic Note
CONSONANTS: b, d, f, h, k, kp (labio-velar plosive with no English equivalent), m, n, ŋ (as ng in English *sing*), ny (as gn in French *agneau*), p, r, s, t, w, y
VOWELS: a (as o in English "hot"), ɛ (as e in English "met"), e, i, ɔ (as au in English "author"), o, u
Long vowels and consonants: shown by doubling the letter: aa, ss, etc.
Tone not indicated

1. Our project was supported by the Social Science Research Council and the Program of African Studies at Northwestern University. A grant from the Indiana University Ford International Program in 1964 provided time for the analysis and presentation of the material, which in part appears in this chapter.
2. A broad ethnographic survey of Anang culture is found in Messenger (1957).
3. Other spirits aid oath givers, workers of magic, diviners, hunters, and the members of one drama and one music association. Anang religion and religious acculturation are dealt with specifically in Messenger (1959).
4. Anang shrines are referred to as *iso*, meaning "the face of" (the spirit within), followed by the name of the *nnem* or by his or her function.
5. Messenger (1962 and 1971) discusses at length the ɛkɔŋ association.

David W. Ames

A SOCIOCULTURAL VIEW OF
HAUSA MUSICAL ACTIVITY

ZARIA or Zazzau is one of many ancient Hausa states of northern
Nigeria ruled by indigenous Hausa or Habe kings until the outbreak of
a holy war in 1804, led by Usuman 'Dan Fodio, which ended in the
elimination of all but three of the Habe dynasties. Usuman 'Dan Fodio
and most of his followers were Muslim Filanin gida who had settled
in Hausa communities unlike their cattle-keeping nomadic kinsmen,
the Filanin daji or "bush Fulani." The Filanin gida are the ruling
aristocracy today as they were in colonial times. Today, few of them
speak their traditional tongue and their culture more closely resembles
that of their Hausa subjects than of their cattle-raising Fulani
brethren.[1]

The government of Zaria is pyramidal with the Emir at the top
(though he in turn is subordinate to the Sultan of Sokoto, as are other
Emirs).[2] Next in rank, and living also in the ancient walled capital
city of the kingdom, are several titled officials such as the Waziri
(grand vizier), the Galadima, and the Madaki. Next in rank are the
Hakimai, now also called District Heads, who rule outlying districts
of the kingdom, which were formerly fiefs. At the base of the adminis-
trative pyramid are the village heads who administer not only their
own communities but the surrounding hamlets as well. Several of the
modern districts, peopled chiefly by non-Hausa, were formerly vassal
chiefdoms; but these districts had semi-autonomous governments and
still have such privileges as using royal drums (tambura) similar to
those played for the Emir.

Much of Zaria is low orchard bush and grassland, with scattered
granitic outcroppings. There is marshland by the larger streams and a
high-sun-period rainfall of about 40 inches. The basic economy is agri-
culture and the Hausa are excellent farmers. They break the soil and
make planting ridges with the hand plough; they practice mixed

cropping and use cattle manure on their fields when they have it. The staple foods are guinea corn and millet, and they also cultivate maize, yams, cassava, sweet potatoes, rice, sugarcane, and a wide variety of garden vegetables. The chief cash crops today are cotton, groundnuts, and tobacco. The Hausa ordinarily do not keep cattle but regularly purchase milk and butter from the nomadic cattle Fulani. However, the Hausa do keep other kinds of livestock: sheep, goats, chickens, ducks, donkeys, and horses.

The most striking aspects of the Hausa economy are the high development of trade, the skilled artisanship, and the occupational diversity. Even in rural farming communities, few adult males are engaged exclusively in farming. Referring to a typical farming district in Zaria Province peopled chiefly by Hausa, Smith (1962:331) states:

Of the 292 men living in Giwa and its environs in 1949, only 12% depended solely on farming for their livelihood. Another 58% practiced some other subsidiary occupation, whether craft, trade, or wage-labor, the latter being pursued by 20 men. A further 23% had two subsidiary occupations each, and 7% had three or more each.

In Zaria City and the larger towns, a much higher proportion rely very little, if at all, on farming to earn their living; in fact, many are full-time specialists in other economic pursuits though, as in the country, one often encounters individuals who engage in two or more occupations. By and large, these generalizations hold for musicians. A list of common occupations in Zaria City suggests the degree of occupational diversity: tailors, housethatchers, traders, manual laborers, merchants, launderers, farmers, bicycle renters, hunters, brokers, Native Authority administrators, gamblers, leatherworkers, well and latrine diggers, tanners, harlots, pimps, Koranic school teachers, teachers in modern schools, praise shouters, clerks, judges, drivers, motor mechanics, bicycle mechanics, housebuilders (traditional and modern), butchers, porters, weavers, dyers, blacksmiths, potters, Hausa carpenters, European-style carpenters, household servants, medicine vendors, policemen, and musicians of many types (see below).

Occupational groups are most significant in the Hausa social fabric: the occupation of a person or a person's kin probably has more to do with his social status in the community than any other factor. Males inherit their occupation through the father's line and their social status is fixed at birth. About four-fifths of a sample of 257 Hausa professional musicians of all kinds inherited their occupations, and among certain classes of musicians (e.g., hourglass drummers) the proportion was as

high as 95 per cent. Sometimes the mother's line is used to sanction deviation from patrilineal ascription of status, and this is consistent with a pattern of bilateral descent among the Hausa, though ascription of occupation through the father is more highly regarded. A young man who leaves his inherited craft or trade suffers verbal abuse from members of the community and sometimes is even beaten by his father and flees the community. Such persons are commonly abused in the following manner: "You are without shame! Your father was a potter and yet you chose to take up another craft!" The strength of this prescription of occupational inheritance was illustrated by some who steadfastly continued to perform music despite the fact that they relied a great deal more on some other kind of work to earn their living and/or spent a greater portion of their time on it.

Many recorded life histories show that this traditional prescription is now beginning to break down as a result of changes in economic and political life with commensurate changes in social values. Nowadays in the cities at least, a shift in occupation does not always lead to social censure; in fact, it may be even explicitly condoned if a more profitable alternative presents itself or if the new occupation has higher status— which it usually has in the case of the musician, since the occupation has always been ranked low and many young men are said to be ashamed to follow in their father's footsteps. Some musicians stated that they refuse to teach their sons their trade, but rather wanted them to go to school and improve their social and economic status.

A musician's work is referred to by the Hausa as a craft (sana'a), though in Western terms his product is an intangible one and might come under the heading of a social service. In pre-colonial times each craft group had a titled chief whose principal duty was to collect taxes among his group. Some craft groups still have their chiefs today— blacksmiths, butchers, housebuilders, and various kinds of musicians— though the chiefs no longer have the tax collection function. Such chieftainship is ancient. The Kano Chronicle refers to the titled head of the musicians and the heads of six other crafts and the large clan of which they were the heads as the ". . . orginal stock of Kano" in pre-Islamic times (Palmer 1908:65).

The Professionalization of Music

As indicated above, Hausa musicians are a distinct and socially recognized occupational group. A majority of those questioned in Zaria City derived most of their income from the music-praising craft, and many were full-time specialists in this. (More than 80 per cent of a sample

of 153 musicians of all types derived most or all of their livelihood from their work as musicians.) Some musicians, particularly those in the smaller towns and rural communities, work at farming and live mainly by it, but nevertheless, these musicians and their public agree that they should be classed *primarily* as musicians in the occupational or craft sense. Such musicians are commonly court musicians for District Heads, or are farm drummers, and most have inherited the craft which accounts, in part, for their primary identification as musicians.

In the light of the foregoing, it would be appropriate to class Hausa musicians as professionals and their line of work as a profession. In the West these terms have been used for occupations outside commerce, mechanics, and agriculture—usually in medicine, law, education, or one of the arts. The terms imply formal training, technical competence and full-time economic specialization, and as the Hausa musician often satisfies these criteria, we may call him professional, at least in some limited sense, and this is not incompatible with the nature of the Hausa social structure. The ancient Hausa state, with its large urban administrative and trading centers, cannot be termed "primitive." It is a complex, large-scale heterogeneous society which has often been likened to those of medieval Europe (Ames 1967:39–42).

On the basis of comparative analysis, Alan Merriam (1964:125) argues that public recognition of musicians as a distinctive class of specialists is basic to identifying them as professional regardless of the amount of economic support received from this activity. In this sense the Hausa musician can be viewed as a "social specialist" as well as an economic specialist.

Trading and values associated with it are deepseated in Hausa life, and this is not surprising when one considers that most Hausa engage in some form of trade during their lifetime, often starting when very young to hawk wares on the streets. The Hausa are shrewd and tireless traders who enjoy haggling and chatting in the marketplace. Markets range from huge ones of the cities to a few stalls in the small hamlets. Aside from a lively local trade, the Hausa are famed for an external trade in which they range over very considerable distances. The itinerant traders have counterparts in many kinds of itinerant musicians who sell their musical wares in the marketplace.

The Nomenclature of Hausa Music

In the field I soon discovered that the Hausa do not conceive of musical activity as we do in the West. David McAllester's comment on the

Navaho could just as well be applied to the Hausa: "A 'fact' in the Navaho universe is that music is not a general category but has to be divided into specific aspects or kinds of music" (1954:4). The Hausa have no single word for music; instead they refer to "drumming," "blowing," or "singing," and all stringed instruments are "drummed," not bowed or strummed as they are in the West, and their players are called drummers. Again, there is no single word for musician. One must refer to drummers (*maka'da*), hornblowers (*masubusa*), or singers (*mawak'a*). The Hausa often lump together different kinds of praise shouters and musicians as professional acclamators (*marok'a*),[3] and they are assigned extremely low rank.

The Range of Musical Activity and Professionalization

The great variety of musical instruments is consistent with the over-all complexity of Hausa culture. Over 50 instruments were observed and identified among the Hausa in the Zaria emirate in the course of this study (Ames and King 1971) and others I heard about but did not see or hear. The majority of these instruments are played by persons who claim music to be their primary occupation, and most are never played by other than professional musicians or their apprentices. Singing or dancing in public for profit is done chiefly by professionals too. But first let us discuss the nonprofessional.

MUSIC AMONG THE NONPROFESSIONALS

The slaves of the Emir who beat the royal drums (*tambura*) for about two months every year are difficult to classify; however, they are not considered professional musicians by the Hausa community—in fact, they themselves are the first to deny that they are musicians.

What about the production of music by nonprofessionals for pleasure? Forty men in various occupations and ranging in age from their late teens to the forties were asked if they ever played a musical instrument and only three—all young men—answered in the affirmative, stressing that they only played for their own pleasure. Those who replied in the negative usually explained that music was not their inherited occupation or simply that they disliked the idea of playing. Nonmusician informants generally were anxious to disassociate themselves from professional musicians because of the profession's low rank.

The maturer married men (nonprofessionals, of course) were never observed playing an instrument, singing, or dancing. The very idea, for example, of "the-owner-of-a-beard" (*mai-gemu*) playing an instrument, singing, or dancing is considered most ludicrous by the Hausa.

It would be almost inconceivable for the Emir or other titled official of the aristocracy to do so. They are entirely different from the Akan chief described by Nketia (elsewhere in this volume) who dances publicly to the royal drums, or the Igbo chief I observed playing an instrument with the town orchestra. The major exception is group chanting, in a singsong fashion, of Muslim hymns by members of the *Tijaniyya* sect in the neighborhood mosque. Blind beggars are also heard chanting in homes and markets. Some of the younger married men and most of the unmarried ones state that they sing songs for their own pleasure—mainly songs they have heard over the radio or in the movies—but I have rarely observed them doing it in public, and then only when working.

Among nonprofessionals, women of all ages more often perform music than men. Married women frequently sing inside the compound, particularly when they are grinding corn or just for their own pleasure after the evening meal is finished (e.g., *Shantu* music), and sometimes at wedding or naming feasts. This singing (and dancing too) is often accompanied by one of several calabash "drums" or by a handclapping chorus. However, it should be stressed that these performances do not take place in public, only in the inner compound (*cikin gida*) where the wives stay.

Harlots are even less restricted and have been observed on many occasions "shamelessly" dancing in public. A few keep a one-stringed fiddle (*kukuma*) in their rooms to entertain their clients, a practice said to have been much more common in former times.

Small boys and girls play certain instruments viewed by the Hausa as playthings, such as crude whistles made of guinea corn stalks, jew's harps, drums made of tin cans and calabashes, and bullroarers called hyenas (*kura*) made of corn silk, bamboo, or bits of metal. Children sing a variety of game songs, and Koranic school children sing when begging for food.

Unmarried girls, from quite small ones to those past puberty, frequently dance and sing in public right up to the time they get married. They are often seen dancing just outside the entrance of a compound where a naming ceremony or wedding feast is being held or out in the streets on most Friday nights. The drumming is provided by male professional drummers, and sometimes male professional song leaders perform too. Girls also do a dance (*ga'da*) inside the compound at night which is accompanied by singing and handclapping, and married women sometimes lead the singing.

Young men do less dancing in public than the girls, and they sing even less often, because to do so in the presence of girls and old women

is considered "shameless." They do a kind of foot boxing (*sha k'afa*) to special drum rhythms and their movements resemble a dance. Rural young men do a special dance (*rawan gane*) which is performed a few times during the month of *gane*—the third month in the Muslim calendar. It is distinguished by songs ridiculing certain persons in the community who have behaved badly during the preceding year. Some of the young men are now learning to do highlife, rock and roll, and East Indian dancing, but they avoid doing them conspicuously unless they are professional dancers belonging to one of the dance teams of the modern political parties.

A few young men, who vigorously deny they are professionals, form groups which play, dance, and sing out on the streets at night, especially during the month of *Ramadan*. One or more of them plays one of several kinds of flutes made of guinea corn stalk (*til'boro, obati,* and *damalgo*). The performances are considered quite amateurish, though sometimes they receive small gifts of money, cigarettes, or kolanuts. Young men may strum for their own pleasure on a small one-stringed instrument (*kuntigi*) made of an empty sardine can which professionals play too. However, the young men never play most of the musical instruments played by professionals.

The drummers and singers for the *'yan tauri* are another class of nonprofessionals. *'Yan tauri* are known for their powerful magic, which is thought to make them invulnerable to cuts from knives and swords, and they hold competitive public demonstrations of their powers. They also act as body guards for important politicians, for example, the late Premier of the Northern Region of Nigeria. Musicians of the *'yan tauri* can be observed at their public demonstrations and at parades held in connection with the annual Muslim feast days, the visits of important persons, and the turbanings of high officials by the Emir. These musicians also play for boxers who are usually butchers like themselves. Though *'yan tauri* and their musicians are often paid for their performances, they rely chiefly on their professions as butchers and hunters for income. The musicians of the *'yan tauri* do not play as often or as expertly as professional musicians, and they do not view themselves as professional drummers (*maka'da*) because, as their chief in Zaria stated, "We do not beg (*rok'o*) from others to earn our living."

PROFESSIONAL MUSICIANS

The following professionals count music as their basic craft: 1) the musicians of the craft groups; 2) the musicians in the political life;

3) the musicians of recreational music; 4) the musician-entertainers; 5) the musicians for the *bori* cult. There is overlapping (e.g., some hourglass drum players play for the butchers and also play recreational music for the general public); however, Hausa musicians tend to concentrate on one or the other of the classes of music above. It should also be noted that some musicians double as professional praise shouters (*marok'an baki*) and some change over to it later in life. For example, aged drummers of the big farm drum shift to less strenuous praise shouting, leaving the drumming to their sons or younger brothers.

Though a great majority of the professional musicians are men, the wives of musicians sometimes become singers (*zabiya*) in their husband's band, and this is one of the reasons nonmusicians give for refusing to permit their daughters to marry musicians. Some *zabiya* form groups of their own to play for women at feasts (see Table III no. 5). A few instances were noted of women playing instruments ordinarily played by male court musicians, e.g., the *taushi* and the *algaita* (see Table II below).

THE MUSICIANS OF CRAFT GROUPS: Certain musicians are traditionally tied to the following craft groups whose members are their patrons: (a) blacksmiths; (b) butchers; (c) hunters; (d) musicians and praise shouters themselves; and (e) farmers. Table I, below, lists the names of these musicians and the instruments they play.

TABLE I

MUSICIANS OF CRAFT GROUPS

TYPE OF MUSICIAN	CRAFT PATRONS	KIND OF INSTRUMENT PLAYED
Mai-dundufa	blacksmiths	two long single membrane drums: the *dundufa* and its smaller companion, *yar dundufa* (daughter of the *dundufa*). Accompanied by a small conical-shaped drum called the *kuntuku*.
Mai-kalangu	butchers	the hourglass-shaped pressure drum, the *kalangu*.
Mai-komo	hunters	a large two-stringed plucked lute, the *komo*.
Karen Marok'a (the dogs of the beggar minstrels)	musicians and praise shouters	the hourglass-shaped pressure drum, the *kalangu*.

TABLE I—MUSICIANS OF CRAFT GROUPS—*Cont.*

TYPE OF MUSICAN	CRAFT PATRONS	KIND OF INSTRUMENT PLAYED
Mai-gangan noma	farmers	a very large double-membraned drum, the *gangan noma* (drum of farming), accompanied by a smaller single open-ended drum, the *kazagi*.

The *mai-dundufa, mai-komo,* and *karen marok'a* play almost entirely for their patrons. The *mai-gangan noma* sometimes play for members of the aristocracy as well as for their patrons. Though the *mai-kalangu* is traditionally the drummer for the butchers, the younger *kalangu* drummers play frequently for girls' dancing and boys' boxing (see recreational music below).

Barber-tattooers, not listed here, also use drums to attract customers, and they drum and sing special songs while tattooing, which is designed to lessen the girl's fear. Some drum themselves (when working with another tattooer) and others temporarily hire professional drummers.

Musicians for craft groups attend their patrons' naming ceremonies, marriages, and their turbanings, if they receive a title. Many also tour the countryside, visiting the towns and hamlets where their hereditary patrons are to be found.

MUSICIANS IN POLITICAL LIFE: These can be classified into three main groups: a) ordinary court musicians; b) famous singers and their bands; and c) the musicians and dance teams of modern political parties.

[Ordinary Court Musicians]

The court musicians play for titled officials of the ruling aristocracy: The Emir; high court officials; department heads in the Native Administration, as the administration of the emirate is still called; and district heads. They reside in the same towns as their patrons and play for them at their residences at least once a week, usually on the "eve of Friday" (*daren juma'a*) which is an important night to the Hausa since they reckon that Friday, the Muslim holy day, starts the night before.

The Emir has about 50 musicians including two court jesters, a snake charmer, and a group of eulogists who do not sing praises but shout them. They are all referred to collectively as the *masartan sarki.* Other members of the aristocracy have far fewer than the Emir.

A list of the different kinds of instruments played by the court musicians can be found in Table II. With the exception of the *kalangu*, which is rarely seen, all of these instruments are played only for the aristocracy and thus can be considered symbols of status.

TABLE II[4]

INSTRUMENTS MOST OFTEN PLAYED BY COURT MUSICIANS
OF THE RULING ARISTOCRACY IN ZARIA EMIRATE

Taushi, a large single membrane cone-shaped drum
Banga, a small single membrane cone-shaped drum covered with rags.
Kotso, a single membrane open-ended hourglass drum with tension cords
Algaita, an oboe-like horn
Gangar algaita, small double-membrane drum played with the *algaita*
Gangar saraki, large double-membrane drum
Kakaki, the famous long Hausa trumpet made of tin or brass
Farai, horn made of bamboo and wood about 2½ feet long
Kaho, a roan antelope horn
Jauje, a double-membraned hourglass-shaped pressure drum
Kalangu na Sarki, very much like the *jauje* but usually smaller
Tambura ("royal drums"), large single membraned kettle-shaped drums.[5]

[Famous Singers and Their Bands]

These singers eulogize in song political personages such as the Sardauna of Sokoto, late head of the ruling party of the northern region; emirs of the northern region; high officials who are usually members of the aristocracy; and wealthy merchants. Many of them are at least nominally musicians of certain emirs of the north, like the famous Sarkin Taushin Sarkin Katsina ("Chief of the *taushi*-players of the Emir of Katsina"). They travel more extensively than ordinary court musicians, singing songs of praise for personages wherever they go, though they compose songs to honor their traditional patrons as well. They can be distinguished from ordinary court musicians by their superior artistry and by their composition of songs in addition to the traditional ones they sing for their patrons. Some of the famous singers do not have a single aristocratic patron: for example, Shata, who is the best known of them all. Whether or not they have a single patron, such musicians travel extensively throughout the northern and western region of Nigeria and, sometimes, to other countries, e.g., Niger. Most of their income is derived from the celebrities whom they visit and praise on these trips.

Though so many of their patrons are prominent in political life, the

famous musicians are, in a very real sense, the musicians of the Hausa common people. Many of them compose topical songs—for example, commemorating Independence—and government ministries some-times hire them to compose and perform educational or propaganda songs. They make phonograph recordings and are heard over the radio. The general public enjoys listening to them and less famous musicians imitate their styles and songs. Their music is, in part, recreational music and also serves important political functions.

It should be noted that there are many itinerant professionals who sing for the same persons and in much the same way, but have made few or no recordings and are not as well known.

[The Musicians of Modern Political Parties]

The large single-stringed fiddle (*goge*) players and their calabash drummers are those most often formally associated with political parties. They play for party dance teams which perform in the beer gardens of the hotels in the cities of Hausaland. The dance teams do a new popular dance called *rawan kashewa* or *rawan banjo*. The *goge* player is the head of the band and has the title "Chief of the drummers" plus the name of the political party, e.g., *Sarkin Ki'dan NPC* ("Chief of the drummers of the NPC"—NPC stands for the Northern People's Congress). More will be said about these musicians in discussion of artistry and function.

MUSICIANS OF RECREATIONAL MUSIC: These musicians and the instru-ments they play are listed in Table III below. Professor Nketia's defini-tion of recreational music for Ghana is followed here: music which is ". . . not ritually or ceremonially bound" (1962b:10). But to this we should add that we are referring only to professionals who regularly play for different occupational groups and social classes. The musicians who play primarily or exclusively for the craft groups also play certain kinds of recreational music at the feasts of their patrons.

All the musicians listed in Table III play for naming ceremonies and wedding feasts, at least from time to time; however, nearly always, the *kalangu* or the *kwairama* drummers—by far the most common types of musician of any class, with the possible exception of farm drummers—can be found playing for the girls' dancing at these feasts. These popular drummers also play for boxing and wrestling contests put on by the young men, for girls' dancing on the streets Friday nights or any pleasant moonlight night, and for special plays put on by the young men and girls during the harvest season.

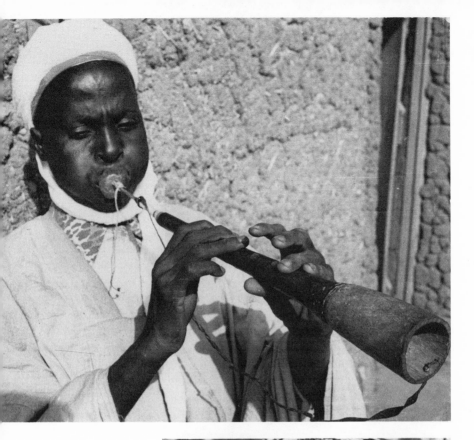

n *algaita* player for a Hausa
strict band (above).

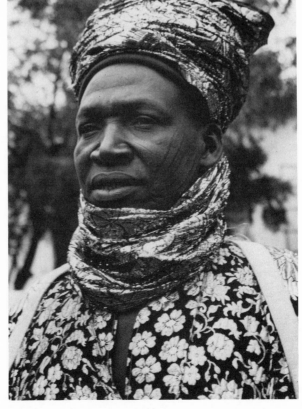

famous singer, Sarkin Tau-
i Alha-ji Mamman, known
l over Hausaland. He has
ade many phonograph re-
rdings and is frequently
eard on the radio. He is
ief of the *taushi* drummers
d singers for the Emir of
atsina.

TABLE III

MUSICIANS OF RECREATIONAL MUSIC[6]

TYPE OF MUSICIAN	INSTRUMENT(S) PLAYED
1. *Mai-kalangu* who drums for girls and young men.	Such drummers always play two hourglass-shaped pressure drums (*kalangu* and *'dan kar'bi*) and are accompanied by a single membrane cone-shaped drum (*kuntuku*)
2. *Mai-kwairama*	A double membraned drum (*kwairama*) often made of a metal drum
3. *Mai-goge*	The large single-stringed fiddle (*goge*) mentioned above
4. *Mai-kukuma*	A smaller version of the *goge*
5. *Zabiya*[7]	A generic term for a professional female singer who may sing to the accompaniment of one of several instruments: *kwairama* (drum); *kukuma* (fiddle); calabash drums, etc.

The *goge* and *kukuma* fiddlers (3 and 4 in Table III) and their calabash drummers often play in the houses of prostitutes and in beer drinking places. They are also to be found at *wasan misisi* or *kalankuwa* plays, at the naming and wedding feasts of the wealthy, and at any large public gathering. As has been mentioned, the *goge* fiddlers regularly play for political parties, and, for many this is their primary source of income. Some *goge* players also play for *bori* ceremonies.

MUSICIAN-ENTERTAINERS: These musicians—listed in Table IV—all have in common the fact that they are entertainers specializing in comedy of various sorts. They perform in markets and other public places and are itinerant much of the year. They dress in funny hats and trousers, do imitations, sing amusing songs and say funny things. They also dance in a bawdy fashion stripped to the waist—behavior considered shameful, yet amusing, by Hausa audiences.

MUSICIANS FOR THE BORI SPIRIT-POSSESSION CULT: Musical instruments are not played in the mosque, and music is excluded from everyday Islamic ritual with the exception of the unaccompanied chanting of religious poems and Muslim hymns.

TABLE IV

MUSICIAN-ENTERTAINERS

NAME	TYPE OF INSTRUMENT(S) PLAYED
1. 'Dan Kama	Single membrane open-ended hourglass drum, no tension cords (gangan 'yan kama)
2. 'Dan Gambara	Beat various kinds of drums: kalangu (with no 'dan kar'bi), kazagi and tallabe
3. Na Buta (also called 'Dan Kacakaura or 'Dan Galura)	Sings and talks while shaking a tin can rattle
4. Mai-tandu	"Drums" made of large stiff leather bottles shaped like the miniature ones (tandu) in which eye make-up is kept

The Muslim scholar, teacher, and mosque head never plays an instrument or sings secular music or dances. They consider many kinds of Hausa music to be wicked, particularly goge music which is called the music of the devil. A Koranic scholar and head of a small mosque was thought to be mad because, from time to time, he would sing secular songs and dance in public to the amusement of some of the impious youth in his neighborhood.

The position of music in Hausa bori cults sharply contrasts with the Islamic pattern. Bori adherents believe in a host of spirits (iskoki) which possess their initiates while dancing to bori "drumming" and singing. Bori musicians are the only ones who regularly play music as an integral and necessary part of Hausa religious ceremony. Bori is concerned with curing sundry physical, social, and psychological ailments. It also functions simply to provide exciting entertainment; namely the "drumming," singing and dancing which is basic to a bori performance. The most important spirit is called the "chief of the drummers" (Sarkin Maka'da) and musicians consult this spirit when they have professional difficulties. It is interesting to note that the musician's rank in the bori spirit world is the antithesis of the real world.

One or two of several kinds of stringed instruments[8]—usually a small two-stringed lute called the garaya—accompanied by gourd rattles are used to bring on the possession of the bori dancers, and the player of the lute often sings songs praising the spirit(s) being called.

Despite the fact that *bori* is disapproved of by pious Muslims, its musicians are to be found in all of the principal towns in the Zaria emirate, and in the district of Mak'arfi, for example, most of the village groups have one or more players.

Aesthetic Expression other than Music

Though the following review of the range of aesthetic expression is necessarily, in part, a reflection of my Western-oriented tastes, wherever possible I have tried to emphasize areas of Zaria Hausa culture where the people themseles either explicitly or implicity exhibit some interest, and, of course, only a few of the forms of aesthetic and artistic expression can be treated here. Boas (1955:12) provides us with a useful guideline in his distinction between all-inclusive aesthetic expression which may even occur in man's reaction to natural phenomena, and artistic activity where the emphasis is on the creation of cultural forms by man. I can recall very little interest in the kinds of things Westerners consider beautiful in nature. Flowers are not highly valued as they are, for example, among the Indians of southern Mexico. There was little evidence of interest in sunsets and beautiful landscapes.

The Hausa have an exceptionally high regard for horses—for their good looks as well as the prestige they give the owner. Of course, like all peoples, the Hausa value good looks in human beings, and, like all peoples, they have their own rather arbitrary traditional standards of beauty. Light-skinned women are prized as wives despite the fact that the Hausa are predominantly Negroid. In addition, in many linguistic contexts, white and black symbolize "good" and "bad" or "pleasant" and "unpleasant."

The artistry of the Hausa is most evident in speech, song, verse, costume and house decoration, as well as in the usual crafts of handpowered economies.

Like many other West African groups, the Hausa liberally salt their conversations with proverbs, sayings, and cleverly contrived metaphors. Symbolic statement is especially developed in song lyrics and formal poetry—two art forms which are closely related among the Hausa.[9] Hausa writing in Arabic characters has aesthetic appeal just as Chinese script does.

A dominant and universal form of artistic expression is in the production and wearing of clothing. Fashions are constantly changing, especially the clothing of the young people. Though most of the

materials (cloth, thread, etc.) used in Hausa clothing today are imported, the Hausa creatively tailor gowns and beautifully embroider them. The consumer, too, creatively selects and wears this clothing, which often includes locally manufactured jewelry, shoes, and cloth. The Hausa have a sophisticated and daring way of combining colors and forms, best exemplified by the immense variety of hats and turbans worn by the men.

Ordinarily, in gift-giving, a fine gown is valued more highly than other goods of an equivalent value—perhaps only the gift of a wife, a horse, or, in former times, a slave, would be appreciated more. Emirs and other persons of rank and wealth constantly give gifts of clothing: for example, the Emir of Zaria and others among the aristocracy who have court musicians annually give each of them a gown and a turban; in some cases, they receive little else from their masters. The Emir of Zaria estimates that he gives out one hundred gowns each year to musicians alone. Young men spend a large proportion of their income on fine clothing, and girls are thought to choose between rivals on this basis. At the feast of *Id-el-Maulaud (K'araman Salla)* everyone—commoners and royalty, men, women and the children—put on their best clothing, usually purchased especially for the occasion. The high point of this feast is the marvelous parade put on by the ruling aristocracy and their retainers, in which even the horses are elaborately decorated.

Though the Hausa are renowned for many craft skills, house construction—particularly house ornamentation—has a peculiar artistic excellence and interest: the graceful arches of the interior domes of the traditional sun-dried brick house or the low relief sculpture or multi-colored decorations on the side of the house facing the street.[10] In the lyrics of one of the women's grinding songs, the singer tells how she wants to marry the owner of a finely decorated house. Though some Zaria houses are decorated with representations of such things as bicycles and watches, most exhibit only simple, finely executed, abstract geometric designs, and the same can be said of leatherwork and the like. The Islamic notion that it is blasphemous to imitate the human form or any other handiwork of God has acted as a brake on the development of the graphic and plastic arts. In the light of this, it is not surprising that the outstanding students over the years in the best university fine arts department in Nigeria have come from the south (famed for its sculpture) and not from the north.

There are numerous Hausa craft traditions which exhibit a high degree of technical skill. Throughout northern Nigeria the Hausa derive aesthetic pleasure from the ornamental designs and patterns to

be found in their leatherwork, metalwork, carved calabashes, mats, woven cloth, basketry, jewelry, pottery, etc.

Artistry in Musical Production

SOME METHODOLOGICAL NOTES

It is difficult to isolate and define art in Hausa musical activity. Music is woven tightly into the everyday social life of the Hausa community. Dancing, parading, working, and other forms of social action such as praising members of the aristocracy give pleasure to Hausa audiences, not so much as individual arts but as a total and integrated performance—for example, dancing, costuming, artful praise-shouting and music.

Further, it may be more difficult for people to articulate their reactions to music than to a plastic art like West African wood sculpture. The latter is more tangible—it can be viewed and perhaps handled repeatedly, and often for long periods of time. Symbols represented in the sculpture, too, can be readily identified and interpreted. Hausa music, on the other hand, is more elusive. It is seldom performed twice in the same way, and of course, when there are no lyrics, symbolic interpretation is more difficult. Moods such as melancholy—common in Western music—are not expressed in Hausa music; a Hausa musician says, "The purpose of music is to make people happy!" And Hausa musicians do not play when people are sad because of a death or a serious illness, except for a *bori* curing rite.

Professional musicians, of course, can be expected to be more articulate about their craft than listeners, but tastes in art are not established and maintained by musical specialists alone. Exclusive reliance upon Hausa musicians as informants would not provide a clear or full picture of the music. For example, talking to leading artists usually yields scant data, for they commonly view themselves as outstanding musicians but neglect others. It is relevant that in an early article Boas (1948:312–315) disapproved of recording only the esoteric knowledge and views of priest-specialists, arguing that an accurate description of a religion could be obtained only by concentrating on the behavior of the nonspecialist.

I prefer, then, to rely for the most part on the Hausa community in selecting artists for discussion. Reliance on Euro-American standards would of course be unsuitable. I have observed that Westerners generally—including trained musicians—find Hausa music exceedingly

tedious and lacking in artistry. Since musical taste is usually formed unconsciously from early childhood, it is not surprising that cultural shock often accompanies exposure to exotic music. The shock is, of course, stronger the more alien the music is to the listener's tradition. North Americans are strangers to the music of northern Nigeria as compared to the music of groups to the south with which we have become a bit more familiar through Afro-American forms developed by the Blacks of the New World (*e.g.*, the Yoruba-like music of Cuba). Richard Waterman made a similar point to an academic audience of North Americans when about to play recordings of exotic non-Western music: "You have probably heard that music is an international language. Well, today I am going to disprove it!"

SOME HAUSA DEFINITIONS OF ARTISTRY

The terms aesthetic, artistry, art, and artist are, of course, derived from the intellectual life of the West and it is difficult to find Hausa equivalents for them. In England, prior to the 1840's *art* meant any kind of human skill and *artist* signified any kind of skilled person as *artisan* and *craftsman* do today. After the 1840's *art* and *artist* came to refer only to the so-called creative and imaginative arts (Williams 1960:xiv). The Hausa conception of the musician is closer to the older English meaning of *artist*. I repeat that the Hausa consider professional music a craft (*sana'a*) despite the transient and nontactile nature of the product. However, concerning at least three types of musicians (see below), the Hausa themselves distinguish a run-of-the-mill craftsman from an out-of-the-ordinary one who impresses them with more than technical skill—with originality, inventiveness, ability to improvise. According to Professor Nketia (see his paper in this volume), the best performers in Akan society are also the most creative and, as among the Hausa, they are usually singers rather than instrumentalists. Many non-Western cultures are said, by Westerners, to lack interest in musical originality: the Hausa, for one, resemble many Euro-American societies in placing a high value on it.

It is easier to define artistry for musicians alone because of the availability of data, and the more difficult problem of developing a really meaningful definition which would hold for all of the arts. Relying upon Hausa thinking and behavior, we can speak of a Hausa musician as being an artist if he is an especially inventive individual or a clever improviser who is unusually effective in stimulating intellectual interest or emotional response in his Hausa audiences. Musical production is

nearly always a social act and rarely takes place in isolation. Thus the effect on the audience seems to be a basic consideration in the Hausa's own definition of the outstanding musician.

What can I say of responses of Hausa audiences to musical performances? Men are not very demonstrative either in words or gestures. The size of the audience and the gifts given to a musician best indicate opinion. The donor quietly gives a gift to a professional praise shouter who announces it to the crowd and transmits it to the musician.

Occasionally, in the villages one can observe a pleased bystander walk into the ring of spectators and personally place a coin on the musician's forehead. Another exception to the pattern of minimal overt response is smiling and laughing at musician-entertainers, but this is for the comedy, not the music. Sometimes women, particularly harlots, can be heard making an ululating cry (*'guda*) when pleased by a performance.

Overt disapproval is also minimal and is indicated by small audiences and few gifts.

Generally, then, the immediate response to an artistic performance is not obvious—it is internalized, so to speak; inwardly the spectator may be having a strong emotional reaction of pride or anger, or one of a milder sort such as an intellectual interest in the lyrics of a song or sensuous pleasure from the music or the poetry of the lyrics.

If artists can be defined as inventive people or virtuoso improvisers who are exceptionally effective in communicating with an audience, the great majority of Hausa musicians cannot qualify as artists; in fact, most are rather unimaginative "tub-thumpers," so to speak. Nevertheless, many are solid craftsmen in the technical sense. In fact, they may be respected as such in their communities; yet there is little that is original or unusually exciting in their playing, and this is reflected in the response of the community to them. Many nonmusicians indicated that they would not walk across the street to hear the ordinary court musicians of the Emir play; few, if any, were observed listening to them when they played weekly in front of the Emir's palace. However, if a famous singer or one of the other artists mentioned below starts playing, he immediately attracts a crowd willing to pay money to hear him. The ordinary musicians of the Emir and of other members of the aristocracy most often play only the traditional songs of praise associated with the office held by their masters. These are the same songs, essentially unchanged, that were played and sung by their fathers and grandfathers.[11] However, they do not feel inferior because of their lack of inventiveness; for deviation from the prescribed manner of playing

these songs is viewed with alarm. Moreover, these traditional practitioners have the highest status among all types of Hausa musicians.

The Hausa consider famous praise singers and certain hourglass drum (*kalangu*) players and larger one-stringed fiddle (*goge*) players to be outstanding artists. Others might be mentioned, but for purposes of discussion we will limit ourselves to these. Some musician-entertainers, like a famous '*Dan Kama* of Zaria, are artists, but they have been excluded here because they rely more on mime and humor than on musicianship. Inventive praise shouting, which often is a *tour de force* (see Smith 1957), by professional praise shouters (*marok'an baki*, "beggars of the mouth") who play no instruments, has also been excluded.

1. FAMOUS SINGERS: What do they have in common? They are all good technicians, but this is not what distinguishes them. Hausa informants suggest that what sets them apart is their ability to create interest, to titillate, and to arouse emotion—particularly, the feeling of pride and sometimes, even anger—in their audiences. But what is the locus of this appeal in their performances? Though the Hausa are not accustomed to speaking of the elements of a performance separately, seemingly endless discussions—including hypothetical questions and analysis of song texts—revealed that the locus of their appeal is the lyrics of their songs. The tune of a song, though less important, should be original if composed by a great artist. The instrumental accompaniment—ordinarily drumming—is usually taken for granted unless it is noticeably bad, and even less attention is paid to the voice quality or voice production of the singer. It is often conceded that unknown singers often have as good if not better voices than famous ones.

The strong appeal of the lyrics appears, as suggested above, to stem from interesting content, power to evoke emotions, and clever wording. No less important is the ability of the artist to improvise on the spot. Some songs are topical, like several written in 1960 commemorating the independence of Nigeria. They may comment on public morals in a thought-provoking way or encourage the people to support some government program. Most, however, are designed to praise personages who reward the singer handsomely, and in these songs it seems that it is not what is being said but the *artful way* that it is said that attracts the listener. Sean O'Casey (1965:50) suggested a relevant "law" of aesthetics when he wrote, "We do not want merely an excerpt from reality; it is the imaginative transformation of reality, as it is seen through the eyes of the poet, that we desire."

The Hausa enjoy rich imagery and oblique references and rhyme endings. I would also venture the notion that the Hausa's sophisticated sense of rhythm requires the singer to be most careful about his word stress and phrasing—more so than in Western music—so that it is compatible with the basic "regulative" beat of the song, which must be adhered to strictly. A very famous singer, Alhaji Muhamman Shata, uses hand motions to signal to his drummers the rhythms he desires while in the midst of composing new lyrics in an impromptu fashion. The famous singers I have heard use traditional instruments and forms, for the most part, but they rework them in original ways.

The ability to compose lyrics on the spur of the moment seems to be the principal reason that Shata and others like him are so popular. Shata himself showed repeatedly in an interview that he was particularly proud of his improvisations. I have also discussed these songs with two well-known Hausa poets who write on secular subjects. They were both impressed by the originality and poetic quality of the song lyrics composed by famous singers like Shata and Sarkin Taushin Sarkin Katsina. They flatly stated that the lyrics were good poetry and, since these are learned men who have a much higher rank than the musicians, this is very high praise indeed. Hausa "literary" poetry is closely associated with song. Both are referred to by the same word, wak'a or song, and both are sung, but in different fashions. Poets do not have an instrumental accompaniment when they "sing" their songs, though one of them at least has toyed with the idea, yet did not do so for fear of being thought a musician.

In conclusion, the paramount position of the lyrics of songs to the Hausa was succinctly put by an elderly man who said, "What would be the use of it?" when I remarked that much of Western music is purely instrumental.

2. CERTAIN KALANGU AND GOGE-PLAYERS: The Hausa also recognize artistry in the playing of instruments, notably the pair of hourglass-shaped drums, played by a single performer, called the kalangu and the 'dan kar'bi; and the large one-stringed fiddle called the goge. Though these instruments accompany singing, especially the goge, they are used for dancing, and some of the best and longest virtuoso performances are heard in this context. Hausa do not ordinarily sit and listen to kalangu drumming without dancing, singing, or some other activity.

Both instruments are played for young people; the dancers and the audience are for the most part young, and since they are receptive to

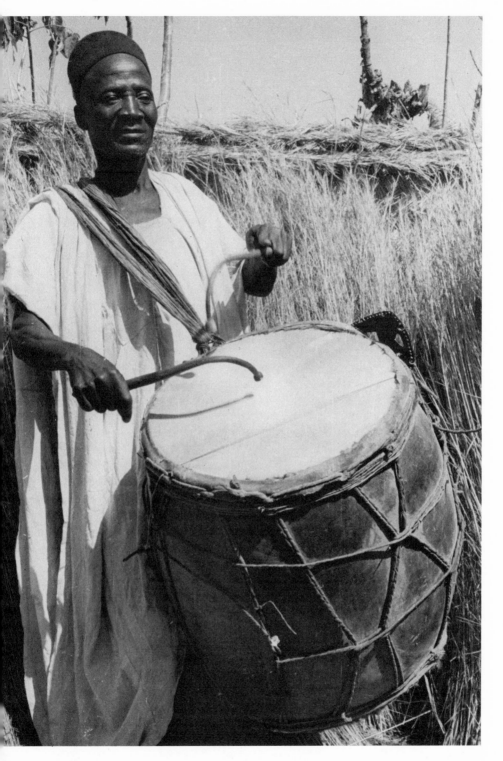

Chief of the drummers for farmers in Giwa District in the emirate of Zaria, drumming on the *gangan noma*.

change and interested in things modern, it is not surprising that inno-
vations are frequently made by the players of these instruments. An
expert player has an almost endless repertoire of dance rhythms but
because there are fads in these, he usually is asked to play only a
limited number of them during any given year. The urban young
people are leaders in innovation, with their rural counterparts lagging
behind, still playing the older rhythms. For example, one of the
fashionable rhythms when I first arrived in Zaria was the twist (pro-
nounced *tuwis*); by the time I left it had already declined in popularity
in the city though it was a "hot" item in rural hamlets.

In recent years East Indian films have been a major influence on
music. In addition to borrowing Indian dances and dance rhythms,
young people sing East Indian songs, and for some, musicians compose
lyrics in Hausa. Why do the Hausa like these films? Informants stated
they were attracted by the good music and dancing. The answer would
seem to lie in cultural compatibility. East Indian rhythms, like those
of West Africa, are outstandingly complex. Many kinds of percussion
instruments are used to produce intricately intertwined polyrhythms.
Most Westerners are in their infancy insofar as their level of apprecia-
tion of such rhythms, but the average Hausa can listen to a drumming
composition with the same pleasure we derive from listening to per-
formances where the melodic line is stressed. They note subtle dif-
ferences in drumming that escape the Western trained ear; for ex-
ample, they remember the rhythms they have heard in the films and
when a local drummer borrows them they can immediately identify
them. How many Westerners remember rhythms they have heard in
films?

But theirs is not slavish imitation. First, the elements are selectively
borrowed and then reworked, utilizing local instruments, styles, and
techniques. The emergent forms are not a simple mixture of East
Indian and Hausa elements, but a unique and creative amalgam.

Though the foreign influence is considerable in this music, the ma-
jority of the songs, rhythms, and dances are of local derivation. They
too, however, reflect change, *e.g.*, the soldier (*soja*) dance and rhythm,
or the *goge* tunes which incorporate fragments of the Nigerian army
bugle calls. *Goge* rhythms and songs are also created for a new and
exceedingly popular dance form (*rawan banjo*) which has developed
with the growth of modern political parties in northern Nigeria.

The Hausa single out certain *goge* or *kalangu* players as outstanding
performers, it seems, because they borrow and rework foreign and

domestic music in a creative manner. Some of them are improvising virtuosi and are recognized as such by their Hausa audiences.

As a nonspecialist I won't attempt to describe this virtuosity in technical terms. I offer the following observations and impressions for their possible worth. Both the *goge* "violin" and the *kalangu-'dan-kar'bi-kuntuku* combination of drums are versatile instruments which permit the talented and creative musician to improvise in a wide range of sounds and rhythms. I have heard the best known and best liked *goge* player in the north, Audu Yaron Goge, playing for the *rawan banjo* dance teams of the NPC and NEPU, the leading political parties at that time. He kept his performance exciting and interesting. As a veteran listener to Western jazz and classical chamber music, I was impressed with his ability to improvise endless variations on any tune, and at the same time, to produce a variety of unusual tones and percussive effects. The nearest parallel to the Hausa fiddle music in Western music are the "hot violins" of Joe Venuti and Eddy South, who played with American hot jazz ensembles in the nineteen twenties and thirties.

There were many *kalangu* drummers in Zaria City and its environs, but only one or two were famous and much sought after to play for the young people's dances. In time, comparing their performances with others, even my alien ear could discern individuality and authority in their playing. Improvisation as well as technical skill was an important part of their appeal and, as stated above, this combination of drums permits an almost endless variation of percussive effects as well as of tonal changes.

As with contemporary rock and roll musicians, sex appeal also has a good deal to do with the popularity of these musicians among Hausa girls. Some elderly *kalangu* drummers explained that they gave up drumming for the girls because they no longer had their youthful good looks and consequently the girls would not come out to listen to them. One volunteered this opinion, "The girls do not want their drummers to be ugly and scrawny like an old bull." Some older *goge* and *kalangu* drummers also mentioned that they can't play for the young people because they can't play the popular new tunes and rhythms.

Professional Values and Attitudes

The notion of producing art for the love of it is notable for its absence in the outlook of the majority of Hausa musicians; rather they have a

commercial attitude, or perhaps more correctly, a craftsman's mentality. Their music is viewed purely and simply as the means for earning their bread. Most informants indicated that they would not play for their own pleasure if they shifted to another occupation and some asked, "What would be the use of it?" Eighty-five per cent of a sample of 28 urban and rural professional musicians stressed that earning a living was their primary reason for playing music.

As I have stated above, "artist" musicians are conscious of, and proud of their originality and inventiveness, and their virtuosity is recognized and rewarded. Though it is difficult to judge whether their primary motivation is desire for money or pride, I judge that the former is paramount. Ordinary musicians are not original or inventive and they freely admit it, giving no indication they are ashamed of it, though they often have a high opinion of their own technical skill and are lively competitors for audiences and gifts. They rely a great deal on magic for success.

Western notions having to do with the proprietorship of music have little or no application to the Hausa. Hausa musicians borrow freely and imitate each other without ever giving a thought to payment or permission. Informants stated that the only real limit to imitation is skill.

The Training of the Musician

The status of most musicians is inherited patrilineally and ascribed at birth. Musical ability is thought to be inherited from the father, though occasionally it is said to come from the mother through her milk. Hausa acknowledge that some fail to inherit musical talent altogether and consequently have to take up another occupation. Three quarters of a sample of 60 musicians of all types received formal training before becoming professionals.[12] Formal training may be defined here as conscious instruction, involving demonstration by the teacher and observation and correction of the learner.

About half of the musicians interviewed were educated by close kin, most often by their father. The child is given conscious instruction, though the pattern of instruction varies somewhat with the type of instrument to be played. The following pattern can be considered typical. A father who is a drummer gives his small boy a toy drum—often improvised from a small calabash and a bit of membrane. Formal instruction with a regular instrument may commence as early as 7 to

10 years of age. The child is told how to hold the instrument and his hands are positioned properly. He is told to observe his father demonstrate how to manipulate it and then he is told to imitate him as closely as possible. If the child makes a mistake, he is beaten or harshly rebuked. This insistence on exact imitation and severe punishment for mistakes may explain, in part at least, the dearth of creative artists. (Moreover, many naturally talented persons may not become musicians because they did not inherit this occupational status at birth and their reluctance to enter the profession because of its low rank.) The novice practices in the home for a year or two before he attempts to play in public, and then if he is considered expert enough, he is allowed to play with his father's group. Boys are usually allowed to play only a certain kind of instrument at first; however, they are allowed to graduate to another instrument when they are deemed old enough and sufficiently expert in playing it. This, of course, means that the training of the musician often continues intermittently from childhood through early adulthood, and sometimes even beyond .

This process often entails learning a host of songs, and with some exceptions, learning the genealogies of clients in order to eulogize them properly. (Professional praise shouters, close companions of the musicians, must pay even more attention to the family pedigrees.) Along with his musical training, the child is also taught how to behave respectfully toward actual and potential customers in the community (see "Social Visibility" below).

As stated above, about as many musicians were trained by nonkinsmen as by kinsmen. Some received instruction from both, turning to nonkinsmen later in life for specialized training when desirous of learning to play a new kind of music. The eldest son not infrequently fails to receive instruction from his father due to the custom of avoidance and feeling of shame between parents and their first born, in particular. An instance was also recorded of an affectionate father who refused to instruct his son because he wished to avoid punishing him in the manner expected of a Hausa teacher. Of course, those who did not inherit the occupation account for a large part of those who were not trained by kinsmen.

Another form of training is apprenticeship to nonkinsmen. Apprenticeship involves no verbal or written contract between the apprentice or his parents and the musician. While learning, the apprentice not infrequently lives with his master, who feeds and clothes him. As soon as he becomes expert enough, the apprentice plays in his

master's band and may receive a small share of its earnings. At first he plays the type of instrument given to young musicians, although he starts to learn the master's instrument whenever possible. The apprentice is expected to go on errands, do odd jobs around the house, and work on his master's farm if he has one. After leaving his master, he may return from time to time to pay his respects, and perhaps to give a gift, though payment for the training, other than the work he does while an apprentice, is not compulsory.

Social Visibility and Social Distance

Much of the behavior of musicians is peculiar to them and predictable. A way of approaching this subject is to describe some of the ways the musician is socially visible in Hausa society.

There are two badges of their status: the obvious one of the musical instrument on the person of the musician, and the nature of his dress. The musician often wears gowns made of brightly colored and richly patterned cloth. The items of clothing seldom match since they have been received as payment from different clients and patrons.

The musicians' manner of greeting patrons and potential patrons and, generally, persons of higher status is revealing. First of all, they are expected to go to the homes of their patrons to greet them, since Hausa generally expect persons of lower rank to visit them (rather than vice versa) as a token of respect. They squat down on their haunches (*durk'usa*) before these persons and as an additional token of respect, they initiate the greetings with more pious blessings than usual. Non-musicians do the *durk'usa* too—e.g., junior kin before senior kin—but I observed that they ordinarily do not squat so low or so often, especially to nonkin. Some of the older musicians even make a point of soiling their gown on the bare ground while squatting.

When attending a wedding or a naming ceremony musicians can be seen outside the entrance hut and compound walls where only young men and beggars sit, rather than inside where most of the guests are. Musical performances are held outside the entrance hut, except for those of professional female musicians which may be held in the inner courtyard where the wives reside. When visiting their clients upon a nonceremonial occasion, musicians do not ordinarily sit in the outer or inner hut with the master of the house and his friends. Though they may enter to greet him, they remain squatting near the doorway rather than joining the others on the mats spread on the floor.

Social distance or the lack of social acceptance can also be seen in the refusal of many nonmusicians to eat out of the same bowl with a musician or to lodge in the same dwelling with him.[13] There is even a stronger feeling about marrying musicians. Most, according to a survey made among more than 300 nonmusicians of varying occupations, would also refuse to permit their daughters to marry a musician.[14] In actual fact, however, musicians cannot be considered an endogamous group since their life histories indicate that they frequently marry the daughters of nonmusicians—though these are often persons of low social status, such as butchers. Musicians stated repeatedly that marriage between musicians and members of the aristocracy are unheard of. I did, however, record one instance of a daughter of a district head marrying a musician.

Nonmusicians among the Hausa allege that musicians have weak characters, though rural folk are generally less critical of them than city dwellers. A majority of 201 persons interviewed stated that musicians are lazy, sly, dishonest, adulterous, and servile.

Socio-Economic Status and Rank

Since I have written of status in many contexts above, the following will be in the nature of a summary. First of all, it is evident that ascribed status as a musician is far more common than achieved status. Two hundred and two out of a sample of 257 Hausa professional musicians of all classes inherited their occupation. Of those defined as artists, a notable exception is the famous singer, Shata, whose father was a trader and a city-dwelling Fulani. However, a considerable minority of lesser known musicians who were studied fell into the achieved status category—particularly the musician-entertainers and other musicians of the lowest rank.

The collective term for professional instrumentalists, singers and acclamators is *marok'a* (Ames and King 1971:62;132), which may be translated as persons who acclaim others for payment. *Marok'a* is a derogatory term. Acclamation dominates most of the music performed by professionals, and patrons are bombarded with words of praise, which are often simultaneously sung, shouted and simulated on musical instruments. Nonmusicians consider such acts debasing and refer to *marok'a* disparagingly.

The position of the musician in Hausa society poses two striking paradoxes: 1) though they have very low rank, they are functionally

important; 2) their economic position is often higher than their social rank—in fact, certain famous musicians enjoy a very high standard of living.

The professional musicians are very persistent and clever. Some are feared because of their reputation for using innuendo in song to abuse a parsimonious customer, though they must exercise caution lest they be taken to court. They have been viewed as "pests"—so much so that a series of ordinances were passed throughout Hausaland in the nineteen fifties, designed to restrict their activities and to lessen their numbers.

In general, though the Hausa like music, they do not respect the persons who produce it. Even famous musicians are not socially respected, though they may be admired for their artistry, and like the Emir's musicians, may be somewhat less obsequious than ordinary musicians.

Social rank (*daraja*) means much to the Hausa and acts as an important guide in everyday social intercourse. Musicians readily rank themselves low compared to most other Hausa, though this is not to say that they are all satisfied with their place. Court musicians tend to rank themselves higher than ordinary musicians.

Nonmusicians ordinarily assign a much lower rank to musicians than musicians do to themselves. For example, in a sample of 54 musicians, 57 per cent considered themselves as lower in rank than housebuilders, 33 per cent as lower than butchers, and 20 per cent as lower than barbers. However, in an urban sample of 118 nonmusicians, 90 per cent considered musicians as lower in rank than housebuilders, 76 per cent as lower than butchers, and 92 per cent as lower than barbers.

One hundred and fifty persons in Zaria City of varying age, sex, and occupation were asked to assign low, middle, or high rank to 15 kinds of musicians as well as to most of the other occupational groups. A majority of the respondents assigned a low rank to each kind of musician (see Table V below). Court musicians and farm drummers were ranked somewhat higher than the others, and this seems to be a reflection of the exceptionally high rank of their patrons, since the ruling aristocracy, Koranic scholars, and farmers, respectively, had the highest rank of all, with wealthy merchants being a close fourth. Most of the musicians, however, are clearly near the bottom of the social scale. Only thieves, men who deal with feces in their work, praise shouters, strong-man magicians, female impersonators, professional gamblers, *rawan kashewa* dancers, and pimps are rated as low or lower than 67 per cent of the musicians (Nos. 6–15 in Table V). The farm

drummers and the court musicians were ranked just a notch above other musicians on about the level of the following lowly occupations: hunters, porters, herb medicine vendors, servants, and calabash-menders. Butchers are generally known to have low rank among the Hausa (Smith 1959:248), but the court musicians and the farm drummers were ranked below even them.

TABLE V

PERCENTAGE OF NONMUSICIANS ASSIGNING A LOW RANK TO DIFFERENT TYPES OF MUSICIANS

PER CENT	TYPE
55–59	1. Emir's horn-blowers
	2. Emir's drummers
60–69	3. Drummers for farmers
70–79	4. Special praise singers, for the Emir, who praise in the Fulani language (*Bamba'dawa*)
	5. Players of small one-stringed fiddle (*kukuma*)
80–89	6. *Kalangu* drummers for girls
	7. Three-stringed lute (*molo*) players
	8. Players of large two-stringed lute (*komo*) for hunters
	9. *Mai-sarewa*, a professional flute player
	10. Players of large one-stringed fiddle (*goge*)
90–100	11. *Karen Marok'a*, the musicians of the musicians and praise shouters
	12. *'Dan Kama*, a musician-entertainer
	13. Players of a very small lute (*kuntigi*)
	14. *'Dan Gambara*, a musician-entertainer
	15. Player of a small two-stringed lute (*garaya*) for the *bori* cult

There is social mobility among Hausa musicians. Some leave the profession for one of higher rank (and perhaps higher pay). Children of musicians may refuse to take instruction, rejecting their ascribed status. A considerable minority have achieved the status of a musician through their own efforts, but "achieved" is ambiguous since, in most cases, the mobility is downward in rank.

In another paper (Ames 1967), I have shown that negative attitudes toward certain kinds of music and the low rank the musician holds can be explained in large part by the impact of Islam, especially the iconoclasm of Shehu Usuman 'Dan Fodio and his Fulani followers.

Functions of Music

The functions of many kinds of Hausa music have been noted above and summarized elsewhere (Ames 1969), and so the discussion here can be confined to the famous singers and the *kalangu* drummers.

1. FAMOUS SINGERS

Entertainment is their most obvious function. Somewhat paradoxically, the common people find the songs entertaining despite the fact that so many are devoted to praising rich and powerful persons, particularly the ruling aristocracy. The persons praised, of course, find pleasure in hearing themselves praised; in fact, it is the singers' intention to make them so overcome with pride that they give handsome and generous gifts to the praiser. The musicians have a word for this technique, *zuga*, which means to blow up fire with bellows as in a smithy. And, indeed, the "fired-up" targets of such praise have given musicians, impulsively, hundreds of pound-sterling notes, a horse, or even an automobile.

Generally, praise-singing and praise-shouting are a principal means of reiterating certain values basic to Hausa social structure. The songs praise the man's ancestry, wealth, high office, magnanimity, piety, generosity, fame, and even bravery in battle—though this last is an anachronism. References are made to the fear and awe that the nobleman inspires in others, and to sundry prestigeful activities such as an audience with the Queen of England or a trip to England or Mecca.

These songs, of course, specifically help to sustain and justify the high status of the nobility and wealthy merchants, and indirectly, the whole structure of social relations. Both the musicians and their patrons reaffirm their status by publicly acting out their separate roles: the former not only by singing praise songs, but by begging and otherwise debasing themselves; and the latter by encouraging these performances and giving the musicians the handsome gifts which are expected of them.

In effect, this eulogizing in song is often addressed as much to the office a man holds as to his person. This is particularly true of the traditional praise words (*taken sarauta*) which are simulated on the horns and drums by the court musicians and sometimes sung or shouted. When a succession of individuals hold the same office, the only alterations necessary are in the kind of praise (*kirarai*) which involves a recitation of the office holder's family pedigree. M. G. Smith

(1957:41) makes this point in his analysis of the eulogizing and "begging" (*rok'o*) of Hausa praise shouters and musicians.

> . . . the most elaborate developments of *roko* are associated with the highest levels of power and authority, and that periodic ceremonials reassert the relation between the nobility and the values of the social structure. In this respect it is utterly irrelevant whether the official addressed is a reprobate or a saint, a tyrant or an honest administrator; *roko* is directed towards structural values as such, not at individual character.

Praise songs, as noted above, were written for some of the leading politicians of the Northern Region, notably the Premier who, like most of them, was a member of the aristocracy. These songs were frequently heard over the radio (many Hausa have transistor radios, even in the villages) any time of the year and apart from election campaigns. There is no doubt they served to enhance the personal prestige of the politicians and consolidated their power. The Premier's contention that he was a "natural ruler of the land" was supported by frequent references to his direct descent from Usuman 'Dan Fodio.

2. KALANGU DRUMMING FOR GIRLS' DANCING

This music has an obvious recreational function: it is an inseparable part of the complex of dancing by Hausa girls which is done chiefly for pleasure. However, it has some other less obvious functions. Probably the most important are flirtation, courtship, and the selection of mates, since most of the spectators at these dances are young unmarried men. Not only do the young men and girls have a chance to view and compare potential mates or lovers, but the young men are provided with an accepted means of indicating to a girl their interest. A young man calls one of the professional praise shouters to his side and tells him to announce that he is donating such and such sum of money for a certain girl to come out and dance. The more he gives in her name the stronger the gesture. The money ends up in the pockets of the musicians and praise shouters, but the important thing is that the girl is pleased and made proud by this public declaration of interest in her, and both of them gain some prestige from the action. If another suitor is present, he may try to outbid his rival and the praise shouters often skillfully play one off against the other.

A more formal expression of this pattern called *kwanta* is associated with a young people's play called *kalangkuwa* which is organized by the drummers about once a year. In a *kwanta* which means "untied," the girls sit in a special place until their boy friends or kinfolk "untie"

them by giving a gift in their name to the praise shouter and musicians.

Another dimension of this complex is the playing of a special personal rhythm or phrase (*taken samari* or *taken yan mata*) on the *kalangu* for one of the girls or one of the young men in the audience (Ames, Gregersen and Neugebauer 1971). The young man requests the musicians to play either his girl friend's *take* or his own. The drummer simulates on his hourglass pressure drum the tone and word stress of the *take*-phrase as it is spoken in the Hausa language, and the praise shouter or one of the boy apprentice *kuntuku* drummers chants the words for all to hear.

These *take* are not only a kind of personal badge or identification but a socially approved mechanism by which a young person can state publicly something he wishes to say about himself or others. The content and function of these *take* are too varied to be described adequately here, but it is interesting to note that some of them, though by no means all, are devoted to self-praise: a young man boasting of sexual prowess, or a girl boasting of fine clothes. The *take* of a young man often simply links his name with that of a girl. Other *take* obliquely abuse rivals in love or obstructionist parents.

Merriam (in this volume) indicates that a professional musician among the Bala always plays in situations deemed important by the society. As we have seen among the Hausa, different kinds of professional musicians play in a wide variety of social situations, ranging from drummers who play just for boys' wrestling and foot boxing to those who specialize in praising the emir. So one cannot say that professionals among the Hausa play only for socially important events or only for those which have a specially significant social function. Nevertheless, musicians do have a major role in the drama of Hausa society despite their low social rank, and this is yet another statement of paradox in the position of the musician in Hausa society.

NOTES

1. The study was commenced late in August of 1963 and was terminated in the middle of December, 1964. This paper developed during a sociological investigation of the profession of musicians among the Hausa of Zaria Emirate in the Northern Region of Nigeria. A brief survey was also made of the court musicians of the Emirs of Kano, Katsina, and Abuja. The writer gratefully acknowledges the financial assistance of the Joint Committee of African Studies of the Social Science Research Council and the American Council of Learned Societies which made

this study possible. I wish to thank Professor Michael J. Smith, Professor Robert Thompson, and Mr. David Insley Ames for their cogent comments on an earlier draft of this paper.

A phonemic note is necessary. Throughout this paper whenever "d," "b," or "k" are used with apostrophes in Hausa words, they stand for the following kinds of glottalized stops; bilabial ('b); alveolar ('d); and velar (k').

2. Today a modern provincial governmental structure, representing the government of the Northern Region, is superimposed over the traditional emirate system. For an excellent detailed description and analysis of the political structure past and present, see M. G. Smith's *Government in Zazzau,* 1960.

3. Occasionally one hears the word drummers (*maka'da*) used to refer to a crowd of musicians which may include horn-blowers, singers, and the players of stringed instruments as well as drummers.

4. Other instruments (*e.g.*, the small stringed fiddle, *kukuma,* and the large drum beaten for farmers, *gangan noma*) are sometimes used by musicians other than those of the court to accompany songs in praise of the aristocracy. However, they cannot be reckoned as symbols of status like those listed in Table II since they are not used exclusively for the aristocracy.

5. The *tambura* can be possessed only by the Emir and the heads of several semi-autonomous vassal chiefdoms. Permission is given for them to be beaten for two high officials, the *Madaki* and the *Galadima,* at the time of their installation.

6. There are other less common musicians of this class, *e.g., mai-tallabe, mai-kuntigi* and *mai-jitar* or *karen Gusau.*

7. The Emir of Kano has a *zabiya* among his palace musicians and former Emirs of Zaria have had them.

8. The other instruments played are the *molo,* which is like a *garaya* but has three strings, and the *goge* fiddle. Unlike the *garaya,* they are often used for secular music.

9. See page 148.

10. See A. H. M. Kirk-Greene's "The Walls of Zaria," *Craft Horizons* XXII, 1962, pp. 20–27.

11. A. V. King (1965) has demonstrated that most of the praise-songs for the aristocracy in the Katsina Emirate are traditional survivals from the 19th century.

12. Much higher percentages were recorded for the most numerous types of musicians, *e.g.,* drummers for farmers, drummers for the youth, and court musicians.

13. In a sample of 299 persons, 42 per cent refused to eat with musicians, and 41 per cent refused to lodge with them. About as many refused to eat or lodge with other lowly occupations such as calabash menders, herb medicine vendors, weavers, and hunters.

14. In an urban sample of 162 persons, 68 per cent refused to allow their daughters to marry musicians. In a rural sample of 153 persons, 54 per cent indicated they would not allow their daughters to marry musicians.

James H. Vaughan, Jr.

əŋKYAGU AS ARTISTS IN
MARGHI SOCIETY

ALTHOUGH we have learned much about the distinctive iron-working customs in most African societies and notable area patterns, the social role of blacksmiths in African society has been inadequately studied. This may be attributable to reactions against an older anthropology which made the study of material culture its hallmark. The relative sterility of that approach and the fruitfulness of a more behavioral orientation is not denied. However, it is unfortunate that the reaction against studies of material culture seems to have extended to the social behavior of smiths, for their social distinctiveness is found almost continent-wide.

The definitive study of metals in Africa by Walter Cline was published in 1937, and it is surprising and regrettable that no one has re-examined the topic in the light of recent data. I except from this injunction a few Europeans who nevertheless have somewhat different interests (*cf.* Cerulli 1956; 1957 and Clément 1948). Cline's monograph is a careful, unpretentious study of the distribution of techniques and customs concerning the production and use of metals in Subsaharan Africa. The conclusions are modest, and he explicitly refrains from a prolonged discussion of origins, although he offers some "speculations" in the last chapter. The study may be illustrative of the best in comparative studies of material culture. Unfortunately, as Cline seemed to foresee in his introduction, it is also illustrative of the last of those studies, although Professor Herskovits requested a revival and updating of such studies in the Lugard Memorial Lecture in 1959.

Inattention to the iron-working complex leaves us with no systematic framework within which to discuss so distinctive a category of persons as smiths. Furthermore, it encourages explanations of this distinctiveness which have never been rigorously examined. The two explanations most frequently offered are based upon history and psy-

chology. The first, which at least falls within the purview of anthropology, suggests that iron workers represent a tradition historically differentiated from the remainder of the society. This thesis has never been systematically investigated because of the scarcity or ambiguity of the evidence. Cline doubts the hypothesis, and if we grant that the iron-working complex is more than 2,000 years old in Nigeria (Fagan 1965:114), it seems curious that such distinctions should still persist without clear evidence of migration. However, I will return to the presumed historical differentiation of smiths among the Marghi.

A more obscure hypothesis enjoys popularity among "grand theorists" and some professionals interested in religion. It accounts for the distinctiveness of iron workers throughout the world through the "mysterious" quality of metals. This position, also challenged by Cline (1937:140), has been elaborately discussed by Mircea Eliade in *The Forge and the Crucible* (a translation of *Forgerons et Alchimistes*). He clearly states his conviction in the book's foreword:

But what the smelter, smith and alchemist have in common is that all three lay claim to a particular magicoreligious experience in their relations with matter; this experience is their monopoly and its secret is transmitted through the initiatory rites of their trades. All three work on a Matter which they hold to be at once alive and sacred, and in their labors they pursue the transformation of matter, its perfection and transmutation (1962:8–9).

This is, of course, an extremely difficult hypothesis to prove, and Eliade most certainly has not done so for Africa. Nevertheless, a part of this explanation may be relevant to considerations of the aesthetic aspects of iron working, and I shall return to it.

Blacksmithing as a profession has rarely been considered as artistry, although iron has long been recognized as a medium of artistic creation. Two obstacles are at once apparent; first, the nature of the blacksmith's products, and second, the manner of his recruitment. Because blacksmiths are almost wholly involved in the production of utilitarian objects, they are denied the position of artist in some traditions of Western society. Their status is that of craftsmen or artisans. In Africa, we are confronted with a second difficulty, for blacksmiths there usually constitute a class of persons whose positions are ascribed by cultural traditions. This is contrasted with the conventional idea of the artist as an achieved status. These criteria need to be re-evaluated by aestheticians, and vague assumptions about blacksmiths as a class need to be investigated by ethnographers.

In the following presentation I will consider the əŋkyagu caste who

are the smiths in Marghi society, describe the production of iron, and discuss the əŋkyagu as an artist. The data herein were collected in 1959 and 1960 while I resided at Kirŋu in the Marghi kingdom of Gulagu.[1] I was not primarily interested in aesthetics and did not investigate Marghi smiths with this particularly in mind. I had not realized how important əŋkyagu were in Marghi society until I arrived in the field, although fortunately the importance was congenial to my personal interests and experience. (I worked in a foundry for a time, my father once worked as a blacksmith, and my wife's father runs a small machine shop and forge.)

There was only one family of əŋkyagu at Kirŋu, but there was a very large settlement at Ghumbili about a mile away. Some of my better informants were əŋkyagu. This at first worried me lest my Marghi friends think me only interested in exotic behavior, but my concern was unfounded, for Marghi are themselves very curious about əŋkyagu, though their reserve keeps them from satisfying that curiosity.

Marghi Concept of Art

Since the Marghi have no concept homologous to art, let me make some comments about what I mean by the term and how I think it is applicable to the study of culture. Anthropologists have long held that art is universal in human society, though their definitions of the term have frequently been ambiguous or inadequate. When it is said that art is universal, I take this to mean that in all societies there are culturally selected artifacts—*behavioral* as well as material—which evoke certain evaluative responses qualitatively similar from society to society and which can, generally, be called aesthetic.

This is quite similar to the definition offered by the aesthetician Joseph Margolis: "A work of art is an artifact considered with respect to its design" (Margolis 1965:44). The definition is consistent with anthropological usage and superior to most definitions offered by anthropologists, especially in the context of Margolis' general discussion of definitions of art. Particularly relevant for anthropologists is his underscoring of the problem in a definition which is inherently evaluative. Definitions which depend upon "skill," "competence," "beauty," or similar concepts will confuse, in one degree or another, the distinctions between good and bad art with the distinctions between art and nonart. For example, masks as a class of cultural artifacts may be art within Margolis' value-neutral definition without regard to whether they are skillfully or incompetently made; the latter considerations distinguish between qualities of masks.

It is the response to an artifact which indicates to the culturally naive that it is art. To Margolis this behavior consists of considering with respect to design, but this should be expanded. It is a response wherein a subject views an artifact critically with respect to attributes perceived to be intrinsic to it. The criticism need not be necessarily formal nor even conscious. Rarely does an individual decide to use his critical judgment, rather this type of response is elicited because of the nature or setting of the artifact. This kind of behavior is what I shall call an aesthetic response.[2] It is unfortunate for cross-cultural studies of art that we have focused more attention upon the artifact than upon the response to it, for this emphasis does not explain why strikingly different artifacts in different societies often evoke similar responses. Also our cultural predisposition makes us reluctant to classify tools, for example, as pieces of art, because we find it difficult to realize that an iron implement may call forth a response which is primarily aesthetic.

It should also be recognized that Margolis' definition is a dynamic one which depends upon behavior, i.e., considering. But it fails—deliberately I believe—to raise the issue of the dual nature of considering. Art is communicative and involves both the artist and his critics or in more general terms his audience. Presumably there is enough agreement so that the audience sees the product of the artist as a work of art. (At this level we are not considering how the work, once it has been classified as art, is judged.) It is important, however, to realize that occasionally these two positions do not agree. I will argue below that a certain distance between artist and audience is common and perhaps necessary, but here I am referring to a divergence in kind rather than degree.

There are two instances in which this type of disagreement is likely to occur. In the first we have what might be called subcultural specialization of artistic tastes, usually related to a relatively distinct differentiation of artists within the society. This is illustrated by our own society with its subculture of the arts. The second instance of diverging values of artist and audience occurs in artistic innovation—not merely artistic creativity, but the creating of new concepts of art, as when new techniques, subjects, media, or uses of art are introduced into the society. This second case may occur under the circumstances of the artistic subculture, but it need not, and has clearly occurred in all societies at various times. The social distinctiveness of castes presents certain analogs with the first instance. However, in most cases, including the caste discussed in this paper, the distinctiveness of the group is *not* primarily related to aesthetic values, and they are actually

more integrated into the society from this point of view than are many artists of Western society.

The əŋkyagu in Marghi Society

The Marghi are one of the pagan tribes which inhabit that part of the highlands of Northern Nigeria which was formerly Northern Cameroons. The customs considered in this paper were observed among the mountain Marghi (*Margyi Dzirŋu*) bordering the Republic of Cameroun. These are the least acculturated Marghi, and their traditions of iron working are the most distinctive. They are also the only Marghi who today smelt iron ore. In the rest of the area iron and steel, indirectly imported from Europe, have apparently supplanted the indigenous product. It is possible that the Marghi *Dzirŋu* were the only smelters of iron, providing iron for the less mountainous kingdoms to the west, but this is uncertain. However, əŋkyagu in the latter areas have always done their own smithing.

The society of the Marghi *Dzirŋu* is divided into four major hereditary social categories. Three are agamous and the fourth endogamous. Every kingdom has a ruling clan which, however, is usually different from kingdom to kingdom. Consequently, the royalty of one kingdom may only be a commoner clan in another. Commoners (*talaka*) and royalty are distinguished from one another solely by the dynastic ties of the latter, and, except for the heirs and potential heirs to the throne and persons very close to the king, there is little significance to the distinction. The main body of the society are the *talaka*, who represent many clans and live scattered in villages and hamlets in the mountains and valleys of the kingdoms. Both royalty and *talaka* are farmers who sell their surpluses and buy luxuries in weekly markets.

The other two categories are quite different from these, and different from each other as well. The *mafa* are hereditary bond servants, frequently servants of the king. In the past, *mafa* were created as legal punishment, as a consequence of warfare, and occasionally as pawns or tribute between kingdoms. Although the status continues, *mafa* are no longer recruited. They are a small class, though somewhat more numerous in the royal village. I knew three families of *mafa*; the origins of two were remote and unknown while the third had been traded for food some 60 or 70 years ago. *Mafa* are not restricted in whom they may marry, and their daughters are likely to be wives of any Marghi. Although there is a tendency to regard *mafa* as slaves,

the term frequently connotes an invidious status not characteristic of Marghi *mafa*. *Mafa* have few indentured obligations and they may own farms. With diligence they can acquire wealth, prestige, and power.

The final class in Marghi society is the əŋkyagu, commonly translated as blacksmiths.[3] əŋkyagu are composed of agamous clans, but as a group they are endogamous—both men and women. əŋkyagu are the only Marghi craft specialists who by tradition do not farm. One sometimes hears jests about a person who is not farming, "as though he is an əŋkyagu." (Once an əŋkyagu made the same jest toward me.) Male əŋkyagu do blacksmithing, are undertakers, do leatherwork including the traditional garments of all men and women, do the body scarification characteristic of Marghi women, and are reputed to be the society's best musicians. Females of the caste are called *kwiŋkyagu*, and they are the society's potters and help their husbands in leathercraft. In general any specialty is likely to be attributed to əŋkyagu, including diviner (*malaga*) and medicine man (*pitipitima*).

Within Marghi society, əŋkyagu are not referred to as "Marghi," a term which is reserved for non-əŋkyagu. Certain relations between əŋkyagu and Marghi are strictly regulated. They never eat or drink together; at beer markets əŋkyagu must bring their own drinking vessels and no Marghi will drink their beer. əŋkyagu reputedly eat such foods as snakes, lizards, and monkeys, which no Marghi would think of eating. In large groups əŋkyagu tend to associate with one another and remain apart from Marghi. In general, Marghi regard əŋkyagu with considerable awe and some seem to fear them. Despite the constraint in Marghi-əŋkyagu relations, it seems inappropriate to refer to əŋkyagu as a despised caste. I feel some discomfort at even considering that they are of lower caste. The emphasis of the relationship is upon difference rather than upon superiority or inferiority. An example might illustrate this attitude. On one occasion a male əŋkyagu about 25 years old, closely followed by a young girl of about 14, walked past a group of Marghi men. During the exchange of greetings it was discovered that the girl was his wife. This caused many incredulous comments, for Marghi rarely take a wife permanently until she is 17 or 18. One Marghi concluded, "Those əŋkyagu are truly different people."

These social patterns are those a casual observer is likely to note, and Marghi readily recognize them. However, in some instances there are noticeable variations in this pattern. When Marghi and əŋkyagu are neighbors, there is a good deal of normal social intercourse, though the dietary and marriage prohibitions are never disregarded. In fact,

one Marghi informant who was quite friendly with an əŋkyagu family
had so frequently observed the process that he was very nearly an
expert on smithing. On several occasions I saw him operating the
smith's bellows and once he helped hammer some iron into a bar,
which is the stock form of iron. Though this is very unusual, it is ap-
parent that notions about əŋkyagu as a social category do not preclude
the development of less ritualized relations. Similarly, some of the
notions about the specialties of əŋkyagu are not borne out in practice.
Although they are always prominently mentioned as musicians, I
found only one professional musician who was an əŋkyagu. Diviners
and medicine men also proved to be only occasionally əŋkyagu. It
seems that the category əŋkyagu has the connotation of specialist, and
əŋkyagu are suggested for any specialized role, although these roles
are not actually reserved for the caste.

The Caste and Political Structure

Perhaps the most fascinating social facet of the əŋkyagu caste is its
tie with Marghi political organization. In the histories of the establish-
ment of several of the kingdoms of the Marghi *Dzirŋu* there are
legendary ties between the royal clan and the əŋkyagu. The founding
ancestor of the kingdom of Gulagu was befriended by əŋkyagu, and,
using their arrows (əŋkyagu arrows are different from Marghi arrows),
he killed many hyrax. When he shared his kill with his Marghi neigh-
bors, they were so impressed with his generosity and skill that they
made him their leader. In another instance a founding ancestor was
given an old *kwiŋkyagu* to cook for him. When she conceived, the
father was recognized as a person of unusual powers and was made
their leader. These stories are used to explain why many *Dzirŋu* kings
are required to marry a *kwiŋkyagu* in apparent violation of the marital
prohibition.

 In these kingdoms the installation of a king is a complex ceremony
lasting several days and showing considerable local variation, but a
consistent feature of each ceremony is the role of the əŋkyagu. A group
of əŋkyagu elders from Sukur—the oldest kingdom—are feted for sev-
eral days, after which they shave the new king's head leaving only a
single lock of hair, the symbol of royalty. They receive gifts of meat to
take back to their homes. Although əŋkyagu have nothing to do with
the selection of a given king, it is generally said the əŋkyagu "make"
the king.

 The king is assisted by a council composed of a clan elder from each

of the oldest clans in the kingdom (Vaughan 1964:1083), a *mafa*, and at least in Gulagu, the head of the kingdom's əŋkyagu as an *ex officio* member. These councils have virtually no power today, but I was able to question all members, and each could still explain what his traditional duties had been. Although there seems to have been no responsibilities for the əŋkyagu apart from being the king's private smith and undertaker, he received—and still receives—gifts of meat from the king at all major religious ceremonies. He, of course, may be thought of as representing all the əŋkyagu of the kingdom. It is also interesting that he had more rights than responsibilities. His position is largely ceremonial but emphasizes the autonomy of the caste. Significantly, he has the title *ptil* (king), and except for the head of the kingdom, no other person may bear this title. *Ptil* əŋkyagu wears a royal hairlock and has a distinctive bracelet of iron which is symbolic of his office. The position is hereditary in the male line.

Finally, the əŋkyagu are related to the political organization in that the Marghi king is buried as though he were an əŋkyagu. Each Marghi clan has some distinctive burial customs, but none has customs common with the əŋkyagu who are buried in an upright position surrounded by charcoal. The Marghi king is also buried in this position, and like the *ptil* əŋkyagu, is buried seated on an iron stool. This affinity of king and əŋkyagu is known by all and, perhaps, imparts to the king some of the awe reserved for the caste and induces the populace also to behave with additional deference toward him.

Meek (1931:1,228n) briefly implied that the relationship between əŋkyagu and king could be explained by historical events. He wrote, "There are good reasons for believing that chieftainship was among many tribes introduced by immigrant blacksmiths." There seems to me little justification for this. If anything, it seems that the hierarchical kingdom of the Marghi is the innovation of the non-əŋkyagu. Furthermore, as we shall shortly discusss, Marghi know the process of smelting ore and it seems unlikely that they knew this but did not know smithing. The removal of the epidermis at the əŋkyagu burial of certain clans[4] does, however, emphasize what we already know to be characteristic of the Marghi: that they are composed of numerous clans with distinct historical traditions, and that some əŋkyagu clans claim southern rather than eastern origins, as do most Marghi clans.

We are confronted here with a common dilemma in seeking explanations of cultural phenomena. It would be preferable to give an historical account for the peculiarity of əŋkyagu in Marghi society, but we simply do not have adequate evidence. We must then rely upon a

functional explanation for which we do have pertinent evidence. It is apparent that Marghi and əŋkyagu have achieved a symbiotic relationship which helps to integrate the society. The fact that the one smelts ore while the other works the iron is itself indicative of cooperative differentiation. The integration of Marghi and əŋkyagu is obviously economically advantageous. Marghi need the specialties of the əŋkyagu, and əŋkyagu, in order to achieve requisite skills, need liberation from subsistence activities.

There is an additional need for a show of societal unity arising from the divine kingship which is characteristic of these kingdoms. The Marghi king is symbolic of his kingdom; he *is* the kingdom, and his many ties with the əŋkyagu emphasize this. The relation between king and əŋkyagu as manifest in the saying, "Only the king and əŋkyagu do not farm," is made more meaningful; it is an acknowledgment of the unity of king and kingdom, made necessary by the social disparity of əŋkyagu.

Of course, it cannot be said that because Marghi society has these requirements, they developed this symbiotic relationship. A functional explanation does not account for origins. However, it can be seen that this institutional arrangement satisfies cultural requirements and does so with apparent efficiency.

The impact of Western culture has not been felt among the Marghi in a manner comparable to the rest of Africa, and this perhaps accounts for the effectiveness of the relationship between the Marghi and əŋkyagu. The importation of stock iron has already been mentioned, but this has not affected the blacksmithing profession. Importation of products is still largely at the level of luxury items, and most products of əŋkyagu have not suffered from competition. Hoes, knives, spears, pottery, and leather goods are all still in demand. However, one may foresee that either direct competition from mass-produced products or the creation of new demands may alter the əŋkyagu's role in the local economy.

It is already apparent that population size may make the old relationships unrealistic. There are more əŋkyagu today than are needed in most kingdoms. As a consequence many əŋkyagu must farm and neglect their craft specialties. This condition is either of recent origin or has not seriously challenged the existing order. But we may suspect that the continued existence of əŋkyagu who do not conform to the norms of the caste will eventually lead to the dissolution of caste distinctions. For example, I encountered one woman whose clan name was the same as that of an əŋkyagu clan. She was defensive about this. When I had the opportunity of mentioning the similarity of the

clan names to the local king, he privately admitted that they may well have once constituted the same clan. The fact that clans have masculine and feminine names probably obscures the relationship; since clans generally go by their masculine name, the clan name of a kwiŋkyagu may not be recognized as such.

Iron Production

SMELTING[5]

Iron working occurs in two distinct phases: the smelting of the iron ore, and the fabrication of the metal. The first process is rare in tribal societies today, and it is only in the remote areas that one still finds it. The village in which I lived stopped doing its own smelting about 1955, but ten miles further into the mountains smelting could still be observed.

Obtaining iron ore is not a problem for the Marghi. Unlike the inhabitants of the Jos Plateau where apparently the ore had to be extracted from its rock matrix, the Marghi have ready access to abundant supplies of magnetite. Magnetite is so plentifully distributed in the soil of the mountain valleys that after a rain it literally stands out in every path and gully. This magnetite looks, to the layman, like iron filings, consisting of tiny linear particles of black lustrous iron.

Because the iron is heavier than the soil, rain washes the soil away leaving collections of the black magnetite easily visible at the bottom of any depression. While it is still damp and before it has worked back into the soil, it can be collected like a mud ball, and with further washing, completely separated from the earth. Although some valleys are known as particularly good reservoirs of iron, it can be collected almost everywhere. (My yard was full of it, and photographs taken after rains reveal the characteristic black streak in all paths.)

This ore, called əfizawa, is collected and placed in large pots for storage. As we have already seen, the collection of əfizawa and the smelting may be done by any Marghi. It is not—and apparently never has been—the prerogative of the əŋkyagu caste. When a man lives close to the source, the əfizawa is stored in his compound. However, where Marghi live on mountain tops—unless the top forms a plateau (as at Sukur and Ghumbili)—there are a few places at which əfizawa can be collected. Consequently, it is gotten in the valleys and stored in caches at the bases of the mountains. These storage points are shared by all the men of a village. Before the əfizawa is converted to yəŋ— the solid metallic state—it is washed once again.

The smelting complex (hya) is usually located within a short dis-

tance of the *əfizawa* storage. Each family—more properly each compound head—has its own furnace, and even though sons might use their father's *hya*, there are many smelting furnaces for each village. While mapping a valley not more than a mile long, over two dozen furnaces were found. None were any longer in use, and it was difficult to tell how many had been used at any one time. But it seems unlikely that there have ever been more than fifty compounds in the immediate vicinity. At places where several hearths converged, the ground was literally covered with ash, cinders, slag, and broken tuyères.

All *hya* which I saw were built into the side of a hill or mountain. This creates a natural wall on one side, and an upper level about three feet above the floor of the *hya* is made into the side of the hill. A clay furnace is built into the wall; the furnace (*ku; hu*) is about three feet high or as high as the wall. One side of the furnace, ogivoid in shape, protrudes from the wall. There are two openings; a circular hole about eight inches in diameter at the top and a larger arched opening at the bottom measuring 18 to 24 inches across the base and about the same dimension vertically. The rims of both of these openings are decorated. The structure is surmounted by a wall of dried mud which shields the upper level from the heat and smoke rising from the furnace. Furnaces suffer from the ravages of heat and rains and must be rebuilt each year.

The bellows operator sits on the upper level behind the wall almost directly over the furnace. The body of the bellows (*bubuti*) consists of two clay pots, about ten inches in diameter, from each of which extends a pipe (*minjagho*) approximately ten inches long. These parts are enclosed in a dried clay matrix. The tops of the bellows are loose goat skin with small wooden handles in the centers. The *minjagho* meet at the mouth of the tuyère (*dzvu*) which extends vertically into the furnace. Since the two *minjagho* serve as air intakes as well as exhausts for the bellows, they are not integral with the tuyère. The length of tuyères varies with the height of furnaces; they are, however, generally five to six inches in diameter along the body with a two to three inch opening. The upper end of the tuyère is funnel-shaped so as to direct the air exhausted from the bellows into the furnace. There are, occasionally, incised lines around this end of the pipe. The bellows and tuyère of the *hya* are identical with those used by smiths in working iron. Marghi consider the *dzvu* to be particularly symbolic of əŋkyagu.

The remainder of the *hya* is a working area enclosed by a low rock wall. Near the center is a columnar pedestal (*dugar*) on which the *əfizawa* and instruments may be placed. (Some deserted *hya* do not

An *aŋkyagu* family at work. Milǝmasha (center) works on the scabbard of the *jaŋgum* described in the text (pp. 180–81). His brother, Ijesǝbu, beats a *jaŋgum* to sharpen it; in the background two of his sons work on a leather *dzar*. One of his wives holds a new basket drinking vessel to the right. The three pots in the background contain his divining paraphernalia.

seem to have had these.) There is also a water pot sunken into the floor of the *hya* and a small cache (*thlədim*) for the smelted iron (*əptiryəŋ*). The only other items regularly used in the smelting process are a paddle (*garaku*) used in charging the furnace, a pick (*cul*) for removing charcoal from the iron, and sticks for removing the iron from the furnace.

əfizawa is only smelted during the second month of the Marghi year which coincides with the beginning of the rainy season. Not surprisingly, this is also the time of year for making hoes (*məntsu*), by far the most common iron product. On the first day of smelting the owner of the *hya* will have prepared a mild sorghum beer called *psu*, which is often used ritually, and a chicken will be sacrificed so as to allow its blood to flow on the furnace (cf. Gardi 1956:facing 140). The chicken is cooked, and the meal is eaten by all those who will be working at the *hya*. If it is necessary to seek the help of someone with a superior knowledge of smelting, it may be necessary to kill a goat in order to have a worthy feast. During smelting the workers wear the traditional ram skin loin garment (*pizhi*). In the past this was the normal dress of males, but as a rule today it is worn only on ceremonial occasions or during heavy labor.

The furnace is charged with charcoal and wood kindling. When the fire is laid, the lower opening in the furnace is blocked with old tuyères. The fire is then started with tinder and stoked through the upper hole, called the "mouth of the furnace" (*myahu; mjahu*). As the bellows operator forces air into the furnace, additional charges of charcoal are placed in the top. During this operation the *əfizawa* is on the pedestal. As the fire approaches the heat requisite for smelting—a point judged by how long the fire has been burning and the "way it looks"—the *əfizawa* is kept on the floor of the *hya* to the right of the furnace. From here it is scooped with the paddle and put into the furnace. Charcoal and *əfizawa* are put into the furnace alternately seven times. A much greater amount of charcoal is included in each charge than *əfizawa*.

The amount of iron which can be smelted is limited by the heat generated in the furnace. The heat is never sufficient to produce molten iron, rather it produces a "spongy bloom." The hottest part of the furnace is around the tuyère and it is here that the *əfizawa*, having filtered through the burning charcoal, collects as a bloom. Too much *əfizawa* would exceed the heating capacity of the furnace and be wasted.

The iron, while it is in the furnace, is in a pasty state and bits of

charcoal get into it or adhere to it. The bellows are operated after the last charge is placed in the furnace to insure that all the əfizawa is melted at the bottom of the furnace. Sassoon reports that the smelting is complete in 40–60 minutes (1964:176); however, I found that with the making of the fire and the removal of the iron the time was much nearer to 90–120 minutes. He also reports an informant's estimate that he could produce nine cores (blooms) in a day (p. 178). I would point out that this would be an extremely hard pace and would undoubtedly require several bellows operators. To remove the yəŋ—and it is now conceived of as iron—the tuyères blocking the bottom opening of the furnace are removed and water thrown on the fire. Long sticks are used to clear out the ash and expose the bloom which is then picked up on a forked stick and dropped into the pot of water. After it has cooled, it is taken from the water and the external charcoal impurities removed with a pick. The bloom resembles a sponge, hemispheric in shape measuring about seven inches across. This əptirəŋ is the crude iron of the Marghi. It may be stored for a time in the cache of the hya but eventually it will find its way to an əŋkyagu who alone may smith iron.

SMITHING

The smithing of iron is the most complex specialty of Marghi technology. Some of the equipment is identical to that used in smelting, but whereas the smelting process is largely a routine process, in smithing the skill of the smith is crucial. The smith is, of course, an əŋkyagu. The smithy—pthla—(mpthla according to Hoffman 1963:31) consists basically of a bellows and tuyère and a stone anvil. The bellows of the pthla, although identical to that previously described, is not usually called bubuti but rather kərpthla which means head of the pthla. It is usually located up a gentle slope from the fire with the tuyère (dzvu) extending down between two stones which hold it in place and which form a wall for the fire. The fire, rather small in size, is of charcoal and made in a depression surrounded with stones at the mouth of the tuyère. A large flat anvil stone lies in the floor of the pthla near the fire, and occasionally there is an upright stone which can also be used as an anvil. The entire pthla frequently is surrounded by small stones which delineate its perimeter and it may be covered by mats on sticks which shield the smith from the sun. Pthla used during the rainy season are of the same basic structure but are covered by large conical thatched roofs.[6]

The tools of the smith are primarily but two: an all-purpose hammer (mvəl), and a pair of tongs (məgatsu). The mvəl is quite similar to the

Bukoba hammer pictured in Cline (1937:90). One end is blunt and cylindrical, the other tapered and rectangular in cross section. The *mvəl* is not hafted and can be used in a number of ways. Holding it from either end, the sides strike the metal in a club-like fashion. The cylindrical end is used for rough shaping and the rectangular for flattening metal. The *mvəl* may also be held in the middle of the metal, or struck with one end. The pointed end creates maximum force, though in a small area only. When a smooth, truly hard anvil is needed, the *mvəl* is struck into the ground and the blunt cylindrical end provides the surface. In such cases the hammering is done by a more conventional hafted hammer. Whereas the tuyère seems to be a particularly symbolic relic of the *pthla* from the viewpoint of a nonsmith, to the smith the *mvəl* is the symbol of his life. They are highly prized and I found that I could not buy even a damaged *mvəl*. One Marghi whom I knew made a loan to a smith taking his *mvəl* as collateral; it was a safe loan.

It will perhaps be useful for illustrative purposes if we take a bloom of iron, smelted by a Marghi, and follow it through typical steps leading to the fabrication of a hoe. When the smelting period is concluded, the blooms are carried to a smith who will agree to forge (*bdlu*) them into iron bars (*dəbəl*); it takes about two to make a bar. The smith will require payment in money, food, or a portion of the iron. The bloom is heated at the *pthla* and beaten into shape. This process separates the charcoal impurities from the metal. The bar formed is approximately 13 inches long, three-quarters of an inch wide, and three-sixteenths of an inch in thickness. Each end is flattened and fanned-out. Formerly, these bars were the most honored media of exchange among Marghi. In some areas they were the sole acceptable bridewealth, and in Sukur they are still occasionally so used. The value of *dəbəl* is not easily converted to money. Government records from the nineteen thirties indicate that they were worth about 3 shillings each; however, they seem to be worth much less today. At Sukur bridewealth consists of more than 300 bars.

The owner of the iron will take his bars home for future use, either as a medium of exchange or as raw material for needed tools. When he wants a hoe he must again approach a smith and negotiate a fee. He may stay at the *pthla* if the smith is prepared to work that day, but more likely he will leave his bars and return for the finished product. Smiths like to have enough work to justify making or collecting charcoal and arranging for a bellows operator.

When the hoe is to be made the bar is heated and slowly pounded

to shape. Because the fire is small and the area of heat restricted, the smith works from one end, shaping as he moves up the bar. As the heat gets closer to the smith's hand he will handle the iron with tongs. The bar is usually folded over in making a hoe so that it forms a more compact mass. If there is difficulty in getting one piece of iron to fuse with another, a mud flux is used. The blade of the hoe is circular and thin but the hafting part is heavier and thicker. The hafting socket is shaped like a hollow cone with an open section in the side. Into this the handle is forced. This manner of hafting is typical of Marghi implements as opposed to some nearby tribes who haft by inserting a tang into the handle. The smith can provide handles for hoes but does not normally do so. A hoe can be fabricated in an hour and one-half, but the time varies considerably with the condition of the original iron. Incidentally, a hoe rarely lasts longer than one year.

Products of əŋkyagu

The smith makes a wide variety of products. The following are items which I collected or which I observed being made: hoes, knives, sickles, axes, small adzes, arrow points, tweezers, needles, razors, spears, throwing-knives, bells, chains, tobacco pipes, beads, bracelets and other jewelry, and "medicines." Most of these are common items of material culture and can be made by any smith. However, some are prestige items which are infrequently made and which are likely to be produced only by the most skillful of smiths. Throwing-knives (*miŋa*), a variety of arm-dagger (*jangum*), and spears (*masu*) fall in this category. I want to discuss the construction of the *miŋa* and the *jangum*, because I believe it may give some insight into the work of the blacksmith and its appreciation by Marghi.

Lagercrantz's diffusionist study of throwing-knives hypothesizes that, "It is . . . within the area of distribution of the f-shaped group (of throwing-knives) that we must seek the place of origin . . . ," and he later adds, "It is . . . from the region south of Lake Chad that the knife has spread" (1950:204–5). This conclusion is borne out by Marghi ethnography, for they are about 150 miles south of Lake Chad and have a throwing-knife—the *danisku*—which is "f" shaped. This is probably the oldest form of Marghi throwing-knife and is today reserved for ceremonial use only. *Danisku* seem to symbolize the masculine weapon *par excellence* and are carried by boys going through their initiation and again when they take their first wife (Vaughan 1960). The throwing-knife most commonly seen in a secular context is the

miŋa kər. It is shaped like the *danisku* except that a large flat blade
projects upward from the top of the "f" and the upper tip of the "f"
curves up like a hook. The *miŋa kər* is usually carried on the shoulder
and incites considerable admiration.

It is interesting as an aside to this discussion that Marghi do not
throw their "throwing-knives." They are hand weapons. It is doubtful
that they were used in organized warfare, which was conducted largely
with spear and shield. Barth observed "danisko" in 1851 and called
them "handbills" (1857:II, 111 & 214), which undoubtedly referred
to the old English weapon or its derivative, a type of pruning-hook.

Not many *miŋa kər* are seen today and when I asked my friend
Miləmaska, who was the *ptil əŋkyagu*, to make me one, I learned that
he had never made one himself and only remembered assisting his
father as a boy. Nevertheless, he agreed and set a date for the work.
On that day he had borrowed an old *miŋa kər* on which to model mine.
He used strap steel as his stock iron. Because of the length of the *miŋa
kər* (26 inches), he frequently had to join another piece of strap steel
to the product. Each time he coated the pieces of hot iron with mud
and they fused suitably. Technically, the most difficult part is the join-
ing of the central spike to the main shaft. A piece of iron about two
inches in length was first fused to the shaft—rather like a spur—and in
the crotch so formed, the spike was situated. The mud flux was then
added and the three pieces fused together. It should be clear that by
fusing I do not mean that they are melted, rather they are forged
together.

The most interesting part of the fabrication from an artistic view-
point was watching Miləmasha decide upon the appropriate shape of
the weapon. Although he had another as a model, he did not slavishly
copy it; rather he took proportions from it. Miləmasha would hold the
model up and look at its curves, measure them with the span of his
hand, and then do the same with his product. His only explanation
was that he wanted it to be "good." The one he was making was some-
what longer over-all than the model and the final proportions actually
differed. The most noticeable differences are that Miləmasha's product
is larger above the spike; its spike is perfectly straight rather than hav-
ing a slight downward curve, and the handle has less of a reverse curve.
It is apparent that the over-all conformation is set by tradition, but
that the smith is allowed enough latitude to show his own virtuosity.

The story of Miləmasha's *miŋa kər* has an interesting conclusion.
His *miŋa kər* was in fact not a good one. His modification in propor-
tions, I believe, was primarily a consequence of his attempt to make a

A piece of iron is beaten to form a charm. The iron strap in the foreground is of European manufacture.

Milemasha working on the *jangum* described in the text. The leather is being placed in the handle.

bigger weapon. It was difficult to know how he felt about his own product since the Marghi always deprecate themselves and their achievements. However before I had gotten the weapon to my compound it had been viewed with marked indifference by a person I met on the trail. He stated that the old *miŋa kər* were the good ones, but I am sure that the antiquity of anything is of little relevance to its appreciation by Marghi. I did not find anyone else who could state specific differences between this *miŋa kər* and others that I bought. They merely praised the others and ignored the new one. The observable difference seemed to be in the proportions which generally give the "good" *miŋa kər* a wider and more balanced appearance. The failure of Miləmasha's work to meet with approval was not because he was an inferior smith for he was acknowledged as the best smith of the kingdom. He confirmed this praise when he manufactured the most admired product I ever saw among the Marghi, an arm-dagger.

There are three types of knives in common used by Marghi: the *wamala*, a knife used by women for cutting food and burning designs in gourds, the *kikya* (or *kyigha*) which is a man's knife usually worn about the waist, and the *jangum*, a large knife carried in a sheath which hangs from the wrist or forearm. An important man will wear the *jangum*. When discussing a *jangum* one is inevitably told that in the old days one *jangum* was equivalent to one slave. *Kikya*, which are the most common knives, are about 15 inches long, their blades undecorated, and their wooden hilts covered with black leather. Sheaths are made of flat wood covered in black leather; the chape is broad and blunt. The sheath covering is embossed lightly with designs composed of parallel lines. A new *kikya* can be bought for about 3 shillings 6 pence.

In contrast, the *jangum* made by Miləmasha was 20 inches long. The blade is decorated down its midrib with opposed hatched triangles and intermittent arcs and with grooves parallel to its edges. The designs are cold-stamped into the metal. Though blade decorations may vary, the hilt of a *jangum* is quite distinctive. Each has a heavy iron core covered with woven leather strips, surmounted by a decorative iron pommel. The pommel is usually a half disc, but on Miləmasha's *jangum* it is more elaborate. The main shaft of iron extends from the grip and is capped with a solid cone. Extending down from the cone, on either side of the shaft and close against it, are two strips of iron, each ending in a spiral. The hilt is of woven black and red leather

strips. The scabbard is equally elaborate and covered in part by crocodile skin, a typical feature of the best *jangum*. Designs are woven into the crocodile skin with red and black leather. The chape is teardrop shaped and also covered with crocodile skin. The arm ring is also of red and black leather, and from it hang plaited leather strands and fringe. It sold for 20 shillings and could have brought more.

Miləmasha's *jangum* is different from others in that it is longer and the pommel and sheath are more elaborate. Perhaps the most outstanding quality of it is its feel. The pommel on a *jangum* acts as a counterpoise and for this reason these knives have better balance than *kikya*. On this particular *jangum* the longer blade and heavier pommel combine to give a balance that is remarkable in a weapon so long. This weapon was admired whenever it was seen. Total strangers would stop to see it and ask to heft it; given the reserve of Marghi, this is an unusual compliment. It is difficult to tell whether this special admiration for Miləmasha's weapon was due to the prestige inherent in a *jangum*, and the Marghi's traditional interest in weapons, or to the qualities of this particular *jangum*. But by comparing reaction to it with that to other *jangum* and weapons, it seems clear that this instrument was appreciated for its own excellence.

Two other products made by Miləmasha may shed some light upon his talents. I obtained a fine pipe scraper from an old man in a distant kingdom with the intention of giving it to a friend. When I lost it, I tried to get Miləmasha to make me a new one. He had never seen one and was unenthusiastic about my description. His product was distinctly inferior, meeting my minimum requirements, but little more. He did not really understand what he was making and was uninterested in it. On another occasion I requested him to make me a needle-tweezers (*mthlkamtu*), an instrument carried by women. He knew what one was and had doubtless made several, but what he made surprised me. It was indeed a needle at one end and a tweezers at the other, but in between, the metal had been flattened into a double edge blade. The instrument was perhaps twice as long as the women's *mthlkamtu* and, of course, more useful. This was an innovation, a new tool. The motivation behind it is unclear. The most obvious motive was Miləmasha's desire to please his customer and show his talent, but there was also an implication that a man should have something more than a woman's tool. In this innovation there was creativity, to be sure, and Miləmasha was acknowledged to be clever. But the new instrument was regarded as a utilitarian curiosity, not a work of art.

Nonmetal Products

əŋkyagu, of course, do many other things besides blacksmithing. Two
of these activities give insights into Marghi notions of goodness. The
ram skin loin garment, or *pizhi*, worn by men is a product that may
show significant variation. The basic garment is the full skin of a ram
trimmed in a stylized fashion. The əŋkyagu tans the skin, fits it to its
owner, and trims it. However, some *pizhi* are more elaborate than
others. They may have an incised design around the back and down
the buttocks pointing to the ram's penis. Additionally, the tail of the
ram which hangs at the small of the wearer's back is embossed and
tufts of hair left on it although the skin is otherwise clean. These
characteristics are indicative of a good *pizhi*. Ordinary *pizhi* are only
trimmed. To an extent a good *pizhi* is dependent upon the owner's
ability to pay an extra premium, but primarily the embellishments
indicate that the *pizhi* belongs to an important man. Such a *pizhi*
on an undistinguished person would be inappropriate. The qualities
of the *pizhi* become virtually inseparable from characteristics of its
owner and may be modified. The evaluation of the product is prac-
tically inseparable from knowledge of its owner and, of course, related
to the abilities of its maker.

Kwiŋkyagu are the potters for the Marghi. The clay is collected and
kept wet with a solution of water, pulverized bark, and root. Pots
(əntəm) are modeled with a small hand pestle (*ndati*). A basal mold
(əghwa) is the surface against which the clay is pressed. The əghwa is
a cross-section of a tree trunk about 15 inches long and 10 inches in
diameter with a concaved end. Kwiŋkyagu use these as stools, and
there is a style of stool occasionally seen in Marghi compounds which
is called əghwa. The əghwa has only a slight depression in it so that the
clay is rotated after each blow of the *ndati*. In this manner a spherical
body is formed around the potter's hand. She works from the inside,
as it were, in making the body of the pot. The bases are joined to fluted
collars. The upper parts of the pots are rubbed smooth with a string of
seeds soaked in water. This leaves a slightly scratched design at the
top of the pot and a slip on the upper half. They are fired in a pit, and
cool to a dark brick red. Firing may cause breakage, particularly where
the collar joins the body. Should it rain on the hot pots they break.
For this reason, and because the firing is done with dried grass, pots
are not made in the rainy season.

A skilled potter, using an apprentice, can make and market as many
as 20 pots in a week—and the process is thought of as a week's work.

The outstanding qualities of some Marghi pots are so well known that middlemen buy them and resell them in Maiduguri more than 100 miles away. A good pot has a distinctive metallic ring when it is tapped. Pots are sold to wholesalers for 6 pence who then sell them in Maiduguri for 3 shillings. *Kwiŋkyagu* sell their pots locally in the weekly market for about 1 shilling 6 pence.

There are many different shapes and sizes of pots but the manufacture is generally the same. Characteristically the pots used as religious shrines (*i'iwa*) are not well made because they are not used as pots. The criterion of use is of very great importance in pottery; pots are valued for their utility not their appearance. Although a *kwiŋkyagu* may recognize her own pots, or those of a neighbor, Marghi cannot, and consider the point irrelevant.

Becoming an əŋkyagu

Since əŋkyagu are born into their caste, the question of role recruitment is somewhat simplified. On the other hand, the specialties of an əŋkyagu are many, and he must achieve a notable technical competence. This knowledge is accumulated through years of observation and apprenticeship. One of a boy's first tasks is operating the bellows; later he will sharpen knives (by beating) and do other cold-metal tasks and eventually take short spells at the forge, heating iron and making smaller utilitarian objects, usually for immediate sale. There is very little overt instruction in this process. The father will likely be in charge of all work until the youth establishes his own forge or becomes much older. He will tell his son what to do and when to do it. A Marghi father's authority is absolute and the interaction between a father and son is usually direct and blunt with a clear maintenance of superiority and subservience. If a youth makes a mistake or does a bad job, he is likely to be dismissed and possibly censured, though open criticism is a severe and unusual act among Marghi. Often young men are more capable and willing to do more difficult work than their fathers will permit them. A typical working group of əŋkyagu might consist of two brothers with one or two sons of either. The eldest brother would be clearly the master, but the younger brother would be free to carry out his own tasks provided they could be coordinated with the total work. The sons would be likely to do tasks specified by either of the fathers.

Leatherwork, which requires less skill, is done by young men before they are allowed to use the forge independently. Occasionally, girls

may assist in leatherwork, particularly when someone is needed to hold the leather.

Management of funerals requires little specialized knowledge but is handsomely rewarded; a goat is usually given the əŋkyagu assisting at a funeral who is likely to be a compound head.

The apprenticeship of girls is strikingly different from that of boys, but nonetheless it follows the general pattern of relations in strongly patriarchical and patrilineal families. In Marghi families the mother is an unambiguous figure of affection; consequently, a mother and her children are close and friendly. A kwiŋkyagu mother gently helps and encourages her daughter in making pots. Girls, at about the age of 12, begin in earnest to make their own pots from the mud collected by their families. Their mothers encourage them though they do not assist them. Very frequently, when these pots are set out to dry, they crack. One may see the consequences of a girl's work in the privacy of an əŋkyagu compound. However, the dignity of the Marghi is such that one does not comment upon their irregular shapes nor joke about their failures. The girls destroy their products and try again another week. Mothers comment benignly about the efforts of their daughters without a trace of censure.

It is perhaps a common failing of sociological analysis to assume that role assignment in a caste system is synonymous with role achievement. One might assume that the societal assignment of əŋkyagu makes a person all of the kinds of craftsmen mentioned above; Marghi believe it to be so. However, the society has a surplus of smiths, and we may add that not all kwiŋkyagu make pots. In short, not all əŋkyagu are craftsmen though most have some knowledge of the crafts. Rather it is those persons within the əŋkyagu caste who are sufficiently motivated and skilled who become the society's artisans. There are the conventional opportunities for individual skill to be recognized and channeled into the profession. Not surprisingly, however, the best craftsmen are usually the eldest sons of men skilled in the same craft.

Marghi Aesthetics

Let us briefly survey the traditional typologies of the arts in Marghi culture. Marghi live in an area of Africa which might be called art impoverished since they produce nothing comparable to the products of most of West Africa. The most exotic Marghi achievements are doubtless their rock paintings and rock gong music, which are a part of the men's initiation and betrothal ceremony of certain South

Marghi kingdoms and done at a specified time and place by all eligible males. Although the Nigerian Department of Antiquities considers these paintings to be art, the Marghi do not consider them to be aesthetic creations. I have commented on this elsewhere as follows: "No initiate approaches the act creatively; no one views them for their artistic qualities. Some are recognized as being more realistic than others and to that extent more skillful, but this is a fact totally irrelevant to the paintings as far as the Marghi are concerned. An analogy to a collection of signatures seems apt; some more legible than others, some done with an elaborate flourish, but all basically attesting to the presence of certain individuals upon a certain occasion" (Vaughan 1960:51).

Designs placed upon calabashes constitute the other conspicuous form of graphic art. The woman who owns the gourd usually burns the design in it. Occasionally the design is etched into the surface which is then rubbed with red ochre and oil, the etched parts finishing redder than the unetched. Designs are made on the outside of the calabash only and are, typically, concentric about a symmetrical geometrical design at the bottom. Unsymmetrical, nonconcentric designs appear at the upper rim and seem to run off at the edge. Quite frequently one or more of the concentric rings includes a representation of cowrie shells. Occasionally, women consciously imitate the designs of other tribes; the most popular is a geometric design which they call "Fulani." After the design is burned into the gourd, the calabash is rubbed with oil which heightens the yellow color of the unburned gourd.

Although calabashes are traditionally decorated, considerations of beauty are clearly secondary to utility. əncala mənagu, a good calabash, always refers to the utility of the gourd, not to its beauty. A circumlocution, "good to the eye" (mənagu anu li), must be used to express the latter idea. Yet obviously, it takes times and energy to decorate the gourd, and as noted, some women use designs peculiar to other tribes; so, it cannot be entirely a matter of utility. Decorating calabashes is a social event; women do it as they sit and gossip with their neighbors. Marghi like to do things together; they do not like to be alone, and in some instances it does not seem improbable that being together is more important than the task they seek to complete. I am suggesting here that the social context of decoration is as important as the decorated calabash. I do not mean to say, however, that the decoration is irrelevant, for clearly, Marghi recognize competence and appropriateness in design.

The only plastic arts are those few weapons produced by əŋkyagu

which we have already discussed. Marghi have no tradition of art carving such as masks, headdresses, or statuary. The only carved artifacts are stools, stirring sticks, pestles, mortars, and beds, and of these only stools have any decorative markings. These are occasionally scored with a hot knife but such markings are incidental to the value of a stool. Anyone with the requisite skill may make these items. Carvers are not full time specialists and are considered similar to petty merchants or butchers. There is a general notion that əŋkyagu are carvers, but I never found it to be the case. This idea undoubtedly stems from the fact that əŋkyagu do most of the specialized work in Marghi society.

Marghi do not readily perceive aesthetic qualities in objects but the performing arts of music, dance, and folklore are treated differently. Good dancers and, particularly, good singers are widely known and appreciated for their talents. əŋkyagu enjoy no special reputation as singers or dancers. Singing always accompanies social dancing, which is a principal medium of social intercourse for the unmarried. Dancing is done at night during full moon and following the larger weekly beer markets. The singers for social dancing are females, who are not paid for their services but who are flattered and cajoled into attending. A man's dance, called dzəgwədzəgwə, is an important event at feasts. This, too, incorporates singing and for very important events the lead singer, a male, may be paid for his services. At funerals both men and women may dance. The dances of women are distinctive funeral dances which are done to the accompaniment of drumming and the singing of men. When men dance at funerals they dance dzəgwədzəgwə; but it is done only at the funerals of the old, which are considered to be festive occasions. It is important to realize that Marghi do not dance (fəl) at a funeral, they cry (ti). If a drummer must be procured for any dance, he will be compensated, and traditionally the drummer would be an əŋkyagu.

I will only summarize here the conclusions previously reached in a discussion of Marghi folklore (Vaughan 1965). To Marghi it is not the tale, per se, which is appreciated but the telling of it. An individual has personal preferences in tales, of course, but generally a traditional tale is not evaluated so much as the performance of a story session. There are certain linguistic patterns which, while not conclusive, are indicative of this emphasis upon performance. There are two words which generally mean good: mənagu and misidagu. The latter has a more restricted use than the former and seems to apply to immaterial qualities such as taste and order. A folk tale, as a tale,

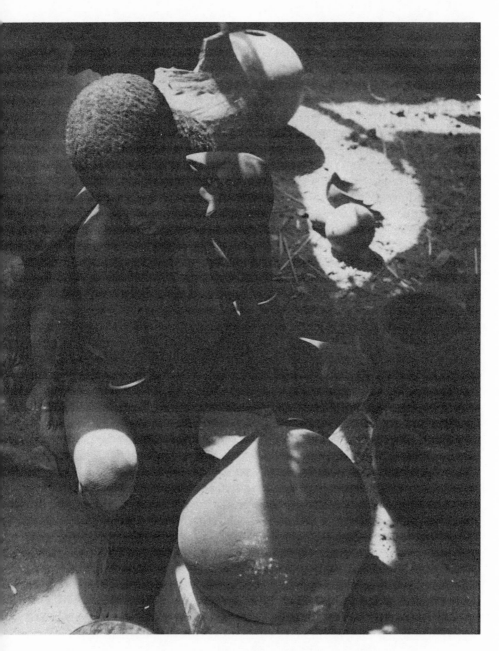

A *kwiŋkyagu* potter (see pp. 182–83). The fluted collars have not yet been added.

can only be *mənagu*, by which is meant that the tale has a quality of
goodness intrinsic in it; it is a proper tale, a tale which meets the
criteria of a Marghi story. However, the telling of it may be *misidagu*,
which is a description—even a judgment—of the performance of the
teller. On the other hand, although the tale is *mənagu*, it may be told
poorly and will be so recognized. The language seems to direct sub-
jective evaluation or appreciation toward performance. Although a
tale is not material it is treated almost as if it were.

Marghi can and do express opinion about performance but rarely
about a product. To say that a thing is good (*mənagu*) or bad (*dumi*)
is to speak of its objective aspects. To then question such judgments
would challenge the veracity or the perception of the observer and
this is considered a serious breach of etiquette. Granted the closeness
of Marghi communities, both in terms of kin relationships and their
emphasis upon continguity, such a challenge would be socially dis-
ruptive. On the other hand, in things which are called *misidagu*, there
is no objectivity implied; disagreement, without the implied challenge,
is then possible.

Now, let us consider how the work and products of *əŋkyagu* fit into
this aesthetic. There is no problem with respect to performance.
əŋkyagu musicians are judged like any others, with the possible excep-
tion that there may be a "halo effect" for *əŋkyagu*. In terms of per-
formance at the forge or in other technological performances, there are
few spectators and no Marghi is capable or apt to make any evaluation;
certainly the classification *misidagu* would be inappropriate. It has
been indicated that although Marghi appreciate products largely in
terms of utility, they do appreciate aesthetically certain products of
əŋkyagu, namely weapons.

There emerges from these materials a pattern of relations which may
be summarized in the following manner:

Marghi (non-*əŋkyagu*) create no material products which are pri-
 marily appreciated for other than practical reasons.
Marghi appreciate and evaluate taletelling and musical performances
 including playing, singing, and dancing.
Certain weapons which are manufactured by *əŋkyagu* are appreciated
 aesthetically.
əŋkyagu may be appreciated as musicians or taletellers (the latter is
 only hypothetically true since tale sessions are largely family and
 kin matters).

The rejection of Marghi products as *objets d'art* has already been
partially explained on grounds of their tendency to view products as

empirical, unchallengeable parts of reality. But we must ask why əŋkyagu products are exempt from this characterization. In part, this may be because əŋkyagu are not, in the vernacular, Marghi, and Marghi are not intimately involved with their products. A disagreement about the evaluation of a *miŋa kər*, for example, can always be explained by a lack of familiarity with the product and its production. Even the negative assessment of Miləmasha's *miŋa kər* only inferred poor workmanship and never made any commitment as to what was a good weapon. It was a judgment by consensus, a consensus which was never challenged. But this is only partially satisfactory for we may still ask why they are willing to make this aesthetic judgment on only some of the əŋkyagu's products and not on others. Here we can perhaps call forth the concept of cultural focus.

Marghi are very much involved with their political organization. The affairs of the kingdom and hamlet are major concerns of men; furthermore their loyalties are intense and bound to the political unit. Frequently political loyalties are stronger than clan loyalties. The traditional kingdoms were mutually hostile and warfare very common. Open conflict is a traditional method of social identity. Even today membership is frequently phrased metaphorically in terms of aggression. For example I was, on occasion, identified in terms of the village for which I would "fight." Fights between members of different villages or kingdoms are today quite common and the government views the Marghi, particularly the unacculturated mountain kingdoms, as a troublesome lot. With this orientation it is scarcely surprising that Marghi are interested in weapons. They are the material representation of the focus of their culture.

Conclusions

There are certain things about Marghi arts that may have little relevance for cross-cultural comparison. The categories of linguistic approbation which so nearly correspond to notions of objective and subjective goodness are perhaps a case in point. Their reluctance to talk of objective goodness is consistent with Marghi interpersonal behavior, which eschews direct expression in favor of circumlocution and deferential qualifications. This mode of behavior, which is surely crucial to understanding a Marghi definition of artistry may have little validity for other known cultures. There are, however, three points raised by this discussion of əŋkyagu in Marghi culture which are appropriate to broader studies of art and the artist.

There is first the matter of the recruitment of the artist. There was

a period when anthropologists paid little attention to how an individual became an artist. However, it would be unfortunate if we went so far in our pursuit of the psychology of individual creativity that we overlooked many equally important sociological factors. It would be fatuous to insist that because əŋkyagu are born into their caste they should not be considered artists. Admittedly, caste is probably the clearest case of role and status ascription known—apart from sex and age—but there are ascriptive features in *all* role fulfillment. The statement that a society provides persons to fill its roles hardly needs defense.

It would, however, be equally foolish to assume that because an individual occupies a certain status that he plays the role like every other occupant of that status. I am not arguing that all əŋkyagu are artists. Individual variations in opportunity and skill provide variation in role performance even though the caste system channels persons to the roles. The argument here is against either a rigid exclusion or inclusion of individuals into a social category. The evidence presented herein would indicate that some əŋkyagu are artists *because of* their ascriptive status, but that other əŋkyagu barely conform to the minimum standards of their caste.

A second conclusion from these materials is hardly more than a suggestion concerning the possible relationship between an artist and his society. The exclusiveness of the əŋkyagu caste and their presumed exotic behavior make them nearly unknown to most Marghi. The forge is a mystery to these people; they know nothing of the techniques of pottery making and they, of course, have no reason to discover more. The Marghi hold the products of the əŋkyagu in awe. Could this have an appreciable bearing upon their acceptance of some products of the forge as art? In many societies, artists are people apart, not of course necessarily outcasts or bizarre persons, but persons with a special gift, something which others do not and cannot have. In short these materials are suggestive of a relationship between artistic achievement and the social distinctiveness of its creator. This supports some of the statements of Bullough (1913) concerning the importance of distance in art, though in this instance the emphasis is more upon the distance between artist and audience than between the work of art and the audience.

This argument may seem to support the position of Eliade cited at the beginning of this chapter. However, I am not saying that blacksmiths are distinctive because of their mysterious abilities and knowledge, but that they *and* their technology are mysterious because they

are socially distinctive. Although Marghi do have some specific notions about supernatural powers of the tuyère, these notions are insignificant when compared to the variety of mystical ideas which they have about əŋkyagu. Most of these presumptions would be dispelled or ignored were it not for the rigidity of the caste system. Few əŋkyagu customs are any more exotic than some found among other Marghi clans; even the widely voiced belief that əŋkyagu eat unclean things like snakes and lizards is also true of the Mamza clan, one of the most prestigious of clans from the west. It is the caste system itself, whose origins we cannot now know, which accounts for the mystery associated with əŋkyagu. In this sense, there may be a difference between əŋkyagu as artists and more achievement-oriented artists in other societies, for əŋkyagu are by nature mysterious and believed to have unusual powers. More conventionally recruited artists may have to demonstrate their powers to a skeptical society or in some other way indicate their distinctiveness.

There is, again, some linguistic evidence which is interesting though far from conclusive. In discussing words and their meanings, we are, of course, confounded by trying to infer in one language what is meant in another. Hoffman gives one translation of the Marghi verb *nia* as "to create." *Nia* is a verbal derivative of *nu* which means "to mold" and is the only verb appropriate to the making of pottery. Possibly *nu* may only be used when speaking of the molding of clay (Hoffman 1963:127 and see comment in section 222, p. 128). Unfortunately, there are not enough samples of truly indigenous uses of *nia* to see if it encompasses all we mean by "create," but the pairing of the verbs "create" and "mold" and the close connection of the latter to əŋkyagu should be investigated further.

A final point emerging from the Marghi data has to do with the classification of the arts and their presumed interrelatedness. This paper has emphasized the creators of art by centering upon the əŋkyagu. But it seems that the Marghi do make important distinctions between the categories of "product" art and performance art. One is tempted to say that Marghi aesthetics are concerned largely with performance, though admittedly their appreciation of weapons does not conform to this. Merriam (1964:259–74) has raised the question of the interrelationship of the arts, and the Marghi seem to give evidence of a culture in which with few exceptions only one aspect of what *we* call art is viewed aesthetically.

Anthropologists are aware that artistic evaluations are culturally bound. Standards of beauty, goodness, and the like must be demon-

strated, not assumed. Students of art know that the standards of art are to be inferred only from the values of the society whose art is under consideration. But often they decide what will be considered as art (masks, statuary, folktales) before they go to the field. The Marghi materials emphasize that, quite apart from the evaluation of art, what *may be* art is culturally defined. I have made a similar point with reference to clan histories among Marghi which are not judged aesthetically; consequently I do not consider them as part of their folklore (Vaughan 1965). Marghi clearly do not consider rock paintings or calabash decorations fitting topics for artistic activity, while they do view weapons as products which are worthy of an aesthetic appreciation. Were this view carried far enough it could revolutionize our museums of primitive art and material culture. But more to the point it could seriously alter most of our studies of art in the non-literate societies.

This revives the plea for studies of societies not so well known for their art—societies like the Marghi. These societies may do some violence to our cultural-bound notions of art, but the sterility of much of the writings on art indicates that some violence might be welcomed.

NOTES

Linguistic Note: The best authority on the Marghi language is Hoffmann (1963); for reasons of simplicity I have adopted a modified spelling of Marghi words, omitting tonal indicators and the symbols for bilabial and alveolar implosives. The following symbols may need special explanation.

ə A central vowel of varying degrees of openness, similar to the English sounds leg*a*l and b*u*sh.

dl A voiced alveolar lateral.

gh A voiced velar fricative. But note that in the word Marghi this is *not* the case, as in this single instance I follow the spelling of Barth who used the h to harden the g.

ŋ A voiced velar nasal as in si*ng*er.

thl A voiceless alveolar lateral. Hoffman uses the symbol tl.

1. The field work upon which this article is based was made under a grant by the Ford Foundation for field work in 1959 and 1960.
2. It is apparent that this is only one type of behavior which might be stimulated and, for example, one might also react in terms of economic considerations. Any simple reaction will probably be rare, and most often several responses will merge.

3. Our interest here is primarily in aesthetic aspects of the əŋkyagu caste. A more conventional discussion of the caste as a social stratum of Marghi society can be found in Vaughan (1970:59–92).

4. While visiting in the kingdom of Dluku, I observed the funeral for a *ptil əŋkyagu*, a ceremony which provided an exception to the general similarity to royal funerals. In this instance the burial was on the third day following death, in contrast to the usual custom of burying on the day following the death. Just before the corpse was carried from the compound to its grave, the skin was removed from the arms, chest, and from a part of the face. This custom, which is not characteristic of all əŋkyagu clans, is also practiced by the Higi and Kilba (Meek 1931:I, 257–58 and 197–98) tribes immediately south of the Marghi. The king of Dluku is buried in the fashion of the smiths from Sukur, to the east, from which the royal clan migrated.

5. An excellent article on smelting at Sukur with photographs has been published by Hamo Sassoon (1964) which supplements this description. Sukur is a proto-Marghi community at which I observed smelting in 1960. They speak a dialect of Marghi, but there are important differences of vocabulary between Sassoon's and my description which I am unable to explain.

6. The symbolism of *dzvu* or tuyères is of particular interest. Although pottery is the exclusive province of *kwiŋkyagu, dzvu* are made by men. They are viewed with awe by non-əŋkyagu, and frequently, they are placed in fields to protect the crops from being stolen. The characteristic verbalization of the powers of the *dzvu* is that it will prevent women from stealing. If asked what will happen to women who violate the injunction, it is said that they will have difficulty in childbirth. While Marghi can see that a *dzvu* looks strikingly like a penis, none, apparently, sees any connection between this and the peculiar powers of *dzvu* over women.

James Fernandez

THE EXPOSITION AND IMPOSITION
OF ORDER: ARTISTIC EXPRESSION
IN FANG CULTURE

Culture is aesthetic preference drawn large

SINCE Ruth Benedict proposed to define culture as personality writ large we have come to a fuller appreciation of what confining stereotypes such dramatic generalities breed. The field of culture and personality studies which has since developed is at once more specific in concentration and empirically dynamic in orientation than is implied in such a statement. Research aimed at national character or modal personality may still have heuristic or pedagogic utility, but it is not a preoccupation which is any longer directly relevant in elucidating the behavioral process, insofar as the anthropological psychologist has anything to say about it.

The field of anthropological aesthetics, however, continues to flex its often inchoate insights into the relationship between two previously separated categories of our understanding. It may stand therefore as a useful challenge for us to phrase—as we have in the title—these insights in the form of a large presumption. The challenge is useful because there has tended to be an instrumental bias in the study of culture,[1] and the importance of expressive elements has been underrated. But culture is qualitative experience as much as it is a utilitarian bag of tools. Moreover, the set of aesthetic patterns carrying and expressing that experience, patterns often generalized as a style, may well "shed light upon the interior articulation of cultures" (Mills 1957:17), and the social relationships of the culture carriers.

For the purposes of this discussion an analytic distinction is made between culture and society. We follow the distinction first proposed by Parsons and later stressed by Kroeber and Parsons together:[2] society is a causal-functional system of interactions; culture is a logico-meaningful system of symbolic relationships. Culture and society are interpenetrating and reciprocating aspects of the same phenomenon, but it is still necessary to distinguish between activity and meaning.

194

The important distinction between the aesthetic and artistic[3] follows from the above in this way: both the aesthetic and the artistic mean qualitative experiences, but in the former, the emphasis is upon the appreciative perception of this kind of meaning, while in the latter, one refers to concrete activities—the creative production of objects or events which contain this meaning.

Leach (1954:37) has suggested the "intimate relationship between ethics and aesthetics" and proposed that certain kinds of art styles may well express ethical ideals current in the society as to the proper social relationships between man and man. But this may also be true of the relationship between man and nature. To put it differently, it would seem very possible that the values expressed in doctrines of right action envision or presume some particular kind of harmony in the universe —and thus, implicitly at least, are aesthetic statements on this broadest of scales. There is, in short, a pleasure in seeing quality in a person or manifesting it oneself; it is the pleasure of witnessing right action, an aesthetic or artistic pleasure as the case may be.

What this right action may have to do with harmony in the universe however may be obscure for those without anthropological experience. The difficulty arises because of our own pragmatic values which stress man over or against nature rather than man in nature. Very often, however, we find members of nonliterate societies extending their system of social relationships into nature itself, as Durkheim and later Radcliffe-Browne demonstrated in respect to totemism. By this or another projection "the universe as a whole is [becomes] a moral or social order governed not by what we call natural law but rather by what we must call moral or ritual law" (Radcliffe-Browne 1952:130). This point is important to our discussion.

It is also relevant to recall Victor Turner's distinction between repetitive and changing systems. In the former (the primary concern of anthropologists), the over-all cosmological order is brought through its lifegiving repetitions by means of ritual and right action. Laura Thompson (1945) has shown for the Hopi the degree to which all their activities are bound up with this perpetration of a logico-aesthetic universal order. In our own changing systems, though there may still be, as in Newtonian Mechanics or Spinozistic philosophy, an intellectual sense of cosmic order, there is no logico-aesthetic sense of the grand design—a total prevailing harmony of things which exerts a strong logico-aesthetic compulsion on the individual in favor of careful artistic idea and action. It is this universal harmonized order of repetitive systems that will arise in subsequent discussion.

Among the older Fang people of western Equatorial Africa, features of whose culture we examine here,[4] I did not find explicit obeisance to any kind of universal harmonious order out of which man must derive his most crucial definitions of self and situation. Those with strong roots in the precontact culture of the turn of the century (up to 1915) tend to take a pragmatic and particularistic view of disorder and conflict. Immediate solution is demanded so that tranquility and harmony (*mvwaa*) can be restored to village life, but there is not the awesome implication of universal order. I have elsewhere said:

> It must be pointed out that logico-aesthetic integration of a total culture, if not an impossibility, can only in any case be the consequence of "relentless concentration on the whole life process as an art." Thompson (1945) has argued that this exists among the Hopi. We do not find it among the Fang. They are too materialistic and opportunistic to be constantly preoccupied with living all of life out in an aesthetically satisfying manner. (Fernandez 1966b)

Nevertheless, there are elements in Fang belief of a dynamistic conception of the supernatural and a strong preoccupation with what I have translated as ritual sin (*nsem*):[5] that is, with transgressions which are understood as somehow a violation of the natural order of things. I think it valid to interpret Fang belief in these instances as implying, albeit implicitly, a universal order. Ritual life, however, was not very highly developed in traditional culture, probably because the Fang for at least a century were in the turmoil of a very rapid migration out of central Sudanic Africa. For this reason total universal order was not celebrated in the compelling and preoccupying manner which Thompson argues to be the case for the Hopi. Logico-aesthetic integration of the Fang universe was frequently implied, but never fully stated, in ritual, myth, or in the beliefs and values of everyday life.[6]

This point enables me to come to the substance of the argument in this paper. We intend to examine Fang artistry in terms of its exposition of order in, and imposition of order on the universe, both social and natural. Among Fang, at least, those who simply expose aesthetically pleasing harmonies for the delectation of their compatriots, while esteemed, are not highly respected and are of low rank.[7] On the other hand, those who impose harmony upon their compatriots, thereby enhancing the quality of Fang life, are greatly to be respected and are of high rank. For they have done the most difficult of all things. They have acted to make universal harmonies manifest in social life which is in its nature, as far as the Fang are concerned, ever disturbed and

endlessly gravitating to a state "nasty, brutish and mean." In the case of religious leaders this means the closer approximation of secular disorder to sacred order.

Artistic expression clearly takes place within a social and natural order to which it makes inevitable reference. For our purposes here we conceptualize this relationship in terms of the exposition and imposition of order. As it happens among the Fang, it is the plastic arts that merely expose while it is the oratorical arts (in social and political life) and the ritual-myth arts (in the religious life) which impose order. We have stated the substance of this argument in our own terms, but we shall see that it does not violate the facts of the aesthetic and the artistic in Fang culture, both in its traditional and its transitional form. The materials we examine will enable us not only to assess the status and role of the artists in relation to order in Fang life, but it will also enable us to suggest propositions about the relation of art to social and cultural integrations.

The Exposition of Order

CARVING

The Fang reliquary figures (*mwan bian, eyima bieri*) constitute a well known and often praised style of African plastic art. In contrast to the very high valuation set upon them in Europe and America,[8] the Fang only learned to value them over the years, probably in response to the voraciousness of European collectors. Tessman (1913) testifies to the ease with which they were acquired at the turn of the century in contrast to the inviolability of the ancestral skulls over which they posed. Due to the pressures of missionaries and government, the reliquaries were either broken up or dismantled. Whole craniums, or portions of them, fell into individual hands. As a consequence, a proportionately greater number of figures were elaborated by the Fang to accompany the now dispersed relics of the ancestors. Frequently, and possibly stimulated by a custom of the Loango, pieces of bones were actually worked into the trunks of the figures, greatly increasing their value in the eyes of the Fang. Therefore, in recent decades these figures have been much more difficult to acquire than formerly. In the last decade, production for any religious purpose has virtually ceased, even in Rio Muni where in contrast to Gabon, these figures, usually somewhat modernized, are still produced for interested colonials and other collectors. The brief discussion that follows describes the situation in which these figures were produced, the qualitative experiences

associated with them in the eyes of the Fang, and the position and role of the sculptors themselves.

The economy of the Fang was never well articulated. Though inter-village and long distance trade was present, it operated on a sporadic basis and there were no fixed markets. Iron-working was the closest approximation to a specialized trade and even iron-workers maintained farms and kept an eye to family subsistence. On the other hand, practically all mature men whiled away the long periods of debate and discussion in the men's council house (*aba*) at some craft or another—basket-making, fish trap construction, the carving of spoons or other utensils, the carving and polishing of canes and pipes, the polishing and incising of brass ornaments. For the individual involved, there was artistic satisfaction in having produced implements of quality, insofar as he achieved quality, and for his peers, there was aesthetic satisfaction in the contemplation and use of his product.[9]

Over a period of time, in any village and among various villages, preferences and particular skills sorted out artisans inclining them toward specialization. There were those who spent most of their time in tying baskets, others in making spoons. Still, it was rarely the case that a man would conceive of his main business in the Council House as that of tying baskets or making spoons. These activities remained secondary occupations. Moreover, whatever skills a man had or developed were usually regarded as particularly his own and very little attempt was made to pass them on to the younger generation in his own line. His younger relatives might tend to take up the same skills by simply proximity and example, but there was no institutionalized attempt to assure this—except in the case of iron-workers. But even here, inheritance of the necessary knowledge and skills was never so tightly controlled as to establish particular clan rights to the trade as occurred elsewhere in Africa. Finally, although a man might become associated with a particular craft, not infrequently it would become tiresome to him and he would turn his hand to another.

Those who carved reliquary figures (*mbobeyima*—carvers) worked in this context. Their product was, in general, more highly regarded than the crafts we have mentioned, but customarily they would work on their carving in the same casual and secondary way as any of the other craftsmen. Their subsistence preoccupations were the same as those of their fellow villagers. They were not impelled by any family tradition, and I have no record of any father making attempts to teach this craft to his son. Most frequently it was a classificatory uncle—a mother's brother's "brother"—who was credited with the stimulus that

first set a man's hand to wood.[10] The record shows, moreover, that a man might carve two or three statues over a year's time, then turn to something else and not return to carving for a number of years. The output of recognized carvers was surprisingly low. I have estimated, though it is difficult to get valid information of this point, that the average lifetime output for traditional carvers who had not commercialized their skills under colonial blandishments was not above ten figures and probably lower. This is explained not only by the relatively casual manner in which this carving was undertaken but also by a tendency of men, who had removed a portion of their extended family from their village, to fabricate their own figures for the new reliquary.[11] The nature of Fang culture was such that men might feel a passing competence in almost all of its aspects. The great range of styles and relative crudity of the majority of reliquary figures pictured in the field collections of Tessmann, Grebert, and others[12] testify to the degree to which the carving of most of these figures was undertaken by relatively inexperienced men. In the face of the utilitarian need to have a figure to "defend" (*aba'ale nsuk*) the reliquary —for that was their principal purpose—any figure would do. Aesthetic considerations were secondary. Any statue can function atop the reliquary, though some statues are to be preferred.

Though in the face of need aesthetic considerations may have been secondary, they were still present, and accomplished carvers were known and remarked widely. Because of their skills, they might be requested to carve statues for the reliquaries of other lineages and other clans. But they were never overwhelmed with requests, not only for the reasons detailed above, but also because of the feeling—not a requirement—that the family reliquary ought really to be guarded and decorated by the hand of some kinsman either consanguinal or affinal.

Fang dance masks and standing drums have received very little attention from European and American authorities,[13] although they give us a better example of artistic work driving out the crude and the commonplace in the aesthetic marketplace. Frequently, but not always, the men who worked in figures would also work in masks, and vice versa. But every carver preferred his own genre. The demand for masks might be brisk enough to push a man toward specialization. However, few ever did and none, to my knowledge, did so to the extent of giving up their subsistence and other village responsibilities. This is true even in the late colonial period where extended communications, the cash nexus, and European collectors exerted added pressures. Those who did undertake to devote disproportionate time to their art

did so in the face of the opinion that carving, like the other crafts to which it relates, should be a casual and secondary occupation. Men should define themselves principally as family heads, living representatives of the perpetuating lineage, debaters, warrors, hunters, trappers, and agriculturalists. Their skills with wood or reed, vine leaf, or metal are the necessary supplemental skills, and not the essentials, of Fang personality.

Nevertheless there were men who by reasons of character and talent, and because of the satisfactions involved, devoted disproportionate time to carving, developing thereby inordinate skill. The Fang on their part recognized that such skills were not equitably distributed and they were not strangers to the qualities of fine carving.

FOUR FANG CARVERS

My own collecting[14] brought me into close contact with four such men, all well enough known in their districts as carvers—that is, well known for the skill and time they spent in this occupation. Only one of them, Clemente Ndutuma, Clan Efak of the Demarcacion of Akurnam in Spanish Guinea, was, however, actively engaged in carving when I first visited him. One, Mabale Oye, Clan Essangi, Village Nkolabona District of Oyem Northern Gabon, had not carved anything of consequence in a decade. The two others, Eye Mengeh, Clan Mbun (Mobun) Village Antom District Oyem, and Mvole Mo Ze, Clan Nkojen, Village Endum, District Oyem, yearly turned out several masks and figures, the former concentrating on masks and the latter on figures. Only Clemente, to some extent commercialized by the Spanish, worked rapidly, finishing a figure in several weeks time. All the others customarily took a minimum of several months, working sporadically on a figure or a mask, then putting it away entirely for several weeks or a month in favor of other business, whether plantation work or long trips to visit relatives. None of these men, nor any other Fang carver I met, could be hurried. Both Mvole Mo Ze and Mabale Oye claimed that a figure or a mask only took shape gradually, as the spirit moved the carver, and it could be rushed only at the sacrifice of its quality. By this I understood them to mean that there were many other things for a carver to do besides carve. Carvers, it may be remarked, were considerably less responsive to the European's requests than the majority of their compatriots.

Of these four men, only Eye Mengeh had a position of importance in village affairs. He was both *ntolomot* and *mienlam*, most active elder and economically most powerful person in the village. Eye Mengeh's

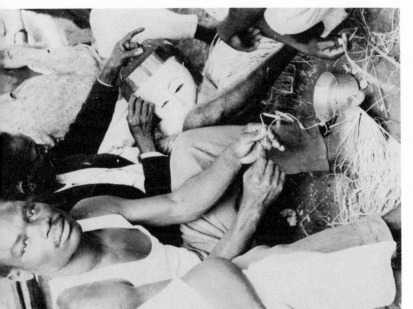

A team of Fang carvers in the men's council house preparing the accoutrements for a mask made by Eye Mengeh of the District of Oyem.

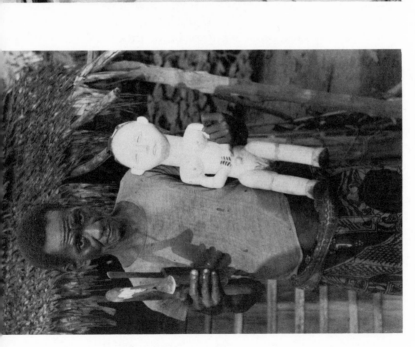

Mvole Mo Ze, a Fang carver of the District of Oyem, with his tools and a new *bieri.*

business acumen and leadership qualities are the exception which proves the rule that Fang carvers are peripheral and not highly respected members of their kin groups. The rule applies without exception to all other carvers encountered. It applies to the other three men discussed here. Clemente lived with his wife and two sons in isolation from his kin and village. Mabale and Mvole Mo were both elderly men who had never accumulated much in the way of wives or renown for qualities of leadership and economic acumen. They rarely participated in debates in the council house though they occasionally contributed caustic commentary and ribald impieties from the peripheries. These contributions were appreciated, but carvers were not infrequently referred to as *okukut*—good for nothings.[15]

I am unable to reach any satisfactory generalizations about the character of Fang carvers from my knowledge of these four men. Mvole Mo was retiring, caustic, and dour. He was his father's eldest son but had been replaced in village affairs by younger brothers. He only smiled when his work was being admired, and then perfunctorily. Mabale was ribald, bouncy, and socially oriented, a source of absurdities and impieties. Heavily preoccupied with sex and his own failing sexual powers, he did not fail to exaggerate the sexual organs of his figures with obvious satisfaction. He was his mother's only son. Eye was formal and dignified, the soul of graceful hospitality. When I did not compensate him quickly enough for his kindnesses to me in his village, he appropriated our brass teapot, which was produced when our transactions were satisfactorily concluded. He had an exaggerated notion of what I should pay for his work, and I was never able to establish a satisfactory clientship with him. Parenthetically, and in reflection, I may say that I do not find him in the wrong. He was a middle son who had supplanted his elder brothers through death and superior competence. Clemente was preoccupied with family resentments and with the evil intentions of his brothers who had tried to bewitch him. He had isolated himself from village affairs and could spend more time therefore in carving. Encouraged by the Spanish, he was rapidly becoming commercialized. He persisted in treating me with the rather exaggerated respect demanded of the African in Rio Muni, and I never learned much about him. I did learn that if I was not at his door the day a figure was finished it would be sold to another. He carved to sell and not with specific clients in mind as was the case with other carvers who were in this respect closer to the traditional situation of special commissions.

Informants frequently argued that the *beyima* were never sold but

were fabricated for the blessing, *abora*, to be obtained by making something to adorn the reliquary. Since this blessing could hardly apply to someone outside the kin group, this statement is a testimony to the degree to which the figures were made within each village and not commissioned from outside. But sometimes they were commissioned from without. When this occurred the leader—*ngomalan*—of the ancestor cult in question made a visit to the carver and commissioned the statue in person. He made several gifts to begin with so that "the carver would see him well"—*a yen nye mbung*—and be properly animated (I was brought very rapidly to understand the utility of this practice). Later the carver would deliver the figure in person and receive final compensation in the form of a modest amount of trade goods and hospitality. (The compensation for carving has always been low.) The statue had to be cermoniously presented to the reliquary—rubbed with the oil of the raffia palm, *djwing*, and accompanied by a meat offering to the craniums—whether it was carved locally or by a stranger. No additional ceremony seemed to be required in the latter case.

ART CRITICISM

The area in which the qualitative experience of the carver, as an artist, and of his audience, as the aesthetically moved, could be best observed was the council house where a great deal of the carving took place. The thesis that there is such a thing as art criticism in nonliterate society is easily supported here. One might almost ask if art lies as much in the act of creation as it does in the relationship between creation and criticism—the artist and his critics. A lively spirit of art criticism flows around the carver as he is in the process of turning out his statue in the men's council house, and it influences his work. The carver has the prerogatives of his creation, but he must still reach some accommodation with his critics who not infrequently consider themselves the final cause of the work.[16] What this accommodation may be depends upon the personalities involved. Mvole Mo Ze retreated from the council house to the solitude of the banana plantation behind the village. But the carver cannot expect to escape his critics when the statue is completed. He cannot, due to lack of status, impose aesthetic acquiescence upon his clients, even though his work is almost always accepted.

The criticism and aesthetic appreciation expressed in the council house most often referred to the way in which the statue was emerging from the block of wood from which it was carved, as well as the

priority and arrangement which the sculptor had given to the various bodily parts. When the figure first begins to become evident and issue forth from the wood—*a yen do ete*—admiration is usually expressed. For this is the crucial moment of the artist's skill and is the miracle, *akyenge*, which he accomplishes. From this point on, criticism and re-action is most often taken in respect to the way the various body parts are carved and the balance established among them.[17]

Though Fang statues, in their style, characteristically exaggerate or suppress the natural, they are, nevertheless, as African art goes, on the naturalistic end of the continuum. The Fang often argue that these figures and masks constitute traditional photographs. Part of the qualitative reaction of the observer is based upon the degree to which the carver has been able to reproduce the human form in accordance with those expectations set by stylistic criteria—very short and flexed limbs, long thin torso and large head. The four carvers we have men-tioned all claim that a good carver must study the human form and be able to reproduce it. That what is reproduced is very far from a re-production of the human form is quite clear to a European. We have in this reference to "our photography" an indication of the degree to which culture can persuade, if not impose a perception upon the senses. This indicates the degree to which artistic conventions can come to have a reality of their own, symbolizing greater truths than are iconically represented.

It is clear that there are limits on the extent to which men can be persuaded of the real relevance of artistic conventions and this is true of the Fang. Moreover, they will suspend disbelief in conventional directions, but not in others. Mabale elaborated a very exaggerated male organ on one of his statues and evoked a spirited reaction—mostly protest. He had clearly violated that collective representation which is the Fang notion of a reliquary figure. He was inspired to tell one woman who gazed on it with disapprobation not to be afraid. The member, he said, couldn't even pass water.[18]

STYLE

I have elsewhere (Fernandez 1966a) indicated that though the Fang argue that their figures and masks represent living persons, as the Europeans represent them in photographs, they rarely argue that these statues represent particular living persons, but only living persons in general. They are not portraits. Since in extended discussion the Fang recognize well enough that the proportions of the statues are not the

proportions of living man, one is led to believe that what the statue represents is not necessarily the truth, physically speaking, of a human body, but a vital truth about human beings symbolically stated. This symbolic intelligence seems to arise from the way the statue holds opposites in balance—old age and infancy, somber passive inscrutability of visage and muscular tension of torso and legs, etc. What is expressed in these statues, then, is the essence of maturity. The mature man, *nyamoro*, is he who holds opposites in balance.[19] The statues express the most fundamental principle of maturity and vitality (whose secret is the complementary interplay of opposites) and hence they lay claim to the most profound reality, despite their stylistic exaggerations.

This interpretation is an inference developed from, but not directly contained in, informants' remarks. It relates to explicit commentary from the Fang on their figures and their relation to the reliquary. In response to the question as to which ancestor the figure represented, I have the following statement from Essona Ekwaga, corroborated by Obunu Ndutuma, Clan Bukwe, village of Sougoudzap, District Oyem:

The figure represents no ancestor. There are many skulls in the reliquary. Who should we choose to represent? And who would be satisfied with the choice if his own grandfather should be ignored. The figures were made to warn others that this was "the box of skulls" and they were made to represent all the ancestors within. What causes us satisfaction in seeing the *eyima* atop the *bieri* is that there we see disclosed our ancestors. Their faces are strong, quiet, and reflective. They are thinking about our problems and how to help us. We see that they see.

What is implied here and in the informants' later remarks is that the statues convey to the Fang the benevolent disposition of the unseen world (*engang*), conceived by them as the world of the dead spirits. The religious figures, in short, in their peculiar tension, their inscrutability atop the collection of craniums help convey to the Fang ancestor worshipper what he so devoutly desires to know—that all is in order in the unseen world. Part of his aesthetic satisfaction in respect to these statues is bound up in a conviction conveyed by them; a conviction that the moral order which is the universe of the unseen is favorably disposed toward him.

Our conclusion at this point is altogether implied in what we have said. It is the carver in his art who enables the order of the unseen to be exposed. Though any statue, regardless of aesthetic quality, may serve to "defend" the *nsuk*, not all obtain to that quality of balance and inscrutability which conveys as it exposes some kind of overriding

order in the universe. The power of the carver's art to help convey this order is esteemed, but by and large it is not, as we have shown, very highly respected.[20]

The Imposition of Order

The rank and role of the Fang carvers described above are reminiscent of that description of Basongye musicians provided us by Merriam (1964:135–138). Merriam indicates how very little determinable status they possess, and he remarks on the ambivalent attitude of the Basongye toward them. They are at once considered to be deviant and unrespectable, lazy, heavy drinkers, debtors and impotents, existing only for music to the exclusion of social responsibilities. At the same time one cannot conceive of village life without them, so important is their function. The desire for the qualitative experiences they provide enables them to capitalize upon their deviancy as other members of society cannot. Merriam makes clear that this ambivalence and the anomalous status and the role associated with it is not confined to the Basongye, but is the situation of musicians in a good many parts of the world including the Western jazz musician.

Similarly with Fang carvers, their product is, by and large, granted more importance than they themselves in social affairs. And they are unable to capitalize on their skills so as to transform these skills into high rank. Nevertheless, if I read Merriam correctly, in comparison with what we have said here, the product of the Fang carvers was not as indispensable nor as valued as Basongye music and song.

The much better comparison with the Basongye case is the Fang chest-harp troubador, *mbomomvet*, who chants the legends of the Fang superhuman ancestors, the famous villagers of Engong.[21] The art of these men is highly valued and they are eagerly awaited in their wanderings throughout the forest. About once a month, one or another of them will come into the village and provide an evening's entertainment. Young and old of both sexes crowd into the council house to hear the three or four hour long recital of legendary events, singing refrains themselves, beating time on bamboo strips, and otherwise directly participating in the troubador's art. They follow the clues he provides as he plucks the chest harp and in his song in order to enter into the mythological recreation that his performance accomplishes. Any of these men is more indispensable than a carver. The social satisfactions of the evening's entertainment in which all elements of the village are brought together in orderly fashion in

mythopoeic recreation are much greater than could ever be associated with the making or contemplation of an ancestral figure. We are arguing here that this imposition of order upon the inevitably antagonistic elements of the village, even though only momentary, is the source of the troubador's greater prestige as artist and producer of the aesthetically satisfying. At the same time, because of the very nature of his profession the troubador has no real position in the social group to which he belongs. He is so frequently away from his village that he has no real authority there. Thus his prestige is a transient and ineffective attribute that he possesses only momentarily in village after village as he passes through.

PALABRAS

Artistic activity and the imposition of order is associated with high rank, however, in the person of the judge of village and inter-village disputes, *nkik mesang*, and the chief debaters, *ntia medzo*, the principals involved in *palabras* in the council house.[22] My contention that their activity is artistic in intent and aesthetic in effect can best be supported if one understands that no ascription whatsoever applies to the argument and judgment of conflicts in the council house. One achieves these highly valued positions through oratorical powers (*nkobongu*—strong speech), an ear for apt turns of phrase and appropriate proverbs, an ability to follow the main course of the debate (*zen adzo*—path of the affair) and separate out the spurious from the relevant, and an eye for the crux of the matter, the kernel of discontent that lies behind the accusations and counteraccusations (*nlo-adzo*—the head of the affair). But all these talents presuppose a vehicle for their presentation to the groups in conflict: a vehicle that will arrest their attention and convince them to return to a measure of harmony in their affairs. In a highly egalitarian, loosely-structured society like the Fang, with very little institutionalized means for coercing compliance with judicial opinion, practically everything rests upon the spirit of conviction made evident in the judgment itself. By the same token, it is no easy thing to strike a judgment that will be acceptable to both parties. So the *nkik mesang* must walk, with great delicacy, a razor's edge, achieving that justice which is, in effect, not the establishment of the truth of the matter, but the reconciliation of two opposing parties to a new modus operandi in their affairs.

While the responsibilities of argument and judgment can be discharged in a matter of fact, quite utilitarian fashion, the most highly respected judges almost always embellish their decisions and argument

with both verbal and kinesic pyrotechnics. Take as an example the *palabra* between two clans—*ebom*.[23] At the end of debate the *nkik mesang* will walk back and forth between the two opposing sides, summarizing at length the argument and interspersing his comment with homilies, aphorisms, and proverbial expressions that here distract and there point the attention of his audience to the essentials of the affair. Now he moralizes; now he is pessimism itself about the relations of man to man. As he talks on, his audience tends to forget the passions of the moment, though not their interest in his final decision. As he walks, he carries in his hands the symbol of his authority—the fly whisk (*akwa*)—for the disputants are but flies to him. As he examines the arguments of first one side and then another, he shifts the fly whisk back and forth to the appropriate hand. Finally at the conclusion when judgment is delivered the fly whisk is placed in the hand on the side of those who have the greater cause (*ba ke oyo*—they go above). This is all very dramatic, particularly since the *nkik mesang* will, in the process of his long disquisition, artfully conceal his final judgment and hold the litigants in suspense. He will give the view of each side such positive airing that one can only conclude that he has judged for them. By doing this the virtues of each side will be extolled as objectively as possible for the mollification of their opponent, making thereby for subsequent ease of accommodation.

If judgment is not artfully done it will likely fail. There are no procedural mechanisms which will guarantee its success. Every *palabra* demands its particular embellishment. The *nkik mesang* must creatively work to shape a new and viable social whole from the raw materials and shattered patterns of behavior brought forth in litigation. The metaphor, *akik* (to slice, to cut cleanly), is important here for it implies the finesse of the operation. After a *palabra* in which·this slicing has been done with particular delicacy so that men are no longer entangled in conflict, frequent allusion is made to the artfulness of the *nkik mesang* and his statements recalled. Fang make a very clear, and what I think must be called aesthetic, distinction between the crude way Europeans handle *palabras* and their own more subtle methods. The European, to paraphrase my informants on this point, does not slice a *palabra* (*akik*); he breaks it (*abuk*). He leaves jagged edges which will continue to fester. To the European judge[24] there is a right and a wrong and that, to the Fang, seems to be all he is interested in. Maintenance of the equilibrium, *bipwen*, between opposing parties does not interest him. He breaks *palabras* apart in listening to them and judging them. Only the very powerful can break a *palabra*

in this way and not pay the future consequence of embittered hearts. In Fang life, harmony and tranquility in the face of the inevitable gravitation towards disorder rests, therefore, upon the artful reconstruction of the integrity of village or inter-village life in the person of the *nkik mesang* or the *ntia medzo*. His method is aesthetically admired. The qualitative experience of witnessing a well handled *palabra* is very profound for the Fang. They speak about its subtlety and persuasiveness long after. Men who can accomplish these kinds of judgment have quite high rank. I submit that this is partially a consequence of the fact that they are able to artfully impose order upon their compatriots—an order which the *nkik mesang* aesthetically perceives to be possible in village life and which he artfully calls upon his peers to approximate.

The Bwiti Cult

In the decade before the First World War there appeared among the Fang of Lambarene and the Estuary a religious revitalization movement known as Bwiti. It gained strong headway and flourished in central and northern Gabon during the inter-war period. It still exists in a multitude of subcults, more than a dozen, throughout the central and northern portions of the Gabon Republic. Initially Bwiti was a reworking by the Fang themselves of their ancestral cult, *bieri*. This reworking took place under the influence of the more elaborate ceremonies and beliefs of a neighboring Bantu people, the Mitsogo of Ogoowe Ngounie. It began at the turn of the century at a time when the Fang, previously a conquering and dominant people, began to sense fully the frustrations of European colonization. About that experience the Fang say simply, "our medicines began to fail us; our ancestors no longer listened." Perhaps 7 per cent of the Fang population is involved in this cult which presents a striking number of forms. Five principal subcults can be distinguished. The data here is taken from the principal subcult, *Dissoumba—Asumega Ening*.

Of interest to us here are the leaders of these cults, *nima na kombo* (those who create), and the ritual organizers and leaders, *yemba* (those who know). It must be kept in mind that cult life is highly dynamic and mobile, and local cult leaders depend for their success on gathering and holding together nuclear cult membership. They are in competition with other local cult leaders to build and keep an economically and ritually strong membership. They must, therefore, organize a cult sufficiently resourceful and dramatic to satisfy the

magical and religious needs of the members. In other words, the role of the successful cult leaders is highly charismatic, enabling its possessor to manipulate old ritual forms, to invent new ones or to incorporate religious elements from outside the cult. All of this is done in the interest of binding the membership solidly to the local cult in the face of a centrifugal tendency: the tendency for members to drift from cult to cult in search of greater personal and social satisfaction. In a very real sense each local cult, even though it exists within a recognizable tradition clearly belonging to one of the five principal subcults of Bwiti, is the artistic creation of the cult leaders. The qualitative satisfactions that their artful employment of myth and ritual makes available to the membership is an important guarantee of the loyalty of that membership.

The various local cults differ markedly as to the degree of logico-aesthetic integration that they are able to achieve in cult life—the degree, that is, to which cult leaders are able to convey their visions and impose order upon their members. It must be pointed out that there is a much higher emphasis upon logico-aesthetic integration in cult life—living out the entire life process as an art and with some measure of consistency—than is characteristic, as we have made clear, of traditional Fang life. This is probably a response to the disintegration in Fang affairs attendant upon colonization. However that may be, differences in ritual performance (*ndong mbung—myon mbung*) are greatly admired and are credited to the cult leaders—the *nima na kombo* and the *yemba*.[25] The superiority of a particular cult is evident in the consistency in dress of the participants, the orderly fashion in which the various types of dances are alternated, the extent and variety of songs in the repertoire (average is about 125), and the degree to which the cult leader, capitalizing on his success in meeting these criteria, is able to project ritual harmonies into the social life of the cult by successfully resolving the disputes of the members. A cult that obtains to a high degree of integration along these lines is an object of admiration and, quite clearly, aesthetic appreciation. Its members, under the guidance of the *nima na kombo*, produce in the weekly celebrations of the cult satisfactions not available elsewhere to the villager confronted with value conflicts and identity problems accompanying social change. Having produced in their cult meaning in the form of a high degree of logico-aesthetic integration, it is not surprising that, from the members who experience it, the *nima na kombo* and his chief organizer, the *yemba*, receive great respect and high status.

We may take as examples of the more than 20 cult leaders inter-

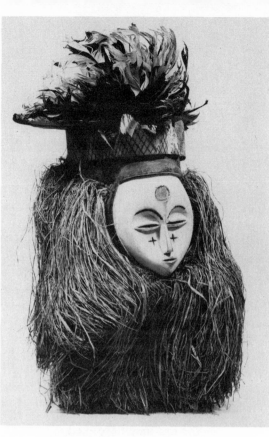

Mask representing a forest spirit and worn by a Fang troubador for a dance of amusement and rejoicing. Made by Eye Mengeh.

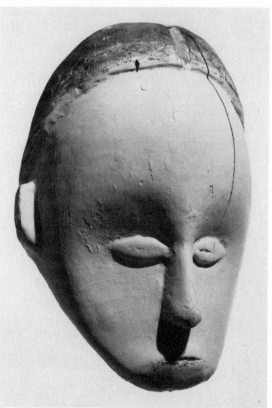

Fang dance mask to be carried on a pole and danced over stuffed figure said to be either Franco or DeGaulle. Made by Mvole Mo Ze in the early 1950's.

viewed the two outstanding *nima na kombo* of West Central Gabon—
Ekang Engono of Kougoulou, District of Kango, and Nzameyo
Nguema of Efulan, District of Medounou. Both of these men admin-
ister tightly organized cult houses with an elaborate ritual and song
cycle smoothly performed and with a high degree of dramatic interest.
Both men have elaborated ritual performances and introduced songs
and peripheral events typically their own and widely remarked. Most
recently, at the time of field work, Nzameyo had introduced a dra-
matic reenactment of the creation of the world,[26] and a more lengthy
cycle of songs and dances preparing for entrance into the chapel.
Ekang during the six day long "Easter" celebrations of 1960 intro-
duced elements from the long abandoned boys' initiation and purifi-
cation ceremony (*soo* and *ndong mba*) into the concluding moments
(at early light) of the all night ceremonies. Both of these men justify
these continual modifications in the ritual procedure as emanating
from their capacity to probe the supernatural—*asok engang*. They
claim the new dances and other ritual forms which they introduce are
based on the ritual of heaven. They are vouchsafed through their par-
ticular ritual capacities and in their position as head of the cult vision-
ary contact with the order of the afterworld. Their followers say of
them, "they have died often and have passed over to God and the
ancestors as a man crosses a stream." Insofar as the Fang find some-
thing appreciable (*mbung*) in the forms that these leaders introduce
or explain in the ritual in some degree, it is because they see in them
the ideal informing the real.

It is of importance to examine the way in which these visions are
accomplished and something of their substance in relationship to cult
procedures. The *nima na kombo* rarely participate in the ritual activity.
Rather, they remain backstage to the rear of the chapel in a detached
state, often under the influence of the alkaloid drug *eboka* (*Taber-
nenthes eboka*).[27] They are observant that the ritual proceeds cor-
rectly, but they are said to be largely preoccupied with thoughts
(*osiman*): the meanings associated with ritual activity. Ekang Ngono,
in order the better to communicate with the ancestors and the after
world, has dug a grave pit under the altar into which he descends dur-
ing the ritual. He remains there hours at a time. Here on a chaise-
longue under the influence of *eboka* he is able to explore the beyond
and develop those visions which he communicates to the membership
and which, from time to time, oblige him to make changes in the
ritual. These visions are usually directly elaborated and reported in the
sermons which he rises to give at midnight. These employ subtle
symbolism combined with aphorisms, proverbs, and moralistic

homilies reminiscent of the speeches of the *nkik mesang* in the council house. But occasionally these visions call upon him to make changes in the ritual, as in the case of the incorporation of elements from the traditional boys' initiation and purification ceremonies. These visions, in both cases, produce creative results in the eyes of the membership, and they regard them as miracles—*akyenge*—which confirm the high prestige of the cult leader.

It is relevant to observe in passing that the relaxed mental state of the *nima na kombo*, from which his logico-aesthetic creativity arises, relates directly to that type of mentation which Kubie (1958:53–65) discusses as being so basic to the creative process. Kubie refers to the capacity to escape the domination of the conscious mind so as to exploit preconscious processes. This exploitation leads to highly fertile use of symbolic capacities in the allegorical and figurative mode. Experience is reshuffled, and through the free use of analogy and allegory dissimilar ingredients are recombined into new perceptual and conceptual patterns. The following commentary to me by Ekang Engono on how his visions made apparent to him analogies (*efonan-bifonan,* likenesses) that he had not previously recognized clearly relates to Kubie's analysis.

Because I have passed beyond the grave I see likenesses, and thus I pull the world together. There is a fundamental unity of things. Many things which seem different are really the same. There is so much conflict, all of which gives rise to *ebiran* and *nsem* (social and ritual sin) because of the action of witchcraft (*mbwol*). The witches have no other object than to confuse people and prevent them from seeing the unity of things. The witch wants to get people alone so that he can eat them, and that is precisely what Bwiti (through my visions) prevents him from doing.

Kubie (1958:90) quotes the experience of a writer in a creative mood which fits Ekang Engon's visionary state in the grave pit. "I don't try to think and I don't try not to think. I do try however to make myself comfortable and free from bodily strains."

We give here one example of "*nkobo akunge,*" the "miraculous speech," of Ekang Engono immediately after ascending from the grave pit. It indicates his creative use of analogy.

Eyene Zame a dzi ki yene nyinga nge a nga yene a berege lire akyenge awu. Engong a nga bulan adzal ézo a nga yen a nyinga. Ekokom za yian ye keh mezo me ye mfonge; esama za kam!

"He sees God" [alternately "miracle of God"] [Jesus] did not see the still pool. If he had seen the still pool he would not have had to return to be shown the miracle of death. When he returned to the village that day he

saw the still pool. The body must listen to the words of the wind. The
group protects!

This short evangile delivered at midnight amidst the awestruck silence
of the membership displays that high degree of condensation without
which creativity in any field, Kubie (1958:34) tells us, would be im-
possible. Since it took me over an hour to unravel it (in the presence
of the *yemba*, not with Ekang Engono himself), I will only refer here
to some of its elements. There is the irony that Christ "he who sees
God" nevertheless did not see death because he was not shown the
still pool. This still pool refers to 1) the primordial ocean (*mang*)
into which the creator, *Mebege*, sent the spider, *dibobia*, to raise the
land, 2) the stagnant pools deep in the forest into which the moon
shines to create the spirits of new infants, 3) the pool of decaying
fluids into which the dead body collapses, 4) the actual pool of water in
the culthouse symbolic of all of these and around which various rituals
take place.

In that pool is summed up the miracle of life and death—since it
represents both creation and decay. When Eyene Zame went to the
village, the land of the dead, he foresaw his decaying body and knew
death. Reference to the Garden of Gethsemane is intended. The body
which knows not death since it can't step over death must listen to
the words of the wind—that is the spirit—which stirring about in the
waters brings creation (reference intended to the biblical version of
creation and the winds in the water). The cult group which is ritually
gathered around the still pool in cult procedure protects against death
by offering knowledge of death and beyond it. If one dances well one
"dies" during the evening ritual. It protects through ritual against the
crucifixion which Christ suffered because he was alone.

In this way does the *nima na kombo*, as he says, creatively pull the
world together by analogies and likenesses so that through symbol in
myth and ritual is a new impression of relatedness and meaningful
integrity created for the membership. In this they have some advantage
over their peers outside the cult undergoing the anxieties of rapid
transition without ritual reintegration.

The effective *nima na kombo* does not content himself with the
creative manipulation of symbolic elements in ritual and myth. He
capitalizes on the qualitative experiences he has brought to the mem-
bership in these realms by projecting the logical aesthetic order of the
cult into secular social relationships. Both Ekang Engono and
Nzameyo Nguema meet with the membership in the council house
outside the cult house—the one the morning just after the cult meet-

ing, the other in the evening just before. They meet to discuss and resolve the disputes and ill feelings that have grown up in the relations of the members. As a background to the arbitration by the *nima na kombo* stands his demonstrated charismatic power, as well as the positive social sentiments created in the all-night ritual. One specific ritual dance after midnight obtains one-heartedness (*nlem mvore*) in the membership, and it is this symbolic accomplishment of unity that the *nima na kombo* recall to the disputants in arbitrating their social difficulties. The words of the *nima na kombo* in this context are much less rhetorical than those of the *nkik mesang* in judging *palabras*. But the same subtlety in following the path and coming to the head of the affair is in evidence. The difference lies in the fact that the cult context in which he works has given the *nima na kombo* residual sentiments and an established sense of order that greatly enhances his ability to establish reconciliation. The power of his moral council is thus to a considerable degree a function of his aesthetic accomplishments. In fact, it is not unusual for the *nima na kombo* to argue in these *palabras* that the antagonisms among the membership create "badheartedness" and prevent thereby the successful development of cult ritual. They are, therefore, a violation of the orderly relationship established between the cult and the supernatural. This may be regarded as a ritual sanction. I think it is equally relevant to call it an aesthetic sanction. For the thrust of the *nima na kombo*'s council is often less directly concerned with the supernatural implications than with the simple unseemliness of the behavior under discussion. It is, he will impress upon the membership, behavior which is simply disorderly (*ebiran—*unaesthetic). It is a threat to the quality of cult life, and the lofty new preferred way of living—*mfefe ening*—that they have established among themselves. The threat to a universal and a transcendent order is left implicit.

Conclusion

We have argued in this paper that the rank of the artist who creates qualitative experiences for his fellows varies with the extent to which he is able to impose order. We have moved up from the art of the carver, who symbolically exposes in his work the nature of maturity and the saving bond between the living and the dead, through the troubador, who recreates a lengendary past satisfying in its chaotic and promethean struggles by comparison to the present, to the chief judge of *palabras*, who symbolizes in his oratory the vision of a good society, an orderly society, in which men can live in harmony. Through

his rhetoric he has some power to impose order on his listeners even in this egalitarian culture. Finally we reach the very high rank and charismatic nature of the cult leader who creates myth and ritual to hold his membership in orderly sacred activity and uses these logico-aesthetic accomplishments to impose order in their secular affairs. The rank of these artists increases with an ever widening sense of order that they are able to expose and does not exclusively relate to their ability to impose order. In either case, their position lies in their capacity to make their art socially relevant, to see, in other words, that the meanings they have created in the manipulation of symbols make an impress upon activity. Here the advantage of the artist as ritualist over the artist as worker in plastics is apparent. In any case, the artist of highest rank among the Fang is he whose artistic activity provides aesthetic meanings, which in turn influence the activity of those who contemplate or, as in the case of ritual, participate in them.

The proposition as it stands, while it seems to fit well enough the case of the Fang, may not be exhaustive nor exclusive. In the case of the cult leader it may well be asked whether or not we are talking about religion or art. Is it not the *nima na kombo*'s religious rather than his artistic nature that imposes order? It cannot be denied that the cult leader has a charisma that is lodged in the supernatural. However, I have tried to show the degree to which that very charisma is enforced, if not created, by the "miracles" of his art. Moreover, while it may be said that the cult leader's high position is backed by his relation to the universe conceived as a moral order, I think it more basic to point out the degree to which this conception of the universe rests upon, in fact is created by, his aesthetic capacities. Artistic activity precedes as much as it succeeds religious meanings. The religious emotion may be a kind of aesthetic appreciation in respect to an ordering of symbols created through artistic activity.

The proposition we have suggested must also be related to repetitive and changing systems and to the degree of integration prevailing in a given society. It is obvious that the high rank and considerable creativity allowed the cult leader is a consequence of the fact that the Fang have been recently undergoing a very disintegrated transitional period as they shift from a repetitive to a changing system. The Bwiti cult represents an attempt to recreate some of the traditional satisfaction of a repetitive, hence highly ordered, universe. In doing so it has far surpassed the traditional logico-aesthetic integration of Fang culture. The challenge to restore order in the disorderly transitional period has given the cult leader much greater opportunities for artistic creating than was available formerly while at the same time the

competition with other cults has set a high rate of creative turnover. The orderly universe which the cult produces is generated by constantly changing ritual-myth processes. In the face of demoralization, the cult leader's art recreates a universe of moral relevance. What have become burdensome obligations are, through him, made desirable.

Therefore, it would seem that in disintegrated or loosely integrated systems much greater respect would accrue to the artistic imposition of order than in highly integrated ones where order exists and need not be created. In the integrated system, high rank would accrue to the artist who exposed the order already known to exist, while the imposition of order would be regarded as intrusive and redundant. The Fang carver has always had the misfortune of working in a disorderly and poorly integrated society. Other arts are more valuable and respected through their impositions upon a fundamentally disordered society. These are all propositions, however, which can be advanced in only the most tentative way. They are subject to much refinement.

What may be difficult to accept in this argument is the association of art with the imposition of order. We have a tendency to leave the imposition of order to those concerned with crude power—the politicians. It may well be that all the mechanisms of social control of modern life enable man to impose order artlessly. But among the highly egalitarian politically unstructured Fang it is impossible to impose order without art. The leader had to be proficient in expressing himself artistically, creating thereby a moving aesthetic spectacle. Malraux has spoken of the tendency in modern life for a genuine art which makes claim on our ultimate humanity to give way to the "arts of delectation." Artistic persons of high rank among the Fang, however, are those who do indeed make claims on the ultimate humanity of the Fang, reminding them of the place of that humanity in a society and universe conceived of as a moral order. The imposition we speak of, in short, is not simply the impress and assertion of brute authority. It is the gaining of authority by "expressing the group"; that is, by being susceptible to their thoughts, feelings, and desires,[28] and giving these things the order of artistic expression.

NOTES

1. John L. Fischer (1963:238) has made this point on a number of different occasions, notably in an article on the social psychological analysis of folklore.

2. Parsons and Shils (1954:173), Kroeber and Parsons (1958). See also Geertz (1957:34) and Fernandez (1965b).

3. We follow the distinction made by d'Azevedo (1958:712).

4. Strictly speaking, the Fang examined here are those southern branches of the much larger Yaounde-Fang linguistic group A–70 (Guthrie 1953:40–44) living in northern and central Gabon and Spanish Guinea (Rio Muni). All of these, along with the Bulu and Ewondo of the Southern Cameroun, are grouped under the French name Pahouin, Pangwe (German), or Pamue (Spanish) in the literature. The data are taken from three subgroups roughly coterminous with dialectical differences: the southern Ntamu and the Fang proper of northern and central Gabon and the Okak of southern Spanish Guinea. The latter two groups are sometimes called the Betsi to distinguish them from the Ogoowe River Fang. All of the Pahouin are an egalitarian highly decentralized people. As is typical of peoples of the rain forest, the size of the Fang economic unit has always been small, rarely exceeding 20 people. The relations between heads of extended families, often even of nuclear families were competitive rather than cooperative. Socially and politically speaking, there was minimal over-all order.

5. As distinguished from social sin (*ebiran*) (Fernandez and Behale 1962:260). It can be argued that the notions of defilement and impurity—*nyol abe* (bad body)—are the consequences of nonaesthetic activity; just as the secondary rituals elaborated to counteract these states are a restoration of the individual to harmony in relation to a larger aesthetic whole. This is discussed further below.

6. Tessmann, in his classic ethnography (1913:II, 20–39), finds a transcendent order implied in the various Fang cults and discusses the various rituals, particularly of the *soo* cult, as the dramatization of the struggle between good and evil in the universe, coupled with the attempt, pessimistically, to shift the responsibility for evil from man to the universe itself. I could get no satisfactory corroboration for Tessmann's interpretations, though similar preoccupations do arise in the reformative cult of Bwiti. It has, however, a much more optimistic view of universal order.

7. The term status is avoided because it is a complex leitmotif in the intellectual history of the social sciences. By rank we mean the position assigned to any member of a group by his fellows in virtue of his capacity to influence the behavior of others in the group. Prestige and/or respect accompanies high rank. Esteem is the positive attitude held towards a person who successfully fulfills the expectations of his position regardless of its rank. Our argument here, in respect to these definitions, is that influencing the behavior of others can only be accomplished artfully among the Fang.

8. A very substantial price, in the tens of thousands of dollars, was given for a famous Fang reliquary head from the collection of Sir Jacob Epstein. This head is now one of the prize items in the collection of the Museum of Primitive Art, New York.

9. The term for exceptional skill or talent—*akeng* (in the Ntumu dialect *akunge*)—is, in substantive form, applied to the skillful or talented person—*nkengbe*. The term *akeng* is sometimes translated secondarily as art and *nkengbe* as artist (Galley, *Dictionnaire Français-Fang, Fang-Français*. Neuchâtel, n.d.) though it is clear that the creativity component of skill and talent, so essential to the Western use of the term and its distinction between the artist and the artisan, is not implied. In my own experience, it is true, the term *akeng* was often used with a connotation of awesomeness as if the skill in question was as much lodged in the supernatural as in the natural course of events.

The distinction between the good and the beautiful arises in relation to these

materials. The three generic terms of appreciation in Fang—*mbung, mve, mba* (or *mbamba*)—are all translated as meaning both good and beautiful (*bon et beau*) by Galley and others, though they tend to have their appropriate semantic space. *Mbung* for example is particularly applicable to feminine qualities and *mve* to the masculine *Mve* and *mba* are extended more often to beneficial social actions. A person who conducts himself skillfully in social relations so as to promote harmony would be appreciated more likely as *mba* or *mve* than as *mbung.* Thus in reference to our discussion here, *mbung* is the term of appreciation more often employed in respect to ancestor figures, *mve* or *mba* to the actions of those imposing social order. In any case, the debate as to the distinction between the good and the beautiful could hardly, for linguistic reasons, by easily posed or satisfactorily carried out by the Fang.

10. Of a total of 15 carvers of masks and figures encountered in the field, only one took up the art from his father. Half were taught by classificatory fathers, *i.e.,* by patrilineal relatives in their own village. The rest picked up the impetus in the villages of relatives, usually on the mother's side. But this teaching process is not sharply defined and often consists simply in the chance to help cut away excess wood before shaping. Since almost all children sculpt animals and figures out of the very soft and spongy wood of the raffia tree *dzam,* they obtain some practice in the art without any formal kind of apprenticeship.

11. Village fission was frequent, usually taking place through the cleavage of two extended families (*ndebot*) who were no longer able to live together as one *mvogabot*—"village of people." When the reliquary itself was divided in this cleavage, a new figure was needed. Because of the greater stability of villages in the early days, there was less demand for figures than was characteristic of the intense fission of the colonial period. Even in cases of village fission, however, there was not inevitably a need for a new figure as two extended families may have been celebrating the ancestor cult together but maintaining separate reliquaries. Tessmann pictures such a situation (1913:II:125). In short, the demand for reliquary figures was not very great in traditional times.

12. Tessmann (1913:II; 118–20); Grebert (1921:79). In 1957 an anti-witchcraft and purification movement swept northern Gabon in which a great number of reliquary figures were confiscated. The vast majority of these were, by any standards, very crude objects.

13. Fagg and Elisofon (1958:160) remark how little is known of these interesting masks. Both helmet and half face masks were made. The Lowie Museum at the University of California contains some of the best examples of each to be found in European or American collections.

14. Made for the Lowie Museum of the University of California, Berkeley.

15. Importance is a function of wealth, calculated by reference to the number of wives, and of effective authority exerted in the council house.

16. This tendency to consider the carver as only the efficient cause of aesthetic satisfaction is corroborated by the degree to which many Fang, not themselves carvers, have definite formal criteria in mind to which the statue ought to conform. The following criteria of Ayang Ndong, Clan Essisis, Village Etsam, District Medouman, are not untypical. "A statue has six cutting points: 1. forehead to chin, 2. chin to knee, 3. back of head to buttocks, 4. buttocks to tip of calf, 5. tip of feet to knees, 6. tip of calf to ankles. All of these cutting points in any good statue should be in a line."

17. Both arms and both legs, for example, should be carved with identical

proportions so that the figure is balanced. This applies to eyes, ears, feet, etc. Mabale Oye, the oldest man who carved for me, was failing in sight as well as in concentrated muscular control. His figures, therefore, showed some imbalance. Though more interesting to me for that reason, they were criticized by the Fang.

18. The presence of women at the carving seems inconsistent with the function of the figure to "defend" the reliquary against the uninitiated: women and children. The custom of keeping children and women out of the council house, however, is nowadays much relaxed. But in any case it was not the figure in the process of carving that had awesome power. It only developed this power through its ritual associations with the reliquary itself.

19. He is, for example, able to balance off conflicting opinions in debates in the men's council house. But, more fundamentally, he most successfully combines the contradictory inheritance of female blood (maki me mininga) and male sperm (meyom), each of which provides him with a different set of qualities—reflection and will, etc.

20. It should be reiterated that it is more than the carver's art; it is also the ritual association with the craniums which gives the statue its power. Since the carver himself does not usually participate in the ritual process by which the statue is incorporated into the ancestral cult and located atop the reliquary, very little charisma attaches to him.

21. The mvet legends are justly famous in equatorial Africa. Among other Europeans that have examined them closely are H. Pepper and P. Alexandre. M. Ndong Phillippe, former deputy and mvet troubador himself, began publishing a literary version of these legends in the Gabon journal of primary and secondary education, Réalités Gabonaises # 1 through 12.

22. There are various categories of palabra ranging from adzo—the mild local affair—through etom, a much more serious affair involving a deep cleavage in social sentiments, to ebom—inter-clan disputes usually involving blood debts.

23. The ebom was a rare palabra, but features of it exist at every level of litigation and judgment.

24. We refer here to the European judge in district courts. In Gabon, this person was usually the Chef de District Adjoint who worked through an interpreter.

25. The social structure of the cult is, in contrast to traditional Fang life, hierarchical and the spiritual progress of the individual member is three phased. A member passes progressively from the stage of neophyte (mvon) to adept (bauzie) to knowledgeable organizer of ceremonies (yemba). Should his talents be sufficient he may become director and initiator of ceremonies (nima na kombo).

26. This innovation is discussed in Fernandez (1965a).

27. This drug, a mild alkaloid, prepared from the powdered roots of the Eboka plant, is said by the members of Bwiti to lighten the body and enable the soul (nsisim) to escape and comingle with the ancestor spirits.

28. Herbert Read (1963:69), in defense of "art engagé" and in defense of the artist, or at least the man of imagination, as king and society's only proper leader, makes the distinction between the kind of leader who impresses the group by asserting his authority, and the king who expresses the group by being susceptible to their thoughts, feelings, and desires. This distinction differs from, but is relevant to, our own. That we have employed the term "imposition" with rather a special meaning is clear. The range of its meanings are so broad in Webster, however, as to permit the use of the term without any pejorative attachments.

Daniel J. Crowley

AESTHETIC VALUE AND PROFESSION-
ALISM IN AFRICAN ART: THREE CASES
FROM THE KATANGA CHOKWE

THE Chokwe, also known as Quicos, Badjokwe, Batshioko, and Watschiwokwe, evidently originated in northeastern Angola in the sixteenth century through the intermarriage of Lunda aristocrats with the indigenous Mbwela population (McCulloch 1951:32–33). First hunters, then slavers for the Portuguese of Bihe, and now de- sultory agriculturalists and enthusiastic urban-dwellers, the Chokwe number over 1 million. The tribe has moved from its homeland in all directions; north and east into the Leopoldville, Kasai, and Katanga provinces of the Congo (now Zaire), southward into central Angola and Zambia, and westward to the Ovimbundu highlands. Chokwe culture and language are marked by great regional variations, partially explained by the fact that many Chokwe now live interspersed with other peoples, most of whom have a prior claim on the land through the *droit du premier occupant*. As immigrants, the Chokwe tend to be sanguine, nonconservative, and relatively open to Europeanization, Christianization, and urbanization. Organized urban Chokwe com- munities exist in Kinshasi, Kahemba, Tshikapa, Luluabourg, Lubumbashi, N'Dola and in other Copperbelt towns, Livingstone, Luanda, and even in distant Johannesburg. At the same time, most Chokwe are still quite "bush" because of poverty and isolation in the surrounding undeveloped regions.

The vitality and theatrical qualities of the arts of the Chokwe have attracted considerable scholarly attention, and indeed, after the Yoruba, Dogon, and Bini, are perhaps the best reported in Africa. The incomparable collections of the Museu do Dundo, a private museum created by the Companhia de Diamantes de Angola (DIAMANG), and of the Sociedade de Geografia in Lisbon are made up almost ex- clusively of Chokwe specimens. Redinha (1953; 1956) and Bastin (1961) have published exhaustive analyses of styles and techniques

represented in the Dundo collection, and Himmelheber (1939) has made a study of Kwango Chokwe artists that is particularly pertinent to this discussion. Furthermore, the ethnographies of Jaspert (1930) and Baumann (1935) contain lengthy descriptions of Chokwe arts and crafts as they function in the culture. Frobenius (1928) has published 37 tale texts, and there are shorter collections by Dellille and Burssens (1935), Montenez (1939), and others. Vicente Martins' (1951) collection of 157 Chokwe aphorisms is a model of its kind. Recordings of contemporary Chokwe music are sold commercially in Angola, and large unpublished tape collections are stored in the ethnomusicological archives in Dundo. The Chokwe region forms the southern boundaries of the sculpture-producing area of Africa stretching northwestward to the Gambia. The Makonde-Mawia of Mozambique and the South African Zulu are each isolated, and the sculptures often credited to Barotse and Lozi are actually made by the so-called Wiko, Chokwe and Luena immigrants into northwestern Zambia.

Every Chokwe considers himself at least a potential artist. The Chokwe personality has been characterized by a number of alien observers:

> Schutt (1881) thought them more intelligent than the Lunda, Carvalho (1885) admired their energy and decision, Pogge (1880) their intelligence and grace. Magyar (1859) refers to them as aggressive and revengeful, and Livingstone (1857) found them greedy and ferocious. Torday (1925) remarks on their strong national spirit, their solidarity and loyalty to one another. Mendes Correia (1916) describes them as intelligent, laborious, war-like and adventurous, with a genius for conquest and dominance, and with ability to absorb the inhabitants of the tribes they have conquered. White (1950) comments on their conceit and self-confidence and their eagerness for Portuguese acculturation. (McCulloch 1951:32)

With the possible exception of grace, all these characteristics still mark the Chokwe, who as a result were roundly disliked by all three colonial powers, and by most missionaries and civil servants. Instead of hard, dirty, greedy, and without dignity, in the course of field work we found the Chokwe eminently rational, earnest, quick-thinking, and rather repressed by the elaborate conventions of their culture when faced with the problems of immigration and acculturation.

Methodology of the Field-Project

The research on which this paper is based took place between January and August, 1960, in the then-Belgian Congo and the contiguous areas of Angola and Northern Rhodesia (now Zambia), with headquarters at Dilolo Gare, Katanga, supported by a Ford Foundation Foreign Area Training Fellowship. An American missionary, on being apprised of the research plan, remarked that, "It's like trying to study art in Little Rock. There isn't any here, and even if there were, this wouldn't be the time to study it."

Actually, the increasing political tensions preceding independence probably speeded our collecting of nearly 800 ethnographic specimens —not all of them art—for the Lowie Museum of Anthropology, University of California, Berkeley; the study collection of the Department of Anthropology, University of California, Davis; and several private collections. Chokwe craftsmen were eager to work for cash; Angolans in particular readily parted with old and less-than-old pieces in return for Congolese and Rhodesian currency. Before the outbreak of terror in Katanga, a trade route for Chokwe carvings was established from the Angolan hinterland across the unmarked frontier to Dilolo Gare; six Katangese *mukanda* initiation schools had contracted to deliver their masks and paraphernalia on completion of their rituals. Many famous carvers, metalsmiths, potters, basketmakers, and other craftsmen in a 30-mile radius of Dilolo Gare had accepted commissions, and others were making objects in hopes of future sale. The resident Chokwe Grand Chief, the Mwa Tshisenge, presented us with a rare basket as a mark of his approval, sold us several pieces from his collection, and graciously permitted his court carver to accept commissions from us.

We accepted as a basic premise that art activities are not some unknowable divine fire beyond the understanding of mortal man, but rather the arts can profitably be studied by the same methods as those used cross-culturally in studying religion, family organization, and other intricate and deeply personal aspects of culture. One never expects to know all about an institution, much less an individual, but with adequate time, effort, good will, and perspicacity, a fairly good working knowledge of the subject can be developed. Hidden preconceptions become apparent to the researcher, and he must be prepared to find unexpected and often unsympathetic results. Although I expect to be accused of denying in advance the existence of something I

cannot prove, I do not believe that an individual or a society can feel strongly about something they never mention, or for that matter, have no words to describe. This is no more than the obverse of the old idea that the major interests of a people will be reflected in the richness of their vocabulary on these subjects, the oft-cited case being the descriptive terminology for cattle among the Nuer (Evans-Pritchard 1940). This point of view contradicts a belief widely held, at least in our culture and epoch, that the creative act and the experiencing of its products are by their very nature incapable of being described or discussed. In practice, artists in our culture as well as in most others prove to be voluble about their activities, at least on the technical level, though understandably they do not often sound like art historians or aestheticians.

Proponents of a related idea, the so-called intentional fallacy, hold it unnecessary to consider the artist or his intention in evaluating his work and fallacious to judge a work of art successful (or beautiful) to the degree it accomplishes the aesthetic and/or other goals of its creator. This viewpoint, although widely held (Beardsley 1958, Hospers 1954–1955, Gendin 1964), seems untenable without a supracultural, supraepochal absolute criterion by which all art may be judged. Art historians and aestheticians continue to act as if such a criterion exists, but to my knowledge never state it. If the study of comparative arts is to advance, we must find a way of demonstrating in an irrefutable manner the invalidity of cross-cultural and cross-epochal value judgments of art objects—or the validity of the concept of culture as it applies to the arts—so that the art establishment will come to perceive and understand the nature of the problem.

In the field, we used the most obvious and traditional of anthropological methods, particularly observation, undirected interviewing, and where feasible, participant observation. Because of the complex linguistic situation in the area (where French and Portuguese are the administrative languages; Chichokwe and Kiluena are used in schools; Kilunda, the language of the artistocratic chiefs; Kiswahili, the railroad trade language; and no English-speaking informants were available), a multilingual questionnaire in English, French, Chichokwe, and Kiswahili was used for gathering documentation for specimens as they were collected. This questionnaire elicited necessary information about the artist, his training, background, methods, sources of material, and his description of the functions of the specimen. Although French-speaking translators were used whenever available so that the data could be gathered word-for-word, the questionnaire

made it possible to gather at least some information without translators. The answers were recorded phonetically and later translated. This was useful in Angola where our Congolese translators were forbidden entry visas and in cases where artists were members of lineages inimical to those of the translators. All documentation for specimens was typed on punch cards for later sorting.

After rapport had been established and commissions given to a number of artists, some experiments were attempted:

1) An artist was asked to make six masks exactly like one he had just brought to us.

2) An artist was asked to make a mask in six stages of completion.

3) Artists were asked to make miniature copies of large objects, and giant copies of small objects.

4) Artists were asked to make copies of objects shown them in photographs. Subjects included ancient Chokwe objects, stylistically distinct Chokwe objects from other areas, objects from other Congo tribes and from West Africa, objects from Mexico and Oceania, and objects from a rival carver.

5) Artists were asked to make objects requiring materials with which they were not accustomed to working: a metalsmith was requested to do a mask, a carver a ritual adze in wood, etc.

6) New materials were introduced: brown wrapping paper, colored inks, burlap, manila construction paper, carbon paper, crayons, watercolors, and commercial paints. European carver's tools were en route when we were forced to leave the Congo.

7) Portraits were commissioned in all possible media.

8) Artists were requested to introduce literary subject-matter into their art, e.g., the pseudohistorical tale of Lueji, the Chokwe ancestress.

In another series of experiments less pertinent to this paper, we varied methods of paying for collected or commissioned pieces, haggling sometimes and paying overmuch other times, requesting credit, offering to pay in goats rather than in cash, using foreign currency, large denominations, metal coins as against paper money, and employing collecting agents on a percentage basis.

The most useful device was the institution of a kind of museum of Chokwe art in the field headquarters, which was an ordinary concrete block house with large casement windows, situated on a busy corner where roadworkers waited to be paid. The walls were decorated with public Chokwe arts, and other sculptures, baskets, and pottery were arranged on tables. A similar display of secret *mukanda* initiation

paraphernalia was in an interior room where it could be shown to men, and on occasion, to intrepid women. Since most of our best informants never came to Dilolo Gare, we carried a similar traveling show with us along bush roads, with local barkcloth bags for secreting the ritual masks and objects. Both displays were immediately popular and never failed to draw a crowd. We asked the viewers to give opinions of individual pieces, to rank several pieces, and even to give their reasons for their preferences. When a piece was criticized, the speaker was asked to suggest suitable changes, or "how he would have made it." Great care was taken to catch and record comments of others while a person was being questioned, and the informant-translators later reproduced as much as possible of the controversies that broke out between viewers. I do not doubt that much of this material was distorted by linguistic problems, the nature of translating, the unnatural situation of talking with a European under the scrutiny of one's friends, the novelty of the very idea of interviewing or of taking seriously the ordinary objects of daily life, but within these limits, some idea of Chokwe aesthetic values became apparent.

The Range of Expression of Aesthetic Value

The problem of differentiating art from nonart among the Chokwe is minimized by the degree of institutionalization of art education and production. Furthermore, verbal skills are greatly admired, and Chokwe pride themselves on being able to verbalize clearly—a skill learned by boys in the *chota* or men's hut. Added to this, the Chokwe are literally "a nation of artists," with each person feeling himself capable of producing fine work, and hence perfectly qualified to comment on the work of others. Chokwe art has continued to be produced, in spite of drastic changes in religion, economy, and political life, because of support from the courts of chiefs, and the functions of art objects in the recurring *mukanda* (initiation rites). The total image of art production is not unlike that of more familiar cultures and epochs such as Medieval Europe or contemporary Mexico.

The "range of expression of aesthetic value" of the Chokwe include the following:

1) Wooden masks, both secular and religious.

2) Religious masks of resin-covered barkcloth.

3) Secular wooden figures, including representations of masked dancers, decorative figures for splats of stools and chairs, dolls for children, and animal figures for home decoration.

4) Religious wooden figures, *mahamba* and *jinga*, used in individual magic practice. Other types of uncertain function. Miniature figures also used in professional *mganga* divination.

5) Wooden bowls, food stirrers and paddles, ladles, hair combs, flywhisks, pipes, bellows, and other household objects. Other materials such as leather, metal, and pottery used to complete or embellish some of these objects.

6) Decorative wall paintings, both abstract and representational, made by women and boys, using colored clays.

7) Calabashes, either polished or incised with abstract and representational designs.

8) Decorative and/or functional metal objects, such as hatchets, adzes, knives of many sizes and designs, daggers, gongs, hoes, arrowheads of many designs for specialized uses, and other tools.

9) Leather scabbards, belts, pouches, etc., sometimes tooled, but also with the animal hair still in place, and used for its textural quality.

10) Pottery bowls, pots, trays, pitchers, decorative figures, ashtrays, and elaborate water carafes (*milondo*) with sculptured figures and incised or impressed decoration, all for use solely by Africans.

11) Coiled and plaited baskets in many forms for particular uses; wicker burden baskets, manioc sieves, and chairs; fine mats.

12) Musical instruments of many types and materials, often embellished and highly admired as works of art, including drums, slit gongs, gourd xylophones and gongs, thumb pianos, flutes, rattles, and stringed instruments both plucked and bowed.

13) Costumes and mask hoods of knitted fiber and/or imported wool yarn.

14) Traditional barkcloth clothing has been completely replaced by trade cotton, much of it designed by Congolese and manufactured in the Congo. Instruction by Belgian nuns in the *Foyer Social* has spread sewing, knitting, embroidery, and other needlework skills among the women. Any consideration of contemporary aesthetic attitudes among Chokwe women must include their evaluation of clothing and also cicatrization, teeth filing, and coiffure.

The verbal and mimetic arts of the Chokwe are considerably less well documented, but their basic types appear to be:

15) Folktales (*ishimo*) with both animal and human characters.

16) Pseudohistorical legends, told as true, concerning the origin of tribes and lineages. No "religious" myths were heard.

17) Proverbs (*ikuma*) and sayings (*mianda*).

18) Secular and religious songs, including some obviously influenced by European forms such as Portuguese *fado*.

19) Dances, both secular and religious.

It should be noted that this list is essentially what an alien observer might consider to be art, also providing the techniques were skillfully executed. But the Chokwe give higher evaluation to metal objects, whether elaborated or strictly utilitarian, than outsiders would.

In the Chokwe mind there are two aspects to what we call art, the technical and the functional, or to use our traditional terminology, form and content. Most of the verbalizing by the Chokwe artists—and I suspect by other artists—concerns *how* to make the objects under discussion. For instance, the elaborate processes involved in smelting iron from ore in a furnace hollowed out of an anthill are understandably described as "a miracle," and help explain the high status of all metal objects, even those made from trade iron. The Chokwe expend great effort in gathering particular materials for their art, and artists will talk at great length about the properties of particular materials for particular uses. Techniques, tools, the styles are discussed and compared, but the strictly aesthetic aspects of an object are not always clearly differentiated from the technical. Knowing how to make an object well *includes* knowing how to make it beautiful, a standard which would hold for most craftsmen in other cultures, including our own. Indeed, the concepts of good and beautiful are not differentiated in Chichokwe, both being described as *chibema* (*chipema* in Angola). Thus an ugly woman who is a faithful wife and good mother is *chibema*, but so is a pretty but faithless wife. This lack of linguistic distinction between the aesthetic and the moral became a favorite subject in the *chota* men's houses. It was ultimately decided that the differentiation was made on the basis of context, and one French-speaker suggested that the similarity in sound between French *bon* and *beau* imply a common linguistic origin and relatively recent differentiation.

The second consideration is how the art object is intended to function in Chokwe culture, and here there is a certain distinction between what might be called the religious and the secular, or more exactly, the special and the ordinary. The most theatrical art forms are all associated with the *mukanda* initiation rituals for boys (and to a lesser extent girls) which employ masked dancers representing 30 or more stock characters who are spirits and who may be generalized ancestors. These 30 personages or *mikishi* (singular, *mukishi*), in spite of their religious connotations, dominate all of Chokwe art, and may appear

at village secular dances or political rallies. Their representations, often
in symbolic "shorthand," appear on such mundane objects as pocket
combs (*chisakulo*) and porridge paddles (*luiko*). At the same time,
while there are many objects without reference to *mukanda* characters,
representation of non-*mukanda* subjects appears to be rare except for
birds and snakes.

The Masks of Mukanda Rites

Between the ages of 7 and 15, groups of Chokwe boys usually number-
ing less than 20 and often from a single family, lineage, and/or village,
are segregated in the bush away from their homes, families, and
friends. They are first circumcised by a specialist usually brought from
afar and, when healed, are put through a period of initiation which
may include hazing, formal instruction in the arts, religion, magic
practice, and sex. Initiates wear no clothing except a short palm fiber
skirt suggestive of the *tutu* of classical ballet and sometimes a brimmed
hat of woven leaves. All live together in a small, crudely constructed
hut in the bush, and eat cold food brought from their village by an old
woman, the only female they are allowed to see. Although much of the
actual instruction is carried on by older boys and young men, one of
whom is assigned to each initiate, the *mikishi* appear at the opening
and closing festivities of *mukanda*, and may take an active part in the
daily routine as well. *Mukandas* may last from six weeks to a year, with
three months the contemporary average.

This institution, which has been reported from Livingstone
(Zambia) to Leopoldville Province, is shared by many tribes and
evidently the unique barkcloth masks and red, white, and black decora-
tive style are an integral part of the practice. Since *mukanda* has been
exhaustively (if not definitively) described in the literature (Mc-
Culloch 1951:85–91), it will be discussed here only as it applies to the
problems under consideration.

The most important *mikishi* in Chokwe art are:

Chikuza—the "father of the *mukanda* lodge" and final authority on
discipline, represented by a tall, conical barkcloth mask surmounted
by a long cord and tassle. Chikuza is fierce, and carries a long willow
whip with which he attempts to beat any women or boys he sees.
Chihongo (or Chirongo)—an aristocratic figure, possibly the apo-
theosis of a chief, represented by a large barkcloth mask with char-
acteristic wide, swooping, off-the-face hatbrim and round, jutting

beard. Wooden masks of Chihongo are known, and small wooden figures of him are among the finest crafted of all Chokwe sculptures. The dancer wears a skin-tight knitted fiber costume, and in the Dilolo Territory at least, a palm frond skirt over *paniers* à la Marie Antoinette, so that when he dances, his hip movements suggest an exaggerated hula.

Kalelua—a stern personage who chases boys and women, wearing a barkcloth mask surmounted by a huge sombrero-like hat and a skin-tight knitted fiber suit with plain palm kilt like that of an initiate.

Chiheu—"impotent man," a small round barkcloth mask with buck teeth, worn with knit costume and kilt, under which is often concealed a large wooden phallus and testicles of dried calabashes. He chases women in parody of Chikuza.

Chizaluke—a small round barkcloth mask with white existentialist chin whiskers and three raised knobs across the top of the forehead, said to represent "an old village chief." The dancer nods his head as he dances.

Mwana pwo—"young girl," the favorite subject of Chokwe art, represented by a male dancer wearing a skin-tight knitted fiber costume with false bare breasts, a skirt or "diaper" of trade cloth, a heavy bustle filled with sand and decorated with feather cockades or fringe, and a wooden mask surmounted by a representation of a wig formerly fashionable among Chokwe women, represented by a wooden extension of the mask, by an animal pelt, or by a wig itself, made of knotted fiber impregnated with liquid clay. Mwana pwo dances with short, mincing steps, and appears to vibrate while the bustle leaps and the rattles resound. The dance is extremely difficult and tiring, and is considered humorous by the Chokwe. Mwana pwo sometimes does acrobatics on a tightrope or tall pole, or walks on stilts, and is thought to personify femininity and grace. Although Mwana pwo's function in *mukanda* is evidently connected with sex education, she is often called upon to entertain a chief's guests, advertise a political rally, or even to collect funds from motorists at a crossroad.

The remaining mask types of *mukanda* are less clearly categorized, and appear less frequently in art. Ngondo, a mask with bug eyes made from halves of calabashes, while unimportant among the Chokwe, is a major figure in Pende *mukanda*-like initiation rites, and the Luena favor Linya pwa with his puffing cheeks and high crest.

Techniques

All these masks, with the exception of Mwana pwo, are made on a frame constructed of pliable withes firmly lashed in place with fiber, then covered with local barkcloth which is tailored to shape and sewn in place with fiber cord. The whole construction is then heavily coated with a black tar-like tree resin which may have a matte or shiny surface. The surface is traditionally decorated with dots, stripes, and zigzag designs drawn in red (*ngula*) and white (*pomba*) clays. In recent years, however, fine masks have been made with brown wrapping paper from a Greek grocery, replacing the heavier barkcloth, and with red and white commercial enamel or red cotton or flannel trade cloth and white paper—sometimes cut with pinking shears or otherwise scalloped by hand—replacing the colored clays. Resin *mukanda* masks are usually made by the organizers of the rites, and are used for only one *mukanda*, since they tend to deteriorate rapidly when worn, not only because of the necessarily intense dancing required of a *mukishi*, but also because of their great size, weight, and composite construction.

Mwana pwo and other wooden masks and figures are made by processes similar to those of West Africa. A suitable tree is found and cut down, different species for different types of sculpture, with heavier wood preferred for chairs or easily-broken objects such as hunters' whistles, and lighter wood preferred for masks. A section of the tree is then roughly cut to the approximate size and shape of the planned object, using a small locally-made wooden-handled iron adze. The rest of the log is kept for future use, or given to another carver. The piece of wood is held in the left hand, the adze in the right, and this stage of the carving proceeds with startling rapidity with chips of wood flying in all directions as the figure emerges. The adzing technique is different from any used in our culture, not only because the block of wood is constantly moved by the carver (rather than the carver moving around the block), but also because the chopping action of the adze is one we associate more readily with crude labor such as splitting logs. Yet the Chokwe carver can control with considerable precision the degree to which the adze will penetrate the wood, as well as the exact placing of the cut. Two basic cuts are used, one which enters the wood roughly parallel to the outer surface and tears back a slice, and a second cut which chops off the slice where it still remains fastened. Thus the wood is actually rent away from the block in fairly large chunks. A large mask can be completely blocked out in detail in less than half

an hour. The adze is even used for quite fine work, but the final smoothing and precise details of cicatrization, ear conformation, and the like are made with a locally-made *poko* paring knife. The wood may then be rubbed with sand or rough-surfaced leaves, and in both these final processes it may be supported on a log or block of wood between the carver's legs. Pyrographic decorations may then be added with a heated knife blade or commercial nail, or the surface may be colored with red-brown *ngula* clay or vermillion or yellow juice from ripe or green *chindende* fruit seeds or blackened by charring with a candle. Uncolored surface designs may be incised on all these prepared surfaces, or the surface may simply be oiled. Figurines may be further decorated with trade beads, kilts of barkcloth or trade cloth, fur or feathers, and wooden masks may be decorated with the wigs described above, knitted fiber neckpieces (which are sewn to the costume), small antelope horns, pelts, shells, nuts, copper earrings, noseplugs, and teeth of metal or whitened wood.

Only a few such descriptions of Chokwe technology can be given here, even for the plastic arts which are the subject of this paper. The graphic arts, folklore, music, and dance are also sufficiently complex to require detailed analysis, since each has famous practitioners and wide variation in interpretation of traditional forms.

Technical Training

It was possible to observe the teaching of the arts in two different institutional situations, in the *mukanda* and in the school of apprentices around a famous professional carver. Although several *mukanda* were studied, the teaching methods described below were observed at the village of Katende Jean, in the Luena *chefferie* of the same name 35 miles southeast of Dilolo Gare.

Each of the 17 boys who had been circumcised was assigned an older boy ("shepherd" in the literature) who was in charge of his deportment and education. Before dawn each day, the initiates were roused from their beds of leaves in the *mukanda* lodge by the whip of the *mukishi* Chikuza, and made to dance for an hour or so as the sun came up, accompanied by a large and a small drum played by older boys. Their dance steps and timing were criticized by the masked figure, who often attempted to whip a clumsy boy to the amusement of the others. In late afternoon, a second dancing class was held, the *mukishi* being represented by a rather battered mask of Kalelua placed on a post, and the older boys criticized the dancers. In both cases, the

dancers wore only the palm frond kilt and were arranged in a single line. Dance steps were unnamed, but were evidently associated with particular *mikishi* or other masks such as Katoyo, a clownlike secular mask, or Ngulu, a secular pig mask used in evening social dances. The basic steps are variants of the kick and the shuffle, the body weight alternating from leg to leg, and with the dancer remaining almost in one place throughout the dance. Arm and body postures varied from dance to dance, and no attempt was made to have the dancers in unison at any one time. According to the Chef du Secteur, Katende Jean, whose eight-year-old son was an initiate, dancing of this type is limited to *mukanda*, as a kind of basic requirement for future specialized dancing as a *mukishi*. The characteristic quivering steps of Mwana pwo or the hula of Chihongo were not observed among the boys, but their footwork appeared similar to these.

The full range of specialization exists in dancing outside the *mukanda*, from the man who learns basic steps in *mukanda* but dances little afterwards, the man who dances in secular village fetes only, the amateur *mukishi* dancer who appears only in his own village, to the complete professional, who is supported by a chief and functions as his courtier, or may travel from court to court and live off tips from audiences and host chiefs. There are similarly Chokwe carvers in all these degrees of specialization.

Musical skills are taught in the same way, with the older boys as mentors of the younger, and both under the supervision of a few qualified adults. *Mukanda* provides ample opportunity for each initiate to play each type of drum and the large *chikuvu* slit gong, since these are used several times daily. Rattles, flutes, and thumb pianos are commonly made and played individually during *mukanda* as well. Needless to say, a great many boys come to *mukanda* already knowing how to play one or more of these musical instruments, having been taught by their peers, older boys, or father or uncle. No sight is more common in Uchokwe than a boy walking along a road playing a flimsy thumb piano of balsa-like wood with bamboo keys. In village dances, pre-*mukanda* boys often join in the drumming, even for professional dancers, either to spell one of the regular drummers or merely to tap out the rhythm with fingers, knuckles, or sticks on the side of one of the drums. Women and girls are the chief singers at village fetes and often practice together as they work at household tasks, particularly when crushing manioc with mortar and pestle. Women also commonly shake rattles and clap their hands in elaborate rhythms to accompany drummers and dancers.

The making of masks and musical instruments follows this pattern combining observation, emulation, instruction, and practice, and is seen in its simplest form when a boy attempts to copy his father or maternal uncle as he makes a small and crude *jinga* charm. Pre-*mukanda* boys are not allowed to observe the making of *mikishi* masks, since they and all women are supposed to believe that the *mikishi* are spirits incarnate—a fiction strictly upheld by most conservative men and women but not by younger urban Chokwe. Boys, however, may make dolls representing *mikishi* as gifts for their sisters or cousins and combs and brushes (with small nails replacing bristles) for themselves and sometimes also small crude masks to be used as toys. They are also allowed to watch their fathers or uncles making *mahamba* figures for luck in hunting, the minimal art activity of most Chokwe men. In the *mukanda* itself, the boys are required to make some barkcloth masks, and to repair those which wear out in the course of the ceremonies, and also to carve wooden masks, *jinga*, and *mahamba* figures. Those who find carving congenial may then persuade a well-known carver to teach them further after the *mukanda* is over.

The choice of a carving teacher is based on convenience and family connections. Among the artists studied, many had learned from their fathers, but a large number had also been taught by maternal uncles or maternal grandfathers, since many rural Chokwe are matrilocal. Older brothers, nonrelated older boys, and age peers were also mentioned as teachers. Most of this education is casual and unpaid, but sometimes a formal apprenticeship relationship is set up when a carver is otherwise unwilling or when there are a number of boys requesting training. In this case, the pay is usually in the form of sheep or goats, which are also the common forms of payment for commissioned art objects. In some cases, cash may augment the payment in kind, and of course, the boy is expected to do all the hard work, gathering suitable materials, finding trees of the right size and species, sharpening tools, and what is more important, taking over the hated agricultural labor every Chokwe must do for sustenance. This latter help is the real lure of the apprenticeship system for the carver, allowing him precious leisure either for its own sake or in order to carve, and escape from despised field labor. For the apprentice, the output in labor and family livestock are rewarded by greater prestige and usually greater skill than he would have been able to achieve in his family village. Chokwe boys are glad to get away from the dominance of their family elders, find the carvers demanding in labor but lax in discipline, and enjoy the camaraderie of the other apprentices.

There are a number of other means of obtaining training in arts and

crafts. At least a few Chokwe boys have attended the Ecole des Beaux Arts in Elisabethville (now Lubumbashi), and one was said to be a commercial artist employed by a newspaper, but his name could not be recalled. Others have learned to carve from Europeans at missions or from Luba or Mbunda carvers with deviant styles. In areas where basketry grasses or pottery clay are found whole families of craftsmen will produce these crafts for sale to the surrounding area and distribute their wares in nearby weekly markets. In these families, the mother may work along with the father, and the children serve as apprentices, preparing materials and doing the noncraft chores.

No guilds, endogamous castes or lineages of craftsmen have yet developed among the Chokwe as they have in West Africa. But the art of smelting and working metal with its particular prestige and aura of magic and secrecy, attracts chiefs who are proud of their skill as *fuli* or metalsmiths. Such craftsmen may have the same degree of fame as a carver. In this case, the Chokwe do not differentiate between utilitarian metal tools and functionless prestige objects such as ceremonial axes or daggers carried by chiefs. Elaboration is appreciated, whether in cold chisel designs on the metal, in tooled leather loops or scabbards, or in wooden handles carved or decorated with pyrography or trade cloth.

It will be noted that, in spite of the existence of means for carrying on art education, most people learn most of their skills simply by emulation and occasional demonstration by a person more skilled than they, but not necessarily by an expert. Girls, for instance, pick up basketry this way from their mother, aunts, grandmother, or other village girls, and it is also the commonest method of learning to make pipes, dolls, common musical instruments, crude wall paintings, and nonprofessional mortars and pestles. Art education, like so many other Chokwe cultural elements, consists of a number of distinct but more or less equally acceptable means toward a common goal, with the choice left to the individual. Thus the practicality and efficiency credited to the Chokwe are manifested even in art training and go far to explain the continued vitality of Chokwe art in the face of immigration and urbanization.

Three Professional Artists

SANJOLOMBO AND HIS SCHOOL

The first professional artist chosen for detailed study is the prototype of the traditional *songi* (woodcarver) surrounded by apprentices and followers. Sanjolombo is the village chief of a village bearing his name

in the Luena *chefferie* of Katende Tshipoye, 30 miles southeast of Dilolo Gare. He is now in his sixties, a slight, finely-featured old man with graying hair and a fine pattern of wrinkles spreading over his face and body. He is conservative, non-Christian, has never attended any school, and usually wears nothing but the traditional wraparound kilt of trade cloth (originally barkcloth). Elegance and authority are expressed in his every gesture, and he is shown marked deference by all, even raffish street boys.

Sanjolombo was born in the village of Chokolutwe (or Xacalutue) of uncertain location, but probably in the Alto Zambeze Province of Angola, where his father was village chief. After having been impressed as a road laborer by the Portuguese administration, he and his crippled younger brother Kawina Liwema decided to emigrate to the Congo. Although dates and distances are vague in their minds, the emigration probably took place about 25 years ago. Sanjolombo is very much a Chokwe because his mother was a Chokwe, but his father was half-Luena, which may explain his having settled in a Luena *chefferie*, where many of the residents of his village are Luena. The two tribes, distinct in language and other aspects of culture, share matrilineal kinship structure, and the lineage system cuts across tribal lines. Although Sanjolombo indicates the direction of his home village as southward, he lives only a mile or so north of the Angola-Congo border, so he may simply be indicating Angola in a general way. The stylistic affinities of his art are not yet identified, but it can be stated definitely that they are distinct from the Caianda-Nana Candundo-Cavungo style of stools (*chitwamo*) with thin, flat legs, splats, and runners covered with precise geometrical incising, the style predominant in Alto Zambeze. Rather, the similarity of his "spherical-headed" style to Ovimbundu pieces suggests that he may have come from the western part of Chokwe-Luena country near Vila Luso in Moxico Province.

But whatever his ultimate origins, Sanjolombo is now considered the dean of Katanga Chokwe *songi* in the Dilolo Territory. His pieces can be identified by many men and boys 50 miles to the north, and although he rarely leaves his village situated at the end of a particularly difficult sand track, he has received many commissions from chiefs, professional dancers, and Belgian administrators, from as far away as the Sandoa Territory 100 miles northward. When the news spread through Dilolo Gare that new masks from Sanjolombo had arrived at the field headquarters, large numbers of men and boys stopped to see them, providing an ideal opportunity to collect expressions of opinion

and relative value. The gasps of delight, the rush to handle the pieces, the good natured arguments over authenticity and detail, all served to indicate the centrality of Sanjolombo's art in the consciousness of the Chokwe of Dilolo.

Sanjolombo's village consists of perhaps 20 families housed in thatch-roofed houses with clay-brick or concrete block walls, scattered haphazardly along a creek and sloping hillside covered with brush and small trees. Unlike most Chokwe villages, it does not have a central plaza and grid pattern of streets, but the numerous small buildings of a single family are usually built around a bare, sandy yard wherein most of the family work takes place. Sanjolombo and Kawina Liwema each have two wives, and there are a number of children, adolescents, and adults who use the yard. Perhaps 300 feet from this cluster of buildings in the direction of the road stands a low, square, thatch building similar to the low, open-sided *chota* or men's palaver house, except that three walls are covered with thatch, and the fourth wall, facing away from the road but opening on the creek, is left open. This building, less than 10 feet square, functions as the usual workshop for the carvers. Because of its isolation and enclosed sides, they can work on objects forbidden to the sight of women and uncircumcised boys. If the objects are not secret, the carvers sometimes sit and work in the shady area in front of the *chota*, which seems to function not only as a carving atelier but also as the village men's house. At any time, two or three young men or boys can be found watching the work in progress, and occasionally lending a hand or offering a criticism or suggestion.

Two boys are formally apprenticed to Sanjolombo, one from this village (who lived at home) and another from a nearby village, who lived with Sanjolombo. The father of the local apprentice and San-jolombo's brother Kawina Liwema, both of whom have learned their art from Sanjolombo, also work on pieces, as do a number of other local young men. Since Sanjolombo has taught most of them in the course of *mukanda*, although not formally as apprentices, they work more or less in his style and under his watchful eye. Although indi-viduals are invariably given credit for particular pieces, the formal apprentices and the village boys undoubtedly gather most of the ma-terials, and carry out such chores as sharpening tools, dyeing fibers in river silt, knitting costumes and neckpieces of locally-made fiber, and painting objects with red clay. Because of constant inspection and criticism, the level of skill of all pieces appears absolutely consistent.

But even though it is impossible for an outsider—Chokwe or Euro-american—to distinguish between a piece by Sanjolombo and another

by his brother or apprentices, in either style or technical skill, there was a tremendous variation in style in the total output of the atelier. They seemed to work in three distinct styles: 1) the traditional style of large barkcloth *mukanda* masks decorated in red and white clays and raffia (usually real barkcloth but red and white commercial paints here); 2) a unique woodcarving style used for wooden masks, figures, and the figures used to decorate stools; and 3) a strange, seemingly archaic style of figure with smooth spherical head with small features placed close together and low on the sphere, and thick body with bent legs and minimally represented arms, often carrying on some action such as shooting a rifle.

The barkcloth style is similar to that found elsewhere in Angola, Katanga, and Zambia, and relatively conservative because barkcloth rather than brown wrapping paper or burlap is used, and daubs of paint rather than red trade cloth and white paper cutouts decorate the masks. One is tempted to conclude that *mukanda* masks, with their religious associations, are less susceptible to innovative variation than other kinds of objects, except for the fact that wooden masks, particularly Mwana pwo and Chihongo are used in the same ceremonies and have the same origin, yet vary considerably from carver to carver. An alternative explanation is that the complex composite nature of barkcloth masks limits the amount of variation possible, but this is denied by the very profusion of types of barkcloth masks as well as their baroque nature which lends itself to considerably more improvisation than wooden masks.

Sanjolombo's major style for wooden objects is the opposite of his generalized and conservative barkcloth style, being unique and immediately recognizable as his. The faces are relatively small, and the surface of the mask curves from ear to ear, but not from forehead to chin. The material is usually fine-grained wood, oiled to a medium brown color, and decorated with pyrography or softer wood colored with red clay and pyrography. The style's main feature is ridges—eyes are represented by ridged slits enclosed in the traditional "eyeglasses" aureoles of Angolan Chokwe Mwana pwo masks, the mouth is made of two similar horizontal ridges separated by a slit or by small carved teeth, and cicatrizations on the forehead, between, under, or at the sides. The eye depressions are also represented by ridges, or by raised crosshatching, which might be considered the superimposition of horizontal and vertical ridges. Masks are very finely smoothed and finished and come complete with knitted fiber neckpiece and wig of loose black-dyed raffia.

On *tuponya* (singular *kaponya*) figures and stool figures, the same style elements are used to represent Chihongo, Kalelua, Chikuza, and other *mikishi*, as well as Mwana pwo, generalized men, women, and dogs. The faces are exactly the same as masks, except for the simplification required by the drastic reduction in size. The raffia wig is replaced by a representation of it in raised crosshatching, and a similar effect represents the red and white markings on the headdresses of *mikishi*. Bodies are usually somewhat short and thickset and rather abstract in form, the sides of the torso and legs often being in the same or parallel planes, as are the arms if represented as not resting against the torso. Fingers and toes are represented by minimal incising, and both hands and feet are blocky wristless extensions of arms and legs. There is no attempt at realistic representation of musculature, but the umbilicus, ruptured and/or outlined with cicatrizations, is commonly featured. Dogs and other animals are equally abstract, but may have circular pyrographic designs to represent spots. The animals closely resemble the larger animal divination figures made by Wiko in Barotseland, many of whom are Chokwe from central Angola, again suggesting the origin of Sanjolombo's style in southern Moxico.

The third or "spherical headed" style is also widely known as Sanjolombo's, and the body can be considered a drastically simplified and undecorated version of the *tuponya* bodies. When queried about this style, Sanjolombo reported that he had learned this way from his father, his major teacher, and that it was only used for figures. He claimed to know of no magical, fertility, or other religious uses or significance for the smooth spherical head, but pointed out that *mahamba* and *jinga* figures have these functions but are quite different in style—with short, broad faces, conical coolie hats, and necks the same circumference as torsos. In common with many ethnographers, he could not distinguish the Ovimbundu from the nearby Mbunda and the distant Umbundu of Luanda.

Sanjolombo and his group were at pains to present their work in the best possible light. On first meeting, he showed us several incomplete pieces, and allowed us to buy one that supposedly had been commissioned by a Belgian *agronome*, saying he would make him another. We asked him to make several pieces, a Mwana pwo mask, a barkcloth mask, and a spherical-headed figure such as he had sold us. When we arrived two weeks later, we were seated on stools at the edge of the yard in the shade. After a suitable interval, while we chatted over cigarettes (provided by us), a falsetto voice could be heard singing and shouting in the distance, and the women began to make a particular

yodeling ululation that gives warning that a spirit is in the vicinity. The *mukishi* appeared from behind us, forcing us to swivel around on our stools to see his fantastic figure darting from behind trees, waving and lunging at women and boys. On arrival, the *mukishi* danced ecstatically for us to improvised drum effects by older boys using buckets or stools, smoked a cigarette *through* the mask, told jokes using occasional French words, lectured us seriocomically, instructed us on the proper way to "dance the mask," and completed his show by begging a few francs before dancing off down the road.

In a half hour or so, the dancer returned with his paraphernalia and the new mask carefully hidden in a huge barkcloth bag, and we began the traditional haggling over price. Although we had explained our position as teachers and our desire to show Chokwe art to the students and others, they obviously felt that we really intended to use the masks for magic practice involving dancing. The wealth of Europeans is commonly explained in terms of superior magical powers, supposedly gained by eating human flesh and blood obtained in cans which contain kidnapped Africans who were processed in firehouses. The whole complex of ideas is usually termed *mumiani*, and, unfortunately, too intricate to be described here in detail. In any case, they expected us to pay well for the masks and related dances. When we objected to the high prices, a dollar-down-dollar-a-week arrangement was suggested and later on carried out. When we did not have enough small denominations of currency, the carvers preferred to give us credit rather than accept the local equivalent of a twenty dollar bill, saying "The white man will say we stole it." If we tried to lump all objects together to simplify and shorten the considerable time spent in haggling, we were told that each piece was the product of a different hand, although we had evidence that some at least were composite work of several apprentices and a master.

Except for the existence of three styles in one school of carvers, the total similarity of technical skill from old master to youngest apprentice was remarkable, suggesting either that the training of all had been rigorous, or more likely, that each piece was criticized and corrected until it achieved the desired standard of excellence.

ULULI KOMBANIYA, COURT CARVER

The second professional artist is also a *songi* or woodcarver, but rather than a master surrounded by his protégés, he is a young refugee supported by an enlightened chief. Ululi Kombaniya was born in 1922 at Sacanje, Angola, "between Saurimo [called Henrique de Carvalho

on Portuguese maps] and Tshikapa," and hence from the Lunda Province, the Uchokwe heartland and location of the Museu do Dundo. His last name was said to come from the Portuguese *Companhia*, from Companhia de Diamantes de Angola (DIAMANG) which controls his home area. He was trained by his maternal grandfather, Saupite, who died in 1958, after which time he moved to the border village of Chiloaje on the Angola side of the Kasai River north of Dilolo. When the Portuguese administration again threatened to impress him for road work, he crossed into the Congo and settled in the village of Mwa Kanyika, the deposed chief of the Chokwe *chefferie* of Tshisenge now ruled by his younger brother, the Mwa Tshisenge. The villages of the two brothers are only a few hundred yards apart and about 12 miles north of Dilolo Gare. Mwa Tshisenge, in spite of his advanced age, is an extremely intelligent and popular ruler, and after the supposed defection of Samutoma, Grand Chef of the Katanga Chokwe, from ATCAR to CONAKAT political party, Tshisenge became the de facto Grand Chef, and his village, the tacit Chokwe capital. But even before this pre-independence change of status, the Mwa Tshisenge had invited Ululi to settle near his court, and to produce objects for his use. As time went on, Ululi became a kind of court carver, providing the Mwana pwo masks, decorated wooden bowls, combs, decorative snakes, stools, and other accoutrements of the chief's home, court, and dancing place. Other craftsmen, particularly basketmakers, metalsmiths, and potters also provide objects for the chief, but because of the centrality of carving in Chokwe culture, the prestige of the Grand Chef, and the skill of Ululi, he is easily the most popular artist in the Dilolo area.

Ululi's style, unlike those of Sanjolombo's school, is narrow and distinctive and, because of his distant origin and recent arrival, unlike the products of any other local carver. After completing the carving of a figure, he smooths the surface carefully with leaves and sand, then blackens the wood completely with a lighted candle, being careful not to char any part of the surface. He then incises elaborate designs into the surface, sometimes representing scarifications, hairdresses, the backbone, raffia costumes, palm fiber dancing kilts, knitwork, the fur, skin, or scales of animals, or abstract patterns. The incised designs are left uncolored, the light *mufufu* wood contrasting with the blackened surface. He also occasionally uses heated European nails to make geometric designs on unblackened areas, and sometimes colors the eyes, headdresses, or other sections of figures in vermilion or orange-yellow with the seed of the *chindende* fruit. He works only in wood

and does not make barkcloth masks, but a *mukanda* had not been held in the area since his arrival.

With the permission of the Mwa Tshisenge, Ululi accepted commissions "to make some fine things" for us. His first efforts, besides a previously-made snake from the Mwa Tshisenge's collection, were two small Mwana pwo masks stained bright red, with pointed chins, narrow slit-like eyes, pierced ears, thin flat noses with matchstick plugs through the septa (an archaism no longer worn by Chokwe women), and circular raised cicatrizations on each cheek. The Mwa Tshisenge insisted on keeping one, and we were allowed to purchase the other, but only after both were displayed in an impromptu dance in our honor. This mask was probably our most popular single piece among the young men of Dilolo, and represented the height of sculptural fashion at the time. More important, its possession served to authenticate our project in the eyes of conservative Chokwe, particularly the officials of the ATCAR political party, so that other carvers presented themselves for commissions, and nonartists collected objects and information for us.

Ululi's next products were four *tuponya* figures representing *mikishi*, made at our request to show the essential details of each of the stock characters of *mukanda*. The figures of Mwana pwo, Chihongo, Chikuza, and Kalelua, carefully incised and touched with red, illustrate the functions of *mukanda* masks as seen by the Chokwe. His next objects—a particularly fine bird, a monkey climbing a tree, and a bowl on a pedestal—although secular, were in exactly the same style, but with touches of yellow color rather than red.

Ululi, with his boyish appearance and deferential manner, proved to be a useful informant, especially when questioned in public. He obviously enjoyed the opportunity to discuss his work with Euroamericans while surrounded by an admiring throng of his own people. Although he usually suggested the subjects for his future commissions, he could also carry out detailed instruction to the letter. When asked how he got his ideas for carvings, he said that he planned them beforehand while he was resting or working on other objects. In his words, *Kausonga mubunge yenyi* ("I make them up in my heart"). When asked if he ever got ideas any other way, he told about having a dream wherein he saw a snake swimming in a lake while birds around the lake began to chide or mock the snake. When he awoke, he decided to carve this dream, which turned out to be a circular disc (the lake) with wavy and straight incised lines (reflections in the water, the waves) on which rested a raised three-dimensional snake undulating

across the center, surrounded by four squat birds with large eyes, arranged around the outer edge of the disc, and fastened to it by pegs and glue. The snake and birds were incised very simply, and the latters' eyes were stained yellow. Although snakes and birds in the round are the commonest decorative objects in Chokwe homes, their significance is unknown. Maesen, who found wooden snakes secreted under Chokwe beds in the Tshikapa-Kahemba area, suspects they have fertility symbolism, but neither he nor I ever found a Chokwe who would admit this or describe any other function than decoration. The birds, often crudely crafted, badly painted, admittedly made by small boys, and readily sold for very little money, are in even greater supply. Since almost all showed signs of wear, they do not seem to have been made especially for sale to us. When asked why the Chokwe have so many snakes and birds in their homes, Ululi answered rhetorically, "What do you want us to carve?" After all, ritual paraphernalia is hardly suitable for interior decoration. In any case, neither Ululi nor any other informant ever indicated that the "dream" guidance was related in any way to common snakes and birds.

Interestingly enough for the study of style, a similar "dream" was found in the huge collection of the Museu do Dundo, with incised surface and one more bird. The documentation for the piece, Catalogue No. G 588, was "tuponhe (i.e. *tuponya*, "figures"), Cacolo, Luachimo River, Kioko, offered by Sr. Napoles in 1948." The Luachimo River describes fairly accurately the region where Ululi was born and raised, but Cacolo is an administrative post 100 miles southwest of the river. However, carvings in a very fine black-and-white incised style were purchased near there from a Portuguese administrator and from a trader. The Dundo piece, stylistically identical with Ululi's Katangese work, was believed by him to be his own work after we described it. He had made many objects for Portuguese administrators and diamond mine officials, as did his grandfather and other members of his school. And the more typical style of the Luachimo River area is the "classical" Chokwe style in dark hardwood, knobs in the form of wigged heads, realistic hands with fingernails, a high polish, and brass nailhead decorations.

SAKACHIGA, A COMMERCIAL POTTER

Lest the sculpture of the Chokwe be overstressed, the third artist chosen for analysis is Sakachiga, a Luena potter who makes his entire living by his craft. He has a small and very simple workshop and kiln at Komba, near Kayeweta, on the Katende Muashi road about 35

miles southeast of Dilolo Gare. When first encountered, he was selling pots in Katende Tshipoye, a good 40 miles west of his kiln on a minimal road, but all within Luena *chefferies*. He is an older man, probably around 50, serious and businesslike, and not particularly talkative. However, when we visited his workshop, he showed his tools and methods and willingly parted with pots in several degrees of completion (none of which arrived whole in this country).

Sakachiga's specialty is *milondo* (singular, *mulondo*), a kind of heavy water cooler and pitcher or carafe. Its usual shape is spherical, with a flat base, a large handle, a cylindrical opening in the top, sometimes with a lid surmounted by a clay sculpture, and with a pouring spout probably derived from a European teapot. This object, considered the finest kind of pottery art, is almost unreported in the literature, and may be a fairly recent adaptation of European forms. Most *milondo* are quite similar in form to traditional Chokwe water pots, which are spherical with a cylindrical neck, and may have incised geometrical patterns, and rest on a woven grass ring. The molding technique is simple but skillful, being built up from flattened pieces of clay with great speed and assurance, and the surface is always unglazed and blackened, either by lampblack while firing or by paint when cool. The spout, handle, and lid make a traditional jar into a *mulondo*, and some of these, evidently from Katende Jean and in the van den Eynde Collection, are made from white clay and left natural color after firing. No white *milondo* were found in the field, and the black types proved as difficult to collect as to ship. Many of the finest examples, in daily household use, were simply not for sale, although new ones were available from two local potters. However, an old *mulondo* surmounted by a seated woman replacing the top opening and lid, and collected at Chindua near Sakambundji but said to be "from Katende or Angola," seems to me one of the finest art objects collected.

Sakachiga is a recognized artist, and his wares have traveled far. In the Dundo Museum, we found a piece marked *Sakachiga bei 30* ("Sakachiga price 30" [francs]). The signature in his pieces is cut into the shoulder of the *mulondo* with crude block letters, suggesting that both writing and the signing of pieces are recent innovations. The signature was admired by an informant, although it seemed ill-placed to us, and too crude for the fine knife incising elsewhere on the *mulondo*. Interestingly enough, the artist is called Sakachiwa in Kiluena, but signs his wares with the more Kiswahili-sounding Sakachiga.

The sculptured lids of *milondo* have evidently led to the making of

clay figures of the inevitable birds, usually guinea fowl (*kanga*). Busts with masked *mikishi* are also found, and the Dilolo potter Sayambisa Kalendjisa has made portrait busts of political leaders, the Mwata Yamvo, the ancestress Lueji, and the author and his wife, using standardized features characterized through distinctive coiffure, crown, beard, or scarification. Figures of turtles are also made, as well as a turtle with an ashtray hollowed into its back, designed for local African homes. But by far the major production of commercial potters is cooking pots, produced in all sizes, and almost always with an incised rim and spherical bottom for use on charcoal or the earth.

Professional potters charge high prices, reflecting the even higher prices of imported aluminum cooking ware in the Congo. The two Dilolo potters, Sayambisa Kalendjisa and Libaya Lenge, made their entire livings through their craft, and peddled their wares by bicycle or sold it in the weekly markets. Both employed an apprentice, but Sakachiga was training his two sons, who also worked a field near the pottery. Potters are relatively well off financially, having access to cash which most farming Chokwe find very difficult to obtain. The attitudes of potters toward their art, similar to those of carvers, are largely technical—admiring dexterity, speed, symmetry, hardness of finish, and variety of design. The nonpotter public talk less of pottery than carving, and admire it for less time when it is on display, but enjoy watching potters at work. No Chokwe ever verbalized the implication that carving is more important to them than pottery, although they commonly stated that carving and metalwork were equal in status. Basketry, usually the work of women, was admired as expertise, but hardly considered in the same class as male activities, even by women.

Formal Values

These three artists were chosen because they are thoroughgoing professionals, so recognized by Chokwe and alien observers, and because they illustrate three related roles for artists, as head of a school of apprentices, as a court carver, and as a full-time professional craftsman producing for the market. There are several other kinds of professional craftsmen among the Chokwe, for instance the metalsmiths and the makers of fine mats and baskets, and a lower level of folk artists such as the women who decorate their house walls with colored clays (Redinha 1953).

The formal aesthetic values of these men and their audiences have already been indicated in part. With the results of the use of exhibits

of Chokwe art to gather aesthetic values through verbalizations, it is possible to summarize Chokwe aesthetic values as follows:

1) Most Chokwe artists prefer their own work to all others, with the possible exception of their teacher's. They can differentiate their own work from all others, even when done in exactly the same style. One carver, Kazunda Mayonde, stated, "I wake up. I say, 'Today I will make something,' and I make it. I am the best, I made four men carrying a heavy thing!" As he talked, he took the characteristic pose of each man who was depicted as lifting a *chikuvu* slit gong. This may suggest how seriously artists take themselves in that they may have details of poses and weight distributions worked out before they begin to carve.

2) Chokwe artists prefer the local style to all others, which they usually describe as "old-fashioned," "of the bush," or "not modern like ours." Nonartists also tend to prefer local work, and women loyally choose the work of their husbands and brothers as superior to all other, suggesting that other factors than the purely aesthetic are involved.

3) Chokwe artists and their public prefer the new to the old, comparing a new mask to a young man, "strong and fine looking," and an old mask to an old man, "sick and broken." On this ground, they reject Angolan pieces, which they describe as "the way people used to make these things, not nice like ours." The Angolan pieces, with their patina of age and use, sensitive surface and expression, and dark monochrome color, are, on the other hand, among the few pieces that would interest a purist "collector" of African art.

4) Both artists and consumers prefer slickness of technique to boldness of design, consistently choosing the smaller, finely finished pieces over the larger, cruder, more spectacular pieces. Of the theatrical barkcloth masks, they prefer decorations of paper cutouts and red trade cloth to the messier clay or paint, because, in the words of Tshijika Floribert, a translator, "la figure est plus claire." Brown paper or burlap is preferred to barkcloth on functional grounds, being lighter and easier to wear.

5) A further example of the taste for fineness is the fad for fine-line cicatrizations on the faces of Mwana pwo masks, usually shallow incising colored the same as the rest of the mask surface, and hardly visible while the *mukishi* dances. Masks with pyrographic decorations, or with raised cicatrizations similar to actual facial keloids are considered ugly and crude, the basic reason why Ululi's masks are considered finer than Sanjolombo's by the young men of Dilolo. This

attitude reflects the changing evaluation of traditional cicatrizing and teeth filing, now disliked by urban Chokwe as "the marks of the bush," although still practiced by rural people who consider unfiled teeth "like animal's teeth," and an uncicatrized girl hideous and vulgar. Both groups still prefer a woman to have a cicatrized abdomen, however, because of its erotic value in sex play, so that female figures always possess abdominal cicatrizations carefully hidden by a cloth kilt, and uncicatrized girls wear strings of beads around their waists under their clothing, to make up for the lack.

6) Undecorated objects have less value than decorated, are less "*chibema.*" For that matter, very few things are left completely unadorned, even a functional mortar having a series of raised ridges around its base. In surface decorations, the designs have names, exhaustively documented by Bastin (1961), even though most appear completely abstract, and have only vague reference to actual representation.

Although Chokwe standards of excellence are almost always exactly the same as those of the Western world—smooth finish, neatness, bisymmetry, efficient control of tools, and respect for the nature of the materials, figures that stand up and baskets that are solid and hold their shape—nevertheless, Chokwe taste in design is not ours. As Western observers, our favorite artists were most often old men, and many were Angola-born. We preferred the older, more severe Lunda style to any pieces collected in the Congo, and we also liked the fantastically conceived *mukanda* barkcloth masks, although these were considered a lower category than wooden masks by the Chokwe. We preferred clay decoration to paper cutouts, and liked thicker cicatrizations as being more effective on smooth faces and making a better balance with eyes, mouth, and other openings. Perhaps the biggest revelation for us was that Chokwe masks are essentially dance regalia, theatrical costuming designed to be seen in motion in combination with music, dance, and social, political, and/or religious activities. Chokwe art is never designed for shrines and temples, to be viewed from one position, but is carried, handled, used, worn, which goes far to explain not only its continued vitality but also its size and materials.

Stereotypy and Innovation

The problem of continued freshness and originality that so concerns Western artists is not an important issue with the Chokwe. Each type of object has certain characteristics which it must have, others which

it may have, and the artist is quite free within these limits. Since many
objects are made only for oneself or one's family, there is no guardian
of tradition to enforce conformity. Conversely, since many things are
sold or traded or made on commission, there is no great value in inno-
vation for itself, and no Chokwe artist has ever mentioned that he was
tired of making Mwana pwo masks. Even professional artists make
only a few things of each type per year. Each object has its own indi-
viduality, while all are recognizably in the same style and from the
same hand. In this sense Chokwe and other traditional arts seem to
have more authority than our creations. People want art objects, not
only for their primary function as dance regalia or stools or water jars,
but also because they give them personal pleasure and a measure of
prestige in the village. Chokwe are houseproud, and even small
thatched huts in the bush have elaborate gardens, covered porches,
and shelves to hold potted plants. Urban houses of concrete block
with galvanized iron roofs are painted in patchwork designs in the
colors of Gauguin's palette. Interiors are clean and filled with doilies
and glass vases in the Belgian tradition, and a few Dilolo houses have
Venetian blinds, flowered draperies, and car ports.

Through 1960 Chokwe artists had not yet discovered the possibilities
of tourist art, although three trains a week were held up at the border
by customs inspections, and travelers often had time to stroll through
the town. The usual travelers, however, were Belgian administrators
and their families who were notoriously uninterested in local arts. The
Chokwe may have found a much better market with the foreign
U.N. troops, who showed their interest in African art by looting the
Musée Léopold II in Elisabethville of all its best specimens. A news-
paper reported that an enterprising Irish soldier had hired some Luba
in northern Katanga to turn out tourist figures and masks designed by
him. Given a similar opportunity, the Chokwe will certainly delight in
producing for a market. It has been suggested that the famous Chokwe
chairs, with their elaborately carved splats representing genre subjects,
their leather seats and nailhead decorations, are early examples of
tourist art, since the chair is obviously of Iberian origin. The fre-
quently obscene subjects on the splats are thought to have been
requested by the Portuguese soldiers, but Chokwe concern with mating
and fertility could also have found expression this way.

If Chokwe artists do find a suitable market for tourist items of good
quality, unlikely in the present political situation, their lack of dis-
tinction between fine and applied art will stand them in good stead.
It appears that the traditional arts with the best chance for viability
in world markets are those which are literally both fine and applied—

functional objects of no great cost that are so well made as to warrant collection and display.

It can be seen then that very ancient stylistic elements have been preserved by Chokwe professional artists in the process of retaining their traditional religious and magical beliefs and practices. The style and the content travel together through time, with each local or individual variant considered to be the "right" representation for the spirit or other concept in that immediate locality. In my view, the style functions rather like a stereotype in the minds of the artists and their patrons, *the* way to carve an eye or incise a drum. This is not in the least to denigrate the creativity of these artists, since all artists must work within their cultural limits, not the least of which is the fearsome "tradition of the new" of contemporary Western art. And while the subjects and styles of Chokwe artists are to some extent stereotypic, their materials and methods are open to radical change as more functional materials, better tools, and easier techniques become available.

Although it does not appear likely in the near future, the market for Chokwe art will one day broaden to include foreign tourists and collectors. But this need not be as destructive as it was elsewhere in the Congo Basin or in West Africa. And even there, the professional artists (for example, among the Yoruba) appear to have weathered the storm better than nonprofessionals working under the inspiration of religion. This wave of colonialization and Christianization is already past, leaving Chokwe identity and pride intact. The sanguine Chokwe professionals are more than ready to meet the challenges of foreign taste and to produce finely crafted objects in traditional styles if the market so dictates. It remains for foreign collectors to support contemporary African art in traditional styles munificently enough to allow the artists to resist the blandishments of the wholesalers and the production line.

An important goal of research must be to draw the attention of the present Art Establishment to recent field data on the arts in Africa (and by extension, to other non-Western areas). Only in this way can we demonstrate the culture-bound nature of aesthetic judgment and thus the invalidity of much of the evaluation of non-Western arts by Western scholars. At the same time, the new information we can provide on the meanings and functions of these vital arts in their cultural contexts gives the alien observer new insight and infinitely greater appreciation. With greater knowledge and increased sensitivity to cultural variation, perhaps one day we will be able to formulate more clearly the nature of style and the relationship between tradition and individual creativity.

Alan P. Merriam

THE BALA MUSICIAN

The Basongye people occupy an area in the present Eastern Kasai Province (formerly part of the Kasai Province) in the Republic of Zaire (formerly the Democratic Republic of the Congo), which lies between the fifth and sixth parallels south and is bordered on the east by the Lualaba River and on the west by the Lukula River. They have apparently been in their present location since approximately the fifteenth century when they were the founders of the first Baluba empire. After having been dispersed by Arab slave raiding in the 1870's, and by other violent events in succeeding years, the Basongye regrouped themselves about 1900 into three major divisions—the so-called pure Basongye in the east, the Bekalebwe in the south, and the Bala in the northwest. It is the last group which forms the basis for the present study.

Field research[1] was carried out in 1959 and 1960 over a period of approximately one year in the village of Lupupa Ngye which is located 40 kilometers northwest of Tshofa, at that time in the Territoire de Sentery and District de Kabinda, the easternmost district of the Province du Kasai. The people of the Bala subgroup of the Basongye numbered 7,149, according to Belgian government figures for 1958; the population of the Basongye as a whole was estimated at the same time at about 150,000. Lupupa Ngye had a population of 243 permanent residents, plus about 25 others who were in the village for varying lengths of time as storekeepers and their families, roadworkers, and other transients.[2]

The economic basis for Lupupa Ngye is agriculture, with manioc and maize the staple crops, supported by peanuts, yams, various legumes, fruits, and other crops. Cotton and peanuts are grown as cash crops. Although game is scarce in the area, there are hunters who attempt to gain their livelihood by hunting, and fishing is an important occupation. Domesticated animals include goats, chickens, pigeons,

and dogs. Systems of gift giving provide an important means of distribution of wealth.

The social structure has both patrilineal and bilateral aspects; while it is organized around, and traces from the male side, an individual is related to all persons on both sides of the family and may not marry into the patrilineages of any persons to whom a relationship can be traced. It is often difficult to find suitable marriage partners in a village the size of Lupupa Ngye, and the result is that of 65 current marriages, 40 are with women from outside the village. Residence is strictly patrilocal, bridewealth is a very important part of marriage, and women retain their ties with their father's patrilineage.

The political structure is organized in a pyramidal fashion, headed by a chief who is responsible to a council of six notables. Four notables-in-training meet as a part of the village council but do not take public part in its deliberations. The village is physically divided into two halves, each of which is further divided into two parts: the four quarters are headed by quarter chiefs, who operate as counselors and legal adjudicators for family and quarter disputes. The people, acting as a body in public meetings, have the absolute rights to impose or depose any functionary in the hierarchy.

The Bala believe in a single god, Efile Mukulu, who created the world and man through the agency of a culture hero, Mulopwe, but who now takes relatively little direct part in the affairs of man. Opposed to him is Kafilefile who is considered to be the personification of evil. Often in opposition is Kalombo, a sort of half-supernatural being who plays the trickster role. Spirits of the bush are represented only by the *milungaeulu*, enormous witless beings controlled by sorcerers, and finally, both witches and ancestral spirits constantly make their presence felt. The four most important religious philosophic tenets embrace 1) the reincarnation of the *kikudi*, or spirit; 2) fatalism and predestination; 3) the concept that it is men who control death and that Efile Mukulu is not involved in death save in exceptional circumstances; and 4) the belief in an elaborate system of agencies of death deriving from human actions, including sorcery, witchcraft, malignant souls, the capture of shadows, and a complex of magic practices (see Merriam 1961).

Folklore includes tales, myths, legends, proverbs, and tongue-twisters. Graphic arts are not practiced, but plastic arts are represented in the carving of fertility figures, of which at least five local styles can be distinguished among the Bala. Weaving, dyeing, mat-making, pottery work, and forging are present to varying degrees, and a major

source of income in 1959–1960 was the manufacture of raffia platters and baskets which were sold as far away as 600 to 900 miles in major cities of the Congo.

The language is Kisongye (Samain 1923); it is a tonal language of the Niger Congo family and shows close relationship to the languages around it, including Otetela, Chiluba, and even Kiswahili. Most people in Lupupa Ngye speak at least one other language besides Kisongye, and persons may speak as many as six different languages.

Music Instruments

While I do not intend to give a detailed technical description of Bala music, it is impossible to discuss the role and status of the Bala musician without some reference to music instruments, for the musician is judged both by his fellow musicians and by society at large in terms of his relationship to and skills in playing specific instruments.

A number of Basongye instruments have been described that are not found in the village of Lupupa Ngye or in its immediate environs. These include flutes, blown gourds, the *nzenze* (a chordophone), the end-blown horn, certain forms of small slit drums, one form of long skin-headed drum, and leg bells worn at the ankles. The villagers are familiar with almost all of these instruments, but say that while they were formerly used, they were "just a fad," and that others have replaced them.

Six major instruments are found in the village today, and of these, three are far and away the most important in the scale of values. The *kisaghshi*, probably the least important, is a twelve-toned plucked idiophone; this instrument is distributed widely in Africa south of the Sahara and is known by a number of terms, including *sanza*, *mbira*, *likembe*, and others. The Bala *kisaghshi* consists of a small sounding board to which are attached twelve thin strips of a harder wood; the strips are fastened to the sounding board at one end and run over a bridge which elevates their opposite ends—the raised strips are plucked with the thumbs. The Bala play three different classes of songs on the instrument, and for each class the keys of the *kisaghshi* are differently tuned. The songs are social in nature, and boys and young men play the instrument primarily for recreation—to pass the time when on a journey, and in other similar situations. No particular distinction is attached to the ability to make or to play the *kisaghshi*.

Of more importance, but still not central to the achievement of true musicianship, is the *etumba*, or skin-headed drum. The *etumba* is a

chalice-shaped drum (see Boone 1951:Pl.VII, 7) made from a wooden frame about 15–20 inches high, hollowed out and covered with a goat-skin head; construction takes about five full days (Merriam 1969). Although all *matumba* are constructed alike their names vary according to their particular musical functions: the *katumbi* is the smallest, "the drum that has the small voice, that never changes its rhythm;" the *mulonda mutumbi*, "follow the first," and the *etumba dikata*, "drum, big voice." Drums are always played with the hands, and three different striking positions are noted by the Bala. In performance, the *katumbi* always starts first and plays an unvarying pattern, the *mulonda mutumbi* joins it and plays a different but also unvarying pattern, and the *etumba dikata* comes in last with its improvisations serving as an accenting factor in this ensemble. The relative time of entrance of each drum is fixed. The drums are played in various combinations, depending upon the type of music being performed. The drummers are almost always youths. While good drumming is a part of certain types of music, no special importance is attached to it, nor does the drummer gain any particular status from his skill.

The *edimba*, or xylophone, consists of three parts: the wooden base or frame, the cushioning of soft fiber which rests upon the frame and supports the keys, and the keys themselves. In construction, the pitches of the keys are obtained from a central tone, the *fumu edimba*, or "chief of the xylophone," which the maker is said to carry in his head. In fact, absolute pitch does not seem to be a part of Bala music culture, and the central tone is obtained either by approximation or from an old xylophone. Xylophones are always used in pairs with the two instruments tuned to the same scale but with a different, though overlapping, absolute range. In performance, the lower-pitched *edimba* plays one of three standard patterns, while the performer on the higher-pitched instrument states the theme of the song and improvises upon it, often using a number of standardized phrase patterns. Ostensibly the xylophone is always made for the chief of the village to whom it must be presented and for whom it should be first played; it is consecrated with chicken blood which insures that the ancestral spirits will be kindly disposed toward the player and the instrument. The xylophone is used at the induction of a chief, but it is more often accompaniment for popular songs and dancing for young people. The skilled xylophonist is not given a special title, nor is he ranked within the hierarchy of musicians. Nevertheless his status is higher than that of a *kisaghshi* player or a drummer. There is reason to believe that xylophones are

very ancient instruments of the Bala that fell into disuse during the upheaval caused by the Arab slave wars in the latter part of the nineteenth century, and that they have been more recently reintroduced into the culture. This is borne out by the fact that the old people refer to them as instruments "which our fathers had," while young men say with certainty that the xylophone was introduced during their lifetimes.

The three remaining instruments in the Bala repertoire together form a group of signal importance both to the central music activities and to the status of those who have mastered them. These are the *esaka*, or rattle, the *lubembo*, or double metal gong, and the *lunkufi*, or wooden slit drum. Although each may be played separately on specific occasions, the three taken together are regarded as the core instruments of the Bala, producing the most important music.

Of the three, the *esaka* is least important; it is a small basket rattle, the base of which is a convexly curved portion of gourd on which is woven a basket made from stiff fibers. A carefully selected number of dried kernels of corn is put inside the rattle before the handle is fitted to it. *Masaka* are made by women and played both by men and women, but when the instrument is used to accompany the double bell and slit drum it is played exclusively by men.

The *lubembo* is a small double gong made from metal; the two bell-shaped gongs are fastened together by a curved metal handle. The instrument is village property, and theoretically at least, is bought by small assessments on individual villagers; it is held for the village by the person who is also responsible for the village fertility figure. The Bala do not make the *lubembo*, but purchase it from the Batetela or Bekalebwe, their neighbors to the north and south respectively. The instrument is heard most frequently in women's songs; but in men's songs, where it is used always in conjunction with the rattle and slit drum, the *lubembo* is absolutely necessary.

The *lunkufi*, or slit drum, is central to the music thinking of the Bala. The instrument is almost always purchased from outside the village, among the Batetela; it is made from wood, trapezoidal in shape, triangular when viewed from the ends. About three feet in height, it is made from a single block of wood which is shaped and hollowed so that at its top there are left two lips of wood of different thickness; it is struck with rubber-headed mallets at three points on each of its sides and each point produces a different pitch. The *lunkufi* is used in a great variety of situations, but always in those of importance to the society. All musicians who wish to be accorded the status of a professional must be expert in playing it; all wandering musicians use it

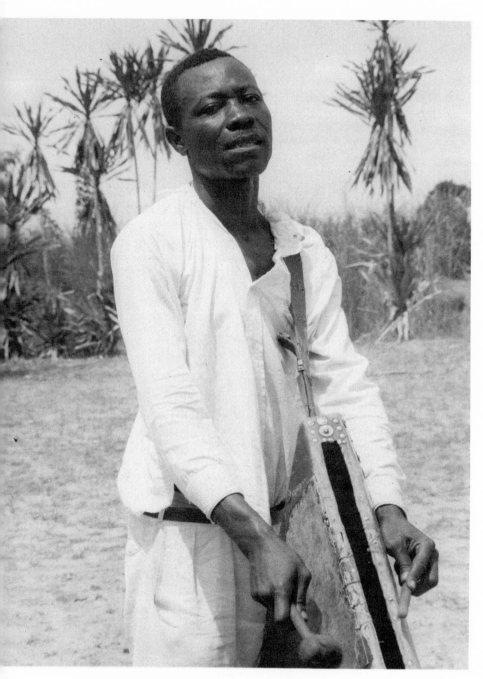

Kapwe, an *ngomba* (professional musician of the highest rank),
playing the *lunkufi* (slit gong).

as their major instrument. The *lunkufi* is vital to the successful phases of a funeral, and it is used as a signaling device both within the village and from village to village. The drum names given to all adult male villagers are played upon it, and it is used, in combination almost always with the rattle and double gong, in a variety of specific types of songs for special occasions. Like the *lubembo*, the *lunkufi* is village property, held for the village by its player and sometimes, though not always, stored with the village fertility figure. The *lunkufi* is almost always stated to be the oldest instrument known to the Bala, and its origin is attributed to the Batetela. It is quite certainly the most important music instrument for the Bala.

Classes of Bala Musicians

We have spoken briefly about these various music instruments in order to give a general background concerning the music material culture, but more importantly, because Bala evaluation and classification of musicians depend upon what instruments they play and how well they play them. In making such evaluations the Bala sometimes differ among themselves; the individual musician, for example, invariably names himself as the outstanding musician of the village and tends to make his classification in terms of the instrument or instruments he himself plays. Thus a xylophonist and drummer stresses the importance of being able to play these instruments well; after naming himself as the best musician, he usually includes those who play the same instruments in the first rank and relegates those who play other instruments to the second rank. It is possible, however, to distinguish classes of musicians, and while not all people in Lupupa Ngye would agree without reservation, the general grouping is as follows. For male musicians, five terms are used. The *ngomba* is a professional of highest classification, and though some individuals ranked some village musicians in this category, it is most often reserved to traveling musicians who make their living in this manner, who can play all instruments, but who are most highly skilled on the *lunkufi* and who use it almost exclusively. A musician of the second rank is called *ntunda*; he may also be able to play almost all music instruments, but concentrates his talent on the *lunkufi*. The *ntunda* is not likely to be a traveling musician, but rather is the local musician who is acknowledged as the village *lunkufi* player. The third ranking musician is called *mwiimbi*, and he is also a villager and a player of the *esaka* and *lubembo*. A *nyimba* is a song leader who does not play instruments, or at least does not pretend to do so with a degree of skill which would place him in

the higher, instrumental grades. He is respected for his ability to lead the singing group, to set the proper starting pitch, and to choose the proper song. Finally, those men who sing as part of the group are called the *abapula*, and this carries no particular distinction.

A similar system of ranking is applied to various female music-makers. At the top of the hierarchy is the *kyambe*, who must play the *esaka* and *lubembo* well. Women tend to stress the fact that the *kyambe* holds her rank by virtue of the fact that she can play and sing alone, as opposed to playing and singing as part of a group. Such occasions might arise in connection with rhythmic cooperative labor; the *kyambe* stands to one side providing the basic rhythms. Special songs at birth require solo singing by a professional as well. There is no title for women which corresponds with *ntunda* for the men, but following the *kyambe* comes the *miyaka*, who is a female *esaka* and *lubembo* player of somewhat less competence. The *nyimba*, or female song leader, is next, followed, as with the classification for males, by the *abapula*, or singing group taken as a whole.

Professionalism

In speaking of these various ranks or grades I have used the word "professional," and this raises the important considerations of what is meant by the term and how it applies to the musicians in Lupupa Ngye. I have discussed this problem at some length previously (Merriam 1964:123–30), but a brief resumé is apropos here. In the first place, it seems clear that the musician is a specialist in whatever culture he is found. The amount of labor performed in any given society is always divided, with specific tasks allocated to specific groups of individuals and, in the words of Herskovits (1952:125), "each of the sub-groups whose members perform a particular aspect of the work may be regarded as specialized in its particular calling, and the kind of labor each performs in achieving this can be denoted as its 'specialization'." The potter, the palm-nut cutter, the shaman, or the musician is an economic specialist, for he performs particular tasks to which he is assigned by the society, produces a particular kind of good or service, and contributes to the total labor requirements of the society. Thus the musician must be regarded as a specialist, but the further question is whether this automatically makes him a professional.

Professionalism in our own society is usually defined in terms of economic criteria; that is, the true professional is one who is totally supported by his specialization, while those who do other kinds of work as well are part-time specialists. If the criterion be economic,

however, it may be suggested that there must be a number of degrees
of professionalism when the problem is approached cross-culturally,
for payment clearly runs along a continuum from occasional gifts at
one end to complete economic support at the other.

There is another and probably more important criterion for the
recognition of the professional, and this is the acceptance an individual
gains in his own community.

In other words, the "true" specialist is a social specialist; he must be
acknowledged as a musician by the members of the society of which he is a
part. This kind of recognition is the ultimate criterion; without it, profes-
sionalism would be impossible. Although the individual may regard himself
as a professional, he is not truly so unless other members of the society
acknowledge his claim and accord him the role and status he seeks for
himself . . . Complete acceptance . . . depends upon public recognition of
the musician as a musician, whether or not this is accompanied by any
sort of payment, and the granting by society of the privilege of behaving
as a musician is expected to behave (Merriam 1964:125).

Social acceptance and payment in our own society go hand in hand. In
other societies where there is payment there seems also to be social
acceptance; but it is not necessarily true that in all societies where there
is social acceptance there is also payment. As an example of the last,
we may call attention to the Flathead Indians of western Montana
where specialists in music are socially acknowledged but never paid or
even given gifts because of their ability and role. If total economic
support is the criterion for professionalism, no Flathead musician
meets the requirement, and yet there are outstanding musicians in that
society whose abilities are recognized and who are always the leaders
in music events.

Among the Bala, no musician is a complete economic specialist.
Even the *ngomba*, who is a wandering musician, keeps his ties to the
land, which he cultivates himself when possible or leaves to the care
of members of his family. All informants are agreed on this matter; all
say that it is impossible to make one's complete living from music,
though some will argue the question as a theoretical point. At the same
time, the *ngomba* makes substantial sums of money in comparison
with what the average Bala farmer can hope to earn. During the course
of a major funeral in late September and early October of 1959, the
hired *ngomba*, whose presence at such a funeral is an absolute require-
ment, earned a total of $31.20. The average income for a male villager
in Lupupa Ngye was then about $100 per year, and thus the musician

realized almost a third of this amount in the course of a week's work. However, as will be discussed below, it is in the character of the musician to spend his money unwisely, and within a few days this particular musician had disposed of almost all he had earned.

The Musicians of Lupupa Ngye

Among the people of Lupupa Ngye there were a number of individuals whom we might call musicians; that is, instrumentalists and singers who performed with some degree of skill and who took active part in music events. In the end, however, the judgment of the villagers was that only three of these musicians were deserving of a title in the hierarchy and a fourth hovered on the fringe. No musician received the highest classification of *ngomba*; this was reserved to wandering musicians who visited the village on occasion. Two individuals were usually ranked as *ntunda*, though one of these, Chite, was more universally acknowledged than the other, Mandungu. The criterion for the *ntunda*, it will be recalled, is that he concentrate his efforts on the *lunkufi*, or slit drum, although he may play other instruments as well, and this Chite did. He was the appointed *lunkufi* player for the village, sending signals to other villages, calling the members of Lupupa Ngye together on important occasions, and playing the *mashina*, or praise names, for the male villagers at celebrations for the village fertility figure and protector once a month. I do not recall ever having seen or heard Chite playing an instrument other than the *lunkufi*, although I have seen him give instruction in the form of correction to another musician playing the rattle and double gong.

To some extent, Chite shared his duties as *lunkufi* player with the second *ntunda*, Mandungu, and some jealousy was present between the men. Mandungu was the younger of the two and was not the official player for the village. He played the slit drum very well, as well as the rattle and double gong. He was acknowledged to be the second best xylophone player in the village and was accomplished in the theory and performance of the *kisaghshi*. In fact, he was probably a better musician than Chite, but Chite held the official position. Also certain personality characteristics made other villagers somewhat contemptuous of him in an amused way.

The third musician, Mwepu, held the title of *mwiimbi*, a player of the rattle and double gong. Mwepu could not play the slit drum, nor to my knowledge did he ever play any other instrument; he says that he formerly played the xylophone but gave it up "because it is for

children." It is Mwepu who sings the important praise names for the male villagers.

The fourth musician, Nkolomoni, was the youngest of the group. He was a xylophone maker and player, and a drummer, but these skills did not fit into the formal ranking scale in the village. Nkolomoni was an excellent musician and important to the village for his musicianship, but most of his activity was in connection with younger men and social songs, and he remained on the fringe so far as being accorded recognition was concerned.

In Lupupa Ngye, some women were accorded the status of *miyaka*, *nyimba*, and *abapula*, but the rankings tended to be confused and uncertain; there was unanimity, however, that no practicing female musician deserved the rank of *kyambe*. Because my work was concentrated on the male musician, only passing reference will be made below to the female musicians.

None of the four male musicians noted above supported himself entirely by his music, and the remarks of one leading political dignitary about their prime skills, occupations, and other activities confirm this. For the four musicians, this man's judgments were as follows: Chite—"singer, player of the *lunkufi*, farmer, drinker, gatherer of raffia"; Mandungu—"not able to be a farmer, xylophone player, *lunkufi* player, *kisaghshi* player, drinker"; Mwepu—"highly skilled at finding grubs in palm trees, drinker, night watchman, debtor, cutter of dead bodies, quick to anger, palm wine maker, hook and line fisherman" (note no mention made of skills as a musician; whether simply by oversight, I do not know); Nkolomoni—"singer, xylophone maker and player, drummer, maker of raffia platters, great sleeper, maker of fish traps, and hook and line fisherman." From my observation, these evaluations are generally borne out, particularly those regarding livelihood. Chite was considered the best raffia gatherer in the village and met most of his financial needs in that way; both Mandungu and Mwepu worked for me, and I was their major means of support; Nkolomoni made good raffia basketry which he sold to another man in the village who, in turn, traveled to major Congo cities to sell it from door to door. Although all four men made part of their living from music, none supported himself completely in this way, and even the traveling professional never cut his ties to the land.

Training

For most of the Bala, musicians are born and not made; it is the general feeling, with one or two exceptions, that music ability is inherent

at birth and is dependent on the parents a child is fortunate or unfortunate enough to have. In short, music talent for the Bala is inherited. This is a matter arranged by Efile Mukulu (God), who may decide to bestow music ability on someone from nonmusical parents, but if he does so, it is the exception rather than the rule. Talent can be inherited from either parent, although it is more likely to come through the male line—the Bala are patrilineal.

Talent may well run in families, but individual differences may also be present within families; the latter suggestion was most strongly made by a female musician; the gist of her words is recorded in my notebook as follows: "Definitely, all people are not born with equal music ability. Just as definitely, music ability is inherited, and thus it is far more likely that the child of a musician will be a musician than that the child of a nonmusician will be a musician. But there are always individual differences, arranged by Efile Mukulu, and thus her firstborn appears to be much more musical than her secondborn. There are children who, right from the start, are attracted to music, and turn their heads toward the sound, while others just aren't interested. But individual differences are important and exist between children of the same parents, and even between twins. Music ability may be inherited either from the father or the mother, or from both. In Mandungu's case, he inherited from his mother, who was *kyambe*; his father, Mukume, doesn't know anything about music."

Three of the four male musicians discussed here agree to the general principles described here; the fourth denies individual inheritance and holds instead that it is the environment in which the child grows up that is important. His view is the small minority opinion in Lupupa Ngye.

Once a child's music ability is manifested, Bala society offers two major means by which one may become a musician. The first is by imitation, a means of music training practiced widely throughout the world (cf. Merriam 1964:146–50), and we shall have occasion below to cite several accounts of this process as described by some of the Bala musicians. A second means of training, however, is through an apprenticeship system under a recognized performer.

When a young person wishes to learn a particular music instrument, for example, he approaches the established musician who decides whether he will accept the student. If he does, instruction takes place over a period of several months depending upon the quickness and understanding of the neophyte. The teacher works with his pupil at stated and regular times, if possible, explaining his role, teaching him basic rhythmic and melodic patterns as well as song texts, and sometimes using the technique of guiding

his hands on the instrument. Payment is made to the instructor in chickens, which have a ritual significance in the culture, and when the teacher considers the neophyte ready, he gives him permission to play in public. All proceeds of the first three or four performances are given to the teacher, and throughout the teacher's lifetime some share of the proceeds may be given him. It is clear that some students learn more quickly than others, and different kinds of instruction are apparently given for different kinds of instruments, with some, such as the xylophone, not included in the apprentice system (Merriam 1964:158).

Each of the four musicians we have been discussing gave me some account of what his mode of training had been; the four accounts, reproduced below from field notes, differ sharply in detail, but each illustrates some of the learning processes in Bala culture.

Chite's account follows: "Chite learned the *lunkufi* from Chite Kamamba who, in the process, held his hands and showed him where and how to hit the instrument. Chite was about 16 at the time, and says that the notables came to him one day and told him that he was a smart child who ought to learn the *lunkufi*. At that time Chite Kamamba was the village *lunkufi* player, but he was getting old, and thus went to the notables himself and said they ought to recruit a young person to learn. The notables called Chite before the village fertility figure and protector, and Chite Kamamba played the accompanying rhythms with the sticks on the rim of the *lunkufi*. Then they told Chite to play them as he did, and they knew then that he would be a good candidate. Chite says that he was glad to go to Chite Kamamba and learn 'because I thought of all the money I would make.' The Bala are fond of stressing the value of money but in fact they are extremely proud of having been singled out for village honors.

"Chite took a month to learn, but he cannot tell me how often or for what periods of time he went to Chite Kamamba. He paid Chite Kamamba a cock for teaching him, and that was the only flat payment. However, in such a case, Chite says that when the apprentice starts to earn money from his playing, his master can take the money from him, and Chite Kamamba did, twice. When the apprentice has really learned and is considered competent in his own right, then the master can no longer take the money; the apprentice is half-obligated however, to give him part of his earnings, at least from time to time.

"Chite Kamamba also taught Mankonde, who knows well how to play *lunkufi* but who simply does not wish to play now for reasons of his own. Mankonde, in turn, taught Lumami, but everybody is against Lumami and so he never gets much of a chance to play.

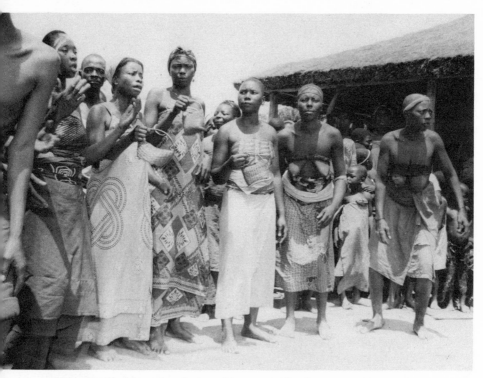

Taken during a funeral in Lupupa Ngye. Female relatives of the deceased man singing and dancing; some are playing the *esaka* (rattle; pl. *masaka*).

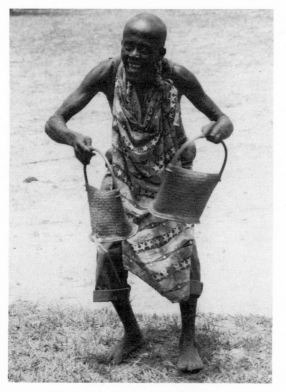

An itinerant musician playing two *masaka*.

"Chite has taught his two successors, Mandungu and Mwepu, of whom he considers Mwepu a rank beginner and Mandungu an accomplished performer. Chite no longer takes money from Mandungu, but says he has, lots of times; now it is up to Mandungu to pass over part of the take if he wishes to.

"Chite also knows the *lubembo, esaka,* and *kisaghshi.* He learned the *esaka,* which he considers very easy, in Bwelongo, a Batetela village; he was there for other reasons, but saw the players, watched, and picked it up all by himself in five days. He learned the *lubembo* from Nkyelo, a Mupina, who showed him how to hold the instrument, told him to watch, and then had him do it by himself. He did not pay for the instruction, and says that he learned in two days. The *kisaghshi* he picked up all on his own, and he says he is very good. He practiced about a month before he was really accomplished."

Mandungu's description of how he learned to play the xylophone adds some further information; again we cite from field notes: "Mandungu learned to play the xylophone at Lumba, but before this he had already learned how to play the *kisaghshi.* This he learned from a friend in Sankia who showed him directly what to do. Mandungu says that if one wants to learn the *edimba* it is very wise to learn the *kisaghshi* first and then translate what he has learned to the xylophone. He says that he found the same notes on the two instruments. On the *kisaghshi* there are 10 keys, divided into 5 on the right and 5 on the left. To duplicate this on the xylophone, one forgets the two lowest keys on the left, and the rest duplicates the tuning of the lower xylophone. He says that no one taught him the xylophone directly; no one held his hands or told him what to do—he simply translated his *kisaghshi* knowledge to the xylophone."

My field notes also indicate that Mwepu acknowledges that his brother Chite taught him much of what he knows: "Mwepu says that he learned both the *lubembo* and the *esaka* from his brother Chite about five years ago. This was an entirely conscious wish on his part to learn something new, and he asked Chite to show him. Chite used a number of devices in teaching him. He held Mwepu's hands and went through the proper motions with him. He used the vocal mnemonic patterns to teach the proper rhythms. Mwepu himself practiced constantly, both with the rattle in his hands and by just going through the proper motions when he did not have a rattle and was walking somewhere. He says that it took about a month to learn the two instruments.

"He says that he started learning to sing about 18 years ago at the time his elder son was born. He got interested through listening to Sambi, the father of Mulenda, and his brother Chite, and he tried to imitate them. After a while he went to Sambi and asked him for instruction, specifically in how to sing the *mashina*—male praise name songs. For this instruction he paid Sambi a large chicken, but this was the only payment. In return, Sambi taught him all about this kind of song, and it took a year—Mwepu says that he went to Sambi every morning and every afternoon. Mwepu says that he learned how to sing the sounds of the songs himself; it was the special instruction in the song type that he got from Sambi. Mwepu learned the *lubembo* from Chite at the same time he learned the *esaka*. He learned in the same way and says that it took about two weeks to learn it properly."

Nkolomoni speaks not only of how he learned to play the xylophone but also of how he learned to construct it; he adds what, for him, was the compelling reason for wishing to learn: "Nkolomoni says that a friend of his, Kitenge Evariste, was the one responsible for his knowing how to make a xylophone. The friend told him to come and help when he was making a xylophone, but this was not to teach Nkolomoni but rather because the friend needed someone to help. Nkolomoni says that he watched three times before he thought he could do it, and thus he would have seen six xylophones being made. He says that he asked no questions except once when he asked what kind of wood should be used for the keys; in this case Kitenge refused to tell him, wishing to guard his own knowledge, but Nkolomoni watched and decided for himself what it was. Kitenge did not offer advice or instruction. A friend in another village was the instrument of his learning how to play the xylophone. He learned when he was twelve and living with Ngoyi Marcel; in Ngoyi's house there were a couple of xylophones and Nkolomoni says he watched others playing and when they had gone would try for himself. Ngoyi never gave him any direct instruction, never tried to tell him how in words, never held and directed his hands. He just learned by watching and trying himself. He says that he started playing the xylophone because he was then playing the *etumba* and he saw that the xylophone player got more money than the drummer. He says he liked to play the drums, but he liked the money too."

These four statements not only indicate and describe various modes of training the musician; they also indicate that practice is a recognized requisite for the musician. This is stressed not only as a part of

the initial learning process, but also as a continuing preoccupation throughout the musician's performing life. It is impossible to know precisely how much practicing is actually done, but all musicians say it is a necessity and that they spend perhaps three or four hours a week in this way.

Social Status and Role

To this point we have discussed musical instruments and their importance in defining grades or ranks among the musicians, the grades or ranks themselves, the major musicians in Lupupa Ngye, their attitudes toward inheritance of music ability, the processes of learning, and the importance of practicing. We can turn now to the question of the musicians as a social group, what their attitudes are toward themselves, what the attitudes of society are toward them, what role they play and the status they hold in Bala society.

Musicians, as such, do not seem to form a visible social group within Bala society, for they are too few in number and do not tend to live together or to maintain close social relationships. At the same time conversations with both musicians and nonmusicians confirm that there is a stereotype of the musician which indicates that his status and role are clearly identifiable in the society. The four major musicians were clearly aware of its existence in the following statements they gave on what they thought of themselves and their fellows.

I noted Chite's views as follows: "Musicians love to play music; this is what they want most to do. They drink more than other people, but they do not drink when they are playing because one cannot drink and play at the same time [observation does not confirm that this is, indeed, the practice]. Musicians demand things from other people. They are not strong, and they need people to work for them. Chite says that he used to be strong, but that he has played the *lunkufi* so long that he has become feeble 'like a woman,' and that he is no longer habituated to working in the fields and doing the other normal work of men.

"Musicians are not lazy, he says, but they do not like to farm. They like to "marry" more than others, but not him. They like *very* much to eat; they are real specialists at eating. They like to be with other people, but like best to hang around with other musicians. They talk about music with other musicians, but mostly they like to plan out where to go to make money by making music. They talk over the various musicians in the area, and discuss the state of repair of their instruments, but mostly they talk about money. They don't talk much about women."

Mandungu is perhaps not quite so kind to himself and his fellow musicians. He says, "Musicians like to profit more than other people. They like money. They like to eat meat. They drink more. They anger quickly. They demand things. They look for trouble. They are lazy for other kinds of work, but not when it comes to music."

Nkolomoni agrees that "musicians don't like to work in the fields, and they don't like to quarrel. They drink a lot, but xylophone players don't because they cannot drink and play at the same time. Musicians are restless; they like to travel, and they don't stay in one place. They are not usually concerned with their wives—with their children, yes, but not with their wives."

Mwepu adds: "musicans like to ask for things, they like to eat, they do not like to farm. They are lazy, they like to drink, they like to have women but do not like to marry them. They do not like to stay with the villagers, but prefer strangers because from them they can make more money. They like to eat, amuse themselves, stay, and move about with other musicians, and not with the villagers. They are definitely not lazy when it comes to making music."

These various statements are echoed by nonmusicians, some of whom tend to be more severe and some less. The prevailing view, then, in Lupupa Ngye is that musicians can be discussed as a group and that their behavior deviates from the norm expected of other villagers. This is further emphasized by the fact that very few people wish their children to become musicians; to the contrary, most people, including the musicians, say flatly that this is not a desirable occupation.

Chite says that he does not want his children to be musicians because "musicians have to be grasping about money or they will be bankrupt. They must guard their money" because they don't have much. Kitoto, a female musician, responded similarly: Musicians are considered like women because everyone can boss them about and, when commanded, they cannot refuse. She does not want her children to be musicians, and is strongly emphatic about it, "because musicians are lazy." Further, "if a musician doesn't have a father who can help him, then he doesn't make enough money to support his family." There is a connection in her mind with "musician" on one hand and "has to sponge off his father" on the other.

Most people, in speaking of this problem, bring up the point that musicians are not their own masters, that the nature of their work makes it imperative that they accept the orders of others. The most frequent comparison made is to the village *lukunga*, who is the lowest of the notables and who serves as the town crier. "No, I don't want my child to be a simple musician who plays all the time for other people.

I want other people to play for him. An *ngomba* is like the *lukunga*; everybody orders him about."

Musicians are, of course, "ordered about" by other people; it is the nature of their work that others hire them and, to a certain extent at least, tell them when to play. Most other occupations and specialties of the Bala are of a different nature. Farmers work independently, a raffia gatherer works alone and sells his product as an entrepreneur, and fishermen and hunters do the same. Most Bala deal in goods rather than services, and those who do sell their services are the political and religious leaders whose positions demand respect.

Equally important is the fact that the stereotype tends to be a reasonably accurate reflection of the musician's actual behavior. This may be illustrated by the four musicians named above. The first is a very heavy drinker, he does not farm, he smokes hemp, he could not hold his wife and does not have the respect of the villagers. The second is the worst debtor in the village, a very heavy drinker, and a hemp smoker. He is a man of violent temper who could not hold his wife; he is impotent and, indeed, the only impotent man in the village. He does not farm, no one trusts him, people snigger at him behind his back. The third is a very heavy drinker, has a violent temper, does not farm, and is distrusted in the village. The fourth is a heavy drinker, a possible hemp smoker, and does not farm. He is considered a physical weakling and scorned for it in the village. He is the butt of many jokes and much ribaldry partly, at least, because he is also a braggart.

All of these patterns of behavior are held in varying degrees of low esteem by the villagers. A physical weakling does not conform to ideals of manhood, and a man who does not farm is almost automatically considered to be physically incapable of doing the work of farming. To be impotent is perhaps the most degrading situation in which a man can find himself. Drinking is a normal part of life, but heavy drinking is not, except in one or two cases where it is common knowledge that a man cannot help himself. As for alcoholism in the Western sense, no musician is considered to fall into the category, although other villagers do.

In sum, the status of the musician in Lupupa Ngye is low on the social scale; in fact, probably no individual or group of individuals (with one possible exception to be noted below) is in a position of lower status. This however, is only one aspect of the situation, for there are other factors which must be taken into consideration as well.

While musicians themselves tend to stress their differences from

ordinary people and to make it equally clear that their own behavior is perhaps not the most desirable in terms of village standards, no musician fails to add that he and his fellows are among the most important people in Lupupa Ngye. Nkolomoni, after pointing out these deviations, adds that "people like musicians and help them with their fields and to pay off their debts. People don't want them to leave the village, and this is why they help them. People do not like to be in a village where there are no musicians. Musicians are more important than ordinary people because when there is war it is the musicians who give strength and force to the people; it is the same when there is work to do." Mandungu says: "Musicians are more important than ordinary people. They are required for a funeral, they are paid when others are not, and they work for everyone. The musician is like a chief. People always gather around musicians." Mwepu adds: "Musicians are more important than other people because everyone likes them and because everyone is happy when they play." Chite says: "Yes, the musician is like the *lukunga* in that he is ordered about by others, but he is more important and more respected than the *lukunga*. A musician is like a woman because everyone likes him, and because he is difficult to replace."

This attitude is also held by nonmusicians; thus Mayila, a man of great gentleness, and by his own assertion, one of little music ability says: "Musicians are not lazy, but it appears that way because people do things for them and thus make them seem lazy. For example, if a musician wanted a new house in the new village site, other people would build it for him. Yes, musicians are like the *lukunga* in that they can be ordered around, but they are also like a chief because everyone wants to have them around." Efile says that "musicians are lazy, but they are more important than other people because they keep the people of the village happy." Even Kitoto, who was vehement in her scorn for the behavior of the male musicians, says that "other people always want musicians around."

There emerges, then, a more complex social pattern than might have been suspected. Even though the social status of the musician remains low, his importance to the society is very high. Though as an individual he may be scorned and stereotyped as a person of little consequence, his functions in the society make him essential. Indeed, nonmusicians, when proffered the suggestion that the village might be better off if these n'er-do-wells were banished from it, reacted with seriousness and, in some cases, almost horror. "Life in a village without musicians is not to be considered, and people spoke of leaving the village were

no musicians present. This reaction cannot be taken lightly, for the bonds of kinship and economics which tie an individual to his village are extremely difficult to break" (Merriam 1964:136). Without musicians a village is incomplete. People want to be happy, and music-making is associated closely with happiness. Without musicians a proper funeral cannot take place and the monthly celebration for the village fertility figure and protector cannot be held. Musicians perform a variety of functions in village life which no one else can replace; life without them cannot be normal and it is not to be contemplated seriously.

Bala musicians seem to be fully aware of their ambivalent position in society and to take advantage of it in a variety of ways. It often seemed difficult, for example, to understand why the villagers continued to lend money to Mwepu, for they knew that he abused their trust, that he was the worst debtor in the village by a goodly margin, and that the chances of repayment were extremely slim. Indeed, Mwepu was constantly berated, and the money he did manage to earn was often removed from his pockets by physical force, but he continued calmly to request loans from the villagers and to receive them. The answer to the problem lies in the fact that he was a man of importance to the normal process of village affairs, particularly because he was the only man who could sing the praise names for the male members of the village. Thus, though his house was the meanest in the village, though he was abnormally heavily in debt, and though he was looked down upon as a man who could not be trusted and who was not normal in the male role, it was necessary to keep him in the village at considerable social cost.

The role of the musician, as conceived in Lupupa Ngye, then, is a deviant role which allows the musician to engage in types of behavior which do not accord with that normally conceived as characteristic and proper for males. Bala society allows but one other comparable role—the kitesha, who avoids normal male responsibilities by taking the female role, although homosexuality is not a part of the associated behavior (Merriam 1971:94–7). He dresses like a woman, cooks, gathers firewood, and makes known his differences from other men in these and other public ways. The musician does not till the fields, does not undertake the normal tasks expected of men, and publicizes his differences by drinking, borrowing, spending his money unwisely, and so forth. Both roles allow the individual to live outside the requirements of normal behavior and to capitalize upon this alteration of social rules. Even in those cases in which he goes too far, punishment

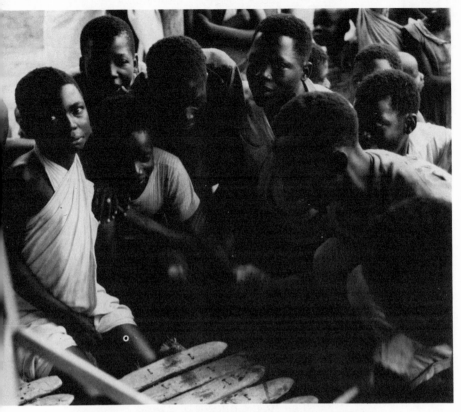

Nkolomoni playing the *edimba* (xylophone; pl. *madimba*).

Mwepu, a *mwiimbi* (professional musician of the third grade), playing the *lubembo* (double iron gong).

may be waived. A visiting professional musician who committed adultery with the wife of one of the high village notables was forgiven by the outraged husband and allowed to continue on his wandering way.

The behavioral pattern for the Bala musician can be summed up as one of low status and high importance, coupled with deviant behavior allowed by the society and capitalized upon by the musician. This general social role seems comparable to that of the jazz musician in the United States, the *griots* of Senegambia in Africa, the Arioi Society of Polynesia, and other musician groups in societies around the world (cf. Merriam 1964:137–43). At the same time, the pattern is not repeated in all societies—e.g., among the Flathead Indians—but it is apparently so widespread that it deserves close scrutiny as one of major importance when viewed in world-wide cross-cultural perspective. It is also suggested that this pattern may very well hold true for painters, sculptors, dancers, raconteurs, writers, actors, and other artists as well. At present there exists no explanation, so far as I know, for why this pattern should exist among musicians in such wide distribution.

The Bala Concept of Music

We have seen that the social role of the musician is separable from other roles in Bala society, and that therefore the musician stands apart in certain ways as a unique individual. The question now is whether the sounds he produces—i.e., music—are also set apart from other sounds normally heard by members of the society. The answer to this question must certainly be in the affirmative, for it is logical to assume that if no distinction can be made between music on the one hand and nonmusical sounds on the other, there can be no such thing as music. Either all sound will be music or no sound at all will be music and thus cannot exist. Again I have discussed this matter at considerable length elsewhere, and the following account will be drawn directly from that source (Merriam 1964:64–7).

Among the Bala, there is a clear concept of what music is, although it is not expressed directly. In speaking to this question, the villagers tend to respond with aphorismic statements such as the following:

> When you are content, you sing; when you are angry you make noise.
> When one shouts, he is not thinking; when he sings, he is thinking.
> A song is tranquil; a noise is not.
> When one shouts, his voice is forced; when he sings, it is not.

Using statements such as these, as well as detailed questioning and observation, it is possible for the outside observer to construct a three-part theory of noise and music as held by the Bala.

In the first place, music for the Bala always involves human beings; the sounds which emanate from nonhuman sources are not, and cannot be, considered music. No informant classifies the sound of singing birds as music, nor does the wind sing in the trees. The consistency of this point of view is emphasized by the fact that only certain kinds of supernatural or, more accurately, superhuman manifestations are capable of producing music. The *milungaeulu*, which are purely non-human beings, not only do not make music but are entirely mute. However, the *bandoshi*, or witches, have their own songs which they sing together at periodic conclaves; this is explicable in terms of the fact that witches *are* human beings pursuing an evil course in life and are not considered to be anything but human, though they do have extra-normal powers. There is some difference of opinion among the Bala as to whether the *bikudi*, or ancestral spirits, sing, but this is more a question of whether the singing can be heard than of whether music is produced. The elders say that on exceptional occasions the ancestral spirits can be heard singing in the bush at night, and this is consistent with the theory of music since ancestral spirits are conceived to be human and thus capable of making music. Younger men, however, say that the elders are foolish and that the night noises ascribed to the ancestral spirits are really the crying of the jackal and thus not singing at all; this again is consistent since animals cannot produce music of any kind. Finally, song is not a part of myth or legend. Although the ability to sing or play a musical instrument comes directly from Efile Mukulu (God), Efile Mukulu is not conceived as a music producer in the sense that he sings himself, nor do the culture heroes involved in the creation of the earth and man sing in the course of their creative activities. Thus the idea that music is created only by humans is consistent within the framework of Bala conception.

This view of music as produced uniquely by human beings is not universal, in Africa or elsewhere. J. T. John, for example, records an origin tale for the xylophone in Sierra Leone, which ascribes the first tune played as having been taken from a bird song (1952:1045). This, of course, is in sharp contrast to the Bala concept.

The second point in the Bala theory of what constitutes music sound is that such sound must always be organized. A random tap on the xylophone or drum is not enough to fulfill the criterion, but neither does the sound of three drummers making a single tap together on their drums, even though it is organized. The third criterion, then, is

that to be music the sounds must have a minimal continuity in time.

By these three criteria—music is produced exclusively by human beings, it must be organized, it must have minimal continuity in time —the Bala do define the boundaries between music and nonmusic. Not surprisingly, however, there is an intermediate area between the two in which some disunity of concept is expressed and in which the context of the sound determines its acceptance or rejection as music.

Whistling is one of these areas, and Bala informants simply disagree as to whether this is or is not music. But there are different kinds of whistling. One can whistle as a signaling device in the course of the hunt, and here the Bala are unanimous in saying this is not music. Differences of opinion appear when one is discussing the whistling of a recognized tune. The Bala also produce sound by blowing into the cupped hands and into various devices such as the ocarina (Merriam 1962). The latter, called *epudi*, is again a signaling device used in hunting; it is also blown as sporadic accompaniment to certain hunting songs, but in neither case is it considered that the sounds are music. On the other hand, blowing into the cupped hands can be done as a melodic and rhythmic accompaniment to certain dances, and in this case it fulfills the criteria for music and is accepted as such. The same is true of *epudi* playing. Finally, although singing is differentiated from singing in nonsense syllables, both are accepted as music, while humming lies in the borderline area and is accepted as music by some and rejected by others.

Nketia has made similar observations in generalizing about African music (1961:4–5), but except for some theoretical attempt to differentiate speech from song, there is virtually no information available in the ethnomusicological literature concerning this important folk evaluation. Yet it is of the highest importance, for it delimits what is musical in the society and shapes not only music itself but even stories about music and concepts of the origin of music. Without such concepts differentiating musical and nonmusical sounds, there could be no music.

We have seen, then, that for the Bala there exists a distinctive group of sounds which can be differentiated from other kinds of sounds and which represent a phenomenon which can be called music; further, these sounds are produced most specifically by a small group of men and women within the society whose behavior and social role are special and who can be called musicians. Thus both music and musicianship are separable entities for the Bala, standing apart from other activities and behaviors. But the musician is not the only specialist, nor is his activity by any means the only kind of activity differ-

entiated in the society. The Bala differentiate further kinds of activities and associate certain behaviors with them; thus, "he is a chief, and therefore he must do such and such, and he is doubtless also a witch," or "he is a farmer who produces crops, and he must work hard in his fields in order to produce them." The question for us is whether music for the Bala is art, whether the musician is an artist, and whether the end result of the musician's activity is regarded aesthetically.

Art has been defined in many ways in our own society—by artists, art historians, aestheticians, and even anthropologists—but one theme seems to run rather generally through these definitions: that art is closely connected with objects, whether they be tangible, as in the case of sculpture, or intangible, as in the case of music. These objects are the products of the activity which produces them, but the difficulty lies in separating artistic from nonartistic objects, for many objects are produced in a culture, including the tangibles such as spears, clothing, houses, bowls, and so forth, and the intangibles such as music. Thus it seems clear that to deal with art only as objects or products *per se* tells us very little, for there is nothing in the idea of objects as such which separates one as artistic from another as not artistic.

Some qualification must therefore be added, as for example in Herskovits' definition of art as "any embellishment of ordinary living that is achieved with competence and has describable form" (1948: 380). Taking this definition backward, music among the Bala has describable form from the analytical point of view, though the isolation and description of elements of this form are not a feature of Bala thinking. Music is also achieved with competence in that value judgments are made by the Bala concerning good and bad musicians and music. But is music an *embellishment* of *ordinary* living for the Bala? The answer is probably that it is not; rather, music is simply a phenomenon of culture which is worked into the general framework of behavior and belief and which is accepted as another aspect of ordinary, expected and predictable events. It is true that music "makes people happy," but so does a good meal. It is true that without it a major funeral cannot take place, but neither can a funeral take place without a corpse. It is true that a music situation can move people emotionally, but so can greeting a seldom-seen relative. Thus the difficulty with this definition is discerning the dividing line between "ordinary living" and the "embellishment of ordinary living." Music for the Bala does not seem to be something extra.

A third kind of definition is found in Bascom's statement that "art is concern with form for its own sake" (1955:247). Such a definition demands the attribution of a conscious awareness on the part of the

276 ALAN P. MERRIAM

artist both of the elements of form and of their manipulation; as we shall see below, neither of these criteria seems to be met by the Bala.[3] d'Azevedo has added another element to what is basically the same kind of distinction in writing that "art is distinguished by an additional dimension—the creative manipulation of elements of form toward the production of esthetic objects" (1958:709), and it is at this point that we begin to reach something we can handle. That is, whatever art may be, a large element in it appears to be the attitude taken toward it both by the creator and the contemplator. While I would certainly not offer it as a *definition* of art, I would say that what is art depends upon what people say is art and that the difficulties in cross-cultural definition arise when one encounters a culture in which the concept of art as such does not appear to be present.

A key point in d'Azevedo's formulation is that art is directed toward "the production of esthetic objects" as its goal, and at another place the same author refers to the aesthetic as "the qualitative feature of the event involving the enhancement of experience and the present enjoyment of the intrinsic qualities of things" (1958:706). Thus what is aesthetic in d'Azevedo's terminology is an attitude rather than the action involved in creating the art product, and with this I find myself in essential agreement, though perhaps I would take it a step further in saying that the presence of art in any society may depend also upon the presence of an aesthetic. I do not see how there can be art by any save an outsider's terms unless there is an observable special attitude toward art; and I do not see how such a special attitude can be conclusively postulated unless there is a verbalized "philosophy of the aesthetic." Thus in determining whether a phenomenon is artistic, we must first determine whether there is an aesthetic attitude toward it on the part of the people concerned; otherwise, we are simply reading the formulae of our own culture into another.

The difficulty here is that it is extremely troublesome to know what is meant by aesthetic, both because the term has been handled in such a variety of ways and because it has been applied only in the Western context. I have speculated on this matter at considerable length elsewhere, and the reader must be referred to that source for fuller discussion of the brief outline which follows (Merriam 1964:259–76). In short, an attempt was made to distinguish six factors which, taken together comprise a general concept of the aesthetic in Western society, and to discuss their implications, including their presence or absence in two societies, the Bala (there designated as the Basongye), and the Flathead Indians of western Montana. The discussion was developed along the following lines.

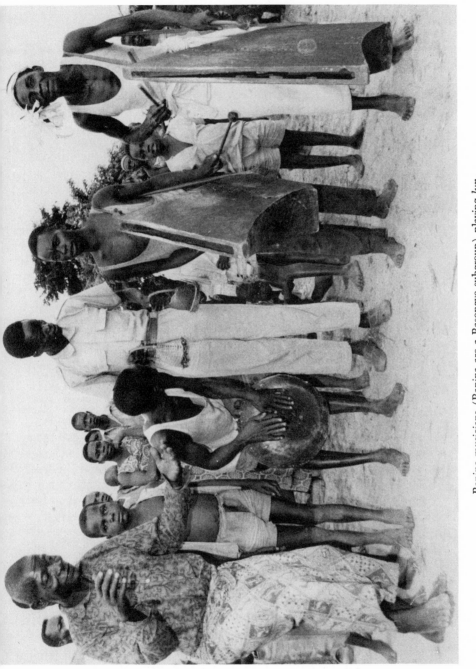

Bapina musicians (Bapina are a Basongye subgroup) playing *lun-kufi, masaka,* and *etumba* (single-headed drum; pl. *matumba*).

The first factor in the Western aesthetic is *psychic distance* by which is meant the ability of the person interested in music to remove himself from it, to hold it at arm's length as it were, and to examine it for what it is. The Bala do not and cannot do this, for each song depends heavily upon its cultural context and is conceptualized in this relationship. Music is not abstracted from its context, nor regarded as a thing apart, but rather is thought of only as a part of a much wider entity, i.e., the total framework of belief and behavior.

The second factor in the Western aesthetic is the *manipulation of form for its own sake*, but again the Bala do not meet the criterion, for their concepts of music as made up of formal elements which can be broken down and isolated from one another are not extensive, and if formal elements are not isolatable they cannot be consciously juggled to arrive at a fresh form. Obviously the Bala must change the elements of form to arrive at new compositions, but the point is that this is not a conscious process. The Bala individual does not sit down and consciously recombine elements of structure into a new song; rather he is believed to be the "unconscious" agency through which music is given to man by superhuman beings.

The third factor concerns the *attribution of emotion-producing qualities to music conceived strictly as sound*; that is, in Western culture, being able to abstract music and regard it as an objective entity, we credit sound itself with the ability to move the emotions. A song in a minor key is sad and makes the listener sad; certain kinds of music can be gay or pathetic or produce any one of a number of other emotions.

The difficulty here harks back to Basongye conceptualization which makes it impossible to abstract music from its context. While in Western society we can state flatly that a minor mode or a particular key induces emotion, it seems doubtful that the Basongye can. In the first place, so few elements of music structure are isolated that it would be difficult to find anything analagous to a "mode" or a "key" which could be correlated with emotion. Equally important is the fact that Basongye music is not abstracted from its context; a piece of music always has a set of social and cultural associations which automatically go with it. Given this, how can we distinguish the impact of the music sound from the impact of the associations? Is the Musongye moved by the sound of music, or by the context in which it is performed or with which it is associated? On hearing a funeral song, do people weep because of the music or because it is a funeral? (Merriam 1964:265–66).

It must be stressed once again that in the Western aesthetic it is the music sound itself which is considered capable of stirring the emotions.

The minor key, in no matter what context, has itself this capability; it is not that we use the minor key exclusively for funeral songs. Thus the enormous importance of the abstractability or nonabstractability of music from its cultural context is again brought to the fore. Since the Bala do not separate their music from its cultural associations, we can do no more than suggest that the problem cannot be solved. It is strongly indicated however that music in itself can produce emotionality only in association with other factors.

The fourth factor involved in the Western aesthetic is the *attribution of beauty to the art product or process. It is not suggested here* that art and beauty are the same thing, but rather that in the Western aesthetic beauty is irrevocably tied up with art. There appear to be no terms devoted to beauty among the Bala which parallel the Western concept except in a most distant relationship. For the Bala, music is *bibuwa*, a term which has to do with the inherent quality of goodness in a nonhuman phenomenon; thus a palm tree is *bibuwa* and music is *bibuwa* because both are inherently good things within themselves. The only Bala term which comes close to paralleling our concept of beauty cannot be applied to music. The Bala simply do not attribute the idea of beauty to music or make a clear-cut connection between the two. While it must be repeated that art and beauty are by no means identical, the Western aesthetic inevitably makes this a very strong association.

The fifth factor is the *purposeful intent to create something aesthetic*. While this is somewhat similar to the manipulation of form for its own sake, the difference lies in the word "aesthetic." The Western artist sets out with the deliberate intention of creating an object or sound which will be aesthetically admired by those who view or hear it, and this element of conscious striving reemphasizes the abstractability of art from its cultural context. But for the Bala, the absence of the first four factors of the Western aesthetic makes it very doubtful that there can be purposeful intent, and this is further marked by the fact that Bala musicians do not admit to composition, holding rather that music comes from Efile Mukulu (God) who wills it so at that instant. There simply does not seem to be among the Bala any purposeful intent to create something aesthetic.

The final factor in the constellation of traits making up the Western aesthetic is the *presence of a philosophy of an aesthetic*, and in a sense this factor is a summary of the five that precede it:

We have indicated time and time again that no verbal concepts exist for this or that among the Basongye or the Flathead . . . The contrast between

these two societies and Western society in respect to an aesthetic is precisely most noticeable in the verbal sphere. The Western aesthetic *is* primarily verbal; while gesture and bodily attitude complement the verbal, it is the latter which is most characteristic. Reference is made again to the "verbal jungle" which has grown up around the aesthetic, the plethora of terms and descriptive adjectives, the verbal play which surrounds the central concern. Indeed, what distinguishes the Western ideas and ideals of form and beauty is a definite "language of the aesthetic," and it is precisely this which is lacking in both Basongye and Flathead societies. We may pose the crucial question, then, of whether an aesthetic exists if it is not verbalized; the answer seems clearly to be that it does not, at least *if we use the Western concept of the aesthetic, which is exactly what has been done in these pages.* By Western definition and practice, then, neither Basongye nor Flathead have an aesthetic. Both societies engage in activities which lead to what we would call artistic ends; both societies clearly make evaluative judgments, but neither society has the Western aesthetic. (Merriam 1964:269)

It is easy to say, especially in questions of the arts, that something is there which the artist does not see, but this can be extremely misleading, particularly in the cross-cultural situation. Analytical evaluation is a necessity for the understanding of human phenomena, but its successful application depends upon the demonstrability of clear-cut evidence from which conclusions are drawn. The evidence in this case indicates that the Bala do not have an aesthetic, as defined in Western terms, and therefore it is difficult to see how they can have art from their own point of view. That they make evaluative judgments about the tangible and intangible phenomena we call art is clear, but they make judgments about many phenomena in their culture in the same manner. That they "do things with a flair" is clear, but they also practice sorcery with a flair, and it is questionable whether even we can properly include sorcery in art.

I do not doubt for a moment that other African cultures do have both art and aesthetics; indeed, d'Azevedo's description of the Gola (1958) and Messenger's of the Anang Ibibio (personal communication) convince me that these societies, among others, do have both as we define them in the West. These, however, are the easy cases, for the people themselves provide us with reasonably clear-cut intellectualized categories of art, and equally clear aesthetic reactions to them. But any cross-cultural definition of art, the artistic, and the aesthetic must consider not only the positive examples but the negative as well, and it is peoples like the Bala who pose the difficulties. Art is a very special thing in our culture, and we see and evaluate it from very

special points of view. Where these are paralleled in other cultures we are fortunate, for our cross-cultural comparisons and understanding are greatly facilitated. But the problems arise when we find a culture like the Bala in which what *we* call art, even though separable as objects produced by people whose behavior is special, is merely something else that man does.

NOTES

1. The field research on which the information in this paper is based was carried out in the former Belgian Congo from July, 1959, to July, 1960, under grants from the National Science Foundation, the Belgian American Educational Foundation, and to Barbara W. Merriam a grant from the Program of African Studies of Northwestern University. The author also wishes to acknowledge the close cooperation of l'Institut pour la Recherche Scientifique en Afrique Centrale (IRSAC), and l'Université Lovanium of Leopoldville.

All photographs in this paper are by Barbara W. Merriam.

2. While Basongye woodcarving, especially sculpture, has been discussed in a substantial number of works (see, for example, Olbrechts 1959), only two general ethnographic monographs exist, both fragmentary and now of considerable age. The first of these, *Les Basonge* (van Overbergh 1908) is a compilation of writings by explorers, missionaries, traders, and government administrators, most of whom wrote as interested observers rather than trained social scientists. Their work is arranged under a number of ethnographic headings, and the result is a potpourri of scattered, though interesting, bits of information. The second, "Les Basonge," is a 28-page chapter in *Notes ethnographiques sur des populations habitant les bassins du Kasai et du Kwango Oriental* by E. Torday and T. A. Joyce (1922). Though brief, it presents a more cohesive picture of the way of life of the Basongye than the van Overbergh work, but the research on which it was based in 1907 was apparently of very short duration, carried out among the Batempa, one of the northwestern Basongye subgroups. Other than scattered information from articles in various sources, these two works stand alone.

It will be noted that the spelling of the tribal name varies. Van Overbergh and Torday and Joyce use "Basonge," while my own references are to the "Basongye." Maes and Boone (1935:170) give the following: "Basonge, Ba-Songwe, Bassonga, Bassonge, Bassongo, Bassonie, Wasonga," as well as "Baluba, Baluba ba Nkole, Bayembe," and do not give "Basongye" at all. The people themselves say that their own name for themselves is "Basongye," and the term "Basonge" is that applied to them by the Baluba. Thus the term "Basongye" is used here, although the literature reveals the alternative spellings noted above, of which the most frequently used is "Basonge."

3. It is Bascom's contention (personal communication) that his definition does not imply any conscious manipulation of form, but I do not see how being "concerned" with "form for its own sake" can be anything but conscious.

Warren L. d'Azevedo

SOURCES OF GOLA ARTISTRY

THERE are among the Gola of Liberia many persons who as wood-carvers, singers, dancers, musicians, storytellers, and other specialists are recognized within the culture as representing a mode of conduct, a type of personality, and a set of life-experiences relatively distinct from those of other persons. These individuals fit into a broad category in Gola culture roughly equivalent to that suggested by our concept of "the creative personality," and some of them are artists. Though I know of no clearly equivalent Gola term or concept for the artist as we apply it to the role and status of certain persons in our society, I will show in this paper that there is a type of person engaged in activities among the Gola for which our concepts are applicable.[1]

The fact that the Gola do not have a distinct term for artist or art, as we conceive it, or that they may categorize roles somewhat differently than do we, should not prevent us from differentiating activities and values in their culture which seem similar if not identical to certain phenomena that we can find in our own. I know, for example, a Liberian ethnographer who enjoys the interpretive exercises of categorizing European or American acquaintances into "dreamers" and "non-dreamers," very much as he would do in evaluating certain kinds of orientations and behavior of persons in his own culture. Though these particular categories may seem alien to us, it is not long before one can perceive what is meant. Moreover, the designations begin to strike one as specially apt and strangely familiar.

Among the Gola, just as in our own society, not everyone who carves wood, tells stories, plays an instrument, or decorates something is included in a category that implies specially creative persons, or those whom we would call artists. As with us, certain activities of this sort are stereotyped so that anyone who engages in them to any extent is suspected of having all the other characteristics of the type as well. A

child who plays more than casually at carving wood, singing, story-telling, or mimicry is observed intently by adults. Consequently, many details of his general behavior which might ordinarily have gone un-noticed begin to be interpreted as signs of his life's orientation. Just as parents of an odd but intriguing child in our own society might anxiously ponder whether he will turn out to be either a ne'er-do-well or a great inventor, so Gola parents might express mixed admiration and weary exasperation by declaring, "he is just like those wood-carvers," or "this child knows the days of my life!"

The last statement is much the same as our "he'll be the death of me," but the Gola are much more literal than we. The strange child is an immediate as well as a potential danger to his family and fellows. He may be the agent of malevolent forces which bring sickness and death. He may be in league with an angry ancestor or a subversive soul from a rival lineage or chiefdom. Sorrow and fear surround such persons, and they may die young through the violence of some super-natural agency or of the righteous community itself. At the same time, the ambivalent attitude toward the unusual child includes the pos-sibility that he may bring gifts of greatness and power to his family and society. The legends of all truly great persons among the Gola—whether warriors, diviners, chiefs, curers, entertainers, or craftsmen—refer to their peculiar and unpredictable characteristics as children and to the concern of parents and other adults about their destinies. Re-markable successes in life are associated with personal traits that indi-cate supernatural guidance and unique gifts. The extraordinary indi-vidual of this kind is considered to be in constant and precarious struggle with mysterious forces which seek to alienate him from society. If he achieves a degree of success in the world, and brings honor to his family and community, it is believed that he has mastered these forces and turned them to benevolent ends. But if he dies in youth or lives to become a person of wealth and power through disloyalty and trickery, it is said that he was ruled by evil powers.

The Gola concept of the extraordinary person is, therefore, more concretely rationalized than our notion of the creative person or genius. But the characteristics of this type of person also constitute an arche-type in the culture which is applied to explanations about individuals performing many kinds of activities. Among these are persons whose roles and specific productive activities would fit our designations of artist and art. Entertainers, sculpturers, and other skilled producers of aesthetic objects are subject to evaluation and interpretation in terms

of the archetypical criteria. They are, in fact, set apart as a distinct subcategory of persons, though such distinctions are not easily discovered by the investigator from another culture.

The discussion which follows is a presentation of materials concerning a particular type of individual among the Gola who is immediately recognizable in terms of our concept of the artist. But in order to appreciate the significance of this recognition, or the problem of understanding the peculiar role and status of the artist among the Gola, it is necessary to provide a setting of certain relevant features of social organization and cultural premises.

The Regional Setting

The Gola number from 50,000–75,000 persons in northwestern Liberia. They are organized into many small chiefdoms, each representing the territory of a founding patrilineage. All political and sacred offices of these local units were filled in the past by members of ranked lineages who could trace descent to a legendary founder. Early in the twentieth century the Liberian government imposed a pattern of indirect rule in the hinterland through the establishment of Paramount Chieftainships over clusters of traditional units whose territories were adjacent and whose histories involved extensive intermarriage between ruling lineages and longstanding economic and political cooperation.

In the nineteen fifties, the building of roads by the Liberia Mining Company and Goodrich Rubber Plantation opened the eastern section of Gola territory, from Monrovia to Bomi Hills, to new commerce. But sections to the north and east along the upper Lofa River and bordering Sierra Leone are still isolated and little known. This interior area is considered by the Gola to be the homeland from which they dispersed toward the coast during the past three or four centuries, establishing new chiefdoms in the lowland forest near the coastal Vai, and on lands wrested from the De. The process of Gola expansion has been part of a general movement of peoples into the coastal sections of Liberia and Sierra Leone, which has resulted in distinctive regional demographic and cultural features.[2] It is an area of linguistic and ethnic diversity where unstable confederacies have temporarily united local units of different tribes under warchiefs competing for dominance in a vast network of trade between the coast and the interior.

One of the major mechanisms for the development of regional interrelations among frontier confederacies of diverse peoples was the *Poro* type of fraternal organization. *Poro* (*Bōn* or *Bōn poro* in Gola)

emerged from basic forms of secret societies common to most peoples in this area of West Africa, and was the counterpart of the sororal association (*Sande*) in the task of socialization and maintenance of traditional institutions in local communities. It was also the instrument of validating political and economic control over larger and more complex units. As a sacred and secret vehicle of political diplomacy it provided alternate channels for the settlement of disputes between chiefdoms through councils of *Poro* elders and other officials with jurisdiction over large areas. Despots and upstart warchiefs were kept in control by traditional authorities with the threat of secret *Poro* negotiations which could produce effective resistance.

Like most of their immediate neighbors, the Gola have been intensive slash-and-burn agriculturalists with rice as a principal crop. Agriculture is supplemented by the gathering of forest crops such as nuts of the oil palm, fibers, and various fruits and tubers. Goats, chickens, and pigs are kept to some extent in villages, and wealthy persons may have a few cattle. Hunting and fishing, important activities in former times, have subsided with the depletion of forests and game. Localized markets were not developed among the Gola, as they were with certain of their more populous neighbors to the north and east, but an extensive system of exchange in surplus crops and manufactured goods existed through the agency of itinerant traders and by individuals carrying their own products to distant markets on the coast or into the interior. Local surpluses were accumulated in the hands of chiefs and other wealthy individuals who, in turn, organized trading caravans and expeditions.

In traditional Gola chiefdoms agricultural activities were the focus of the economy, and political power was based upon control of land and the efficiency of the farming population. The prestige of the ruling patrilineage depended on the wealth it could command through the exploitation of its population and lands, and its ability to defend the territory against conquest. The leaders of the chiefdoms, therefore, strove to increase the size of the population under their control, and to maximize self-sufficiency by encouraging a diversity of occupations. It is said among the Gola that a ruling family with much land inherited from the founding ancestors is rich in honor, but it is poor in power unless it also controls many persons. A great man is one who can attract large numbers of people to follow him. Preferably these persons are his kinsmen, but more frequently he must offer his patronage in land and protection to strangers. In the period of Gola expansion the descendants of the founders of new territories encouraged settle-

ment from wandering groups regardless of tribal affiliation. These newcomers validated their allegiance by working the lands, by gifts of women and slaves, and by paying tribute through various prescribed services. In many chiefdoms the number of "followers" of leading men, including attached families, warriors, practitioners of magic, advisers, interpreters, entertainers, and craftsmen, exceeded the population of members of the ruling patrilineage.

Vocational Specialization

In traditional Gola society there were many activities that might be pursued as vocations or even professions.[3] However, it is necessary to distinguish between those vocational specializations connected with statuses assigned by high ranking kinship groups, determined during an individual's infancy with regard to his character and destiny, or assumed as a matter of choice and competitive effort.

The vocations involving the most intensive ascription are those of the sacred offices of the local secret society organizations. *Poro* and *Sande* officials are selected from among a limited number of elder candidates in the high ranking lineages of the chiefdom. Ideal rules of descent and inheritance are strictly adhered to and public rituals validate the assignment. Theoretically, the same prescriptions hold for the selection of secular rulers who are supposed to be appointed by the sacred elders from among the most able candidates of the core lineage. On the level of local village organization or in small, relatively isolated chiefdoms, this is the case. But in large heterogeneous chiefdoms, and certainly in the mixed confederacies of the past, these rules gave way to expedient support of able and aggressive leaders who forced their way into power and who, in many instances, successfully maneuvered the elders into acceptance of fictionalized credentials.

The vocations of the priesthood and of political leadership are among the few activities of Gola communities whereby the individual may be freed entirely from agricultural or other basic subsistence tasks. This is, in part, attributable to the fact that the incumbents of these offices belong to the wealthy land-owning descent groups of the chiefdoms who can afford to support them. Usually they are wealthy persons in their own right with many wives, children, and retainers to work the lands and to carry on other economic activities. As they are most often elderly, the special respect and release from labor accorded the aged in large families is accorded them. In addition, the incumbents of major religious and political offices are allowed to exercise certain rights and to expect favors. Secret society officials may impose

fines for infractions of law or for improper deportment. During the period of intensive secret society activity, they may command members to work their lands or harvest their crops. All solicitations for blessings, ritual performances, and other services must be accompanied by an initial gift, quite separate from the actual payment which may be demanded later. Similar conditions obtain for chiefs, though they have additional emoluments from taxation, court fees, and duties imposed on trade.

In former times, and even today, in the more conservative villages and chiefdoms, the status of the blacksmith was virtually that of an office in the local *Poro*. The importance of iron for weapons and agricultural tools and the skills required in their production surround blacksmiths with an aura of urgency and mystery. The blacksmith's shop and its equipment is protected by ritual sanctions. Only members of *Poro* may step inside; the feet must be bare and the voice must be subdued and speech at a minimum. The blacksmith makes the knives that are used in circumcision and frequently performs the ceremonial act for *Poro* initiates. This gives him a position of importance in the *Poro* organization and all the public respect of a sacred elder. Blacksmiths are not *selected* for their vocations as is the case with secret society and political officials, but status is attained through apprenticeship and special aptitude demonstrated early in life.

These vocations are relatively unique in that they represent professional roles permanently supported by local communities, and those chosen to follow the professions are recruited from patrilineages of highest rank. There is also a small class of honored specialists who enjoy unusual privileges as well, but these will be discussed in the following section. Skills of various kinds are highly generalized so that most small communities have members adept in a wide range of craftsmanship, forms of entertainment, therapeutic and magical practices, hunting, fishing, and trading. Local groups that maintain self-sufficiency and proficiency in these skills are greatly admired. Public ceremonials are occasions in which the special abilities of individuals are exhibited and rewarded by gifts and applause. The "bush schools" for young secret society initiates encourage specialization by offering instruction to those who show aptitude, or by preparing them for occupations befitting the ranks of their families. They are allowed to act out respective vocational roles during the long period of seclusion, and when they at last emerge "newborn" to the awaiting community, they are expected to present evidence of their training by participation in competitive public performances.

Yet, apart from the few exceptions noted above, these abilities

seldom develop into full-time vocations. They are maintained as avocations providing minimal supplementary income through exchange of services among members of the local group. Most of those whose talents and motivation incline them to intensive specialization can only do so by seeking a larger area of demand. They are itinerant in that they must frequently travel long distances to places where their services have been commissioned, and they are often required to reside for long periods away from their own villages. A famous specialist may have more requests of this kind for his services than he can meet. He may even be attracted into the permanent service of a wealthy patron in some distant chiefdom of another tribe.

The primary support for such specialization comes from the patronage of wealthy and powerful persons. In the past, great chiefs vied with one another to attract specialists to their entourages. The competition for a renowned warrior, a seer, an entertainer, or hunter was so great that legend tells of wars between chiefdoms resulting from it. The services of famous specialists were exchanged among rulers as gifts and favors in diplomatic relations. This involved regional interrelations transcending local traditions and tribal boundaries. Specialists from other tribes and distant places had much prestige, and it was possible for them to accumulate wealth by a period of service to a foreign patron. For example, the Islamic adviser or seer (*Mole*) from the Mandingo (*Maniŋka*) peoples of the far interior was a highly valued member of the retinue of every great leader.

In recent times the focus of patronage has shifted to the few remaining wealthy families of tribal chiefdoms, to Paramount Chiefs, government officials, and Europeans. The idea of seeking the patronage of the wealthy and powerful is one of the basic instrumental values of Gola culture. A young person wishing to get ahead in the world engages in a series of attachments to individuals from whom some advancement in knowledge, wealth, or prestige can be gained. This may take the form of voluntary servitude or of apprenticeship. It may also involve going to distant and strange places. Such travel is thought most likely to provide dramatic success and is a romantic and adventurous theme of Gola legend. It is said that very few can become great among their own people, but everyone knows of the marvelous exploits of those who have gone away and returned after many years, rich in money, wisdom, and followers. In all the larger villages and towns of the interior the reality of this situation is demonstrated by the fact that most full-time specialists are only temporary residents. Traders, shopkeepers, tailors, curers, entertainers, and craftsmen of all sorts

carry on their vocations at the invitation of the leaders of the community, for as long as there is advantage to be gained.

Formal professional associations or occupational castes do not exist among the Gola, as they do in some of the neighboring tribes to the east where craft specialization and markets are highly developed. Independent craft guilds, frequently under strict *Poro* regulations, were an important feature of the economy over large sections of this region. Special secret societies of vocational colleagues, requiring oaths, initiation ceremonies, and apprenticeship also have a wide distribution. But among the Gola and some of their immediate neighbors professionalism is more individualized. Some collective guidance is provided by the local *Poro* and *Sande* organizations through the specialized training administered to initiates. Since all adult citizens are members of these associations, the more skilled among them may influence the development of skills in the novices.

Status of Specialists

Strongly ambivalent attitudes exist with regard to special skills and abilities. The individual is thought of, first of all, as a member of a lineage from which he is considered to have inherited his personality and his potentialities. Thus, his primary obligation is to the family which possesses him as a property, has a legitimate claim to all that he produces, and must accept responsibility for his acts. His second major obligation is to his local community. His secret society training and oaths unite him with his fellows in a bond of absolute loyalty as "children of the country" under the chiefs and elders who are the "fathers of all the people." If he attaches himself to another family or patron, he is expected to perform temporarily as the child and personal property of his new "owner" or "protector." As a property, he and the things he accomplishes cannot be alienated permanently excepting through intricate procedures of validation involving agreements and compensation.

But competition among members of major sublineages is intense, and the desired goals are achieved only by a few. Some children are favored by their elders because of the lineage rank of their father or the status of their mother among their father's wives. Others are favored because of their relative age or submissiveness. These children are kept close to their parents, the sons being groomed by their male relatives for leadership and the daughters for important marriages. But there are many others who are mere instruments of family fortune.

They are loaned as pawns to a family client or patron, or if they show any talent, are sent off as apprentices to some skilled person. In recent times, government and missionary schooling has been seen as a kind of apprenticeship where certain children may be placed as an investment in their future value to the family. Still others remain at home as virtual servants, sharing only minimally in the inheritance of their fathers.

Cleverness and special knowledge open the way to numerous alternative means of achievement, which circumvent the restricted arena of opportunity provided by families and local communities for their own members. To pursue these alternatives a young person must have great personal initiative which in turn may alienate the good will of one's relatives. In former times, a common way to seek one's fortune was to run away to join the mercenary army of some renowned warchief or to beg the protection of a wealthy patron in a distant country. Apprenticeship to an Islamic teacher or to a great craftsman might prove to be a stepping-stone to an independent vocation. Today, one seeks out the few remaining chiefs of the region, government officials, or Europeans. If opportunities are not present in the hinterland, one goes to the city to seek one's fortune. Formal education, a wealthy foreign patron, and a period of training abroad are the ultimate of means.

Though the attainment of wealth and political power are ultimate goals for ambitious individuals, there are other kinds of attainments which provide freedom of choice and release from dependence upon the approbation of the local group. These involve full-time specialization in some activity for which one can receive an income apart from farming and which requires mobility and weakening of permanent ties with any local group.

No matter how great a specialist is considered to be, unless his special skill is subordinated to basic subsistence tasks, or unless he is using it to achieve conventionally ambitious ends, he is praised with reservation. This is particularly so with reference to older persons who have never accumulated wealth or dependents, but who continue to specialize in some full- or part-time activity that brings little or no income. In Gola terms they have forfeited their birthright and renounced the security and prestige which are the expected rewards of old age. They are often strange persons who arouse both awe and contempt because of their apparent disregard of normal aspirations or deportment. Yet they may not be indolent or stupid and are often capable of remarkable things. The major source of suspicion about

them arises from the fact that they are relatively self-sufficient individuals whose abilities are unique and whose aspirations are largely private.

Regardless of degree of specialization, however, certain vocations are thought to attract such persons more than others. Independent specialization in magical practices, in entertainment, and relatively non-utilitarian forms of craftsmanship is particularly subject to these attitudes. But in order to understand this aspect of Gola values it is necessary to take into account the beliefs which the Gola hold concerning the origin of personality and talent.

Talent, Virtuosity, and Genius

Gola attitudes concerning exceptional skills are permeated with the idea of supernatural power and guidance. A clear distinction is made between those pedestrian abilities which many persons may achieve through careful observation and practice, and those which give evidence of unique gifts which compel an individual to concentration and excellence in a line of work. This is even true of such basic and generalized activities as farming and other subsistence tasks. If a person pursues any activity with intensive interest and becomes known for a degree of superiority in performance, spiritual guidance is suspected. The degree of full-time specialization or professionalism is not a decisive factor in these judgments. Many successful professionals might be excluded from the category of exceptional persons, while certain part-time or casual specialists are held up as prime examples.

The Gola believe that there are sentient spirits behind all natural phenomena. These are classed into three general categories: the *jina* who are the spirits of sky, forests, mountains, and waters; the *anyun fa* who are the ancestral spirits; and *esẽ* ("witches") who are the spirits of evil persons, rejected by the world of the living and of the ancestors alike, wandering endlessly about doing terrible deeds. The various spirits of the world live in communities of their own in places under the earth, in the sky, or in distant forests and mountains. But all of them carry on commerce with human beings and concern themselves with human affairs. The ancestors, in particular, watch over the activities of their descendents, and their anger or pleasure has an immediate impact upon the living. Because they reside in the world beyond they have full knowledge of the meaning and causes of all happenings, and therefore must be appealed to in times of crisis. Witches are unwel-

come intruders and their destructive and cannibalistic acts, carried out through helpless human agents, must be countered by specialists adept at detecting and trapping them.

Over all things, but not directly accessible to human supplicants, is *Daya* who has created and ordered the world. The various spiritual agencies of the cosmos act as intermediaries between *Daya* and mankind. It is to these agents that one prays—the spirits of nature, the ancestors, or even the free-roving malevolent entities who are nonetheless emissaries of the distant unknowable sphere of ultimate truth.

The ancestral spirits will not respond to private or antisocial appeals. They are united in defense of the prestige and fortunes of their living descendents and jealously scrutinize every act. If they are angry they may bring sickness or disaster to one who endangers the lineage; if they are pleased all prosper. They will listen to prayers only from respected elders of a family on behalf of the family. They must be praised continually, presented with gifts, and their graves tended. There are special old people who are believed to commune with the ancestors through dreams and prayers. They are known as *anyun zolo* (people who pray). The *anyun zolo* of the ruling houses of chiefdoms are selected by the councils of elders to represent the entire local community in propitiation of the ancestors who founded the community. At this level of organization, the *anyun zolo* are the sacred personages who fill the offices of priests and priestesses of the *Poro* and *Sande* secret societies.

While the elders and the ancestors are morally committed to custodianship of the public good, the *jina* of the world are not. They are amoral beings of various kinds, each representing distinctive characteristics and powers. The *a teva teva* are small elf-like creatures of the forests who play fantastic tricks on travelers and who control the wilderness domain. *Anyun to* are spirits of the mountains, among which are the *o dulu*, terrifying monsters of the deepest mountain rainforests. The latter move through the country with great speed, leaving trees flattened in their wakes. *Anyun kwui* are the spirits of the waters who have human form, depicted as "bright"-skinned and often golden-haired. Frequently they appear as water snakes or other aquatic animals. Various spirits of the sky, particularly those of storms, have great powers. Thunder and lightning are their weapons. In addition, there are the innumerable spirits of animals which wander about, much as the souls of human beings may do while the body sleeps. All of these entities are referred to as *jina*, a term which has wide currency throughout this region of West Africa.

A famous Gola singer practicing with her aides.

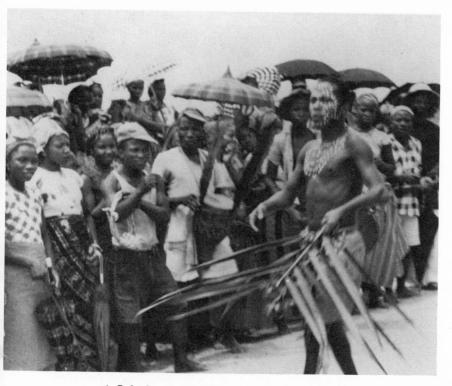

A Gola dancer at a celebration with drummers.

Though each class of *jɪna* has its own characteristics and powers, the individual spirits of each type are like human beings in seeking personal advantage. It is possible for individual human beings and individual *jɪna* to form alliances which are known as "friendships." In fact, every human being has such a potential "friend" even though he may not know of it or may have scrupulously avoided it. Some persons are born with a friend that has joined them in their mother's womb, or who was inherited from a relative who passed on the friendship to the beloved descendent after death. Others "discover" their spiritual friends later in life in the most unpredictable circumstances. It is believed that such friends are sometimes lost from one another and go about in life searching to find their counterparts. This can be dangerous, for an ambitious man or *jɪna*, desperate to gain the advantages of a friendship, may encounter an unscrupulous counterpart and form an alliance which is destructive to both.

These beliefs, validated by myth and expressed in on-going social relations, are a profoundly significant aspect of Gola life. The potential spiritual friends of human beings are known as *neme* (literally, "the thing found"). They are usually of the opposite sex, and the relationship can be so intense as to overshadow all others. To the Gola, the concept of the *neme* as a powerful tutelary spirit provides explanation for a wide range of human conduct and, particularly, for the exceptional person. Every human being is considered to be born with his own individual character involving a degree of inherited talent or *emɔnɔ* ("sense" or "wits"). Or it may be said of a person *wo na bene* (he is very able), implying much the same as our word "talented." But without "luck" (*ké du*),[4] which comes through the gift of power (*egòò*) granted by a *neme*, a personal talent may never bring greatness or success in life. Though each person has certain innate abilities and an individual way of thinking (*edí ne suwa*—"what is inside the head," the "inner mind"), it is the *neme* which guides one to special knowledge (*na jíkea je*—"new thoughts," or "ideas") and gives one an advantage over other persons. This knowledge comes through dream or vision (*egwa*), which creates the condition for communication between "friends." A person reflects the character of his *neme* and shares its thoughts and powers. This is referred to as *anyun gbɪ iyâigba yi gwá gó ne suwa* (every man is different in his own way of dreaming).

The *neme* is jealous and makes great demands on its human friend in exchange for favors. Theoretically, each person has a private code of rules (*negba*) which he must follow that expresses his commitments to the spiritual relationship.[5] These rules restrict his conduct, force

him to scrupulously avoid certain foods, reveal to him the symbolic significance of certain natural objects associated with the *neme,* and bind him to secrecy. The personal totemism of this private relationship with a *neme* is closely connected with the collective form of totemism of some great patrilineages whose members believe that they are bound by the rules of a particular class of *jina* which has provided the tutelary spirits for the eponymous ancestor and most of his descendents. Under these conditions, the *egba* becomes a secret shared within the descent group and enforced by the local secret society organizations.

The private *neme* relationship is thought to be varied in quality and fraught with dangers for the individual as well as the community. The *neme* is selfish and is concerned with its own mysterious, nonhuman ends. It promises success to its human friend, but always at great cost. The cost is in the form of some personal sacrifice—restrictive rules of personal conduct, physical impairment, the death of one's beloved relatives, or something as crucial as childlessness. The most desirable *neme* is one which had a former friendship with an ancestor and represents the class of *neme* shared by other members of one's kinship group. Such a *neme* has learned to respect one's family and to consider its interests as well as that of its friend. Also, such a friendship can be discussed with one's relatives without breaking *egba,* thus bringing trust rather than suspicion among family members.

The most perilous relationship with a *neme,* however, is one which is formed later in life, through direct solicitation by a *jina* or an overly ambitious human being. Under these conditions the pact is likely to be fulfilled at enormous cost. The *jina* offers fulfillment of very specific wishes such as wealth, love, political power, and fame, but demands in return very specific gifts that are always shockingly destructive to one's human relatives and friends. It may demand one's own early death or that of a relative. It may request that one provide favors to its own kind; for example, a hunter may be required by the spirit of a leopard to allow leopards to attack and feed upon members of his community. A terrible oath is sworn from which one can never escape. Luck or power gained in this way is known as *bléno* or *bondo,* and one suspected of it is feared.[6] These are not friendships, but conspiracies between a bad *neme* and an unprincipled human being.

Because the *neme* relationship is one of precarious struggle between private and public values, between one's own self and a powerful seductive spirit, it is claimed among the Gola that the average person rejects any advances from *jina.* This can be done by refusing to keep such matters secret. Telling others about them discourages the *jina.* If

it persists, however, one may go to a specialist whose *neme* is of the same class and pay him to intercede. The process is usually effective, but the person has given up a major means of achieving greatness in the world. It is said that "without *neme* one can be happy and live a good life, but one will never be truly great among men." There are many other persons who have no recollection of having been aware of *neme*. It is said of them that they "do not know themselves," or that they "would not feel a cow fly's bite."

Two terms which denote exceptional persons of the genius type among the Gola are *yun edi* (a person of special mind) and *yun gò gwá* (a dreamer). These are persons whose character and works reveal the spiritual source of their powers. They may be found in all walks of life and in all circumstances. They are usually specialists of one kind or another, but not necessarily full-time professionals. Certain vocations are, because of their nature, predominantly represented by persons of this type. Most diviners, curers, sorcerers, and other manipulators of magic are considered, by virtue of the requirements of these practices, to be *anyun edi* under the guidance of *neme*. Some herbalists, however, and other makers of medicinal potions need not be guided directly by spirit powers but may have learned certain techniques from another who is. In all special activities the Gola make a distinction of this kind between the skills which ordinary persons may attain in accordance with their various talents, and those which are clearly extraordinary and proof of supernatural support.

The title *zo* is conferred on individuals who have demonstrated a high degree of disciplined skill in certain vocations over a substantial portion of their lifetimes. It denotes a respected person of wisdom of a particular kind, an expert, or more specifically, a master. A *zo* is one who has become a virtuoso in some field of specialization and who has earned the trust and admiration of the entire community. Not all persons referred to as *ma zonya* (plural) are *anyun edi* or *anyun go gwa*. They may be merely individuals who have performed exceptional services to the community and who are custodians of a body of knowledge and technical procedures that can be taught to others. They are, therefore, exemplars of proper conduct, of the rewards of rigorous training, and of the ideal relationship between the individual and society.

The significance of the title as a reward of virtuosity tempered by responsible citizenship is confirmed by the fact that this honor is bestowed by the secret societies. The hereditary offices of the local *Poro* and *Sande* organizations automatically confer the title of *zo* on

incumbents of the offices. Certain older specialists such as blacksmiths, curers, or diviners receive the title as a degree constituting recognition by the leaders of *Poro* and *Sande* of their expertness. A *zo* who is also *yun edi* or *yun go gwa* is considered to be truly and extraordinarily great. The implications are that his *neme* is not only of superior power, but also of benevolent and profound character.[7] A *zo* with *neme* has proven by his life's work that the spiritual powers derived from the relationship have been channeled into service of family and public ends rather than to private and selfish advantage. Thus, the *zo* is the laureate, the exceptionally talented person whom the elders and ancestors have singled out as most worthy of their special regard.

Becoming a *zo* signifies, therefore, that the leaders of one's family and community have provided a credential of professionalism. Few men or women receive the title until they have attained the age at which they might ordinarily become elders, though occasionally an exceptional person may be so designated in middle age. The value of *zo*-ship is immense. Though his lineage rank may in some cases be lower than other elders of more important families, his title provides him a ritual status in local secret societies which may be equal or higher than theirs. Furthermore, the formal validation of his specialized skills brings him honor and trusting acceptance beyond his own community. His services are sought far and wide. The *zo* is the true professional among the Gola, a master of a body of knowledge, and a source of pride to his community.

The *zonya*, as publicly acknowledged virtuosi, must be above suspicion. No person suspected of sorcery (*gò nànà*) or a secret bargain (*blénɔ*) with an evil spirit could attain this status. Those few *zonya* who are known to be guided by powerful tutelaries have gained the confidence of the community by proving that their *neme* is controlled or "trained" (*e goyé*) for the good of all.[8] This is accomplished not only by competence and good character, but also by relinquishing much of the secretiveness about spiritual powers. Though there is always some crucial and secret aspect of the *neme* relationship, a *zo* is more inclined to submit to scrutiny in this regard. He will speak openly of the category of *jina* to which his *neme* belongs and may even describe the personal characteristics of his friend. He makes no secret of the special laws which his spirit imposes upon him, and the public is expected to respect them as well.

A refusal to pay a fine demanded by a *zo* may become a matter of court litigation or secret society reprisal. In this way the community takes responsibility for satisfying the tutelary and has given public

recognition of legitimacy to the relationship between an individual and his private supernatural agent. Collectively, the spiritual guardians of the leaders of great patrilineages and of the *zonya* whom they have appointed represent the positive supernatural forces which have entered into a great alliance or covenant with man. They provide the magical power (*egòò*), the "genius" (*neme*), and the "inspiration" (*e jíke jia*—"great ideas") without which human societies would have no leadership and the Gola would have been destroyed by their enemies.[9]

There are certain kinds of individuals, however, about whom it is said that they love their *jina* more than they do any human being. Such persons seem to be living in a different world from their fellows and are oblivious to the practical requirements that orient the lives of other members of society. It is hoped that they will become great *ma zonya*, but this is seldom the case; for the exceptional abilities of such persons are usually concentrated in some activity which they pursue as an end in itself at the expense of the standard goals associated with leadership, wealth, and honorable titles. These people are most often to be found among the craftsmen and entertainers. Though they usually excel above all others, they are too irresponsible and "unambitious." It is said of them that their *neme* is too strong and that they have given themselves over entirely to the love of a *jina*. They live only part of their lives in the world of human beings; the other part is lived with the spirit spouses. As a result, they are unable to form any lasting attachments among human kind, but are restless rovers who cannot be happy in one place. They show unconcern and frivolousness about all those things which others take as the important business of life. This behavior is different from that of many other brilliant persons who consort with *neme*, but who do so in terms of specific goals of self-aggrandizement that are considered common to most men and involve activities which are useful to society. It is more like the behavior of children or lovers who live for the moment and who have their minds fixed on one desire above all others. Such persons cannot be assigned to positions of serious responsibility; for though they often accept important tasks with great self-assurance, they cannot be counted on to carry out their obligations or to work effectively with others. They will always return to their own ways and private interests without having gained any enduring good for themselves or their fellows.

It is with reference to personalities of this kind that the dissonances in Gola values concerning transcendency in achievement are most sharply revealed. The system of beliefs and practices discussed above

clearly provides a wide latitude for the expression and rationalization of deviant behavior. Moreover, it offers the specially endowed individual opportunities to create and defend a relatively unique role for himself outside the standard role expectations of family or community. This deviance from the norms of Gola society requires the exercise of those instrumental values which are explicitly discouraged by the community but which are, at the same time, continually reinforced by belief. The exceptional individual whose aims are unconventional and who seeks an independent mode of personal expression must learn to manipulate the symbolic elements of this highly amenable system of values. The most effective course is to construct about one's self an aura of mysterious inner urgency involving peculiar outward manifestations of rigorous discipline to a code derived from a secret covenant. Those who succeed in convincing themselves as well as others of the authenticity of a unique spiritual companionship achieve a degree of insulation from direct public sanction granted to few in Gola society. This requires not only dramatic exposition of relevant personality characteristics, but also the demonstration of remarkable skill in the making or doing of things which impress others as marvelous and beyond human capacity.

Identification of Gola Artistic and Aesthetic Values

The application of the concept of the artist to delineate a particular category of persons and activities among the Gola requires that it be significant to members of the culture as well as to the outside observer who has brought it with him as part of the repertoire of his own cultural experience. In this discussion the activity of art is defined as the conscious manipulation of expressive and qualitative symbols to produce objects intended for appreciation in aesthetic terms. The concept of the artist as an individual whose intent is *predominantly* focused on gratification of aesthetic interests provides the rudiments of a distinction between artistic activity and various other activities which are merely enhanced by artistry. Thus, the skilled craftsman or entertainer, though engaging in the exploitation of media and forms which we normally associate with art, is not necessarily an artist unless his personal orientation and skills are directed to the production of an object of a particular kind.

In this connection I am reminded of the participation of a Gola elder in that portion of the ritual of turning over authority of secret society education from men's *Poro* to women's *Sande* in which he (in

his role as local sacred administrator of both associations) was required to lead the men in a serpentine dance through the center of the village. I was struck not only by the differences between the executions of his part as he practiced it in many different villages, but also by the contrast it posed to the performance of other persons carrying out the same role elsewhere.

He was a very old, rather comical appearing man who sported a jaunty knitted cap festooned with the leopard teeth insignia of his office. He customarily wore a loose fitting white gown and maintained the ceremonial tradition of going barefooted, while the other elders had long adopted European shoes or ornate Mandingo sandals. His public appearance always aroused mixed admiration and amusement. It was said of him that he had been a very wild and headstrong youth and that now in his senility he did many foolish things. Nevertheless, he commanded great respect, not only by virtue of his family and office, but also because of his merciless wit, his occasional outbursts of rage, and his unpredictable temperament. My own observation of him frequently gave me the impression that he was caricaturing his role, and this was confirmed by his own sly comments about himself and his followers, as well as by comments made about him. In this he was something of an oddity among the reigning elders of the chiefdom whose deportment was standardized to Gola concepts of dignity expressed by impassive countenance and aloof detachment on ceremonial occasions.

In one village he would lead the men's dance with an extremely slow stately walk, looking neither to the right nor left, and occasionally lifting his head in a disdainful gesture of ignoring the crowd. Because of his leisurely gait, the dance lasted an hour or so longer than customary, tiring the men and making the crowd of on-lookers impatient. There was, however, suppressed mirth and whispered comment wherever he passed. It was said, "See, he is showing us he is truly of the house of kings," or "He comes like a storm today!" Later, when I questioned him, he told me that the people of that village had always been difficult to control, so that when he went among them he showed "the hard face of the old kings who could have sold the people as slaves to far country." The idea amused him and he repeated the stance and gestures he had used in the ceremony.

At another village, some days later, he performed quite differently. He moved at the head of the line with a slow, whimsical, and self-absorbed swaying of his body which produced a kind of syncopated counterpoint to the vigorous line of young dancers behind him. Later

he remarked to me that this was "an old man's dance" in a village where he had many close relatives and the people show him love. Village by village I watched him enact various facets of his personality and public image, always self-aware and always the subject of special comment. Sometimes he was the clown, sometimes the drunken elder making wild mysterious gestures and incoherent utterances that some took as the language of the ancestors. Sometimes he flew into contrived rages and refused to continue his role in ritual until small fines were paid to pacify him. He was anticipated from village to village, and the people speculated about his mood and what might be expected of him.

I have selected this example of behavior because it is not typical of what the Gola normally accept as the proper bearing of a man of his office and age. Though he was a very unusual figure among the sacred elders, he did nevertheless represent a type of person which the Gola more often associate with the itinerant storyteller, the village ne'er-do-well or allowed fool. It was said of him that he had in fact been such a person in his youth and if it were not for his fortuitous membership in a high ranking lineage he would never have achieved the position he now held. He brought to his sacred role elements which were unique and apparently unprecedented in that context. He was also able to manipulate them so that they became acceptable and even a source of admiration.

The point here is that the observer might justifiably ignore these individualistic aspects of action and report merely the bare outlines of acts required by ritual. For purposes of describing a ceremony or analyzing its function within a larger system conceived as religious ritual, or rituals of socialization and social control it might not be pertinent to the problem at hand to include data on stylistic variations of this kind. On the other hand, the observer may interpret these variations from a number of other points of view. They could be interpreted as instrumental features of the wily old man's maintenance of authority —that is, as political acts. Economic aggrandizement was also involved. The acts did actually contribute to such possible ends by a devious route. Moreover, they might be interpreted as expressions of personality traits or as indications that the Gola will accept a wide range of deviant behavior from holders of certain offices. The question as to the validity of all or any of these interpretations cannot appeal to the observation of concrete acts in social situations alone, but must include investigation of subjective data among the participants.

My own knowledge of the old man suggests to me that the specific acts in question are, in part, explained by *all* of the above interpreta-

tions. This is merely to say that one can find an economic, a political, a religious, or an individual personality component in all action. But the old man *elaborated* the essential activities prescribed by his role and the ritual. He *manipulated* symbols which produced effects that were intended to be appreciated in themselves and in their own terms. I know this through long association with him and by frequent interrogation of his motives. His style of behavior was indeed an expression of his view of himself and of his attitude about the world around him. But I was more struck by his awareness of the complex motivation behind those acts which I have singled out. He knew that his behavior verged upon the bizarre and unacceptable in Gola terms. At the same time, he shrewdly estimated the consequences to his prestige and comprehended the boundary beyond which he risked public disgrace or sanction from his peers. Furthermore, he revealed by his remarks about himself that he understood the dynamics of his unique public image which had about it the charismatic aura of the man whose age and special powers placed him beyond the standards of ordinary men. Though other great elders might have the same prerogatives, he fully utilized them.

This utilization, however, was not directed entirely to the ends of prestige, power, or other external aggrandizements. It seemed much more important to him that he was understood and accepted in his own terms, that he had been able to make of himself an object of appreciation, that he was able to communicate ideas of satire, comedy, or symbolic tyranny without losing his essential dignity. This pleased him, and he would frequently reenact the situations explaining how this or that person had responded in the crowd, and would boast that the whole character of a ceremony had been permeated with qualities he had imposed upon it. It was this self-conscious absorption in immediate gratification of aesthetic appetite and the urge to create conditions for evaluative enjoyment which caused me to think of him as something more than the sacred elder, the successful heir to a position of power from his lineage, a unique personality, or as an opportunistic old man. He was to some extent an *artist* as well. Yet something more is required in our formal use of the term than the recognition of elements of artistic action imposed upon his role as elder and secret society official. We need to know *to what extent* he was an artist, or we may very well conclude that most if not all persons among the Gola are artists. We must therefore modify our definition by adding the criteria of distinctive role and style.

For an individual to be considered as *an artist* it should be possible

to demonstrate that artistic activity is not merely an aspect of other roles which predominate in his participation in society, but that it constitutes a role in itself, recognized by himself and others. This requires, among other things, that we can ascertain some consistency of performance, some regularity in production, and some stabilization of unique attributes, all of which we think of as style. From this point of view, I would not be inclined to designate the old man as an artist unless data could be provided to show that the artistic aspects of his performance were consciously or unconsciously "intended" by him to result in objective forms that could be appreciated *in their own terms and relatively independent of the requirements of his other roles, statuses, or personality commitments.* It would also help to know whether the "products" of his artistic activity were viewed as relatively independent objects of appreciation by other members of his culture. The latter is not essential to the identification of *the artist*, but provides indication of the level of aesthetic and artistic evaluation that is either awakened by the action or that can be anticipated.

I have used the example of the old man because it is a marginal case in point and clearly illustrates the problem of identifying an activity as artistic when it is embedded in, or appended to, activities of another kind which predominate. In this case, artistic activity *was* being carried out as style of performance which embellished and stretched the boundaries of the old man's assigned role. Within the limits of the heuristic definition employed here (cf d'Azevedo 1958), these auxiliary activities constitute *artistry*, but are not sufficient to denote the role of *artist*. By the same token, an artist might engage in political or religious acts in the course of performing his major activity, but this would not make him a politician or a priest. Thus, if we should wish to hypothesize that aesthetic and artistic behaviors are universal in human culture, it does not follow that *the artist* or *art* are necessarily universal. Art and the artist appear in societies where there is a clearly differentiated system of values, objects, and roles which have primary aesthetic and artistic functions. Institutionalization in this sphere of Gola culture is less developed than it is in our own or in other complex cultures. Nevertheless, incipient institutionalization of aesthetic-expressive behavior does exist, both implicitly and explicitly, in Gola society, and these systems are at least analytically separable from other systems of behavior.

The degree to which certain kinds of personalities are associated with specialized activities and values is one index to the identification of independent structures. Gola culture provides extensive rationaliza-

tion for exceptional behavior, and I have attempted to show how these concepts are utilized by individuals for a wide range of alternatives in the performance of roles. Certain roles allow considerable deviance in the expression of interests and aspiration. Though deviant behavior of this kind is tolerated within the flexible boundaries of Gola norms of conduct, it gives primacy and explicitness to motivations and goals which run counter to the ideal moral precepts underlying the basic institutions of society. Such behavior is subject to both positive and negative evaluation, and the conflict in public response is only precariously resolved. Admiration, heightened awareness, and amusement are tinged with fear of the improper, the anti-social, and the inhuman. The qualities of behavior which arouse responses of this kind are associated not only with persons, but adhere symbolically to the things they produce.

There are certain vocations which are inimical to the attainment of zo-ship or the full status of respected elder. Earlier in this paper it was pointed out that most zonya were persons who had achieved some distinction in the service of the community. Not all zonya possess supernatural powers, but those who do are most often individuals who exhibit unusual abilities in warfare, blacksmithing, or one of the many categories of magical practice such as curing or divining. These specializations are often continued as vocations after the degree of zo is conferred. But there are some vocations which are never represented among zonya, though persons bearing this title in their later years may have shown skill and interest in such activities—as was the case with the old dazo described above.

Qualities of Aesthetic-Expressive Roles

A common Gola allusion to the behavior believed to be associated with certain vocations is made by the comment that a person is "acting like" a storyteller, a singer, or a woodcarver. It has much the same significance that references to minstrels, actors, or hippies have had in our own culture. Older people frequently admonish the young by warning them that they may turn out to be like such persons. Any behavior which is particularly expressive or intent upon public display is referred to jokingly or contemptuously in this way. It includes any concentration of interests in recreative activities such as games, dancing and music, or time spent in making of non-utilitarian things for pleasure or for diversion.

The general terms which denote activities of this kind are e fɔwɔ

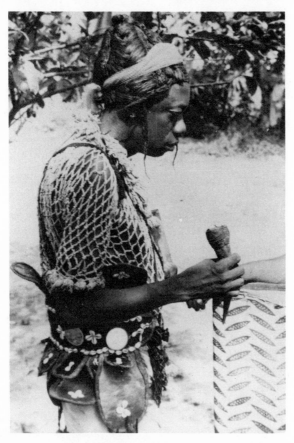

Itinerant magician and storyteller, Cape Mount, Liberia.
(Donated by Dr. L. Varaschini.)

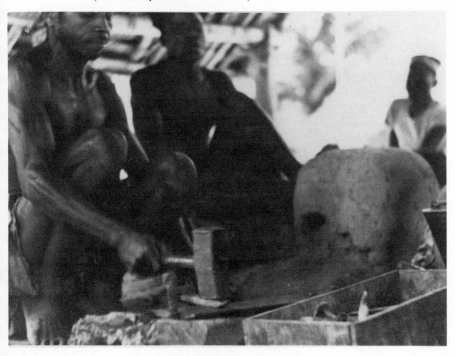

A Gola blacksmith at work.

(play) and wō dá (festivity or feasting). Both carry the connotation of "pastime," or "fun" as well. Thus a person who spends an inordinate amount of time and effort in such pursuits is wo máné fɔwɔ ziŋgbe (one who likes play too much) or wo máné dá gbe (one who likes feasts or good times). The Gola concept of play subsumes all activities and objects that are taken as ends in themselves. Funeral wakes (é ziava), for example, are sometimes alluded to as é ziava fɔwɔ (a mourning play), and the professional woman mourner who puts more than the required amount of zeal into her work is said to be "making a play." This in no way implies dissembling, but merely that a spectacle is being presented and that both performer and observers are intent upon the creative act and appreciation. Any elaborate decoration or personal adornment (e kpa), or anything that is kept because it is novel or attractive, may be referred to as ne fɔwɔ (a plaything) or ne ma dí (a thing for entertainment—usually in connection with dancing and singing). An old man might use these terms in speaking of his newest and youngest wives. They may be employed as reciprocal endearments between lovers, or with regard to any strongly desired but frivolous object.

The above concepts apply primarily to recreation and entertainment where pleasurable experience is the focus of activity. Persons who either informally or professionally give emphasis to such activities are known as anyun fɔwɔ (literally, the players), or anyun ma dí (the entertainers). Though these terms are used loosely to denote any persons who are celebrating, gambling, or playing games, they also have specific reference to semiprofessional and professional performers in the various categories of entertainment.

Another term which is important for the analysis of the concept of artistry among the Gola is ne fɔno (something imitated or portrayed). This denotes a photograph, a drawing, a sculpture, a shadow, or a reflection in the water. Mimicry or a dramatic performance may also be referred to by this term. It connates something created either by man or supernatural agents and that it is a likeness taken from an original model. The term comes closest to designating the objects and activities we associate with the graphic or plastic arts. A woodcarver or painter of wall murals may be referred to as yun fɔno ne (a maker of images or representations).

These terms and their uses provide evidence that the Gola do conceptualize a category of persons who are performers and artisans of a special kind. Play, festiveness, display, and the making of images are activities which, when focused in a specialization or vocation, consti-

tute for the Gola most of the qualities which we associate with the concept of the artist's role.

The Gola word *e sié* is the equivalent of our word beautiful, but it applies to anything which is good, fine, or attractive (also *na tévi*— good to look at). The emphasis, however, is upon the remarkable or the wondrous. Something marvelous or fascinating is described by the superlatives *e sié sié* or *e sié ziŋgbe*. But it may be set apart from ordinary goodness, truth, or propriety, and may detract one from these verities. Intensity of feeling and the giving way to spontaneous enjoyment also may be conditions produced by the bad or ugly (*e sìè*). The interplay of revulsion and attraction is recognized, for example, in the response to certain masks, spirit impersonations, natural phenomena, or human behaviors which verge on the morally reprehensible, the overwhelming, or the unusual. One is caught up in contradictory emotions, but is made almost powerless to escape the entrancement. Such things may be *e sìè*, as well, and not merely the simple opposite of what is ordinarily good or beautiful. One may speak of such a thing as though it represents all facets of terribleness or of badness, but in the tone of immense admiration and pleasure, much like the French "*il est formidable*" or the current American idiom "it is *too* much."

Profound reflection, *gongo súwá* ("inside thought" or, literally, the thought of the stomach), and a state of awe or dread (*e jul*), are connected with remarkable things. It may be said of such an object *e kúbá jù* (it possesses fear) or that it causes a person to become overly excited (*e jila*—to boil or tremble), or that it is a great deception (*kábi*). Feelings of this kind are aroused by behavior and objects which give hint of hidden meanings or which present exaggerated versions of reality. People who skillfully do and make things of this kind do so by means of unnatural skill and knowledge. They are ambitious to prove their powers by putting what they have dreamed into visible or audible form.

These interrelated qualities of personality, social orientation, and certain material objects are focal aspects of those roles in Gola culture which symbolize values that are distinct from the ideal norms of the society. The model of such roles springs from concepts of traditional Gola culture which provide rationalization for certain forms of deviancy and privatized motivation. The cultural roots are the same as for all supernaturally endowed specialists, including the sorcerer or the opportunistic upstart pledged to an unprincipled tutelary. But artistry differs from these in the kind of activity performed, its function within society, in the orientation of its values and in its products. The

activities are directed to the creative manipulation of the symbolic content of culture, and to the production of objects intended for public appreciation. The ideal incumbent of such a role represents a type of personality which is in itself a model for the behavioral criteria assigned to the role. Other incumbents who do not meet all of the criteria are, nevertheless, subject to a degree of stereotyping by the culture which imposes its expectations on all behavior associated with the roles.

The Vocations of Artistry

There are relatively few vocational specializations in Gola society which are associated with a clearly differentiated role of artistry. Individuals who may be identified as artists by the definitions posed in this paper seem to cluster in certain related occupations. These are wood-carving (and carpentry), singing, dancing, musicianship, blacksmithing (primarily casting and jewelsmithing), weaving, legerdemain and acrobatics, storytelling (and orating), and wall decorating. Many of these activities are closely interrelated in that an individual adept at one will often engage in others with a high degree of skill. They are carried on by a very small number of individuals as full-time or even semi-professional occupations. In a chiefdom of about 2,000 persons I was able to identify three professional woodcarvers (one of whom had become a carpenter), five singers, seven musicians, nine blacksmiths (three of whom had become jewelsmiths), one weaver, and two storytellers. There were undoubtedly others, but not sufficiently renowned to come to my attention. Additional representatives of these and other specializations were often to be found in the villages of the chiefdom, but they were temporary residents on commissioned assignment or on tour soliciting patrons for their services.

A survey of other chiefdoms indicated that the situation was not significantly different, though the proportion of specialists in the various categories might vary. The population of Gola chiefdoms is small, and distances between villages and sections are not great. A pattern of itinerancy and residential mobility for most specialists makes their services available over a wide area. Limited demand is, in part, responsible for their small numbers, but their excellence and highly specialized skills tend to minimize competition from inept persons. For this reason, some of them are able to support themselves without regular farming or participation in other local subsistence tasks.

With the exception of some blacksmiths, none of these persons, regardless of age, were *zonya*. Not only was this the case in the chiefdom

where I resided, but I was able to confirm the pattern for a number of other chiefdoms as well. The general response of persons questioned on this matter was that itinerant specialists in these fields (excluding most of the professional blacksmiths who are permanent local residents) cannot attain *zo*-ship due to the nature of their work and its effects upon their character. Should such a person give up his line of work and settle to a steady way of life in one community where he has family and friends, he might eventually become a *zo* or, at least, an honored elder in his old age.

None of these specialists of the chiefdoms with which I was most familiar were personally well-to-do, though some were members of wealthy and high ranking families. Most lived from commission to commission when on tour and seldom brought back adequate funds to provide for more than a short period of stay in their home villages. Those that had a wife or two and children might leave them for long intervals. Upon return they might find that wives have gone to their own families, taking children and belongings, and leaving house and farm in disrepair. Other relatives might turn away in disgust or appropriate the house and land, relegating the wanderer to the status of dependent or client. Whenever one of them is known to have collected a particularly large fee, relatives and other claimants send collectors after them. Much of the secrecy and air of mysterious privacy of itinerant craftsmen and entertainers is jokingly attributed to their desire to keep their whereabouts and their fees hidden.

The factor of itinerancy cannot be applied exclusively to the vocational specializations mentioned above. There are itinerant traders, teachers and advisers (both native and Muslim), curers, and diviners. In some of the larger villages there are full-time hunters, tailors, and petty merchants who support themselves through a vocation in semipermanent residence. In former times mercenary warriors would be included in this category. Professional *zonya* and numerous part-time or nonprofessional specialists of various kinds may engage in some degree of roving clientship within the limited area of their own chiefdoms or adjacent chiefdoms. Every village has its roster of persons acclaimed locally for some amateur ability in magical practice, herbalism, craftsmanship, or entertainment, as well. These activities are carried out on a household or village basis, and as minimal economic supplement to farming and other subsistence tasks. Most Gola learn to sing, dance, tell stories, or exhibit some skill in one or many special activities while they are very young. In local ceremony, informal festivity, and in the ordinary requirements of ongoing daily life, even

the smallest village can produce the minimal skills necessary to any viable unit of Gola society. Village and chiefdom self-sufficiency is one of the ideals of local elders and is a goal of local secret society training which these elders direct.

Yet the thing that is not always possible to obtain is the product of exceptional skill or the excitement and prestige that comes through acquiring the services of a famous specialist on a competitive basis with other communities. To command such services one must have wealth or live in a large central village in the company of important persons who encourage the flow of commerce. Truly fine things are not often seen other than in relation to the ceremonial or ostentatious occasions sponsored by important persons or the collective efforts of associated communities during the periodic rites required by tradition. It is on such occasions that one sees products of great craftsmen of all kinds, the singing and dancing of those who seem more like the *jina* of dreams than human beings, amazing tricks and feats of endurance, dazzling dress and ornament. But the greatest of these are seldom products of local work. They represent family treasures that have been brought out for display and services which have been solicited from afar. The novelty and gloriousness is attributed to the wealth and influence of great persons who can attract clients to them from near and far and to the work of that class of persons who are always on the move in order to make their products available.

It should be pointed out here that the role of artist among the Gola involves recognition of a style of conduct as well as styles of workmanship expressed in the presentation of public objects or events. The Gola have terms for concepts equivalent to our notion of style. The word *gá* refers to much the same as our words trade or profession. Thus, *yun gá* is a person known for a specific vocation and implies specialization.[10] But to *recognize* the work of an individual is to perceive *kùwā féi* (sign of the hand). This term means precisely what we mean by *style*. One knows the work of a man by *kùwā féi*, and great craftsmen and entertainers can be identified by elements of style which mark their work or which appear in the work of their apprentices and others who have borrowed from them. It is said of a new or relatively unknown specialist that his handiwork is also unknown and that few recognize his work. Of others it is said that "the world knows the sign of their hand." It is of interest to note that this is also said of elements of a person's mode of conduct. Each person has his ways (*e tuwó yun*).

These ways are not only to be associated with types of persons, but with types of vocations and roles. Therefore, there are ways for chiefs,

for warriors, for elders, for blacksmiths, for entertainers, for children and adults, etc. But there are also ways which identify individuals, and these can become signs which are recognized everywhere as emanating from a particular individual. To be renowned is to have one's ways and one's handiwork recognized far and wide, to have one's name attached to acts and things, to become legend. For some, fame is a natural consequence of good or bad works; to others it is a necessity, yearned for, and sought after as food or love. The Gola attribute the latter orientation to those persons whose vocations seem to thrive on public display and attention.

The mode of conduct associated with players (*anyun fɔwɔ*) and the makers of images (*anyun fɔno*) is to be found intensively clustered in the vocations of craftsmanship and entertainment. These are the vocations in which the role of artist is most clearly differentiated among the Gola; though, as I have pointed out, *artistry* is not the exclusive province of *the artist* in Gola or any other society. The roster of vocations in which artists are found and which the Gola most commonly associate with the type of individual described above is as follows.

SINGING

Singing as a vocation offers opportunity for a high degree of professionalization. Singers (*anyun gbemgbe*) are in constant demand for entertainment at funeral feasts and village festivals. They are required at all receptions in honor of important persons and in the traveling retinue of chiefs and other leading persons. Most professional singers are women, though professional male storytellers are also expected to be accomplished singers. Great female singers are renowned throughout many chiefdoms for their youth, beauty, and songs.

Wealthy men compete with one another for the prestige of having such women in their entourage, and the glory of a particular chief is often attributed to the famous singer who leads his songs of praise during a festival or his dramatic entrance into a town. A very great event is remembered for the number of famous singers whom important men have either commissioned for it or lent to it. Some singers are not attached to any one patron, but make their services available to the highest bidder. Such women develop their own retinues of lead singers, choral accompaniment, and male musicians, and may spend their time in continual tour of the country or under patronage of Liberian government officials.

In a culture where everyone has learned to sing and dance as part of early socialization and secret society training, there is intense ap-

preciation for virtuoso performance. The renowned professional singers are clearly distinguished from the numerous semi- or nonprofessional local singers who competently perform in secret society ritual or informal village "plays." Their way of life and their excellence surround them with an aura of glamor and legend similar to that of some popular entertainers in our own culture. Moreover, there is the factor of supernatural endowment. Beauty and success in youth are among the gifts which famous singers have gained from their *neme*. They also have been given the ability to invent new songs spontaneously during performance and to remember a repetoire of hundreds of songs accurately. Their wit and daring in song texts and their talent for eulogy are especially admired. They are also admired for endurance, for singers will compete with one another in festivals by continuing day and night without rest or sleep. It is said that they are driven to excess by their desire to please the crowd and their fear of the deep sense of loss and unhappiness which they experience when such events have come to an end. It is also believed that the *neme* of each singer is jealous of competition and wants its human companion to achieve fame above all others.

In the legends of all great singers there is an episode in which they are described as having bested all competitors in endurance, singing continually through days and nights, accompanied by fresh contingents of helpers to replace those who fall exhausted. I once saw such a singer on her third day of performance being supported by two of her helpers as she staggered through the early morning hours of a sleeping village. A small group of intrepid villagers still followed her about. Her voice was hoarse, but every ounce of her remaining strength went into making herself heard above the sound of her chorus and the instruments. A few hours later she fell unconscious and was carried to a guest house with shouts of praise. This ended the festival, but her feat was recounted throughout the country during the following weeks and other singers envied her.

Professional women singers are said to enjoy the adoration of all men, but they are inconstant and distressing wives or lovers. Their real lovers are their spiritual guardians, and in many cases, they have sacrificed their ability to have children in exchange for beauty, voice, and songs. They can cause men to love them above all women, but they are fickle and prefer to go from one man to another. They are proud and will show humility to no one. In this they do not behave as the ideal Gola woman should, but their powers protect them, and their abilities bring such enjoyment that they are allowed to be as they are. There are

some older women who are professional singers, but it is an arduous and dangerous life. Most professional women singers give up the work when their beauty fades. Some become despondent and die; others marry and bring prestige to the households of wealthy families.

DANCING

Dancing is also a generalized activity among the Gola. All ritual and festival involves mass participation in both singing and dancing. But again, it is virtuoso dancing which attracts special interest. There are very few professional dancers (*anyun yiva*) as such, though they are said to have been numerous in former times. Virtuoso dancing by both men and women is actually a related skill of other performing vocations such as those of the professional singers, storytellers, acrobats, and musicians. Gola secret societies (*Poro* and *Sande*) are known by surrounding tribes as "dancing societies." Great stress is placed on dance as part of ritual and training of youth. The *dazoa*, sacred officials of pan-tribal Gola *Poro*, are accomplished virtuoso dancers, and all lesser sacred officials are expected to show some special talent in this regard. The masked spirit impersonators of both *Poro* and *Sande* are selected not only for their rank in secret society organization, but also for their ability to dance.

Gola virtuoso dancing is quite different in style and form from group dancing in which everybody participates. The latter is slow, somnambulistic, and intent upon collective response to music and traditional public choreography. Virtuoso dancing is highly individualized with emphasis upon difficult, even acrobatic, movement which is intended to awe the beholder. Agility and dexterity are the predominant qualities. The performing role of the professional dancer is much like that of the singer. He usually performs within the circle of a crowd of dancing villagers in what amounts to a competition with other virtuosi. Endurance, assurance, and incomparable feats determine success in the contest. Young village men and women will frequently enter the circle to compete but are soon bested. The personal qualities attributed to these individuals is similar to that of the singer.

MUSICIANSHIP

Expert musicianship is encouraged for talented youngsters in secret society training. The most important instruments are three or four types of drums played by men and the gourd rattle (*gele*) played mainly by women as accompaniment to singing and dancing. Other less common instruments are the gourd belly-harp (*koninai*), the hand

piano (*bonduma*), and dancing bells of brass and iron (*bamande*). Xylophones, various gongs, clappers, and rattles are also in evidence, though rare and apparently borrowed from other tribes. Professional musicians are men, though women singers and dancers are always adept at the *gele*. A good musician is expected to perform well on all instruments. Male drummers constitute the core of any orchestral ensemble in ritual or entertainment. A professional drummer can play all varieties of drums, each requiring specific patterns of rhythm and style of performance. He is an expert at accompaniment and impro- visation. As drummers are in great demand, it is possible for an ac- complished drummer to live by these services if he is willing to move from place to place. If he is also known for his performance on the gourd harp and other instruments, his services are even more negotiable.

There is no general Gola term for music or musician. Music is the voice or speech (*mié*) of specific instruments, and the musician is the master of the instrument. Thus *wo simé* is one who plays the *simé* drum, while the sound it makes is *simé mié*. Great professional mu- sicians are believed to receive their skill from a tutelary, and their relations with their instruments are so intimate that no other person is to handle them without permission or ritual absolution. Defilement of an instrument is said to "kill" it, and a musician mourns the "death" of his instrument as he would a loved one. It is said that he has no one to speak to until he finds another like it.

Professional musicians represent to the Gola the epitomy of the irresponsible wanderer. They have little time for family and consort with shiftless persons and other musicians. They are only happy when at "play" and they avoid all serious work. Though they often earn large sums of money in commissions, they are always poor because of child- ish generosity and spendthriftness. Furthermore, they are wild and unmanageable, given to periods of drunkenness and other unusual behavior.

In confirmation it was pointed out to me that two well-known drummers, whom I had seen at many public events, had begun to act strangely during a very disastrous current drought. One had had a dream in which an ancestor came to him warning that fires would devastate all villages of the area unless the people made sacrifices and gave up their evil ways. The other was told by his *neme* that he should go about the country in rags warning of the danger revealed to his friend in a dream. Both became, for a time, minor prophets speaking to large crowds in the villages of three chiefdoms. They were always

rewarded with a collection of coins and gifts of food. Many of the villages conducted public sacrifices to the ancestors against the threat of fire. Those who told me of this indicated that most people doubted that the prophecy was real, for musicians, singers, woodcarvers, and other such people were prone to take on the airs of diviners and wise men, but that it was necessary to make sacrifice because the dreams *might* be real.

STORYTELLING AND ORATORY

Professional storytellers (*anyun odife*), or "tellers of many fables" (*anyun bla ma doŋ*) present some of the most complex dramatic performances to be found among the Gola. It is a vocation for men, though certain exceptional women participated in the past. Itinerant storytellers wander from village to village either as temporary clients of wealthy patrons or by soliciting invitations by means of junior associates who travel on ahead to proclaim their skill. Some storytellers travel alone, choosing local drummers and other helpers from the villages where they perform. But famous storytellers tour with large retinues of professional musicians, dancers, singers, and apprentices. The movements of such a troupe are heralded over wide areas, and people will walk long distances to see them in the towns where they play.

The standard storytelling performance is built around a cycle of fables (*ma doŋ*). Wide latitude is allowed the renowned storyteller in the choice and arrangement of tales, as well as substitutions of his own invention. These are richly larded with witty asides to the audience and impromptu comments on the private lives of local citizens. The storyteller is also a master of *ka bande* (moral legends and myths), *ma sai* (proverbs) and *ke koli* (riddles), all of which are intricately woven into the performance. But a truly great performance involves the aid of musicians, dancers, and supporting actors. The storyteller must himself be a dancer, a mime, and a singer who, as central performer, directs the participation of the company. These performances may go on for an entire night and are often continued for many nights thereafter.

It is interesting to note that the storyteller's costume is frequently an exaggerated version of that worn by the sacred *dazoa* of the *Poro*. This is a gesture both of satire and of bluster, symbolizing the storyteller's role as daring social critic and buffoon. It is said that, in fact, many *dazoa* were professional storytellers in their youth and that this accounts for their oratorical eloquence and persuasiveness. Ex-storytellers

are frequently called as advocates in court matters or as orators com-
missioned by chiefs to exhort the people at public gatherings. But the
professional storyteller is looked upon as a strange rootless wanderer.
He and his troupe have much the same status during their visits to
Gola villages as do a band of gypsies or a small touring circus in some
rural areas of our society. Regardless of the quality of their perform-
ance, an aura of ominous intrigue and hazard surrounds them.

In the past certain great warriors were known as storytellers and
orators. They were sent about as "speakers" of the chiefs. As a mark
of particular honor the title of one of the many peripheral *Poro* spirits,
which gave them the right to appear in the mask and costume repre-
senting that spirit, could be conferred on them. One of these imper-
sonations is known as *na fai*, who announced wars and made major
political proclamations. Another is *kɔ kpɔ*, known today as "the talking
devil," who is something of a witty clown or allowed fool with un-
limited license for public insult.

Young people show talent for storytelling and oratory by engaging
in the practice of *pa pa*. These are impromptu groups of local ado-
lescents who form a troupe around a particularly daring and skilled
leader. They wander through the village accompanying him with
instruments, dance and sing as he shouts out clever versions of gossip
about the citizens. He beats a small gourd or hollow stick drum, which
is the *pa pa*, and occasionally pauses to exclaim in a loud but beseech-
ing voice: "It is not I who say these things, but the *pa pa* here who puts
the words in me." It is said that all citizens who have something to be
ashamed of, whether chief or slave, run into their houses and hide
when *pa pa* comes into town. Angry parents and other relatives may
seek out their children when the performance is over and beat them
severely for the embarrassment they have caused.

One leading citizen whose son had played a leading role in the
formation of one of these groups told me that he had punished his
son so that he would know "if he is to go on acting like a *bla ma doŋ*,
he must learn to suffer like one." Later the son told me, "My father is
right in this. I have gone with bad company because they praise me
for what I do. But if I am to be a chief someday I cannot run about
like any storyteller. I will not have the respect of important men."

LEGERDEMAIN AND ACROBATICS

The Gola are profoundly fascinated by the performances of expert
illusionists and acrobats. The term for such persons is *anyun kwái dùlù*,
which approximates the meaning of our terms magician or trickster.

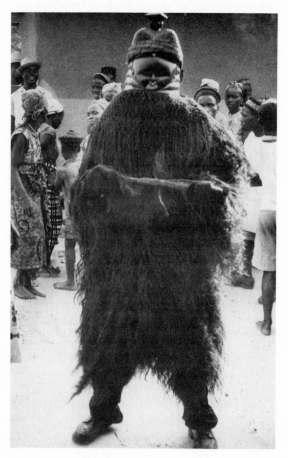

A Zo *gbe* of Gola Sande in full regalia.

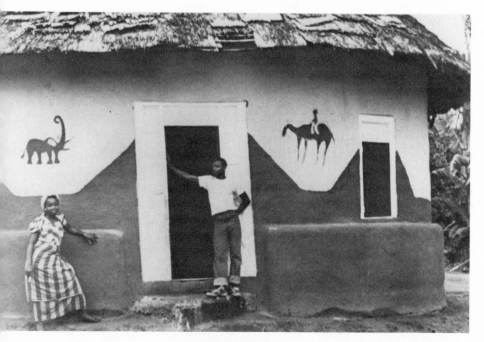

A decorated Gola house.

This is to be distinguished from the more general term for persons who control and practice supernatural powers—*anyun gòò*—and whose vocations are essentially those of curing, divining, and counter-sorcery. Nevertheless, one who practices *kwái dùlù* may also be referred to as *yun gòò*, particularly if his skills are so extraordinary as to indicate real supernatural sources of power.

Any prodigious feat of sleight-of-hand or of ostensibly inhuman skill and physical dexterity becomes *kwái dùlù* when it is presented as a public demonstration of awesome and confounding acts.

Such acts are part of the ritual performance of the *dazoa* of *Poro* who make use of sleight-of-hand skills with their "wands" and other paraphernalia during public ceremonies. The *gbetu*, one of the masked spirit-impersonators of the *Poro* society, is especially known for its amazing acrobatic feats, its ability to increase its height from less than three feet to more than ten while dancing, its traditional act of "giving birth" (producing a smaller replica) during performance, and the most remarkable deed of taking a furiously burning torch into the center of its dry raffia costume.

Children and adults are intrigued by "tricks" of various kinds and admire those who are proficient. When it became known that I was interested in this sort of thing I was visited frequently by amateur jugglers and groups of young people presenting one of their number who could perform some amazing acrobatic turn or contortion. I was also shown popular tricks of illusion involving disappearing and re-appearing objects, and carefully tied bundles of large sticks inside narrow-necked gin bottles. When I reciprocated with my own feeble repertoire of a vinegar-soaked egg in a bottle, and a Japanese disappearing cigarette box, I was deluged with admirers and competitors.

This turned out to be precarious sport, however, for all *kwái dùlù* arouses some apprehension and distrust. Though it may be, on the one hand, an expression of innocent and playful deftness, it may also indicate a dangerous inclination or ambition to consort with evil powers. This behavior, and the term for it, is strongly associated with the frightening monsters of the mountain forests, known as *ó dùlù*, who confuse travelers with hallucinatory noise and obstacles. It was not long before I began to receive strong hints from the local elders that I was showing too much interest in such matters for someone of my station in life and that solid citizens would avoid my house if I continued. Needless to say, I desisted.

The occasional roving troupe of professional *anyun kwái dùlù* attracts more public attention than any other type of performer. Like

the itinerant storyteller, these performers may tour as individuals, putting together a group of supporting musicians and dancers from selected or volunteer local villagers, or they may travel as a permanent team. A standard professional troupe is led by an expert illusionist and dancer, accompanied by two or three male musicians, one or more female singers, and a number of female children who perform with the adult acrobatic dancers. A typical performance is reminiscent of our own vaudeville or variety show, or of circus acts. Costumes are flamboyant and are often exaggerated or comic replicas of the garb of important functionaries. Traditional symbols of power and status such as *kauri* shells and leopard teeth are much in evidence.

When a well-known troupe is expected to arrive in a particular town large crowds will gather there for days in advance. On the day of performance the troupe enters town ceremonially, dancing and singing and playing instruments. It then parades through the quarters of the town, followed by the crowd, and terminates at a prescribed place—usually the central public square—or before the house of a local patron. The musicians and singers begin by singing the praises of the star performers and the host and announce the marvelous sights which all are about to see. Then there is acrobatic dancing with contortions, tumbling, and juggling. The small girls—who are said to be in a drugged or hypnotic trance—are thrown and tossed about in a remarkable manner without the slightest show of fear and remain limp and pliable throughout the performance.

At some point, the leading performer is announced. His paraphernalia is brought in and arranged. This consists of a number of boxes and sacks. Frequently a miniature thatched hut is set up for him to retire to for dressing and other preparation between demonstrations. The repertoire of such a performer may comprise a number of sleight-of-hand or illusionist tricks familiar to us; for example, the disappearing and reappearing object, removing a seemingly endless and impossible assortment of objects from a small sack or box, changing an object solicited from the crowd into a small animal, walking through fire, escape from bonds, invulnerability to pain or weapons, ventriloquism, causing the disappearance and reappearance of associates, etc.

The crowd responds with gasps of astonishment, and it is said that in some instances performances have been so astounding that audiences have panicked and run from a village, later threatening the fleeing troupe with death. Unfortunately, I was never favored with an exceptional presentation of this kind, but I have observed some which equalled in skill and prodigiousness anything which I have seen among

performers in our own culture. Furthermore, Gola audiences must be a delight and an enormous stimulus to any such performer. I have often wondered whether a Houdini would survive their acclamation.

These itinerant troupes of *anyun kwái dùlù* represent true professionalism among the Gola. They are feared, despised and intensely admired at once, and their members are considered always to be strangers from afar which no one would wish to have as village neighbors. In fact, many of these troupes are made up of persons from various tribes, and when they are playing in the locale of any one of the group, that person stays elsewhere and does not rejoin the troupe until it has moved on. Their income is derived from commissions of patrons and from collections of gifts made during their performances. If a particular season is slack, the troupe disperses temporarily to work small farms or to put themselves into service as laborers.

BLACKSMITHING AND RELATED CRAFTS

The traditional blacksmith (*yun blú*) represents an ancient and sacred profession among the coastal tribes of this region. All aged blacksmiths are *zonya* by virtue of their position in high-ranking lineages and the ritual importance conferred on their craft by the *Poro* society. The skill of working with metals was considered one of the most mysterious and remarkable forms of knowledge in the traditional culture.

Metals, particularly iron, were crucial to the agricultural economy, and were widely used for currency, ornament, and ritual objects. The relative scarcity of metals in this area of intensive and expanding agriculture over the past 500 years or so was undoubtedly one major factor in creating the special status of the blacksmith. The rapid increase of population in the coastal forests after the sixteenth century stimulated an insatiable demand for iron and other metals. The European trade, in which metal bars, tools, weapons, and utensils became prime items of exchange for slaves and other West African commodities, only partly met this demand.[11] The skill of the blacksmith provided a means of converting certain metals procured either from Europeans or from the diminishing trade with the large tribes of the savanna highlands into items of local manufacture and style.

Until very recent times, native agricultural tools made by local blacksmiths were preferred to European forms. These included hoes, machetes ("cutlasses"), and knives. Among the Gola this preference still obtains, though European utensils rapidly replaced pottery and basketry more than a century ago. The conservatism of agricultural practices is a major factor in the continuing importance of the black-

smith in rural areas. But this importance is much diminished in all but the most traditional chiefdoms, and the economic role of the blacksmith has, in many sections, disappeared entirely; there remains only a moribund and ritual function for elder blacksmiths or their descendents.

Blacksmiths are also associated with the implements and activities of circumcision ceremonies, and tradition requires that the knives be of a certain form and of local manufacture. The local blacksmith frequently performs the surgery of circumcision. Furthermore, blacksmiths produced and repaired all weapons of hunting and warfare in the past. Some of them were even accomplished gunsmiths and were able to make replicas and parts of European firearms. Today many items of this kind are produced merely for ritual purposes, as sacred emblems, or objects in ritual regalia and ceremony.

Closely related to blacksmithing, both in training and technique, are a number of traditional as well as modern vocational specializations. Here it becomes necessary to distinguish between the blacksmith as a sedentary professional figure in local village organization and all those who receive their initial training under blacksmiths but go on to become other specialists of one kind or another. Every competent local blacksmith has a group of talented boys apprenticed to him. Some of these will replace him when he is too old to work or will set up workshops in nearby villages under authority of elders of their lineages and the *Poro* society. Others, however, do not qualify for this highly selective role, either because of lineage rank or personal characteristics that put them at a disadvantage as candidates for office. It is said by many older well-established blacksmiths that considerations of lineage rank and other traditional criteria frequently result in the selection of the least promising of youth for local office. Interestingly enough, such views are also commonly expressed by elders of families who complain that the children of slaves, pawns, low-ranking relatives, and other wards are sometimes more intelligent and able than their own favored children.

In former times the subspecializations connected with general blacksmithing were essentially the making of metal ornaments (chain necklaces, bracelets, bells, medallions, rings, and mountings for gems, beads, ivory or wood objects), figurines (ritual animal and human forms for magical practitioners or toys, dolls and showpieces for the wealthy), weapons (elaborate spears, swagger sticks or clubs, knives, swords, and even remodeled European guns), decorated utensils (cups, spoons, knives, bowls, and imitations of European or African trade ware). A variety of techniques was used including open molds, the

lost wax process, stamp pressing, filing and cutting, and work with wire and malleable metals. Today, the range of these products has decreased and very little ornamental work is done by local blacksmiths. What activity of this kind remains is carried out by highly specialized individuals who usually have some initial training as blacksmths, but who concentrate on a particular skill. These are primarily makers of personal adornment whom we might include under the general rubric of "jewelsmiths." The Gola term which covers their varied activities is *anyun blu kāī* (metalworkers) or the more specific term *anyun yène kpai* (makers of ornaments).

Such craftsmen are usually itinerant or are periodically attached to a wealthy patron. They most often work by commission, but in some of the larger market towns, or in Monrovia, they set up a tenancy arrangement in the shop of a Mandingo or Lebanese merchant. Some of the more successful jewelsmiths take on apprentices who, in turn, peddle their own and their masters' wares to the homes of wealthy tribesmen, Liberian officials, or Europeans. These specialists in ornamental and prestige objects tend to fit the criteria for the artist (or the *anyun fɔno*) in personal characteristics, conditions of work, and in kind of product more than is the case for the local official blacksmith.

In contrast to those craftsmen whose initial training is derived from blacksmithing, there are a number of specializations connected with modern industry. Some men who might have become local village blacksmiths have received highly specialized training in Monrovia and from European companies with machinery. A few local blacksmiths have learned to make metal parts for engines and appliances. Others have gone off to work in Monrovia at repair shops. This skill commands high prestige in the tribal areas, and such a person is referred to as *zo ma kāī* (master of metals, or master machinist). The term for blacksmith and all that it signifies in traditional and ritual association might be applied to the accomplished machinist or mechanic, but not to the specialist in ornaments or decorative objects. The explanation given for this is that the jewelsmith is not doing serious work, whereas the local blacksmith and the machinist are capable of making things which are essential, that without them there would not be food or civilized ways.

WOODCARVING

In Gola society the woodcarver, much like the singer and musician, typifies the role which might be designated artist in our own society. The *yun maku hē* (one who carves wood) is the true "maker of images"

(*yun fɔno*) and represents in Gola culture the kind of individual whose behavior is strange—irresponsible yet marvelous, dangerous yet attractive, and childish though wise.

Woodcarving is done by men and is usually learned through apprenticeship to an older artisan. However, there are some woodcarvers who claim never to have submitted to such instruction but that they received their skill through observation and spiritual guidance. Like Gola singers and musicians, the woodcarvers are most prone to attribute the finest work to those who "dream," whose *neme* is the source of their creative ideas. It is also said that a potentially great woodcarver can be detected in childhood by his special behavior involving signs of strong spiritual connection, unusual food preferences, and early attempts to master certain technical skills or to imitate the work of others. Though this is thought to be true also of special children who might turn to other similar vocations, it is made particularly explicit with regard to woodcarving. Such children are looked upon with mixed admiration and despair by their parents. Attempts are made to dissuade them by punishment or through appeal to a diviner or other practitioner. If a child persists, however, special note is made of his unique interests during secret society training, and often he is put under the tutelage of a local amateur or semi-professional carver while *Poro* school is in session.

When unusual skill and determination is demonstrated against all obstacles, some parents or guardians may send the child away to be apprenticed to a renowned craftsman in hopes that he will become successful. But there is considerable ambivalence about this and most adults feel that such activities are deviant and unrewarding. The child, it is said, will grow up to reject his family and embarrass them by his shiftlessness and disloyalty. As a result, many woodcarvers say that they learned their craft clandestinely in youth and speak with varying degrees of bitterness or self-pity about the hardships and misunderstanding that they encountered.

The cultural attitudes about the woodcarver and his products are shared by woodcarvers themselves. A number of such men whom I interviewed at length spoke of themselves and their craft with an air of humorous or sardonic self-depreciation. At the same time there was a persuasive quality of self-dramatization and assertiveness, a romanticism about themselves which seemed to fully compensate for their sense of ambiguous status and social disapproval. These contradictory qualities varied in intensity among them, but they were particularly obvious in highly motivated and proficient individuals. Their life

histories were presented to me as though they had spent their lives waiting for the opportunity to be interviewed. The material was well organized, with crucial events in their personal development highlighting significant social relations and conscious expression of subjective evaluations of their own worth and weaknesses. Though I found this to be the case with certain individuals in the other vocational specializations discussed above, it was among professional woodcarvers, singers, and musicians that this intensive focus on self-conscious rationalization was observed as a common role characteristic.

A peculiar feature of the woodcarver's role is the major product which is associated with it, the headpieces and masks of the *Poro* and *Sande* associations. These are traditionally and ritually important objects commissioned from renowned woodcarvers, but which nevertheless do not earn them the prestige and status attendant upon similar services provided by the official blacksmiths and the *zonya*. The woodcarver is in the unique position of being solicited by members of both the men's *Poro* and women's *Sande* associations for these sacred objects. Thus he has access to secret knowledge about their production and use which is supposedly limited to all but the most high-ranking elder members of these associations.

The relations between a woodcarver and those leading women of *Sande* who approach him for a commissioned mask is highly ritualized. The carver demands that they treat him with all the respect due the creator of an object of such importance. They must humble themselves by disrobing and must utilize an elaborate language of deference. Furthermore, they must carry on all negotiations with him in secret tryst, pay him an initial and final fee without fail, and provide food and other comforts for him and his guardian spirit during the entire course of creation. The penalty for any infraction of these requirements is the destruction of his handiwork or exposure of the women's unreliability in secret society council. The carver is considered to retain total ownership and control over his work until all requirements have been "satisfied" and the sacred product has been given a "new name," by which it is validated as a ritual object of the secret society. But it is believed also that a carver has the power to crack or otherwise demolish his handiwork if at any time he feels that it has been desecrated or that he and his *neme* have been insulted.

The relation of the woodcarver to clients from the men's *Poro* is similar, but it does not carry with it the sense of awesome danger and responsibility that is attendant upon his services for *Sande* where he is one of those privileged men who have crossed the precarious

boundary into "women's business." It is this feature of the wood-carver's work that is referred to more than anything else in general comment, and it is this feature which is most often noted by carvers themselves as an indication of their importance and the crucial nature of their craft. Excitement and danger lies in the fact that they are dealing with aspects of ritual knowledge reserved only for the elder *zonya* and other functionaries of the secret societies; yet they are not *zonya* themselves, and they are not among those consecrated by ritual or lineage rank into the sacred and exemplary class of traditional of-ficialdom. They are considered to be outside the sphere of direct con-trol by the sacred communal orders and guided by sources of power which are particularly individual and unpredictable. For this reason they may bring catastrophe upon themselves and others.

The work of woodcarvers is in great demand, but this demand is concentrated on relatively few professionals or semi-professionals. Again, itinerancy or commissions from widely spaced patrons is es-sential to the maintenance of a full-time vocation. Local demand is sparse and dependent upon the fluctuation of secret society ritual, ceremonial calendar, agricultural seasons, and levels of prosperity. But in the larger context of clustered chiefdoms a number of renowned woodcarvers and their advanced apprentices are able to find as much work as they wish. Few professional woodcarvers work continually at their craft, however, for it is said to be too arduous and spiritually ex-hausting. After a period of intensive work some will retire to small farms for supplementary income and to escape from the demands of creative work. Others will go off to the towns to spend their accumu-lated funds in revelry.

Woodcarvers do not specialize in secret society ritual objects, though the masks are thought to be their most glorious accomplish-ment. Their occupation is highly generalized and it is said of them, in particular, that they involve themselves in all things which have to do with "play" and "representation." Most woodcarvers are also singers and musicians of considerable skill and are, in fact, the makers of musical instruments. Some are adept at ivory carving and metal work. It is to the woodcarver that one will go for carved toys, figurines, carved storage chests, or decorative combs and utensils. They are known for their generosity to children and women friends, always presenting them with some marvelous and delightful object they have made. Woodcarvers are frequently the decorators of houses (*yun kpá sā*) who are called upon to paint murals on the walls of freshly clay-rubbed buildings prior to any major event. Though others may

participate in this activity as well—particularly young boys recently released from *Poro*—woodcarvers are thought to be specially skilled in executing decorative ideas.

In former times woodcarvers were always commissioned to carve the porch posts of the houses of leading citizens and all ceremonial buildings. More recently this activity has been replaced by ornamental carpentry and cabinet and furniture making. The homes of distinguished persons have intricately constructed shutters and doors, as well as hand carved furniture and storage boxes. These things are sometimes made by woodcarvers or more frequently by men who have begun to specialize in carpentry, as the demand for such products has increased with the spread of European tools and styles. They turn out replicas of traditional objects for the urban trade, while at the same time maintaining small village carpentry shops for more utilitarian items. These latter activities are frowned upon by the traditional woodcarvers who see them as a threat to the older styles and standards of the craft.

The traditional woodcarver also looks upon these more recent and proliferated crafts as the work of the incompetent and unscrupulous who will turn their hand to whatever will sell. Attention is called to the hasty execution, the improper preparation of wood and dyes, and the "tricky" use of European tools to create the illusion of mastery. It is also denied that such craftsmen are dreamers or guided by *neme*. The implications of these views are much the same as what might be meant in our culture by the statement that a talented person has sold out or that he is uninspired and a hack.

WEAVING AND OTHER CRAFTS

Weavers (*anyun juwa dé*—"those who weave cloth") are included here because there are individual weavers who represent the role-type which is under discussion, though their vocation does not carry with it the charismatic stereotyping common for others. Weaving is an occupation of men, and in most of the coastal sections of Liberia it is on the decline due to the availability of inexpensive European and Japanese trade cloth. "Country cloth" is, however, very much in demand as a prestige item, particularly for the robes of dignitaries and as gifts to officials. Cotton is still grown in some of the more conservative interior sections of Gola territory, but much of it is procured from Loma, Kisi, or Mandingo traders. Inexpensive handloomed cotton cloth is sold by Mandingo and Lebanese merchants. This is usually of

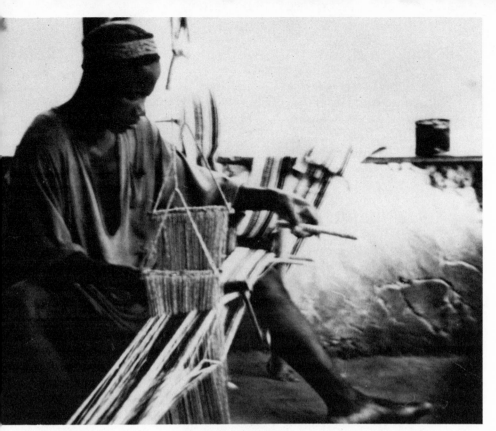

Seku, a Gola weaver.

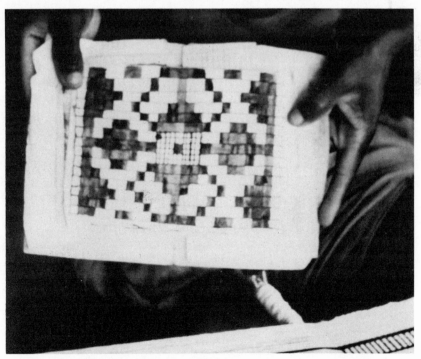

A "pattern book" of Seku, in which he records his "dreamed" designs.

poor quality with many bright colors and impermanent dyes. Some of it is machine loomed in Africa and Europe for the trade.

Among the Gola the old style cotton cloth, made by traditional methods and in accordance with traditional tastes in design, is highly admired and preferred for ceremonial dress and furnishing. Cotton yarn is spun by women and then woven by male weavers into long strips four to eight inches wide on a horizontal loom. These are later rolled into bundles of strips of the same design to be sewed by the weaver or a tailor into gowns, rugs, or blankets. It may take three weeks or longer to make enough cloth for a large gown. The best Gola weavers are considered to be those from the interior Kongba area, and the work of traditional Vai, Mende, Kisi, and Loma weavers is also admired.

In most sections the weaver is an itinerant who works by commission. He may be called from his home village by a far-distant patron who subsidizes his travel and subsistence for the period of time required to execute a wardrobe or other desired materials. The patron will set him up in a special workplace, and when he has concluded, pay an agreed amount for the products as well as additional gifts for satisfaction. In former times each large village had numbers of weavers attached to the households of well-to-do families, and only famous weavers were solicited from afar. Today, however, weavers are scarce and they are continually sought after for services. Some of them have many apprentices which they send out on commissions.

The designs used for cloth are highly traditionalized, and most weavers follow the patterns provided them by their teachers or copied from older work. But there are a few renowned weavers who are considered to be specially innovative and creative in this regard and who are referred to as dreamers. Such men are said to dream new designs through the aid of their tutelaries. Their technical abilities and products are thought exceptional. One man of this type with whom I worked kept a notebook in which he sketched all of the patterns or "ideas" which came to him in this way. He seldom repeated a major design from commission to commission unless specifically asked to do so, and his designs were known by his name over large areas. Other weavers copied his ideas, but because these often diverged from traditional styles, they were careful to attribute them to him. The apprentices of this man were sought after, and some of them were known for the fact that they specialized in one or two of the designs of their master.

Other specializations associated with weaving are embroidery and tailoring. Most skillful and successful weavers are also adept at fancy

sewing and embroidery. A few men are specialized in these activities and are called upon to decorate gowns and linens. Wealthy families will commission an embroiderer to embellish European-made sheets, bedspreads, pillows, tablecloths, and curtains with intricate multi-colored designs and, occasionally, elaborate pictorial scenes with the effect of tapestry. There are others who specialize in fine embroidered caps of the Mandingo type or in the making of ornaments or the ritual costume of *Poro* and *Sande* initiates and masked impersonators. Where special excellence and innovation is demonstrated in these tasks the craftsman is thought to be guided by supernatural inspiration.

The tailor (*yun yai ene*—"one who sews things") is a more recent type of specialist responding to the increasing use of European cloth and styles of clothing. Almost every village has at least one professional tailor who has learned his trade in some urban center and has earned enough to buy himself a sewing machine. But a good tailor, no matter how excellent his work, is never considered to be a man of inspiration. A great weaver would not desecrate his product by appealing to the services of a tailor for its completion, but insists upon traditional hand sewing and native materials. Embroiderers are frequently employed by tailors, however, in order to decorate clothing and linens sold by them.

In former times leatherwork, pottery, and basketry were produced among the Gola, but today what items of this kind that are used by them come from large market centers of the interior among such peoples as the Loma and Bambara. A few old men and women are still able to make baskets, but these are no longer the varied and decorated types which are said to have been made earlier. Women once made pottery utensils and other objects, but I found no con-temporary instance of this activity in Gola villages, though it is still extensive among more interior peoples. A few weavers and woodcarvers will upon occasion make small ornaments of woven fiber or fired clay, but these are isolated novelties. It is said by older persons that there were famous craftsmen of these materials in former times and that the decline of these occupations was brought about by the availability of foreign trade goods.

The Gola Artist: Some Further Considerations

I was some time in the field before discovering the Gola artist as I have defined the role in this paper. They are neither identifiable nor approachable until one has had some experience in the culture and

until one's interest and intent has become widely known. The greatest obstacle to recognition of artistry and the artist in societies other than our own is the myopia imposed by our preconceptions about art, and the latent biases concerning the relation of art to society. Because of the undeveloped state of a theory of art in social science the ethnographer is just as prone to interpretive distortion in this area as any other member of his culture.

I must admit that in the first phase of my field work among the Gola the question of artistry was quite peripheral to the central concerns of investigation, and in retrospect, I am aware that I did not expect to find artists in the sense that I am now discussing them. My orientation to the special objects and performances which I might have designated as art was qualified by assumptions that "craftsmanship" or "artisanship" were more appropriate terms for the activities which produced them, for there seemed to be little evidence that they were not entirely embedded in the structure of traditional institutions or that they functioned in the context of any independent system of values and social relations. This view was reinforced by the ethnographer's caution with regard to cross-cultural interpretations derived from the anticipations of our own culture. This caution exerts a positive as well as negative effect upon observation; it can discourage the observer from the pursuit of data that might disclose phenomena the reality of which has been tacitly denied. In the study of artistry in society the restrictions imposed by lack of systematic methodology and theory, combined with those imposed by cautions concerning the common sense hypotheses constructed from experience in one's own culture, can also insulate the investigator from discovery.

Prior to going into the field I recall being intrigued by the continual references in the literature to abundant and dramatic forms of workmanship in the various crafts. When I arrived in Liberia I saw numerous examples of such work in the shops of Monrovia, in collections of Europeans, or peddled by urban itinerant traders. During my first few weeks in Gola villages, however, I was keenly disappointed by sparseness of artistic products and the absence of public interest or information about them. I attributed this to rapid social change and to the decline of traditional institutions. There are a number of early notations in my journal indicating that I was struck by what seemed to be the aesthetic impoverishment of everyday Gola life and the extremely pragmatic orientation of values. Nevertheless, I interviewed various local craftsmen and performers when I found them and interrogated my informants about these matters. In the index to my notes

I find that all data of this kind were placed under a category of "art and esthetic values." It contains, primarily, specific data on craft techniques, descriptions of dance and singing performances, house murals, decorated utensils, and carved wood objects. I frequently noted the difficulty of eliciting any comment about them excepting in the most utilitarian and minimally "aesthetic" terms. It seemed as though Gola aesthetic-expressive values were focused on symbols of power dominance in the political sphere and in secret society ritual.

The contrast between these observations and those which appear in my notes some months later is great. In the first phase of field work the sources of my meagre information on aesthetic or presumably artistic phenomena—when I gave attention to them—were those at hand. I spent most of my time in small and relatively isolated villages. Local craftsmen, performers, and their immediate relatives provided the setting, and the scanty inventory of specializations and products of rural settlements was the reference. Now and then I would see some object of the kind I had expected to find in general use—a finely carved housepost or rice mortar, an elaborate wall mural or personal ornament. The maker was invariably described to me as a person famous for his work, but who lived elsewhere or who was no longer living. I would note the names of such persons, but when I passed through villages that had been given as their homes, I was told they had not been seen for some time and there seemed to be a reluctance to discuss these matters.

Later I came to understand how much this situation was a function of my own role. My entrance among the Gola had been announced by officials in Monrovia as an event signaling the commencement of a study of Gola history and customs. The news spread through the chiefdoms rapidly, and wherever I went groups of elders of the high-ranking lineages presented themselves as "historians" of their villages or chiefdoms. This was very useful to me in the initial phase of ethnographic survey, and certain information became available to me in a very short time that might have otherwise been withheld. But those with whom I worked represented the most conservative leadership of society and their notions as to what I should learn or what I should be most interested in conditioned their orientation and influenced directly the behavior of all others whom I approached.

My interest in kinship, lineage segmentation, the history of local communities and chiefdoms, in myth and specific customs was fully acceptable in the arena of investigation and discourse. But matters of technology and special services were set aside as peripheral, and if I pressed for information in this area I was impatiently referred to some

specialist who was not available at the time. I was, therefore, dealing primarily with the aristocrats of Gola society whose focal concerns were those of political and religious structure. Craftsmen and performers were persons of low status who provided services to those who could afford them. The finest work from such persons became the property of wealthy patrons who used them to enhance their own prestige. When one admired the work of a singer, a musician, or woodcarver, one was usually informed of the name of a patron as though the identity of the actual producer was insignificant. The fact that this was not actually the case and that the attitudes toward certain types of craftsmanship and entertainment functioned in the context of complex systems of value and social relations was something that began to emerge only after intensive and accumulative experience in the culture.

The work of professional artists is mainly in evidence on festive and ceremonial occasions. At these times every attempt is made to enhance the importance of the events by bringing forth from family treasures and storage lofts the fine ornaments, utensils, and ritual objects which have been collected over generations. It was not until my interest in such things became widely circulated in the context of my investigation that I began to meet specialists who were known for exceptional workmanship. I did not seek them out (as this proved unrewarding), but they began to come to me with their products and to solicit me as patron for local performances. The establishment of a patron-client relationship and the indication of my serious interest by regular commissions created the conditions for meeting and working with professional Gola artists of all kinds. It soon became clear that my previous observations had not been involved with art at all but with the work-a-day craftsmanship and recreational pursuits of Gola life. My later work provided an entirely new perspective and my notes are permeated with an atmosphere of discovery.

While working through the material I have presented in this paper, two fundamental provisos came to mind concerning the study of artistic phenomena in other societies. First it seems to me quite unrewarding and, perhaps, misleading to *look* for "art," or to expect that one will elicit elegant articulation of aesthetic values from members of a society who are not the actual producers of the materials one has tentatively classified as artistic products. Furthermore, these materials may not be works of art at all, and one's informants may be talking about utility or technology and offering the simplest of aesthetic responses to the investigator's strange questions. Secondly, it is most often only the *artist* who has something to say about the processes of

creation and the products of the activity we would call art, while other members of his culture may tend to react to the product in much the same way as the average person in our own society who is neither artist, critic, nor art lover. This presents a problem in all cultures where the terms and categories of native concepts are quite different from our own and where the "obvious" becomes a pitfall for both the informant and the investigator.

As matters of art are still among the most *obvious* to us, due to the lack of rigorous empirical investigation and a social theory of art, the problem of delineating artistry and the role of artist in any society remains one of the last elementary challenges of culture and social structure. Finding *the artist* in another society is, in fact, no less difficult than finding the artist in our own, when one decides to put one's mind to it.

The roster of vocations which I have presented as predominant vehicles for the artist role among the Gola does not, in itself, define the Gola artist. As I have pointed out, it is merely that the kind of person whom I have identified as *artist* and whom the Gola recognize as a relatively distinct type seems to occur most frequently as a participant in these activities. Not all Gola dancers, singers, musicians, storytellers, magicians, blacksmiths, woodcarvers, and weavers are artists in these terms, nor would it be accurate to say that individuals of the artist type cannot be found among a wide range of other activities and conditions of life. But certain of these vocations and their associated activities are, to the Gola, particularly symbolic of roles, personalities, and products which we in our culture tend to designate as artistic.

In the introductory section of this paper it was suggested that the role of the artist in our own culture is strongly influenced by archetypical concepts of art and the artist. To a considerable degree they may condition the response of the community to the artist and his products, contribute to the changing status of the artist in society, and help to explicate and stabilize those values which transform innovations into traditions. These concepts also appear to create an effect of stereotyping all incumbents of the role so that the charismatic qualities of the archetype are assumed or anticipated in those who participate, and certain kinds of behaviors or products are spontaneously judged to be artistic. A similar effect may take place with regard to other crucial roles such as that of the scientist and the political or religious leader. A common feature which unites these phenomena is not intrinsic to the respective roles or their actual incumbents, but is

the symbolic attribution of special knowledge and powers to those who engage in these activities in a particular way, who seem to exemplify the ideal criteria of the roles so fully that others are both influenced and judged in these terms. Another common feature of such archetypic phenomena is that they magnify those aspects of roles and their performance which justify a given line of action as an end in itself.

It has been pointed out that the role of the artist emerges most clearly among the Gola in connection with vocations or statuses which are not embedded in the structure of local institutions. The special titles and ranks which are conferred on exemplary officials of tribal government, of the secret societies, or of the learned professions of curing, divining, and master blacksmithing are seldom if ever conferred on those who are primarily engaged in specializations of artistry. The ideal communal values of Gola culture are focused in official roles, and incumbents are selected and evaluated with reference to rigorously prescribed criteria of lineage rank, personality, and evidence of social responsibility.

The role of the artist, however, is associated with values that underscore particularly individualized, subjective, and expressive qualities of Gola behavior. It represents achievement and success with relative independence from the ideal communal requirements and sanctions of the local group. In this sense it provides a mirror for the ambivalence and tensions in the Gola value system. As in our own society, a high degree of voluntarism is attributed to the artist as well as a certain invulnerability with regard to sanctions for deviance. The sources of motivation and ability of the artist are considered to be more remote from common scrutiny than they are for most other activities.

I have shown that there is in Gola culture a role similar to that of the artist in our own culture, though it is not so clearly differentiated by concepts and terminology which separate it from closely related roles, or which classify its varied manifestations. The Gola terms signifying "the players," "entertainers," and "the makers of images" come closest to being designations for the role, and the meaning is made particularly explicit with reference to those whose vocations are singing, storytelling, musicianship, or woodcarving. With regard to these activities, the role concept appears to be more than incipient and constitutes a well-defined roster of attitudes which offer evaluations and anticipations of the incumbents' behavior. Yet there are also individuals in other occupations who identify themselves and are designated by others as meeting the criteria for the role. It was not until I had established empirically a system of concepts associated with

artistic production in Gola culture that I was able to recognize the artist type and the artistic object in any but the most obvious occupations and social situations.

The most fertile source of information about artistry is artists themselves, and particularly those artists who self-consciously present themselves as typical. There is a high degree of correlation between the actual behavior of such individuals and the attitudes about them expressed by other members of the culture, though they tend to defend through self-glorification and intricate rationalization what others take to be enigmatic and aberrant. They are persons for whom artistry is a way of life, who have formulated an ideology of supportive concepts, and who seem to be as much concerned with the presentation of self as an object of aesthetic evaluation as they are with the completion of specific artistic products.

The self-conscious personality and the artistic product are so intimately related that the artist of this type always sees his product as part of the self, inalienable excepting through violence and betrayal. Thus he becomes exemplary, both to other artists and to other members of his social group, providing an expression of those values which have become most illustrative of the role. These expressive qualities adhere to his person and are also transmitted to his products. At the same time they are assigned through public stereotyping to all others engaged in relevant activities or who express elements of the archetype and become a model of reference in the self-evaluation of those artists who strive for a conscious role identity.

The archetypical Gola artist is one who "dreams," and whose creative inspiration is supported by a very special relationship with a tutelary. His personality is thought to be shaped in a particular way by an intense devotion to a *jina* (*neme*), who is his spiritual counterpart and who reciprocates his devotion. His work in life is focused on activities that express the quality of the *neme* friendship not only in his personal behavior but in the creation of external forms that project the "ideas" given to him by his spiritual companion. In this the artist may be distinguished to some degree from certain sorcerers, diviners, heroic warriors, *zonya*, and other remarkable persons who are *anyun gò gwá* (dreamers). The latter are engaged in activities which may be considered oriented to the practical on-going business of the world, and success is attributed to an essentially pragmatic and impersonal exchange of services between human and nonhuman agents. But the artist reveals by his behavior that he is preoccupied by a profound absorption in a relationship of love. He appears to be concerned seriously with little else than the "gift" he has received from his lover

and is intent upon transforming its essence into forms that can be presented for the admiration of others.

Among those persons whom I met who were considered to be *anyun go gwa* in various vocations, it was the artist of this type who presented the most unique and articulate explication of talent and creative processes. They invariably spoke familiarly and affectionately of their *neme*, and always with a tone of exacting respect and inner elation that we associate with chivalry and romantic love. This was in very sharp contrast to the response of *anyun go gwa* in other vocations, who tended to be distrustful, secretive, and evasive when asked about such matters. Those artists who were dreamers openly claimed to work directly from "patterns" or "pictures" which their *neme* had put into their minds. More than other artists, they were inclined to discuss their anxiety or depression about technical adequacy in connection with the demands of inspiration. Most artists, like other members of Gola society, do not easily express matters of personal insecurity, for a confident stance in public is considered to be one of the most important assets for success. But the special artist type to which I am referring here seems compelled to humble himself in this regard.

The artist's product is seen, from the point of view of the archetype, as an objectification of a way of life and the embodiment of specific values manipulated by him under spiritual guidance. All that is artist and artistry in Gola terms is congealed in the artist's product. It at once personifies his own unique qualities as a person, the qualities of his spiritual counterpart, and reflects what he believes to be important in the world. Once completed, it can never be considered apart from him, but must be respected as a part of himself consecrated by the power of a spiritual benefactor. Even when the original producer is unknown or forgotten, an object whose qualities are such that it gives every evidence of having been produced under these conditions is dealt with in the context of prestation. It cannot be handled or exchanged in an impersonal way. It moves in the sphere of gifts and ritual. This is true of all goods and services involving the concept of unusual creative power.

Furthermore, a large proportion of the products of the traditional artist is produced for secret society activities. The products also appear at major festivals such as funeral feasts and in the honorific setting of praise to important persons. Thus, even the casual and purely decorative works of the great artist have the charismatic aura of sacred things. They are extensions of a person and symbolic of special power. Such things are convertible to other spheres of the economy only when they are "dead," when it is felt that the original "owner" or producer will

not press his claim. Otherwise they are considered desecrated if bought or sold as ordinary items. Conversions can only be made through stealth by appeal to intermediaries such as foreign traders or nontribal urban dwellers.

The artistic product associated with the archetype acquires its qualities not only from the conditions of its creation, but also from the fact of creation itself. For the average Gola the processes of artistry that occur between the initial inspiration of the artist and the public presentation of his result are only vaguely perceived. Matters of skill and technology are not part of the discourse between the artist and the public and remain mysteries of creation shared only among the producers or held as the cryptic property of an individual. Thus to the public the product of the archetypical artist is miraculous, and the artist is viewed essentially as a daring entrepreneur in exchanges of gifts between human society and a special supernatural realm. The years of training and arduous application of the artist are seen as tasks imposed upon him by his tutelary for whom he is a passive instrument.

I have shown that this is not the way the artist views his relation with *neme*, but that to some degree it provides him with the desired insulation from public scrutiny and control. He encourages the illusion of spontaneous creation and presents his results as a gift of spirit. The product, therefore, is not perceived by others so much as an embodiment of the intention of the artist as it is of the intention of a supernatural personality.

The effect of the artistic object is profoundly enhanced by this concept of creativity. It qualifies all response to innovations, novelties, and special interpretations of traditional forms presented by the players and makers of images in Gola culture. The awe which surrounds them involves ambivalent reference to deviant human behavior supported by extraordinary access to supernatural power. It is reinforced also by the myths of relations between the autochthonous human and nonhuman beings of the Gola past which provide the rationale for the sacred institutions of *Poro* and *Sande*. Yet the artist's role is unique in its relative individualization and independence from the communal orientation to myth. The artist has established a personal contact with a spiritual agent outside of the sphere of communal supervision of such relations. His products, like his person, represent qualities which are both heroic and eccentric. As the child of society his work is a kind of eternal "play" but his playthings are the more-than-lifelike symbols which awaken disturbing thoughts and values which lie for the most part dormant in culture.

An elder of *Poro* expressed this very clearly to me while we were

watching the entrance of the masked *Sande zo gbe* at a funeral feast.
I had taken the liberty to remark that I recognized the work of a par-
ticular carver whose masks seemed to be popular through the entire
chiefdom. "Yes, that is the man," he said (ignoring my indiscretion),
"How could such an ignorant and foolish man make so fine a thing?
As old as I am I cannot understand it. When I am among the ancestors
it is one matter I will look into first of all. The *neme* which follows me
and my family tells us to be wise and great people in this world.
But the *neme* which follows that man makes his work great and turns
his mind to crazy ways. It is something only *Daya* knows."

This nostalgic and benign musing of a sacred elder of Poro reflected
a common view about the artist and seems to me to point out in a most
direct way the function of the archetype as a model for evaluation and
social integration of the artist. This elder, like many whom I talked to
about these things, expressed a general sense of concern that the old
Gola world, which once nurtured itself on the "gifts" of extraordinary
persons, was becoming narrower and more restricted. It was said that
fewer people are born in each generation who know how to be friends
with *jɪna*. "All the young people today run after new ways. They have
no time for *neme*. They think the *kwi* [Europeans and Americans] have
stolen all the *jɪna* for themselves. But there are good *jɪna* who love the
Gola, and who walk about looking for friends who no longer want
them."

The elders of the more conservative chiefdoms often explain the
changes taking place in the world about them as due to the fact that
the "good *jɪna* of the Gola" are leaving the mountains and streams
because "we do not pay them respect as we did in the old days"; they
are going to "some other country where the people will love them."
This is also a view which Gola artists share with the old respected
zonya who are also *anyun gò gwá*. It reveals a tragic sense of loss of the
Gola *genius*.[12]

Significantly enough, it is the traditional Gola artist, who represents
the archetype, together with the traditional exemplars of Gola society
who today share in the maintenance of the vestiges of that ideal linkage
between man and supernatural agencies which provided the arena of
arbitration for truth and greatness in the vigorous tribal world of the
past.

NOTES

1. This paper is a much condensed version of the original work prepared for
the SSRC-ACLS Conference on The Traditional Artist in African Society at Lake

Tahoe in 1965 under the title, "The Artist Archetype in Gola Culture." The latter appeared as a limited publication of the Desert Research Institute of the University of Nevada (Preprint No. 14), Reno, Nevada, February 1966. A slightly revised version under the same title was issued by the publisher in 1970. The reader is referred to this earlier work for a more detailed exposition of some of the materials discussed in the present paper.

The field research upon which this paper is based was carried out during 1956 and 1957 with the support of a Ford Foundation Foreign Area Fellowship.

Gola, along with Temne, Bulom, Krim, Kisi, and a number of other languages of West Africa, has been classified previously as part of a "West Atlantic" grouping, but more recently Dalby (1965) has classified it as belonging to a smaller unit of languages which he refers to as "Mel Languages." The only published study of Gola is that of Westermann (1921) among the mixed Kpele and Gola population of Fuama Chiefdom on the St. Paul River. Considerable dialectic variation and change may be indicated by the fact that much of the vocabulary he collected at that time is not recognizable to the central or northern Gola with whom I worked, nor to some modern informants from the St. Paul chiefdoms.

In the present paper a simplified orthography is employed for native terms. Double vowels are used for length, and the tilde for nasalization. Relative pitch is indicated by accent marks, (*e.g.*, *dí* high, *dì* low, and *dî* rising-falling). The symbols for all consonants and vowels carry the values given for them in Westermann and Ward (1933:xv–xvi) or are, otherwise, the same as for IPA.

2. Cf. d'Azevedo (1959; 1962a; 1962b).

3. I use the term *traditional* to denote those basic features of Gola society and culture which prevailed prior to the recent imposition of full Liberian government authority on tribal affairs, and the rapid reorientation of tribal culture to the economic and political integration of a modern African nation.

In this discussion *vocation* refers to any calling or occupation which is a primary source of income for an individual, or which commands the major portion of his interest and time. An *avocation* may be the same activity carried on as an occasional or supplementary occupation. Vocations are usually basic determinants of status and role. Among the Gola such distinctions are difficult to apply, for most persons are more or less directly dependent upon agricultural subsistence activities. Nevertheless, the distinction is made between farmer (one whose major activities are actually carried out on the land) and, let us say, a family head, town chief, or blacksmith who may be members of families all of whose members are primarily engaged in agricultural pursuits. The Gola do not say of a man, "he is a farmer, but he is also a blacksmith." An ex-family head or an ex-town chief is referred to by this title regardless of what his present source of income may be. Thus certain vocations are status-indicators which adhere to the individual throughout life regardless of shifts in role or occupation. Avocations are also recognized as casual or nonpecuniary activities—for example, a chief or blacksmith may be known as a person with some skill as an herbalist or storyteller, yet who makes no special claims in this regard or does not require standard remuneration.

Vocations most often involve diversified activities, whereas a *specialization* implies the pursuit of a concentrated or limited line of work or interest. When we speak of increased specialization of occupations or vocations we mean that activities have been subdivided into parts represented by socially recognized roles and statuses. *Professionalization* may occur in generalized vocations as well as in specializations and involves more complex criteria of recognition by colleagues, etc.

4. Other usages of this term are for "influence" or "pull." It covers all of the meanings of our term "lucky" and of the contemporary American idiom "swinging." In Gola culture, however, the sources of luck are made more explicit. An alternate term is *fēī fuwa* (bright or white face) which means essentially "a good countenance." It also implies "to have one's face washed," which means that one has gone to a practitioner to be cleansed of sins or bad luck—that is, one has changed one's fortune and it shows on the face.

5. *negba* or *egba* is literally translated as "the thing forbidden." It applies specifically to such restrictions as mother-in-law avoidance and incest and totemic tabus. But it is also used more generally to indicate any private charter of behavior prescribed by supernatural agencies or by personal preference.

6. The first of these terms refers to an oath made to gain protection from harm: the second is an oath sworn to effect something. The most heinous form of oath is *kpángbá* which means to "tie" or "nail down" a curse against someone.

7. The most common *jina* of *ma zonya* and other persons of high office are the *anyun kwui* (water people). The priests and priestesses of the secret societies are the custodians of the ancestral shrines of the Gola. Myth establishes that the *neme* of the eponymous ancestors were *anyun kwui*, so that the most sacred shrines are those connected with water.

8. *e goye* is, actually, "a trained person" or "one being trained." The term also means "one being fed" or "one being cared for." Thus, it is frequently used to designate a ward or apprentice. In general, it means one who has been well brought up.

9. The decline of the great De chiefdoms of the early nineteenth century, for example, and the dispersal of the De people are attributed to the defection of De *ma zonya* to Gola chiefdoms. Today, the Gola say the same for themselves. The disintegration of traditional chiefdoms and lineages is attributed to the defection of intelligent young people to urban centers and government, and also to the withdrawal of *jina* from Gola territory. The destruction of the sacred mountains of the Senje Gola at Bomi Hills is said to have angered the totemic spirits of the founding lineages, and that spiritual support has been withdrawn from all of the shrines of the area.

10. The term *zo* is also used idiomatically as an unofficial title for anyone who shows mastery and superior skill in any line of work. For example, *wo ya zo yiva* (he is a master dancer) suggests that the dancer is *like* a *zo* in his profession or that he has no peer.

11. For a discussion of this aspect of tribal economy and developments on the West Atlantic coast, see d'Azevedo (1962a).

12. The supposed increase of crime, delinquincy and witchcraft is sometimes attributed to the fact that young people of great talent and ambition are no longer controlled by the codes of positive tutelary relationships. An elder of *Poro* once told me: "When a man is the kind of person born to have a proper *neme* behind him, and he refuses it, or it does not find him, that man is better dead. He will suffer all of his life. He will bring suffering to his family. His mind will dream of success, but he will not have it and he will not be satisfied. He will do anything for power, but he will have no guidance. That is what is wrong today. There are only bad spirits remaining in our land."

Commentaries

K. Peter Etzkorn

ON THE SPHERE OF SOCIAL VALIDITY IN AFRICAN ART: SOCIOLOGICAL REFLECTIONS ON ETHNOGRAPHIC DATA

THE search for ultimate origins of human practices and institutions has generally not been one of the concerns of sociologists, although evidence of the existence of social institutions that engage our study today does appear in the empirical records of earliest known society.[1] These records reveal that activities connected with what one would call art in modern society were a part of early human cultures. Today references to art among contemporary non-Western and Western peoples abound in the literature of social science. It appears as if art not only is one of the "original" activities of man but represents one of the universals that characterize all humanity and calls for a search to explain this phenomenon by students of comparative and systematic sociology. In fact other topics have preoccupied sociologists much more than the study of art, a consequence of some extrascientific considerations and not a reflection of the degree of scientific significance of this enduring human practice. Many topics of highly circumscribed historical relevance preempt most of the professional literature in sociology even today. With this essay a small attempt will be made to redress the imbalance. It is not implied that sociologists have never dealt with the subject of art and aesthetic behavior, but rather that they have done so insufficiently.

The sheer neglect of aesthetic behavior might be considered as one of the shortcomings of contemporary sociology. When writers in sociology mention the arts at all, it is usually in a discourse on such exotic forms of behavior as narcotic addiction among dance musicians, a type of discussion that can be only incidental to systematic exploration of the social significance of art, or the study of art as a major institution.

Although some of the founding fathers of sociology dealt with the arts, they can hardly be absolved of the same criticism that can be ap-

plied to most contemporary sociology texts, which, according to C. Wright Mills (1943), are presently the only comparable systematic treatments that cover the entire field of sociology.[2] A search of several contemporary texts indicates that the subject matter of art is relegated to a few paragraphs, or perhaps a skimpy chapter, or that coverage is omitted altogether.[3] When earlier sociologists such as Max Weber, Georg Simmel, or Emile Durkheim dealt with the arts, it was only to show how certain features of artistic life illustrate other general sociological principles. Sometimes they focused on a selected topic in the history of art, or limited their attention to a particular medium. Thus, they also neglected to move from specific observations to implications on the universal character of artistic phenomena in human society.

Perhaps this limited emphasis of sociological studies was fostered by methodological problems connected with generalizing from a wide range of different artistic phenomena. Specific examples of what has been regarded as artistic phenomena in the record of mankind are as diversified as the range of artifacts connected with other human pursuits. Tools, decorations, vestments, shelter, modes of hunting, styles of life—in short what anthropologists frequently used to call the material culture of human groups—represent many variations in detail among the numerous human population. Not only do their morphological features vary from place to place, but so do their meanings. Moreover, there is some independence of variation between morphology and meaning. In some instances the style of certain culture items can be shown to have changed within a given population while their meaning or sometimes function did not undergo any major transformation. These observations can be extended to objects classified as art objects or phenomena of art.

Throughout the history of man, social groups responded to selected objects in ways that are germane exclusively to these objects, thereby producing the special category of art objects. It is necessary to distinguish between those objects or vehicles that cause particular responses because of their imputed religious (magical) powers from those that are of interest because of aesthetic meanings. In many instances, of course, this separation can only be made analytically since we know from the contemporary world that objects of religious art may carry both aesthetic and mythological connotations.

For heuristic purposes an area or sphere within categories of human interaction called *social validity* of art is a useful concept. This term suggests that among interacting people similar cognitive responses or meanings are evoked through the shared symbolism communicated

by a work of art. In other words, response among such beholders is so consistent that the meaning of the work of art may be assumed to be approximately equal. In this sense, and in this sense only, is the work of art treated validly as one work of art. Individuals outside a given sphere of validity, i.e., people with different responses, in different cultures or different historical periods, will not appreciate or approach the work of art exactly as do participants in this sphere of validity. Among *outsiders* the art object may cause aesthetic reactions peculiar to its existence singling it out for attention. After all, museum objects all over the world are treated differently than identical objects not hung in special places or set on pedestals. There may be several spheres of validity for one and the same object as changing responses to works of art throughout history readily suggest.

There is little doubt that in this conceptualization we do not qualify as participants in the sphere of social validity of most artistic phenomena. For instance, we cannot entirely understand the meaning of ancient cave paintings nor the meaning of the art of some contemporary native or tribal group unless we engage in extensive sociological research with the objective of placing the works of art into their cultural, historical, and symbolic context. There is always some reservation, if we do succeed in understanding the culture, whether we have not at the same time become a totally acculturated member of the group, at which point we as members of the society who are fully socialized in the appropriate tradition of symbols will ascribe to works of art a different validity than the student of tribal art.

While theoretical attention to the relations between art and various social contexts cannot be said to be new, increased methodological sophistication in the social study of the arts—just as in other fields of sociological inquiry—was developed relatively recently. Differences between methodological approaches have sometimes dictated the appraisal of scholarship in this discipline. A social scientist's judgment of the relevance of studies of a more humanistic orientation depends on his concept of social science, and a humanistic flavor is still representative of much writing in art history. It became gradually fashionable in this literature to infer generalized relationships between social conditions and artistic production from detailed intrinsic analyses of artifacts (the study of works of art in museums, for instance). Vice versa, explanations for the status of art, frequently even for concrete examples of art such as the appearance of certain stylistic features, are advanced by pointing to certain features of the social scene and marking them as causes of artistic developments. It may be helpful to intro-

duce at this time the distinction between a social view of art and a sociological theory of art.[4] The former represents generalized attempts at suggesting plausible rationales for imputing certain dependency relationships between art and society.

Such suggestions do not compare with the status of a sociological theory of art, *i.e.*, a universally applicable set of propositions that can be shown to be either empirically adequate or inapplicable through standards of scientific procedure. While it is occasionally argued that there has been little scientific work in this area because concern with the social study of the arts has developed only recently, we have already seen that this is patently false. It may well be that the traditional, less formalistic and quite parochial concern with the social study of the arts may have produced more *meaningful* insights in this complex area than the more ambitious and infantile sociological study of the arts. Nevertheless, there is a growing awareness in the sociological discipline that art represents an institutional area which demands scientific study.

Just as the endeavor to uncover the true origin of art is fraught with pitfalls and arbitrary decisions, so it is risky to attempt dating the beginning of inductive sociological study of art with the naming of two outstanding contributions: Charles Guyau and Pitirim Sorokin.[5] While the work of each is significant in its own right, they are selected here also for another reason: their methodologies illustrate somewhat different emphases in the current concern with the sociological study of the arts. Guyau's approach is specifically oriented toward exploring links between literary developments and their social bases through the analysis of the *content* of novels and the *social position* of their writers. Pitirim Sorokin's complex methodology operates on two levels: a *macroscopic* delineation of historical epochs by empirical comparative analyses of artifacts, and on a *microscopic* interpersonal level, the analysis of relationships between individuals implicated with works of art as creators, beholders, and instrumental exploiters. Neither Guyau nor Sorokin, however, imputed special psychic qualities to the works of art or their producers, an approach that is still initially taken by Max Weber and is frequently found among writers in the psycho-analytic-psychological tradition. Weber, for instance, felt it at first convenient to sidestep some major methodological issues by inventing and applying the concept of charisma—the imputation of special qualities to leaders whose leadership he was unable to explicate through their sociological power base. He abandoned this concept in his own detailed sociological studies.[6] Although some of Guyau's vitalistic

sociology treats individuals as independent variables, in his writing on art he suggests that the most genuine art is found in those examples of artistic activity which present to us at once the most personal and most social apperception of life. The conditions for these personal realizations are in society, in the network of social communication. In Guyau's words, creative artistic style is created as an "instrument of sympathetic communication" and "esthetic sociability" (Guyau 1920:xxiv).

Art and Sociology

The sociological concern with art takes as its point of departure the study of objective dimensions of interpersonal relations, and as it were, stays on the surface of the skin of the artists and their publics. This does not simplify matters of analysis; indeed, it may make the interpretation and analysis of social phenomena more demanding—since it is more subject to objective tests and scrutiny by others. The sociologist cannot impute phenomena to the mystical charisma of the artist—he has to demonstrate the peculiar responses that an artist calls forth in his public by explaining roles and expectations generated in the public and in the artist about behavior that is proper and in keeping with the role-set of the artist. Thus, the sociologist will need to show the history of artistic (stylistic) traditions; how they are kept alive in social groups; how they are internalized both in the creators and the receivers; how role specialization between producers and receivers comes about; what the criteria of selection of stylistic traditions are; how these, in turn, are legitimated in social groups; how socialization mechanisms work in enforcing these—and how, when failing, changes in the artistic tradition come about through the opening up of previously delimited artistic forms to experimentation and the acceptance of "foreign" stylistic elements and perhaps completely new forms of art.

On *a priori* grounds, it would seem to be more feasible to design empirical studies of art life in social contexts which are not as fraught with social change and structural complexities as is the industrialized West. And, indeed, my reading of the papers prepared for this volume on African art confirmed this expectation. Obviously I cannot argue that these papers bear out this *a priori* assumption—since many factors may have contributed both to my own perception and to the selective preparation of the papers. One must always remember that the quality of the papers, excellent though they are for what they are, cannot do full justice to the complexities of African societies and their art. They

are abstractions, and thus give a more simplistic than accurate representation. After all, what can one find out about the art history and practices of peoples whose history is longer than that of Western man within several months of field work? Regardless of this *caveat*, the assumption can hardly be challenged that social conditions for maintaining indigenous styles and norms in tribal society are more integrated than in Western societies—if these are taken as wholes. This assertion is backed by the authority of Marx's work on social change, all anthropological writing known to me, and the sociological literature on modernization. By working with the African data, the sociologist can develop methodological tools which may sharpen his perception for art in the more familiar Western social context.

Although most people have some concept of what is meant by the terms art, art objects, artists, art behavior, art phenomena, and so forth, we cannot take it for granted that there is consensus of meaning nor that these meanings are precise enough for scientific discourse. An article by Haselberger (1961) in *Current Anthropology*, moreover, illustrated that there is quite a difference in opinions connected with defining what is *primitive* art. Although this discussion did not raise the more general question of what is meant by art, it supports the need for an explicit discussion of this point (Claerhout 1965).

We must identify the specific area of social behavior with which the sociology of art is concerned. In order to be precise, the terminology must suggest that the sociologist studying art is not really studying art, but rather he is analyzing social patterns in which objects (which may be called art) are handled in a specific way by a people. Leopold von Wiese stated this position succinctly in an early discussion on the sociology of art before the German Sociological Society. He showed that art must be comprehended as a *soziales Gebilde* (something formed socially). He argued that art produces connections among people, that art is, as it were analogous to a force around which people are grouped. Hence, if one analyzes the field of interactions which are peculiar to the particular medium which created these relationships, then one studies art from the point of view of the sociologist who is concerned with social relations (von Wiese 1931:127).

Guyau (1920:1) studies the novel in order to demonstrate "le but le plus haut de l'art est de produire une emotion esthétique d'un caractère social." Programmatically he subdivides conventions of artistic style into those "of the social world" and into those of art which, however, are often the "consequences of the same nature as those of the world at large" (Guyau 1920:71). Art is not something that *is*; instead

it is a consequence of social conventions and subject to the same conditions which are responsible for these conventions themselves.

While this view of the sociological concern with art may appear overly narrow, one moment's reflection indicates that it is as wide and full of possibilities as is the imagination of the sociologist. It allows for the study of interpersonal relations among individuals that are somehow brought into relationships with the work of art either as producers or beholders. It permits analyses of art as a focal point of interaction such as examining a work of art that is being discussed, looked at, listened to by an audience. Moreover it promotes the view of art as a result of particular historical developments in the social evolution of a group (insofar as it reflects stylistic features that are historically specific if not unique). In other words, von Wiese's narrow definition is only narrow in the sense that it emphasizes the social nature of the sociological study of art. It eliminates by fiat the nonsociological approach to the study of art which places some immanent power into the work of art or imputes charisma to the artist, raising them above the realities of social perspective.

While Guyau and Sorokin have been singled out as contributors whose works illustrate the empirical direction in the sociological study of art, there are also a great many other scholars who should at least be briefly mentioned if we wish to provide a somewhat more rounded background to our present discussion. Foremost are a number of German scholars including Georg Simmel, whose catholic interest in cultural themes caused him to contribute widely to topics on music, the theatre, painting, sculpture, and literature.[7] While his lasting influence has been in providing a formal definition for the discipline of sociology and in introducing social psychological perspectives into the schism between scholarship which took either the individual or the social system as predominant theoretical orientation, his followers today lean heavily on his nonspecialized, *i.e.*, cultural writing.[8] Of similar stature in the Germanic sociological tradition are Vierkandt and Thurnwald, both of whom deal explicitly with phenomena of art.[9] Both, however, like Simmel, contribute mainly in essayistic and speculative or programmatic terms rather than in strictly scientific fashion. Although both have empirical data at their command, specific analyses of these data, with questions about art as primary focus, are not central to their work. Max Weber, too, mentions matters of art throughout his many discussions in illustration of numerous classificatory points. With the exception of a fragmented and incomplete manuscript on music, however, he never investigates artistic phe-

nomena directly. They serve subsidiary purposes in his gigantic effort
at coming to grips with the complexity of social analysis.[10] Wilhelm
Dilthey, a contemporary of Weber and Simmel who wrote more ex-
tensively on art[11]—while he is more generally thought of as a critic of
sociology than as a sociologist—is a direct precursor of the sociology of
knowledge and thus also of the sociology of art. His writing tends to
suggest that a sociological study of artistic phenomena must start
and end with the analysis of the individual's role in social life. He
argued that only individuals and not interpersonal constructs repre-
sent true data of science. Hence, the study of artistic phenomena in
society is reduced to the study of individual involvement with the
creation and recreation of art and opens the road for romanticist dis-
course on qualities of human experience.

The second decade of the twentieth century saw the appearance of
a number of programmatic essays by lesser known sociologists.
Schuecking (1944), Tietze (1925), and Sauermann (1931) dwell on
methodological problems. Occasionally they illustrate selected points
by unsystematic references to artistic phenomena in society. More
recently during the early nineteen thirties, the German Sociological
Society devoted portions of their proceedings to discussions on the
sociology of art, which again were largely devoted to methodological
issues void of empiric substance.[12] Some of the programmatic points
raised during these sessions, however, were later applied to substantive
research, especially by students of Leopold von Wiese.[13]

In the French intellectual community, developments in bringing
empirical research to the sociology of arts were not much different. A
recent discussion of problems with creativity in the sociology of the
arts shows that—as in the German case—relatively little empirical re-
search can be quoted (Duvignaud 1959). A number of problem areas
for sociology are referred to. Hypothesized attitudes toward matters
aesthetic are listed, each of which would pose different methodological
implications for sociological analysis, especially since each of them
would define differently what is art, and thus the subject matter of
study. None of these problems, however, has evolved out of empirical
investigations, but as in the case of the German materials, represents
a program for someone else's sociological studies.

Many French sociologists today, thus, have not come much further
than their illustrious predecessor, Mme. de Stael.[14] Nor can it be said
that Guyau's tentative examples inspired much imitation. From the
combined French and German record it would appear that an en-
counter with practical problems derived from empirical work with

examples of artistic phenomena might force sociologists to abandon speculative writing and turn to integrating their researches with conceptual schemes that can produce theoretical propositions of sociological significance. Some of Charles Lalo's theses, especially in his *Notions d'Esthétique* (1952), come somewhat closer to this objective.

Earlier treatises by American sociologists devote entire sections to the role of art in social life. For instance, Cooley (1966) discusses social conditions under which the arts are likely to flourish in a society. W. I. Thomas (1901) in his early *Source Book of Social Origins* reprints entire selections from a number of ethnographic studies dealing with art and appends a lengthy bibliography on the sociology of art. Moreover, he summarizes these studies and derives suggestions for sociological investigations. However, as in the case of the other scholarly traditions, systematic empirical concern with art does not directly derive from these encouraging programs. James H. Barnett (1959:204), in his survey of the beginnings of the sociology of art, passes without interruption from Herbert Spencer's writing to Pitirim Sorokin, whose work he characterizes as "the most ambitious and extensive work in this field." While no doubt the subject is not entirely neglected in this lengthy period, no major development intervened in English or American sociology until the nineteen thirties, which brought the work of Sorokin (1937–1941) and John Mueller (1934; 1935; 1938) of Indiana University. Some psychologically oriented empirical research, in the meantime, had preoccupied students of the arts.[15] Following the individualizing trend of American social thought, much of aesthetic analysis was reduced to a study of variations in individual perception response. Thus, Mueller's reminder that Sumner's structural concept "folkways" could be applied also to the study of the institution matrix of art was greeted by some writers as some form of sociological imperialism.[16] It redirected attention from the individual to the matrix of social life.

Art as a Social Variable

There is considerable agreement among sociologists that art can be conceptualized as a social variable for purposes of sociological analysis. It is an elementary proposition that any patterned behavior can constitute a variable for social analysis. Since behavior in connection with art tends to be patterned, social responses toward art may as well be treated as social variables.

In general, these agreements assume the scientific nature of inquiry

in the social realm and are based on generalized objectives of science. The purpose of the sociological study of social phenomena can be broadly described as the isolation and delimitation of significant social-cultural variables and subsequent clarification of interrelationships among these variables and possible relationships with any others. Whatever differences of interpretations appear in the literature, they tend to agree with these major premises. Many variations deal with questions of strategy in defining what are artistic phenomena, considering such questions as whether artistic phenomena should include only established works of art or also significant social relationships that are generated by them; what constitutes significance in the realm of the social variable of art and perhaps, what are the limits of scientific inquiry into these topics which border on the humanities or belong to their methods of inquiry.

Insofar as human behavior is articulated with artistic phenomena, there is little doubt that one is dealing with a discernible set of observable social activities. These can be singled out for analysis by observers and participants alike, although it is frequently easier for the observer to notice the peculiar patterns of interaction and to assign significance to them. As in the case of the native who is unaware that he is handling a treasure (which the visiting collector would like to see placed in some Western museum for safe keeping), so participants in many social relationships may be unaware that these represent a wider pattern of interaction.

The overriding question then appears to be in what sense does artistic behavior and its consequences constitute a variable in social-cultural life, and what are the determinants for its relative significance toward other variables? Franz Adler (n.d.) observed in this connection: "It is social approval, social acceptance, which makes art art, religion religion, science science and so on. Inversely, it is social rejection which turns what might be art, religion, or science at another time or in another place into Kitsch, heresy or superstition." In the same paper, Adler continues to outline how sociologists can gain insight concerning the web of relationships which link creators with terminal recipients of creative products. Specific analyses of the roles of creator, diffuser, and recipient in a variety of creative fields delineate different modes of social organization for creative expression and reception.

Adler's emphasis on social interaction among people involved with art leads the student of the social implications of art to view art behavior in its extrinsic dimension (Mannheim 1963). At the same time, it directs the student who is primarily concerned with intrinsic aspects

of art to the social dimensions within which this art exists. Thereby the person of the artist, questions of authorship, of personal creativity and aesthetics, are brought into immediate focus and cannot be obscured through oblique references to artistic traditions or immanent forces in the works of art and their tradition. It is made clear that artists and persons participating in the artistic behavior systems are instrumental in creating conditions for artistic involvement, that they have social positions with status and status strains, that they can be ranked objectively and *are* ranked, irrespective of the sociologists' interests, by their fellow artists, critics, perhaps even customers. Frequently sociologists determine criteria for evaluating artistic role performance by the degree to which individuals specialize their role behavior in artistic behavior systems or engage in artistic behavior systems or engage in other roles (creative or "occupational") (König and Silbermann, 1964). By viewing art behavior as a social variable, the analytic emphasis is placed on the network of social relations engendered by art and only secondarily on the artifact of art. At the same time, it must be recognized that the study of the social nature of art cannot be undertaken without some consideration of the art object which forms the focus for the social networks involved in its existence.

In order to pursue the social study of art some kind of definitions of art and nonart must be established. Unfortunately, most general definitions of the field assume as established knowledge what should and must first be a focus of analysis. Many sociological definitions could be cited, but to my knowledge none differs significantly from Barnett's survey of the sociology of art. He divided art into "fine arts— music, literature and the visual arts, the combined arts—such as the dance, the theatre, and opera, and the applied arts which include such specialties as ceramics, textile design, and miniature painting." Barnett's (1959) category of the popular arts as an added category of art apparently cuts across these divisions of the field. He separates the popular arts by their utilization of modern mass media as means of expression and by their purpose of entertainment. Adler's (n.d.:1) simpler definition may be added here as further more recent illustration. He understands by art "the behavior surrounding painting and sculpture, but also literature, music and architecture." Such definitions assume that conventional language is sufficient to delimit the field. They overlook the obvious fact of continuous disputes concerning what is art, *i.e.*, whether Western popular arts are indeed art or whether a given work of art becomes debased once it becomes the common property of the masses. I would like to argue that it must be shown

what the peculiar *artistic* characteristics of painting and three dimensional expression are with which the sociologist studying art is concerned, *i.e.*, how painting differs from house-painting and sculpture from the making of a snowman, or the creative problems of an adwriter from those of a playwright.

The following illustrations indicate that sociologists have long been concerned with this problem. Ten years ago Bensman and Gerver (1958) suggested the utility of examining the special characteristics of artistic communication by focusing analysis on "the creation, development, expansion, exploitation, and criticism of their [the artists'] central techniques and methods" which differentiate serious from "mass" art. Earlier Adorno pursued a similar theme in his studies of radio music during the nineteen forties. He argued that traditional differences between simplistic forms of popular music and complexities of art music have become obscured through the mechanical reproduction and simplification of radio reception. Symphonic music, he felt, was threatened by devaluation to the status of ordinary hit music because of its technically inappropriate transmission over the air waves (Adorno 1939). In a major study during the nineteen thirties, Walter Benjamin explored the consequences of mechanical reproduction for art. As soon as the aesthetic concern with authenticity of a work of art has become meaningless—on account of the principle of mechanical reproducibility —he argued, the social function of art becomes inverted; it is not anymore the direct manifestation of a cultural tradition to which it is linked as if by rituals; but by its technology it becomes freed from its parasitic existence; thereby it loses all claims to "eternal validity" (Benjamin 1936).

Georg Simmel, in his extensive work in cultural sociology of the first decade of this century, always starts with an examination of the peculiar nature of the art media, their technical problems, and concrete attempts at solving them, before he turns to discussions of their sociological implications. Thus, in his studies on the theatre he first examines technical relationships between the writer and his work, and the written script and the staging of the play; in his work on painting, he examines the technical problems of rendering three dimensional subject matter in two dimensional space; or in his essay on music he inquires into technical differences between simple folk and sophisticated art music (Simmel 1882; 1906; 1922). The general concern of these and the other sociologists who have attempted to limit the concept of art is to discover the essential similarities in the social networks surrounding art objects and to distinguish them from those attached

to other vehicles of human communication. Discussions concerning these special criteria, however, may also readily be found in the written work of aestheticians and art critics.

In this discussion I will attempt first to define some common denominator of artistic communication. The arts have certain qualities which transcend the qualities of general nonartistic forms of communication. In the words of Baensch (1961:10–36), for example, art is an intellectual activity whereby certain perceptions of the world are transformed into "objectively valid cognition." Somehow works of art appear to give eternal form to emotional dimensions or feelings. He argues that the value of a work of art "lies solely in the power with which it forms and fixes a certain emotional content and makes it universally accessible." If we grant this statement to be representative of others, the special characteristics of art communication transcend the here and now and relocate the social structural boundaries of syntactics and semantics into the realm of unbounded *universal* validity. In ordinary and conventional communication these boundaries can always be limited to highly specific (*i.e., not* universal) social contexts of delimited social milieux, if communication is socially significant or valid.

In ordinary communication there exists a relatively high degree of what Colin Cherry (1961) calls pragmatic impact of communication symbols. Expressed somewhat differently, this means that the lexicon, syntax, and semantics (and their associated rules) are known and acted upon in similar fashion both by creators and receivers. These conventional agreements represent the measure of validity of communication symbols. If artistic communication were to be *universally* valid, the range of the social circle of those who share the same rules for the manipulation of these communication symbols would have to coincide with universal mankind. But this cannot be assumed *a priori*. For one, there is no mammoth socialization machinery by which the universal world could become indoctrinated with the technical lexicon, syntax, and semantics of the arts so as to represent a community sharing these communication criteria. Not even the sophisticated modern intercontinental communication technology via outer space can as yet serve this purpose. Moreover, the history of art is replete with examples of the total absence of meaningful communication between artists and audiences on much less than a universal scale.

On the basis of such sobering considerations, it seems that the special empirical characteristics of art are not their universal validity but rather their universal invalidity, *i.e.,* that relative to other vehicles of

communication (the language of chemical formulae, mathematics, or even ordinary speech), the arts tend to communicate pragmatically very little. Beholders of even the greatest works of art probably react to different aspects of the work, and are probably moved by different aspects every time they encounter them again. On such a basis, it seems to me to be tenable to argue that the special characteristics of artistic communication approximate nonrational forms, while ordinary forms of communication may be called rational—empirical and germane means toward empirical ends. Simmel already had suggested something similar when he argued that the arts express emotions in a diffuse manner (Etzkorn 1964b). Put differently, this might mean that the special characteristics of the arts are such that their technical dimensions express only limited specific communication. One of the special problems of the sociology of arts, then, consists in examining how the social action systems of the art world are built around such meager pragmatic bases. One might ask, for example, the extent to which the coterie around some prominent artist is based on their common capacity to understand artistic communication rather than on other, nonartistic reasons. Or, more generally, one might study the various natures of social conditions for different artistic forms of communications, since they are among themselves distinguished by specialized artistic syntax and semantics.

While in ordinary forms of communication sender and recipient employ the same code for sending and reading or responding to the communication vehicle, vehicles of artistic expression tend to be particularly ill-suited for establishing pragmatic connections between senders and recipients. Objective and subjective interpretations tend to differ in important respects and communication tends to convey little pragmatic information (Cherry 1961). The response to a carving, for example, may produce pleasure in the beholder irrespective of the fact that the creator may not have wished to convey anything pleasurable. Or, a beholder may enjoy a painting although he may not be acquainted with techniques of art analysis applicable to the period, school, or style of the painting, and thus miss completely the idea contained in the creator's expressive form. Hence, the pragmatic consequences of a carving or other art artifact may vary with each viewer (although on some level of response there may be some similarity of reaction concerning selected aspects among certain or all viewers). The pragmatic communicative impact, thus, would depend on the social experience of the viewers and on their mastery of the semantics and syntax of the art style, *i.e.*, familiarity with appropriate systems of iconography and iconology.[17]

The Nature of Artistic Communication

Insofar as different levels of communicative precision within social communication systems may be distinguished, I will use the term artistic communication here to mean those communication systems which approximate the conditions suggested for nonpragmatic communication. The main import of this decision would be to place the study of the social aspects of art into a continuum with other aspects of study of social phenomena. As a consequence, perhaps, less effort will be devoted toward solving such essentially insoluble problems as whether primitive art is art or whether music is art. Instead the sociologist might learn more about human behavior and the conditions under which social relationships become stabilized around artifacts which have or attain symbolic meanings to those interacting through or even with them.

Pierce's (1965:266) statement that: "Successful art requires the appreciation of an audience as well as the talent of the artist" isolates the three essential ingredients of human, and thus also of artistic, communication. Manheim (1964) described them as *three basic categories* of communication: the communicator, the conveyed message, and the audience. He goes on to suggest that: "One must assume that an effective communication—one which elicits the intended audience response—establishes a compatible relationship between these three categories. A given audience is receptive to a limited variety of messages and responds only to particular communicators, and, likewise a given speaker is capable or willing to convey only certain types of messages." If these generalized statements are applied to the specific context of art communications, they refer to social controls and incentives over individual communicative expressions and audience responses which can be empirically related to the social structural conditions that ensure success or failure of the communication. In greater detail, analysis of these social conditions of the artistic communication process requires that the conditions be specified which relate to:

1) *Creation Processes of Artistic Communicative Expressions.* Under this heading must be treated questions such as: Under what social conditions can artistic communications be encountered? Put more directly, what are the social conditions that allow one to categorize certain forms of communication as art? And, how are these processes institutionalized? Since such conditions occur in all known social systems, this task should be brought within the range of present scientific methods.

2) *The Peculiar Technical Dimensions Employed in Expressive Media.* Under this heading belong questions such as: What are the social conditions responsible for the preponderance of selected art techniques or stylistic features in given social groups? Are these conditions entirely related to specific socialization (apprenticeship) processes, or perhaps related to certain trade and market mechanisms that result in supply of selected raw materials and create limited demands? Are there particular traditions which are enforced by and linked to other institutional areas such as the kinship system, religious social practices, traditions concerning the division of labor along sex or age-graded categories?

3) *Systematic Variations in Social Response Patterns to Art Artifacts.* Under this rubric belong such questions as: whether the real or purported authorship for art artifacts is relevant to the appreciation of the objects in social systems, whether art objects have status conferral functions for creators and/or owners, whether social positions and role specializations within the relations are identical or different for critics, systematic collectors, foreigners, anthropologists. Questions concerning the instrumental use of objects in manipulating the power structure of groups may also be profitably raised.

In order to obtain empirical evidence toward exploring this general paradigm of human communication, a number of additional suggestions will be presented before we look more closely at the African data in the collection of essays in this volume. These suggestions for the kind of concrete evidence to be looked for cut across the three basic categories.

We need to know in fairly great detail how individuals on all levels of contact with artistic communication vehicles come to define their own relations to them. We need to know, for instance, for the creator or artist as well as for the audiences:

1) The social process of acquisition of the lexicon of artistic expressions adequate for reacting to (or creating) concrete examples of art

2) Information concerning the social control mechanisms that enforce conformity to these standards, *i.e.*, that make the lexicon a usable instrument in the framework of the given social group

3) Representative examples of how particular subgroups develop and specify rules for more restricted employment of communication devices, thus creating exclusion effects within the larger group. Here

we need also to know the impact of these exclusion techniques on the solidarity of the group especially with respect to maintaining the artistic integrity of the groups' art forms
4) The range and limits of experimentation with expressive forms which is tolerated within the group and accepted as indigenous creations.

With information concerning human communication that approaches answers to these generalized questions, we can then map networks of social interaction surrounding works of artistic creation.[18] No doubt variations in the nature of social networks linking different types of creators and consumers of art vary—but it is variation that frequently opens up fruitful lines of inquiry. The variables for the social study of art turn out to be types of social reciprocities (interactions) between creators and beholders *and* point toward the relative significance of artifacts in affecting these very interpersonal relationships.

A Sociological Look at African Art

We have now come to a point where it will be profitable to take a direct look at empirical evidence about art. The readers of these pages as well as the writer are unfortunately removed from the data by geographic distance and methodological predilection, since our comments will draw primarily on the written reports of anthropological field workers collected in this volume.

I would like to preface my discussion of details by commenting on a number of general impressions about African art, which I gained from reading these papers. It appears that African art presents a different order of impact on Western academic observers than does the art of their countries of orientation. Their reports, whether it is an anthropological description of Fang carving, details about Marghi blacksmiths, or Bala musicians (to mention some at random) are not couched in the stilted language of Western academic art criticism and/ or appreciation. The activities of persons involved in art are analyzed, the art product is described, and little time is being wasted with trying to argue that this art is high-, medium-, low- or no-brow, op, pop, or top-less, mass, low- or mid-cult, or camp. Related to this is a second impression. The language of these writers allows the reader to recreate an imagery of what the descriptions are about. When Thompson in his paper contrasts the superior skill of one carver over that of another

by saying, "Labintan had conceived a human nose, for example, with pleasingly moderate measurements while Salawu had not," the reader can sense something about the image of this work.

Moreover, in all reports there are materials which allow us to gain a fairly concise picture of social events surrounding works of art, their creation, their uses, and their audiences. Writers place particular emphasis on the ongoing artistic process, the social position of the creators of art and associated variations in esteem. That there is such an emphasis on the here and now of artistic creation and reception is perhaps related to the relatively primitive state of preservation of material culture objects. With the exception of bronze, what there is in art objects in Africa are products of the relative present. As such they have immediate meanings, and can call forth responses that are understood in relationship with the present and the social history of their creation. Frequently these objects are still viewed in the context of their creators and particular social settings in a tribe, kin group, or village. Hence, when we speak of African art, we generally are dealing with pieces that can be situationally located by social group, function, and probably specific social meaning. On the whole the status of an art object is clearly influenced by the social position of its creators; a good piece of art is made by a good artist—and in this sense there does not seem to be any art independent of the social situation in which it is embedded or from which it emerged.

The meaning and reality of social situations can even be extended into the world of spirits. For example, an Anang carver's success as a carver is linked to his ability to relate himself with ancestor spirits (Messenger). More common, though, are more clearly empirical reports on social experiences. Among the Fang the status of an orator varies with the wider social situation in which he practices his art: he has high status if his activity influences activities of others through the aesthetic meanings that he is able to command (Fernandez). Among the Gola the artist who specializes in producing art objects for foreigners is "not really Gola"; he becomes an outsider. The reason given for treating him as an outsider is that he produces for a non-Gola audience, *i.e.*, he partially excludes himself from the social situation and tradition of his own group (d'Azevedo).

The writers on African art in this volume tend to provide us with fair amounts of information on what might be called the social-role attributes of artists. This is done along with inputing values to the art product. The dual emphasis distinguishes reports on African art from what one tends to encounter in written accounts of Western art life.

Thus Ames gives us a listing of role attributes that describe Hausa musical practitioners. Mature married men are never observed dancing, singing, or playing an instrument, and their female age mates may sing or dance only inside compound walls; younger men, on the other hand, sometimes sing for their own pleasure. It is young unmarried girls and children who can sing and play instruments without shame. Nor is the range of musical expressions restricted for harlots. The general esteem of public music-making appears to be low among the Hausa, since, for instance, nonmusicians do not care to share quarters with musicians and do not allow their daughters to marry them. Hausa employ specific techniques for reaffirming their low evaluation of musicians. Musicians are encouraged to perform and then are rewarded with handsome gifts which are viewed as too valuable in comparison with the value of their musical performance. A similar treatment is found among Bala musicians. Merriam reports that Bala musicians are considered lower than other Bala men, that they are ordered about and that they are not their own masters, that they are considered to be lazy and bad to their wives, and poor handlers of money. "Probably no person or group is in a lower position than the Bala musician," he states. There are relatively few of them, and they are not organized as a group—except for music-making situations which, by definition, require some order and organization. Limited degrees of professional group organization are also reported among Gola artists. They go about their work in such a fashion that it is difficult to maintain a distinction between Gola artists and craftsmen (d'Azevedo). Yet the artist is characterized by a special relationship with his guardian spirit who shapes and influences his personality.

These illustrations from a number of papers on African art reveal that artists and their products may be singled out for sociological analysis. We realize that their attributes are not always distinct, nor do they form a category exclusive to themselves. They are of an order that is subject, just as other forms of conduct, to direct control by members of their respective societies. For instance, they are given low status, are prevented from certain forms of conduct, or are encouraged, or rewarded. Having the role attribute of artist does not, on the whole, depend on some claim to transcendental revelation, power, or function. The ideological overtones characteristically found in descriptions of art activities in the West are notably absent in these papers. This may be attributed primarily to the successful effort of these anthropologists to avoid imposing their own, *i.e.*, Western, notions on the exposition of their materials. It may also reflect on the absence of formally developed

ideologies concerning the function of art, which frequently is identical with the absence of a formal aesthetic, among these peoples. For the sociological approach suggested in our previous discussion, this absence of ideological overtones in the descriptive materials does not represent a handicap. The definition of art tentatively proposed earlier does not require that an ideology or formal aesthetic define for a social group what is art. It will be recalled that the category of social behavior that is called art behavior is defined solely by the quality of interpersonal transactions, *i.e.*, the largely nonrational or nonpragmatic nature of the art communication system.

Native Views on Aesthetics and Art

In looking over the essays on African art with this notion in mind, the reader will notice that there are remarkable differences in the ways *peoples define their art*. Merriam's Bala and d'Azevedo's Gola might be viewed as representing two extremes. The Bala, apparently, have no special aesthetic vocabulary with which to discuss separable art objects. They did discuss them in the same way as they made judgments about other phenomena in their culture. In Merriam's portrayal, what we would call art in Bala culture, even though it is separable as objects produced by people whose behavior is special, is merely *something else* that man does. As a consequence, music to the Bala is a phenomenon of culture which is worked into the general framework of behavior and belief and is accepted as an aspect of ordinary, expected, and predictable event sequences. Music for the Bala is not something extra. Nevertheless, Bala clearly differentiate between what they consider music and nonmusic. Birds do not sing! Music always involves human beings who organize sound which has continuity in time. While Merriam is careful not to impose Western interpretations on these native distinctions between music and nonmusic, his general discussion of Bala culture suggests that there is a variety of interaction patterns that are observed among musical and other artistic *specialists* and their not-so-distinguished fellow tribesmen. However, more intensive comparative analysis of various types of interaction patterns between specialists in symbol manipulation and audiences in Bala culture would be needed in order to be able to decide whether the various forms of communication, *i.e.*, the social use of symbols, does permit a differentiation among more and less precise, rational and nonrational, and for that matter, more or less artistic modes of human expression.

The presence or absence of an art ideology might indeed be a less

significant indicator of the nature and variety of human communications in a population. The ideology of the advertising media in the United States, for instance, which raises television commercials and Army and Navy recruitment posters to the level of advertising art does not detract from the specific, directed, and pragmatic message contained in these media. There is little doubt in my mind that these media, ideologically glorified as artistic, are highly pragmatic and therefore nonartistic means of communication. Only to certain groups of individuals, but certainly not to the American culture at large, do they represent something that approximates art in our definition.

Among the Gola, artists and art constitute a mirror of cultural values which reflect underlying ideas of personal fulfillment or conduct. Although d'Azevedo shows that the Gola have no clearly equivalent term for our term art, they have a *type of person* engaged in activities to which our aesthetic concepts can be applied, if merely as likeness. The Gola term *ne fɔno* connotes something created by either man or a supernatural agent and comes closest to designating the objects and activities Westerners think of as art. Moreover, like some Western aestheticians the Gola are said to feel that through art the human genius struggles for freedom and expression. Hence, while the Gola seem to have an art ideology surrounding certain social activities, comparable activities among the Bala are not distinguished by such an explicit system of terms and values.

Thompson focuses specifically on the aesthetic of the Yoruba. He indicates that there is a direct relationship between the activities of art and artists and emotional ideals. He suggests that African critics measure and express in words the aesthetic quality of works of art. Moreover, he implies that the Yoruba feel that the Westerner as an outsider has an underdeveloped and weak ability for perceiving the aesthetic in Yoruba art. Bascom also indicates that art as art exists among the Yoruba and that it is recognized by them as such. Among the Chokwe, Crowley reports that there is much concern with the technical aspects of producing objects. Knowing how to make an object well includes knowing how to make it beautiful. Moreover, concepts of good and beautiful are not differentiated from one another. Similarily, the Chokwe do not distinguish between what we would call fine and applied arts. Many art objects have practical applications as stands, regalia, stools, or water jars. Yet they give a person personal pleasure and prestige. Chokwe artists inevitably share the psychological characteristics of their culture. Every Chokwe, according to Crowley, considers himself at least a potential artist. Among the Fang,

Fernandez writes that it is impossible to impose order without art. He shows that there is a close association between art and the imposition of order by "expressing" the group, by being susceptible to their thoughts, feelings, and wants. By rendering these things in an order of artistic expression, the artist gains authority. It is the oratorical arts which impose order in social and political life; the ritual—mystical—arts do the same in religious life.

Ames, as does Merriam, also suggests that it is difficult to find direct native equivalents for our Western aesthetic terms. The Hausa distinguish, however, between man-produced and other forms of experience, referring in aesthetic terms most often to man-produced forms. Aesthetic terms are frequently associated with evaluations and observations on the production and manner of weaving clothing. They place high value on splendor and changing styles. Great renown can also be gained for house ornamentations, which are mostly in abstract geometrical design. Again the lack of correspondence between Western and native art ideology did not obliterate the presence of art among the Hausa. For example, they have terms of their own, which they use consistently, for specialized interaction systems which are clustered around art objects.

Vaughan shows that while the Marghi rigidly distinguish between product and performance art, not all forms of performance are aesthetically evaluated. Since clan histories are not judged aesthetically by the Marghi, Vaughan does not consider them as art; nor do the Marghi consider rock paintings or calabash decorations in this category. On the other hand, Vaughan also shows that weapons are worthy of aesthetic appreciation and that in the performing arts of music—and folklore—performers are widely known and appreciated for their talents. He also suggests that there is some specialization of musical instruments. Some of them are used only on certain occasions. This leaves the drum as the principal significant musical instrument in the culture.

The African groups represented in this volume would confirm Bunzel's (1929) observations that art among the Pueblo Indians is something more frequently felt than systematically discussed. On the whole we find little terminological elaboration of aesthetic qualities in the native languages. But all field workers represented in this volume, in spite of this primitive development of aesthetic terminology and unsophisticated ideology, noted specific types of social relations and interpersonal networks surrounding various sets of art activities. This would lead me to infer that such objects generate limited categories of

social and individual responses, meanings, or feelings that are distinct and idiomatic in these cultures. The various art media within their spheres of social validity express ideas, concepts, feelings, hopes, and traditions which are shared by the informed beholder.

That there is role specialization in all human groups can be assumed as an axiom of social science. These essays on African art show that in all these groups, even in those in which there is no developed aesthetic ideology, individuals involved in the production of art communication are singled out as specialists. The Bala, for instance, consider a person a professional musician who is an expert in playing the slit drum. Merriam reports that the Bala's evaluation and classification of musicians depends on what they play and how well. A musician is judged by his peers and by society at large in terms of his relationship to and skills in playing specific instruments. There is a further differentiation in that general classes of musicians can be hierarchically ranked. The *ngomba* is the highest male professional musician. He travels and plays all instruments and almost exclusively plays the slit drum. On the other hand, the lowest group is represented by the *abapula,* who are singers in groups and have no particular distinction. The ranking seems to follow from highly skilled instrumental to purely vocal performance and from individuals with tribal-wide experience to those whose audiences are limited to the local village. Specific sets of criteria, thus, have been identified among the Bala as evaluative performance criteria for the role of musician.

d'Azevedo also reports specific criteria found in his Gola studies. For a person to be a Gola artist, his artistic activity must constitute a role in itself which is recognized as such by the person and others. It cannot be only an aspect of other roles which he plays. Nor will a skilled craftsman or entertainer be considered an artist unless his intent is predominantly focused on gratification of aesthetic interests. The range of artistic specialization, though, is relatively circumscribed and only a small number of individuals carry on art activities in a full-time capacity. The major vocational specializations which are considered artistic are carvers, singers, dancers, musicians, acrobats, magicians, storytellers, orators, house decorators, carpenters, and, in former times, basket weavers and pottery makers. On a lesser degree of perfection, most Gola learn to sing, dance, tell stories, and exhibit some specialized skill. The smallest village can produce enough varied skills to maintain the necessary activities of a lively unit of Gola society. Yet, the exceptional skill and the excitement of prestige that comes with getting the services of a famous specialist is much more difficult to obtain. Crafts-

men responsible for beautiful designs and ornaments are usually anonymous. Most of the praise goes to the person whose wealth and taste was responsible for the finished product, not to the source of the workmanship of the craftsman.

In a similar sense, Crowley reports that the Chokwe are a nation of artists in which each person feels himself capable of producing fine works of art and qualified to comment on the work of others. The Hausa, on the other hand, consider a person an artist if he is especially inventive, as a clever improviser who is unusually effective in stimulating intellectual interest and/or an emotional response in his audiences. Ames reports that high value is placed on originality and that the Hausa distinguish between the out-of-the-ordinary craftsman and the average producer of articles. Hausa notice deviations from prescribed manners of performance. Those who stay within the tradition in their performances have the highest status of all types of Hausa musicians. Social status of performers and creators is here related to some extent to evaluations of their role performance and to specific, technical aspects of the works of art with which they interact. How individuals use the reservoir of symbols in the culture becomes a means for ranking artistic specialists and also for distinguishing the run-of-the-mill producer from the full-time or accomplished role specialist.

In this review we have seen not only how art is defined and how native artists are evaluated by certain African peoples, but also that in each single population it was possible to isolate evidence about interaction networks surrounding works of art, their creation and appreciation. These interaction networks display in some instances special sets of evaluative aesthetic terminology, while in others the anthropologists' report little evidence of an articulated aesthetic. While further field work might unearth such vocabularies, we can infer from the already collected data about occupational specialization that within the various cultures studied here there is agreement concerning the identification of these activities and the assignment of rank and values within the total range of cultural expression, *i.e.*, that spheres of social validity of art can be demonstrated. There is, in fact, a danger in drawing conclusions from the absence of a developed aesthetic terminology among certain informants and peoples. A recent interview study of prominent American avant garde painters showed that these artists employed terms of ordinary work experience in describing the process of their very artistic creations (Rosenberg and Fliegel 1965). From this evidence—if we follow the examples of some anthropological field workers—we must infer that these impressionist American artists cannot be artists since they do not use a special language in describing

their role performance. If, on the other hand, one were to refer to contemporary aesthetic literature on the work of these very artists, ample art ideology would be displayed, and the conclusion would be quite different. This same example also cautions us from inferring too much about actual artistic practice from evidence about articulated art ideologies. In this context I am somewhat puzzled about the practice of obtaining data about aesthetic matters only after the payment of informers' fees (*cf.* Thompson), and the informants' preferring to reveal such information about the art of others rather than their own creations. As in the case of the American contemporary painter, the aesthetic discourse of the professional critic may have little bearing on the artist's expression and on his criticism of his own work. Instead, the discourse of aestheticians can be shown to be addressed to other aestheticians, just as the literary critic tends to write for and be read most avidly by the fellow critic, bypassing the bulk of literary expression.

With this cautionary note we can now pass on to an examination of the evidence in these papers on the social process by which artists and their audiences acquire the lexicon of artistic expression, the social control mechanisms which enforce conformity to traditional standards, and various sources of change and tolerated experimentation.

Artistic Socialization of Artists and Audiences

As is the case in more complex Western societies, participation in the cultural activities of African tribes is not a random phenomenon. The newborn member acquires specific outlooks, attitudes and behavior in response to socialization experiences that are peculiar to his own growth and development. Naturally, the more homogeneous a group tends to be, the less diverse will be the experiences and the less likely there will be a wide range of different behaviors. Among many of the African tribes surveyed in these pages, it appears that the degree of homogeneity in the reception and appreciation of art is so high that some writers (*e.g.,* Crowley) suggest that among their people every single tribesman could be an artist. The central role of Fang tribal art in giving symbolic representation of basic rudiments of social order has been illustrated in Fernandez's work. But while most of the papers presented in this volume describe the artistic socialization process of artists, the writers do not treat in any detailed manner the more generalized processes by which members of society at large are introduced to art or acquire the receptive skills necessary for its appreciation.

Many of the societies investigated here commonly believe that

talent is inherited (for instance, the Bala), but the majority of them also take specific pains to provide an individual with technical facility for giving proper expression of his talent. Thus it is acknowledged that talent without technical skill, and skill without continued practice do not result in outstanding artistic competence. In the Bala apprenticeship system children with musical ability are trained, and as in some of the other societies, payment for this training by an expert is rendered in the form of farm products. While the Bala do not seem to treat it as a secret that artistic skills have to be acquired from a recognized teacher, the Gola require of their apprentices that they swear on pain of injury or death to members of the apprentice's family that he may not reveal the techniques, the teacher, or the place of instruction concerning certain objects to anyone (d'Azevedo). More recently, it appears government and missionary schools have been used as a kind of general apprenticeship situation where certain children are sent, so to speak, as an investment in their future support value to the family. This would be in keeping with a Gola notion that formal education, a wealthy foreign patron, and a period of training abroad are the ultimate of means to social ends.

The Chokwe select carving teachers on the basis of convenience and family connections. Most apprenticeship relationships are casual and unpaid. When there is payment, it is in the form of goats and sheep. Apprentices must do all the hard work and must take over the hated agricultural labor required of every Chokwe for his subsistence, and Crowley suggests that it is because of this agricultural help that farmers are stimulated to accept apprentices. He observes that there is a noticeable similarity of technical skills between the old master and the younger apprentice. Moreover, because of constant inspection and public criticism the level of skill of all peers in the learning situation appears to be consistent. Yet, in spite of the Chokwe system of art education, most artists learned their skills by watching others.

Hausa music instruction begins around the age of seven or ten according to Ames. Children practice in their homes for several years before they play in public. They are taught by patrilineal family members. On the whole the status of musician is patrilineally inherited and ascribed at birth. However, there is an alternative road to becoming a musician. It is possible to become an apprentice to a nonkin. When such an individual has acquired sufficient musical skill he is then permitted to perform in his master's orchestra. Messenger reports a similar arrangement among the Anang. While the art of carving is generally passed from father to son, a youth who is not the son of a carver may attach himself as an apprentice to an artisan and learn the craft. Not

all carvers accept such outside apprentices. Some, however, have as many as six. The Anang apprentice must follow his tutor wherever he goes. He is not paid for pieces that he carves, even when the tutor can sell them without additional retouching. Becoming an Anang carver is a costly endeavor, since the expenses of the apprenticeship itself are high and additional gifts are rendered to the master at the end of the youth's apprenticeship. Among contemporary Yoruba Bascom points out that modern education interferes with the development of artistic and craft skills. Nowadays, children are frequently sent away to boarding schools. The traditional apprenticeship process required that a boy be apprenticed to a master craftsman for a specified period and fee. During this time the apprentice served as a master's assistant, ran errands, performed odd jobs. He started with simple objects and worked under the master until he had mastered his craft. Among the Marghi Vaughan reports many specialties of əŋgkyagu. These must be performed on a notable level of technological competence. This knowledge and skill is obtained through years of observation and apprenticeship. Thompson also reports the apprenticeship practice. As in the case of the Gola, however, the technical matters are often guarded as trade secrets.

These extracts are representative of the lack of detail concerning the process of transmission of technical skill, and more generally lack information on the inculcation of the lexicon of artistic expression. We would infer, though, that there is relatively little variation in style, mode of expression, and technical workmanship between masters and apprentices so that the homogeneity of artistic expression representing the stylistic unity of a tribal area is maintained within the length of at least a generation. Solidarity between master, apprentice, and the apprentice's parents seems to be expected in all the areas surveyed. Likewise, expectations of the society do not appear to be violated by the art practices encountered among them. It would thus appear feasible to argue that the folk system of viewing the teaching and apprentice process in tribal society corroborate the analytic principles developed in my earlier sections on the Sociology of Art and on Artistic Communication. Similar conclusions can be reached after reading the excerpts that assure artistic continuity in the subsequent section on social control processes in tribal society.

On Social Control Processes of African Art

In this section we will consider the evidence in the various reports that refers to practices in African society that assure artistic and stylistic

continuity of art expression. One such mechanism, of course, the highly
structured apprentice situation, has already been described. We also
noted here that apprentices are working in public and are subject to
the evaluation and appraisal of their work not only by their masters
but also by bystanders and the wider public. This situation can be
generalized beyond the apprentice situation to the work roles of the
master craftsman himself.

Although d'Azevedo suggests that among the Gola the legitimation
of the status of artist arises from an inner individual justification which
is based upon an intense devotion to personal convictions, he also
observes that the threat of group sanction is imminent in both appreci-
ation and production of art. Positive and negative sanctions of artistic
production come perhaps most easily to the attention of Western
observers on the occasions of public festivals. Both d'Azevedo and
Thompson mention that artists are highly visible and important par-
ticipants in such proceedings. Under festival conditions, Gola aesthetic
values are given fullest expression through the deportment and adorn-
ment, the demonstration of skill, and public appreciation. Among the
Yoruba Thompson indicates that festivals also provide a setting for
criticism. Elders critically observe the behavior and dance movements
of young men who aspire to be granted the honor of carrying the senior
headdress of the local *Epa* cult. In addition to involvement in festivals,
Ames shows that Hausa musical production is nearly always a social
act. Effectiveness in communication seems to be basic to the Hausa's
own definition of what constitutes an outstanding musician.

The extent to which an artist becomes a respected member of his
group would appear as a direct function of his ability to please
audiences as well as his peers through his artistic expression. Mes-
senger's observation concerning the social control process that assures
the purity of Anang art should be recalled at this point. He suggested
that it is a rare apprentice who fails to develop the necessary skills of
carving. On the other hand, the apprentice who does not master the·
craft is not advised to abandon his training by his master. He is driven
away by the ridicule of the audience who always watches the artisans.
In this manner, the artist is truly performing a public role which is
subject to public scrutiny and continuous social control. He must con-
form to the expectations of the bystanders or he will experience nega-
tive sanctions. Unfortunately, though, we do not have adequate detail
in these reports about the nature of these public expectations. There
is no doubt that a certain degree of latitude of expression is being
granted and, perhaps, even expected. Where the boundary lies between

liberty of expression and license, however, has not been documented at this time.

While the evidence on social control of art is relatively undeveloped in the papers in this volume, there is enough support here that it does in fact exist to recommend that future writing and research on the arts in society pay more specific attention to this topic. There is a considerable body of literature in social psychology dealing with topics of reference groups that may be a useful guide in developing methodological tools to conceptualize these problems for the anthropological researcher. The basic question to be investigated is to what extent individuals are influenced in the definition of artistic roles by activities of others in significant social situations. Thus, it will be necessary to obtain data on interaction patterns between artists and audiences. The collection of data on highly successful as well as rejected artists and art should be included in study designs and reports of research.

On Sources of Change and Innovation

Much theoretical discussion has been devoted to the subject of social change throughout the literature of the social sciences. Illusive as the subject is for empirical analysis, anthropologists for many years had been the major contributors of specific data. It is a missed opportunity that these reports on art in African societies are not richer on this particular subject. It appears as if the majority suffer from a particular historical bias. Data are presented primarily about the here and now of life in these tribes. It might well be that the techniques of field work make it impossible to elicit information about previous customs, practices, and roles of function of art objects in these cultures. If this is so, perhaps one should alert the reader to these problems so that future field work can be improved.

The analysis of the role of arts in society could be among the more reliable ways of studying changes in social structure, in value systems, and of other indices of social stability. If one takes an art object produced in a given culture, analyzes its function in different time periods and situations, and analyzes the social-structural implication, *i.e.*, the networks of social validity of the work of art, much can be learned about historical developments surrounding art. This approach seems to have been neglected here in that the majority of them only suggest that their societies have been undergoing many structural changes without relating these changes directly to evidence on the roles of art and artists. All of these groups have only recently come in contact with

European-Western culture. The evidence also suggests that extended trade is a major activity of most of the tribes. As a consequence, information on changing trade patterns, possible changes in contact situations, possible changes in supply of different types of raw material, and similar data would be of potential significance in an analysis of the changing role of arts.

That such sources of change are present in these areas can be gleaned from some of the reports. d'Azevedo writes that the Gola live in an area of linguistic and ethnic diversity and recently expanded toward coastal areas. The recent contact with Europeans has reinforced their own highly utilitarian and prestige oriented values. Thus, one source of change in traditional Gola art is increased spatial mobility. Gola craftsmen and artists are directly affected since before the outward move demand for their products fluctuated with the wealth of ruling tribal families and sectional fortunes. Crowley writes that contact with European forms seems to have influenced the carving style of an outstanding Chokwe. Thompson indicates that the Yoruba style of life and urban orientation predated European penetration. The data on culture contact and outside influence on native styles is, however, primarily suggestive.

Other variations and challenges to traditional modes of expression have been indicated in the essays of some of the contributors. Ames, for instance, shows that Hausa musicians imitate and borrow freely from musical materials without asking permission for doing so. He suggests, however, that they are neither creative nor inventive and are said not to be ashamed of these traits. Both Crowley and Vaughan suggest that their peoples also have little concern with originality. Among the Chokwe each type of object has certain characteristics which it *must* have and others which it *may* have. Only within these limits is the artist free to experiment. Since, however, many objects are made only for the use of the family, there is little supervision which enforces conformity. The Marghi view innovations as utilitarian curiosities, but not necessarily as works of art according to Vaughan. The Anang, as we have seen, rigidly circumscribe most forms of artistic expression. Messenger observed that some innovation and experimentation is permissible and expressed most easily in the making of the "ugly" masks which represent the ghosts. Young men especially will commission ghost masks from those artisans who experiment, innovate, and stress original forms.

A significant observation is reported by Messenger, who shows that innovation is not highly valued by laymen, but is so by the professional

carvers. This, no doubt, might represent a major force in innovating change of artistic expression. It would have important parallels in Western art history. Another potential source of change is also discussed in Messenger's data. This is the development of the guild structure among the Anang who have adopted the assembly-line principle for the manufacture of carvings. Each carver in the guild specializes in making a certain part. Rewards are fixed by seniority and based on performance principles. The impact of these developments on the status of art in tribal society demands further study.

Some Comparative Reflections

To anybody who is familiar with ethnographic data on Africa, none of these excerpted materials will sound very startling. However, they are notable for the refreshing contrast to the more philosophical manner of discussing Western art they present. These reports are cast in a down-to-earth idiom and reflect something about the quality of African art life, the liveliness of the interaction patterns among creators, critics, apprentices, and appreciators. The sphere of validity of native art seems to be reflected in the involvement of the tribal members in their art. It appears that any given tribal area, if treated as an entity by itself, reflects a wholeness, an impression of solidarity of experience and value that Western observers of their own society hardly ever report. Art in given tribal societies has realistic correlates to the people involved. In fact, one might even assume that tribal members share the meaning of art communication, that they agree on the degrees to which a given art object communicates specific information and is at once aesthetically opaque, *i.e.*, the degree to which objects are artistic and not merely pragmatic communication vehicles of their culture. In part, we suggested this is so because art is intertwined with other activities. In contrast, in Western society art can frequently be totally left out and yet the meaning of social existence would continue as if unaltered. In African society, art, religion, kinship relations, in fact the total circle of social events of tribal societies, are so deeply interconnected that one can hardly imagine any single one left out. I suppose it is because of this deep involvement and integration of artistic affairs in everyday life that some observers of African art can say that everybody is potentially an artist. Indeed, given the level of artistic elaboration, such statements might be quite accurate. No one, however, would dare to make this or a comparable assertion for an entire Western society.

In Western societies, similar observations have been made only in

the context of subcultures. Thus, for instance, Kaplan (1955) in describing folksinging in a mass society refers to data on folksingers in the San Francisco Bay Area. She shows that within this delimited style of artistic expression and restricted social category, folksinging, as an artistic activity, takes on a fairly central role in the daily lives of these people. Among certain jazz musicians, similar observations have been made (Becker 1963). Although in these cases we are dealing with particular subgroups within a complex society, study of parallels between the involvement in aesthetic activities encountered in a homogeneous tribal group and relatively homogeneous groups within a complex Western mass society can provide valuable insights for sociologists.

The person-to-person relationship in an artistic subculture (think, for instance, of Bohemian art in the West, i.e., Kaplan's folksingers) is in many ways analogous to primary relations within the apprentice situation of African peoples. Youngsters are apprenticed to some master craftsman; they work along with him until they reach a certain level of skill, then they may execute orders that were initially given to the master craftsman and yet get no credit for their own performance. Finally after an extended period of involvement with a master craftsman, they may be permitted to experiment on their own. Thus, there is a long period of personal involvement with some expert. In this socialization process they acquire traditional modes of expression and learn artistic technical skills as well as social skills appropriate to the execution of the role of artist. In these roles, as apprentice and later as accomplished artist, numerous contacts with tribal members and/or traditional audiences (customers of traditionally-related populations) take place. In other words, the artist has acquired the tribal vocabulary of artistic expression, a specific lexicon and syntax, and he has acquired proper aesthetic judgments for combining these artistic elements so that the semantics of his art are communicable to his potential audiences. Since he knows something about his audiences (he has learned that, too, in the process of his apprenticeship), he is likely to be relatively successful in acting out his role. Consistent role models have surrounded him during his socialization as a member of the tribal group and as apprentice specialist and in his role of artist. The audience helps him delimit his own role definition, both in the narrow sense of artistic specialist and as interacting member of the group. There does not seem a chance for the alienation of the artist in African society, unless the tribal order is disturbed to a considerable extent. Only once

the support networks of social exchange (psychological as well as economic) become weakened (as is apparently happening in the case of the Gola), personal problems of identity—similar to those in the more complex West—may then also afflict African artists.

In Western societies, the very heterogeneity of reference models during socialization and of potential audiences imposes considerable burdens on artists (Ettman 1966). To some extent it may even be difficult to acquire certain skills for artistic creation since fashions and fads frequently dominate the critical scene. The generalized social status of the Western artist is also affected by the heterogeneity of values about art. Artists, thereby, tend to share the experience of most occupations in that practitioners become characterized by status profiles; *i.e.*, their status varies with different groups within the social structure. For instance, a folksinger may have fairly high status within his reference community of folk-addicts, yet he may have considerably less status for his art among addicts of the Princeton-Columbia project in electronic music. And analogous to African tribal society, a Western artist may have local but not cosmopolitan fame.

Since the economic consequence of favorable critical appraisal may be considerably more serious for sheer survival of an artist, and since moreover the artistic lexicon and syntax of expression are most likely more complex—due to the convergence of different artistic traditions and technical means of presentation—the success of the Western artist depends on gaining access and holding a supportive audience. He may be acting more self-consciously toward meeting these strictures of his role than the artist in a less-complex social setting with a more predictable and uniform audience.

Concluding Remarks

Although I have been highly selective in my illustrations from the data on African art and the history of the sociological concern with art, they are sufficient to suggest the direction of current interest in a sociological look at art.[19] In contrasting the data on African art with Western writing, a particular social reality for native African art seems to emerge. Only under selected, atypical circumstances does one encounter similar observations about art in the West.

Further comparative analysis seems to be called for. This will follow some of the lines of inquiry already commenced in the work of the contributors to this volume. For one, African as well as Western data

show that the sphere of—what I have called here—*social validity* of art is circumscribed by definable networks of social interaction. These are the networks within which works of art call forth approximately similar meanings and responses. In the West these networks are more difficult to chart than in the African data at hand since in Africa they tend to coincide with the boundaries of a tribe or even a cult group within a tribal area.

Second, African criteria (social, aesthetic, technical, etc.) by which cultural objects are accorded the special status of art communication may also be applied to the study of Western art. Thompson's data show that there are definite technological characteristics of workmanship, among other qualities, that allow Yoruba to differentiate good from bad Yoruba art. Pursuing these lines of inquiry might clear up the confusion frequently encountered in the West over whether mass produced works of art cease to be art once they have been distributed to the masses through mass media. Perhaps it can be shown empirically, to what extent an art object is art, that it is art only insofar as it is treated in a certain fashion (calls forth personal or emotional responses) in a social circle in which it connotes diffuse meaning. Perhaps, one may be able to clarify the conditions under which the art of one group becomes a museum piece for another, or what makes an object produced for the art market, no doubt precious, expensive, status-conferring, etc., but not a valid communicator of art. No doubt, new spheres of social validity, of new meanings (the pecuniary equivalent attached to art is possibly such a meaning), may be established for transplanted art objects; such a meaning will be different in essential and existential dimensions from the sphere of social validity I have outlined. The student beholder of medieval masterpieces in the gallery of the University of Nevada art department may react to them as expensive, precious, and aesthetically satisfying museum objects—but not as meaningful art of South German Monks. He does not have the iconographic nor iconological facility to approximate the original meanings in these works, he does not know the lexicon of this particular art nor its social and cultural correlates.

Third, while it may cause a certain amount of consternation to conceptualize art in social-interaction terms rather than as a museum experience, the social study of art should be able to evaluate the here proposed tentative analytic definition of art through further comparative study in different cultures. The sociologist must develop such an approach in his treatment of art as one of the many nexi of social

interaction. This focus is infinitely more adequate to analyze human creative expression, especially since in this view art can be treated as a terminal product, an end of human activity, rather than a means.

NOTES

NOTE The generous support of the Behavioral Science Research Committee of the Desert Research Institute, University of Nevada, in providing funds towards research into the history of the sociology of art is gratefully acknowledged. Appreciation also extends to Miss Mary White for her intelligent preparation and pre-coding of excerpts from the papers read at the Lake Tahoe Conference on the Traditional Artist in African Society.

1. Bücher (1909) summarizes ethnographic evidence on art activities of numerous native peoples in his discussion of patterns of primitive work. Most of Chapter I is devoted to demonstrating that even the most elementary and practical tools give evidence of artistic elaboration. Joyce O. Hertzler (1961:505) summarizes more recent anthropological evidence and concludes: "... art has been universal in man's social life, as common as his economic and religious interest and activity."

2. According to Mills (1943), "Teaching is a task which requires a type of systematization to which the textbook answers. . . . such systematization occurs in a context of presentation and of justification rather than within a context of discovery."

3. Enzer (1965:415) cites from a content analysis of 83 texts published prior to 1951 by A. H. Hobbs which produced no references to art. He continues, "where the topic was treated in more than cursory references, the authors regarded artistic phenomena as either too trivial for the social order or too ambiguous."

4. This terminology is suggested by Alvin Boskoff's (1957) essay. This essay shows that with the emergence of sociology as a *discipline*, for the first time in human history a distinct possibility was provided of obtaining verifiable, comparative knowledge of an organized nature concerning both universals and particulars of human behavior.

5. See for example the various editions of M. Guyau (1920 [1887]). All my references will be to the eleventh edition, published in 1920. For Pitirim Sorokin's (1937–1941) work, the reader should consult the original or reprint editions. For ready reference, Sorokin's own abridged (1957) one volume edition may be useful.

6. For an extended discussion of methodological problems with using the early Max Weber terminology, see Alex Simirenko (1965).

7. Georg Simmel's principal contributions to sociology have been made available in English translation by Kurt H. Wolff (1950). Major appraisals of Simmel's contributions to sociology in English are those of: Theodore Abel (1929), Nicholas J. Spykman (1925), Kurt H. Wolff, ed. (1965), and Lewis A. Coser, (1965). Among Simmel's more important contributions to the sociology of art are the three listed in the references (1882; 1906; 1922).

8. Kurt H. Wolff's own research and writing may serve as an illustration. See

for instance his 1965 article, as well as many of his other studies cited in this article. Erving Goffman's *Encounters* (1961) reveals surprising parallels of argument to Simmel's essay on the "Dramatic Actor and Reality," although no credit is given.

9. Alfred Vierkandt (1926) presents a highly concentrated version of his views on the social study of art. Richard Thurnwald's approach is best studied in his 1929 contribution.

10. The main portions of Max Weber's sociological writing have been ably summarized in Reinhold Bendix (1960), which includes complete bibliographies of his writing available in English. Weber's single study in the sociology of art was never completed. The extant fragment is available in English translation (Weber 1958).

11. On Dilthey see T. A. Hodges (1944). Of his own work the most directly relevant is his 1933 publication.

12. *Verhandlungen des 7. Deutschen Soziologentages*, 1930, Tübingen: J. C. B. Mohr, 1931.

13. Marta Mierendorff in her appraisal (1957) mentions several students of Leopold von Wiese whose doctoral dissertations explore implications of this teacher's ideas. Since then major empirical research has been carried on in the sociology of art and the analysis of mass communication at the Soziologische Institut of the University of Cologne under the direction of Alphons Silbermann, himself a prolific contributor to the sociology of art. Alphons Silbermann's *The Sociology of Music* (1963) is available in translation.

14. Morroe Berger recently edited and translated *Madame de Stael: On Politics, Literature and National Character* (1964). Berger characterizes and summarizes her significance in his introduction: "Her contribution to our understanding of literature was not merely to point out that it is an 'expression' of society; so is everything else that human beings do. Madame de Stael's merit lies in her having specified certain relations between art and social life" (p. 72).

15. There is no dearth of studies by psychologists as can be seen from a glance at the bibliography in Carl E. Seashore (1938).

16. Some indication of the intensity of this debate can be gleaned from John H. Mueller's (1954) article which is an attempt to defend the sociological study of the arts. In the European literature the same theme can be observed of sociologists justifying studies by pointing out that there is no desire toward interference with the humanists' work, but that sociologists can contribute knowledge which the humanist with his techniques does not discover. On this problem see Kurt Lenk (1961), especially his critique of Arnold Hauser, *Philosophie der Kunstgeschichte*, p. 420 *passim*, as social history but not sociology.

17. The use of these concepts is exemplified in Erwin Panofsky (1955).

18. A modest test of this conception is Etzkorn (1966).

19. In recent years a number of doctoral dissertations have been completed at several universities which take as their focus the intensive analysis of specific creative or performing artistic specialists. Several of these are summarized in chapters of Robert N. Wilson (1964).

George Mills

ART AND THE ANTHROPOLOGICAL LENS

Since the model of man is never finished, he harbors his opposite.

RENÉ CHAR

ART is a primary means by which individual and social values are expressed. d'Azevedo (1958) has pointed out that this fact is oddly incompatible with the anthropologist's neglect of art. Crowley in this volume says that art critics and art historians have neglected anthropology. This mutual neglect between art and anthropology points to disparities between the artist's and anthropologist's approaches to experience. For the scientist, there are three kinds of propositions: tautological, testable, and detestable. For him, most of art falls into the category of the detestable. One of the reasons for the anthropologist's neglect of art may be a kind of dumb awareness that art threatens to raise problems that he cannot handle within the framework of science. This neglect of art is unwarranted, not because the anthropologist's fears are groundless, but because the cultural anthropologist already finds himself in such difficulties that a concern for art will not appreciably deepen his perplexities. My purpose in this paper is twofold. First, by comparing how the cultural anthropologist works with how art is enjoyed, I want to bring out some of the difficulties and perplexities into which a scientific study of culture plunges us. Second, I want to apply the results of this effort to the anthropological study of art, with specific reference to the papers on African art in this volume.

Experiencing a Work of Art

Sometimes in reading a poem I am caught up in the poetic presentation; I am one with it; I am simply aware. At other times, something happens in the course of the experience to make me aware that I am being aware in a special way. The smooth flow of the experience is interrupted. Sometimes the interruption is due to my admiration for a

379

bit of technical dexterity or felicitous phrasing. Saying Yes! to some part of the poem is different from saying Yes! to the poem as a whole. Grasping the poem as even-textured seems to make of it a world in its own right, a world from which the poet has stepped so I may enter in. When the smooth flow of the experience is interrupted, I am more aware of it as a virtual world, creation of human beings with uneven skills. For the reader as recreator bears as much responsibility for the success of the poem as does the writer as creator. For whatever reason, on some occasions the experience does break down and one has to step outside of it to fix it.

What is it that I step outside of? The smooth flow of the experience of the poem. Is this the same as stepping outside of the poem? If by "poem" one means "appreciation of the poem," the answer has to be: no. When I sense the disparity of parts of a poem, if the poem lets me go, then I might step outside of it. Instead, the poem may force me to pay attention, to appreciate it more deeply, to apprehend it more truly.

The conclusion is this: Whatever differences I may find between the smooth flow of the poem and the tinkering interruptions of that smooth flow, they are both phases of a process of deepening apprehension. The interruption of the smooth flow becomes a means for re-establishing it, for I now read the poem with these considerations taken up into it. We must be careful about rigidly distinguishing the smooth flow and the tinkering as different modes of awareness. So far as they contribute to our understanding of the poem's virtual world, they are inextricable, one from the other.

Yet they are different. How exactly do they differ? I am tempted to say that the tinkering is concerned with parts of the poem whereas the smooth flow has to do with its wholeness. This statement is vague. What, for example, do I mean by wholeness?

Talking about works of art does seem to be a matter of talking about parts or their relations—this image or passage or phrase or patch of color as against that one. We have words for more general categories: romantic, grandiloquent, imagist, happy, colorful, childlike. These words do qualify the whole. Nevertheless, even these terms do not wrap up the whole and hand it over in substitute form. When we talk about qualities of the whole, we are only talking about aspects of the whole, and the whole eludes its aspects as readily as it eludes its parts. No matter how extensive the enumeration of parts and aspects of the whole may be, it never encompasses the whole. The process is self-defeating. The more parts and aspects we recognize, the more numerous become the possible interrelations among them; the more these inter-

relations are recognized, the more difficult becomes the problem of synthesizing them. The more we succeed, the more we fail.

I cannot establish the wholeness of works of art by showing that discourse cannot encompass it. What if wholeness is a verbalistic fantasy? What reasons are there for believing in the reality of the wholeness? The answer lies in considering the space and time of art. Every *spatial* art takes place in a restricted space, every *time* art in a restricted time. Now it begins, now it ends; here it is, here it is not. There are always boundaries separating what is to be included in the work of art from what is not to be included. This marked-off area is the realm of art.

The realm of art may be actual or virtual. A painting of mountains which takes up nine square feet may represent nine square miles of landscape. A novel which takes weeks to read may represent one day. One of the artist's resources lies in the interplay between actual and virtual realms. A novelist may introduce unprepared-for events to make you feel that he is talking about the actual world. A collage may mix painted realities with bits of actual reality. Titles of works of art may intermediate between these two realms. For any work of art, the artist makes clear where the boundaries of its realms, actual and virtual, lie, thus notifying you that those particulars contained within the realms are to be considered in their relations with one another. This carries with it no presupposition as to how these particulars will be related. The relations need not be harmonious. Anti-art like that of Dada may create hodgepodges, but even a hodgepodge is possible only if artist and appreciator accept the basic principle of boundaries and look for the meaning of what is included within the boundaries.

Wholeness has another aspect: the funding of different experiences of the same work of art. This is especially true of complex works. One must go back to them over and over again to discover all that is there. The principle still holds that "all that is there" is included within the boundaries established by the artist as part of the process of creation.

Wholeness, then, is all that is included within the boundaries of the work of art? This is ambiguous. What is the work of art? Is it the object or performance? Is it the subjective experience of the creator or re-creator? These questions have no easy answer. The work of art is clearly not the physical object. When several impressions of a print are made, the several different objects constitute one work of art. It is also inadequate to limit the work of art to subjective experience if only because subjective experiences may differ, may cancel one another out, may require correction. We might think of the work of art as all pos-

sible versions which are relevant to all that is contained within the boundaries established by the creator. However, it is not necessary to identify the work of art with precision before accepting the fact that it has boundaries. It is difficult to deny that the actual realm of the work of art has actual boundaries. The boundaries of the virtual realm may be harder to specify because these depend to a greater degree upon one's interpretation of the work's meaning. If the reality of the actual boundaries can be accepted, then the reality of the actual wholeness may also be accepted. The wholeness is not only the particulars, but also the way they hang together or, in their togetherness, fall apart.

If the parts are known verbally, conceptually, discursively, abstractly, how is the wholeness known? In answering this, we walk a knife edge. W. M. Ivins (1948) holds that the work of art is indivisible, single. It cannot be broken down into a bundle of abstractly labeled parts. It has only the one peculiar concrete quality or characteristic of being itself as a whole. He calls this characteristic *ipseity*, itselfness. All one can say about a work of art is that it is what it is. This makes the work of art, in Ivins' words, either a member of a class of entities that have nothing in common or the sole member of a unique class which can only be defined by reference to its sole member. One is apt to conclude that, since discourse is always about categorizable entities, there can be no discourse about uncategorizable works of art. The next step is to say that the grasping of wholes depends upon some process of understanding which is as unique as the works of art which they grasp; each unique work of art requires a unique epistemology. With that, one has fallen off the knife edge. Rather, we understand works of art the way we understand any complex whole. It may be difficult to say how this is done, but the difficulties of talking about the process do not detract from the reality of our experiencing complex wholes. A strict view of empiricism will soon exhaust the possibilities of language and pass beyond them, but it may still be moving in directions which language has pointed out. Kaplan (1959:49–50) writes:

Critical judgment in the arts . . . is based on experience, both direct and indirect; not experience of sensory surfaces only, but reaching below them to both meaning and value; and not a summation of distinguishable bits of perception verbalized in a set of protocols, but an unanalyzed configuration of largely inarticulate awareness. Can we be confident a priori that no critic ever knows what he is talking about?

Another aspect of awareness is relevant to this discussion. Su Tungp'o (Lin 1942:1067) has a parable about a blind man who has never seen the sun. Someone tells him the sun is like a brass tray. The

blind man strikes a brass tray and hears its sound. Later when he hears the sound of a bell, he thinks it is the sun. This parable is relevant to my earlier comments about the reading of a poem. First, the success of a poem presupposes experience outside of the realm of art (this is another indication of the reality of the boundaries). If one has not experienced the actuality, the imagery of the poem may have no meaning or may be interpreted far from the intended mark.

It may be useless to talk about a poem to someone who has not read it. Much of the absurdity of today's art talk is due to the fact that it is directed at people who have never experienced the works of art referred to.

Suppose a man blind from birth wants to know what it is like to see blue. You can give him all the latest scientific information about blue without results. You can translate the experience of seeing blue into some dimension of experience of which he is capable. You can play him blue music or read him blue poetry or feed him blue food. As in the parable, you will be providing him with analogous and therefore misleading experiences. Only the seeing of blue can give the experience of seeing blue. Once blue has been seen, it can be talked about scientifically or referred to in poems.

I have said that appreciation of a poem results from cooperation among three kinds of awareness: direct experience of real winters, real fires, real evenings, real dyings, etc.; a putting-together or funding of the experiences of these images into a whole experience; and conscious analysis of the meaning of parts of the poem in relation to one another. The example of the blind man suggests that however cooperative these different kinds of awareness may be in producing appreciation of a work of art, they are not reducible one to the other. Discourse cannot substitute for immediate experience, including the experience of the wholeness of a work of art. Similarly, immediate experience cannot substitute for discourse. Those who say that analysis is the enemy of appreciation are either talking nonsense or failing to make clear what they mean by analysis. Discourse may clarify and amplify the experience of wholeness; this is the function of good criticism. This is not to deny that there may be analytic approaches to art which do impede rather than facilitate appreciation.

The Experience of Art and Understanding a Culture: An Analogy

Let us examine the possible analogy between a culture and a work of art. The points at which the analogy breaks down are especially revealing of the nature of anthropological awareness and its problems. One

enters into a poem equipped with nonpoetic experiences that make the poem intelligible. This is not comparable to going from one culture into another. Poetry moves into life and life moves into poetry: because they are interdependent systems, one facilitates understanding of the other. Cultures, however, are discontinuous systems organized around different values, different conceptions of the meaning of life and death and the nature of man. The internalization of one such set of meanings, far from aiding in the comprehension of others, makes such comprehension more difficult. Going from one culture into another is like passing from the world of Alexander Pope into the world of Shakespeare, from the world of Edgar Guest into that of Jean Genet, or from the world of romantic art into that of classic art.

The trap is set by anthropology itself. According to theory, enculturation gives the individual a lens through which he tends to view all experience. Unless the anthropologist is willing to suspend his principle in his own case, he has to admit that this lens affects his own perception of other cultures. He may claim to have a special lens, a better lens, perhaps a self-correcting lens (I shall come back to this), but he can hardly deny that he has a lens.

Let us call the lens he is looking through a blue lens. Suppose that he is looking at a yellow culture. The impression he gets will be one of greenness. Knowing this, he may try to devise ways of seeing yellow-green rather than blue-green. Though little thought has been given to this problem, it seems to be crucial for the study of culture, especially at the level of organizational principles: ethos, configurations. Examples are our "fair play"; the Navaho configuration translated "harmony"; Japanese *on*; "coolness" in our current jargon. Experience of these configurations is more difficult than experience of fires, winters, evenings. Configurations are attitudes toward experience, organizational predispositions, ways of making sense of large aggregates of entities and situations.

Because these organizational principles may permeate a whole culture and may extend below the level of explicit awareness, they can be understood in all of their nuances only by one who is fluent in that culture. At the worst, we are caught in an unresolvable dilemma. He who is born to an alien culture has the requisite grounding in experience for understanding its configurations, but he may be unable to detach himself sufficiently from that experience to make the kind of formulation which is useful to anthropology. The anthropologist, though adept at the formulations, may find it hard to acquire the depth of cultural experience which is necessary if his formulations are to match the originals. The native finds it hard to step out long enough

to do anthropology; the anthropologist finds it hard to work his way in sufficiently to grasp the alien configurations.

Let us move on to the second point at which the analogy of a culture and a work of art breaks down. If the free flow of my appreciation of a poem is interrupted, I begin to think about parts of a poem. I have a problem with the poem, I formulate the problem, and I try to solve the problem by tinkering with the poem. This involves the use of a critical language which is more adept at naming and relating parts than at directly handling the wholeness of the poem.

In some ways, the work of the anthropologist is analogous. He too runs into difficulties. He fails to understand why certain things are done as they are. He formulates problems, makes analyses, sets up hypotheses, and gathers more facts that bear on these hypotheses. In a way analogous with the work of a literary critic, he advances his knowledge of the culture. The anthropologist, however, intends to go beyond the work of the critic. Correcting and deepening his appreciation of a culture is but a first step. He wants finally to elaborate propositions that apply to all cultures. He wants to do the work of the aesthetician as well as that of the art historian and art critic.

The necessity for this additional step, which is productive of a host of new problems, can be shown in this way. It has been my assumption that any act of awareness, to be itself apprehended, must be apprehended in its own way. Poetry must be understood poetically, music musically, love-making lovingly, and certain kinds of configurations must be understood in experience as processes organizing actual events. The anthropologist's aim, however, is not merely the enjoyment of these diverse experiences for their own sake. His language does not feed cultures as the critic's language feeds art, rather it is the other way around. For the anthropologist, his language, his science, is of primary concern, and the cultures he studies are secondary. How are these different ways of apprehending experience and these different cultural interpretations of experience to be brought to a common focus? Can it be done? These are questions which we have not put to ourselves. At least we can say this: if the language of the critic finally disappears into his experience of the work of art, the language of the anthropologist ends by living its own life, having its own functions and claim to existence.

The Anthropological Lens

The analogy of culture and art has been useful in raising the problem of what I will call the "blue anthropologist." Completely objective

knowledge is knowledge of which the object known is the sole determinant; to such knowledge, the knower makes no contribution except the neutral act of knowing. Whether such knowledge is possible, and whether natural science approximates it more closely than social science, are questions that cannot be gone into here. Four points are of special concern to the anthropologist.

First, to what extent is the understanding of alien values, especially those integral to a culture, dependent upon our direct experience of them? These values are not merely intellectual but also have sensuous, emotional, and purposive components.

Second, assuming that these values do have to be experienced directly, at least to some degree, how successful can we be in achieving that experience? The chief difficulties here are 1) our training as anthropologists is largely intellectual, with little time wasted on nuances of feeling-tone, and 2) the lens through which we perceive everything, itself the product of a particular culture, has built into it presuppositions and biases which may be severely limiting. The bias for detached intellectuality is but one of these.

Third, assuming that this direct experience is possible, how do we verify conclusions concerning the nature of direct experience?

Fourth, how are these conclusions to be brought to focus in the central concern of anthropology without severe losses in the transition from direct experience? In addition, is the language of anthropology any more successful than the language of art in grasping wholenesses? Finally, how are all of these conclusions to be communicated to others?

Everything points to the nature of the anthropologist's central concern, his focus of effort, his lens. Before we can arrive at answers to these questions, we have to know something about the nature of this lens.

Any intellectual system must have starting points. By starting points I mean beliefs about the nature of things, using both "belief" and "nature of things" in the broadest sense. In a highly self-conscious intellectual system, the acceptability of these starting points, as starting points, is taken for granted. How provisional this taking-for-granted is, how self-corrective any system can be, how much of the very platform on which it stands can be put in jeopardy by the activities which the system makes possible, is itself one of the major issues. The point is: some starting points are necessary. If everything has to be proved, nothing can be proved. For example, it is an assumption that the pattern one-plus-one equals two applies to a sufficient amount of experience to make the assumption worthwhile. There are situations to

which this pattern does not apply or in which its application gives only superficial information about the situation. Nevertheless, if we are willing to assume that one-plus-one equals two applies sufficiently often to justify its use, we can proceed to elaborate, with this as a starting point, a mathematical model of reality. The mathematics so constructed cannot be used to prove the assumption; otherwise all systems of thought, regardless of how much they contradict one another, would have established themselves long since in impregnable towers. Evidence may be adduced from outside of the system to show the reasonableness (or unreasonableness) of the assumption, but this same assumption, because it makes possible the proof of other beliefs, itself escapes proof from within the system.

When I try to put these anthropological starting points into some kind of order, I find that the crucial consideration is my reason for studying human lifeways, my purpose. The nature of the anthropologist's lens varies with his purpose (cf. Burtt 1962).

Within the scientific approach, there are two choices. Kroeber (1953:362) has several labels for the first of these: phenomenological, historical, contextual, integrative. This is the "approach which 'preserves' its phenomena, tries to integrate them as such, and therefore depends much on the building-up of context." It is this approach which Boas (1948:257, 258) has in mind when he writes:

The phenomena of our science are so individualized, so exposed to outer accident that no set of laws could explain them. It is as in any other science dealing with the actual world surrounding us. For each individual case we can arrive at an understanding of its determination by inner and outer forces, but we cannot explain its individuality in the form of laws . . . the material of anthropology is such that it needs must be a historical science, one of the sciences the interest of which centers in the attempts to understand the individual phenomena rather than in the establishment of general laws which, on account of the complexity of material, will be necessarily vague and, we might almost say, so self-evident that they are of little help to a real understanding.

Kroeber would not let the aims of anthropology rest here. Seeing things whole in terms of their context is an essential part of a process which grades into humble intellectual tasks like ordering and classifying and arranging phenomena. It is reasonable to believe, says Kroeber, that anthropology will pass out of this natural history stage to become a true science, that is, an analytical one, equipped with "an adequate intellectual theory system" that conforms to the extended reality of nature, a science which is concerned with processes and causes.

The scientific approach is communal. By this I mean more than that science is social. Art is also social. The artist works in a style which he shares with other artists, and he works for an audience. Perhaps, therefore, the best word for this aspect of anthropology is cooperative. Art is rarely cooperative. Even in group performances like ballets and symphonies, there is usually a maestro who subordinates the activities of other performers to his interpretation of the work of art. By contrast, the established parts of anthropology often consist of a precarious consensus among those best qualified to know. Lacking precise means of confirmation, we rely upon this consensus as our best test of propositions.

What makes the difference between artistic expression and scientific communication, between intuition and consensus? When you try to imagine what the awareness of an animal is like you have to drown yourself in a world of nameless qualities, an iridescent continuum of shifting shapes and colors (if the eye is right), of tactile and thermal sensations, as well as all sorts of emotional and visceral promptings. It may be impossible for human beings, except perhaps under the influence of drugs, to put themselves into this animal world. To reach it, we would have to let most of the distinctions which we take for granted ooze away; we cannot think them away, for it is thinking which established them in the first place. An animal does establish connections between its inner states and outer conditions; otherwise it would never succeed in eating, but this is done with less than human dependence upon the mediating function of language.

Man is the animal who refuses to be drowned in sounds, colors, and inner promptings. What keeps him from drowning? The answer is: those concretions of discourse from which the qualities have been wrung out.

The abstraction "blue," for example, is not blue. If it were blue, it could refer to but one shade of blue, *i.e.*, that shade of blue which it happened to be. To be capable of referring to all shades of blue, it must become that which is common to all shades of blue, that consistent constituent which can be taken away from all shades of blue. To become this, it must become, by an odd quirk of things, nonblue; it must purge itself of blueness. Blueness is more blue than any particular example of blue precisely because it is not blue.

"Blue" does have a residual qualitativeness, a residual immediateness: the sound of the word activates the senses and may activate feelings. This residual qualitativeness is necessary for the abstraction to exist; since we have not reached the era of ESP, we must still com-

municate by means of one old-fashioned sense or another. However, the precise nature of the qualitativeness—the sound of "blue," or the pattern it makes when printed on a page—is arbitrary so far as the meaning of the word (its pointing to a class of experiences) is concerned.

To the extent that abstractions denature or render irrelevant the underlying realm of qualities, they allow us to transcend the vivid reality in which nonhuman animal life is drowned. We look back upon our own vividness, we draw lines across its surface and paste labels on the areas marked off. With those who have been schooled in our own system of demarcations and labels, we can coordinate our responses to the various entities we have distinguished.

Anthropological knowledge, being cooperative, gravitates toward a language of abstractions as a way of achieving consensus. A language of abstractions interrupts the underlying undifferentiated continuum in two ways. Not only does it draw lines and make distinctions which from the viewpoint of this qualitative continuum are arbitrary—since totally different systems of lines and distinctions are equally possible— but it handles these distinctions in a special atomized and serial way when it comes to make propositions. Though the following quotation from Kaplan (1959:49) refers to philosophical knowledge, it is equally applicable to anthropological knowledge:

. . . empirical verification is still usually dealt with as though it were a cumulation of simple observations. Because as philosophers we build up knowledge piecemeal in our rational reconstructions, we too easily overlook the knowledge of silent growth or sudden understanding, for neither lends itself to synthesis from the elementary components yielded by the analysis of other sorts of knowing. Our inductive logics are based on experiential or semantic atoms, which serve in probability counts or measures of confirmation. Cognitions which are not appropriately atomistic fall outside the purview of such logics and so lose the name of knowledge.

It is possible, as McLuhan (1964:ix) suggests, that this bias for a kind of abstract thinking which, at the highest levels, has withdrawn itself from any particular sensuous and emotional context is related to our emphasis upon phonetic writing. An ideogram, he points out, is an "inclusive *gestalt*, not an analytic dissociation of senses and functions"; it is a total intuition of being and reason. Hieroglyphs and ideograms do not bring about a separation from the web of family and tribal subtleties. Phonetic writing, however, proceeds on a different principle. "Semantically meaningless letters are used to correspond to seman-

tically meaningless sounds." The phonetic alphabet, he says, in a statement which may itself exemplify the perils of phonetic statements, is the "technology that has been the means of creating 'civilized man' "—separate individuals equal before a written code of law, continuity of time and space, and separation of imagination, emotion, the senses, and rationality from one another. Phoneticism is a major resource for winning freedom, not only from clan and family ties, but also from aspects of the self.

Another aspect of the lens, in addition to purpose, cooperativeness, and use of abstract thought, is the preference for naturalistic explanations. Behavior which takes place on the basis of other assumptions about the nature of things, such as animism and theism, must be paraphrased in naturalistic terms, reinterpreted so as to fit into the naturalistic framework. There is no need to indicate why the preference for naturalism exists; it is enough to say that, like other major starting points, this assumption affects all aspects of our work.

Yet another aspect of the lens is earnestness. I use this term because it is the one which Huizinga sets over against his concept of play. Huizinga (1950:13) sums up the formal characteristics of play by calling it

a free activity standing quite consciously outside "ordinary" life as being "not serious," but at the same time absorbing the player intensely and utterly. It is an activity connected with no material interest, and no profit can be gained by it.

Huizinga mentions other characteristics of play, but these will suffice. In tracing the history of play in human affairs, he says that play was important in primitive culture and in the early stage of civilization, but he also says (1950:206) that it

has been on the wane ever since the 18th century, when it was in full flower. Civilization to-day is no longer played, and even where it still seems to play it is false play—I had almost said, it plays false, so that it becomes increasingly difficult to tell where play ends and non-play begins.

Huizinga attempts to determine the importance of play in various contemporary activities, including science. He reaches this "tentative conclusion" (1950:204):

. . . we might say that modern science, so long as it adheres to the strict demands of accuracy and veracity, is far less liable to fall into play as we have defined it, than was the case in earlier times and right up to the Renaissance, when scientific thought and method showed unmistakable play-characteristics.

In his foreword, Huizinga says,

Were I compelled to put my argument tersely in the form of theses, one of them would be that anthropology and its sister sciences have so far laid too little stress on the concept of play and on the supreme importance to civilization of the play-factor.

This neglect of play stems from anthropology's incapacity for dealing with play's chief characteristic: that it is intrinsically satisfying. Huizinga rejects all explanations of play which assume that play serves something other than play. Fun, for him, is an integral part of play. Even if you show that play does fulfill other functions than playing, you finally come to such questions as why is playing fun, why does the baby crow with pleasure, why does the gambler lose himself in his passion, what is the nature of this fun that it cannot be reduced to anything else? "Here we have to do with an absolutely primary category of life . . ." (Huizinga 1950:3).

As an example of why anthropological theory is incapable of dealing with this "primary category of life," I shall refer to functionalist theory. Gregg and Williams suggest that on the basis of functional theory only those customs persist which satisfy individual needs or maintain the equilibrium of the social order, this equilibrium often being thought of in organic terms. Assumed in this is some form of adaptation to the natural environment. The purpose and justification of any behavior, then, is the support it gives to a complete system comprising environment, persons, and social order. To think about play in functionalist terms would be to make it serve something other than play. Play, interpreted functionally, ceases to be play. To see the intrinsically rewarding spirit of play as activating whole segments of a culture is to undo the knots of the functionalist scheme and to tie a few knots toward a kind of intrinsic theory of behavior and culture.

For example, can Plains Indian culture be explained solely in terms of the problems raised by the environment, by the prerequisites of the sociocultural system, and by the needs of the individuals making up the system? To solve the problems of survival, does the Plains Indian have to go as far as he does in the elaboration of his culture? Can we explain the Plains Indian's culture without taking into account the possibility, not only that he is doing some things because they are intrinsically rewarding, but also that this is the only explanation for his doing them, or for his doing them with such intensity? With his coups-counting and braggadocio, he is comparable to a jazzman who has gotten hold of a horn and a good tune and blows and blows and

blows till his brains rattle. It is not enough to say that all this is taken care of by some concept akin to that of "functional autonomy," according to which that which has to be done for some other reason takes on an intrinsic value of its own. Possibly there are disfunctional autonomies, intrinsic satisfactions so imperious that they force individuals or groups to cut the corners on what seem obvious extrinsic demands. Is Simeon Stylites in touch with something so good that he can afford to be indifferent to the maggots stirring about in his sores? The question, however justified it may be in general terms, takes us beyond the confines of science.

This brings out the difference between a science of explanation and a science of prediction. A science of explanation concerns itself with the interrelations among all of the constituents of a situation, including human motivations. For a science of prediction, however, the inwardness of human existence may be irrelevant.

What I have said about the anthropological lens might be summed up by saying that it assumes the existence of a particular kind of order in the world of man, an order that is naturalistic, based on earnestness, etc. Open to question is not only the nature of the particularizations, but also the very assumption of order itself. Despite all that has been written about culture, there has been very little systematic effort to examine the assumptions implicit in our ideas about the nature of cultural order (see Hoyt 1961). One question is: what kinds of order are possible? Mechanical? Organic? Evolutionary? Catastrophic? Forms of order for which we now have no names? Another question is: what degree of order is necessary for culture?

Finally, an important aspect of the anthropological lens is what, following Bullough, I shall call psychical distance. Bullough is using the term as an aesthetician; I am extending its application. What Bullough means by the term can be illustrated by a haiku.

> In the depths of the
> flames I saw how a peony
> crumbles to pieces.

Concerning the circumstances of its composition, Kato Shuson has this to say:

> In the middle of the night there was a heavy air raid.
> Carrying my sick brother on my back I wandered in the
> flames with my wife in search of our children.

The poet sees the very flames which threaten his life as flower-like. At

a moment of imminent death, he sees the fire as life. At a moment of extreme practical need, he sees the fire with a scrupulously disinterested poetic eye. It is as if in a moment of direst extremity, his practical interests had snapped from sheer overtension, resulting, not in collapse, but in a new order of experience, a new illumination of experience, using what Bullough calls a "brighter light."

Bullough makes several points about this experience of psychical distance. The distance is between us and our affections, or between us and the objects that play upon our affections. Though distance has its negative side in that it inhibits practical attitudes and behavior, by tearing off all of the ordinary labels it also reveals wholly new aspects of things which have been obscured by our obsession with the conventional and practical. Bullough uses the term "revelation" to describe this experience and says that it is a factor in all art.

It is also a factor in science. A man doing research cannot let his needs and biases as a human being and citizen color his conclusions. An odd thing happens when you transplant the idea of psychical distance from aesthetics to the social sciences. It becomes apparent that science, for the scientist, can become a kind of practical interest in a way that poetry for the poet does not. This has some connection with the communal nature of science. The scientist's desire to have his predictions prove out is only the most obvious practical urge he needs to control. Defending the whole establishment of science in which theoretical positions, prestige, power, privilege, and personality characteristics are mixed together is another aspect. Only an exceptional individual, such as Einstein, can envision a complete overturning of the theoretical establishment.

These questions about psychical distance take us back to issues which Huizinga raises. Is science, pursued in the fullest spirit of disinterest, to be thought of as supporting the earnest view of behavior or the spirit of play?

One wonders also how important McLuhan's strictures concerning phoneticism and abstraction are in explaining the development of psychical distance in science, especially if its occurrence in science were paralleled by comparable developments in art and even perhaps in religion.

We do seem to have another assumption built into the anthropological lens. This is the assumption that discourse is the supreme key to human behavior, and that therefore all other approaches to experience may be subordinated to the demands of discourse. It is possible to take the naive view that this is nothing more than a bias of

literacy. Radin has tried to spell out some of the effects of this bias in *Primitive Man As Philosopher*.

This examination of the anthropological lens indicates that a vast amount of distortion, interpretation, paraphrasing, and translation is woven into the texture of anthropology. Behavior based on a religious worldview has to be reinterpreted within a naturalistic framework; complex, paradoxical aesthetic statements have to be recast in a neater, sequential mode of discourse purged of the very ambiguity which made the original aesthetic form so desirable; a playful view of life must be translated into the lingo of earnestness; irrationalities have to be adjusted to a rational model; disorder must be assimilated to whatever notions of order the anthropologist has in his head. It is impossible to escape the admission that these are distortions, paraphrasings, translations. The reply will be that such distortions, paraphrasings, and translations are forced upon us by the venture we have undertaken, that is, by the elaboration of a science of culture or behavior. We should at least face squarely the difficulties into which this venture plunges us. Were a student of literature to proclaim the virtues of a brand of literary criticism based upon translation, he would be met with derisive noises. How can a science of man based mainly on translations escape similar derision?

Experiencing Alien Values

Consideration of the anthropological lens has deepened the problems with which I started. Consider this statement by Kroeber (1953: 372-3):

. . . values are principles of organization of culture and therefore influence culture. If culture is an order of phenomena of nature, values are therefore phenomena of nature, even though subjective ones. Existing within the cosmos, they are a legitimate and necessary subject of natural science investigation . . . values evidently are intimately associated with the most basic and implicit patterning of the phenomena of culture . . . it looks as if values must be found, got at, or determined by empathy. That means not by some mystic or supernatural means, but by experiencing them in some degree. I think one has to live himself into values in order to know what they really are. Not that one has necessarily to become a complete member of another culture, to go native or foreign. Perhaps one can get values by observing, listening, asking. You can certainly reach some of the values of Indian philosophy or Chinese literature by reading; but even that is an experiencing. Values have got to be felt, at least vicariously: I think that has to be recognized.

There is a fear of feelings. It is said, "Feelings are one thing, but science another." Yet if feelings are important phenomena, we will have to operate with them; and if the only way to get hold of them is by experiencing them —well, we shall just have to experience them, or go in for a wholly different subject to study than culture.

Kroeber glosses over the very difficulties he intends to raise. To say that you can reach some of the values of Indian philosophy by reading sounds like a joke because much of that reading will tell you that you will never comprehend those values by reading alone. Our concern with intellectuality obscures the difference between a knowing brain which spouts words and knowing guts which are capable of transforming the self. Watching the Zen master slap the pupil, we write in our notebooks, "The slap conveys the immediacy of reality." What does this sentence mean? Without being slapped ourselves, without preparing ourselves for that slap, without the experience which the slap conveys, we know nothing about what the master and pupil are giving and receiving, to and from one another. The Indians and Chinese are far more aware than we of the subtle ways men have of standing in their own light and casting into themselves shadows that confuse all of their perceptions, even of themselves.

When we experience alien values vicariously, we do experience something. This something is a concoction of alien and personal elements: some form of greenness. As we experience the greenness, we have the feeling that we are experiencing what we are intended to experience: yellowness. Like the blind man who felt the elephant's tail, we take the elephant to be like a rope. The best check upon our feelings would be the knowledge that we are not experiencing yellow, but this knowledge (except for the logical possibility which I am working out) comes only with the direct experience of yellow, here precluded by the interposition of a blue lens. The lens is not a monocle which can be screwed in or out of the eye at will. This explains the function of the master in Oriental systems of self-transformation. The student fancies that he has solved the riddle, fancies that he has reached a deeper level of selfhood, just as the anthropologist fancies that he has experienced alien values. The master sees around the student's pretensions and sends him back for more work. Who can play guru for the anthropologist and send him back for more meditation when he is found to be still dwelling in realms of idle discrimination?

The principle of the "blue anthropologist" applies equally to the individual frames of reference, schools of thought within a movement like anthropology, and opposing worldviews, say, those of science and

art. Redfield summarizes an example from anthropology (1962:99–100).

> The values of the anthropologist may have some relevance to the anthro-
> pology he does . . . John Bennett . . . recognizes in the descriptive literature
> of Pueblo life two contrasting views of Pueblo culture: one in which the
> integration of Pueblo culture and society is emphasized; in which it is seen
> that all sectors of Pueblo life are bound together by a consistent, har-
> monious set of values which pervade categories of world view, ritual, and
> so forth; and associated with this integrated configuration is an ideal per-
> sonality type, with the virtues of gentleness, non-aggression, modesty,
> tranquility, and so on. With this he contrasts an alternative view, which
> represents Pueblo culture and society as marked by considerable covert
> tension, suspicion, hostility, anxiety, fear, and ambition . . . In Bennett's
> paper the argument is made that the difference in interpretation is a dif-
> ference in emphasis resulting from differences in the values of the two sets
> of investigators . . . It might be that a choice between these two could be
> made on purely scientific grounds, or it may be that the value position of
> the anthropologist who carries on the investigation is, perhaps, necessarily
> a part of his subject matter. Related to this is whether the propositions of
> the anthropologist are purely descriptive or existential, or whether they are
> also normative. This raises the question whether such concepts as stability,
> adaptation, survival, and integration tend to become values to the anthro-
> pologist; and it runs over into the question as to the separability of norma-
> tive and existential propositions anywhere. From this one moves to a much
> broader consideration of the value positions that are open to the anthro-
> pologist with regard to his own scientific effort and his position in the larger
> society.

It is perhaps possible to resolve this conflict by assuming that both
views of Pueblo life are true but incomplete; even so, putting them
together would seem to involve important changes in both. The prob-
lem I am talking about, though related, is even more subtle. Kroeber
writes (1953:359):

> What . . . the humanities failed in was systematic conceptualization. It is
> obviously hard to take a series of aesthetic judgments and weld them
> together into an intellectually satisfying coherence. That the humanists
> failed to do. It is probably impossible to do. An adequate intellectual theory
> system has evidently got to conform to the extended reality of nature also.
> That humanists did not feel the need of—in fact, claimed exemption from.
> This perhaps remains their greatest defect today. As scholars, they exact
> evidence; they do not exact its broadest possible intellectual organization.

What interests me is the statement that it is probably impossible to
weld together a series of aesthetic judgments into an intellectually

satisfying coherence. Isn't this exactly what Kroeber was proposing in the longer quotation concerning values? If I accept that it is next to impossible to pass from a set of aesthetic judgments to an intellectually satisfying theoretical scheme without doing violence to the aesthetic judgments, I distinguish three ways of approaching cultural configurations: the deductive, the aesthetic, and the inductive.

The deductive position has a purity which allows it to be briefly summarized. The deductive anthropologist takes as his aim the development of a theoretical scheme for the prediction and perhaps the control of behavior, accepting on faith the assumption that discourse is the key to human behavior. Burrowing into the interstices of alien cultures, empathizing with alien values, feeling a way into alien arts, religious systems, and worldviews, all become irrelevant exercises. The key which the deductive anthropologist seeks can be arrived at, he hopes, by less circuitous means. He has only to sit down and begin grinding out intellectual keys, secure in the belief that one will finally fit the locked door.

An example of work which is largely deductive is Kluckhohn and Strodtbeck's *Variations in Value Orientations*. The five value orientations, each with three variations, were not arrived at by laborious inductive analysis but arose out of general knowledge of the human predicament. Subsequent empirical work was undertaken to test this value-orientation theory in five communities of the United States Southwest.

The aesthetic approach subordinates the desire for an intellectual scheme to the need to experience alien ways of life "from within." Edmund Carpenter (1965:56) expresses this aim when he says, "I see anthropology as far more than the study and presentation of man. It's experiencing man: sensing, apperception, recognition. It's art." Carpenter exemplifies this approach in a book called *Eskimo*. This is not so much an ethnography as a tentative exploration of such subjects as Eskimo orientation, acoustic space, mechanical aptitudes, and attitudes toward art, all designed to bring out idiosyncrasies of the Eskimo viewpoint. The book uses not only a text by Carpenter, but also paintings and sketches by Frederick Varley, and some carvings collected by Robert Flaherty. In a review of this book, Dorothy Lee (1960:165–77) points up characteristics of Carpenter's approach which constitute a lens sharply distinguished from the one I have already described.

Carpenter supplements the usual lineality of discursive statement with the simultaneous methods of television. "Thus, Eskimo topography, geographic knowledge, and orientation are presented inter-

dependently in Carpenter's prose and Varley's paintings of vast spaces, alive with the sense of discovery." Rather than simply represent the facts by means of abstractions, Carpenter hopes also to present them through aesthetic means.

The usual work in anthropology has a finished quality. You have the impression that the author knew exactly what he wanted to do, selected precisely the right group for his purposes, settled unerringly upon the correct baggage of ideas and techniques, used impeccable tact in his dealings with the people, proceeded precisely on schedule, and finally returned home to write up his results with exemplary logic on a type-writer as white as the Pope's. The impression which Carpenter conveys brings you directly to his side to join in a groping act of understanding which is not finished when the book ends. "Carpenter says in effect: this is as far as I could see and understand; this is as far as I could go, but there is much more to pursue."

The authority of the collectivity is questioned—not out of theoretical considerations, but out of the imperatives of experience. Carpenter writes (1965:55):

Though I have written, over a period of 15 years, on a variety of topics concerning my life with the Eskimo, I have never, until recently, attempted to describe those experiences that touched me most, the images that come to mind when I think back, the ones I live with. I've wondered whether this failure derived from personal censorship or from poverty of expression; whether the words used to cover ordinary experiences failed when the situation went beyond; whether the spirit and memory didn't recede as well. The few times I tried, in relaxed moments, to tell someone what it felt like to undergo intense happenings, I faltered: "It was more involved than that . . . I guess I loved her, but that says nothing . . . he sat in the dark, crying, blaming me . . ." Words failed, images failed, even memory failed. The whole key and rhythm of my life had been altered forever by a handful of experiences that left no communicable mark. And even now, as I wait for the right words, I wonder how accurate, how honest, these descriptions will be, and to what extent I am working them up a little afterwards.

The alien values you have difficulty reaching may be your own values.

A similar attitude comes out in *Eskimo*. Lee (1960:166) puts it this way:

There was a time when I feared that Carpenter was reaching a point where he would feel that to write a monograph about his friends would constitute a betrayal or a violation of their integrity. He wrote to me from Fury and Hecla Strait: "I have never been with friendlier companions. It would be very difficult for me to record many texts . . . and as for giving tests, it just

couldn't be done. They accept me . . . but I could never 'hire' an informant or even find an informant. But just by looking and listening I've had some vivid impressions; beyond that I have not penetrated."

Yet, just because he looked and listened Carpenter did penetrate "beyond that." And what he found he has been able to present without violation, as an artist. He writes with wonder, with humility and empathy, and with something like reverence. It was not necessary for him to write "about" his people after all, in detachment and analysis, for he presents them inviolate with immediacy.

This kind of work neither tries to be exhaustive nor does it select according to a predetermined system.

He plunges into Availik experience without defense, shedding all the cognitive and conceptual armor he can, and allows his imagination to be caught. He participates, but does not observe in the usual sense of the term. I get the impression that only later after he returns to being Edmund Carpenter, the anthropologist, he recreates his experience in its fullness. He goes over it thoroughly and intensively recovering each minute detail that goes into the discovery of a new order of perception, a new way of apprehending man's place in the universe.

Carpenter's work clarifies the analogy of the anthropologist and art critic, on the one hand, and aesthetician, on the other. Carpenter is using the resources of discourse, as would an art critic, to light up the labyrinth of qualitative experience, of configurations and ethos. The task of the critic is itself so demanding that he finds it difficult to pass from concrete enigmas to the making of vapid abstractions about culture in general.

In discussing the inductive approach, I want to go back to the major questions I previously raised. Can alien configurations be directly experienced?

The first thing to be said is that the color analogy suffers by being excessively Kantian. A configuration is taken to be an austere absolute which refuses to bestow one bit of its absoluteness upon any of the systems designed for knowing it, a Thing in Itself whose business is to be baffling. However, if the absolute bestows none of its absoluteness upon any of the ways by which it is known, how can one say that it is absolute? If the yellow culture never communicates its yellowness to the anthropologist, who because of his blueness is forced to see it as green, why must the anthropologist take for granted that the culture is a yellow one?

One alternative is to see knowledge as being paradoxical, and this in

two ways. First, each of us is simultaneously apart from other individuals and a part of them. Each is apart from another in the sense already mentioned: no one can directly share the promptings of another's nervous system. Each nervous system exists in a solitude which would be complete were it not that the nervous system is of such a nature as to allow for indirect communication with other human beings through language, as well as direct participation in their experience through feeling. Human solitude is an open solitude; what keeps it open is our ability to share felt-thoughts with one another, to put ourselves in the place of others, to ooze along with them. As a human organism, I may be a Thing in Itself, a separate entity, but as a human being, I am a Self in its Thing, and it is this Self which is receptive to the intimations of other human beings. It is unfortunate that the intimations which others give off to me must be muddled by the intimations which I in turn am giving off to them, but that is the way it is.

Second, knowledge is a paradox because the source of my knowing, my humanity, is also the source from which that knowledge is "tainted." If objective knowledge is knowledge determined solely by what is known, then objective knowledge is impossible. Without feelings, assumptions, and a perspective of my own I could not grope my way into a different set of feelings, assumptions, a different perspective; far from knowing others objectively, I could not know them at all. When Mabel Dodge pictures Richard Wilhelm as stripping off his Germanic nature to don a Chinese one, as if both were suits of clothes, she is indulging in romanticism or describing an experience which is not generally available. The very desire which the anthropologist has to understand an alien culture in native terms is an obstacle in the way of accomplishing this end, for only an alienated native would manifest the same desire.

Redfield (1953:Chap. VI; 1962:Pt. I) has discussed the problems that arise when work with other cultures is regarded as an "unsolvable paradox." He concludes that we do not want ethnologists so balanced that they have no humanity. We want a balanced profession, a varied lot of anthropologists (Redfield 1953:157).

The current tendency to go into the field to solve specific problems exaggerates the distortions produced by the anthropological lens. It strengthens our allegiance to a theoretical position, it brings to the front certain hypotheses which require proof or disproof, and it loads us down with apparatus which give a sharp and restricted focus to our perceptions. If we limit our efforts to this, we shall never get at those permeating aspects of culture which are crucial to behavior.

The anthropologist who goes into the field with a problem is primarily concerned with science. The people he studies are holding out to him not so much their humanity as possible solutions to his problem. Carpenter (1965) cares more for the humanness, in all of its idiosyncrasy, of the people with whom he lives than for his theoretical constructions and the problems they create. What Carpenter is doing is not merely the inductive phase of a scientific enterprise, it can also be looked at as a different enterprise entirely, a kind of humanistic anthropology to be set over against scientific anthropology. Where scientific anthropology is concerned with tidying up its picture of reality according to the generally accepted fictions of science, humanistic anthropology is concerned with sharing in the experienced reality of human beings in all of its multifariousness.

A configuration is the shape of an experience or a number of experiences, learned as part of the experience. It is not something separate from the experience, a form to which the experience is fitted. The anthropologist may abstract the shape in order to compare it with other configurations, other shapes, but if he treats his abstraction as being determinative of the experience, he is confusing fiction and reality. Understanding an alien configuration is a matter of, first, letting your own experience assume the alien shape, and then, perhaps, finding some way of communicating this shape to others. To let experience assume this new shape one needs time and a certain kind of nakedness or innocence. To hear the music, one must set aside the tune that is jogging through one's head. Although I grant that setting aside the shape of things as one has learned it from birth is more difficult than setting aside an obsessive little tune, nevertheless I think there are ways in which such a willing suspension can be accomplished. The ability to do this has affinities with what the scientist calls distinterestedness, with what the aesthetician calls psychical distance, and with what the sociologist calls role-distance and ecstasy (Berger 1963) and with the idea of no-knowledge (Siu 1957). If it be argued that the effort to suspend one's theoretical assumptions can only end by making those assumptions implicit, and that implicit assumptions cause more harm than explicit assumptions, then we might develop a kind of eclecticism, a taking possession of all theories regardless of how inconsistent they may be. I can imagine a patient, for example, some of whose experiences might respond to a Freudian kind of examination while other experiences seem more Jungian in character, so that his therapist, to be most effective, ought to have all psychological systems at his disposal. Similarly, an anthropologist might use a variety of views to sensitize himself to many aspects of a culture without allowing him-

self to become committed to and therefore limited by any one of them.

Attempts to suspend the lens, to minimize differences between the anthropologist's role as participant-observer and the roles of those born to the culture, produce their own problems. If you reject questionnaires, formal informants, even note-taking, on the grounds that these, by emphasizing the observer part of the role, interfere with the participant part, how can you be certain of the correctness of your memory when the opportunity for recording information does arrive?

The problem of verifying one's understanding of configurations is two problems (excluding for the moment the problem of distortion due to the medium of communication): verification of particular configurations, and verification of the whole arrangement of configurations which give the culture its structure. For example, Clyde Kluckhohn in his paper on the philosophy of the Navaho Indians never makes clear why Navaho configurations should be generalized in the way he does except that this is the way in which he happens to see them. One way to meet the problem, at least as concerns explicit aspects of culture, is to derive, not only the terminology, but also the structuring, from the native worldview as given by the natives. The work on lexical domains is relevant. Lexical domains also suggest important starting points for the study of implicit aspects of culture. Failing guidelines of this sort, about all we have to fall back on is consensus on the part of the most sensitive and best qualified observers, and the way in which various aspects of a culture point in the same direction. The first is no help when a culture has been described by one person, and the second is subject to distortion by the anthropologist's penchant for systematization.

Finally, there is the problem of communicating one's conclusions concerning alien configurations. Even those who find it most difficult to disturb the native context, who are most averse to the paraphrasing or translating which communication entails, no matter what the medium, will feel some urge to share their experience and so will come face to face with these problems. Having lived in another culture, one has, to some degree, embodied or enacted the configurations. The problem of communication is the problem of communicating the meaning of an enactment. The enactment is the totality of the anthropologist's participation in the culture. The problem of meaning arises out of the need to make something of this experience; to make something else of it. However closely they are related, the meaning is not the experience —unless one adopts a Zen attitude. The meaning consists of a selection and arrangement of the facts, of the givens (or rather the receiveds)

of the enactment. This "something else" in which meaning inheres is at once lesser than the enactment of the configuration and greater than it is. It is lesser by being a condensation of the enactment. The meaning eliminates details, and usually telescopes the temporal and spatial dimensions of the experience.

Further, every medium of communication has its limitations. If each culture is regarded as giving one glimpse of human potentialities, each medium of communication may be regarded as giving one glimpse of a culture. This suggests the possibility of a massive attack upon a culture with all possible media of communication (I wish I hadn't thought of this; someone is bound to try it). Even here there is no synthetic medium, no way of summarizing the results of all. It isn't even possible to regard the anthropologist's enactment as the synthetic medium, for it is only *his* experience of the culture, and it is wise to assume that the range of experience within that culture exceeds his own.

This "something else" in which meaning inheres is also greater than the enactment by intensifying it and by drawing out of it implications that were hidden in the enactment itself. If art is the lie which is truer to life than life itself, then why may not an anthropologist's presentation of a culture be truer to the culture than the culture itself? A movie like *Nanook of the North* comes close to realizing this aim.

Scientists may object. Why must the communication of meaning enable the recipient of the communication to share, at least vicariously, in the quality of the anthropologist's enactment? Let's leave that sort of thing to the artist.

It is true that historians write about periods of history which they have not and could not experience directly. Yet the historian usually recognizes that, by one vicarious means or another, catching the quality of life of a period is an essential part of his task. From the beginning, we should have insisted that every ethnography be accompanied by a transcription of field notes or a personal account of the author's work so that the credibility of the ethnography could be assessed and the biases of the writer compensated for. It is not merely that the quality of experience is of intrinsic interest; for some purposes it may be irrelevant. It is rather that the quality of a man's confrontation with an alien order, the quality of his participation in that order, and of his efforts to enact its configurations, are all important for estimating the value of the meaning which he has extracted from it.

The communication of the meaning of the configurations is finally a compromise between the personality of the anthropologist with all

of his limitations, the purpose of his study, the lens he is using, the methods he employs, and the biases of the medium of communication which he has chosen. It is when we come to consider the difficulties of communicating configurations that the logic of humanistic anthropology, on the one hand, and of deductive anthropology, on the other, stand out with refreshing clarity.

One can say, with assurance, this much about the inductive approach to configurations other than one's own: in today's shrinking world, it is better to have some shared knowledge about other cultures, however imperfect that knowledge may be, than none at all.

The Complex of Art

The papers collected in this volume make clear that no simple definition of art is possible, that art comprises an intricate set of activities touching upon many sides of man, a set of overlapping circles with several centers. While any one of these centers may be taken as the primary focus of concern, the complexity of the whole undertaking called art must never be forgotten. If one thinks of art in this broad way, the major centers of concern can be specified. First, we are most apt to think of art in terms of the work of art, the object or the performance, which is distinguishable in one way or another from non-artistic objects and performances. Second, the object or performance implies a maker or a performer. The whole complex may be approached from the viewpoint of the artist's personality. Third, since art is a social as well as personal accomplishment, it can be approached from the viewpoint of the established definition of the artist's role, the context in which his personality works out its aesthetic career. Fourth, art can be thought of as involving a special attitude. It is at least an enhancement or embellishment of experience, at most a kind of virtual world which parallels the world of everyday experience. Fifth, the whole range of artistic-aesthetic activity can be looked at from the viewpoint of appreciation, of the audience. Sixth, the social quality of art, at least when it is fully developed, implies an ability to talk about what is done, to criticize objects and performances, to say what is good about them, or why they fail. The study of aesthetic values becomes another means of access to the whole complex. It is difficult to deal with any of these without becoming involved in all, but if we look at the papers here, we find that Thompson is centering on Yoruba art criticism, and Bascom is dealing primarily with a personality, or at least a single person, the Yoruba carver, Duga of Mẹko. At the same time, d'Azevedo

seems to be working primarily with status-role considerations, while a good many of the other writers take the work of art as their central concern.

The initial problem is how, for any culture, one identifies the set of overlapping circles which constitute art, and how one takes the initial step across the magic line separating art from nonart. The most obvious choice is to adopt the native aesthetic and be guided accordingly to work of art, artist, role, attitude, and audience. But what if native habits of talking about their doings do not include an aesthetic? The papers answer this question in three ways. First, Merriam presents a carefully worked out conception of the meaning of art, as the West sees it, and concludes that the Bala do not have art in this sense. That his study of a people who presumably have no art should be included in a book on art is not as strange as it might seem. He is writing about the Bala musician; a musician makes music; and music, as everybody knows, is an art. The logic is rough-hewn, but at this point in the cross-cultural study of art, who cares? The second way of answering the question proceeds in much the same way but with less attention to the problem of defining art. Here I would include the papers by Ames, Bascom, Crowley, Messenger, Nketia, and Vaughan. In the third place, two of the papers, those by Fernandez and d'Azevedo, introduce fresh approaches to that old question, What is art? These last are highly promising for the concern expressed in this paper: how we may systematically attain to an understanding of the configurations of a culture through familiarity with its art, however defined. With this concern in mind, I shall do three things: 1) indicate why art is especially helpful in getting at cultural configurations, 2) take a look at the papers in this volume as they deal with the aspects of art which I have mentioned, and 3) consider the conceptions of art with which Fernandez and d'Azevedo are working.

Art and Cultural Coherence

Malinowski refers to culture as a seething mixture of contradictory principles. The view of art which interests me can be summarized by saying that art is a major way of ordering this seething mixture, of giving this seething mixture that coherence which sets one culture apart from another. Sometimes art is the only ordering process whose complexity matches the complexity of what is to be ordered.

There are two reasons why art, as distinct from discourse, is capable of doing this: the complexity of its symbols, and its capacity for en-

gaging all sides of a human being. One of the fundamental character-
istics of art, as we ordinarily think of it, is its sensuousness. Into what-
ever reaches of meaning and imagination the work of art finally
extends, it enters these realms by way of the senses. Music is made up
of tones and the qualities of instruments, painting of forms and colors,
architecture of spaces and masses, poetry of the sounds and rhythms
of words and the qualities of their referents. This preoccupation with
sensuousness not only heightens the vividness of experience, it also
heightens its ambiguity. What exactly is a piece of music, a dance, a
poem communicating, what exactly is it intended to communicate?
When the sensuousness becomes embodied in symbols that point
beyond their own sensuous vibrations, then the ambiguity has a
definite locus and can be spelled out, without losing its quality of
ambiguousness.

The concreteness of a poem's imagery may make it possible to read
the meaning of the imagery in different, even conflicting emotional
directions at the same time with no sacrifice of coherency of meaning.
The result is a richness which can never be reduced to a paraphrase in
prose, to a language deliberately purged of ambiguity. Because art is a
presentation rather than representation of experience, it is capable of
this kind of oblique and simultaneous utterance of complexities
(Dorothy Lee calls this a nonlineal codification of reality), which may
finally result in paradoxes. It is no accident that Jesus chose to speak
in parables which are fundamentally aesthetic. The concreteness of
the imagery, the everyday choice of objects—seeds, sons, sowers,
servants, vineyards—make the statements of Jesus seem deceptively
simple and commonplace, yet they also produce a suggestiveness of
meaning which goes on working long after the imagery has been
assimilated by the mind. Furthermore, a discursive statement of the
intended meaning might raise theological issues and foster argument
rather than a spirit of devotion.

For much the same reason, the work of art, if it is to be thoroughly
understood, may demand the participation of all aspects of a person.
The senses echo in the emotions, the emotions echo in intuition, intui-
tion echoes in reflection, and all of these reverberate through imagina-
tion, a compound of them all.

That this use of sensuous symbols, condensing a multiplicity of
experience and meaning into concrete images, is characteristic of non-
literates is made clear by Fernandez in his paper on the sermons of an
African reformative cult (1966a:68):

Not only the incongruous but even the contradictory find their unification in the symbol. In fact it might even be argued that any really pervasive symbol unites opposites. So while iron stands for patrilineal continuity and masculine vitality, it also as the instrument of war stands for death and destruction. The paradox of such coincidence is not only apparent in Fang culture, it is real. The symbol is an instrument of communication by which such life-difficulties can be grasped.

Fernandez quotes Leach as saying that nonliterate peoples "are much more practiced than we are at understanding symbolic statement . . . even cultivating a faculty for making and understanding ambiguous statements."

In this book Fernandez provides a similar example of the complex, expressive possibilities of art, this time based on Fang sculpture.

I have elsewhere indicated that though the Fang argue that their figures and masks represent living persons, as the Europeans represent them in photographs, they rarely argue that these statues represent particular living persons but only living persons in general. They are not portraits. Since in extended discussion the Fang recognize well enough that the proportions of the statues are not the proportions of living man, one is lead to believe that what the statue represents is not necessarily the truth, physically speaking, of a human body, but a vital truth about human beings symbolically stated. This symbolic intelligence seems to arise from the way the statue holds opposites in balance—old age and infancy, somber passive inscrutability of visage and muscular tension of torso and legs, etc. What is expressed in these statues, then, is the essence of maturity. The mature man, *nyamoro*, is he who holds opposites in balance. The statues express the most fundamental principle of maturity and vitality (whose secret is the complementary interplay of opposites) and hence they lay claim to the most profound reality, despite their stylistic exaggeration.

Sculpture becomes an appropriate vehicle for expressing the Fang conception of maturity as holding opposites in balance because, stylistically, it is itself a holding of opposites in balance.

Understanding the Work of Art

One of the things which would help in the handling of the work of art is a systematic outline of its aspects. These would vary considerably from one medium to another. There is no thought of atomizing the work of art or of practicing some kind of reduction that enables us to escape the difficulties presented by its wholeness. As I have tried to

show, dealing with the work of art discursively inevitably entails dealing with it part by part or aspect by aspect; to do this may be a legitimate part of understanding its wholeness. It certainly does not entail the assumption that there is nothing to the work of art but its parts taken separately. Such a list of the aspects of a work of art would function solely as a reminder of what to look for, what to think about.

One of the aspects of art which is invariably neglected is style. While the iconology of painting, for example, is relatively easily related to configurational concerns, we are less adept at interpreting the stylistic aspects of painting: handling of figure and ground, use of borders, the extent to which the design is crowded into the format, the use of principles of organization, etc. (see Mills 1959). All of these aspects of style are of tremendous importance so far as the ultimate effect of the work is concerned.

I have indicated that Fernandez sees the Fang reliquary statue as expressing the essence of man, his maturity, his ability to master paradox and live with it. In developing this idea, Fernandez does not do much with the stylistic characteristics of the sculpture. Wingert (1950:48) says of this same sculpture, "Fang figures have a quiet aloofness of expression that is at times combined with an aggressive open mouth; potential energy is represented in the schematic organization of their stylized shapes." This interpretation of the style perhaps is in accord with the function of these pieces in defending the reliquary against uninitiated women and children, but it is questionable how well it is in accord with still another function, that of expressing the benevolent disposition and overriding orderliness of the unseen world.

Another problem has to do with identifying the work of art. The usual distinctions of medium, say, as between mask-making and dancing, may so cut up behavior as to make it impossible to see exactly how these arts are being used to express configurations. My knowledge of African art is not adequate to provide an example, so I shall fall back on the group dances of the Pueblo Indians of the United States Southwest. Not only is man joined to man in these group dances, which are defined by the Indians themselves as of cosmic importance, but also the hypnotic quality of the dancing makes for wholehearted participation in it; the dances are not only a symbol of one's belonging to a group, they do much to create the sense of belonging. In addition, the dances succeed in uniting the group to the rest of the universe. This is accomplished chiefly through the style of the masks. The masks cover the heads of the dancer, thereby reducing the importance of the face, the most characteristic part of the human body. The masks also pro-

vide surfaces on which the symbols of various powers important to these people may be painted: plants, animals, natural elements. The diverse forms of the universe are gathered together and unified in the conventional symbols of the mask style, and this aesthetic expression of the coherence of all things parallels but also expresses in a vivid way the idea that the dancer becomes the power of the mask he puts on, that the forms of the universe are so bound up with one another as to be in some degree interchangeable. Dancing is regarded as the Pueblo Indian's chief work. The dances keep the forces of the universe in harmony and equilibrium, they help to maintain fertility, they insure rain. Thus, even the sweat-of-the-brow imperatives of human existence are taken care of by means of activities that are intrinsically satisfying. However, were the anthropologist to show a highly technical concern for the masks alone, or the dances alone, he would overlook the way in which Pueblo configurations are expressed by a conjunction of these activities—expressed perhaps in the only way they can be satisfactorily expressed. Our concern, then, from the viewpoint of configurational expression, ought to be not so much with individual works of art or even styles, by themselves, but with art complexes, conjunctions of art forms which, taken together, objectify these large imaginative constructions lying at the heart of culture.

The Artist and Cultural Coherence

So far as the personality of the artist is concerned, life-histories would be especially valuable. An African *Sun Chief*, for example, ought to throw light on every one of the centers of this series of overlapping circles, as well as to suggest clues to configurational matters. Bascom says that Duga of Mẹkọ lets the wood choose its own color. The cooperation which this implies between the carver and his material may relate to a larger sense of cooperativeness between man and nature as a whole.

Autobiographical statements may help to make sense of the vexing question, perhaps a merely verbal one, as to whether the artist "leads" culture in its changes or has his work passively molded by it. Crowley (in this volume) touches on this problem, while Kubler (1961) takes an opposite viewpoint. When Kroeber (1944) talks about the principles underlying the work of an epoch, say Renaissance painting, he may be committing a historical fallacy by abstracting the configurational preoccupations of the epoch and then attributing them, at a level almost of motivation, to the individual artists of that epoch.

Working with concrete creative situations, as seen from within in a life-history, may enable us to see whether or not this problem is an artificial one. It may help us to understand more clearly the processes of stylistic change as one phase of configurational change.

An effort to shift from an earnest, problem-solving view of behavior to one which includes or even emphasizes intrinsic rewards would welcome such autobiographical materials. If you ask an artist why he works, he may well reply with a stereotype, such as, "For money." While the stereotype may contain an element of truth, doubtlessly it will mask subtler aspects of motivation which the artist does not want, or is unable, to discuss. If, however, he is set to free reflection on his work as a musician or carver, he may reveal, at least indirectly, motives which he could not verbalize when directly challenged.

Autobiographies ought to illuminate that third center with which we are concerned, the artist's role. It is curious how little d'Azevedo has to say about artifacts and styles. One finishes his paper feeling that it is the artist's role which is his real work of art. The nostalgia expressed in the final paragraphs is not for lost arts but for lost culture, for those *jina*, forgotten by the Gola, who are forced into exile in search of human beings who will love them and be willing to make the sacrifices which their gifts entail. One wonders whether this emphasis is the Gola's or d'Azevedo's. Autobiographies might help us reach an answer.

A closer look at artistic roles might give access to a matter which is utterly fascinating but barely touched upon by anthropologists: psychical distance. The implications of psychical distance and its analogues in science and even religion are tremendous. The relation of individual and society ought to be rethought in these terms, as well as the problem of freedom and determinism previously touched upon.

Speaking of the Basongye musician, Merriam says (1964:137), "The musician, though low in status, is in the last analysis a person of very high importance, allowed to follow a role which puts him outside the requirements of normal behavior, and allowed to capitalize upon it. Even in those cases when he goes too far, punishment may be waived . . ." Merriam goes on to say that this "pattern of low status and high importance, coupled with deviant behavior allowed by the society and capitalized upon by the musician, may be fairly widespread and perhaps one of several which characterizes musicianly behavior in a broad world area."

Kaplan (1961:135–6) says of psychoanalytic theory:

It is not that art is thought to be the reward of neurosis but that neurosis is viewed as a punishment for art. The artist is guilty of the sin of *hubris*, taking unto himself the prerogatives of the divine. The arrogance of his passion to create makes him rival the Creator. What God hath put together he tears asunder, to remold it in his own image, nearer to *his* heart's desire. If his efforts succeed, it is only with God's help; inspiration is the touch of God's hand by which the artist becomes empowered to create. But to look upon God's glory is to be smitten with blindness; and he that wrestles with the angel of the Lord becomes lame.

If we equate God, after the manner of Durkheim, with society, we find the quotation expressing the same ambivalence as Merriam's. In addition, it suggests an explanation of the pattern which Merriam describes. Society recognizes the threat to its established patterns which the artist's reconstructions create, and therefore it "punishes" the artist with low status, circumstances that foster neurosis, and the opportunities for deviant behavior. At the same time, it recognizes the work of the exceptional artist as an extraordinary manifestation of the human spirit, or of the divine working through man, and therefore it places its stamp of importance upon those works. It may be that this freeing of the bad boy artist and the development of a feeling for psychical distance go hand in hand, the one reinforcing the other, until the artist is able to play freely with his medium in aesthetic terms alone, that is, he is free to develop psychical distance. One question that arises is whether innovators other than artists—Radin's men of thought, for example—are regarded as being in touch with supracultural sources of inspiration as often as artistic innovators are. It may be that the artist's ability to seize upon and shake the whole of a human being rather than his intellectual side alone produces a tendency for men, regardless of culture, to associate the artist with divinity.

The importance of this for configurational thinking is considerable. We have usually treated the recurrent shapes of behavior as integrative, as having a centripetal effect. We should also consider the centrifugal aspect of culture, its tendency to fly apart, to contradict itself, to remain a seething mixture of irreconcilable principles without collapsing.

What I have to say about the artistic attitude—embellishment, psychical distance—I have already said in connection with role. Looking at this whole complex called art from the viewpoint of appreciation should help to make clear exactly how the artist gets his effects, how

he manages to touch upon the very sources of vitality. Ames' contrast between charismatic musicians like Shata and the nine-to-five court musicians nicely reveals those qualities which make some forms of art an effective presentation of cultural configurations.

It is possible, finally, to look at the system of overlapping circles which is art from the vantage point of aesthetics. If we regard aesthetics in the largest sense as the ability to formulate and be verbally aware of any aspect of art, we can consider some uses of aesthetics which Thompson, rightly enough, did not touch upon.

1) Messenger shows that the Anang theory of artistic talent is far more democratic in its ascription of gifts than ours. What effect does this have upon the size of the audience, the definition of the artist's role, the way values are expressed, the choice of mediums, and so on?

2) Native conceptions of how the circles of art overlap, and of their relative importance, ought to indicate what mediums are most important for the study of configurations. Crowley, for example, was forced by the purposes he set himself to study an art which the Chokwe themselves did not regard as of first importance. While ethnocentric choices of this sort are often inescapable for practical reasons, such choices should never be made for reasons of ignorance. Aesthetics ought to lead us quickly and efficiently into the native way of thinking and feeling.

3) Also, native conceptions of how the circles of art overlap may indicate how those mediums, which we are apt to put asunder, fit together to form art-complexes, shaped more truly or fully along configurational lines than are individual mediums.

4) Finally, native language usages may help give meaning to stylistic characteristics, whose interpretation is more difficult than that of subject matter. Thompson gives a couple of examples. The first has to do with balance; his discussion of this organizational principle is based upon a Yoruba poem.

Examination of the aesthetic elements of this poem . . . reveals that they all come together again on another plane: they are thermal opposites, some of them, whose resolution is actually a formal goal of Yoruba religion. A red feather is "hot," a green leaf is "cool": their symbolic union in the orange-and-green beads which the Yoruba diviner wears about his wrists is one way of saying that the cult of divination is charged with the precise and exact task of finding and establishing balance.

It is clear that a classification of visual powers so systematically developed would not constitute mere function or utility. On the contrary, the moral

is unambiguous: a man of aesthetic sensibilities is a man of happy continuity.

The second example has to do with line.

> ... the basic verb to cicatrize ... has multiple associations of the imposing of human pattern upon the disorder of nature: chunks of wood, the human face, and the forest are all "opened," like the human eye, allowing the inner intelligence of the substance to shine forth. The phrase ... (lit. "his eye is split open") means (1) his eye is open (2) he has become sensible (3) he has become civilized. Thus deeply imprinted upon the Yoruba mind are the civilizing qualities of line.

Finally, I shall discuss the views of art offered by Fernandez and d'Azevedo because these seem especially useful from the viewpoint of an interest in cultural configurations.

Fernandez begins by assuming that our study of culture has been overbalanced on the side of earnestness and instrumentalism and that this imbalance may be corrected by attention to the expressive side of culture, its qualitative aspects. He thinks of art as the creative production of objects or events which have qualitative meaning. In a technical sense, this is not a definition at all. A definition ought not only to mark out what will be included as art but also provide a standard by which good art can be discriminated from bad art. However, the many-centered approach to art makes it unnecessary to boggle over this lack of definition; we are looking for something to study, not something to define. What qualitative experiences constitute art? Or, better, what qualitative experiences does Fernandez decide to concern himself with? In starting with the idea of order, Fernandez explicitly seizes on an idea which underlies all of man's major concerns—"religion," "science," "morality," and "art." While the Fang are not as pre-occupied with the logico-aesthetic integration of experience as are the Hopi, for example, "there are elements in Fang belief of a dynamistic conception of the supernatural and a strong preoccupation with . . . transgressions which are understood as, somehow, a violation of the natural order of things." Fernandez therefore thinks it valid to interpret Fang beliefs as "implying . . . a universal order." One can look at this experiencing of order in many ways. Fernandez chooses to look at it as a qualitative experience, thus bringing it within the scope of his conception of art. He is now free to compare the work of a carver of reliquary figures, a judge of village and intervillage disputes, and a leader of a Bwiti cult because all of them are qualitatively concerned with the exposition or imposition of order.

It will . . . be argued that the status of these artists increases with an ever widening sense of order that they are able to expose and does not exclusively relate to their ability to impose order. In either case their status lies in their capacity to make their art socially relevant, to see in other words, that the meanings they have created in the manipulation of symbols make an impress upon activity. Here the advantage of the artist as ritualist over the artist as worker in plastics is apparent.

Some might hold that this extension of the concept of art from carver to troubador to chief judge of palabras and cult leader is confusing and destructive of useful distinctions, such as that between art and religion. Fernandez himself anticipates the criticism by suggesting that although the cult leader's status is backed by his relation to the universe conceived as a moral order, "this conception of the universe rests upon, in fact is created by, his aesthetic capacities. Artistic activity precedes as much as it succeeds religious meanings. The religious emotion may be a kind of aesthetic appreciation in respect to an ordering of symbols created through artistic activity." If one goes back to the primal qualitativeness of the experience of order, "culture is aesthetic preference drawn large"; this does not exalt art over religion, but it does make clear that both art and religion are pigeon holes, or, better, pidgin holes, and that arguing about whether behavior belongs to one or the other is meaningless. We are justified in following out the implications of the Fang manipulation of complex symbols wherever they may take us. The usefulness of this for anyone concerned with configurations—a term I put with art and religion—is obvious.

The approach which d'Azevedo takes is similar in its open-mindedness. He thinks of art as the manipulation of expressive and qualitative symbols to the end of producing objects intended for appreciation in aesthetic terms. By "appreciation in aesthetic terms" he refers to qualities which are appreciated in themselves as objects of special enjoyment and display. The artist is the individual whose intent is *predominantly* focused on gratification of aesthetic interests. This enables d'Azevedo to draw a wavering line between individuals who are engaged in artistic activity and those whose activity shows only a certain amount of artistry. Of this wavering line, d'Azevedo says, "Thus, the skilled craftsman or entertainer, though engaging in the exploitation of media and forms which we normally associate with art, is not necessarily an artist unless his personal orientation and skills are directed to the production of an object of a particular kind." What particular kind of object is called for? At least it is clear that the production in certain mediums or certain forms is not enough to qual-

ify a person as an artist. After discussing the behavior of a remarkable old man, a man of position and power, a unique personality, an opportunist, but also a person capable of toying with his role in various ways, partly for his own gratification, partly for that of others, but always without losing dignity, d'Azevedo decides that despite the artistry which the old man shows, he cannot qualify as an artist. What he needs to qualify as an artist is a "distinctive role and style."

For an individual to be considered as *an artist* it should be possible to demonstrate that artistic activity is not merely an aspect of other roles which predominate in his participation in society, but that it constitutes a role in itself recognized by himself and others. This requires, among other things, that we can ascertain some consistency of performance, some regularity in production, and some stabilization of unique attributes, all of which we think of as style.

Again he says,

Art and the artist appear in societies where there is a clearly differentiated system of values, objects, and roles which have primary esthetic and artistic functions. Institutionalization in this sphere of Gola culture is less developed than it is in our own or in other complex cultures. Nevertheless, incipient institutionalization of esthetic-expressive behavior does exist, both implicitly and explicitly, in Gola society, and these systems are at least analytically separable from other systems of behavior.

The kind of person whom d'Azevedo identifies as artist, and whom the Gola recognize as a relatively distinct type, seems to occur most frequently as a participant in singing, dancing, instrumental music, storytelling, performance of magic, blacksmithing, woodcarving, and weaving. d'Azevedo is careful to point out that all of those who take part in these activities are not artists, nor are artists limited to these activities alone.

The role of the artist combines two orientations. "The first is that of the artist in the service of art, committed to ideology and course of action for its own sake and in terms of its own values. The second is that of the artist in the service of society with major reference to deferred ends such as personal aggrandizement or social contribution." The archetype of the artist in our culture is derived primarily from the qualities of the first orientation. The assumption is that this is also true of the Gola archetype.

d'Azevedo summarizes the Gola archetype in terms of six general categories: the concept of creativity, the motivation of the artist, his deviant behavior, matters of skill and style, and the objectification of

artistic values through dramatization of a way of life and the concrete productions of artistry.

It is especially interesting that this system of values, objects, and roles for the Gola has about it an element of contraculture, that it gives "primacy and explicitness to motivations and goals which run counter to the ideal moral precepts underlying the basic institutions of society." This is reminiscent of Merriam's remarks about the musician.

It may be said that both Fernandez and d'Azevedo were lucky in hitting upon cultures with highly developed configurations which could be handled in this way. The art of other cultures, however, may be more pedestrian. This view, as d'Azevedo shows, is too simple. If art is to lead to a grasp of the larger configurational aspects of culture, we must resist the tendency to be satisfied with conventional conceptions of art. d'Azevedo accomplished this resistance for two reasons. First, he noticed that the work-of-art conception of art got him involved, not with artists, but with craftsmen and others who did craft work for recreation or utility. It was therefore necessary to reverse the usual order. He did not come at the artist through the work of art but at the work of art through the artist. He points out that finding the artist in another society is no less difficult than finding the artist in our own. Second, he could easily have confined himself to a work-of-art definition of art because the Gola themselves have a term *ne fɔno* (something imitated or portrayed), which designates at least the products of visual art. Despite these allurements, he was able to go beyond these obstacles and discover, still in the name of art, far more significant aspects of Gola culture.

Fortunately, having discovered the Gola artist and having located the mediums in which he prefers to work, d'Azevedo does not intend to ignore the products of his skill. He promises to tell us more about the works of Gola art which issue from this conception of the artist's role. Not to have, finally, a full presentation of Gola art would be a great disappointment.

John Ladd

CONCEPTUAL PROBLEMS RELATING TO
THE COMPARATIVE STUDY OF ART

MANY puzzles and paradoxes seem to arise when we try to apply the category of "art" to tribal cultures. On the one hand, it can quite plausibly be maintained that these societies have no art at all—in the full blown sense of art as we apply it to Western art; on the other hand, there are certain products and activities found in tribal societies which naturally seem to come under the category of art, although it is sometimes, with condescension, called primitive art.

It is always tempting for anthropologists to ask whether or not an interest in art and the production of art is a universal trait of mankind to be found, in one form or another, in every society. In this connection, it seems plausible to maintain that aesthetic activities of some sort or other constitute a significant part of human life, individual and social, and that we may expect to find them *in some form or other* in every society. But here again we face the question: are we really talking about *art*?

Anthropologists are particularly conscious of the difficulties raised by questions about "tribal art," because, on the one hand, they must be on their guard not to impose Western categories of thought (and value) onto their data, and yet they are anxious to vindicate the position that native societies have, in their own special and unique way, discovered and developed aspects of human experience that have a high significance and value of their own. The more of a relativist one is, it would seem, the more of a dilemma this becomes.

Simply put, the question before us is: is tribal art "art"? And the answer is, obviously: Yes and No. (We can, of course, ask the same question about music: is music art? Yes and No!) It is important to see that this is not a question that can be settled by collecting more data, for it is a question that still persists after we have all agreed about the facts.

417

It would seem that all we have to do to settle this issue is to agree on a definition of art, for the question appears to be only a verbal one. But this is precisely what cannot be done, because of the nature of the concept of art and of the other related concepts such as aesthetic quality, experience, taste, etc. Concepts such as these simply cannot be defined in the way we are demanding that they be defined.

Aesthetic, Ethical, and Scientific Concepts

During the past few years, philosophers have become increasingly interested in the peculiar features that render certain kinds of concepts incapable of clear-cut definition. This is a development that is associated with the later Wittgenstein and the rise of so-called Ordinary Language philosophy. It is a reaction against the earlier logical positivist thesis that meaningful concepts must be susceptible of rigorous definition by means of symbolic logic in empirical terms. In effect, the newer philosophy gives full recognition to the fact that there are some valid, rational concepts that are not strictly definable in scientific terms, but still have some interesting and distinctive logical properties of their own.

Some of the puzzles that I have mentioned arise, I believe, from failure to recognize that the concepts with which we are dealing, viz., aesthetic concepts, are inexact, fuzzy concepts that are quite different from scientific concepts or other kinds of concepts that are susceptible of exact definition. Wittgenstein (1953) compares the attempt to define such concepts with the attempt to "draw a sharp picture corresponding to a blurred one . . . Anything—and nothing—is right. . . . And this is the position you are in if you look for definitions corresponding to our concepts in aesthetics and ethics." One moment's reflection on some of the definitions that have been offered of "work of art," "beauty," "aesthetic experience," etc., will, I think, show this to be true.

Aesthetic and ethical concepts are distinct from purely descriptive, empirical concepts in that they a) are open-textured, b) are multifunctional, c) involve criteria, d) are essentially contestable, and e) employ persuasive definitions.

To begin with, the kind of concepts we are discussing are "fuzzy," "inexact," or "open-textured." That is, they are complex concepts involving a congeries of qualities no one of which is sufficient for the concept to be fully applicable. Compare the concept of an acid, chemically defined, with the concept of a friend. The first can be given a

rigorous scientific definition, but not the second. We obviously run into difficulty when we try to define "being a friend," for as soon as we fix on any particular quality as necessary for a person to be a friend, we have started to distort the original conception itself. It is essential for a concept of this sort to be left open-ended, so to speak. "Being a friend" refers to a cluster of qualities, and if a person has a lot of them, then he may be considered a friend. Indeed, part of its usefulness as a concept is due to its "open-texturedness." Precisely the same kind of open-texture is found in concepts like "art." It has to be open-textured so that it can be used for a number of different things, which, however, may resemble one another in various important ways.

A second aspect of aesthetic concepts is that they have several other logical functions in addition to that of describing the object to which they are applied. For example, they are a kind of value concept, and as such they have an "appraisive" function. To characterize an object as a work of art is to commend it, to praise it, to single it out for special attention and consideration, and so on. In other words, "work of art" is an honorific term. There are, of course, some contexts in which "work of art" may be used purely descriptively, say, to locate it in a museum or in an art store, but this fact merely illustrates once more the open multifunctional character of the concept. It is quite clear that many debates over whether a certain object, or type of object, is to be considered "art" is basically a question of how the object is to be appraised; *e.g.*, "Is abstract painting really art?" in effect means: "Shall we accord it the same consideration as we give to works like the paintings of Rembrandt, Cezanne, etc.?" I hope that no one thinks that *this* is a silly question that can be settled easily by means of a definition of words.

A third interesting aspect of the concepts under discussion is that they are articulated, that is, they are constituted by and formed out of various qualities, which qualities themselves serve as criteria or reasons for the application of the concept. Thus, in the example of "friend," there are many criteria (say, facts about a relationship) that can be used to justify the use of the term "friend." Discussions and debates about whether or not to use aesthetic or ethical concepts generally consist of mentioning such constituent qualities as criteria. They form the rationale behind one's use of the concept. This peculiar trait of these concepts makes them in a sense "rational" rather than merely "emotive" concepts. Accordingly, if someone describes an object as a work of art, he must be ready to say *why* he thinks it is so, and to do this he

must refer to some of those qualities of the object which justify its being so-called because they are "criteria of a work of art."

Another important aspect of an aesthetic or ethical concept is that its application is essentially contestable (Gallie 1968). That is, there is something about the concept that creates meaningful and rational debate about whether or not it should be used for an object. This is obviously true about the concept, "work of art," for there are many occasions in which there is something to be said both for and against calling an object a work of art, and a debate over the issue may be immensely rewarding.

Finally, the use of definitions in discussions about art and ethics is quite different from their use in science. In contrast to scientific discussion, definitions of the former lay down as essential to the concept being defined some of the qualities (or criteria) that can be used to back up the claim that the concept is applicable. In effect, such a definition incorporates the definer's own standards into the concept being defined. Thus, definitions in aesthetics and ethics endeavor to close down the debate by prescribing in favor of one of the contestants. In Stevenson's words, such definitions are "persuasive definitions."

In any "persuasive definition" the term defined is a familiar one, whose meaning is both descriptive and emotive. The purport of the definition is to alter the descriptive meaning of the term . . . but the definition does *not* make any substantial change in the term's emotive meaning. And the definition is used, consciously or unconsciously, in an effort to secure, by this interplay between emotive and descriptive meaning, a redirection of people's attitude. (1944:210)

The peculiar logical properties of aesthetic and ethical concepts explain why they do not behave logically in the way that other kinds of concepts do, *e.g.*, scientific concepts. Any anthropological investigator of tribal art must take the special logical features of aesthetic concepts into account, for if he does not, all sorts of paradoxes and puzzles will arise.

Let me illustrate this by a very crude example. Someone might propose as a subject of investigation the thesis that people in every society and culture have "aesthetic experiences." Now bearing in mind the appraisive function of the word "aesthetic," this statement amounts to something like this: "all people have significant and valuable experiences of a certain type." This, I submit, is a value statement and not strictly an empirical statement at all, and it cannot therefore be settled by reference to ethnological facts. Indeed, the facts may be

entirely irrelevant to the issue. On the other hand, if one attempts to neutralize the definition, i.e., to make it purely descriptive and non-appraisive, the thesis will become either trivial or vacuous.

Anthropological Investigations of Art

Taking into account the nature and function of aesthetic concepts, there are logically three entirely different types of inquiry that can be undertaken by the anthropologist interested in tribal art. (It may be noted that actual anthropological studies of tribal art often quite legitimately combine these approaches, for reasons that will become obvious presently.) Art may be approached a) from the point of view of the native informant, b) from the point of view of the art connoisseur, and c) from the point of view of the social anthropologist interested in tracing connections between certain kinds of activity (behavior) and other parts of the culture, such as institutions, rituals, roles, etc.

DESCRIPTIVE AESTHETICS

I shall use this term to stand for the inquiry into the aesthetic ideas of another society without regard to the "validity" of the ideas themselves. Thus, like Robert Thompson, we may be interested in finding out about the "aesthetics" of the Yoruba. In view of what I have already said, such an inquiry must not only report judgments, evaluations, and appraisals of the informant, but also must provide an analysis of the concepts themselves. It seems to me that it is quite unlikely that our own concepts, *e.g.*, of art, will also appear in native thinking. After all, the concept of art itself is of very recent origin even in Western thought. What we must do is to discover those native concepts that have a logical function in their evaluative discourse, concepts that in some way resemble or are analogous to our own. In this sort of inquiry, we must always keep in mind that, inasmuch as the concept itself is appraisive and individuals' appraisals differ, the concepts themselves will inevitably vary from individual to individual, and *a fortiori* from society to society. Of course, we should not overlook the possibility that there may be some societies which do not have anything resembling our aesthetic concepts at all.

It should be noted that one rather distinctive aspect of our ordinary aesthetic concepts, applied, for example, to a work of art, is that the kind of appraisal they involve is quite different from simple appreciation. Aesthetic judgment is distinguished from simple enjoyment, for

it demands reference to the qualities of the object. This means that, in contradistinction to reports of likes and dislikes, aesthetic judgments have to be justified, reasons given for them. For this reason, I should think that one of the minimum conditions of "an aesthetic" is a set of concepts—criteria—which can be used for the justification of aesthetic evaluation.

Since aesthetic judgment, as distinct from liking or enjoyment, requires discrimination and perception of the qualities that make up the criteria of, say, a work of art, we have to distinguish the expert-judge, or critic, from the layman who merely likes or enjoys the art object. Thompson has shown us how the expert's evaluations differ from those of the layman among the Yoruba. Some of the other papers in this series, however, fail, it seems to me, to distinguish adequately lay opinions that are really only statements of personal preference, or general utilitarian valuing of objects, from the critical opinions of the art-expert. (Words like "beautiful" and "good" in our language, as well as their equivalences in other languages, generally are used to express general approbation for many reasons other than aesthetic ones. One must therefore be careful not to be misled into thinking that the informant who uses these words is making an aesthetic judgment.)

I have not said much about particular aesthetic concepts such as the concept of a work of art. The general line of my argument is to the effect that such concepts can only be analyzed differently for different cultures, not to mention subcultures.

THE ART CONNOISSEUR

Next we must consider the type of inquiry that is undertaken by the art connoisseur. His principal aim is to appreciate and understand a work of art, and thus to evaluate it. Thus, although scientific knowledge may serve as aids, his basic aim is not scientific in the strict sense. For the art connoisseur art is transcultural; art knows no cultural or sociological boundaries, nor does it respect temporal ones. The true art connoisseur is able to appreciate Greek architecture, Renaissance painting, and African sculpture, as well as works of art from his own culture.

Now it is a frequent mistake of art critics (e.g., the "new critics") to assume that it is possible to appreciate a work of art without knowing such things as the artist's intentions. In the case of African art, it has frequently been pointed out that one cannot really understand a

piece of sculpture, without knowing the cultural and social context for which it was intended. Indeed, simply the symbolic or representational aspects of a work of art require some knowledge of the ideology of the society in which it was made. It seems obvious to me that it would be impossible fully to appreciate a medieval painting of the crucifixion without knowing the story. Why should one expect to appreciate a piece of tribal art without having a similar kind of knowledge?

Not only is anthropological knowledge necessary in order to understand the subject-matter of a work of art, but, as Thompson points out, some acquaintance with the natives' aesthetic criteria is required even to be able to perceive and discriminate the surface qualities of the object itself. In general, then, some knowledge of the aesthetics of the artist's own culture would seem to be a prerequisite for any kind of critical appreciation or evaluation of a work of art.

The chief point that I want to stress in connection with what I have called the art connoisseur's approach is that it cannot be undertaken in a vacuum, but can be followed only by someone who understands the native background of the art as thoroughly as he does the general principles of art criticism.

SOCIAL ANTHROPOLOGICAL VIEWPOINT

I want to discuss here an inquiry which seeks primarily to understand and explain the native culture as an articulated whole and the sociological structure of the society in all of its complexity. It is mainly interested in such things as social roles and positions, social relations and interactions, social mechanisms and functions, and so on. Art is obviously sometimes extremely important for inquiries of this sort, although perhaps it is not always so.

For purposes of discussion, I shall coin the term "art-object" to stand for the sort of phenomena that interests the social anthropologist, by which I mean an artifact (or activity) that has a prima-facie resemblance to a work of art. Art-objects are objects that resemble works of art in some respect or other, even though they need not be works of art themselves. Sometimes the resemblance can be quite superficial; it might be a purely physical resemblance like that of being a painting; not every painting is a work of art, but it would be an art-object. Similarly, ten-cent-store carved figures or pictures would be art-objects. In other words, I want to use "art-object" as a kind of blanket term for objects of certain kinds without regard to their

aesthetic quality or to how they might be appraised by art specialists. It is merely a convenient name to help in gathering data. Its value is purely pragmatic.

I do not want to define "art-object" further as I propose to use it here, nor is there any need to do so. The term serves no theoretical function in theoretical analysis of social phenomena. Once the material has been collected, we can throw it away, for it no longer has any use. Thus, art-objects function very much like the category of religious beliefs—they are primarily collecting and cataloguing devices. Just as for the anthropologist the question of whether beliefs about ancestors should be regarded as a religious belief is a pointless question, so the question of whether, say, a knife is to be regarded as an art-object is equally pointless. Once we know what the beliefs are and what the objects are, and how they function, what they are called by the anthropologist is a question of no theoretical import. Nothing hinges on the label religious or art-object.

In every culture there are certain nodal points, that is, points at which important strands of a culture seem to intersect and that, as a consequence, serve as focal points for understanding the culture. Among the Navahos, for instance, the ceremony called Blessing Way serves as such a point which enables us to get at the heart of the culture. From the reports that I have read about African art, it seems to me that in some African societies, certain kinds of art-objects act as nodal points of this sort; certain musical activities also seem to be nodal points where many facets of the culture come together.

If this is so, then we can use an investigation of certain art-objects as a jumping off place for a study of social relationships and rules, and other social aspects of the culture. This, it would seem to me, is what a great deal of the research in the papers before us is all about.

It should be noted that from this point of view, aesthetic categories and aesthetic concepts *as such* are not essential at all, for, as I have pointed out, they do not serve any theoretical or logical function in this particular kind of inquiry. They are merely ancillary to it.

In closing, I should like to repeat that there is no reason why a single individual anthropologist cannot pursue all three kinds of inquiry at the same time in practice. There are obviously practical reasons why they should be combined, since their findings obviously supplement and complement each other. I have tried to point out here that there are three rather different kinds of objectives and methods corresponding to them, and that certain puzzles and paradoxes arise if they are not kept separate logically.

Roy Sieber

APPROACHES TO NON-WESTERN ART

THE papers in this volume raise—directly or by implication—many of the problems that beset the researcher into the arts of any place or time. Many of these problems have been recognized and solved exclusively with regard to the arts of the Western world. Useful as these conclusions may be for the study of Western arts, it does not follow that the results are necessarily universal in their application. Even a cursory examination of the writings of Western critics would seem to indicate that their conclusions do not apply cross-culturally, or to state it a bit more broadly, the cross-cultural applicability of universals developed within the Western world is not established.

Ladd has noted in his commentary in this volume that Western researchers frequently transfer their own attitudes regarding art to the non-Western societies they examine. The other papers in this volume amply demonstrate his point. d'Azevedo states the case rather carefully when he notes that his discussion concerns "a particular type of individual among the Gola who is immediately recognizable in terms of our concept of the artist." In contrast, Merriam and Vaughan have dealt with societies wherein aesthetics and/or artists or even art, as defined in Western terms, would not seem to exist. But can we establish a continuum of art to nonart (and, concomitantly, artist to nonartist, aesthetics to nonaesthetics) into which we can fit each society as it is studied? Does the Gola artist validate the universality of application of our definition of artist, or is it a chance correspondence, an accidental congruity that in fact clouds the issue?

Of primary importance to these studies are the definitions of the terms art, artist, and aesthetics. The confusions surrounding the terms are due in part to the value judgments contained in most definitions. Again, Ladd has outlined the problem in his discussion. I am concerned and doubtful about the use of these crucial terms in most of the papers. Most of the authors carefully established a definitional

base: their method is sound; their discipline impeccable. Indeed, the method of anthropology, art history, or any other discipline—scientific or humanistic—is to establish a clear-cut verifiable basis for recording data and offering hypotheses. My point is that the critical weakness of this approach evident in these papers lies in the nature of the definitions of art, artist, and aesthetics. Indeed, the charge of ethnocentrism can be laid against this aspect of most of the papers. The application of Western concepts of aesthetics and Western definitions of art, evident in writings of early travelers, missionaries, and colonials, are as common in studies of anthropologists, museologists and art critics and historians. Researchers in all these areas have been guilty of the sin of ethnocentrism, from Pigafetta in 1599 to, I fear, the writers of some of the papers in this volume. Definitions of art and of aesthetics which have been developed in the Western world contain value criteria derived from Western attitudes. These definitions have been applied to sub-Saharan African arts with the inevitable result that our understanding of those arts has been warped.

I am *not* protesting the cross-cultural application of definitions, constructs, or concepts as disciplinary tools. But when they are based upon or contain value judgments derived from the culture of the researcher, overtly or covertly, the results are skewed if not pejorative. As I will argue later, if these concepts are indeed un- (or non-) scientific, they must not be utilized as if they were exact and scientific. And this is precisely how some of the papers do use them. Were we exploring the relationship of the traditional African artist to the contemporary Western artist, using the latter as a base, such usage might be valid. Were we exploring the relationship of traditional African art to contemporary Western definitions of art, the usage might be condoned. Were we attempting to discover if Africans have an aesthetic comparable to that of the Western world, the method is useful (see Merriam 1964: Chap. XIII). If, however, we are at all concerned with the larger problems of artist, art, and aesthetics and attempting to view them cross-culturally, we must re-examine our ground rules.

The remainder of this discussion will be concerned with a few of those ground rules. There is little in the following notes that can be considered subtle, innovative, or definitive. Rather they are suggestive and exploratory, appealing for the initiation or development of areas of research that perhaps can extend our understanding of African arts and possibly of the nature of art itself. I shall deal with five points: 1) the nature of "response" and the question of confining investigation

to verbal responses; 2) the audience; 3) the artist; 4) historical problems; 5) the compilation of open-textured definitions.

Aesthetic Response

The terms aesthetics or aesthetic response are misleading for they contain at least by implication the concept of beauty and the context of Greek art. Further, Merriam has shown that the careful application of a complex Western definition of aesthetics must bring the researcher to the conclusion that certain groups have—by that definition —*no* aesthetic (1964: Chap. XIII). Mind you, the argument is not that the people have no aesthetic (*i.e.*, no response to, or evaluation of, in this case, music) but that by a definition perfectly acceptable elsewhere they cannot be proved to have that particular aesthetic. This is a useful observation, but aids us little in our attempt to understand either the responses of a particular society or the nature of the aesthetic response taken broadly except to raise two major questions. Is our definition of aesthetics broad (or universal) enough to prove useful when applied cross-culturally? Are our tools of assessment sharp and subtle enough to explore this area? Would it not be wiser to set aside at first the problems surrounding a full definition of aesthetics, to explore as thoroughly as possible the responses elicited by works of art and assess these responses, and then perhaps to reconsider the problem of definition? The authors generally assumed that *verbal* responses are necessary; that for an aesthetic response to exist there must be a word, or words, to describe it. Crowley, for example, states in his paper: "I do not believe that an individual or a society can feel strongly about something they never mention, or for that matter, have no words to describe."

The aesthetic systems reported in the papers by Fernandez and Thompson for the Fang and Yoruba, respectively, certainly attest to the fact that in sub-Saharan Africa responses to peoples, places, and situations—including works of art—may be verbalized. Yet the experiences of Merriam and others (and my own) indicate the difficulty or even impossibility of dependence solely on words as (a) a prerequisite to the identification of any response or attitude, or (b) a necessary part of the definition of aesthetic.

It seems to me that responses to objects, acts, or sounds which are gestural rather than verbal might be significant, that such responses need to be identified, recorded, and eventually assessed as part of the

larger problem of identifying the nature of the aesthetic response. Certain gestures exist in our society which, in the ordinary course of events, are not verbalized. Many, perhaps most, of these are not necessarily indicative of an aesthetic response, e.g., shaking hands, tipping one's hat; yet in each case refusal to perform the gestures can be taken as significant. For example, refusal to shake hands could be interpreted as a gesture of enmity; or failure to tip one's hat could be thought to be a boorish act. At the same time, many explicit gestures of approval and disapproval do exist, ranging from applause to nose holding. Still other gestures may be described as empathic or kinesthetic. The reasons for some may be verbalized quite easily, but for others we would be hard put to find an explanation from among the members of our society.

Thompson states: "When a master carver impugns the abilities of a lesser carver his gestures and facial expression can be as eloquently derisive as his words." At another level, Ames indicates that the size of a Hausa audience is a response mechanism reflecting the popularity (assessment of value) of a musician. There seemed to be agreement among the observers writing in this volume that gestural responses, echoing value judgments, do indeed exist. Thompson even suggests that, for the Yoruba, the gestural responses were possibly more general than verbal responses. Specific indications ranged from snapping fingers or rubbing thighs to certain vocalizations such as chuckling or an exaggerated "yes."

I have suggested elsewhere the term "unvoiced aesthetic" (Sieber 1959) to refer to cultural situations wherein the bases for evaluation are broadly shared and there exists no need for a specialized vocabulary for subtle aesthetic dissection. Merriam (1964:271) rightly points out that " 'unvoiced esthetic' is a contradiction in terms within the normal Western usage of the word 'aesthetic.' " This contradiction was, in essence, deliberate; an attempt to indicate the shortcomings of the Western definition of the term, most specifically the lack of universality of application.

I would argue that the entire mechanism of identifying and recording responses be reconsidered. Verbal responses are unquestionably of great utility, but other types and levels of response, or indeed absence of response need examination. In general, field studies of the arts of sub-Saharan Africa have been neglected. Where they have been treated, usually as an aspect of religion or of material culture, emphasis has been placed on the object or act (i.e., the figurine, mask, dance, tale, music, or musical instrument) and the technique of its produc-

tion. In short, emphasis has been placed on the products, the works of art. The behavioral aspects, including the aesthetic or evaluative aspects of their creation and reception, have been all but ignored. In response to the two questions raised above, we must both refine our tools and broaden the base for our research into the aesthetic response. I suggest this broadening begin with research into responses rather than the definition of aesthetics by an extension of our investigations into the area of nonverbal or gestural responses to avoid the ethno-centric limitations of the verbal response as a necessary part of the definition of aesthetics.

Audiences, Critics, and Informants

Secondly, we must reconsider the informants whose responses to so-called works (or acts) of art we record. We tend, in the Western world, to an ambivalent attitude in this respect: we acknowledge the critic's specialized voice, but retain the right to individual responses and judgments. In our compartmentalized world there are few areas where we are willing publicly to voice our own judgment as equally authoritative with that of the specialist, yet we resist ascribing the right of authority to trained experts in ethics and aesthetics to a degree that we would think indefensible were we concerned with medicine, crystallography, atomic physics, or electronics (including the TV re-pairman). We passively accept the right (and value?) of a physician's or physicist's views on ethics or an actor's or athlete's paid opinion of a particular brand of cigarettes. We do not remove our child's tonsils or teach him New Math, but defer to the appropriate specialist; yet we do guide his ethical development and freely warp his view of art.

Western art studies and criticism are so confused on just who has the right to make judgments and speak with authority that perhaps it is only with cross-cultural studies that resolution lies. Few studies of audience responses exist anywhere in art studies. Africa offers a prime field example for such studies for we can no longer question the audiences of Praxitiles or Michelangelo.

With the exception of Thompson's paper, little has been done to study African audience reactions systematically. His paper raises a world of possibilities. Not only can we use his technique to reach an aesthetic for a particular group; we can, as well, learn something of the role of the art form outside its official position as a ritual object. The following are my notes on some areas of potentially fruitful research that his paper introduces.

A) The subject. It is necessary to know the exact relationship that obtains between the test subject and the object, sound, or act to which he is responding. Certainly significant differences would occur in the responses to a mask, for example, if the subject were: the artist; a rival artist; the owner; a cult member; a member of a rival cult; an adult male; an adult female; a child; or other.

B) Are there formalized group responses distinct from individual responses? Is, for example, the response *in camera* of an adult male or female significantly different from his or her response as a member of a group, be it a society or simply a random audience?

C) Can one expect more knowledgeable or systematic responses from the artist/performer subgroup? If so, do responses of such groups reveal a specialist vocabulary? Is the response based on techniques (skill) or on other aspects of the work such as consistency or symmetry? Is the subgroup an in group which is set apart (or sets itself apart) from the society *because* of its specialization?

D) Are there critics? In what way are they to be distinguished from other members of the audience? Is their role ascribed or achieved? Is it related to patronage? Are their responses credited by the other members of the audience? Are their conclusions (judgments) respected?

E) Does patronage affect assessment?

F) Does usage and function affect assessment?

G) Are there aesthetic illiterates?

Systematically collected data on such points as these could, I firmly believe, give us far better insights into the responses to works or acts of art and quite possibly could set us on the road to cross-cultural aesthetics. Further, we must use a comparable approach to discern the particular nature of art and the artist. To date we have transferred our Western concept of Fine Arts to the African. Thus we value sculpture more highly than pottery or weaving. But have Africans established a hierarchy among the arts? If so, is there general agreement upon whether or not it coincides with Western values?

The Artist

In several of the papers the artist is characterized by a distinctive status, or social distance from the rest of the group. This would seem to raise a number of interrelated questions. Is the artist invariably at a distance from his culture? Is this status based on his actions or on his role, *i.e.*,

is it achieved or ascribed? What interactions exist between the artist and his product (the work or act of art)? Seemingly the artist occupies a low status socially, but his works are held in high regard. The artist is often depicted as "different" (Vaughan), of a low class (Ames), or as very nearly the antithesis of the "ideal" member of society (Merriam); yet he produces objects or performs acts which are not only welcome in the society but which often, perhaps usually, reinforce the norms of that society. This is, to me, one of the most provocative points arising from the papers: the distinction made by his culture between the artist and his works. It may indeed be crucial to our understanding and ultimately our definition of art and the artist in any society at any time.

Historical Aspects

In general, anthropological studies tend to stress or confine themselves to the ethnographic present. Rarely do they take into account, nor indeed do they search after, the historical bases of the cultures they describe. Nevertheless, historical aspects of the study of artists and art in sub-Saharan Africa are of potential worth for a variety of reasons. The character of the arts of a particular group is, of course, the end product of an historical development. Knowledge of that development would aid in the understanding of materials, tools, style, form, and function. Further, it may well prove to be a factor in the response mechanisms discussed above. In addition, study of the arts may contribute to, as well as profit from, historical reconstructions.

African sculpture, for example, is usually treated as a tribal phenomenon, presented in terms of geographical distribution with little or no consideration of time depth. Obviously this has proved a useful mode of analysis where style is the major consideration. However, Bascom has shown that it is too limited an approach, particularly when art forms other than sculpture are considered (Bascom 1969b). In short, a reconsideration of even the most generally accepted modes of analysis are in order.

It might be suggested that nearly all of the papers in this volume could profitably have included an historical dimension. The following questions are indicative of the kind of historical inquiry that would prove useful.

(AMES) How closely does the hierarchy of musicians among the Hausa echo that in other Islamic states in West Africa, North Africa, the Near East?

(CROWLEY) Is it possible to reconstruct the dispersal of Chokwe groups? In what ways are these arts affected by this dispersal contact with other groups and by their somewhat militant history?

(MERRIAM) How were Basongye arts affected by the breakup of the Basongye during Arab slave wars and the re-establishment of villages afterward?

(VAUGHAN) Is the specialist caste system among the Marghi related to that found further west?

(MESSENGER) Are the cultural and artistic interactions of the Anang, other Ibibio groups, Ibo, and Cross River groups recoverable?

(FERNANDEZ) Would a study of the migrations of the Fang help in the understanding of style variations?

(D'AZEVEDO) How do the Gola fit into the history of the fairly widespread distribution of the so-called *Poro* Society?

Open-textured Definitions

Ladd points out the difficulty of establishing precise definitions of concepts that are by nature imprecise: ". . . art and . . . other related concepts such as aesthetic quality, experience, taste, etc. . . . simply cannot be defined in the way we are demanding that they be defined." He describes these as "inexact, fuzzy concepts that are quite different from scientific concepts or other kinds of concepts that are susceptible of exact definition." In short, the search for and argument of exact, scientific definitions is fruitless for the concepts "a) are open-textured, b) are multifunctional, c) involve criteria, d) are essentially contestable, and e) employ persuasive definitions." Ladd suggests that the collation of a cluster or congeries of concepts relating to the terms under question (art, artist, aesthetics) would be more useful than further attempts to define the terms scientifically.

It is clear that the contributors and discussants of this volume wish to explore the possibility of more open-textured definitions of art, or a cluster of concepts, as a working basis for further research. The following notes are an attempt to summarize these exploratory views as expressed in discussion and in the papers of the contributors. Admittedly, my own prejudices have affected the selection and evaluation of the materials discussed below. It is crucial to note, however, that a definition is not being attempted, but rather presentation of a congeries of qualities. Thus art may be said to equal the sum of all or part of A plus B plus C plus n (where n is any number of as yet unidentified concepts). In short, no one of the following concepts is indispensible, yet

several (no fixed number or fixed grouping) can be used to identify "art."

A) Art is man made.

Two significant qualifying points must be made here. First, we cannot expect full agreement on any or all of the criteria, and there are substantial differences among societies on this point. While the Basongye apparently consider only the products of man to be art and therefore do not call the song of a bird music, we now call "found objects" art. Yet only a few decades ago the Western world would have rejected this concept. Thus our second qualification must be that even within a single society changes may occur which upset or cause rearrangement of the cluster of concepts of any society.

B) Art exhibits skill.

C) Art exhibits order (pattern, design).

These two points are not necessarily compatible. Skill, as such, does not necessarily result in order. An ordered form may be unskillfully presented.

D) Art conveys meaning.

Terms such as iconography, symbolism, representation, and abstraction become pertinent here. *Meaning* is not always legible cross-culturally, need not be tied to representation or symbol, may be carried associatively and not "exist" in the object, sound, or act itself.

E) Art is the product of conscious intent (including motivation). The intention of the artist involves more than the work of art, *per se*. It may carry a variety of levels of intention: to produce a "work of art"; to entertain; to inspire; to please a patron or audience; to shock or horrify (as, for example, some Yoruba Egungun masks; Thompson refers to this as anti-aesthetic); or simply to earn a living. A further point relates to the difficulty or impossibility of discerning intention when the artist is not available for study. Can we, in fact, discuss or assume intention with regard to archaeological arts?

F) Art is affective (feeling-tone, emotion, affect).

Apparently art does persuade, move, or arouse an emotional response. But we have little knowledge of the nature of this response as I have noted above. How much of the affect of art is contained within the work? How much is associative, relating to meanings and/or responses aroused indirectly by the object?

G) Art conveys a sense of unity, wholeness.

The sense of unity or wholeness is certainly a criterion of twentieth-century art criticism, but is it a universal? Can a work of art be cumulative, as, for example, a medieval cathedral?

H) Response is immediate.

Immediacy may be a twentieth-century concept. Could not the aesthetic response itself be cumulative? Is the concept of immediacy related to the concept of unity?

The points raised here no more than open the discussion. It is entirely possible that through apparent contradictions we can delineate concepts larger than any of the ones listed, but which may contain seemingly antithetical points. An entirely revised definition of art may be possible.

Yet it seems at this point fruitless to speculate further. In all of the points raised in this paper I have been concerned not with solutions *per se* but with suggesting modes of approach and areas of research which will, hopefully, lead to a better understanding not only of the African artist and his works but of art in general. Then through careful examination and testing in the field we can discern the presence or absence of a criterion and understand its definition or interpretation in various cultures.

BIBLIOGRAPHY

Abel, Theodore
 1929 Systematic Sociology in Germany. New York: Columbia University Press.
Abraham, R. C.
 1958 Dictionary of Modern Yoruba. London: University of London.
Achebe, Chinua
 1959 Things Fall Apart. New York: McDowell, Obolensky.
Adler, Franz
 n.d. Toward a Sociology of Creative Behavior. Mimeo.
Adorno, Theodore W.
 1939 Über den Fetischcharakter der Musik und die Regression des Hörens. Zeitschrift für Sozialforschung 7:321–36.
Aldrich, Virgil
 1963 Philosophy of Art. Englewood Cliffs, N.J.: Prentice-Hall, Foundations of Philosophy Series.
Allison, Philip
 1956 The Last Days of Old Oyo. Odù 4:18.
Ames, David W.
 1965 Hausa Drums of Zaria. Ibadan 21:62–79.
 1967 Music and the Musician in Igbo and Hausa Societies: A Comparative Examination. Paper read before the UCLA African Studies Center Colloquium on "Critical Standards for the African Arts."
 1968a Professionals and Amateurs: The Musicians of Zana and Obimo. African Arts/Arts d'Afrique 1:40–45, 80–84.
 1968b Anthology of African Music: The Music of Nigeria, Hausa Music. UNESCO Collection, Vol. I, Bahrenreiter Musicaphon, BM 30 L 2307.
 1969 Anthology of African Music: The Music of Nigeria, Hausa Music. UNESCO Collection, Vol. II, Bahrenreiter Musicaphon, BM 30 L 2307.
Ames, David W. and A. V. King
 1971 Glossary of Hausa Music and its Social Contexts. Evanston, Ill.: Northwestern University Press.

Ames, David W., Edgar Gregersen, and Thomas Neugebauor
 1971 Taaken Saman: A Drum Language of Hausa Youths. *Africa* 41.
Antubam, K.
 1963 *Ghana's Heritage of Culture*. Leipzig: Koehler and Amelang.
Baensch, Otto
 1961 Art and Feeling. In Susan Langer (ed.), *Reflections on Art*. New
 York: Oxford University Press, Galaxy Books. Pp. 10–36.
Ballard, Edward G.
 1957 *Art and Analysis*. The Hague: Martinus Nijhoff.
Barnett, James H.
 1959 The Sociology of Art. In Robert K. Merton, Leonard Broom, and
 Leonard S. Cottrell, Jr. (eds.), *Sociology Today*. New York: Basic
 Books. Pp. 197–214.
Barth, Henry.
 1857 *Travels and Discoveries in North and Central Africa 1849–1855*.
 New York: Harper and Bros.
Bascom, William
 1951 Social Status, Wealth and Individual Differences Among the
 Yoruba. *American Anthropologist* 53(4):490–505.
 1955 Verbal Art. *Journal of American Folklore* 68:245–52.
 1959 Urbanism as a Traditional African Pattern. *Sociological Review*
 7(1):29–43.
 1960 Yoruba Concepts of the Soul. In A. F. C. Wallace (ed.), *Men
 and Cultures*. (Selected Papers of the Fifth International Con-
 gress of Anthropological and Ethnological Sciences) Philadel-
 phia: University of Pennsylvana Press. Pp. 401–10.
 1967 *African Arts*. Berkeley, Calif.: Robert H. Lowie Museum of
 Anthropology.
 1969a *Ifa Divination: Communication Between Gods and Men in
 West Africa*. Bloomington: Indiana University Press.
 1969b Creativity and Style in African Art. In Daniel Biebuyck (ed.),
 Tradition and Creativity in Tribal Art. Berkeley and Los An-
 geles: University of California Press. Pp. 98–119.
 1969c *The Yoruba of Southwestern Nigeria*. New York: Holt, Rinehart
 and Winston.
 1969d The Art of Black Africa. *Carnegie Magazine* 43:293–98.
Bascom, William and Melville J. Herskovits (eds.)
 1959 *Continuity and Change in African Cultures*. Chicago: University
 of Chicago Press.
Bastin, Marie-Louise
 1961 *Art décoratif Tshokwe*. Subsídios para a História, Arqueologia e
 Etnografia dos Povos da Lunda, Museu do Dundo, Publicações
 Culturais, No. 55. Lisboa.
Baumann, H. von
 1935 *Lunda: bei Bauern und Jägern in Inner-Angola*. Ergebnisse der

Angola-Expedition des Museums für Völkerkunde. Berlin: Würfel.

Beardsley, Monroe C.

1958 *Aesthetics: Problems in the Philosophy of Criticism.* New York: Harcourt, Brace.

Becker, Howard S.

1963 *Outsiders.* New York: The Free Press of Glencoe.

Beier, Ulli

1963 *African Mud Sculpture.* Cambridge: Cambridge University Press.

Beier, Ulli and Bakare Gbadamosi

1959 *Yoruba Poetry.* Lagos: Black Orpheus.

Bendix, Reinhold

1960 *Max Weber.* Garden City, N.Y.: Doubleday.

Benjamin, Walter

1936 L'Œuvre d'art à l'époque de sa reproduction mécanisée. *Zeitschrift für Sozialforschung* 5:40–68.

Bensman, Joseph and Israel Gerver

1958 Art and the Mass Society. *Social Problems* 6:4–10.

Berger, Morroe

1964 *Madame de Stael: On Politics, Literature and National Character.* Garden City, N.Y.: Doubleday.

Berger, Peter L.

1963 *Invitation to Sociology.* New York: Doubleday.

Biobaku, Saburi O.

1955 The Use and Interpretation of Myths. *Odù* 1:12–17.

Boas, Franz

1927 *Primitive Art.* Cambridge: Harvard University Press. (Reprinted by Dover Publications in 1955)

1948 *Race, Language and Culture.* New York: Macmillan, 2nd edition.

Bohannan, Paul

1961 Artist and Critic in an African Society. In Marian W. Smith (ed.) *The Artist in Tribal Society.* London: Routledge and Kegan Paul. Pp. 85–94.

1964 *Africa and Africans.* Garden City, N.Y.: Natural History Press.

Boone, Olga

1951 Les Tambours du Congo Belge et du Ruanda-Urundi. Tervueren: *Annales du Musée du Congo Belge, Nouvelle Série 40, Sciences de l'Homme, Ethnographie,* Vol. 1.

Boskoff, Alvin

1957 From Social Thought to Sociological Theory. In Howard Becker and Alvin Boskoff (eds.), *Modern Sociological Theory.* New York: Dryden Press. Pp. 3–32.

Bowdich, T. E.

1819 *Mission from Cape Coast Castle to Ashanti.* London: Murray.

Bowen, T. J.
　1858　*Grammar and Dictionary of the Yoruba Language.* Washington, D.C.: Smithsonian Contributions to Knowledge.

Bücher, Karl
　1909　*Arbeit und Rhythmus.* 4th ed. Leipzig and Berlin: B, G. Teubner.

Bullough, Edward
　1913　"Psychical Distance" as a Factor in Art and an Esthetic Principle. *British Journal of Psychology* 5:87–118. [Reprinted in Melvin Rader (ed.), *A Modern Book of Esthetics.* New York: Henry Holt. Pp. 401–28.]

Bunzel, Ruth
　1929　The Pueblo Potter: A Study of Creative Imagination in Primitive Art. In Ruth Bunzel (ed.), *Columbia University Contributions to Anthropology,* No. 8.

Burtt, E. A.
　1962　The Value Presuppositions of Science. In Paul C. Obler and Herman A. Estrin (eds.), *The New Scientist.* New York: Doubleday. Pp. 258–79.

Carpenter, Edmund, Frederick Varley, and Robert Flaherty
　1959　*Eskimo.* Toronto: University of Toronto Press.
　1965　Comments. *Current Anthropology* 6:55–66.

Carroll, Father Kevin
　1961　Three Generations of Yoruba Carvers. *Ibadan* 12.
　1967　*Yoruba Religious Carving: Pagan and Christian Sculpture in Nigeria and Dahomey.* London: Geoffrey Chapman.

Cerulli, Ernesta
　1956　L'inizione al mestiere di fabbro in Africa. *Studi e Materiali di Storia delle Religioni* 27:87–101.
　1957　Il fabbro Africano, eroe culturale. *Studi e Materiali di Storia delle Religioni* 28(2):79–113.

Cherry, Colin
　1961　*On Human Communication.* New York: John Wiley & Sons, Science Editions.

Claerhout, Adriaan G. H.
　1965　The Concept of Primitive Applied to Art; Discussion of a Problem Posed by Adriaan G. H. Claerhout. *Current Anthropology* 6:432–38.

Clément, Pierre
　1948　Le Forgeron en Afrique Noir. *La Revue de Géographie Humaine et d'Ethnologie* 2:35–58.

Cline, Walter
　1937　Mining and Metallurgy in Negro Africa. *General Series in Anthropology* No. 5. Menasha, Wisc.: George Banta.

Cohen, Yehudi A.
 1964 Sculpture and Social Structure. Paper read at 63rd annual meeting of the American Anthropological Association, Detroit, November 19–22.
Collier, F. S.
 1953 Yoruba Hunters' Salutes. *Nigerian Field* 18(2):1.
Cooley, Charles Horton
 1966 *Social Process*. Carbondale: Southern Illinois University Press, Arcturus Books.
Cordwell, Justine Mayer
 1952 Some Aesthetic Aspects of Yoruba and Benin Cultures. Unpublished doctoral dissertation, Northwestern University, Evanston, Ill.
Coser, Lewis A.
 1965 *Georg Simmel*. Englewood Cliffs, N.J.: Prentice-Hall.
Crowley, Daniel J.
 1954 Form and Style in a Bahamian Folktale. *Caribbean Quarterly* 3(4):218–34.
 1958 Aesthetic Judgement and Cultural Relativism. *Journal of Aesthetics and Art Criticism* 17(2):817–24.
 1959 L'Héritage africaine dans les Bahamas. *Présence Africaine* Dec.-Jan.:41–58.
 1961 Folklore Research in the Congo. *Journal of American Folklore* 84(294):457–60.
 1962a Annotated Bibliography of African Oral Literature. *African Studies Bulletin* (Special issue on Arts, Human Behavior and Africa; Alan P. Merriam, ed.) 5(2):43–441.
 1962b Negro Folklore: An Africanist's View. *Texas Quarterly* 5(3): 65–71.
 1963 Politics and Tribalism in the Katanga. *Western Political Quarterly* 16(1):58–78.
 1971 An African Aesthetic. *Journal of Aesthetics and Art Criticism* 24(4) (Summer, 1966):519–24. Reprinted in Carol F. Jopling (ed.), *Art and Aesthetics in Primitive Societies*. New York: Dutton. Pp. 315–27.
 1972 Chokwe: Political Art in a Plebian Society. In Douglas Fraser and Herbert M. Cole (eds.), *African Art and Leadership*. Madison: University of Wisconsin Press. Pp. 21–40.
Dalby, David
 1965 The Mel Languages: A Reclassification of Southern "West Atlantic." *African Language Studies* 6:1–17.
Dalziel, J. M.
 1937 *The Useful Plants of Tropical West Africa*. London: The Crown Agents for the Colonies.

Danquah, J. B.
 1928 Akan Laws and Customs and the Akim Abuakwa Constitution.
 London: Routledge.
D'Avezac, M.
 1845 Notice sur le pays et le peuple des Yebous en Afrique. Mémoires
 de la Société Ethnologique, II. Paris.
d'Azevedo, Warren L.
 1958 A Structural Approach to Esthetics: Toward a Definition of Art
 in Anthropology. American Anthropologist 60:702–14.
 1959 The Setting of Gola Society and Culture: Some Theoretical
 Implications of Variation in Time and Space. The Kroeber An-
 thropological Society Papers 21:43–125.
 1962a Some Historical Problems in the Delineation of a Central West
 Atlantic Region (Africa). In Anthropology and Africa Today,
 Annals of the New York Academy of Sciences 96:512–38.
 1962b Common Principles of Variant Kinship Structures Among the
 Gola of Western Liberia. American Anthropologist 64:504–20.
 1962c Uses of the Past in Gola Discourses. Journal of African History
 1:11–34.
 1966 The Artist Archetype in Gola Culture. Desert Research Institute
 Preprint No. 14, University of Nevada (Revised and reissued,
 1970).
 1973 Mask Makers and Myth in Western Liberia. In Anthony Forge
 (ed.), Primitive Art and Society. London: Oxford University
 Press. (In press).
DeMille, Agnes
 1962 To a Young Dancer. Boston: Little, Brown, and Co.
Dellille, A. and A. Burssens
 1935 Tshokwe Teksten. Kongo Overzee II(1):41–60.
Devereux, George
 1961 Art and Mythology. In Bert Kaplan (ed.), Studying Personality
 Cross-Culturally. New York: Harper and Row. Pp. 361–86.
Dilthey, Wilhelm
 1933 Von deutscher Dichtung und Musik: Aus den Studien der Ge-
 schichte des deutschen Geistes. Leipzig.
Dodds, E. R.
 1957 The Greeks and the Irrational. Boston: Beacon Press.
Dodwell, C. B.,
 1955 Iseyin, the Town of Weavers. Nigeria 64:118–43.
Donner, Etta [Becker-Donner]
 1940 Kunst und Handwerk in Nordost-Liberia. Berlin: Baessler Archiv,
 B. 23.
Duvignaud, Jean
 1959 Problèmes de sociologie de la sociologie des arts. Cahiers Inter-
 nationaux de Sociologie 16:137–48.

Eliade, Mircea
 1962 *The Forge and the Crucible*. Translated by Stephen Corrin. New York: Harper and Bros.
Enzer, Hyman
 1965 Gambits and Paradigms: Sociology and the Beaux Arts. *Art in Society* 3:412–24.
Ettman, Henry
 1966 A Consistency Approach to Role Conflict Resolution and its Application to the Study of Role Conflict in the Jazz Community. Unpublished master's thesis in sociology, University of Nevada.
Etzkorn, K. Peter
 1964 The Relationship Between Musical and Social Patterns in American Popular Music. *Journal of Research in Music Education* 12(4):279–86.
 1964b Georg Simmel and the Sociology of Music. *Social Forces* 43: 101–7.
 1966 On Esthetic Standards and Reference Groups of Popular Songwriters. *Sociological Inquiry* 36:39–47.
Evans-Pritchard, E. E.
 1940 *The Nuer*. London: Oxford University Press.
Fagan, Brian N.
 1965 Radiocarbon Dates from Sub-Saharan Africa. *The Journal of African History* 6:107–16.
Fagg, William
 1963 *Nigerian Images*. London: Lund Humphries.
Fagg, William and Eliot Elisofon
 1958 *Sculpture of Africa*. New York: Praeger.
Fagg, William and Margaret Plass
 1964 *African Sculptures*. New York: Dutton.
Fernandez, James W.
 1965a The Idea and Symbol of the Savior in a Gabon Sycretist Cult. *Int. Review of Missions* 53(211):281–89.
 1965b Symbolic Consensus in a Fang Reformative Cult. *American Anthropologist* 67(4):902–29.
 1966a Unbelievably Subtle Words: Representation and Intergration in the Sermons of an African Reformative Culture. *History of Religions* 6(1):43–69.
 1966b Principles of Opposition and Vitality in Fang Aesthetics. *Journal of Aesthetics and Art Criticism* 25(1):53–64.
Fernandez, James W. and P. Behale
 1962 Christian Acculturation and Fang Witchcraft. *Cahiers d'Etudes Africaines* 6:244–70.
Firth, Raymond
 1936 *Art and Life in New Guinea*. London: The Studio Limited.
 1951 *Elements of Social Organization*. London: Watts and Co.

Fischer, Eberhard
 1962 *Künstler der Dan*. Baessler-Archiv, Neue Folge, Band 10.
 1963 *Die Töpferei bei den westlichen Dan*. Sonderdruck: Zeitschrift
 für Ethnologie, Band 88, Heft 1, Braunschweig.
Fischer, John L.
 1963 The Sociopsychological Analysis of Folktales. *Current Anthro-
 pology* 4(3):235–95.
Forge, Anthony (ed.)
 1973 *Primitive Art and Society*. London: Oxford University Press.
 (In press).
Frobenius, Leo
 1899 *Die Masken und Geheimbünde Africas*. Nova Acta, Abhand-
 lungen der Kaiserlichen Leopoldinisch-Carolinischen Deutschen
 Adademie der Naturforscher, Vol. 74.
 1928 *Atlantis*, Vol. 12, Dicht-kunst der Kassaiden. Jena.
Fuja, Abayomi
 1962 *Fourteen Hundred Cowries: Traditional Stories of the Yoruba*.
 London: Oxford University Press.
Galletti, R., K. D. S. Baldwin, and I. O. Dina
 1955 *Nigerian Cocoa Farmers*. London: Oxford University Press.
Galley, Samuel
 n.d. *Dictionnaire Français-Fang–Fang-Français*. Neuchâtel.
Gallie, W. B.
 1968 *Philosophy and the Historical Understanding*. New York:
 Schocken Books.
Gamble, D. P.
 1957 *The Wolof of Senegambia*. London: International African Insti-
 tute.
Gardi, René
 1956 *Mandara: Unbekanntes Bergland in Kamerun*. Zürich: Orell
 Füssli Verlag.
Geertz, C.
 1957 Ritual and Social Change: A Javanese Example. *American An-
 thropologist* 59:32–54.
Gendin, Sidney
 1964 The Artist's Intentions. *Journal of Aesthetics and Art Criticism*
 23(2):193–96.
Gerbrands, A. A.
 1957 *Art as an Element of Culture, Especially in Negro-Africa*. Leiden:
 E. J.Brill.
Gerth, H. H. and C. Wright Mills
 1958 *From Max Weber: Essays in Sociology*. New York: Oxford
 University Press.
Goffman, Erving
 1961 *Encounters*. Indianapolis: Bobbs-Merrill.

Grebert, F.
1921 *Au Gabon.* Paris.

Guthrie, Malcom
1953 *The Bantu Languages of Western Equatorial Africa.* London:
Wm. Dawson.

Guyau, M.
1920 *L'Art au point de vue sociologique.* Paris: Librairie Felix Alcan,
1887, 11th Edition.

Harley, G. W.
1941 Notes on Poro in Liberia. *Papers of the Peabody Museum* 19(2).
Cambridge: Harvard University Printing Office.

1950 Masks as Agents of Social Control in Northeast Liberia. *Papers of
the Peabody Museum* 32(2). Cambridge: Harvard University
Printing Office.

Haselberger, Herta
1961 Method of Studying Ethnological Art. *Current Anthropology*
2:341–84.

Herskovits, Melville J.
1926 Negro Art: African and American. *Social Forces* 5(3):291–98.
1938 *Dahomey,* Vols. I and II. New York: J. J. Augustin.
1941 El estudio de la musica negra en el hemisferia occidental. *Boletin
Latino Americano de Musica* 5:133–42.
1944 Dramatic Expression Among Primitive Peoples. *Yale Review*
33(4):683–98.
1946 *Backgrounds of African Art.* Denver, Col.: Denver Art Museum.
1948 *Man and His Works.* New York: Alfred A. Knopf (reprinted
1951).
1949 Afro-American Art. In E. Wilder (ed.), *Studies in Latin Ameri-
can Art.* Washington, D.C.: American Council of Learned
Societies.
1952 *Economic Anthropology.* New York: Alfred A. Knopf.
1959a Anthropology and Africa: A Wider Perspective. *Africa* 29:
225–38.
1959b Art and Value. In Robert Redfield, Melville J. Herskovits, and
Gordon F. Eckholm (eds.), *Aspects of Primitive Art.* New York:
The Museum of Primitive Art. Pp. 41–68.
1961 The Study of African Oral Art. *Journal of American Folklore*
74(294):451–56.

Herskovits, Melville J. and Frances S. Herskovits
1930 Bush Negro Art. *The Arts* 17(1):25–37, 48–49.
1934 The Art of Dahomey. *The American Magazine of Art,* Part I—
27(2):67–76, Part II—27(3):124–31.
1958 *Dahomean Narrative, a Cross-Cultural Analysis.* Evanston, Ill.:
Northwestern University Press.

Hertzler, Joyce O.
 1961 *American Social Institutions*. Boston: Allyn and Bacon.
Himmelheber, Hans
 1935 *Negerkünstler*. Stuttgart: Strecker and Schröder.
 1939 Arts et artistes Batschick. *Brousse* 3:17–31.
 1960 *Negerkunst und Negerkünstler*. Braunschweig: Klinkgardt and
 Biermann.
 1963a *Die Masken der Guere im Rahmen der Kunst des oberen Cavally-
 Gavietes*. Sonderdruck: Zeitschrift für Ethnologie, Band 88, Heft
 2, Braunschweig.
 1963b Personality and Technique of African Sculptors. In *Technique
 and Personality*. New York: Museum of Primitive Art. Pp. 79–
 110.
 1964 *Die Geister und ihre irdischen Verkörperungen als Grundvor-
 stellung in der Religion der Dan*. Baessler-Archiv, Neue Folge,
 Band 12.
Hodges, H. A.
 1944 *Wilhelm Dilthey: An Introduction*. London: Routledge and
 Kegan Paul.
Hodgkin, Thomas
 1960 *Nigerian Perspectives: An Historical Anthropology*. London:
 Oxford University Press.
Hoffmann, Carl
 1963 *A Grammar of the Margi Language*. London: Oxford University
 Press.
Hospers, John
 1954–1955 The Concept of Artistic Expression. *Proceedings of the
 Aristotelian Society* 55.
Hoyt, Elizabeth E.
 1961 Integration of Culture: A Review of Concepts. *Current Anthro-
 pology* 2:407–26.
Hsu, Francis L. K.
 1964 Rethinking the Concept 'Primitive.' *Current Anthropology* 5(3):
 169–78.
Huizinga, J.
 1950 *Homo Ludens, a Study of the Play-Element in Culture*. Boston:
 Beacon Press.
Ivins, W. M.
 1948 A Note on Ipseity. *Journal of Aesthetics and Art Criticism*
 7:38–41.
Jaspert, F. and W. Jaspert
 1930 *Die Völkerstämme Mittel-Angolas*. Frankfurt.
John, J. T.
 1952 Village Music of Sierra Leone. *West African Review* 23:1043–45,
 1071.

Johnson, Samuel
1921 *The History of the Yorubas*. Lagos: Church Missionary Society Bookshop.
Kaplan, Abraham
1959 Philosophic Sense and Mystic Sensibility. *Proceedings and Addresses of the American Philosophical Association* 32:41–64.
1961 *The New World of Philosophy*. New York: Vintage Books.
Kaplan, Arlene
1955 Folksinging in a Mass Society. *Sociologus* 5:14–28.
Kavolis, Vytautas
1965 The Value-Orientations Theory of Artistic Style. *Anthropological Quarterly* 34(1):1–19.
King, A .V.
1961 *Yoruba Sacred Music from Ekiti*. Ibadan: Ibadan University Press.
1965 Music Tradition in a Changing Society. Paper read before the Second Annual Seminar on African Music, University of Nigeria, Nsukka.
Kirk-Greene, A. H. M.
1955 On Swearing: An Account of Some Judicial Oaths in Northern Nigeria. *Africa* 25:49.
1962 The Walls of Zaria. *Craft Horizons* 22:20–27.
Kluckhohn, Florence Rockwood and Fred L. Strodtbeck
1961 *Variations in Value Orientations*. Evanston, Ill.: Row, Peterson.
König, Rene and Alphons Silbermann
1964 *Der unversorgte selbständige Künstler*. Köln-Berlin: Deutscher Arzte Verlag.
Kroeber, A. L.
1944 *Configurations of Culture Growth*. Berkeley and Los Angeles: University of California Press.
1953 Concluding Review. In Sol Tax, Loren C. Eiseley, Irving Rouse, and Carl F. Voegelin (eds.), *An Appraisal of Anthropology Today*. Chicago: University of Chicago Press. Pp. 357–76.
Kroeber, A. L. and Talcott Parsons
1958 The Concepts of Culture and of Social System. *American Sociological Review* 23:582–83.
Kubie, Lawrence S.
1958 *Neurotic Distortion of the Creative Process*. Lawrence: University of Kansas Press.
Kubler, George
1961 Comments. *Current Anthropology* 2:370.
Kyerematin, A.
1964 *Panoply of Ghana*. London: Longmans Green & Co.

Ladd, John
 1957 *The Structure of a Moral Code*. Cambridge: Harvard University Press.
 1967 The Issue of Relativism. *Monist* 47(4).

Lagercrantz, Sture
 1950 Contributions to the Ethnography of Africa. *Studia Ethnographica Upsaliensia*. Volume 1.

Lalo, Charles
 1952 *Notions d'esthétique*. 4th ed. Paris: Presses Universitaires de France.

Langfeld, Herbert S.
 1936 The Place of Aesthetics in Social Psychology. *British Journal of Psychology* 27:135–47.

Lasebikan, E. L.
 1956 The Tonal Structure of Yoruba Poetry. *Présence Africaine* 8–10.

Leach, Edmund
 1954 Aesthetics. In E. E. Evans-Pritchard, *et al.* (eds.), *The Institutions of Primitive Society*. Glencoe, Ill.: Free Press. Pp. 25–38.

Lee, Dorothy
 1959 *Freedom and Culture*. Englewood Cliffs, N.J.: Prentice-Hall.
 1960 Review of *Eskimo* by Carpenter, Varley, and Flaherty. *American Anthropologist* 62:165–67.

Lee, Harry B.
 1947 The Cultural Lag in Aesthetics. *Journal of Aesthetics and Art Criticism* 6:120–38.

Lenk, Kurt
 1961 Zur Methodik der Kunstsoziologie. *Kölner Zeitschrift für Soziologie und Sozialpsychologie* 13:413–25.

Lévi-Strauss, Claude
 1962 *La Pensée sauvage*. Paris: Librairie Plon.

Lin, Yutang
 1942 *The Wisdom of China and India*. New York: Random House.

Linton, Ralph
 1958 Primitive Art. In William Fagg and Eliot Elisofson (eds.), *The Sculpture of Africa*. New York: Praeger. Pp. 9–17.

Little, Kenneth
 1948 A Mende Musician Sings of His Adventures. *Man* 48:26–27.

Lloyd, Peter C.
 1962 Sungbo's Ersko. *Odù* 7:15–22.

Lowie, Robert H.
 1924 *Primitive Religion*. New York: Boni and Liveright.

Maes, J. et O. Boone
 1935 Les peuplades du Congo Belge: Nom et situation géographique. Tervueren: Musée du Congo Belge, *Publications du Bureau de*

Documentation Ethnographique, Série 2—Monographies Idé-
ologiques, Vol. 1.

Manheim, Ernest
1964 The Communicator and his Audience. In Werner J. Cahman
and Alvin Boskoff (eds.), *Sociology and History: Theory and
Research*. New York: Free Press of Glencoe. Pp. 503–15.

Mannheim, Karl
1963 The Ideological and the Sociological Interpretation of Intellectual
Phenomena. Kurt H. Wolff, translator. *Studies on the Left*
3:54–66.

Margolis, Joseph
1965 *The Language of Art and Art Criticism: Analytic Questions in
Aesthetics*. Detroit: Wayne State University Press.

Martins, João Vicente
1951 Subsídios Etnográficos para a história dos Povos de Angola:
Ikuma ñi mianda iá Tutchokue. (Provérbios e Ditos dos Quio-
cos). Lisboa.

McAllester, D.
1954 *Enemy Way Music*. Cambridge, Mass.: Peabody Museum.

McCulloch, Merran.
1951 The Southern Lunda and Related Peoples. *Ethnographic Survey
of Africa. West Central Africa, Part I*, International African
Institute. London.

McLeod, Norma
1964 The Status of Musical Specialists in Madagascar. *Ethnomusicol-
ogy* 8(3):278–99.

McLuhan, Marshall
1964 *Understanding Media*. New York: McGraw-Hill.

Meek, C. K.
1931 *Tribal Studies in Northern Nigeria*. London: Kegan Paul.

Merriam, Alan P.
1954 Song Texts of the Bashi. *Zaire* 8:27–43.
1955 The Use of Music in the Study of a Problem of Acculturation.
American Anthropologist 57:28–34.
1959 African Music. In William R. Bascom and Melville J. Herskovits
(eds.), *Continuity and Change in African Cultures*. Chicago:
University of Chicago Press.
1960 Ethnomusicology: Discussion and Definition of the Field. *Ethno-
musicology* 4:107–14.
1961 Death and the Religious Philosophy of the Basongye. *Antioch
Review* 21:293–304.
1962 The Epudi: A Basongye Ocarina. *Ethnomusicology* 6:175–80.
1964 *The Anthropology of Music*. Evanston, Ill.: Northwestern Uni-
versity Press.

1969 The Ethnographic Experience: Drum-Making Among the Bala
 (Basongye). *Ethnomusicology* 13:74–100.
1971a *African Music on LP: An Annotated Discography*. Evanston, Ill.:
 Northwestern University Press.
1971b Aspects of Sexual Behavior Among the Bala (Basongye). In
 Donald S. Marshall and Robert C. Suggs (eds.), *Human Sexual
 Behavior: Variations in the Ethnographic Spectrum*. New York:
 Basic Books. Pp. 71–102.

Messenger, John C.
1957 *Anang Acculturation: A Study of Shifting Cultural Focus*. Ann
 Arbor, Michigan: University Microfilms, Pub. No. 23525. Pp.
 24–195.
1959 Religious Acculturation Among the Anang Ibibio. In William R.
 Bascom and Melville J. Herskovits (eds.), *Continuity and
 Change in African Cultures*. Chicago: University of Chicago
 Press. Pp. 279–99.
1962 Anang Art, Drama, and Social Control. *African Studies Bulletin*
 5(2):29–35.
1971 Ibibio Drama. *Africa* 61(13):208–22.

Mierendorff, Marta
1957 Über den gegenwärtigen Stand der Kunstsoziologie in Deutsch-
 land. *Kölner Zeitschrift für Soziologie und Sozialpsychologie*
 9:397–412.

Mills, C. Wright
1943 The Professional Ideology of Social Pathologists. *American Jour-
 nal of Sociology* 49:165–80.

Mills, George
1957 Art: An Introduction to Qualitative Anthropology. *Journal of
 Aesthetics and Art Criticism* 16:1–17.
1959 *Navaho Art and Culture*. Colorado Springs: Taylor Museum of
 the Colorado Springs Fine Arts Center.

Montenez, P.
1939 Quelques contes et fables des Tshokwe. *Brousse* 4.

Morgan, Douglas N.
1950 Psychology and Art Today: A Summary and Critique. *Journal
 of Aesthetics and Art Criticism* 9:81–96.

Mueller, John H.
1934 *Studies in Appreciation of Art*. Eugene, Ore.: University of Ore-
 gon, Studies in College Teaching, Bulletin 3.
1935 Is Art the Product of Its Age? *Social Forces* 13:367–75.
1938 The Folkway of Art: An Analysis of the Social Theories of Art.
 American Journal of Sociology 44:222–38.
1954 Baroque: Is it Datum, Hypothesis, or Tautology? *Journal of Aes-
 thetics and Art Criticism* 12:421–37.

Munro, Thomas
 1948 Methods in the Psychology of Art. *Journal of Aesthetics and Art Criticism* 6:225–35.
 1951 *The Arts and Their Interrelations.* New York: The Liberal Arts Press.
 1963 The Psychology of Art: Past, Present, Future. *Journal of Aesthetics and Art Criticism* 2:263–82.
Murray, Kenneth
 n.d. Notes on the Arts and Crafts of Lagos and Colony. Unpublished manuscript.
 1938? Native Minor Industries in Abeokuta and Oyo Provinces. Unpublished manuscript. Lagos.
 1961 The artist in Nigerian tribal society: A comment. In Marian W. Smith (ed.), *The Artist in Tribal Society.* New York: Free Press of Glencoe.
Nketia, J. Kwabena
 1955 *Funeral Dirges of the Akan People.* University of Ghana.
 1958a Yoruba Musicians in Accra. *Odù* 6:35–44.
 1958b Akan Poetry. *Black Orpheus* 3:1–17.
 1961 African Music. *AMSAC Newsletter* 3:4–8.
 1962a The Problem of Meaning in African Music. *Ethnomusicology* 4(1):1–13.
 1962b *African Music in Ghana.* Accra: Longmans.
 1963 *Drumming in Akan Communities of Ghana.* Edinburgh: Thomas Nelson and Sons.
 1963b *Folksongs in Ghana.* London: Oxford University Press.
 1964 Unity and Diversity in African Music: A Problem of Synthesis. *The Proceedings of the First International Congress of Africanists.* Pp. 256–63.
 n.d. *The Sound Instruments of Ghana.* (Unpublished manuscript.)
O'Casey, Sean
 1965 The Wit and Wisdom of Sean O'Casey. *Show* 5:50.
Olbrechts, Frans M.
 1933 Notre mission ethnographique en Afrique Occidentale Française. *Bulletin des Musées d'Arts et d'Histoire* 5:98–107.
 1959 *Les Arts plastiques du Congo Belge.* Bruxelles: Editions Erasme.
Ottenberg, Simon and Phoebe Ottenberg
 1960 *Cultures and Societies of Africa.* New York: Random House.
Palmer, H. R.
 1908 The Kano Chronicle. *Journal of the Royal Anthropological Institute* 38:65.
Panofsky, Erwin
 1955 *Meaning in the Visual Arts.* Garden City, N.Y.: Doubleday.

Parsons, Talcott and Edward Shils (eds.)
 1954 *Toward a General Theory of Action*. Cambridge: Harvard University Press.
Pierce, John R.
 1965 *Symbols, Signals and Noise*. New York: Harper & Row, Harper Torchbooks.
Radcliffe-Browne, A. R.
 1952 *Structure and Function in Primitive Society*. Glencoe, Ill.: Free Press.
Radin, Paul
 1927 *Primitive Man As a Philosopher*. New York: D. Appleton-Century Co.
Rank, Otto
 1932 *Art and the Artist*. Translated from the German by C. F. Atkinson. New York: Alfred A. Knopf.
 1959 *Otto Rank: The Myth of the Birth of the Hero, and Other Writings*. (Philip Fred, ed.). New York: Alfred A. Knopf.
Read, Sir Herbert
 1963 *To Hell with Culture*. New York: Schocken Books.
Redfield, Robert
 1953 *The Primitive World and Its Transformations*. Ithaca, N.Y.: Great Seal Books.
 1962 Introduction to Values. In Margaret Park Redfield (ed.), *Human Nature and the Study of Society*. Chicago: University of Chicago Press. Pp. 98–101.
Redinha, José
 1953 *Paredes pintadas da Lunda*. Lisboa: Publicações Culturais da Companhia de Diamantes de Angola
 1956 *Máscaras de madeira da Lunda e Alto Zambeze*. Subsídios para a História, Arqueologia e Etnografia dos Povos de Lunda, Museu do Dundo, Publicações Culturais, No. 31.
Rosenberg, Bernard and Norris Fliegel
 1965 *The Vanguard Artist: Portrait and Self-Portrait*. Chicago: Quadrangle Books.
Roth, Ling
 1903 *Great Benin*. Halifax: F. King and Sons
Samain, A.
 1923 *La Langue Kisonge: Grammaire–vocabulaire–proverbes*. Bruxelles: Goemaere, for Bibliothèque-Congo 14.
Sassoon, Hamo
 1964 Iron-Smelting in the Hill Village of Sukur, Northeastern Nigeria. *Man* 64, Art. 215.
Sauermann, Heinz
 1931 Soziologie der Kunst. In K. Kunkmann (ed.), *Lehrbuch der Soziologie und Sozialpsychologie*. Berlin.

Schaeffner, Andre
1951 *Les Kissi: Une société noire et ses instruments de musique.* Paris: Hermann et Cie.

Schneider, Harold K.
1956 The Interpretation of Pakot Visual Art. *Man* 56(108):103–6.

Schuecking, Levin L.
1944 *Die Soziologie der Geschmacksbildung.* [tr. *The Sociology of Literary Taste.*] New York: Oxford University Press.

Seashore, Carl E.
1938 *Psychology of Music.* New York: McGraw-Hill.

Segall, Marshall H., Donald T. Campbell and Melville J. Herskovits
1966 *The Influence of Culture on Visual Perception.* New York: Bobbs-Merrill.

Sieber, Roy
1959 The Esthetic of Traditional African Art. In F. Rainey (ed.), *Seven Metals in Africa.* Philadelphia.
1962 The Arts and Their Changing Social Function. In *Anthropology and Africa Today*, Annals of the New York Academy of Sciences 96(2):653–58.
1965 The Visual Arts. In Robert A. Lystad (ed.), *The African World: a Survey of Research.* New York: Praeger. Pp. 442–52.

Sieber, Roy and Arnold Rubin
1968 *Sculpture of Black Africa.* The Paul Tishman Collection. Los Angeles: Los Angeles County Museum of Art.

Silbermann, Alphons
1963 *The Sociology of Music.* New York: International Publishers.

Simirenko, Alex
1965 Critique of Party Charisma. *Indian Sociological Bulletin* 3:75–78.

Simmel, Georg
1882 Psychologisch und ethnologische Studien über Musik. *Zeitschrift für Völkerpsychologie und Sprachwissenschaft* 13:261–305.
1906 Über die dritte Dimension in der Kunst. *Zeitschrift für Aesthetik* 1:65–69.
1922 Der Schauspieler und die Wirklichkeit. *Berliner Tageblatt* 7.

Siu, R. G. H.
1957 *The Tao of Science.* New York: Massachusetts Institute of Technology and John Wiley and Sons.

Smith, M. G.
1957 The Social Functions and Meaning of Hausa Praise Singing. *Africa* 27:26–45.
1959 The Hausa System of Social Status. *Africa* 29:248.
1962 Exchange and Marketing Among the Hausa. In Paul Bohannan and George Dalton (eds.), *Markets in Africa.* Evanston, Ill.: Northwestern University Press, Pp. 299–334.

452 BIBLIOGRAPHY

Smith, M. W. (ed.)
 1961 *The Artist in Tribal Society.* Proceedings of a symposium held at
 the Royal Anthropological Institute. London: Routledge and
 Kegan Paul.
Sorokin, Pitirim
 1937– *Social and Cultural Dynamics.* 4 vol. New York: American Book
 1941 Company.
 1957 *Social and Cultural Dynamics.* Abridged, one volume. Boston:
 Porter Sargent, Extending Horizon Books.
Spiro, Melford E.
 1968 Religion: Problems of Definition and Explanation. In M. Banton
 (ed.), *Anthropological Approaches to the Study of Religion.*
 London: Tavistock Publications. Pp. 85–126.
Spykman, Nicholas J.
 1925 *The Social Theory of Georg Simmel.* 1966 reprint. New York:
 Atherton Press, Atheling Books.
Stevenson, C. L.
 1944 *Ethics and Language.* New Haven, Conn.: Yale University Press.
Talbot, Amaury
 1926 *The Peoples of Southern Nigeria.* Vol. II. London: Oxford Uni-
 versity Press.
Tessmann, Günther
 1913 *Die Pangive Völkerkundliche Monographie eines Westafrikan-
 ischen Negerstammes.* Berlin.
Thompson, Laura
 1945 Logico-Aesthetic Integration in Hopi Culture. *American Anthro-
 pologist* 47:540–53.
Thompson, Robert F.
 1965 *Dance Sculpture of the Yoruba: Its Critics and Contexts.* Unpub-
 lished dissertation, Yale University.
 1968 Aesthetics in Traditional Africa. *Art News* 66(9):44–45.
 1969a Moatan: A Master Potter of the Egbado Yoruba. In Daniel Bie-
 buyck (ed.), *Tradition and Creativity in Tribal Art.* Los Angeles:
 University of California Press.
 1969b African Influences on United States Art. In Armstead L. Robin-
 son (ed.), *Black Studies in the University: A Symposium.* New
 Haven, Conn.: Yale University Press.
Thompson, Robert F. and Herbert Cole
 1964 *Yoruba Sculpture: A Bibliography.* New York: Museum of
 Primitive Art.
Thurnwald, Richard
 1929 Anfänge der Kunst. In *Verhandlungen des 6. Deutschen Soziol-
 ogentages.* Tübingen: J. C. B. Mohr. Pp. 248–88.
Tietze, H.
 1925 Die soziale Funktion der Kunst. *Jahrbuch für Soziologie: Eine
 internationale Sammlung.* Karlsruhe: Braun Verlag 1:280–94.

Torday, E. and T. A. Joyce
 1922 *Les Basonge*. In Notes ethnographiques sur des populations habitant les bassins du Kasai et du Kwango Oriental. Bruxelles: Annales du Musée du Congo Belge, Ethnographie, Anthropolgie –Série III: Documents ethnographiques concernant les populations du Congo Belge, Tome II–Facsicule 2, Pp. 13–41.

Trimingham, J. Spencer
 1961 *Islam in West Africa*. London: Oxford University Press.

Tuden, Arthur and Leonard Plotnikov (eds.)
 1970 *Social Stratification in Africa*. New York: The Free Press.

Turner, Victor
 1961 Ritual Symbolism, Morality and Social Structure Among the Ndembu. *Rhodes-Livingstone Journal* 30:1–10.
 1962 Three Symbols of *Passage* in Ndembu Circumcision Ritual. In M. Gluckman (ed.), *Essays in the Ritual of Social Relations*. Manchester: Manchester University Press.
 1967 *The Forest of Symbols*. Ithaca and London: Cornell University Press.

Tutuola, Amos
 1952 *The Palm-Wine Drinkard*. London: Faber and Faber.
 1955 *Simbi and the Satyr of the Dark Jungle*. London: Faber and Faber.
 1962 *Feather Woman of the Jungle*. London: Faber and Faber.

Vandenhoute, P. J. L.
 1948 *Classification stylistique du masque Dan et Guéré de la Côte d'Ivoire Occidentale*. Leiden: E. J. Brill.

van Overbergh, Cyr
 1908 *Les Basonge*. Bruxelles: Collection de monographies ethnographiques III.

Vaughan, James H., Jr.
 1960 Rock Paintings and Rock Gongs Among the Marghi of Nigeria. *Man* 62, Art. 83.
 1964 Culture, History, and Grass-Roots Politics in a Northern Cameroons Kingdom. *American Anthropologist* 66:1078–95.
 1965 Folklore and Values in Marghi Culture. *Journal of Folklore Institute* 2:5–24.
 1970 Caste Systems of the Western Sudan. In Arthur Tuden and Leonard Plotnicov (eds.), *Social Stratification in Africa*. New York: The Free Press.

von Wiese, Leopold
 1931 Methodologisches über den Problemkreis einer Soziologie der Kunst. In *Verhandlungen des 7. Deutschen Soziologentages 1930*. Tübingen: J. C. B. Mohr. Pp. 121–32.

Weber, Max
 1958 *The Rational and Social Foundations of Music*. (Translation, edited by Don Martindale, Johannes Riedel and Gertrude Neu-

wirth.) Carbondale: Southern Illinois University Press.

1964 *The Sociology of Religion.* (Translated by Ephraim Fischoff.) Boston: Beacon Press.

Weir, N. A. C.

1933 *An Intelligence Report on Ogotun District, Ekiti Division, Ondon Province.* Lagos.

Weitz, Morris

1956 The Role of Theory in Aesthetics. *Journal of Aesthetics and Art Criticism* 15:27–35.

Westermann, D.

1921 *Die Gola-Sprache in Liberien.* Hamburg: L. Friederichen and Co.

Westermann, D. and Ida C. Ward

1933 *Practical Phonetics for Students of African Languages.* London: Oxford University Press.

Williams, Denis

1964 The Iconology of the Yoruba. *Africa* 34(2):139–66.

Williams, Raymond

1960 *Culture and Society.* Garden City, N.Y.: Doubleday, Anchor Books.

Wilson, Robert N.

1964 *The Arts in Society.* Englewood Cliffs, N.J.: Prentice-Hall.

Wingert, Paul S.

1950 *The Sculpture of Negro Africa.* New York: Columbia University Press.

1962 *Primitive Art: Its Traditions and Styles.* New York: Oxford University Press.

Wittgenstein, Ludwig

1953 *Philosophical Investigations.* (Translated by G. E. M. Anscombe.) New York: Macmillan.

Wolfe, Alvin W.

1969 Social Structural Bases of Art. *Current Anthropology* 10:3–44.

Wolff, Kurt H.

1950 *The Sociology of Georg Simmel.* Glencoe, Ill.: Free Press.

1955 *Conflict and the Web of Group Affiliations.* Glencoe, Ill.: Free Press.

1965 Hinnahme und Rebellion. *Kölner Zeitschrift für Soziologie und Sozialpsychologie* 17:909–36.

Wolff, Kurt H. (ed.)

1965 *Essays on Sociology, Philosophy and Aesthetics by Georg Simmel et al.* New York: Harper and Row, Harper Torchbooks, The Academy Library.

Ziff, Paul

1953 The Task of Defining a Work of Art. *Philosophical Review* 62:58–78.